REAL WORLD
DIGITAL
PHOTOGRAPHY

2ND EDITION

KATRIN EISMANN, SEÁN DUGGAN, TIM GREY

PEACHPIT PRESS
BERKELEY, CALIFORNIA

REAL WORLD DIGITAL PHOTOGRAPHY, 2ND EDITION

Katrin Eismann, Seán Duggan, Tim Grey

Copyright © 2004 by Katrin Eismann, Seán Duggan, Tim Grey

Peachpit Press
1249 Eighth Street
Berkeley, CA 94710
510/524-2178
800/283-9444
510/524-2221 (fax)

Find us on the World Wide Web at: www.peachpit.com
To report errors, please send a note to errata@peachpit.com
Peachpit Press is a division of Pearson Education

Editors: Anne Marie Walker, Becky Morgan
Production Editor: Hilal Sala
Copyeditor: Sally Zahner
Technical Editor: Wayne R. Palmer
Proofreaders: Liz Welch, Suzie Lowey
Compositors: Rick Gordon, Emerald Valley Graphics; Myrna Vladic, Bad Dog Graphics;
 Diana Van Winkle, Van Winkle Design Group
Illustrator: Jeff Wilson, Happenstance-Type-O-Rama
Cover design: Gee+Chung
Cover Illustration: George Mattingly
Cover Photograph: Seán Duggan
Indexer: FireCrystal Communications

ISBN 0-321-22372-1

9 8 7 6 5

Printed and bound in the United States of America

Katrin

For Pedro Meyer: Your faithful heart, generous soul, insightful eye,
and deep love for photography have enriched the lives of so many people.

Seán

To Anna: For everything…past, present, and future.
To Fiona: For all the times when I couldn't play with you:
Yes, Papa is done working now!

Tim

To Lisa for her incredible love, support, and patience,
and to Miranda and Riley.

Completing this book was possible only with the support and generosity of many people. Our heartfelt thanks and appreciation go to the photographers whose images and insights are featured; to the people that generously lent us equipment, including Richard LoPinto at Nikon Inc., Carla Ow at Sony, Dave Metz at Canon, Steve Upton at Chromix; Dan Steinhardt at Epson, Kim Evans at Lexar Media, Brian Levey at Color Vision, Arlene Karsh and Liz Quinlisk at Gretag Macbeth, Joe Johnson at Really Right Stuff, Bob Singh at Singh-Ray Filters, Jessica Roeber at Kanguru Solutions, Janice Wendt at nik Multimedia, Laura Sanchez at EZPnP, and Cheryl England at Canto; the Photoshop engineering team who answered our questions with patience and wit; the Pixel Mafia (www.imagingrevue.com) for allowing us to quote their words of wisdom; and our long-suffering families, friends, and neglected pets and plants. We promise not to take on another book project until the ink is dry on this one!

Finally we need to sincerely thank our Peachpit Press team: Steve Weiss and Becky Morgan for bringing us all together; Anne Marie Walker, task master with a smile; Sally Zahner, copyeditor who never missed our mistakes; Wayne Palmer, technical editor with a creative eye; and Hilal Sala and the great team of compositors who finessed the words and images into the beautiful page layout. We appreciate every extra minute, every tiny change you let us make, and your understanding of our too often past-deadline requests to "add just one more figure" or to "insert just a few more pages." Thank you all very much.

CONTENTS AT A GLANCE

PART ONE Digital Photography Essentials

Chapter One: Why Digital? .3

Chapter Two: Nuts and Bolts of Digital Imaging15

Chapter Three: How a Digital Camera Works33

Chapter Four: Buying a Digital Camera .81

Chapter Five: Essential Accessories .134

PART TWO Digital Photography Techniques

Chapter Six: Digital Photography Foundations199

Chapter Seven: Seeing the Light .271

PART THREE The Digital Darkroom

Chapter Eight: Building a Digital Darkroom325

Chapter Nine: Download, Edit, and Convert361

Chapter Ten: Essential Image Enhancement401

Chapter Eleven: Digital Darkroom Expert Techniques513

PART FOUR Output, Manage, and Present

Chapter Twelve: From Capture to Monitor to Print595

Chapter Thirteen: The Digital Portfolio .629

Chapter Fourteen: Archive, Catalog, and Backup655

Index .679

TABLE OF CONTENTS

PART ONE Digital Photography Essentials

Chapter One: Why Digital?3

The Excitement of Digital Photography4
 A Brief History .4
 Image Quality .7
 Efficiency and Convenience .10
 Flexibility and Control .10
 Fun! .12
It's Not All Daffodils .12
 Learning Curve .12
 Startup Costs .13
 The Photographer's Responsibility13
Your Love of Photography .14

Chapter Two: Nuts and Bolts of Digital Imaging15

Resolution = Information .15
 Marketing Hype .22
Bit Depth .22
 8 Bit vs. 16 Bit .23
 Capturing and Working with Each24
Color Modes .25
 Grayscale .25
 RGB .25
 CMYK .26
 Lab .26
File Formats .27
 In the Camera .27
 In the Computer .29
 Output .31
 Email and Web .31
Understanding the Concepts .32

Chapter Three: How a Digital Camera Works33

Lens to Imaging Sensor to Media33
The Lens .34
 Focal Length .35

Fixed Lenses .38
Zoom .38
Interchangeable Lenses .40
Lens Speed .41
Lens Quality .41
The Viewfinder and LCD .46
Advantages and Disadvantages .46
LCD vs. Viewfinder .48
The Shutter .51
Pushing the Button .51
The Imaging Sensor .53
Types of Sensors .54
How Sensors Work .57
Analog to Digital Conversion .58
ISO .60
Physical Size of the Sensor .62
Physical Size of Pixels .64
Bit Depth .65
Capturing Color .65
Dynamic Range .68
Storing the Image .69
Digital Media .69
File Formats .74
Flash .77
On-Camera .77
Off-Camera .78
The Informed Photographer .80

Chapter Four: Buying a Digital Camera .**81**
Types of Digital Cameras .81
Entry-Level .82
Deluxe Point-and-Shoot .83
Prosumer .86
Professional Digital SLRs .88
Digital Backs .89
Other Devices .91
Ready to Buy .93
How to Decide .93
Roadmap to a Camera Purchase .93
What Are You Photographing? .94

What Are You Going to Do with the Pictures? .94
Assess Your Immediate Photographic Needs .96
How Much Photography and Computer Experience Do You Have?96
Evaluate Your Personal Bandwidth .99
Determine the Minimum Requirements .99
Important Camera Features to Consider .102
How to Shop .120
How Much Can You Afford? .120
Research .121
Try Before You Buy .122
Evaluating a Camera: What to Look For .123
Evaluating Digital Image Files .129
Where to Shop .131
Making a Final Decision .132

Chapter Five: Essential Accessories .**133**
Your Camera Bag .133
The Camera Manual .135
More Batteries .135
Rechargeable Batteries .136
Battery Grips .138
Batteries: In a Pinch .138
High-Capacity Batteries .139
Charging the Batteries .139
More Storage .142
Camera Media .142
Pocket Drives and Digital Wallets .144
Portable CD Burners .146
The Importance of a Tripod .147
Choosing the Right Tripod for Your Camera148
More Light .156
External Flash Options .157
Lenses .164
Focal-Length Magnification .164
Dedicated Digital SLR Lenses .166
Zooms vs. Prime Lenses .167
Zoom Lens Aperture Considerations .168
Accessory Lenses for Non-SLR Cameras .168
Essential Filters .171
What about Color-Correcting Filters? .178

Stepping Rings .178
Dealing with Dust .179
Odds and Ends .181
 Exposure Tools .181
 General Camera Care .183
 "Assistants" .184
What's in Your Photo Studio? .186
 Lighting .187
 Essential Studio Odds and Ends .193
 Adding Flexibility and Creativity195

PART TWO Digital Photography Techniques

Chapter Six: Digital Photography Foundations199

Setting Up Your Digital Camera .199
 Image Size and Compression .200
 Choosing a File Format .206
 ISO .208
 White Balance .210
 Sharpening, Saturation, and Other Enhancement Options . . .218
 Color Space Settings .219
 Additional Camera Settings .221
 Formatting the Storage Card .222
Exposure Modes .223
 What Is Exposure? .223
 Full Auto Mode .230
 Program Mode .231
 Aperture Priority Mode .231
 Shutter Priority Mode .231
 Manual Mode .232
 Scene Modes .233
Metadata .237
EXIF .237
Taking the Image .240
 Framing .240
 The Importance of Cropping in the Camera245
 Image Relationships .249
How Digital Photography Differs from Film Photography257
 Lens Focal Length .257

Depth of Field .258
Black and White Photography .263
Changing Settings on a Per Shot Basis266
Taking Advantage of the LCD Monitor266
Digital Photography Is Photography269

Chapter Seven: Seeing the Light .**271**
Measuring the Light .272
How Light Meters "See" Light .272
Metering Modes .276
Using the In-Camera Light Meter281
Knowing When to Override the Meter287
Exposure Compensation .290
How and When to Use Exposure Compensation291
Evaluating Exposure: Using the Histogram296
White Balance .307
Creating a Custom White Balance308
White Balance Auto Bracketing .310
Breaking the Rules: White Balance as a Creative Tool313
Evaluating Image Quality on the LCD Screen314
Configuring LCD Settings .315
Checking Focus and Sharpness .316
Editing in Camera .317
The Range of Light .321

PART THREE The Digital Darkroom

Chapter Eight: Building a Digital Darkroom**325**
The Darkroom .326
Lighting .327
The Computer .329
Platform Issues .329
Other Issues to Consider .330
Network .333
Monitor .335
Backup .341
Printers .342
Inkjets .342
Dye Sublimation .345

Print Longevity .346
Print Size .346
Print Media .348
Essential Accessories .349
Card Reader .349
Optical Mouse .350
Wacom Tablet .350
Software .352
Basic Photo Editing .352
Professional Photo Editing .355
Photoshop Plug-ins .356
Digital Asset Management Software359
Ready for Images .360

Chapter Nine: Download, Edit, and Convert**361**
Download .361
Direct from Camera .362
Card Readers .364
Downloading the Images .365
Camera Software .368
Stand-alone Software .370
Choosing the Right Software .373
Edit .373
The Digital Light Table .374
Editing with Photoshop .379
Converting RAW Files .391
BreezeBrowser .391
PhaseOne Capture One DSLR .392
Adobe Camera Raw .393
Sigma Photo Pro .398
On to Optimization .399

Chapter Ten: Essential Image Enhancement**401**
Photoshop Preferences .402
General Preferences .403
File Handling .405
Display & Cursors .407
Transparency & Gamut .408
Units & Rulers .409
Plug-ins & Scratch Disks .410

Memory & Image Cache .411
File Browser .412
Color Settings .413
How Photoshop Handles Color414
Configuring the Color Settings416
Working Spaces .418
Color Management Policies424
Advanced Mode .428
Saving Your Color Settings428
Developing an Image-Editing Strategy429
Evaluate the Image .429
Make an Editing Plan .432
Global Tonal Correction .438
The Importance of Adjustment Layers438
The Tonal Range: A Closer Look441
Improving the Tonal Range Using Levels446
Improving Contrast with Curves459
Basic Color Correction .473
Color Theory .473
Understanding Color Correction with Variations474
Using Color Balance .476
Color Correction with Levels478
Color Correction with Curves489
Basic Image Clean-Up .493
Cloning .494
Healing .498
Patching .502
Spotting .504
Retouching Recommendations508
Cropping .508
Digital Darkroom Flexibility .512

Chapter Eleven: Digital Darkroom Expert Techniques**513**

Sharpening .513
When to Apply Sharpening515
Unsharp Mask Controls .516
How Much Should You Sharpen?517
The Other Sharpening Filters520
Blurring Effects .520
Improving the Light .526

The Importance of Luminosity .526
Dodging and Burning .529
Selection-Based Layer Masks .539
Converting Color to Black and White .556
Using Channel Mixer .558
Gradient Map .561
Toning and Tinting Techniques .563
Toning with a Hue/Saturation Layer .563
Toning with Levels and Curves .564
Merging Images .569
Combining Exposures to Extend Dynamic Range 569
Stitching Panoramas .575
Improving Image Structure .584
Reducing Digital Camera Noise .584
Retouching Chromatic Aberration and Color Fringing 587
Working with High-Bit Files .589
Creating Better Images .591

PART FOUR Output, Manage, and Present

Chapter Twelve: From Capture to Monitor to Print **595**
The Importance of Color Management .595
Understanding Limitations .596
Profiles .597
Where Do Profiles Go? .597
Can You Share Profiles? .597
Digital Camera Profiling .598
Creating the Profile .599
Assigning the Profile .600
Monitor Profiling .600
Adobe Gamma .601
Sensor and Software Packages .601
Printer Profiling .605
Generic Paper Profiles .605
Profiling Services .606
Build Your Own .606
Evaluating Prints .608
Preparing to Print .610
Printer Types .610

Sizing the Image .612
Pushing the Limits with Interpolation .616
Printing via Photoshop .618
Soft Proofing .618
Print with Preview .621
Printer Properties .623
Outside Printing .626
Direct Photo Prints .627
Online Print Services .627
Offset Printing .628
The Perfect Print .628

Chapter Thirteen: The Digital Portfolio**629**
Presenting Photos Online .629
Preparing Photos for Online Viewing .630
Sharing via Email .632
Photo-Sharing Services .634
Web Gallery Software .635
Protecting Photos Online .638
Size Restrictions .639
Visible Watermark .639
Invisible Watermark .642
Table Method .642
Web Programming Protection .643
Limits of Protection .644
Digital Slide Shows .645
Preparing Photos for Projection .645
Slide Show Software .646
Print Packages .648
Photoshop Contact Sheet .649
Photoshop Picture Package .650
Qimage .652
The Benefits of Sharing .654

Chapter Fourteen: Archive, Catalog, and Backup**655**
Master Images .656
Metadata .657
Digital Asset Management .657
Developing a DAM System .658
DAM Software .659

Developing a Keyword System .668
Protecting Your Images .670
Copyright .671
Copyright Mark .671
Copyright Registration .671
Backup .673
Burn to CD or DVD .674
External Hard Drives .675
Tape .676
Offsite Storage .676
Software .676
Long-Term Maintenance Issues .678
Back to Photography .678

Index . **679**

PART ONE
Digital Photography Essentials

Chapter One **Why Digital?**

Chapter Two **Nuts and Bolts of Digital Imaging**

Chapter Three **How a Digital Camera Works**

Chapter Four **Buying a Digital Camera**

Chapter Five **Essential Accessories**

CHAPTER ONE

Why Digital?

Photography is not just f-stops, shutter speeds, camera optics, and film formats and even in this book, photography is not about pixels, sensors, media cards, or software. Photography is experience, exploration, expression, and communication. Whether you pick up a film or digital camera, photography is about seeing more clearly and sharing your vision with others. Sadly, we often (and this includes all three coauthors of this book) forget this essential fact as we get excited over a new digital camera or an update to a favorite piece of software that we can't wait to test-drive. Of course we love the feel of a new camera or lens, but we believe it's important to keep in mind that photography is a very personal expression, and each time you raise a camera to your eye and frame an image, you are really taking a picture of yourself, as mirrored in your point of view, your framing, and your composition.

With this book, we've set out to make the technological journey from digital camera to computer to print understandable and accessible. Our ultimate goal is not to make you into a digital techno-geek, obsessed by numbers, gadgets, and product updates. Our goal is to help you be a better photographer: one who understands the equipment so that you can concentrate on making better pictures—pictures that speak from and to the heart, pictures that communicate and resonate, pictures that matter.

Before we begin, the three of us would like to make one point perfectly clear. This book does not engage in the "film versus digital" debate. In fact, we believe that this argument has been resolved, and that for every photographer or type of photography there is either a good film or a good digital tool to be used. We have shot many a roll of film and between us have exposed hundreds of thousands of digital exposures. But in the end, it's not about film formats or megabytes—it's about the image. So let's begin with the discovery of why and how digital photography is the most exciting thing to happen to photography since the advent of Kodak Kodachrome in 1935.

THE EXCITEMENT OF DIGITAL PHOTOGRAPHY

Anyone who has ever been in a traditional darkroom remembers that first time they watched an image emerge through the developer. It didn't matter what the image was of; the photographer felt welcomed into a magical world of chemistry, muted red lights, and yellow boxes filled with sheets of paper that would bring their images to life. Now in the 21st century, although fewer and fewer people are venturing into a wet darkroom, they are also experiencing a magical moment, when for the first time they successfully download a card of digital images to their computer, open the files, and are able to zoom in to see every detail as crisp and clear as the moment the picture was taken. Who among us can forget the feeling of excitement the first time we sat down with Adobe Photoshop and in a few mouse clicks changed a picture from blah to fantastic. Digital photography is simply fun to do, and in the following pages we will discuss why and show you a few examples that will get you started on your way to being a better digital photographer.

A Brief History

Katrin started shooting with electronic still cameras in 1989. Back then, the cameras were cumbersome, heavy, and expensive, and worst of all they took horrible images. Katrin shot many fuzzy, low-resolution images with a Sony Mavica Video Still Camera, an analog camera that captured still video signals, which were converted via a floppy card reader. They in no way could stand up to a comparison with film, but this didn't matter to her; the look and the feel of this video image palette was new and exciting, and she was hooked.

In 1992, Kodak announced the first professional digital camera system: the DCS 100, based on the Nikon F3. The DCS 100 sported a 1.3 megabyte CCD image sensor and could capture 156 images onto a portable hard drive. Need we mention that the hard drive weighed in at 12 pounds, the camera cost $25,000, and the images were barely acceptable for newspaper use and were used only when deadlines were more pressing than image quality?

In 1994, two digital cameras were announced that signaled the future. Apple Computer debuted the Apple QuickTake 100, an odd-looking hamburger-shaped camera that could capture eight 640-by-480-pixel images. This was the first true mass-market digital camera, with a recommended sales price of $749. It, too, took horrible pictures that didn't print well, and since the Internet was still in its infancy, the camera was of little use to anyone. The second camera to debut that year was released by Kodak and the Associated Press and was aimed at the photojournalist. The NC 2000 and NC 2000E combined the look and functionality of film cameras with the instant access and flexibility of a digital camera. As the NC 2000 entered many newsrooms, newspapers began to migrate from a film to a digital workflow. (For additional information on the history of digital cameras, please visit www.digicamhistory.com.)

Since the mid-1990s, scores of digital cameras have been developed, computers have become faster and cheaper than ever before, and software has grown increasingly sophisticated. Digital cameras have evolved from alien-looking devices that only a mother could love, to pieces of equipment that are versatile, easy to use, as ubiquitous as the latest picture phones, and as performance savvy as the newest full-frame digital 35mm cameras whose image quality supersedes that of film.

Those constant changes and developments are also a source of anxiety. We've heard it over and over again: "As soon as I buy a piece of digital equipment, someone releases a newer version with better, faster features for less money!" We understand your frustration but offer the following instructive example. In early 2000, Nikon Corporation released the Nikon 990, a 3.34-megapixel camera with a twist body and an optical zoom lens (if these terms are new to you, we'll be defining them in Chapter 2, "Nuts and Bolts of Digital Imaging," and Chapter 3, "How a Digital Camera Works"). Three and a half years later the Nikon 990 is still one of Katrin's very favorite digital cameras and she takes it everywhere she goes; **Figure 1.1** shows a photograph she took with it in Mexico City during a

Figure 1.1 Outdated digital cameras can in fact be used effectively for many years as shown in this moody evening photograph of a street-side market stand in Mexico City. This image was captured with a Nikon 990, three and a half years after the camera's release.

conference that celebrated the tenth anniversary of Pedro Meyer's ground-breaking Web site for fine art photography, www.zonezero.com. We find it interesting that when Katrin and her husband, John, were in Mexico City to present on the topic of "The Future of Photography," the two cameras they carried were the 3½-year-old Nikon 990 (which has been succeeded by many newer models) and a Nokia Picture Phone (**Figure 1.2**), which allowed them to send photographs (**Figure 1.3**) from the event to their friends and family simply by punching in an email address and pressing Send.

The history of photography has always been intertwined with technological development and change—with some changes more successful than others. So rather than losing sleep over what's next or which camera has the biggest CCD, let's dive into the most important aspects of digital photography.

Figure 1.2 Looking into the future: Picture phones will be as common as standard cell phones are in 2003.

Figure 1.3 A 640-by-480-pixel photograph from the Nokia 3560 picture phone.

Image Quality

A picture does speak a thousand words, and digital images are stunning in their detail, clarity, color rendition, and crispness. And we're not even talking about a multi-thousand-dollar digital camera. The recent consumer digital cameras that list for approximately $500 are capable of capturing stunning images that can make great 8-by-10-inch prints and when necessary can be pushed to larger formats if the initial exposure was correct and if the photographer's hand was steady (more on the essential skills and equipment to make better photographs in Chapter 6, "Digital Photography Foundations"; Chapter 7, "Seeing the Light"; and Chapter 8, "Building a Digital Darkroom"). **Figure 1.4** shows a hand held snapshot from a Fuji F700, a camera that in 2003 sold for approximately $600. The detail, color, and shadow information is dazzling. Best of all, this camera is so small and light that photographers can carry it with them wherever they go—no more missed shots due to not wanting to schlep cumbersome equipment.

Figure 1.4 This image captured with the Fuji F700 reveals a tremendous amount of detail and sharpness.

For the professional photographer who works on location or in the studio, there is also a wide range of digital cameras available, from portable 35mm digital single lens reflex (DSLR) cameras to high-end scanning backs that capture hundreds of megabytes of information and are used in situations where image quality is most critical, such as for museum

reproduction of ancient and irreplaceable pieces of art. **Figures 1.5** and **1.6** show the versatility of a professional digital camera that can be used for a variety of purposes, from high-end architecture to portraiture. For additional information on types of digital cameras see Chapter 4, "Buying a Digital Camera" and visit the book's companion Web site at www.digitalphotobook.net.

From the casual Sunday snap shooter to the most demanding professional, digital cameras of all types offer fantastic image quality that is only getting better and better every day.

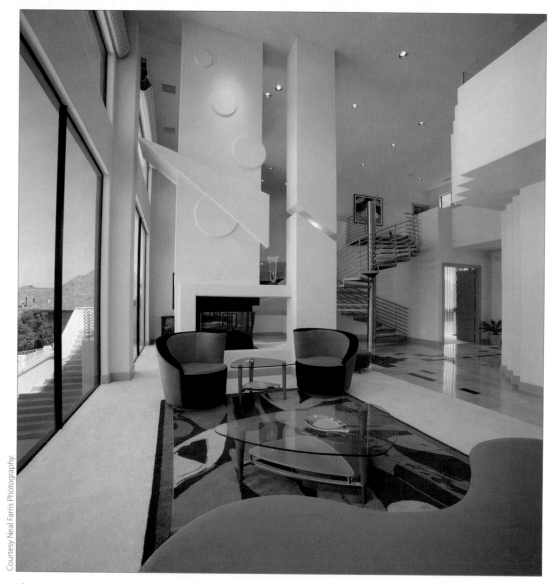

Courtesy Neal Farris Photography.

Figure 1.5 Interior architecture photographed with the Imacon Ixpress 96 Digital Back.

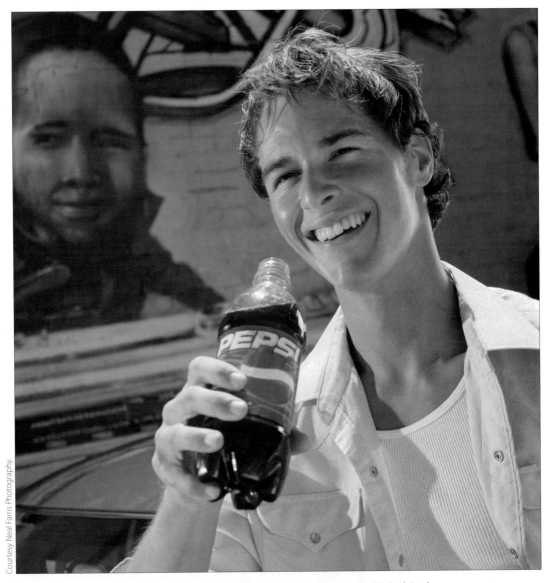

Courtesy Neal Farris Photography.

Figure 1.6 Commercial portrait captured with the Imacon Ixpress 96 Digital Back.

Efficiency and Convenience

There has been much talk that we are a society of convenience and instant gratification. However, many of us still enjoy cooking a leisurely homemade meal, taking a long walk, and going out of our way to see an exciting art exhibit. But when it comes to the efficiency and convenience of digital photography, you won't find louder cheerleaders than the three of us.

The ability to see and evaluate the image you just took on your camera's LCD is a fantastic learning and production tool that in the end will help you to take better pictures. In fact, the LCD screen is changing the photographic experience, as friends and family gather around the screen to see the photos you just took. If by chance you're a bit shy and you need an icebreaker at a party, grab a digital camera before you leave the house and start taking pictures of the guests (**Figure 1.7**). Within a few minutes, you'll be in the center of the action, talking, sharing, and exchanging email addresses. People love to get emails with pictures of themselves!

For the professional photographer, the ability to analyze the image histogram (see Chapter 7), judge image composition, and see how an image fits into a page layout has completely replaced the venerable Polaroid, which was a rather poor image evaluation tool to begin with. Seeing the image instantly on a color-calibrated monitor allows the photographer, art director, and client to evaluate image composition and quality and, more important, know that they have the shot so they can move on. Schecter Lee, a New York–based studio photographer, sums up the advantages of digital: "I love the instant feedback—if you like the digital 'Polaroid' you move on. I can design and edit as I shoot. As a digital photographer I literally live in the *moment*. In portraiture I involve the model or subject and really make the process collaborative without losing flow and momentum. In many senses, shooting digitally is absolutely liberating."

Flexibility and Control

The idea of combining flexibility and control may sound like a new-fangled hair care product, but digital photography allows you to experiment, take risks, and learn from your successes and mistakes, all with the ability to redo and reshoot to get the picture just right. Eddie Tapp, who has been shooting digitally since 1993, says, "The complete control of image quality, color, and the creative process lets me make better pictures for both my personal and client work. I have no regrets of switching from a film to a 100 percent digital workflow."

Both the creative and production control that digital photography entails doesn't end with the touch of the shutter button. After you've downloaded the image you have a second opportunity to create the image you want. Working on the computer, as we'll discuss in Chapter 10, "Essential Image Enhancement," and Chapter 11, "Digital Darkroom Expert

Missing the Moment

Taking pictures and then immediately looking at the camera's LCD does have its downsides. We've seen it time and time again: A person will take a picture and while looking at the LCD will miss a fantastic moment or picture opportunity. Try to resist the urge to review every single shot, because life goes by. Remember you couldn't review a shot with a film camera but still managed to make a good exposure and image composition. So concentrate on what is happening around you rather than being addicted to the LCD.

Figure 1.7 Having fun with digital photography is a sure icebreaker!

Techniques," gives you the opportunity to enhance, improve, and interpret the image to match your personal vision. For some digital photographers, working on the computer is akin to the second shutter release, in which they can rework and improve the image with the same dedication and enthusiasm as when they first pressed the shutter button while taking the picture. For all three of us, the creative digital darkroom work is just as fulfilling as working in the traditional darkroom but without the noxious chemicals or tedious cleanup that a wet darkroom requires.

Fun!

Give us a digital camera and an extra hour or two, and we'll be as happy as puppies with a tasty bone to chew on. There are always new ways to see the world and compositions to experiment with. Taking a digital photograph doesn't involve the cost or time that shooting film does. No more waiting for the photo store to process your film and make prints, and most important no more paying for blooper prints that you just don't want. Since digital photography frees you from any worry about film or processing costs, you'll end up taking more pictures, trying out new points of view, learning from your LCD while you're taking pictures, and finally deciding to keep or delete the pictures you like or don't like.

Photography is about seeing and learning, and for us it's a great reason to go out into the world to learn and experience as much as we can. So without sounding too much like an advertisement for a cruise line, "Get out there! The light is good, the pixels are cheap, and there are pictures waiting to be taken!"

IT'S NOT ALL DAFFODILS

Ground-breaking changes such as the switch from analog (film) to digital photography always involves advantages and disadvantages. We would be doing you a great disservice if we didn't address digital's downsides.

Learning Curve

Depending on your photographic and computer experience, you may need to learn new skills to take full advantage of the benefits of digital photography and digital imaging. We separate those two aspects, because *digital photography* is the act of taking pictures with a digital camera and *digital imaging* is the subsequent process of enhancing those images on the computer.

To develop your photographic skills we've included Chapter 6, "Digital Photography Foundations." This review of basic photography principles and how they impact digital photography will have you up and shooting in no time. We also recommend that you take a basic digital photography class. Good places to look for classes are local colleges and photo workshops, such as the Santa Fe Workshops (www.sfworkshop.com) or at the Lepp Institute (www.leppinstitute.com).

To develop your computer and digital imaging skills, our advice is similar: Take classes and workshops, read articles, or watch over a friend's shoulder as they work on a computer.

Most important, find a project that excites you, keeps you up at night, and won't let you go. This can be a personal project to document your family, a landscape series, or a community documentary. Any project that motivates you to keep honing your photography and software skills is a good choice.

Depending on your comfort level, you may need to develop new skills, which we think is a good thing. You wouldn't want to stay in an analog rut, would you?

Startup Costs

It's no secret that digital cameras, computers, and software can be costly. We all have to pay for them, and sadly sometimes it does happen that as soon as you do buy something—a new version or model is announced. But the camera or the computer you just bought will work fine for quite a while. If the three us bought every computer that Apple or IBM ever announced, we'd be living on the street—not because we'd be broke but because our homes would look like computer warehouses.

So plan your expenditures, and rather than looking to the next big thing, push the equipment that you have for as long as possible. We'll discuss purchasing decisions for both digital cameras and computer workstations in Chapters 4 and 8, respectively.

The Photographer's Responsibility

In the old days of shooting film, we would go on a shoot and at the end of the day drop off a bag of exposed film at the lab and go out for dinner or a drink while the film was being processed. Then either later that night or early the next morning we'd pick up the film at the lab and go to the studio to edit the film on a light table. Please note, we are talking about color slide or color negative film; when we shot black and white, the work continued in the darkroom as we carefully processed the day's shoot and made endless contact sheets.

Well, those days are over. As digital photographers we have no photo lab to rely on, no one to make our contact prints, and certainly less time for dinner and drinks. After a busy digital day, photographers have to download, edit, organize, archive, enhance, manipulate, and often make large-format prints before they can say the job is done. The extensive time requirements to do high-quality postprocessing is something that can be a drain on your health, social life, and family relationships. In fact, this was the one negative aspect that numerous photographers mentioned when we interviewed them for this book. As Jeff Amberg explains, "If you're a digital shooter you have to learn about prepress issues and incorporate a lot of image processing time into your work schedule. Sometimes it feels as if it never ends."

YOUR LOVE OF PHOTOGRAPHY

In the end, it all comes down to your enthusiasm for photography. If you're like us, you're hooked—you wake up before daybreak to look out the window to see if the light is good, you plan your business trips with an extra day or two so you can explore and take pictures, you stay up late at night to finesse the finest image out of your inkjet printer, and in the morning you happily start over again. We love photography—it's our language, our passion, and our way of seeing the world. The bottom line is that you have to enjoy what you do—and we hope that our love for photography and digital imaging inspires you to become as excited and thrilled as we are to make more meaningful and compelling pictures. Enjoy the journey.

CHAPTER TWO
Nuts and Bolts of Digital Imaging

Before you run out and start capturing images with your digital camera (OK, before you go out and take *even more* photos, since you've probably already accumulated more digital images than you know what to do with), you should understand the nuts and bolts of digital photography. The more you understand about digital imaging, the better equipped you'll be to make the most of your digital photography. The key concepts to understand are resolution, bit-depth, color modes, and file formats, all of which we'll cover in overview in this chapter and then in greater detail in later chapters.

RESOLUTION = INFORMATION

Resolution is one of the most important concepts to understand in digital imaging and especially in digital photography. The term *resolution* describes both pixel count and pixel density, and in a variety of circumstances these concepts are used interchangeably, which can add to misunderstanding.

Camera resolution is measured in *megapixels* (meaning millions of pixels); both image file resolution and monitor resolution are measured in either pixels per inch (ppi) or pixel dimensions (such as "400 by 600 pixels"); and printer resolution is measured in dots per inch (dpi) (**Figure 2.1**). In each of these circumstances, different numbers are used to describe the image, making it difficult to translate from one system of measurement to another. This in turn makes it difficult to understand how the numbers relate to real-world factors such as the detail, quality, or potential output size of your image.

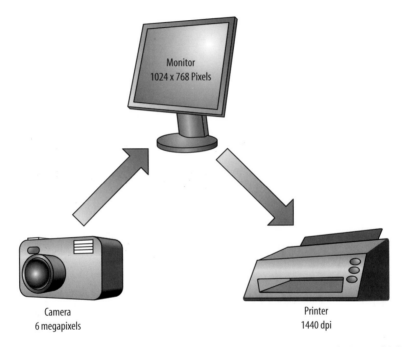

Figure 2.1 Different devices use different units for measuring resolution, which can cause some confusion for photographers. Understanding how resolution is represented for each device will help you better understand the capabilities of each in your workflow.

PPI vs. DPI

Purists will draw a careful distinction between ppi and dpi. Pixels are the dots on your monitor, and dots are, well, the dots on paper. The distinction between the two is subtle, but we feel it's important to use the most clear and accurate terminology. Therefore, we use the term ppi when referring to pixels on a digital camera or display device, and dpi when referring to dots in printed output.

If you hear people using dpi as a general term for resolution, understand that they may mean ppi when they say dpi (and then recommend that they buy and read this book!).

The bottom line is that resolution equals information. The higher the resolution, the more image information you have. If we're talking about resolution in terms of total pixel count, such as the number of megapixels captured by a digital camera, then we are referring to the total amount of information. If we're talking about the density of pixels, such as the number of dots per inch for a print, then we're talking about the number of pixels *in a given area*. The more pixels we have in our image, the larger that image can be reproduced. The higher the density of the pixels in the image, the more detail or quality the image will exhibit (**Figure 2.2**).

Figure 2.2 The resolution of a digital camera determines how much information it is able to capture. The photo on the left was captured at 1 megapixel and contains less detail and less defined edges. The photo on the right was captured at 6 megapixels and contains considerably more detail and smoother edges.

The biggest question to consider when it comes to resolution is "How much do I *really* need?" More resolution is generally a good thing, but that doesn't mean you always need the highest resolution to get the job done. Instead, you should match the capabilities of the digital tools you're using to your needs. For example, if you are a real estate agent who is using a digital camera only for posting photos of houses on a Web site and printing those images at 4 by 6 inches on flyers, a 3-megapixel digital camera is more than adequate for your needs.

We'll discuss in future chapters which resolutions you should have with the various tools you'll use to capture, edit, and print your images.

Megapixels vs. Effective Megapixels

Digital cameras are identified based on their resolution, measured in megapixels. This term is simply a measure of how many millions of pixels the camera's imaging sensor captures to produce the digital image. The more megapixels a camera captures, the more information it gathers. That translates into larger possible image output sizes.

However, not all of the pixels in an imaging sensor are actually used to capture an image. Pixels around the edge are often masked, or covered up (**Figure 2.3**). This is done for a variety of reasons, from modifying the aspect ratio of the final image to measuring a black point (where the camera reads the value of a pixel when no light reaches it) during exposure for use in processing the final image.

Because all pixels in the sensor aren't necessarily used to produce the final image, the specifications for a given camera will generally include the number of effective megapixels. This indicates the total number of pixels actually used to record the image rather than the total available on the imaging sensor.

Figure 2.3 Not all of the available pixels in an imaging sensor are used to capture the image. The masked-out pixels may simply not be used, or they may be used to read a "black point" for the capture.

Where Resolution Comes into Play

Resolution is a factor at every step of the photo-editing process. The digital camera you use to record the scene, the monitor you use to view those images, and the printer you use to produce prints all have a maximum resolution that determines how much information they are able to capture, display, or print. Understanding how resolution affects each of these devices will help you determine which tools are best for you and how to use them.

Camera resolution

Camera resolution defines how many individual pixels are available to record the scene before the lens. This resolution is generally defined in megapixels, which indicates how many millions of pixels are used to record the scene. The more megapixels the camera offers, the more information is being recorded in the image.

Many photographers think of camera resolution as a measure of the detail captured in an image. This is true, but a more appropriate way to think of it is that resolution relates to how large an image can ultimately be reproduced. **Table 2.1** shows the relationship between a camera's resolution and the images the camera can eventually produce.

(Chapter 3, "How a Digital Camera Works," will discuss in more detail how digital cameras work, and Chapter 4, "Buying a Digital Camera," will explain how to choose the best digital camera for your needs.)

Table 2.1 Megapixel Decoder Ring

Megapixels	Uninterpolated Inkjet Output Size	Approximate Uncompressed File Size
1	4"×3"	3MB
2	5"×3.5"	6MB
3	6"×4"	9MB
6	10"×6"	18MB
8	12"×8"	24MB
11	14"×9"	33MB
14	16"×11"	42MB

Monitor resolution

The primary factor in monitor resolution is the actual number of pixels the monitor is able to display. For CRT monitors you can select from a range of possible resolution settings while maintaining excellent display quality. These resolution settings are described by a name and pixel dimension size. For example, XGA (Extended Graphics Array) is defined as 1024 pixels horizontally by 768 pixels vertically. SXGA (Super Extended Graphics Array) is 1280 by 1024 pixels. There are a variety of such standard resolution settings.

In general it's best to work with the highest resolution possible so that you can see as much of your image as possible at once. However, you'll also want to remember that the higher the resolution, the smaller the screen's interface elements will appear on your monitor (**Figure 2.4**).

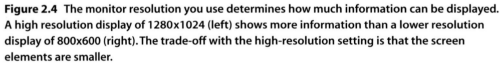

Figure 2.4 The monitor resolution you use determines how much information can be displayed. A high resolution display of 1280x1024 (left) shows more information than a lower resolution display of 800x600 (right). The trade-off with the high-resolution setting is that the screen elements are smaller.

As more photographers start using LCD displays, bear in mind that those monitors have an optimal resolution based on the physical structure of the display. To get the best display quality, you should always use the optimal resolution for your specific LCD monitor. The specifics of monitor selection and configuration will be covered in Chapter 8, "Building a Digital Darkroom."

72 PPI?

One of the most common misconceptions about monitor resolution is that monitors display at 72 ppi. This simply isn't the case. Back in the early days of personal computing, Apple Computer had a 13-inch display that did indeed operate at 72 ppi. Most monitors these days display at a range between about 85 ppi and 125 ppi. The exact number will depend on the pixel dimension resolution and the physical size of the monitor. Again, this number is a measure of pixel density, and so relates to the overall image quality of the display. The higher the ppi value, the more crisp the display and the more capable the monitor is of showing fine detail, without as much magnification.

Printer resolution

For the photographer, the digital image's defining moment is when ink meets paper (**Figure 2.5**). The final print is the culmination of all the work that has gone into the image, from the original concept, the click of the shutter, and the editing process to the final print. The quality of that final print is partly determined by the printer resolution.

Once again, just to keep things confusing—we mean interesting—there are two numbers that are often labeled "print resolution"—output resolution and print resolution, and this is a major source of confusion. The marketing efforts of printer manufacturers only contribute to this confusion (see the following section, "Marketing Hype").

Figure 2.5 A moment of truth for a digital photographer is when ink meets paper, producing the final print.

Output resolution in the image file is simply a matter of how the pixels are spread out in the image, which in turn determines how large the image will print, and to a certain extent the quality you can obtain in the print.

Printer resolution is the measure of how closely the printer places the dots on paper. This is a major factor in the amount of detail the printer can render—and therefore the ultimate quality of the print. Note that the printer's resolution is determined by the number of ink droplets being placed in a given area, not by the number of pixels in your image itself. Therefore, there won't necessarily be a direct correlation between output and printer resolutions.

Each type of printer, and in fact each individual printer model, can be capable of a different resolution. We'll discuss the capabilities of each type of printer, and how to prepare your image files for those printers, in Chapter 12, "From Capture to Monitor to Print."

Marketing Hype

It's bad enough that resolution can be such a confusing topic. But it seems as if the manufacturers of digital photography tools are trying to confuse you even further. It doesn't help that there aren't definitive definitions for many of the terms being used to describe various products. For example, the term *resolution* is used to describe the quality a printer is capable of. However, the number by itself is meaningless because so many other factors go into the final image's quality. Therefore, the only way to use the number is to compare it with the numbers presented for competing printers. What manufacturers are really trying to do is convince you that their product is the best, but in the process the truth can get lost in the hype.

For example, digital camera manufacturers are quick to boast about the number of megapixels a camera is able to capture. This is an important factor to consider, but other important factors also impact final image quality, as we'll discuss in Chapter 4. Keep in mind that you may not necessarily need the camera with the most megapixels for your particular needs. Also, you can generally push digital images to large output sizes (see the next section) even if you don't have the highest resolution to begin with. Other factors, such as lens quality, sensor quality, and special features, are also important when you're deciding which camera is best for you.

The most marketing hype seems to revolve around photo inkjet printers. There is a constant barrage of claims of how many dots per inch the latest printer can produce. Repeated testing has convinced us that photographic output above 1440 dpi produces no benefit in terms of image quality.

By understanding what the various specifications mean and determining which factors are important to you, you'll be able to see through the hype and make the best purchasing decision.

BIT DEPTH

Bit depth describes the number of bits used to store a value, with the number of possible values growing exponentially with the number of bits (**Table 2.2**). A single bit can store up to two possible values (black or white) while 2 bits can store up to four possible values (black, white, and two shades of gray), and so on

Table 2.2 Bit Depth

Bits	Tonal Values Possible
2	4
4	16
6	64
8	256
10	1024
12	4096
14	16,384
16	65,536

(**Figure 2.6**). Digital image files are stored using either 8 or 16 bits for each of the three color channels that define pixel values (see "Color Modes" later in this chapter).

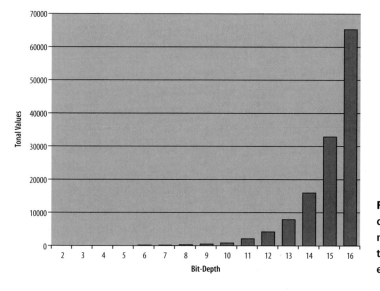

Figure 2.6 As the bit depth increases, the number of possible tonal values grows exponentially.

8 Bit vs. 16 Bit

The difference between an 8-bit and a 16-bit image file is the number of tonal values that can be recorded. (Anything over 8 bits per channel is generally referred to as *high bit*.) An 8-bit-per-channel capture contains up to 256 tonal values for each of the three color channels, while a 16-bit image can store up to 65,536 tonal values per channel. Most digital cameras that offer the ability to capture high-bit images record 12-bit images, which offer 4,096 tonal values per channel.

When you start with a high-bit image, you have more tonal information when making your adjustments. Even if your adjustments—such as increases in contrast or other changes—cause a loss of detail at certain tonal values, the huge number of available values means you'll almost certainly end up with many more tonal values per channel than if you started with an 8-bit file. That means that even with relatively large adjustments in a high-bit file, you can still end up with perfectly smooth gradations in the final output (which will be at 8 bits per channel since current printers aren't able to actually produce high-bit output).

Whether to work with 8-bit or 16-bit images depends on how you'll use the images and the type of photography you're doing. For fine-art output and particularly for images captured under challenging lighting conditions, working with high-bit files can provide a significant quality advantage. When you're producing images for less demanding output—such as widget-like product shots for a catalog—the simplified workflow and smaller file sizes for 8-bit images will meet your needs perfectly well.

Capturing and Working with Each

The actual workflow we recommend for digital images will be covered in future chapters, but let's consider how 8-bit and 16-bit captures will differ.

8-Bit capture

The simplest workflow involves 8-bit captures. These are images captured in standard JPEG or TIFF formats, with no special handling required. Simply take the picture, download it to your computer, and start working (although it really isn't as simple as that, as we'll explain in Chapter 12).

You can get excellent results working with 8-bit images. However, because they don't include the extra tonal information provided by 16-bit images, the exposure must be as accurate as possible to minimize the amount of editing that is necessary. Too much editing on an 8-bit image file will lead to noticeable image quality problems, such as the loss of smooth gradations of tone and color or loss of detail in highlights or shadows.

16-Bit capture

Currently, 16-bit captures are possible only with digital cameras that support capture in the RAW file format (the Fuji S2 also has a high-bit TIFF option, while the TIFF format for most cameras is 8 bit). RAW mode offers a variety of benefits, but because a RAW file is merely a container for the raw data collected by the imaging sensor rather than an actual image file, it must be converted before you can work with it (see "File Formats" later in this chapter). The advantage to RAW mode is that the file can contain much more tonal and color information. So even if you must do significant editing to get the results you want, you can generally still produce a higher-quality image than with an 8-bit capture.

Is more always better?

In the end, the decision of whether to work in 8 bit or high bit depends on your final output and quality needs. We recommend that you test your workflow from start to finish with a 16-bit file and an 8-bit file and then compare the results. Due to the higher image quality, Katrin prefers to shoot and work exclusively in 16 bit.

Keep in mind that if you never captured the information in the first place (meaning you didn't shoot in high bit), then no magic button will ever be able to add that information to a file after the fact. The conservative approach is to shoot in high bit; you'll never regret having more tonal information than you need.

COLOR MODES

A digital image file contains numeric values for each of the pixels in an image. The color mode defines which system is used to describe the pixel values in an image and how the pixel values are organized. Images in grayscale mode can only be black and white, while color images generally use RGB, CMYK, or Lab color mode. In the camera, only the RGB color mode is used, but this can be changed during editing and printing.

Grayscale

As the name implies, the grayscale color mode is for images that don't contain any color. An 8-bit grayscale image can contain 256 possible shades of gray, while a 16-bit grayscale image can theoretically contain up to 65,536 shades. You may think that fine-art black and white photography is just black and white, but close inspection reveals that the prints have subtle tones that enhance the shadows and midtones. For this reason we recommend capturing and keeping black-and-white images in RGB to maximize the tonal range of the image. Even if a digital camera offers a grayscale option, we never use it—we don't trust the camera to make appropriate image editing decisions as to which colors and tones to throw away. If you want to produce a grayscale image, wait to convert the RGB file to grayscale in the editing stage. There are also excellent options for producing black-and-white prints from an RGB file that rival traditional silver gelatin prints in tonality, sharpness, and vibrancy. We'll discuss the conversion of color images to black and white in Chapter 11 and the printing of them in Chapter 12.

RGB

The RGB color mode is the most common one for photographic images. It stores information about the image based on the three additive primary colors of red, green, and blue (RGB). These are the primary colors for *emitted* light and are also the colors that digital camera sensors are filtered to read. In addition, monitors use the RGB color mode to create the display image. These additive primary colors are referred to as additive because each color adds a wavelength of light to produce the final color.

A file stored in RGB color mode will actually contain three individual channels in perfect registration that describe the values of red, green, and blue for each pixel in the image. These values can range from 0 (black) to 255 (white) for 8-bit images. If all three color channels have a value of 0 for a given pixel, that pixel will be pure black; and if all three are 255, that pixel will be pure white. If all three have the same value anywhere in between,

the pixel will be a shade of gray. By mixing different values for each color channel for a given pixel, over 16.7 million possible colors for 8-bit images can be created.

As a general rule, you'll want to save all color images in the RGB color mode. They start that way in the digital camera, and it's best to keep them that way during editing and printing.

CMYK

The CMYK color mode is built on the subtractive primary colors of cyan, magenta, and yellow. These are the colors used to produce color from *reflected* light, such as ink on paper. Black (K) is added to the mix so that true black can be produced on paper.

Even photographers who are already working with their own images are probably not familiar with CMYK files. Fortunately, you generally don't need to worry about working with your images in this mode. In most situations it's best to keep the images in the RGB color mode. The only time you would need to convert an image to CMYK is for offset press output, and hopefully you can leave the CMYK conversion to the printing lab.

Lab

The Lab color mode is relatively abstract. It stores image data in three channels, much like the RGB color mode. However, the information contained in each channel is structured differently than in RGB.

The other color modes define color based on how the colors are produced by a device—either a monitor or a printer. Lab color mode, on the other hand, is a device-independent color mode that describes color based on how it looks. In other words, it doesn't depend on the properties of a monitor or printer to determine what the color will actually look like, but rather describes the color in much the way that the human eye distinguishes it, in terms of luminosity and color defined along two axes of red-green and blue-yellow.

The first channel in the Lab color mode (or "L") is luminosity. This channel describes the relative brightness of each pixel. The "a" channel describes color on an axis of red and green, and the "b" channel describes color on an axis of blue and yellow.

The Lab color mode is used as a reference color space for converting colors between color modes and spaces. It does provide the ability to make adjustments that will affect only brightness values of the pixels in an image, without risking color shifts. Seán is also quick to point out that a variety of other cool tasks can be performed on images in Lab mode for those who unravel its mysteries. We'll discuss these techniques in Chapters 10 and 11.

However, the Lab color mode is far from intuitive and isn't something we would recommend unless you're an advanced user who already has solid experience working in RGB mode.

FILE FORMATS

In an imaging workflow there are four primary areas where you need to make informed file format decisions: in the camera, with the software, with the output, and when storing your master image files. If you've ever looked at the list of possible file formats you can save an image file in, you may have felt overwhelmed by the long list of names and acronyms. We have. Fortunately, you only really need to know about a few standard formats to work efficiently and maintain image quality.

In the Camera

There are three basic file format options available to you when working with a digital camera. Each has its strengths and weaknesses, and each can impact the final image quality.

JPEG

The major advantage of the JPEG format is convenience. Just about any software that allows you to work with image files will support JPEG images. Also, the files are small because compression is applied to the image when it's stored as a JPEG. While this compression is *lossy*, meaning pixel values are averaged out in the process and you may lose some detail and color in the image, if you use the highest quality (lowest compression) settings, image quality is generally still very good.

When selecting the JPEG format in the camera, you will generally have the option of both a size and quality setting. We always recommend capturing the most pixels possible, taking advantage of the full resolution of the imaging sensor in your camera. This size option is generally labeled Large. We recommend setting the quality setting to the highest possible. We'll discuss these options in more detail in Chapter 6, "Digital Photography Foundations."

TIFF

The TIFF file format is generally a lossless file format, which means no compression is applied to the pixels. We say *generally* because the format now also supports JPEG compression, although we don't recommend using it. Most photographers will be familiar with the TIFF file format as an excellent way to store their archival images. However, it's generally not a good option for digital capture, primarily because of the file size.

Because each pixel must have three color values (see the "Color Modes" section earlier in this chapter), the final file size in megabytes with no compression will be three times the number of megapixels. That means you would get an 18MB TIFF file from a 6-megapixel

camera. Besides quickly eating up the available space on your digital film cards, the large files will also take longer to write to the card than other formats.

The TIFF file format is excellent for printing and storing images, but not an ideal solution for recording the images you capture in the camera.

RAW capture

The RAW file format is actually not a file format in the traditional sense. In fact, RAW is not an acronym that stands for anything. It is capitalized only to resemble the other file formats.

Rather than being a single file format, RAW is a general term for the various formats used to store the raw data captured by the sensor on a digital camera. Each camera manufacturer has developed a file format for RAW capture modes. For example, Canon generally uses its CRW format, and Nikon uses the NEF file format. These formats store the raw data as it was recorded by the imaging sensor. Because none of these are standard image file formats, you must convert these files in the computer before you can edit the image.

The RAW TIFF

With the flexibility offered by the TIFF file format, we may see more camera manufacturers using the TIFF format for RAW captures. Canon has taken this route with the RAW capture mode for its Canon EOS-1Ds.

Instead of producing a RAW file that isn't useful until you convert it to an image file, the 1Ds uses a layered TIFF file. When viewing the files with software that doesn't recognize it as a RAW capture, it will appear as a 200-by-300-pixel TIFF image. This provides an excellent thumbnail capability in the RAW format, so you can sort images without converting them first.

However, there is a potential pitfall with this TIFF file. If you change the image using software that doesn't recognize this capture as a RAW dressed like a TIFF, you can lose your images. For example, if you rotate the image using browser software that doesn't recognize the file as a RAW capture, the rotated file will be saved in the format the software sees it in—as a 200-by-300-pixel TIFF image. The high-resolution image stored as RAW data "behind" this thumbnail will be lost forever. Check your software's documentation to make sure it recognizes the image files as RAW captures.

The file size, in megabytes, of RAW captures for most cameras will be about the same as the megapixel count of the camera. There is some variation in this from camera to camera, and some formats such as Nikon's NEF also offer the option to further compress the data. Regardless, the files that result from RAW capture will be considerably larger than JPEG captures, but smaller than TIFF captures.

The advantages of the RAW format are the ability to capture high-bit data, no in-camera processing, and options for adjusting the exposure, white balance, and other settings with great flexibility during the conversion process. The disadvantages are the relatively large file sizes, capture files that must be converted before you can edit them, and the need to work with high-bit files if you are going to obtain all the benefit of the high-bit capture.

Katrin swears by RAW. It's the only format she photographs in (granted, she isn't a sports photographer chasing linebackers down the sidelines). Seán likewise will shoot JPEG only when, say, he's shopping for furniture out of town and wants to let his wife know what the kiddie tables and chairs look like. Tim decides whether to capture in JPEG or RAW based on the perceived potential of the images he's capturing on a given shoot. Often, you can capture in JPEG with excellent results. However, for tricky exposures or where you want to maximize the information captured to get the best final image, RAW capture is worth considering.

In the Computer

After you've captured images with your camera and edited them on your computer, you'll need to save the images for future use. The file format you choose here is in some ways even more important than in the camera. The following are the most common formats.

JPEG

The JPEG file format is less than ideal due to the lossy compression it uses to minimize the file size. The compression is applied every time you save the image. This creates the possibility that the quality of your image will degrade over time due to repeated compression, even when you use relatively high quality settings.

JPEG is an excellent choice for saving images that will be displayed on a Web page or sent via email (see Chapter 13, "The Digital Portfolio."). However, for storing the images you've spent time getting just right, you'll want to use a different format.

TIFF

The TIFF file format has grown more robust, offering support for layered documents and a variety of other advanced options. This makes it an excellent choice for archival storage of your optimized images. In fact, we think it may ultimately replace the Photoshop PSD format, since TIFF is more universally supported and offers virtually all the benefits of the Photoshop PSD format.

TIFF files take up more space than some other types—JPEG files, for example—but the space consumed is worth it. If you want to save all the various layers used to adjust an image (and we highly recommend doing so), then you need to use PSD or TIFF as your file format. While PSD does use nonlossy compression by default, if you use LZW or ZIP compression on TIFF files you'll actually end up with an even smaller file. They are still large compared to a JPEG, but that is a price the photographer should be willing to pay. Besides, hard drive storage is incredibly cheap!

RAW

Since capturing images in RAW mode with digital cameras offers some advantages in terms of ultimate image quality, it would seem to make sense to save your images in the RAW format. But you can't. You may even have seen the RAW file format listed in the Save As dialog in Photoshop's Format drop-down menu. However, the RAW file format in Photoshop is not the same as the RAW capture mode on your digital camera.

The Photoshop RAW file format is provided as a way to send images as raw data to another application that doesn't support other file formats. Trust us—you'll never need to save a file in this format.

Nikon also offers the option to save images in RAW format. With their Nikon Capture software, you can save a processed image as a NEF file. In fact, while in the Nikon Capture software you can make adjustments to the image stored as a NEF file and all you're doing is changing the instruction set of the file. The original data is never touched. This allows you to revisit and reprocess the file within Nikon Capture as often as you like without ever altering the original file.

Photoshop PSD

Many photographers are using Adobe Photoshop to optimize their images. We used to be in favor of saving all archival images in the Photoshop PSD format, because it enabled you to save all the layers you may have used to make the most of an image.

However, as we mentioned previously, the TIFF file format offers all the capability of the PSD file in a format that is not proprietary. We tend to think that the added features of the TIFF format will ultimately make the Photoshop PSD format obsolete, unless Adobe enhances its functionality.

Output

Your images don't need to be in a particular file format to be printable. As long as you can open them with your photo-editing software, you'll be able to print them. Once the file is opened, the file format is largely irrelevant, as the pixels are just pixels.

Of course, not all file formats are created equal when it comes to printing. The same issues that govern your decision about what file format to save your images in will have an impact on the final printing. For example, if you save your images as highly compressed JPEG files, the final prints will reflect the loss of image quality that occurs when compressing the image data.

In general, you'll get your best prints from files saved in the TIFF or Photoshop PSD file formats. JPEG files that are saved at a high quality setting can also be used to obtain very good prints. The key factor is the quality of the image you have saved. If the saved file looks good, so will the print, provided you follow an appropriate color management workflow.

Email and Web

So now that we've convinced you that you need to save your digital photos as TIFF or Photoshop PSD to ensure the best quality, we have to mention the exception to the rule: Don't even think about sending those large files via email! When you send images through email (even when the recipient has a high-speed Internet connection), you need to strike a compromise between image size and quality if you want your recipient to receive the file sometime this century. That means using a file format such as JPEG that compresses the files to a manageable size.

UNDERSTANDING THE CONCEPTS

Throughout this chapter we've presented topics that help you gain a better understanding of the concepts that are important in digital imaging. This knowledge provides a foundation for you to build on as you continue to explore the world of digital photography. In the next chapter we'll delve into the components of a digital camera and how they work.

CHAPTER THREE

How a Digital Camera Works

There's more to creating a great photograph than pushing a button while standing in front of a beautiful scene. We photographers are passionate about the cameras and lenses we work with, and our enjoyment of the craft is apparent as we spend untold hours working to achieve the perfect composition.

You must understand the tools you work with (namely, the camera) to produce the best image possible. Digital cameras differ in many respects from their film counterparts, and it's worth examining how they operate, even if you're familiar with how film cameras work.

LENS TO IMAGING SENSOR TO MEDIA

Photography—whether film or digital—is all about light. The light from the sun or an artificial source reflects off the scene in front of the lens, then passes through the lens to the back of the camera. This process is similar to the way light passes through the lens of our eye to the cones and rods at the back of the eye, and on to the optic nerves. It's when the light reaches the back of the camera that film and digital cameras start to work differently. If cameras could talk, digital cameras would probably complain about how much work they have to do compared to their film camera siblings.

With film photography the light that passes through the lens exposes the light-sensitive film. The film records the light through photo-molecular reactions that embed a latent (nonvisible) image in the film. The latent image becomes visible when the film is chemically processed and developed.

With digital photography the flow of light is the same, but the flow of information is not. When the light reaches the back of the camera, it hits the imaging sensor, which translates that light into electrical voltages. The information is then processed to eliminate noise, calculate color values, produce an image data file, and write that file to a digital picture card. The camera then prepares to take the next exposure. This all happens quickly, with a tremendous amount of information being simultaneously processed and written to disk.

Let's follow the path of light to see how each component functions and what issues affect the final quality of the image (**Figure 3.1**).

Figure 3.1 In a digital camera, light follows a path through the lens to an imaging sensor.

THE LENS

Camera lenses are surprisingly complex and sophisticated in their construction and design, containing a series of elements—typically made of glass—that refract and focus the light coming into the lens. This allows the lens to magnify the scene and focus it at a specific point.

We've come to the conclusion that digital photography requires higher-quality lenses than film photography. Film has a variable-grain structure, whereas pixels are all the same size; this means that digital cameras operate at a disadvantage when it comes to capturing fine detail. In addition, an imaging sensor is more sensitive to light hitting it directly as opposed to hitting it at an angle, resulting in a slight loss of sharpness particularly around the edges of wide-angle lenses. The resulting loss of sharpness can be compensated in part by using a lens of the highest quality.

Focal Length

Different lenses provide different perspectives, and what makes those lenses different is their focal length.

Focal length is technically defined as the distance from the rear nodal point of the lens to the point where the light rays passing through the lens are focused onto the image *plane*— either the film plane or the sensor (**Figure 3.2**). This distance is typically measured in millimeters. From a practical point of view, focal length can be thought of as the amount of a lens's magnification. The longer the focal length, the more the lens will magnify the scene. At longer focal lengths the image circle projected to the back of the camera contains a smaller portion of the scene before the lens (**Figure 3.3**).

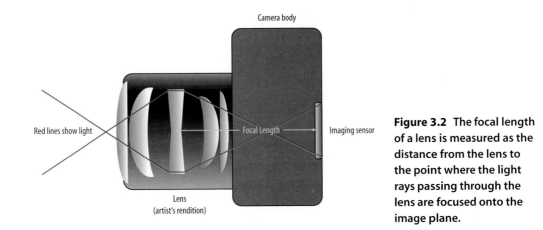

Figure 3.2 The focal length of a lens is measured as the distance from the lens to the point where the light rays passing through the lens are focused onto the image plane.

Figure 3.3 Increasing focal length effectively magnifies the scene. The image on the left was photographed with a 100mm lens, while the image on the right was photographed at 300mm.

In addition to determining the magnification of a scene, the focal length is generally considered to affect the apparent perspective and compression of the scene. In actuality, the focal length isn't what changes the perspective. Rather, the change in camera position required to keep a foreground subject the same size as with another focal length is what changes the perspective. For example, if you put some objects at the near and far edges of a table and then photograph the scene with a wide-angle lens, the background objects will appear very small. If you photograph the same scene with a telephoto lens, you'll need to back up considerably to keep the foreground objects the same size as they were when photographed with a wide-angle lens. This changes the angle of view of the subjects, so that the distance between foreground and background objects appears compressed (**Figure 3.4**).

Figure 3.4 Both images were captured to maintain the same size of the foreground subject. Changing focal length required that the distance between camera and subject be changed, which changed the relative size of background objects.

A Common Reference

The focal-length measurements used for lenses in 35mm film photography are well-known standards. To approximate our standard field of view on a 35mm camera, a photographer would use a 43mm lens. But as any photographer knows, a 50mm is considered standard. In fact, the 50mm lens is slightly narrower than standard human perspective, but it does maintain the spatial relationship of objects in the image very closely to the way we see the world. A 20mm lens provides a wide-angle perspective, and a 500mm lens magnifies the scene a great deal.

With digital cameras, there is tremendous variation in the focal length required to produce a given magnification, due to the range of sensor sizes (more on that in a moment). Because the sensors in virtually all digital cameras are smaller than a single frame of 35mm film, the lens's focal length can be much shorter and still produce the same angle of view one would expect from a lens for a 35mm film camera (**Figure 3.5**).

Figure 3.5 **A typical imaging sensor is considerably smaller than a 35mm frame of film.**

Because of the different sensor sizes and because the focal length measurements used in 35mm film photography are recognized standards, 35mm focal length equivalents are used to provide a common reference for digital cameras.

As one example, the Canon PowerShot S50 digital camera has a lens that can zoom from 7.1mm to 21.3mm. While that is the actual focal length measured in the lens, it doesn't provide a useful reference for the photographer as to how the lens will behave. If you've ever used a 15mm fish-eye lens, you can imagine the unusual scene you'd capture with a 7.1mm lens! Such a wide-angle lens would result in an incredibly distorted perspective caused by the wide field of view if applied to existing 35mm camera standards. However, because of the relatively small size of the sensor in this camera, the equivalent focal-length range compared to that of a 35mm camera would be 35mm to 105mm. This is a measurement the photographer will be much more familiar with. Thankfully most camera manufacturers now include the 35mm equivalents in their technical camera specifications.

Fixed Lenses

Fixed lenses are permanently attached and can't be exchanged with different lenses (**Figure 3.6**). Such lenses obviously make the camera simpler to operate. Their disadvantage is their lack of flexibility. Because the lens is fixed, you can't simply swap in a new lens when you need a different focal length. The only option is to zoom in or out to change the effective focal length of the lens, or to use accessory lenses to get a wide-angle or telephoto effect. Fortunately, most digital cameras with fixed lenses offer zoom capabilities, allowing you to change the composition of the scene quite easily with the push of a button.

Photo credit: Jeff Greene / ImageWest.

Figure 3.6 Compact digital cameras have fixed lenses that cannot be changed, although add-on accessory lenses can often be used to provide a wider or more telephoto view.

Zoom

Zooming in and out on a scene enables you to change the composition of your photograph and influence the spatial relationship of the subjects in the photograph without changing your physical location. With digital cameras, you can accomplish this with optical or digital zoom.

Optical zoom

Optical zoom lenses have a series of lens elements that move within the lens, altering the focal length by changing the relative position of those elements. The photographer can choose from a range of focal lengths, so that the scene can be cropped in a variety of different ways. Zoom lenses may produce images that are slightly less sharp than a prime (non-zoom) lens would, primarily because of the compromises that must be made in the design of the lens elements, such as adding glass elements to produce the range of magnification. However, zoom lenses can still produce excellent results and offer great flexibility.

As mentioned earlier, the zoom range of a particular digital camera is generally referenced as a range of focal lengths equivalent to that of a 35mm film camera. Another common way to express zoom is with an X factor. This factor describes the ability of the lens to magnify the size of a subject between the minimum and maximum focal lengths. For example, if you used a camera with a 3X zoom, the subject of your photo would be three times bigger.

> **TIP:** Move your position before making use of the zoom. We see many photographers use the zoom feature instead of taking a few steps forward. By moving yourself to the optimal photographic position and then using the zoom feature to fine-tune the composition, you improve your options in composing the picture.

Digital zoom

Many digital cameras offer digital zoom to supplement the optical zoom they offer. This is pure marketing hype, and the resulting image is the equivalent of cropping the image in the computer. To put it more bluntly, a digital zoom throws outside image information away.

Digital zoom operates by simply cropping the image that is captured at the maximum optical zoom; it then interpolates the image size up. Unfortunately, this interpolation produces images that are soft and lacking in fine detail. We recommend avoiding digital zoom altogether. Many digital cameras even offer the ability to turn off the digital zoom so you don't use it by mistake. Getting the extra reach is tempting, but the price is usually a significant loss of overall image quality (**Figure 3.7**).

Figure 3.7 The first image shows a picture shot at maximum optical zoom. If digital zoom is used to provide more reach, the quality suffers, as the second image shows.

If the optical zoom offered by the camera isn't enough to provide the image you're looking for, try getting closer to the subject. There are other methods for enlarging the photo, and although they may impact the quality of the image, doing image cropping and resizing in Photoshop will result in better image quality than using the digital zoom. It is always best to get the image right in the camera, rather than trying to fix it later.

Interchangeable Lenses

While many digital cameras with fixed lenses offer a good range of effective focal lengths, they simply don't offer the flexibility of a camera with interchangeable lenses (**Figure 3.8**).

Being able to change lenses as the situation warrants gives you tremendous creative control. Standing in the same spot, for example, you can capture a wide-angle image that shows the full environment of the location and then switch to a telephoto lens to extract a particular element from the scene. Many compact digital cameras let you modify the lens with accessory

Figure 3.8 Digital SLR cameras allow you to change lenses as the photographic situation requires.

lenses, converting it from a normal focal length to a telephoto or a wide-angle lens. But these add-on lenses also add problems, such as softening of the image and color fringing. A digital single lens reflex (SLR) camera gives you maximum flexibility by allowing you to use a wide variety of 35mm lenses (**Figure 3.9**). Just expect to pay considerably more for a digital SLR with interchangeable lenses than you would for a compact digital camera.

Figure 3.9 The ability to change lenses on a digital SLR camera gives you great flexibility. The image on the left was taken with a wide-angle lens, while the image on the right was taken of the same scene using a telephoto lens, focusing on the rocks in the distance.

TIP: While we do our "serious" photography with digital SLR cameras, none of us would be without a compact digital camera. Having a point-and-shoot digital in our pocket, we can document all those situations where we don't need (or want) to carry all the extra gear involved with a digital SLR.

Lens Speed

Figure 3.10 When photographing with low light levels, a fast lens can help achieve a fast shutter speed to ensure a sharp image.

Lens speed measures the amount of light the lens transmits at maximum aperture (minimum f number). A fast lens has a large aperture, allowing the lens to transmit more light—useful in low-light situations such as in the early morning or in candlelight (**Figure 3.10**). A slow lens has a maximum aperture that is small, so very little light can get through. A fast lens might have a maximum aperture of f1.4, while a slow lens might have a maximum aperture of f8. A fast lens is more desirable and is usually more expensive.

We'll talk about obtaining proper exposure in Chapter 7, "Seeing the Light," but for now it is enough to know that a proper exposure depends on both the aperture size and the shutter speed to allow an appropriate amount of light to reach the digital sensor. Increasing the aperture allows you to use a faster shutter speed. A fast lens with a low f rating has a larger possible aperture, meaning that you can use a faster shutter speed than would be possible with a slow lens—a tremendous help in low-light situations.

A fast lens also helps the camera focus. Because the lens transmits more light, the camera will be better able to acquire proper focus, even in relatively low-light situations.

Lens Quality

Regardless of whether you are using a compact digital camera with a fixed lens, or a digital SLR camera with interchangeable lenses, the lens plays a critical role in overall image quality. The sharpest, most accurate images—ones that maintain maximum detail from highlights to shadows—always start with high-quality lenses.

When selecting a compact digital camera, choose one with the highest quality lens possible. With a digital SLR camera you can choose from a wide variety of lenses for a given camera. And whenever possible, test a camera and lens combination to check for overall image quality. The quality of the lens can make all the difference in the final photograph.

Recognizing lens problems

To evaluate the quality of a lens, you need to take a picture with that lens and then evaluate the results. Since other factors can also affect overall image quality—such as photographic technique, imaging sensor quality, and environmental conditions—this isn't a foolproof method, but it's the only practical way for a photographer to test the quality of a lens.

Using a lens test target is the best method for evaluating quality (**Figure 3.11**). One of the most common targets provides fine lines that gradually get closer along their length, which allows you to evaluate the relative resolution of a lens. Unfortunately, these lens resolution charts can be expensive. For example, the commonly used PIMA/ISO Resolution Test Chart, available from Edmund Industrial Optics (www.edmundoptics.com) and other sources, typically sells for about $150.

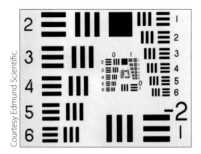

Figure 3.11 Photographing a lens test chart can help determine the sharpness of a particular lens.

TIP: When you want to evaluate the power of a lens to resolve (differentiate) fine detail, consider photographing the front page of a newspaper from a few feet away (Figure 3.12) (or as close as your lens will focus). By evaluating the resulting image at a large zoom setting in your photo-editing software, you can see how well the lens was able to render the fine detail, as well as check for other problems such as color fringing.

When doing any kind of lens testing, always use a tripod and the lowest ISO setting to minimize camera shake and noise.

Figure 3.12 When you don't have access to a lens test chart, you can photograph real-world objects to get information about the quality of a lens.

Sharpness

Sharpness is the ability of the lens to resolve fine detail and maintain edge contrast in those details. Lens resolving power is measured by the number of line pairs per millimeter the lens is able to resolve. To test a lens, photograph the lens test chart and examine the image to see at what point you can still discern individual line pairs of black and white. As the lines get closer together, they will at some point blend into each other.

When evaluating the digital image file for lens sharpness, you have to inspect the image at 100 percent zoom in your software to see the information accurately. Also make sure you check for edge-to-edge sharpness. We've seen many lenses that are sharp in the image's center but degrade significantly at the corners and edges. There is nothing more frustrating than taking an important photograph that is well composed but is just on the wrong side of sharp.

Lens distortion

The elements of a lens bend and focus the light to produce the final image. This process can distort the image. Sometimes this distortion can be a good thing, such as when using a fish-eye lens to provide a unique effect (**Figure 3.13**). Other types of distortion can produce effects that may be undesirable:

- **Pincushion distortion.** Pincushion distortion is where the edges of an image bend inward. It can occur on zoom lenses in the range of maximum magnification, and on shorter-focal-length lenses when telephoto adapters are added. This type of distortion

Figure 3.13 A fish-eye lens provides the ability to capture images with a truly unique perspective.

is easiest to see when there are straight lines near the edges of an image (**Figure 3.14**). The appearance of pincushion distortion can be corrected with photo-editing software.

- **Barrel distortion.** Barrel distortion is the opposite of pincushion distortion. With barrel distortion the image appears to bulge, with straight lines bent outward (**Figure 3.15**). It occurs with zoom lenses at the shorter-focal-length end of their range, or with wide-angle lenses. Again, straight lines near the edges of an image will make the effect more obvious. As with pincushion distortion, barrel distortion can be corrected with photo-editing software.

- **Chromatic aberration.** Chromatic aberrations are caused when light of different wavelengths doesn't get focused to the exact same focal point. Shorter wavelengths of light get refracted more than the longer wavelengths, causing the light of different colors to be out of alignment in the final image. It is most common in the lower-end consumer digital cameras, which tend to use lower-quality lenses. Most professional lenses use low-dispersion glass that minimizes chromatic aberrations. We've also seen chromatic aberration when using less-expensive wide-angle lenses.

 Colored halos at bright edges in an image are another form of chromatic aberration. This phenomenon results when light within the lens creates magenta fringing along the image's edges—particularly those of high contrast (**Figure 3.16**). Fortunately, you can quickly test for this problem by taking a photo of a high-contrast scene and looking for color fringing along high-contrast edges.

 > **NOTE:** Just because you can fix pincushion or barrel distortion and chromatic aberration in software, don't ignore them when evaluating lens quality. Fixing one or two photos isn't daunting, but fixing 100 or more images gets old fast.

Figure 3.14 Pincushion distortion is most easily seen when straight lines are near the edges of an image, where they can be seen to bend inward. (See the white line added for reference.)

Figure 3.15 Barrel distortion is a "bulging" of the scene, and is most easily seen when straight lines near the edge of an image are bent outward.

Figure 3.16 Chromatic aberrations are most likely to occur at high-contrast edges in a picture.

THE VIEWFINDER AND LCD

We need a way to see what the image is going to look like at the time the picture is taken, and a viewfinder provides this. With most film cameras, a viewfinder is a small window you look through to see how the scene looks. You can use that view to fine-tune your composition before taking the picture. Digital cameras include a viewfinder, but they also add an LCD that can be used as a viewfinder (except on digital SLR cameras) (**Figure 3.17**).

When you see someone taking a picture, the presence of an LCD display on the back of the camera is the most obvious clue that they are using a digital camera. With digital cameras becoming such a status symbol, we wouldn't be surprised if someone started selling fake LCD displays that could be attached to the back of a film camera, allowing photographers to hide the unpleasant fact that they haven't moved to digital photography yet.

Figure 3.17 The LCD on a compact digital camera can be used to compose the image, making digital photography much more accessible to even the youngest photographers.

The LCD display isn't included on digital cameras because it's necessary. In fact, there have been some very cheap digital cameras brought to market (and we do mean cheap, not inexpensive) that have not included an LCD display. However, it's an incredibly helpful tool that we wouldn't want to be without. That isn't to say there aren't some disadvantages as well, but overall the LCD display adds tremendous value to the digital photography experience.

Advantages and Disadvantages

We all love instant gratification, and that is the primary advantage of the LCD display on a digital camera. It allows you to preview the photo you are about to take and review the one you just took, to check for exposure and composition, or to share with everyone around you. In addition, you can also look at any of your images at any time after you've taken them. On many occasions we've found ourselves providing an impromptu slide show to friends and strangers who have gathered around the tiny LCD display to see the images we've taken.

With the non-SLR digital cameras, the LCD display adds another dimension by allowing you to use the display as your viewfinder. Instead of putting your eye to the camera to compose the scene, you can hold the camera in front of your face and compose based on the preview display that shows you what the final image will look like. This provides a little more freedom of movement, but also provides the opportunity to take images with unique perspectives. We've all seen the crowds of photographers trying to take pictures of the same subject, with those to the back holding their camera over their head, clicking the shutter release, and hoping for the best. The LCD display on a digital camera takes the guesswork out of that situation (**Figure 3.18**). You can take pictures up high, down low, around the corner, or elsewhere, and still know what you're going to end up with.

Figure 3.18 Using the LCD preview enables you to create images that might otherwise have been impossible.

One of the disadvantages of LCD displays is that they can consume a lot of battery power. When the battery starts getting low, the LCD display is the first feature to be disabled. Minimizing your use of the LCD display will help prolong battery life, but that isn't always convenient. To minimize the power consumed by the LCD display you can turn off the automatic preview, reduce the amount of time the preview is displayed, or resist the urge to frequently review your images.

In addition, trying to review your images on the display outdoors on a sunny day is nearly impossible. You'll find yourself seeking the shade of a tree, holding the camera inside your camera bag, or even contorting yourself inside a jacket to get a good look at your images.

Turning up the brightness of the LCD display can help make it easier to see in bright light, but it also changes the appearance of the image; so you can't really judge proper exposure based on the LCD preview alone. Your best bet is to shade the display as best you can to review your images, and use the histogram feature for exposure evaluation. We'll talk about using the histogram to ensure the best exposure in Chapter 7.

There are a variety of devices available that offer to shade your LCD display so you can better see it. In their various forms these are basically tubes you place against the LCD display to help shade it. Ideally, you want to be able to put your eye against the shade device to block as much light as possible. However, with many of the shades available, the tube is so short that putting your eye up to it will put you too close to be able to focus on the image. Others have magnifiers built in, but these tend to overemphasize the individual pixels in the image, rather than allowing you to view the image itself.

> **TIP:** Tim has periodically found himself using the cardboard tube from a roll of paper towels as a cheap shade for the LCD since it provides enough distance to focus normally on the image displayed.

LCD vs. Viewfinder

Even with all the benefits of the LCD display on a digital camera, you'll still find yourself using the viewfinder at times. Sometimes it will be because the battery is running low and you don't want to waste power on the LCD. Other times it will be out of preference. Whatever the reason, the viewfinder still offers an alternative to the LCD display when composing a photograph. We'll discuss the different types of viewfinders and their relative merits in Chapter 4, "Buying a Digital Camera."

For digital SLR cameras, the viewfinder and the LCD display show you the exact same image, because mirrors are used to project the image from the lens to the viewfinder. However, the viewfinder may not show you 100 percent of the image. This is why with digital SLR cameras you can't use the LCD to compose your scene the way you can on non-SLR digital cameras. In fact, most viewfinders on SLR cameras only show you around 95 percent of the actual scene that will be photographed. That means a small area around what you're able to see will still be included in the final image.

Compact digital cameras use a viewfinder that simply provides a window onto the scene in front of the camera, rather than using the image projected through the lens as your preview. But because the viewfinder is not located in the same position as the lens, the perspective is slightly different. For distant subjects this does not translate into any visible difference between the two. However, when you are close to your subject, the difference between what you see in the viewfinder and what you capture through the lens can be considerably different (**Figure 3.19**).

Often, boxes and lines are found inside the viewfinder to help you compose images at different distances, giving you some indication of how the final image will differ. A lot of this comes down to learning how the image in the viewfinder translates to the final photograph. You can get a feel for this by comparing the scene in the viewfinder with the display on the LCD to see how they differ. Katrin uses this technique by framing a door in the viewfinder, and then seeing how it appears on the LCD. Such a technique can tell you immediately if the display through the viewfinder is centered or skewed.

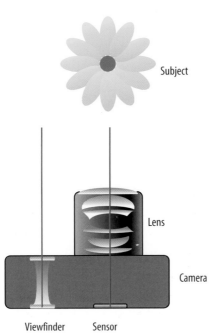

Figure 3.19 On compact digital cameras the viewfinder does not provide an accurate view of the image to be photographed, particularly when the subject of the photo is close to the camera.

Changing the Photographic Experience

In many ways, the LCD display has changed the way we take pictures. The ability to review our photos immediately frees us to experiment more, trying out various perspectives or settings. We can then review the results immediately and try again with a different approach.

For the non-SLR digital cameras, the LCD has become the primary viewfinder. Instead of becoming an attachment to your face, the digital camera is now an extension of your hand, moving anywhere you can reach to take that special image.

And of course, we can now instantly share the pictures we've taken with friends, family, and strangers just met. We can live in the moment, immediately reminiscing about the funny face, beautiful sunset, or other magical moment we experienced just moments before (**Figure 3.20**).

Digital photography allows you to photograph images that would otherwise have been impossible. It opens a new world of possibilities for the photographer. We encourage you to experiment with those possibilities to create some incredible images.

Figure 3.20 Digital photography has changed the photographic experience, allowing us to instantly share the magical moments caught on "film."

THE SHUTTER

The shutter is a complicated mechanism that precisely controls how long the light passing through the lens is able to continue on to the film or digital sensor at the back of the camera.

With a film camera, the shutter remains closed to prevent light from exposing the film until a picture is taken. With a digital camera—depending on the type of sensor used—a shutter in the traditional sense may not even be necessary. Because the imaging sensor in a digital camera is an electronic device rather than a light-sensitive chemical, it can be turned on and off electronically, eliminating the need for a mechanical shutter to control the flow of light. Some sensors still require the use of a shutter, but many digital cameras don't use a mechanical one.

Whether or not there is a mechanical shutter in a particular digital camera, there still needs to be a mechanism to control the exposure of the image, and we still need a shutter release button.

Pushing the Button

Pushing the shutter release button activates a series of events that culminates in the final picture. The sensor must be charged so that it is ready to receive the light from the lens, which is why it is called a *charged coupled device*. The digital card must also be activated so that it is ready to receive data. In the case of the Microdrive, that includes spinning up the tiny hard drive motor.

Besides getting ready to take the picture, the camera must also establish the settings it will use for the picture. That includes setting the autofocus if enabled, calculating the exposure if autoexposure is selected, and selecting an appropriate white balance setting to ensure the colors in the scene are rendered properly based on the type of lighting used. A $300 point-and-shoot digital camera will be slower to respond than a $1500 digital SLR camera.

Once all of these tasks have been accomplished, the camera is ready to trigger the shutter so the imaging sensor can read the light. That's a lot of work to do in less than a second—generally milliseconds. Unfortunately, this whole process can cause irritating delays when you're taking the picture.

Shutter lag time

One of the most frustrating experiences in digital photography is pressing the shutter to photograph your new puppy running on the beach, only to find yourself waiting for the camera to actually take the picture. In the meantime, the puppy has moved out of the frame and you're left with a picture that is missing the very subject you intended to photograph (**Figure 3.21**). This delay is generally referred to as *shutter lag time*, but it's actually caused by more than just a lack of responsiveness in the shutter. As mentioned previously, the camera is calculating the combination of settings to take the best picture. You can sidestep the shutter lag by using the following technique to help you get the picture exactly when you want to.

Figure 3.21 Shutter lag can cause you to miss the photo you were after.

When trying to photograph that puppy running on the beach, hold the shutter release button halfway down as you compose the shot so the camera can prepare itself; then you'll be all set to press the button down the rest of the way the moment you want to take the picture (**Figure 3.22**). Depending on the capabilities of the particular camera, there may be some infinitesimal delay, but we doubt you'll even notice it.

Figure 3.22 By pressing the shutter release button in halfway before taking a picture, you can minimize shutter lag and get the image you were trying to achieve.

THE IMAGING SENSOR

Film does the job of both recording and storing the image photographed. With digital cameras these jobs are split between the imaging sensor and digital media (we'll talk about digital media later in this chapter). The imaging sensor replaces film as the recording medium. The sensor consists of millions of individual light-sensitive pixels. These pixels effectively translate the light into specific voltage values. This process is called analog to digital conversion—or in geek speak, *A to D conversion*. The voltage information that has been translated to discrete digital numbers represents the tonal and color values in the photographic image.

Even though digital cameras take pictures in full color, the sensors are unable to see color. They can only read the luminance, or brightness, of the scene. Colored filters are used to limit the range of light that each pixel can read so that each pixel records only one of the three colors (red, green, or blue) needed to define the final color of a pixel. *Color interpolation* is used to determine the remaining two color values for each pixel.

Types of Sensors

The most widely used image sensors are CCD (charged coupled device) and CMOS (complementary metal oxide semiconductor).

CCD

CCD sensors capture the image and then act as a conveyor belt for the data that defines the image. These sensors use an array of pixels arranged in a specific pattern that gather light and translate it into an electrical voltage. When the voltage information has been collected by each pixel as an image is taken, the data conveyor belt goes into action. Only the row of pixels adjacent to the readout registers can actually be read. After the first row of data is read, the data from all other pixels is shifted over on the conveyor belt so that the next row moves into position to be read, and so on (**Figure 3.23**). The CCD sensor itself doesn't process that voltage and converts it to digital data, so additional circuitry in the camera is required to perform those tasks.

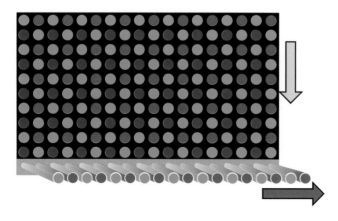

Figure 3.23 The data captured by a CCD sensor is read one row at a time, with the data moving along a "conveyor belt" to be read at the output row.

CMOS

A CMOS sensor is named after the process used to create the components—the same process used to manufacture a variety of computer memory components. Like CCD sensors, the CMOS sensors contain an array of pixels that translate light into voltages. Unlike on the CCD sensor, the pixels on a CMOS sensor include additional circuitry for each pixel that converts the voltage into actual digital data. Furthermore, the data from the

sensor can be transmitted to the camera's circuitry in parallel, which provides faster data transfer from the sensor to the camera circuitry (**Figure 3.24**).

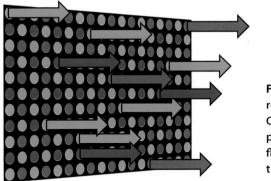

Figure 3.24 Data can be read from all pixels on a CMOS sensor at one time, providing a much faster flow of the image data than with a CCD sensor.

Because circuitry is used at each pixel in a CMOS sensor, the area available to capture light is reduced for each pixel. To compensate for this, tiny microlenses are placed over each pixel on CMOS sensors to focus the light and effectively amplify it so that each pixel is able to read more light. Because cameras using CMOS sensors are able to integrate several functions on the actual imaging sensor, they use less power.

CCD vs. CMOS sensors

Until recently, CCD sensors did produce better image quality and higher dynamic range than CMOS sensors. However, CMOS sensors have improved to the point that they produce excellent image quality. They were originally less light sensitive and were more likely to produce noisy images. Recent developments have helped to overcome these shortcomings, allowing CMOS sensors to be used in professional-quality digital cameras. For example, increased pixel size is improving CMOS light-sensitivity, which in turn improves the ISO. Noise reduction processing in the camera is also being improved. All of these enhancements are allowing CMOS sensors to be used in professional-level digital cameras.

In addition, CCD sensors consume considerably more power than CMOS sensors, and CMOS sensors are more economical to produce. All this considered, we feel that CMOS will continue to improve and will become the standard image sensor in the near future.

Other Sensors

• Fuji Super CCD Sensors

Fuji has produced several sensors that have advanced the standard CCD technology. The company's first Super CCD sensor created a stir with the Fuji FinePix S1 Pro camera. The camera was promoted as producing images at 6.13 megapixels, even though the sensor actually contained 3.07 effective megapixels. To many critics the "funny math" was the result of the octagonal pixel shape used by the sensor; the honeycomb of pixels requires interpolation, resulting in a higher pixel count than if standard pixels were used.

Since the first Super CCD, Fuji has also developed the Super CCD SR and Super CCD HR sensors. The SR stands for superdynamic range. In this sensor there are actually two pixels for each pixel. One of them has a high sensitivity but low dynamic range, while the other has a low sensitivity but high dynamic range. By combining the information from each pixel, the result is an extended dynamic range compared to standard CCD sensors.

The HR sensor is a high-resolution version of the Super CCD. This sensor type enhances the amplification of the light hitting the pixel, allowing more pixels to be packed into a smaller area; this produces a higher resolution in the same sensor size (or the same resolution in a smaller package).

• Foveon X3 Sensor

While most imaging sensors record only a single color for each pixel, the Foveon X3 sensor actually reads all three color values at each pixel site by having three layers of sensors, with the top layers allowing the light to pass through to be read by underlying layers, similar to how film works. This helps to provide higher image quality because interpolation is not needed to produce the final image. The difference is slightly higher detail in the final image. The effect is subtle, but visible on close examination. At this writing, the only camera in production that uses the Foveon X3 sensor is the Sigma SD9 digital SLR. All other compact or SLR digital cameras use either a CCD or CMOS imaging sensor that reads only one color per pixel and then interpolates to determine the other two color values.

• Scanning Backs

Another type of imaging sensor often used in medium- and large-format digital photography is the scanning back. Unlike the sensors used in most cameras, scanning backs do not record the full scene in a single shot. Rather, they scan the image projected by the lens, recording the information line by line and for each color value. This provides a digital image of exceptional quality but requires that the camera and the subject remain motionless during the full picture taking. This is a compromise that reduces the scanning back's utility for many photographers, but the image quality is compelling for still-life studio work, fine art reproduction, and scientific photographers.

How Sensors Work

Regardless of the specific circuitry involved in a particular type of sensor, the basic function is the same. An array of light-sensitive pixels, representing each pixel in the final image, is exposed when the picture is taken. When light hits each of these pixels, a charge builds up proportionate to the intensity and amount of light.

The strength of that electrical charge determines the brightness level for each pixel. More light reaching each pixel results in a stronger signal and a brighter image. If too little light reaches the sensor, the image will be dark.

Blooming

Each pixel is limited in how much charge it can hold—when the bucket is full, it's full, and extra exposure doesn't mean more image information. When too many photons hit a particular pixel and the electrical charge becomes more than it can handle, the charge starts to overflow into surrounding pixels. This is referred to as *blooming*. Antiblooming gates in the imaging sensor can help minimize blooming, but even then it can occur in very-high-contrast areas of the image. Blooming generally appears as a halo or streaking near those contrast edges (**Figure 3.25**).

Figure 3.25
Blooming causes a loss of detail in areas where pixels couldn't store enough data to record the amount of light that reached them.

Proper exposure will eliminate most blooming, although in situations with extreme contrast it can still appear. When in doubt, we recommend slightly underexposing the image. Once a pixel exceeds the limit on the amount of charge it can hold, image detail will be lost in that area of the image.

Analog to Digital Conversion

The sounds we hear in the real world are analog. That means the sound has an infinite amount of variation, with very smooth transitions and no discrete steps from one tone to another—picture a sound wave. If we convert that sound to a digital form, only a specific number of possible values exist, so the transition from one tone to another won't be as smooth. The analog data is smooth, while the digital data is in discrete steps (**Figure 3.26**).

Figure 3.26 Analog data (top) represents an infinite number of possible values with smooth transitions. Digital data (bottom) contains a finite number of possible values, and results in transitions that are not as smooth.

The light coming through the lens to the imaging sensor is information that's in analog form. For an image, analog means smooth transitions between tones and colors, with an infinite number of possible values within a given range. When represented in a digital form, the image information is represented by specific values. The bit depth of the image file determines how many possible values are stored, but it will always be fewer possible values within a given range when compared to analog data. When the sensor captures the scene projected by the lens, it must convert the analog information into digital values that can be stored in an image file.

Analog to digital (A/D) conversion is the process by which analog signals are converted into discrete digital values. This is one of the most critical steps in the photographic process, determining the amount of detail retained and the overall quality of the image. A/D conversion is the essence of digital photography, translating the image before the lens into digital data.

Conversion quality

The number of bits used to define the possible digital values is the primary factor that determines the A/D conversion quality. If an 8-bit number is used to define each value as it is processed, a total of 256 (2 to the power of 8) possible values are available. At 10-bit that number goes up to 1024, and at 12-bit there are 4096 possible values. When more values are available during the A/D conversion, the transitions between tonal values are smoother and there's more detail from bright highlights to dark shadows.

Noise

Noise in digital images is often compared to film grain in traditional photography. The two phenomena are similar, but their appearance and causes are quite different.

Film uses light-sensitive silver-halide particles to capture an image, and these particles form the grain structure of the film. This structure is critical to the ability of film to actually record a scene, but it also gives the image a visible texture (**Figure 3.27**). This effect is sometimes considered undesirable, but it can also add to the mood of an image. Film grain is larger in films with higher ISO ratings, and is more visible when the image is enlarged.

Figure 3.27 Film grain produces a texture in the image that can sometimes be seen as offensive, but often adds to the character of an image.

With digital cameras, a similar problem is noise (**Figure 3.28**). However, noise is not caused by the physical structure of the imaging sensor, but rather by electronic errors or interference. Signal interference from other components within the camera can confuse the voltage information recorded by each pixel. Amplification of the signal, such as when photographing at higher effective ISO settings, also increases the likelihood of noise in the final image.

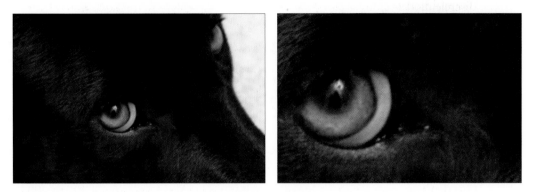

Figure 3.28 Noise in digital images produces a very undesirable result.

Heat can also cause problems with the imaging sensor, leading to more noise. When photographing a dark scene or when using a high ISO setting, it's best to keep the camera cool to help minimize noise. Try taking the picture right after the camera is turned on, or letting the camera cool between shots. Keeping the actual camera cool by avoiding sun exposure or hot cars will reduce noise.

Some cameras will minimize this noise by checking the noise pattern of the sensor with a *dark capture*. Either before or after a shot, the camera reads the values from the sensors with the shutter closed, creating a "map" that defines the noise being caused by the pixels. This noise can then be subtracted from the final image.

In our experience digital camera noise is much less pleasing than film grain and should be avoided. Working at the lowest ISO setting possible will make a big difference. For those situations where you aren't able to avoid noise, we'll show you how to reduce it in Chapter 11, "Digital Darkroom Expert Techniques."

ISO

An ISO (International Standards Organization) rating measures the light sensitivity for film or an imaging sensor. Photographers have become accustomed to thinking about ISO when selecting the film they'll use for a particular photo session. One of the advantages of digital photography is that you can change the ISO sensitivity of a digital camera from shot to shot. With a film camera you would have to change the roll of film to change the ISO rating.

A given imaging sensor has a particular sensitivity to light. The actual sensitivity of the pixels can't be changed, so to produce a higher ISO rating the signal from those pixels must be amplified. This amplification effectively allows the pixels to "see" better under low lighting by adding *electronic gain* to the signal, which bumps up the pixels' response to the low light. This is why you see more noise artifacts in the darker image areas.

When amplifying the signal from the pixels, the chance of noise greatly increases and final image quality decreases. Some cameras such as the Canon EOS 1Ds and the Fuji FinePix S2 Pro are very good at minimizing noise at high ISO settings, allowing you to photograph images all the way up to the maximum ISO setting with good results. However, other cameras are not as effective at minimizing noise, and using even moderate ISO settings can result in images that have an unacceptable level of noise in them.

When to change ISO

To take the cleanest image with the least amount of noise, we recommend using the lowest ISO that your camera is capable of, which in most cases ranges from 100 to 400 ISO at the low end and up to 3200 ISO at the higher or faster end. If you are not able to get a fast

enough shutter speed under the current lighting conditions, try using a tripod, choosing a smaller f number, or as a last resort increasing the ISO to achieve a faster shutter speed. For example, if you visit a museum and take a picture outside you can use the minimum ISO setting (**Figure 3.29**). If you go inside and take pictures of the displays, you may need to increase the ISO setting to get a good exposure with the available light (**Figure 3.30**). We'll discuss more about selecting an appropriate ISO setting in Chapter 6, "Digital Photography Foundations."

Figure 3.29 A low ISO setting can be used when there is adequate light—and is preferred for the best image quality.

Figure 3.30 In low-light situations, a higher ISO can help obtain a picture that might otherwise have been impossible, but it also increases the risk of noise in the image.

Physical Size of the Sensor

The number of pixels and the size of those pixels determine the physical size of the imaging sensor. The higher the resolution and the larger the pixels, the larger the overall sensor must be to fit all those pixels. Compared to the film it replaces, the imaging sensor is generally smaller, although that varies from camera to camera.

Impact on focal length

The overall size of the imaging sensor impacts the effective focal length of the lens. Whether this impact is good or bad is a subject of frequent debate. Some people appreciate the effective extension of the focal length of their lenses, while others perceive the changes to focal length as a limitation.

When an imaging sensor is smaller than the film it replaces, it's cropping the image circle projected by the lens (**Figure 3.31**). Because it is seeing a smaller portion of the overall image circle, the net result is an image that is cropped as though it were captured on film at a longer focal length (**Figure 3.32**).

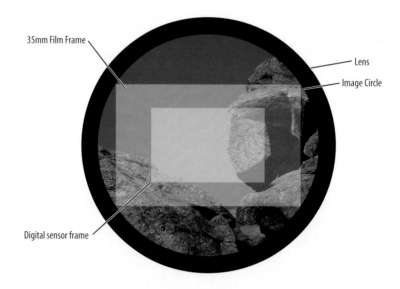

Figure 3.31 The sensors used in most digital cameras are smaller than a piece of 35mm film, cropping the image circle projected by the lens and resulting in a longer effective focal length.

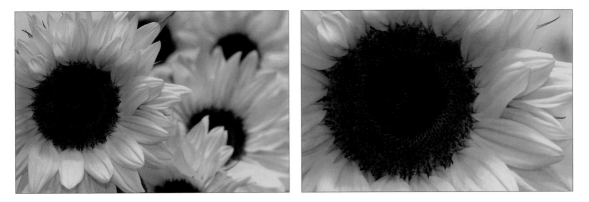

Figure 3.32 A lens of a given focal length used with a 35mm film camera will produce one image (left), while the same lens used on a digital camera will result in a longer effective focal length (right).

One way to think about this cropping is to compare it with what changing the focal length of a lens does. If you take a picture of a scene with a 100mm lens, and then take another picture with the camera in the exact same position but use a 300mm lens, you will have effectively cropped a smaller portion of the scene by magnifying it. Both techniques involve cropping the scene, and both produce an image that makes full use of the film or imaging sensor area. They both produce the same net result, one by actually increasing focal length and one by cropping the image. Unfortunately, this also means that wide-angle lenses will behave as though they weren't exactly wide-angle, but rather more of a "normal" focal length without as much angle of view (**Figure 3.33**).

Figure 3.33 The effective focal length multiplier of most digital SLR cameras decreases the angle of view, in effect magnifying the images. Both images were taken with the same lens. The image on the left was taken with a film-based SLR using a 30mm focal length lens, and the image on the right with a digital SLR (effective focal length 48mm).

Impact on image quality

When an imaging sensor is smaller than the film it effectively replaces, there is actually a potential to improve the quality of the image. Lenses are sharpest near their center, with the edges tending to be less sharp. Because a relatively small imaging sensor is cropping the final image from the center of the image circle, it is capturing the image from the sharpest portion of that image circle.

However, just because the sensor is capturing the image from the sharpest area of the lens does not guarantee improved image quality. The actual size of the pixels in the imaging sensor also plays a role in the overall image quality.

Physical Size of Pixels

The size of the individual pixels impacts the light sensitivity of the sensor (also called the ISO) and the ability to maintain fine detail in the image.

Impact on ISO

As previously explained, the ISO rating system provides a benchmark of the relative sensitivity of film. The higher the ISO, the more light sensitive a film is. That means that higher ISO films require less light to record an image.

With digital cameras, a minimum ISO rating is defined by the sensitivity of the sensor. Larger pixels have more surface area to absorb light, giving them a higher sensitivity, or higher effective ISO. Small pixels are not able to gather as much light, which translates into a lack of sensitivity, or a lower effective ISO.

Impact on image quality

The size of the individual pixels also affects the final quality of the image. Large pixels produce an image that is coarser, because they are not able to capture as much fine detail; smaller pixels resolve finer detail.

However, smaller isn't always better when it comes to overall quality. Because smaller pixels are also less sensitive, the signal they produce will generally need to be amplified more, resulting in more noise in the final image. The optimal pixel size is a compromise between the ability to photograph fine detail, minimize noise, and work at a reasonable ISO rating.

Bit Depth

In Chapter 2, "Nuts and Bolts of Digital Imaging," we talked about bit depth as it related to digital image files. In that case, *bit depth* was a measure of how many possible numeric values could be used to describe one pixel, which determined how many tonal and color values could be represented by an image file at various bit depths. That same concept applies to the imaging sensor and the data it gathers and processes.

The imaging sensor does not have a strict limit on the range of values from light to dark the way film does. Instead, the limits are defined by the A/D conversion and the way the image data is stored. A higher bit depth in the A/D conversion means the image retains more detail. When that file is written (see "Storing the Image" later in this chapter), the bit depth defines how many tonal values the final image retains. For example, a 12-bit A/D conversion would provide 4096 possible tonal values for each color channel, but an 8-bit JPEG photo can only store 256 of those values. This causes a loss of tonal information in the image, and is one of the reasons we highly recommend RAW capture whenever possible (which we'll discuss later in this chapter).

An 8-bit-per-channel capture produces photographic-quality output, but it doesn't provide the overhead required to allow for substantial tonal and color image editing. If you are using a capture mode that supports only 8-bit-per-channel images, it's important that the exposure be as accurate as possible so that only minimal editing is required later to produce the perfect image. We'll show you how to achieve perfect exposures in Chapter 7.

In situations where the lighting is tricky or you otherwise anticipate the need to do considerable editing to optimize the image, we recommend capturing at higher than 8-bit-per-channel bit depth if your camera offers such an option. This is generally only available as a RAW capture mode. When available, this high-bit capture mode allows you to shoot images at 12 bits per channel.

Capturing Color

Imaging sensors are color-blind—they can see only relative brightness levels of light. To determine color values, each pixel has a colored filter in front of it, which means it can only see one color. (An exception is the Foveon X3 sensor, which is able to read all three colors for each pixel. See the sidebar, "Other Sensors," earlier in this chapter.)

Because the primary colors for emitted light are red, green, and blue, these are the colors generally used for the filters that are placed over each pixel. Since only one of the three can be placed over each pixel, the filters of different colors are arranged in a pattern so that each captured color is represented adequately in the data to produce the final full-color image for virtually all digital cameras.

Filter patterns

Most digital cameras use the Bayer pattern for arranging the pixels to capture red, green, and blue. This pattern uses twice as many green pixels as red or blue, because our eyes are more receptive to light frequencies close to green, which falls in the middle of the visible spectrum. If you look at a 4-pixel grid from a sensor that uses the Bayer pattern, the two green pixels would be diagonal from each other, with a red and blue pixel on the opposite diagonal (**Figure 3.34**).

Figure 3.34 Because each pixel on an imaging sensor only records luminosity values for a single color, the filters that define the color seen by each pixel must be arranged in a pattern. The most common pattern is the Bayer pattern, which uses twice as many green pixels as red and blue.

Although each pixel reads only one color, all three values (red, green, and blue) are required in order to determine the actual color of each pixel. To determine the other two color values for each pixel, color interpolation is used. In effect, this technique calculates the missing values based on surrounding values for each of the colors. For example, when determining the red and blue values for a green pixel, the values of surrounding red and blue pixels are taken into consideration to calculate the final values (**Figure 3.35**).

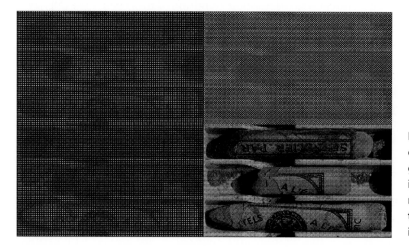

Figure 3.35 The values captured for the red, green, and blue pixels in an imaging sensor must be interpolated to produce the final image.

When the camera is effectively guessing at what the other two color values should be for each pixel, there are bound to be situations where the values are not as accurate as they could be. When this happens, a variety of problems arise.

Color artifacts appear when areas of the image have inaccurate colors that don't match surrounding pixels. For example, you may have a random green area in a clear blue sky. These artifacts are not the same as noise, as they generally happen with neighboring groups of pixels rather than individual pixels, and they are caused by different factors. Moiré patterns are visible artifacts that appear as herringbone or checker patterns, caused by interference between the pixels and fine textures in the image (**Figure 3.36**). They can occur when a photograph includes such things as finely spaced patterns, barren tree branches, and fine cloth patterns. You can often minimize moiré patterns by moving the camera slightly closer or farther away from the subject, or by using a larger aperture. For those situations where you can't avoid moiré patterns, we'll show you retouching techniques that work with all but the most ferocious moirés in Chapter 11.

Figure 3.36 Moiré patterns show as patterns in an image when fine textures interfere with the pixel layout on the imaging sensor.

Dynamic Range

Dynamic range is the ability to capture an image with full tonal detail from bright highlights to dark shadows.

For example, if you're photographing a bride and groom in daylight, a camera with low dynamic range is going to increase the chances that details in the white dress will be blown out to pure white (**Figure 3.37**). If you photograph the couple using a camera capable of a wider dynamic range, the brightest areas of the wedding dress will maintain detail with excellent texture detail in the tuxedo and dark hair. A high dynamic range can help maintain the detail in both bright highlights and dark shadows. A variety of factors affect the dynamic range of a digital camera, including the sensitivity of the imaging sensor, the pixel size, the signal to noise ratio, and the quality of the analog to digital conversion.

Photo credit: Wayne R. Palmer / Palmer Multimedia Imaging

Figure 3.37 When an imaging sensor isn't able to capture the full range of tonal values in a scene, detail can be lost in the highlights and shadows.

If your camera doesn't provide an adequate dynamic range to hold detail in all tonal values in your image, it's generally best to underexpose the scene by ½ to one stop. We recommend underexposure when image areas are blown out to pure white because there is no software magic that can ever add information that wasn't in the file to begin with. By underexposing the highlights, you are capturing tonal information, and it's better to lighten a dark image than to try to darken a light one.

In-camera processing can also affect the dynamic range of the final image. For example, increasing contrast via the camera settings or with image-editing software in the computer

effectively decreases the overall dynamic range by reducing the number of tonal values present in the image. To maximize the dynamic range, we recommend that you not use any in-camera options to increase image contrast or saturation. If the camera adds contrast or saturation to a file, there is very little you can do to offset the change. In other words—don't let the camera make such important decisions without your knowledge. Please see Chapter 6, "Digital Photography Foundations," for additional information on setting up your camera software to capture the best file possible.

When a scene contains a broader tonal range than your camera is able to capture, all hope is not lost. We'll show you how to combine multiple exposures to retain information for more tonal values than your camera sensor is capable of in Chapter 11.

STORING THE IMAGE

Once the imaging sensor has recorded the scene projected by the lens, the camera processes the information gathered by each pixel. It performs a variety of tasks to optimize the image based on the current camera settings. This information then needs to be stored for future use. That means the data must be put on a digital card and written in a file format that can be opened later for editing and printing.

Digital Media

A digital camera stores each picture on a digital media card. This can be thought of as replacing film in some respects (thus the term *digital film*), but there are also important differences. As mentioned earlier in this chapter, film does the job of capturing and storing the image—while digital photography divides these tasks between the imaging sensor that captures the image and the digital media that stores it.

Digital media takes many shapes and sizes, from about the size of a book of matches to the size of a stick of gum. Some newer types are even smaller. Different cameras use different types of digital media. Some cameras even provide the option to use more than one type of card, providing additional flexibility. The media type should be one of the factors you consider when choosing a digital camera, and there are advantages and disadvantages to each type. With the exception of the Microdrive, all of the current digital film options are solid-state devices (meaning no moving parts) that use nonvolatile flash memory for storage. That eliminates the risk of moving parts wearing out, but the components used in these media cards still have a limited life. The average life expectancy is measured in hundreds of thousands of cycles, so for most photographers they will remain reliable until replaced by a new, higher-capacity card. Today's digital media formats have come a long way since the first digital camera was introduced (see the sidebar "Storage Progress Continues").

Storage Progress Continues

The first digital camera targeted at the consumer was the Apple QuickTake 100, introduced in January 1994. This camera included 1MB of internal memory—with no option of removable media. You could take 8 pictures before you had to connect the camera to the computer and transfer the images. At the time that Apple was developing the Apple QuickTake 100, Eastman Kodak was developing the DCS (Digital Camera System) 100 for the professional market. It sported a modified Nikon F3 that was tethered to a "portable" 12-pound Winchester hard drive capable of holding 156 images.

Shortly thereafter digital cameras allowed you to store images on floppy disks, which were readily available but only allowed you to hold a maximum of 1.4MB of images on a single disk. Fortunately the cameras were typically very low resolution at the time, so the files were quite small.

Since then, we've seen rapid development of media for use in digital cameras. The last few years have seen capacity and speed increase at phenomenal rates, while the prices have continued to plummet. This trend continues with no sign of slowing down, and we can only imagine how many images we'll be able to fit on inexpensive digital cards in the future.

• CompactFlash

The CompactFlash format is currently used by the majority of digital cameras (**Figure 3.38**).

There are actually two types of CompactFlash cards. Type I cards measure 1.7 by 1.4 by 0.13 inches, with Type II cards measuring the same length and width but thicker, at 0.19 inches. Both types of CompactFlash cards can be used in a Type II slot, but only Type I cards can be used in a Type I slot. Most cameras that use CompactFlash cards offer a Type II slot for maximum compatibility. The data is transferred to the CompactFlash card through a series of pins.

Figure 3.38
CompactFlash card.

CompactFlash cards tend to be one of the least expensive options on a per-megabyte basis. At this writing they range in capacity from 64MB at the low end, to 4GB at the high end, with cards of 6GB and larger expected soon. As with all computer technology, the capacity will continue to increase and the price will drop as the technology develops.

• Microdrive

The Microdrive was originally developed by IBM, but that portion of IBM's business was purchased by Hitachi and is now a part of Hitachi Global Storage Technologies. Originally available in capacities starting at 340MB, the Microdrive now offers up to 4GB of storage capacity, with higher capacities offered in the near future.

Figure 3.39
Microdrive hard-drive card.

The Microdrive is effectively a Type II CompactFlash card that uses magnetic hard-drive technology for storage rather than flash memory (**Figure 3.39**). Because it contains a very small hard drive for storage, there are moving parts. This involves a higher risk of damage compared to standard CompactFlash cards. Microdrives are very reliable, but it's important to handle them with care to avoid damaging the very small moving components that have fine tolerances. Dropping them can be catastrophic.

Because of the hard-drive technology used by Microdrives, they are more economical than standard CompactFlash cards and are able to operate at higher data transfer speeds.

• SmartMedia

The SmartMedia format is currently the second most widely used digital film format, behind the CompactFlash format. SmartMedia cards measure 1.77 by 1.46 by 0.03 inches (**Figure 3.40**). They are thin and compact, making them easy to store and a bit easier to use than some other formats, too.

Figure 3.40 SmartMedia card.

Instead of using pins for transmitting data to or from a camera or other device, the SmartMedia card uses a flat electrode terminal. This helps to keep the card compact but also increases the risk of static discharge causing a loss of data. These cards are also somewhat flexible, so you run the risk of breaking the tiny wires inside the card if you inadvertently flex the card as you handle it. We also recommend not touching the gold area of the card to avoid possible data loss.

SmartMedia cards are currently available in capacities ranging from 32MB to 128MB. New storage formats appear likely to replace SmartMedia for use in digital cameras. The new formats offer more secure, faster, and higher-capacity storage of data.

• Memory Stick

The Memory Stick format was developed by Sony and is currently used only in Sony digital cameras (**Figure 3.41**). It is about the size of a stick of gum, at 1.97 by 0.85 by 0.11 inches. This relatively compact size is still large enough that it isn't likely to be lost.

The Memory Stick format is currently available in capacities up to 1GB with the new Memory Stick Pro line of media.

Figure 3.41 Sony Memory Stick card.

• xD-Picture Card

The xD-Picture Card is a new format developed by Fujifilm and Olympus that at 0.98 by 0.79 by 0.07 inches is by far the smallest digital film type available (**Figure 3.42**). Compact is generally a good thing, but in this case we're a bit worried about the higher risk of losing these tiny cards. Fortunately, they are rigid and durable, so the risk of damage is quite small.

xD-Picture Cards are currently available in capacities from 16MB to 512MB, and can be used in compatible cameras from Olympus and Fuji. The design allows for future capacities of up to 8GB.

Figure 3.42 xD-Picture card.

Photo credit: Jeff Greene/ImageWest.

Size and speed do matter

The two most important issues to consider when comparing various digital film media are capacity and speed. We don't consider price to be an important consideration. No, we didn't win the lottery, we just feel that quality is more important than price. The prices of these cards are always going down, and in general they are quite affordable. We focus on capacity, speed, and the reputation of the manufacturer to deliver products of the highest quality.

The larger the capacity of the card you purchase, the more pictures you'll be able to take on that card before you need to delete or download files, or change to another card. Using compression settings when taking pictures helps to make the most of the available space on a card, but you pay a price in image quality.

When you head out on a photography excursion, you'll want to make sure you have enough storage capacity for the images you are going to take. By using a laptop or portable storage device (we'll talk about those in Chapter 5, "Essential Accessories"), you can maximize the use of your digital cards by clearing them off and reusing them to take more pictures.

The simple approach to the issue of capacity is to purchase the largest card available. For a more practical approach, consider how many images can be stored on a digital card of a given size. Your camera manual likely has a chart showing how many images can be taken with a specific card capacity using the various capture modes. You can use this as a basis for deciding how much capacity will work for you. Just keep in mind that a higher capacity card also means the potential to lose more images if a card fails. Tim's preference is to use the manual to figure out how many megabytes are required to equate to a 36-exposure roll of film. This provides a number that makes a little more sense based on experience, and it isn't too difficult to translate how much storage capacity will be required to equal a particular number of rolls of film for a photo trip. On the other hand, Seán knows a photographer who only uses 512MB cards because the full contents of each card will fit onto a single CD.

The speed of the digital media determines how fast files can be written to the card. But the camera using the card has to be able to take advantage of that speed. If you are using a camera that can't write data very fast, don't pay more for a card with high performance. Photojournalist and consultant Rob Galbraith maintains a database of CompactFlash card performance with different cameras on his Web site at www.robgalbraith.com.

Your style of photography also impacts the importance of fast digital film cards. Digital cameras include a buffer that stores images before they are written to the digital film card. The size of this buffer determines how many pictures you can take before the camera needs to stop and write data to the card.

When your photography involves taking many pictures in rapid succession—such as with birds in flight, sports, or other fast action—you can quickly fill up the buffer in the camera

with a sequence of images (**Figure 3.43**). Once you fill the buffer in the camera, you have to wait for the images to be written to the digital film card before you can continue taking more pictures. In those situations, you'll want to be sure your digital film card can easily write data as fast as the camera can send it.

Figure 3.43 When you need to capture a series of images in sequence, a fast digital card is a critical factor.

File Formats

When the camera writes the image data to the digital film card, it must do so in a file format that can be read later. This is generally a standard image file format, but it can also be a file format that stores the raw capture data. We discussed file formats in Chapter 2, but let's look at how the various options affect your need for higher-capacity digital media.

Most digital cameras offer the same file formats. The final file size will vary based on the camera settings and sensor resolution, so for comparison purposes we'll reference the files produced by Tim's 6-megapixel Canon EOS 10D digital SLR. With 6.3 million pixels captured, the resulting pixel data would normally consume 19MB of storage space because there are three color channels (6.3 million pixels times three color channels). The amount of space actually required on a CompactFlash card will vary based on the file format selected. The quality of the final image is also affected by the file format.

JPEG

The JPEG file format is the most popular option, and with good reason. It is a standard image file format that can be opened by virtually any image-viewing or -editing software. It also uses compression that reduces the file size. While the compression is *lossy*, meaning it causes a loss of information and quality in the image, the results are very good for prints that don't require significant interpolation when minimal compression is applied.

The option to use minimal compression, which results in the best quality possible for a JPEG image, is generally referred to as Fine or Best mode in the camera menu. If you're going to capture in JPEG mode to minimize the file size, be sure to use the highest quality setting. It still takes advantage of JPEG compression to considerably reduce the size of the file—down to an average of about 2MB for Tim's camera.

With these small file sizes, you need only a 128MB digital film card to approximately equal two 36-exposure rolls of film. With higher-capacity cards, you have the equivalent of many more rolls of film on a single card.

TIFF

The option to capture in TIFF format provides a standard image file that doesn't risk quality loss from compression, although it doesn't guarantee the best image quality possible (RAW capture will do that, as discussed in the next section). Unfortunately, it also means the file will be very large, taking longer to write and consuming more space on the CompactFlash card. Since Tim's camera is producing 18MB worth of pixel data, the TIFF file would also be 18MB. You would only get 7 pictures on the 128MB card mentioned earlier, and even a 1GB card would only allow you to take about 55 pictures.

The TIFF file format can be an excellent choice for saving files on your computer, but we don't recommend it for use in the camera.

RAW

For most photographic situations the JPEG file format is a good choice. However, for situations that involve tricky lighting or when you're trying to capture and retain the highest image quality, the RAW format is the best choice.

The RAW file format allows you to exercise the maximum amount of control over your image. When you use this option, the camera stores the raw data gathered by the imaging

sensor, with virtually no in-camera processing of the image data. This file retains the full bit depth the camera is able to process, which is generally 12 bits per channel rather than the 8 bits per channel available with the other file format options.

The primary disadvantage of the RAW format is workflow. Because it isn't an image file format, you need to first convert the file from RAW to a file format your image-editing software recognizes before you can start working with it (**Figure 3.44**). We'll talk more about these workflow issues and processing RAW files in Chapter 9, "Download, Edit, and Convert."

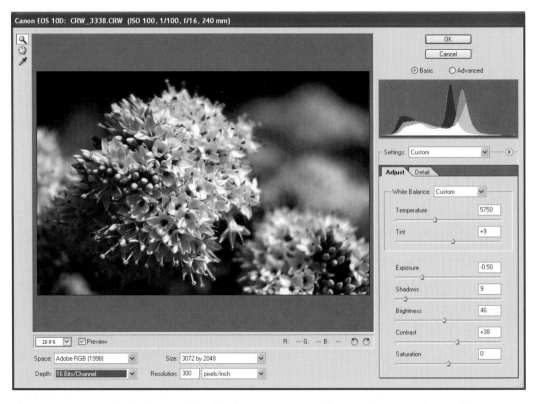

Figure 3.44 Capturing in RAW mode adds the step of converting your files to an image format before you can work with them, but it provides the maximum amount of information in your images to ensure the best quality.

Remember that most imaging sensors record only one of the three primary colors for each pixel, with the other two values for each pixel determined through interpolation. Because the RAW file represents what the sensor actually saw rather than the interpolated color values, only one-third of the final pixel values actually need to be stored. This results in a smaller file size than would normally be required. However, because lossy compression is not applied, the file is still larger than a JPEG file.

But it's smaller than a TIFF file. With Tim's camera, that translates into a file of about 9MB. This is still relatively large, allowing only 14 shots on a 128MB card or about 110 shots on a 1GB card, but this is a relatively small price to pay in storage space and write times to obtain a file that offers the best possible quality and tonal range.

Video

This book is all about using digital cameras for still photography, but we still like to play around with video now and then. Many digital cameras offer the option to record short video clips in addition to still photos. Most cameras use the Apple QuickTime format to record these video clips, but some cameras also use other formats. The resolution (and therefore quality) is very low, but they can be fun for documenting special moments. They certainly don't replace a quality video camera. Even with low resolution, these video clips can quickly fill your digital storage, so you'll want to be sure to have a high-capacity card.

FLASH

Many photographic situations require the use of flash to produce a well-exposed image. It can be used as a primary light source in dark environments, a way to freeze action, or as a fill flash to soften harsh lighting.

Fortunately, just about every digital camera worth considering includes a built-in flash. Many digital cameras also offer the ability to use accessory flashes, with some including a standard hot-shoe mount so that you can take advantage of the wide range of flashes available on the market.

On-Camera

The vast majority of digital cameras include a flash on the camera. This is certainly a convenient option, as we often find ourselves needing more light than the ambient conditions provide. However, we often find that the built-in flash on many digital cameras is a feature we love to hate.

Part of the problem is a lack of control. Most digital cameras don't offer the ability to fine-tune the strength of the flash, so you have to rely on the camera to decide how much light is enough.

The lack of control over flash strength and position becomes a serious problem as the distance to the subject is reduced. When the subject is very close, the flash has a tendency to overpower the scene, resulting in a blown-out image (**Figure 3.45**).

Figure 3.45 The flash on many compact digital cameras doesn't offer adequate control and is likely to produce an overexposed image when the flash is used too closely to the subject of the image.

Because the flash is often positioned very close to the lens, red eye can be a common problem with on-camera flash. We'll talk about how to avoid red eye in the first place in Chapter 7. In Chapter 10, "Essential Image Enhancement," we'll show you how to fix red eye for those situations where it can't be avoided.

Off-Camera

The use of accessory flashes gives you much more control over both the exposure of the image and the effect of the lighting. More and more digital cameras are offering a hot-shoe connection for external flashes, allowing you to use one or more flashes (**Figure 3.46**).

Figure 3.46 A hot-shoe attachment on a digital camera enables you to use a wide variety of accessory flashes that ensure the most flexibility.

A variety of compact digital cameras also allow you to use multiple flashes, so that you can use one flash as a main light source, and one or more as fill lights or backlights (**Figure 3.47**). The options are limited only by your imagination.

Figure 3.47 By using accessory flashes, you can control the lighting to produce the best results.

THE INFORMED PHOTOGRAPHER

When you know how your digital camera works, it can help you avoid common problems and take better pictures. This chapter has given you an understanding of how digital cameras work. In the next chapter we'll take a look at the various types of digital cameras before moving on to helping you with your purchase decision.

CHAPTER FOUR
Buying a Digital Camera

Shopping for something we don't buy every day, such as a new camera, may seem like a daunting process. Perhaps it's a fear of commitment, but there's often the nagging feeling that a better selection and a better deal are just around the corner. When making technology-related purchases, you may also experience information overload; if you're new to digital photography, it can seem like a vast and impenetrable wilderness of new terminology and concepts.

Even if you're a film camera veteran, buying your first digital camera requires an understanding of the types of digital cameras out there, as well as a grasp of both photographic and digital terms, such as *pixel resolution, image quality, media cards*, and a host of other digital details. An added pressure to your buying decision is the unavoidable reality that digital technology is advancing so fast that today's most sophisticated and expensive camera will be surpassed in six months by a model with improved features, better image quality, and a dramatic reduction in price. At some point, however, you just have to lace up your hiking boots, grab your walking stick, and venture into the world of digital photography.

Before you set off, however, it's useful to consult a trail guide such as this book, which will help you plan the quickest and most efficient route to your destination. In this chapter, we map out the terrain for you and organize the decision-making process so that it's a little less mysterious and intimidating.

TYPES OF DIGITAL CAMERAS

In traditional film photography you can choose from a wide range of cameras and formats—from the disposable camera to the 20-by-24-inch Polaroid camera used to create museum-quality photos. Digital photography offers less range in categories of cameras, but if you

understand the types of digital cameras available, what they can and can't do, you'll be able to choose the best camera for your needs (**Table 4.1**).

Table 4.1 Types of Digital Cameras

Type	Typical Users	Common Uses
Entry-level	Novice photographers	Basic snapshots, Web site use
Deluxe point-and-shoot	Amateur photographers, business users	Quality snapshots for personal and business use
Prosumer	Serious amateurs	High-quality prints, catalog use
Professional digital SLR	Professional photographers	Fine-art gallery displays, magazine use
Digital backs	Professional photographers	Fine-art gallery displays, magazine use
Other capture devices (Picture phones)	Anyone wanting fun, spontaneous shots	Fun!

Note: Visit www.digitalphotobook.net for a current list of specific cameras in each category.

Entry-Level

As digital camera technology continues to advance and prices drop, *entry-level* has gone from meaning a camera you settled for rather than chose, to a respectable camera that does a good job provided your expectations aren't too high.

Entry-level digital cameras offer 2- or 3-megapixel sensors, which provide excellent quality for 4-by-6-inch snapshots (**Figure 4.1**). Those cameras will also enable you to produce good 5-by-7-inch prints. And if your images are tack-sharp and properly exposed, you can even push the file to produce good-quality 8-by-10-inch prints.

Where entry-level digital cameras skimp is in extra features. Most have limited options for manual exposure control, their zoom range is often restricted to 2X or 3X, and they probably don't offer a hot-shoe or PC cord connection for accessory flashes.

While these cameras don't boast the best features, you'll still get a good camera at a reasonable price. They're a good choice for novice photographers looking to take snapshots of family and friends and to post photos on a personal Web site—assuming large prints are not the final goal.

The disadvantage of buying an entry-level digital camera is that it doesn't leave room for growth. You'll save money up front, but you may end up spending more in the long run if you need to upgrade to a camera that better meets your needs as your photography improves.

Figure 4.1 Entry-level digital cameras don't offer all the best features, but they are still able to capture images of excellent quality, provided you don't need to produce large prints.

Deluxe Point-and-Shoot

The deluxe point-and-shoot digital cameras offer more flexibility (**Figure 4.2**). They typically have a resolution of 3 or 4 megapixels, with some models now sporting 5-megapixel resolution. This allows you to produce 8-by-10-inch prints of excellent quality—and even 13-by-19 or larger if your shot was perfectly sharp.

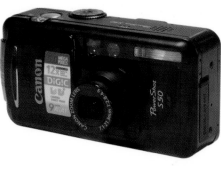

Figure 4.2 Deluxe point-and-shoot digital cameras offer excellent flexibility and enable you to produce 8-by-10-inch prints of excellent quality.

Optical zoom of 3X is standard with cameras in this category, with some offering even more zoom. This category also offers a wide variety of shooting modes to help you produce excellent results in tricky conditions such as fast-moving action, low-light or night scenes, and backlit subjects (**Figure 4.3**). Some of the deluxe point-and-shoot digital cameras also include a hot-shoe PC cord connection or so that you can use external flashes to better control the lighting.

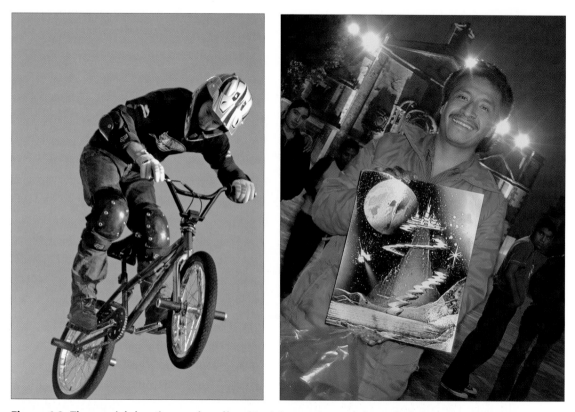

Figure 4.3 The special shooting modes offered in deluxe point-and-shoot digital cameras allow you to easily photograph scenes that might otherwise present a challenge to capture properly.

The deluxe point-and-shoot cameras are an excellent choice for the following types of users:

- Those who want the best quality possible in smaller prints and don't need to produce large prints

- Those who have more than a beginner's interest in and commitment to photography but still want to let the camera do most of the work

- Those who need to produce high-quality prints but aren't professional photographers—such as real estate agents who want to show prospective clients photos of the homes they're listing (**Figure 4.4**).

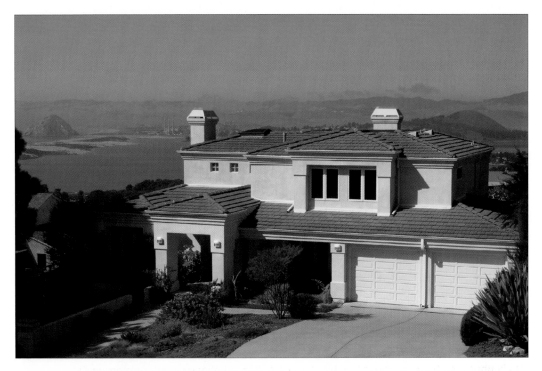

Figure 4.4 Deluxe point-and-shoot digital cameras are an excellent choice for real estate agents who want to show off homes they have listed for sale.

As full-featured as the deluxe point-and-shoot cameras are, they still don't tend to offer serious amateurs all the flexibility they might require. If you're looking for more control over your images and are passionate about your photography, you'll want to step up to a prosumer model.

Prosumer

The prosumer digital cameras are for the "power user" photographers, including serious amateurs—and even some professional photographers (**Figure 4.5**). This category includes both cameras with fixed zoom lenses and basic digital SLRs with interchangeable lenses (**Figure 4.6**). These cameras sport high resolutions—currently 5 or 6 megapixels—allowing you to produce excellent prints up to approximately 16 by 24 inches and even up to 20 by 30 inches and beyond if you really nailed the original shot.

Photo by Jack Davis.

Figure 4.5 The advanced features prosumer-level digital cameras offer makes them a great choice for the serious amateur or even the professional photographer.

Courtesy Canon USA.

Figure 4.6 A prosumer-level digital SLR
offers all the features a serious photographer
needs, and still provides the flexibility of
interchangeable lenses.

Flexibility and control are the hallmarks of the prosumer camera (**Figure 4.7**). In addition to supporting interchangeable lenses (for SLR cameras) or accessory lenses (for fixed-lens cameras), these cameras offer a slew of special shooting modes, full manual exposure control, multiple focus points, and various metering modes. They also include a hot-shoe mount for accessory flashes.

Photo by: Jeff Greene / ImageWest.

Figure 4.7 A pro-
sumer digital camera
with a fixed lens offers
exceptional control
for the photographer
in a compact package.

The prosumer digital cameras are an excellent choice for those who take their photography seriously:

• Advanced amateurs

• Business users who need excellent performance in a convenient camera,
 such as a journalist

• Commercial photographers who produce images for print publications

However, if you are a professional photographer who routinely needs to make large prints, or if you spend considerable time photographing outside in extreme weather, then you might want to opt for a professional digital SLR.

Professional Digital SLRs

If you're looking for a digital equivalent to a 35mm film camera, a professional digital SLR camera is your best option (**Figure 4.8**). A professional digital SLR camera meets the needs of the working professional photographer, with excellent image quality and control. These cameras feature the highest resolutions possible in a digital SLR—currently 11 to 14 megapixels. You can easily print images at 20 by 30 inches, and even go larger with your best images.

Courtesy Canon USA.

Figure 4.8 The professional digital SLR camera offers all the advanced features of the best film cameras and adds the benefits of digital capture.

The professional digital SLRs also use an imaging sensor that's the same size as the 35mm film they replace, so there's no effective focal length multiplier. That means lenses will produce the same results many photographers have grown accustomed to from years working with 35mm SLR cameras (**Figure 4.9**).

Professional digital SLR cameras support interchangeable lenses, giving you access to the wide range of lenses developed for 35mm film cameras. They also feature a flash hot shoe, a robust body, and multiple focusing points.

Their largest drawback is their high price compared with that of film equivalents.

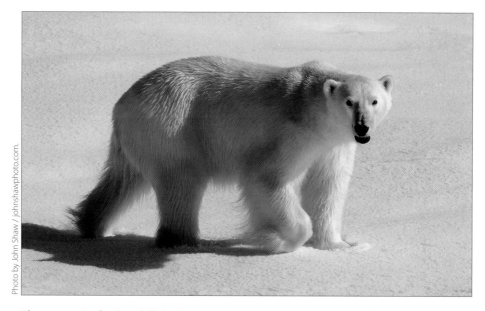

Photo by John Shaw / johnshawphoto.com.

Figure 4.9 Professional digital SLR cameras allow you to produce the best photographic results possible.

Digital Backs

When even big prints aren't quite big enough, a medium- or large-format digital back offers a solution. A *digital back* is a device that attaches to a medium- or large-format film camera body in place of a film back, and allows you to use that camera to take digital images (**Figure 4.10**). Current digital backs offer resolutions ranging from a modest 6 megapixels to a current average of 16 megapixels to the present high-end of 22 megapixels. The higher-resolution digital backs produce huge files that allow you to produce 30-by-40-inch prints of exceptional quality with ease, and considerably larger output when needed. (The upper end of this range is theoretically unlimited; if the viewing distance were long enough, you could get away with huge, billboard-size prints.)

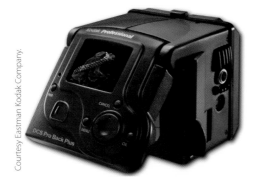

Courtesy Eastman Kodak Company.

Figure 4.10 A digital back attaches to a standard medium-format camera, allowing you to photograph digitally with a camera body designed for film photography.

Of course, all those pixels come at a price. At this writing, digital backs start at $12,000. That doesn't include the camera body or lenses required in front of the digital back. Clearly, digital backs are reserved for the serious professional photographer who demands the best quality for the largest prints. You'll need to be generating considerable photographic revenue to recover your investment.

Besides their high price, digital backs also involve a compromise in flexibility. This isn't because of any inherent limitation of the digital back, but rather it's due to the relatively small selection of lenses available for medium- and large-format cameras. The 35mm SLR format simply offers more flexibility, although without the huge number of pixels you can capture with a digital back.

Digital backs come in three types. The single-shot variety function in much the same way that the other types of digital cameras work. The sensor captures the scene in one exposure, capturing color information for one color per pixel and then interpolating the color values for the remaining two colors per pixel, as discussed in Chapter 3, "How a Digital Camera Works."

Multiple-shot digital backs capture three exposures for each image, using a red, green, or blue filter over the full sensor for each of the three exposures. The three exposures are then assembled into the final image. This provides excellent image quality but requires that the camera and subject remain motionless during the full exposure with consistant lighting, necessitating the use of a tripod.

A scanning back functions much like a flatbed or film scanner to produce an image. It records the image one row of pixels at a time, with the sensor moving across the image projected by the lens until the full scene is captured. As with multiple-shot digital backs, the camera and subject should remain motionless during the full exposure.

If your line of work requires big prints to make big sales, a digital back for a medium- or large-format camera will give you the performance you demand. Just understand that it will come with a big price (**Figure 4.11**).

Photo by: Neal Farris Photo-Design

Figure 4.11 What digital backs for medium-format cameras lack in flexibility, they make up for in resolution. They allow you to capture large image files from which you can produce exceptionally large prints.

Other Devices

Besides the digital cameras we've talked about so far, a variety of other devices can enhance your photography. These range from digital video cameras to cellular phones and other gadgets that also take pictures.

Video cameras

In Chapter 3 we briefly mentioned that many digital cameras allow you to record short video clips. Because of the very low resolution they use, the quality is poor. If you want to record video you can actually display on a TV for friends and family, a digital video camera is the better solution.

The quality of these video cameras varies with price. At the low end you can spend a few hundred dollars and get a video camera with minimal features and good image quality. For a few thousand dollars you can get a video camera with a wide range of features and excellent image quality.

Photo phones

Even cellular phones are getting in on the popularity of digital photography. More and more phones are offering the ability to take pictures, either as a built-in feature or through an accessory camera attachment. The quality isn't great, but it's adequate for sharing candid moments (**Figure 4.12**). You can send images to other similarly equipped cell phone subscribers or download the images to your computer to share via email or the Web.

Figure 4.12 A cell phone that allows you to take digital images won't offer the best quality, but it does offer a unique way to capture candid moments you might otherwise miss.

Gadgets

We all love saving our memories in the form of photographs, and you might on occasion find yourself taking those images with gadgets rather than cameras. Despite the low quality they tend to provide, these devices add an element of spontaneity that might gain you some of your favorite candid images (**Figure 4.13**).

Figure 4.13 Photographic gadgets such as Webcams can add a degree of fun and spontaneity to your photography, although the results won't be of a quality suitable for printing.

Such gadgets include Webcams for taking low-resolution images from your computer, camera attachments for your PDA (personal digital assistant), and cameras for video game consoles. Even Barbie has her own brand of digital camera gadget that provides a way for kids to enter the world of digital photography, although with low-quality images.

If you buy a gadget for taking images, keep in mind that they offer more novelty than image quality, and just have fun with it!

Ready to Buy

There's no shortage of digital cameras that offer a bounty of features to make your photography more fun and rewarding. No matter what type of photography you're doing, there's a digital camera to meet your needs. Now that you understand the types of digital cameras and their features and capabilities, it's time to select your digital camera.

HOW TO DECIDE

Roadmap to a Camera Purchase

Our map is based on both our own experiences with digital cameras and those of colleagues who also have made the journey many times. In it, we break down the decision-making process into the following ten issues:

1. What are you photographing?

2. What are you going to do with the pictures?

3. What are your immediate photographic needs?

4. How much photographic and computer experience do you have?

5. How much time do you want to invest in learning how to use a new camera or piece of software?

6. What are the "must have" features and qualities you need in a digital camera?

7. What other important features (besides image quality) do you want the camera to have?

8. What can you afford to spend?

9. Evaluate and compare the top three cameras on your wish list.

10. Make your decision and commit to it. Yes, that means "show the camera reseller the money!"

What Are You Photographing?

Before you buy a camera, you need to consider what you want to do with it, as this will help narrow down your choices. Will you be photographing birthday parties, family vacations, and Little League games? Will you be using it for your business to create photos for a catalog or newsletter, or to document laboratory research, or for product development? Are you a photojournalist who travels the world in search of groundbreaking images for news and stock agencies? Are you a wildlife, landscape, or fine art photographer interested in creating prints for gallery and museum exhibitions? Or are you a person who is passionate about photography and just wants a cool camera that will enhance your exploration of the creative image?

Each of these purposes suggests a different group of cameras; knowing how you will use the camera streamlines the list of potential models you have to choose from.

What Are You Going to Do with the Pictures?

Determining the needs of the photo, your intended audience, and how exacting your own standards are is also fundamental to selecting the right camera. Do you need to email family photos and make small, snapshot-sized prints to send to all the relatives? Will your images be viewed only on Web sites, or will they be published in newspapers and magazines? Do you want to make large exhibition prints that require quality and sharpness on par with traditional photographs? Does the camera require special capabilities, such as close focusing for macro work or extended exposure times for astrophotography?

Minimum image quality standards

If you will be making prints, the final presentation size and quality of your images will determine the level of resolution your new camera needs to produce. Although you can specify pixel resolution in an absolute way, determining acceptable quality has a lot to do with your own standards for what you expect from an image. If all you want is a nice 8-by-10-inch print of the kids to give to grandma for her birthday, then you will be well served by most of the 2- and 3-megapixel cameras on the market. If you are a photographer who enjoys making large prints from a fine-grained 35mm or medium-format film original, then your standards for sharpness and detail rendition are likely to be more exacting.

Higher resolution comes at a price, of course, so identifying what you intend to do with the images will help determine how much resolution you really need. As discussed in Chapter 3, camera resolution is not the only determining factor for image quality: Optical and camera processing systems also impact image quality a great deal (see "Important Camera Features to Consider," later in this chapter). If you are concerned about accurate color and fine detail, take those into account when considering a camera. **Table 4.2** summarizes the output resolutions required for a number of widely used applications.

Table 4.2 General Resolution Guidelines

Purpose	Output Type	Output Image Size	Megapixels
Internet	monitor display	Web site display	1–2
Desktop color prints	inkjet printer	4"×6"	2
		5"×7"	2–3
		8"×10"	3–5
		13"×19"	5–6
In-house newsletter	laser printer	4"×6"	2
		5"×7"	2–3
		8"×10"	3–5
Advertisement	b&w newsprint	4"×6"	2
	65/85 lines per inch (lpi)	4"×6"/5"×7"	3
		8"×10"	3
Advertisement	color magazine	4"×6"	3
	133/150 lpi	5"×7"	3–5
		8"×10"	5–6
Display prints	photo-direct	up to 20"×24"	6–22
Large fine art		up to 40"×60"	14–48
		larger than 40"×60"	48+

Assess Your Immediate Photographic Needs

Because digital cameras get better every year, with improved image quality and reductions in price, it makes sense to take stock of your immediate needs. We suggest purchasing a camera that not only fulfills those needs, but also gives you room to grow as you learn more about digital photography. Buying a camera that is "one size larger" than you need now ensures you will be happier with it longer. However, don't be swayed by marketing hoopla or grandiose ideas of what you might like to do with the camera. If all you're going to do with it for the next year is document crumpled bumpers for insurance cases and then email the pictures from a laptop via a slow modem line, then buying the latest high-resolution SLR with interchangeable lenses and the ability to shoot 5 frames per second doesn't make much sense.

How Much Photography and Computer Experience Do You Have?

Once you've figured out what kind of photographs you'll be taking and what you're going to do with them, it's time to take stock of your experience level. Have you been photographing regularly for several years, with different cameras, or are you upgrading from the disposable models found in most supermarkets? Do you understand all the photo jargon, computer terminology, and technical concepts, or do you just want to be able to take great pictures without having to worry about too many details? Your comfort level with the basic principles of photography, not to mention your familiarity with computers, should factor into your camera-buying decision.

Although we do think that buying a camera you can grow into is a good idea, you don't want to overshoot and purchase something that is too far above your skill level. If you find yourself torn between a deluxe point-and-shoot and a digital SLR, decide how much you'll be using your new camera. If you'll have only infrequent opportunities to get out and spend time with the camera, then you might be better off starting out with a deluxe point-and-shoot model that has a less-demanding learning curve. A year from now the pricier SLR will most likely be less expensive and may even offer better resolution. If you want to make a serious hobby of photography at that time, you can save some money now and already have valuable digital photography experience under your belt when you finally do move up to a digital SLR (see the sidebar, "Know Thyself: Deluxe Point-and-Shoot or SLR?").

Know Thyself: Deluxe Point-and-Shoot or SLR?

When buying a camera, you should consider the type of images you'll shoot and the kind of photographic experience you want. Those considerations have a big impact not only on the camera you should buy, but also on how much you'll enjoy using it.

If you want to take great pictures with a full-featured camera that is easy to use, then most deluxe point-and-shoot models are more than capable of producing excellent results. Plus, they can be a lot of fun to use. Even though we normally lug around heavier SLRs, we really love these types of camera for the freedom and spontaneity they offer (and, in a pinch, we've even used them as backup cameras). Some deluxe point-and-shoot cameras, such as those with an LCD that swivels and tilts out from the camera body, allow you to create images that would be difficult or impossible to achieve with the traditional SLR design. The flexible LCD is great for low-angle close-ups or for shots where it's inconvenient, or just downright uncomfortable, to contort your body into the required posture to see through an optical viewfinder. The variety of features and ease of use of deluxe point-and-shoot cameras will keep you busy for a long time and provide you with plenty of cool bells and whistles to satisfy your photographic creativity.

Digital SLRs, on the other hand, provide more control over the final image, as well as the ability to use interchangeable lenses; for professional photographers and serious amateurs, this latter point is an important consideration. If you are already used to the control and flexibility that an SLR offers, you may not be satisfied with anything less. For some, nothing compares with looking through the lens of a true SLR. But in the end an SLR is just a tool, and it's important to not fall prey to equipment envy. Using an SLR may provide you with better technical quality in your images, but it will not necessarily make you a better photographer.

Making use of existing camera equipment

If you already own an autofocus film SLR and you have a collection of lenses and other accessories that you want to continue using, then your buying decision may be much easier. Canon and Nikon digital SLRs both accept the full range of autofocus lenses designed for their film cameras. Additionally, the Fuji FinePix S2 Pro and the Kodak DCS-14n are also designed to accept the vast majority of Nikon lenses. One thing to be aware of when using existing lenses that were designed for 35mm film cameras, however, is the focal length multiplier that affects all digital SLRs in which the image sensor is smaller than the

35mm film frame (**Figure 4.14**). See Chapter 3 for more information on how this affects your photographs.

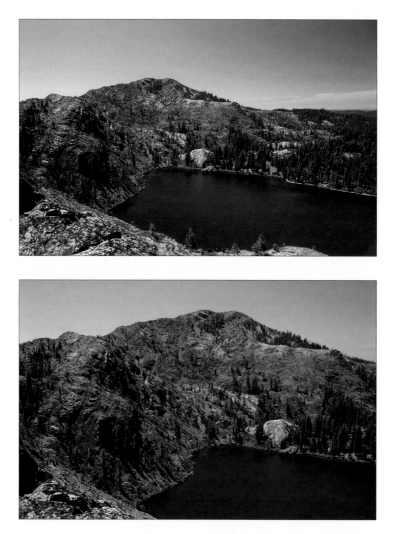

Figures 4.14 Due to a phenomenon called focal length magnification, lenses designed for 35mm film will produce a different field of view on a digital camera where the image sensor is smaller than a 35mm film frame. Since a lens for a film camera is designed to focus onto a larger area (a 35mm frame), when used with a digital camera that has an image sensor that is smaller than the 35mm frame, you only see a center portion of the scene, not the entire view. On the top is a scene shot with a 28mm lens on a 35mm film camera, and on the bottom is the same scene shot with a 28mm lens on a digital SLR. In the digital shot, a focal length magnification factor of 1.6 turns the 28mm focal length into a 45mm focal length.

Evaluate Your Personal Bandwidth

No, we're not talking about your Internet connection here. We're referring to how much time you have to invest in learning a new camera or piece of software. We all have busy schedules that require us to balance careers, hobbies, and family. The promise of any digital technology, of course, is that it makes things easier and saves time. At least, that's what the marketing buzz implies. Despite this idyllic notion, we would be remiss if we didn't tell you that, depending on the type of images you create and what you want to do with them, digital photography can take up a lot of your time. And the time spent looking through the camera lens is only a small portion of it. Of course, it's a much more comfortable time investment than, say, spending hours every day in a smelly darkroom, working with toxic photo chemicals, but it's an investment nonetheless.

Even if you're not reworking every image in a program like Photoshop, mundane chores such as managing your growing collection of digital images can take up a lot of your time. Unlike film photography, where your slides and negatives are delivered to you as tangible items that you can easily file away in a drawer or shoebox, digital photography demands a more responsible file management system if you ever hope to be able to quickly find a certain image again. In addition to basic computer housekeeping, you also need to be vigilant about creating backups, and even duplicate backups, to protect your images from the ever-present specter of hard disk crashes and accidental deletion. We cover these topics in greater depth in Chapter 14, "Archive, Catalog, and Backup."

Being realistic about how much time you can devote to your digital photography is a key component in guiding you to a camera that fits your personality and lifestyle. If your aim in reading this book is to learn how to take better photographs so you won't have to fuss over them in an image-editing program, then you'll want a camera that offers a good variety of features, including a zoom lens, a selection of automated scene modes, and maybe even the ability to print directly from the camera. But if you can't wait to get past this chapter so you can get to the in-depth information about working in a digital darkroom, then you may already be at peace with the fact that you're eager to spend untold hours in front of the computer, finessing your images into a state of perfection.

Determine the Minimum Requirements

Before you begin looking at cameras and comparing prices, you need to figure out what your camera's minimum features have to be to satisfy your photographic needs. This is not the pie-in-the-sky approach to cool features that you may be craving, but rather a serious look at the "must haves" that you need to get the job done. We've already addressed one of the primary criteria—how large you'll need to print the images. Following are some other factors to consider (we'll cover many of these in greater detail later in the chapter).

Features

- **Megapixel resolution.** How much do you need? (See Table 4.2 earlier in this chapter.)

- **Lens options.** Is the lens fixed or a built-in zoom (**Figure 4.15**)? How much zoom do you require? Can you use filters or accessory lens attachments for close-up or wide-angle shots?

- **Exposure options.** Is fully automatic enough, or do you need more subtle controls?

Figures 4.15 Most deluxe point-and-shoot cameras offer a built-in zoom lens.

Performance

- **Response times.** How quickly does the camera respond when you press the shutter button? How fast can you take a second shot?

- **Battery life and cost.** How many shots can you take on a single charge? How expensive are the batteries? Are rechargeable batteries an option (**Figure 4.16**)?

- **Continuous shooting.** Do you need to shoot images in rapid succession?

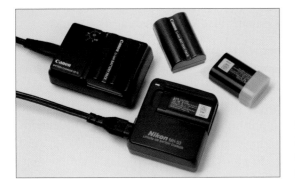

Figure 4.16 Rechargeable batteries help keep your operating costs down and spare the landfills.

Attributes

- **Size.** Are a compact profile and low weight important (**Figure 4.17**)?

- **Ease of use.** Is it well designed? Does the layout of the controls and menus make sense?

- **Ergonomics.** Does it fit comfortably in your hands? Is it easy to hold on to? Can your eye locate the viewfinder quickly?

Figure 4.17 If a compact size is important to you, you'll find a wide range of small, pocket-sized cameras on the market.

Important Camera Features to Consider

Image quality

Since photography is all about creating images, the ability of a camera to produce images with sharp detail, accurate color, and a pleasing tonal range is one of the most important, if not the most important, factors to consider. A camera's megapixel count is the factor that always seems to get more attention than the others (at least from marketing departments). Let's take a look some of the other elements that go into making a good image:

- **Lens quality.** The lens is where the image begins its journey from the real world into your camera, so the optics are the first determinant of how good the image will be. If you have inferior optics that don't effectively focus the image onto the sensor or that produce chromatic aberration or that decrease sharpness, then the quality of all the other components will be compromised. If you're buying an SLR and image quality is important to you, don't try to cut costs by purchasing a cheap, third-party lens. We'll cover what to look for in a lens later in this chapter.

- **Pixel resolution.** Camera manufacturers use this figure to tout their camera over others on the market. Too often, however, this discussion sinks to the level of "I have more megapixels than you do"; and, as discussed in Chapter 3, image quality is more than just the number of pixels. Refer to Table 4.2 for a summary of the possible output sizes that different types of cameras produce.

- **Image sensor.** The type of the image sensor (CCD or CMOS), its physical size, and the internal processing that occurs after the image has been captured can also impact image quality. For more information on image sensors and how cameras process the data collected by the sensor, refer to Chapter 3.

Speed matters

Your next consideration is speed. Until recently, digital cameras were notably slower than their film counterparts when it came to doing anything in a hurry—from starting the camera to snapping the picture to taking the next picture. Below are some of the main speed issues to think about:

- **Boot speed.** When you turn the camera on, this is how long it takes the system to "boot up" and report for duty. This can range from milliseconds to several seconds on some cameras. Henri Cartier-Bresson is famous for photographing the "decisive moment" and creating an image that elegantly captures a fleeting instant in time. Bresson used a 35mm Leica with a mechanical shutter that was always ready and responded instantaneously. Although waiting several seconds may not seem like a big deal, it can be very

frustrating if the decisive moment in front of your lens slips away while you're waiting for the camera to warm up.

On compact cameras, another factor that can delay camera readiness is if the zoom lens has to extend from the camera before you can take a shot. You should also check to see how the camera behaves if you accidentally leave the lens cap on when you power up the camera. One of our pet peeves is cameras that don't recognize this. Leaving the cap on can prevent the zoom lens from extending, which shuts down the camera and produces an error message. To fix the problem, you must turn off the camera, remove the lens cap, and then turn the camera on again. By the time you've done all this, 15 to 20 seconds have elapsed and the decisive moment is a mere memory.

- **Lag time.** This is the aspect of digital cameras that people complain about the most. For many users, this refers to the lag between when you press the shutter button and when the camera actually takes the shot. This time varies from camera to camera, but on compact models it is usually anywhere from ⅒th of a second to over 1 second. With portrait shots, you can lose subtle facial expressions; and with subjects that don't tend to sit still, such as children and animals, shutter lag can make you miss the shot altogether (**Figure 4.18**). Fortunately, manufacturers are addressing this problem, and lag times are much shorter than they used to be. Generally, the more camera you buy, the less likely it is that shutter lag will be a problem. Current digital SLRs have no perceptible shutter lag. Another reason for lag is how long it takes the autofocus system to find a focus once you've pressed the shutter button halfway.

Figure 4.18 Shutter lag: a decisive moment missed because the camera didn't respond quickly enough when the shutter button was pressed.

- **Write speed.** As mentioned in Chapter 3, when you take a photo with a digital camera, the data collected by the sensor needs to be processed before the image can be written to the memory card. The length of time it takes the camera to do this can affect how soon the camera is ready to take another shot. To speed things up, cameras use RAM storage as a memory buffer, which temporarily stores the shots before processing and writing them to the card. This frees up the camera to take more shots, even while the previous images are being processed. The size of this buffer, as well as variables such as the image's size, the file format it's written to, and the speed of the memory card, determines how quickly the camera is ready for the next photograph.

- **Burst rate.** The size of the memory buffer mentioned above also determines the camera's *burst rate*. This rate governs how many shots you can take in quick succession before the camera has to pause and write data to the storage card. You'll usually only need to worry about burst rates if you need to shoot using the camera's continuous-shooting drive mode. The Canon 10D, for example, shoots at a maximum speed of 3 frames per second (fps) and has a burst rate of 9 shots. This means that if you depress the shutter button with the camera's drive mode set to continuous, the camera will record 9 shots in 3 seconds and then pause while it finishes processing the data and writing it to disk.

- **Continuous shooting (frames per second).** If your photography centers around sports or journalism, then the number of shots you can squeeze off in a second matters mightily. Even if you're not a pro, this is a fun and useful feature, allowing you to take sequential shots of moving subjects (**Figure 4.19**). Prosumer models usually offer continuous shooting at anywhere from 1.5 to 3 fps. Professional SLRs, especially those designed for photojournalists, will offer a higher rate of frames per second. Even though the Nikon D1H, for example, is a 2.74-megapixel camera, it can shoot at 5 fps and has a larger buffer that can hold 40 images. In that regard, its motor drive shooting capabilities are no different from a film camera's, where the length of time you can shoot in continuous mode is limited only by the number of exposures on the roll of film.

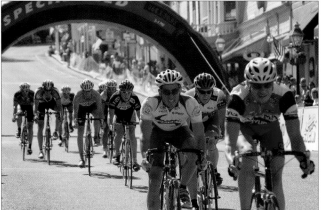

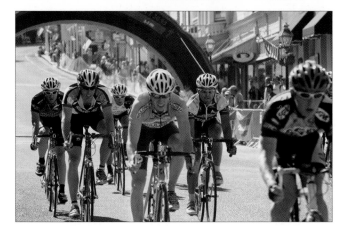

Figures 4.19 Continuous shooting is great for creating a sequence of shots or for photographing fast action, such as sports. There is an interval of 2 seconds between these images of bike racers speeding down a hill.

Viewfinders

Even though features such as zoom lenses and megapixel resolution get most of the attention from the marketing departments, the viewfinder is a key part of the camera that you shouldn't overlook when making a purchasing decision. Since you'll be spending so much time looking through it and composing your images, consider the different types of viewfinders to decide which one works best for you:

- **LCD viewfinders.** All digital cameras worth considering have an LCD screen where you can review images you've taken; on some, the LCD screen serves double duty as a viewfinder, allowing you to preview image composition before you take the picture. Many cameras have LCDs that swivel or tilt out from the camera. These are useful for taking photos where it might otherwise be difficult to position your body to look through a traditional viewfinder (**Figure 4.20**)—such as an extreme low-angle composition of a flower's underside. If you think you might want to explore this "road less traveled" approach to photographic composition, then consider a camera that offers a moveable LCD.

Figure 4.20 LCD viewfinders are changing the photographic experience. Some cameras have moveable LCD screens that make it easy to take low- or high-angle shots.

On the downside, LCDs can be hard to see in bright sunlight. (For that reason alone, Seán favors cameras that also have an optical viewfinder—he likes to be able to "mask out" the rest of the world when composing a shot.) Determine how bright the screen is compared with other cameras and whether it has a brightness control. LCDs also tend to drain the battery, so look for a camera that lets you turn it off if you're not using the screen for composition. Consider also the size of the LCD and how much

of the image it displays. The LCD screen generally shows you between 95 and 98 percent of what the CCD is actually recording.

- **Optical viewfinders.** If you've ever used a point-and-shoot film camera, you're already familiar with an *optical viewfinder* (also known as a *rangefinder*). This is simply a small, separate lens that you can look through to frame the shot. Although these viewfinders are simple and provide less image coverage and accuracy than an LCD, we consider them to be an essential component of a digital camera for cases where bright sunlight renders the LCD unusable. If your camera has a zoom lens, then the optical viewfinder should zoom, too, and give you a good idea of what is being included in the shot.

 Other things to look for are brightness, clarity, and an undistorted image. Since this type of viewfinder does not show you what the actual lens sees, in close-up shooting situations the difference in position between the two can cause parallax error. *Parallax* is when the area recorded by the lens is different from that seen through the viewfinder. An optical viewfinder should have parallax correction lines that you can use as framing guides when photographing close-up subjects (**Figure 4.21**). Some optical viewfinders are tiny, making it difficult to position your eye so that you can see through them. Some cameras offer a *diopter* knob so you can fine-tune the focus of

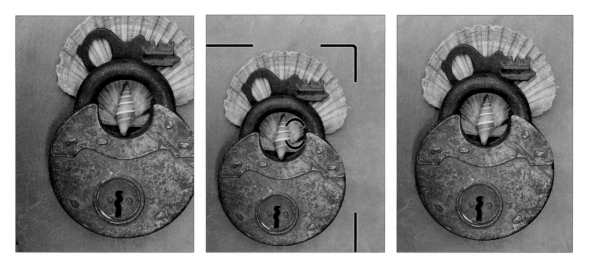

Figure 4.21 Parallax occurs with close-up subjects because the optical viewfinder does not show you what is being photographed by the camera's lens. Parallax correction guides in the viewfinder let you see where the real edge of the frame is, as opposed to what you're seeing in the viewfinder.

the viewfinder. If you wear glasses, this knob lets you adjust the viewfinder to compensate for your own vision (**Figure 4.22**).

Figure 4.22 A diopter control lets you adjust the optical viewfinder to compensate for your own vision.

- **Electronic SLR.** This is a hybrid between an optical viewfinder, an LCD monitor, and the through-the-lens (TTL) capability found on SLR cameras. You look through this device just as you would an optical viewfinder, but instead of looking through a viewfinder directly at the scene, what you see is a tiny LCD screen showing you what will be recorded by the image sensor. There are two advantages to this type of viewfinder: It gives you the more accurate LCD coverage; and since you have to look through an eyepiece to see it, it's very bright and it won't be affected by bright daylight. Higher-end prosumer cameras also provide status information in this type of viewfinder. The main disadvantage is that if you're used to composing your images through a traditional SLR, the electronic TTL view can be disappointing. In feel, this method of viewing the world is much more like a video camera than a true SLR. Seán was once interested in a certain camera that boasted SLR capability, but the minute he looked through the electronic TTL viewfinder, his interest evaporated. If the visual experience of shooting with an SLR and seeing how the actual light affects the scene is important to you, then an electronic SLR leaves a lot to be desired.

- **True SLR.** With a true SLR viewfinder, light enters the lens and is reflected up to the viewfinder through a series of mirrors. Instead of seeing the scene via an electronic monitor or through an offset viewfinder, you are seeing the actual reflected image through the same lens the camera is using to record the scene. With the exception of the differing fields of view that different lenses may produce, this type of viewfinder is much closer in feel to looking at a scene with your own eyes (**Figure 4.23**). The only disadvantage is that the mirrors that provide the through-the-lens view keep the camera from being as small as some of the more compact models that rely on optical and LCD viewfinders. On SLRs, the LCD monitor is only used for image review, never for framing the image. SLR viewfinders are found on cameras in the prosumer and professional categories.

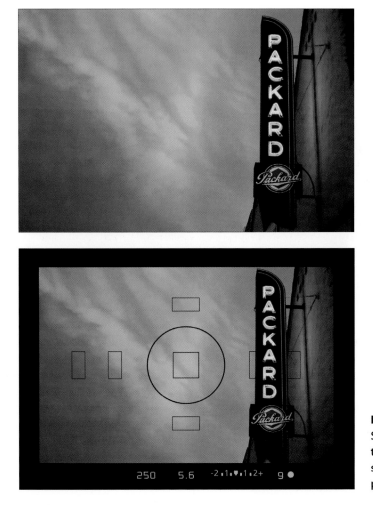

Figure 4.23 With a true SLR viewfinder, you see the same scene and the same light that is being photographed by the lens.

Exposure controls

- **Scene modes.** All digital cameras have automatic, or program, modes that usually do a great job of selecting the proper exposure. Some also offer a selection of *scene modes* that are designed for special situations that might fool the camera's exposure meter, or for where you want to achieve a specific effect. Common scene modes that can be found on many cameras include portrait, night portrait, landscape, beach/snow, close-up, backlight, sports, and fireworks. Scene modes are great for unfamiliar or rarely encountered situations where you don't want to think about which settings to use. To take good pictures, all you need to do is recognize when it's appropriate to use them.

 For example, if you've ever taken a portrait of someone at night with a sunset or sparkling city lights behind them, you've probably been disappointed to find that in the final picture the background was so dark that you couldn't see the scenery. Night portrait

mode will use the flash to illuminate your main subject and a slower shutter speed for the background to record a pleasing exposure of both parts of the image. Beach/snow and backlight modes both compensate for scenes where large expanses of bright areas behind the main subject can fool the camera's light meter, resulting in a scene where the exposure is perfect for the background but the subject is too dark (**Figure 4.24**).

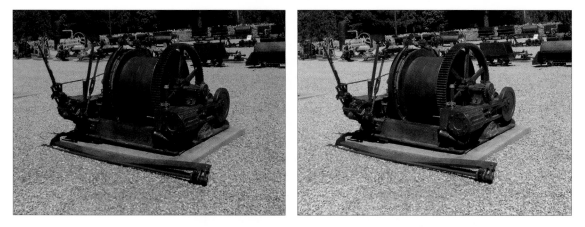

Figure 4.24 A scene mode automatically compensates for well-known exposure situations that can fool a camera's light meter. In the photograph on the left, the bright area in the background caused the foreground subject to be too dark. In the image on the right, a backlight scene mode was used to create a more balanced exposure.

Scene modes are great timesavers; if you're still learning the ropes of camera exposure, they can make the difference between a disappointing picture and a really good shot. They're not just for beginners, either; we frequently rely on them in some situations for the simple reason that they work.

- **ISO.** How sensitive the sensor is to light is specified by an ISO rating. This is the same figure that is used to rate film sensitivities. With film, however, you're pretty much stuck with the same ISO for an entire roll. One of the great things about digital cameras is their ability to set different ISO settings on a per shot, per scene basis. Compact cameras generally offer from 50 ISO to 400 ISO, and many also feature an auto-ISO setting , where the camera determines the best setting. The more advanced the camera, the higher the ratings. SLRs such as the Nikon D100 and Canon 10D offer ISOs up to 1600 or 3200. If you expect to be photographing in existing light situations or working with moving subjects in lower light levels, then you need to consider a camera with high ISO capability. Some cameras, such as the Kodak DCS-14n, offer a higher ISO only with lower resolutions. If this is important to you, make sure that high ISO settings are available at the highest resolution the camera has to offer. Keep in mind that noise levels are likely to be more noticeable at higher ISO settings.

- **Aperture and shutter speed.** Many digital cameras offer semi-automatic modes, such as aperture-priority and shutter-priority modes, that allow you to choose some of the settings while the camera does the rest. Aperture priority controls how much light passes through the lens, while the camera calculates the shutter speed. Conversely, shutter priority determines how long (measured in fractions of a second) that light is exposed onto the CCD or CMOS sensor, while the camera sets the aperture—the *f-stop*.

 A lens that lets in more light (meaning a wider aperture/smaller f number) lets you photograph in lower light levels. Aperture also affects how the image looks in terms of *depth of field* (how much is in focus from foreground to background). Wider apertures generally yield less depth of field, while smaller apertures (higher f numbers) produce greater depth of field (**Figure 4.25**). Due to the shorter focal lengths on most compact digital cameras, however, achieving a shallow depth of field can be more difficult than with film cameras. Prosumer cameras and SLRs do a better job of producing images wth a shallow depth of field.

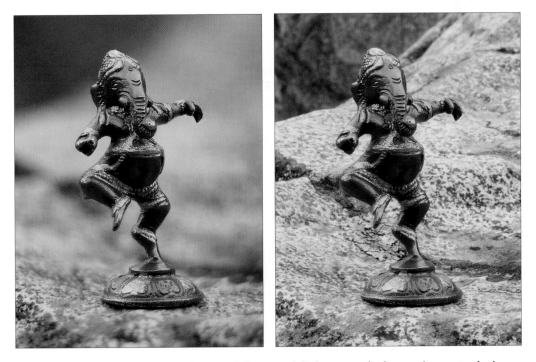

Figure 4.25 Lens aperture not only controls how much light enters the lens on its way to the image sensor, but it also affects *depth of field*, the area of the image that appears in focus from foreground to background. Smaller f-stop numbers yield a wider (larger) opening and result in shallow depth of field. Higher f-stop numbers close the aperture down to a smaller opening and create greater depth of field. Aperture can be used to great effect to change the visual "feel" of an image.

The shutter speed can affect the final look of the image, especially if the photo contains moving subjects. By choosing a slower shutter speed, such as ⅛th of a second, you can add the visual "feel" of motion by slightly blurring a moving object. If you need to freeze action in your photography, you'll want a camera that offers a good choice of fast shutter speeds above ⅟₈₀₀th of a second (**Figure 4.26**). On the other end of the scale, if you routinely shoot long exposures at night, you'll want to be sure that your camera offers a *bulb* setting, where the shutter can be left open for several minutes or longer. Shutter speed can also play a role in image sharpness; camera shake can show up in handheld shots that are photographed with a slow shutter speed.

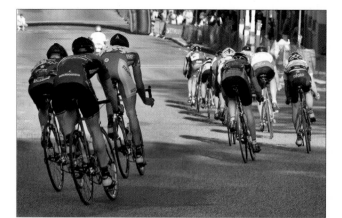

Figure 4.26 Shutter speed controls how long the light coming through the lens aperture is exposed to the image sensor. Faster shutter speeds (⅟₈₀₀th of a second on the top image) will freeze fast-moving action, while slower shutter speeds (¼th of a second on the lower image) render motion as a blur. Like aperture, shutter speed is a technical control that can also be used for interesting creative effects.

Using exposure modes to improve your images or to achieve specific visual effects will be covered in greater detail in Chapter 6, "Digital Photography Foundations."

• **Exposure compensation and autobracketing.** If you review an image on the LCD monitor and you find that it's a bit too light or too dark, *exposure compensation* lets you adjust the exposure and retake the photo without having to calculate a specific aperture

or shutter speed change. It allows you to apply an adjustment, typically in third- or half-stop increments, that gives the scene either more or less exposure. If you took a photo of someone standing next to a window, for instance, and upon reviewing the image on the camera's LCD you saw that the person's face was too dark, you could simply add an exposure compensation adjustment to increase the exposure for the scene (**Figure 4.27**).

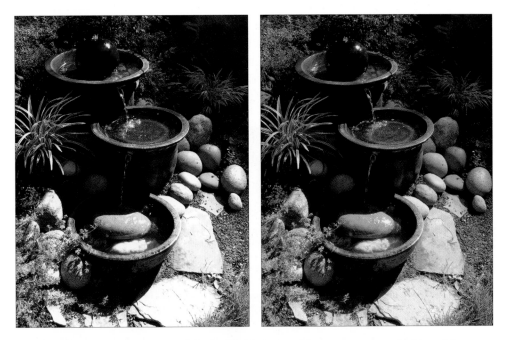

Figure 4.27 In the image on the left, the highlights are blown out to a total white with no detail. After reviewing the image and the histogram on the LCD and noticing this, the photographer used exposure compensation to purposely underexpose the image by 1 stop, which fixed the problem (right).

Autobracketing, found on some prosumer and professional cameras, is similar to exposure compensation. With autobracketing turned on, the camera will shoot a series of shots (usually three) and "bracket," or slightly adjust the exposure for each one. One shot is exposed at the light meter's recommended setting, one is slightly overexposed, and one is slightly underexposed. This way, you can take your choice of shots in situations where the lighting is tricky and the standard exposure isn't working well. Bracketed shots can also be combined in the digital darkroom to take advantage of the best areas of exposure in each image (see Chapter 11, "Digital Darkroom Expert Techniques").

- **Histogram display.** A histogram graphically displays the tonal values of the image. It's useful for evaluating image exposure and for seeing if there are over- or underexposed areas. Many cameras in the prosumer and professional categories let you display a histogram for an image after it has been captured. By viewing the histogram, you can decide if the shot needs to be taken again with a different exposure setting (**Figure 4.28**). Some cameras make it easy to view the histogram after a shot; with others you have to dig through a series of menus to find it, which makes it harder to get at and less useful. If you're primarily interested in an easy-to-use snapshot camera, then a histogram display is probably not that important to you. If you want to take advantage of the increased control that digital photography has to offer, however, the histogram is an important feature. We cover the histogram and its role in the photographic process in greater detail in Chapter 7, "Seeing the Light."

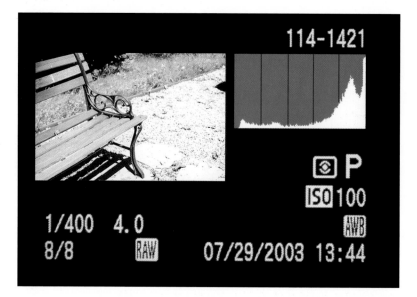

Figure 4.28 The histogram display shows how the brightness values in the image are distributed along the tonal range. A histogram is useful for image evaluation in the field. In the image above, the too-bright highlights show up in the histogram in the way the graphical display is pushed up against the far right side.

- **Tripod mount.** While technically not an exposure control, a tripod mount allows you to stabilize the camera in order to make sharp exposures at slower shutter speeds. Check to see that it is made out of metal and not plastic: Plastic threads can easily become stripped over time, and if you expect to use a tripod a lot, you'll want a metal

tripod mount. If you're interested in creating multi-image panoramic photographs, the tripod mount should be aligned with the axis of the lens. This will allow the camera to rotate around the axis of the focal plane (**Figure 4.29**).

Figure 4.29 The tripod mount should be made of metal, not plastic. For serious panoramic photography, the tripod mount should be aligned along the axis of the lens.

Flash issues

Most digital cameras, even some high-end SLRs, have an on-camera flash unit. At the most basic level, the built-in flash is designed to go off if the camera's light meter determines there isn't enough existing light for a good exposure. In that regard, it's a necessary evil. We all have situations where we need it, but the quality of light that it brings to a scene can hardly be called subtle. Nothing ruins the delicate mood of natural light quite like an automatic flash. Typical problems caused by an on-camera flash include the red-eye effect, overexposed highlights on people who are too close to the camera, and what Seán calls "horror-movie shadows" cast on the wall. Beyond the basic utility of having a flash at the ready, some cameras offer the following additional flash features (red-eye reduction is common to most cameras, while the rest of these features are found on most prosumer and professional cameras):

- **Red-eye reduction.** Red eye, that irritating effect where people look like vampires with glowing red orbs for eyes, has been the bane of photography ever since cameras started sporting built-in flashes. Since this problem affects any camera where the flash is located close to the lens, many cameras offer some feature to minimize red eye. The functionality of red-eye reduction varies, but the two most common methods

are a quick preflash that fires just before the picture is taken, and a steady, bright light that shines in the subject's eyes. Each of these methods is designed to force a subject's pupils to contract (**Figure 4.30**). A contracted pupil presents a smaller opening to the camera and the chance of red eye is greatly reduced. Other approaches involve placing the flash on a pop-up extension to increase the distance between flash and lens (**Figure 4.31**).

Figure 4.30 Red eye reduction can help you avoid the glowing red eyes problem, but many people find the dual flashes irritating and feel that it stifles spontaneous shots.

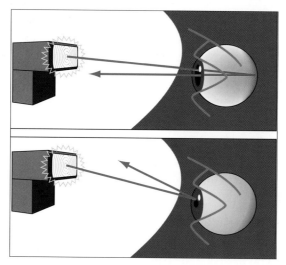

Figure 4.31 On cameras where the flash is close to the lens, the light from the flash enters through the dilated pupils and reflects off the back of the subject's retina, creating the glowing red eyes. A red-eye reduction feature uses a pre flash, or a bright light that shines at the subject, to cause the pupils to contract, preventing the flash from reflecting off the retina.

Although red-eye reduction is a fine idea in theory, in practice it leaves a lot to be desired. The most common problem is not that it doesn't reduce red eye (it usually offers some improvement), but that the dual flashes confuse the subjects. Katrin can't stand it because the first flash (designed to make the pupils contract) goes off and the people being photographed think the shot has already been taken and begin to turn away. When the photo, accompanied by the real flash, is taken a second later, the pose and expression have been lost. Gathering people together again and instructing them about waiting for the second flash rarely gives you a spontaneous photo.

- **Flash exposure control.** Can you control the output of the flash? On some models this is called *flash exposure compensation* and is useful if the flash output seems too strong or weak for a given scene. Being able to dial back the power of the flash can let you create subtle fill-flash effects to open up (lighten) the shadow areas of an image with having it look like a flash was used.

- **Option for external flash.** This is an important feature for serious amateurs and professionals. The most common method for attaching an auxilliary flash is via a hot shoe on top of the camera. For studio flash systems, or for times when you want to mount an external flash on an extension bracket, the ability to plug a standard sync cord into the camera is crucial. A flash unit mounted on a bracket is one way around the problem of red eye. With more distance between the flash and the lens element, the flash does not create the reflections inside the eye that cause red eye. Depending on the type of photography you do, support for external flash may be critical (**Figure 4.32**).

Figure 4.32 The capability to use an external flash, either attached to a hot-shoe mount on top of the camera or on a separate extension bracket, frees you from the less-than-subtle built-in flash.

Design and ergonomics

We've saved this for last, but that doesn't mean it's last in importance. If you take many photographs, you'll be spending a lot of time with your camera in your hand, around your neck, over your shoulder, and up to your eye. Proper design and ergonomics can contribute greatly to your enjoyment and comfort when using the camera. Although ordering a camera via the Internet is a popular option, there's no way to evaluate these items unless you can actually pick up a camera and check it out.

- **How does it fit in your hand?** Is the camera body molded and styled so that it fits your hand well when you hold it? Is it slick and difficult to hold on to, or does it have a surface that provides a good, stable grip for your fingers? If the camera is an SLR, is there enough room between the right-hand grip and the lens mount for your fingers to rest comfortably without feeling crowded (**Figure 4.33**)? Are the battery and memory card doors sturdy, or do they feel cheap and flimsy? Consider the weight and size. If you're in the market for a compact camera, then a low weight and a pocket-sized design might be important features for you. The additional weight and bulk that comes with higher-end cameras is not always a bad thing; a camera with more heft will often provide a steadier platform for taking shots.

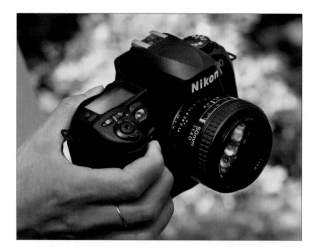

Figure 4.33 You're going to be spending a lot of time with your camera, so make sure it fits well in your hand, is easy to hold on to, and is comfortable to carry.

- **How does it fit your eye?** Bring the camera up to your eye and look through the viewfinder. Is it easy for your eye to locate the viewfinder? Does the tip of your nose rub against the LCD screen and leave greasy smudges? On some compact cameras with smaller viewfinders, this can be a problem and if you wear glasses, it can be very annoying. Is the image in the viewfinder sharp, bright, and easy to see? If there is an informational display in the viewfinder, how well can you read it? Are the letters and numbers easy to decipher? Does the readout distract too much from the image? Does the back of the camera fit comfortably against your face as you look through the viewfinder?

- **Are controls readily accessible?** Study the layout of the control buttons to make sure their arrangement makes sense and that they are easy to operate. Beware of buying a camera where it feels as if you need a second person there to hold the camera while you operate the buttons and search menus.

- **Are the menu and playback options easy to use?** Scroll through the menu items and look for such things as a logical organization, text that's easy to read, and clear naming of the different features. Can you quickly locate commands that are important to you, such as the histogram or a scene mode, or are they so buried that they are inconvenient to access? Study the playback options to evaluate how easy it is to review images. Most cameras provide a quick review of the image for a few seconds immediately after it has been taken and some let you decide how long it stays on screen. Can you zoom in on the image and scroll to check sharpness and whether or not everyone's eyes are open? Can you lock images to protect them from accidental deletion?

Accessories: The Little Things in Life

We have evaluated dozens of digital cameras, and the cameras that include helpful accessories in the basic price are the ones that we seem to remember most. If you spend $500 to $1000 on a piece of equipment, the least the manufacturer can do is include a camera strap and basic pouch to protect your investment (the latter item is rare, however, as camera bags are seen as a possible add-on sale by camera retailers). The following is a list of some of the little extras you might find in a digital camera package.

- Digital cameras devour batteries. Rechargeable batteries and a charger make the camera more convenient, economical, and environmentally responsible.

- Being able to hook the camera up to an AC power supply while downloading files or when working in the studio saves batteries and spares the landfill.

- Manufacturers that deliver cameras with the smallest possible memory card, or no card at all, are not on our shortlist. Compact cameras are more likely to come with a memory card in the box. With prosumer and pro SLRs, it's assumed the customer will want a higher-capacity card.

- Once your lens is damaged, there's nothing you can do to fix it. A lens cap, with the option to attach it to the camera strap, should be included.

- A wrist or neck strap is the cheapest form of camera insurance. If one is included, attach it and use it.

- A bag or pouch to protect your camera from dirt, scratches, and dings is the second cheapest form of insurance. We especially like bags with separate pockets for extra memory cards and batteries.

- All cameras come with some form of documentation, either in booklet or CD form. We prefer well-written, well-translated instruction booklets that slip into a camera bag for easy consultation when needed.

HOW TO SHOP

How Much Can You Afford?

After you have narrowed your search to a category of camera and decided on which features you really need, you need to set your budget. In the time since the first edition of this book came out, prices for digital cameras have fallen dramatically, but you still may encounter some measure of sticker shock, especially if you're considering a professional camera. However, even though digital cameras tend to be more expensive than their film counterparts, you will save a lot of money not paying for film, processing, and related costs such as overnight delivery to and from the lab.

How long it takes for your digital camera to pay for itself depends on how often you use your camera. If you're using the camera as part of your business, your savings in film and processing costs will likely offset the initial purchase price quickly (see the sidebar below, "Digital or Film: The Bottom Line").

Digital or Film: The Bottom Line

For many photographers the advantages of digital capture include the ability to see the image right away, taking a second shot to create a better photograph, and in many cases the greater inherent quality of a digital capture. For Vincent Versace, (www.versacephotography.com) noted digital photography expert, the advantages also include significant savings in cost and time. We had the pleasure of speaking with Vincent, and his insights and candor in regard to the financial aspects of digital capture were both refreshing and intriguing.

As Vincent explained, "In 1998 I was using 6000 rolls of film per year at a cost of $20 per roll (film and processing cost) for a total of $120,000. In addition to that I spent $7000 on Polaroid to test exposure, lighting, and composition. With a digital camera, I of course do not have any film costs and better than that, the first shot, the so-called 'Polaroid,' lets me see the exposure, lighting, and composition as before, but with the inherent advantage that often that first shot is the best one. The model is fresh and relaxed, or the splash was just right. So often when we used Polaroid that first shot was what the client wanted, and we had to go through a lot of film in the, in some cases, blind hope of getting the shot again."

In conclusion to our talk, Vincent offered this advice to professional photographers, "Don't nickel and dime the client. Rather than adding up every mouse click, capture fee, or CD archived—ask the client what their budget is and figure out how you can work within that budget. If you can meet the budget, get the job in on time, and turn a profit, then everyone involved will be satisfied and you'll be hired again."

If you're a professional photographer, another important factor to consider is the huge savings in time that you gain from being able to review and edit images immediately following a shoot. Having said that, however, it's only fair to point out that if you've shot a lot of images—and that's easy to do with digital—it can add up to more time spent sorting shots on a digital light table. Other potential cost savings: You won't need Polaroid proof shots to check exposure and lighting; you can check the shots immediately, either on the camera's LCD or through a direct connection to a computer workstation. Working digitally also allows you to offer additional billable services such as digital retouching, compositing, proofing, and layout.

If you're buying a camera for personal use, the decision of whether to go digital is a matter between you and your pocketbook. If you're new to digital photography and computers, then we suggest just dipping your toe into the water by purchasing a basic camera with a good set of features. This way you can get used to all the little details such as dealing with memory cards, downloading images to your computer, sorting your photos, making prints, and creating backup CDs. With this grounding in the basics, you'll be better prepared when you're ready to move up to a better camera.

Research

Once you have identified what you'll be using the camera for, the minimum feature set, your own experience level, any additional capabilities, and your budget, it's time to hunt down the right camera. Fortunately, there are plenty of excellent resources available (you're holding one right now) to help you make your decision.

The first step is to see exactly what's on the market and how those cameras compare with each other. For this task, the Web is the best place to start. Unlike magazines, which have to prepare articles several weeks or even months in advance of publication, the Web is immediate. Well-run review sites update their content much quicker. Web-based review sites can also devote much more space to their articles, as well as provide sample images you can download. In addition, their evaluations of digital cameras tend to be much more in-depth and comprehensive than those found in most photography magazines (see the sidebar, "Internet Resources").

Talking with other photographers is also a great way to gather information, so track down any friends and acquaintances who already use digital cameras. Some review sites, as well as general digital photography sites, also offer lively discussion forums that are frequented by digital camera owners who run the gamut from the weekend snapshot shooter to working professionals. If you have a question about a camera you're considering, you can post it

to a forum to get feedback from other photographers who already own the same model. Just keep in mind that sometimes the responses on forums are not the most objective you could hope for, and negative comments tend be amplified by the principle of "if there's a problem, people complain, but if they're happy, they don't say anything."

Internet Resources

The Internet is an excellent resource for learning what products are available in a quickly changing market and for finding out what people think about them. For comprehensive listings of the latest cameras and in-depth technical reviews, visit www.dpreview.com, www.dcresource.com, and www.steves-digicams.com.

After you have identified two or three cameras to seriously consider, it's time to talk to as many people as possible who have experience with those cameras. On the Web, visit the discussion groups and forums for entry-level and prosumer cameras at www.dpreview.com, www.photo.net, and www.fredmiranda.com.

Try Before You Buy

After you've narrowed your choice of cameras to a few contenders, evaluate the quality of their performance and output. It's fine to compare the relative merits of the equipment based on published specs and detailed reviews. But in the end, you need to test-drive a camera yourself, preferably under conditions as close to your real-world situation as possible. At the minimum, this means going to a camera store, a trade show, or a colleague's studio so you can handle the equipment and see how it feels (see "Design and Ergonomics" earlier in this chapter). Ideally, you should shoot some images under a variety of conditions to see how the camera performs. If possible, test the camera in your usual shooting environment and take pictures of the things that you plan to photograph. If you're a real estate professional, take pictures of houses; if you need to do a lot of close-up work, take close-ups.

Most likely, your chance to test a deluxe point-and-shoot or prosumer camera will come by borrowing a camera from a friend or by shooting some files at a camera store or trade show. For the latter situations, consider investing in some smaller-sized storage media so you can photograph a variety of images and then take the files home for closer inspection on your computer. The LCD monitors on cameras are no substitute for viewing an image on a large display, where you can zoom in and really check out the fine details.

If you're in the market for a professional camera, most major resellers will work with you in your studio to see how the camera performs in your shooting conditions. Another option for pros is to rent a camera from a professional rental house. At the time of this writing, day rates for Nikon, Canon, and Fuji Pro digital SLRs ranged from $125 to $175, depending on the camera. Although that may seem expensive just to test out a camera, it's a reasonable investment if you'll be using the camera in your daily work. Studio backs that fit onto existing medium- or large-format cameras generally rent from $400 to $600 per day. If you live near a major city, you may be able to locate a rental studio that can provide you not only with a large shooting space, but also with a digital camera back, a workstation, a proofing device, and an assistant who knows the equipment.

Evaluating a Camera: What to Look For

Lens performance

Even an otherwise perfect digital camera can't compensate for optical flaws or distortions introduced in the lens by a substandard lens. When buying a camera, pay close attention to the quality of the lens. Inexpensive, entry-level cameras are likely to have inexpensive lenses that will not give you the optical quality you need. For cameras with interchangeable lenses, the same thing applies. If you buy an expensive, high-resolution SLR body and then put a cheap lens on it to save a few bucks, you might as well save a lot of money and just buy a cheaper camera. The resolving power of high-end imaging sensors, such as that found on the Canon EOS 1Ds, is so great that you have to use them with only the best lenses to make the most of their capabilities.

If you have the opportunity to shoot test files on the cameras you're considering, examine the files, as well as straight prints (in other words, prints that reflect the image as the camera delivered the file, with no sharpening and no color correction) to check the following characteristics:

- **Sharpness.** Check that the image is sharp from side to side and top to bottom. If the lens is a zoom, check to see that the image is sharp through the entire range of the zoom. If the image isn't sharp in the first place, there's nothing you can do to fix this

problem (**Figure 4.34**). When judging sharpness, be sure that the image was captured at a high shutter speed and/or that the photographer used a tripod. An appropriate shutter speed for evaluating sharpness will vary depending on the camera and lens combination you're using. For a compact camera, anything over 1/125th of a second should be fine; for a digital SLR with a large zoom, try to use a shutter speed over 1/250th of a second, or use a tripod. Typically, the longer the focal length of the lens, the higher the shutter speed needs to be. A good rule of thumb for handheld shots is that the shutter speed should be at least the same as the focal length. For example, you would use 1/200th of a second with a 200mm lens, 1/400th with a 400mm lens, and so on. Be sure to factor in the focal length multiplier if it pertains to the camera—a 135mm lens combined with a 1.6x multiplier is really a 216mm lens.

Figure 4.34 This image is sharp in the center but gets progressively softer toward the edges.

- **Exposure evenness.** Look to see if the exposure is even over the entire image. Are the corners darker than the center? Take a picture of a white wall and examine the corners of the image for exposure fall-off. Although this problem can be corrected in the digital darkroom, it's not something you want to fix on every picture you take.

- **Distortion.** Does the image bow in (called a *pincushioning* effect) or out (*barrel distortion*)? Both effects are more noticeable when there is a straight line near the edge of the frame. Don't confuse this with the widening effect that you get when shooting with a wide-angle lens.

- **Color fringing, or chromatic aberration.** This optical flaw shows up when the lens is not focusing all wavelengths of light uniformly onto the image sensor. In the image it appears as slight red, green, or purple color fringes on dark lines or around areas of high contrast. This can be minimized using advanced digital darkroom techniques, but it's preferable not to have it in the first place.

 Refer to Chapter 3 for illustrations showing pincushioning, barrel distortion, and chromatic aberration.

- **Flare.** Shooting toward the light source can create flare, which appears as diffuse light areas, aperture-shaped blotches, and a general loss of contrast (**Figure 4.35**). This problem is minimized by high-quality, coated optics that reduce the amount of light bouncing around inside the lens before it reaches the image sensor.

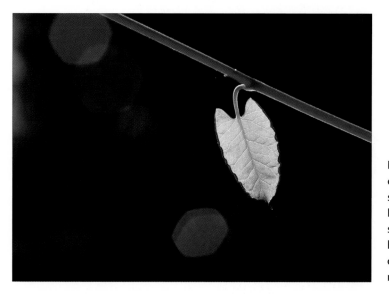

Figure 4.35 The low-contrast light blotches seen in this image are lens flare—the result of shooting directly into a light source. Quality, coated optics can minimize lens flare.

- **Digital zoom.** In Chapter 3, we told you why you shouldn't even think about using this! So don't bother testing this out or letting it influence your camera buying decision. If you're concerned about image quality, turn digital zoom off and leave it off.

Sensor and image processing issues

- **Image processing.** Once the light has passed through the lens and focused on the sensor, a whole new set of issues comes into play. Image quality is influenced by a number of factors, some of which are functions of the CCD or CMOS sensor, others of the analog-to-digital (A/D) converter, and still others of the system the camera uses to write the image to disk. These issues can be difficult to evaluate if you're just testing cameras in a camera store, but when reading technical reviews, pay attention to how the camera handles contrast, edge definition, and faithful color rendition. Check to see if you can bring your own memory card to the store with you so you can shoot some sample shots and then take them home to evaluate them on your own computer where you can zoom in to check for any image deficiencies. You should also see whether certain in-camera processes, such as sharpening or contrast adjustments, can be turned off (preferable) or at the very least turned down.

- **Resolution.** At the most basic level, this determines how large you can print an image without having it look like it's made up of little pixel squares (which, of course, it is). As stated earlier, in a digital camera resolution refers to the number of pixels on the sensor; this, combined with lens quality, determines the camera's ability to capture fine detail.

- **Aspect ratio.** This is the proportion of the image. Most compact and deluxe point-and-shoot digital cameras use an aspect ratio of 4:3, which is the same as your computer's monitor. Digital SLRs try to mimic the proportions of the 35mm film frame and have an aspect ratio of 3:2 (**Figure 4.36**). If a camera offers a panoramic mode, you should read the fine print, as it probably does nothing more than mask the sensor in order to deliver the image in a panoramic shape. This is essentially just cropping in the camera, and it will reduce the number of pixels (effectively lowering the resolution) in the picture.

Figure 4.36 Most compact and deluxe point-and-shoot digital cameras use an aspect ration of 4:3 (top), which is the same as a computer monitor's. Some cameras mimic the aesthetic of a 35mm film camera by offering an aspect ratio of 3:2 (bottom).

- **Dynamic range.** Also referred to as *tonal* or *exposure range*, this is the camera's ability to capture detail in the highlights and shadows of a photograph. It's a function of both the sensor and the processor and is an important variable in selecting a camera. Most digital cameras have a dynamic range similar to color slide film, which in turn is less than the dynamic range for color negative film. CCDs tend to perform just fine when the lighting is diffuse and the contrast is low. If you expect to be taking pictures in the bright sun, however, pay attention to this parameter if you need detail across

the full range. Unfortunately, it's often difficult to find a concrete number for this feature in the vendors' technical specs, so look for technical reviews that test for this. If they refer to it at all, it may be in terms of exposure range, or exposure metering range, as measured in EV. The good news is that, as the technology matures, dynamic range on digital cameras is getting better (**Figure 4.37**).

Figure 4.37 This image shows a good tonal range, with a smooth progression from tone to tone. The histogram for the photo (as seen in Photoshop) also shows a full tonal range, with smooth transitions.

- **File formats and bit depth.** The majority of digital cameras deliver files in the JPEG format. Some also let you choose TIFF or RAW. For most people, a high-quality JPEG offers all you'll ever need, but if you consider yourself an advanced user and you want maximum quality with a high degree of control over the image, then you'll want to consider a camera that can save images in the RAW format. We cover the RAW format in greater detail in Chapter 3, with a look at some of the workflow issues for RAW capture in Chapter 9, "Download, Edit, and Convert." We do not recommend TIFF for a camera format because of the file size. Any benefits you might gain from the uncompressed file are outweighed by the much larger file size.

Bit depth is the number of bits assigned to describe the tonal level of each pixel and refers to the data that the sensor passes through the A/D converter to the processor,

not what the camera ultimately calculates to be the image. Most digital cameras deliver 8 bits per color channel. Higher-end prosumer and professional models that feature RAW files work at higher bit depths. Why should you care about the ability to capture files at more than 8 bits per color? Because it gives you more elbowroom when adjusting color and tonal information in an image-editing application, so you don't have to worry as much about the loss of tonal detail that is an inherent part of digital tonal correction. (See Chapters 3 and 11 for more information on bit depth.)

Evaluating Digital Image Files

As mentioned earlier, try taking some of your own digital storage media to the camera store so you can make test shots and evaluate them on your own computer. Most camera stores, if they're interested in good customer service, should allow you to do this (if they balk, take note; it may reflect their overall approach to customer service). You'll need to find out ahead of time what type of memory cards are used by the cameras you're interested in. CompactFlash is the most common on the market today, but a quick search on the Web can give you the information you need (see the sidebar "Internet Resources" earlier in this chapter).

Try to view the images (straight from the camera, before any enhancement) in a program such as Photoshop that allows you to zoom in to inspect fine details, and that also shows you a histogram of the tonal information. Look for image softness, jagged edges, compression artifacts, noise in the shadows, blown-out highlights, color casts, and excessive noise in the blue channel. Check image histograms for telltale white gaps that indicate missing tonal information. Histograms should be smooth, not spiky (**Figure 4.38**).

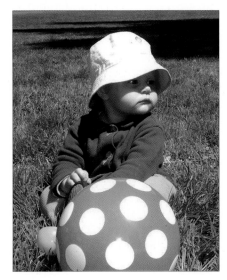

Figure 4.38 In this photo, the white gaps and spikes are symptomatic of harsh transitions, missing tonal values and overall poor image quality.

Buying a Professional Digital Camera

If you're in the market for a professional digital camera, here are a few additional considerations to take into account:

- **High-bit depth files.** For the high-quality output demanded for professional advertising and gallery work, the ability to access high-bit data (more than 8 bits of data per color channel) is essential. Though the files are twice as large as standard 24-bit images (8 bits × 3 channels) and they require more RAM and a faster computer, the price is well worth it. Simply put, a pro camera should enable you to capture high-bit data, preferably in a RAW format. If it doesn't, then it's not a pro camera.

- **Color rendition.** For accurate color rendition, an image needs to contain a full range of tonal values and no loss of information in the shadows or highlights. Neutrals should be neutral (in other words, no color cast) and the transition between tones and colors should be smooth, with no posterization or banding along gradients. A key element to capturing good color rendition is a camera that lets you perform a gray balance to establish a neutral rendition of a true neutral tone. Including a known color and gray reference in the shot (such as the GretagMacbeth ColorChecker) allows you to select a known neutral for balancing the camera. With digital exposures the goal is to gather good information. Even if the contrast seems a little flat and the colors are a bit dull coming right out of the camera, if you've captured good tonal detail (information) and neutral color balance, particularly with a high-bit RAW file, then you can adjust contrast in postproduction.

- **Camera software.** Many professional digital cameras use similar technology and produce similar-sized files, but the software used to interface with the camera can make or break your experience. Try to get your hands on a tryout or rental camera so you can test-drive the software. At the very least, solicit the opinions of other professionals who have used the product

- **Antialiasing (blur) filters.** These are installed in many pro one-shot cameras to reduce the stairstep effect on diagonal lines and to control color artifacts found in high-frequency areas, such as finely woven cloth or hair. In some cameras the blur filter sits in front of the image sensor. The general consensus is that while these filters may help solve some moiré problems, they're not perfect and the reduction in moiré often comes at the expense of a softer overall image (we know some photographers who deal with difficult moiré by actually adjusting the lens ever so slightly out of focus). Other solutions to these problems are software-based and are applied to the image after it has been captured. The camera software for the Leaf Valeo digital back, for instance, includes a moiré-reduction brush tool that is very successful at removing most types of chrominance (color) moiré patterns (moiré that affects the luminance values of an image is harder to remove). If a good portion of your work involves photographing clothing, fabric, or anything that has fine patterns, then you should also consider the viability of a three-pass camera that records three separate exposures for red, green, and blue and then combines them into a finished shot. Because the three-pass approach does not interpolate color data in order to create the image, these cameras don't have problems with moiré. Due to the three-shot nature of these

cameras, however, they are not appropriate for photographing moving subjects. Image sensors with a higher pixel density exhibit fewer problems with moiré, so as the megapixel resolution of digital backs continues to increase, this may become less of an issue.

- ***Warranty and upgradability.*** Does the company offer a good warranty? How much customer support is included with the camera? Will the company offer a replacement camera while yours is being repaired? Before buying, you should inquire about upgrades for both camera and software. A pro camera is an expensive investment, and being able to upgrade the camera during a regular warranty or extended warranty period is important.

- ***Try it before you buy it.*** If possible, we highly recommend leasing or renting pro digital cameras from a local and reputable dealer before you buy one. There is no substitute for trying a camera out in your own studio to get a sense if it will best work for you. When it's time to buy, look to a trusted, local dealer first. Granted, the price may be a bit higher—but who are you going to call when things don't work out? 1-800-CHEAPPRICE? Or a known dealer that understands your market and needs? We've never regretted having a bit more support than we thought we'd need.

Where to Shop

Online retailers

The Internet offers an astounding variety of online camera merchants that compete for your business with aggressive pricing on popular models. Keep in mind, however, that price, while certainly an important part of your purchasing decision, is not everything. Just as critical are whether you are buying from an established, reputable dealer with a fair policy on returns and exchanges. Study their policies carefully before you type in your credit card number.

You should also make sure, if you're purchasing new equipment, that it is in fact new and not a reconditioned camera. Reconditioned usually means the camera developed a problem and was returned. The factory technicians then repair the problem and make sure the camera is brought up to the standards of a new model. Some people have no problem buying a reconditioned camera because they feel it has received closer scrutiny than a new one just off the production line, plus it's less expensive. Just be sure you know what you're buying.

Some online retailers in the United States offer "special pricing" on cameras that are packaged for foreign countries. This is referred to as *gray market* merchandise. While the camera may be the same as one targeted for the domestic market, the contents of the box may differ and the instruction manual may be in a language other than English. The most important reason to avoid a gray market camera, however, is that it might not have warranty coverage in the United States. In many cases, the warranty will only be honored in the country of origin; so if you needed a warranty repair, you'd have to ship the camera out of the country.

If you've never dealt with the reseller before, call the toll-free number. With an actual sales rep on the other end of the line, you can ask questions about reconditioned cameras and gray market products. Just remember that if the price seems too good to be true, there's probably a reason.

Brick-and-mortar stores

A store that you can actually walk into offers a certain comfort level for some people, plus you can derive some satisfaction from supporting the local economy. Prices may be a bit higher in a small store than at a large discount chain, but, as we stated earlier, price isn't everything. Dealing with local people you know and trust should carry some weight in your purchasing decision. If you are new to digital photography and have questions, a knowledgeable salesperson in a camera store can be a valuable resource. The Internet can be an excellent resource for those who don't mind going it alone, but purchasing a camera can be much easier when you are dealing one-on-one with another person who knows the camera well, can answer all of your questions, and will be there the next time you have a problem.

MAKING A FINAL DECISION

In the end, it comes down to this: Will the camera both fulfill your immediate photographic needs and allow you room to grow? At some point, after much introspection, research, and financial consideration, you will have satisfied yourself that you have found the right camera. If it feels good in your hands, has all the features you need, plus some additional ones that are just cool, then it's time to lay down your money.

Buy it.

Essential Accessories

Today's digital cameras come with so many shooting modes and built-in exposure options that you might feel there are more than enough features in the camera to keep you busy for a long time. By adding other items to your camera bag or photo studio, however, you can extend the functionality of your camera, especially for specialized photographic situations such as close-up or night photography. Some of these accessories are designed for a specific purpose, while others are common items such as a notepad or a small flashlight.

In the first part of this chapter, we'll take a look at some indispensable accessories to add to your camera bag. These include everything from spare batteries and extra memory cards to additional lenses and flash accessories. In the second half of the chapter we'll consider items that come in handy for small-studio photography. Also, keep in mind that a tripod is an invaluable accessory for many different photographic situations. We'll cover tripods in greater detail later in this chapter.

YOUR CAMERA BAG

Let's start by taking a little time to look at that vital item that all photographers need—a bag to carry their gear in. Camera bags come in all sizes, from the small pouches designed to fit a compact camera and an extra battery and a memory card, to large photo backpacks for carrying a serious collection of photo gear well off the beaten path. The bag you choose should be large enough to carry the gear you have now, with a little extra room to accommodate any new equipment that you think you might be getting soon.

If you have more than one camera, or your gear requirements vary for different assignments, you'll likely end up with more than one bag. This usually starts as you outgrow your first bag but decide to keep it for those times when you want to travel light. A smaller

bag certainly makes sense for those occasions when you can leave a larger bag in the trunk of the car and head out for an excursion without having to lug all of your equipment.

We like camera bags that let us quickly and easily access all of the essential items. This is known as "working out of the bag," and having a bag that facilitates this practice makes photography in the field more efficient and more enjoyable. The bag should also have a separate area for extra batteries and memory cards that closes securely. Filters and stepping rings should be easily accessible, and a place for a portable storage drive is also nice to have (**Figure 5.1**).

Figure 5.1 A good camera bag is essential for carrying your camera and additional accessories. Ideally it should hold everything you want to take with you and still have a little extra room for new additions.

Finally, the bag should be comfortable on your shoulder with a padded strap that's easy to adjust. If you have several pieces of camera equipment, then the bag will likely have some heft to it. Since you'll be carrying it on your shoulder for extended periods of time, it needs to be comfortable. To get a sense of how it will fit you, we suggest trying it on with all of your gear stowed inside. This means bringing your existing camera bag to the store and loading it into the new bag. Don't worry about what the sales staff will think; if you shop at a quality camera store, they're probably used to seeing photographers do this. The bottom line is that there's no way to accurately judge how the bag will feel on your shoulder or against your hip until you load it up and try it out.

If a traditional bag is not what you need, then consider a photographic shooting belt such as the GripStrip made by Lightware (www.lightwareinc.com). With the addition of different-sized accessory pouches, you can customize the basic, padded belt for the configuration that works best for you. Although Katrin thinks they make you look like a cop, she has to admit that the practical functionality they provide may be perfect for certain types of assignments.

THE CAMERA MANUAL

An important item to carry in your camera bag is that often forgotten, sometimes lost, inevitably dog-eared instruction manual. Unless you purchased a used camera that didn't have one, all cameras come with a manual. Familiarizing yourself with it is one of the most overlooked yet most important parts of using your camera to its full potential. Although it may be human nature to pick up a new gadget and figure it out as you go, you should take the time to read the camera manual from cover to cover.

Digital cameras are actually small computers that boast a wide array of buttons, features, and settings, and in most cases the instruction manual is the quickest way to find out how a certain feature works. Ideally you should sit down with the camera at your side as you read the manual so you can try out the features it covers and familiarize yourself with the controls. Even after you have read (not skimmed) the manual, until you know your camera's features inside and out, we recommend keeping it in your camera bag so you can easily refer to it if you need to. Seán ran into this situation once when he needed to take a custom white balance reading while shooting on location. Even though he had read the manual, because the camera was still relatively new, he forgot the actual steps for creating the custom white balance. Since he had the manual with him, he could quickly look up "custom white balance" and then concentrate on the shoot.

MORE BATTERIES

Digital cameras crave power and lots of it; that's probably the biggest downside to digital photography. When you're out taking pictures, nothing is quite so frustrating as seeing the low battery indicator come on. To avoid this unpleasant situation, you need to have plenty of extra battery power at your disposal. In that regard, extra battery power is arguably one of the most important accessories, together with extra memory cards, that you can buy for your camera.

Digital cameras can be divided into two categories in terms of battery use. Some cameras use disposable batteries or generic rechargeable AA-size batteries, and others use proprietary rechargeable batteries that are made by the manufacturer and usually come with the camera. We feel that the ability to use a rechargeable battery is a very important feature.

Rechargeable Batteries

Rechargeable batteries are not only more cost-effective over the long run than their disposable counterparts, but they're also much better for the environment. We usually have at least one fully charged extra battery in the camera bag in case the first battery runs out of power. When using the proprietary lithium-ion batteries with the Canon EOS 10D and the Nikon D100, in most situations two will easily get us through a full day of photography. Depending on the camera and the type of battery it uses, your mileage may vary. Tim has had excellent results with the rechargeable battery of the Canon DSLRs he uses. "I've been really impressed with the battery use on all the Canon digital cameras I've worked with," he says. "I don't even have to think about recharging; I can go several days with the same charge. I usually use the optional battery grip on the 10D, so I have two batteries and have to think about recharging even less."

> **TIP:** In the evening, make sure to charge up all of your batteries so they're ready for the next day. If you will be photographing in an area where access to electrical power will be infrequent, then you'll need to take more batteries with you to keep going between recharging opportunities.

There are different types of rechargeable batteries that you may be able to use with your camera. Your camera's design will usually determine the type of battery you choose, so be sure to consult the manual before you buy. Here's a rundown of the most common types:

- **Proprietary.** These are batteries that are manufactured to work with your camera, and one usually comes with the camera when you buy it. You can also often find third-party companies that sell a battery to fit your particular camera. We've had good experience with the rechargeable batteries that came with our Canon and Nikon cameras. The good thing about a system such as this is that the charging unit comes with the camera. A potential drawback is that these batteries are relatively expensive, so you may experience some sticker shock when you go to buy a few backup batteries. As of this writing, a lithium-ion battery for the Canon EOS 10D retails for about $55.

- **Lithium-ion.** This is the most common type of battery used for the proprietary batteries that come with many digital cameras. They tend to offer much more capacity than equivalent NiCd or NiMH batteries. For cameras such as the Canon EOS 10D and the Nikon D100, the recharging times are about 90 minutes to fully charge an exhausted battery. Lithium-ion batteries are good only for approximately 500 charge/discharge cycles, after which they must be replaced. The batteries on the Nikon D2H are simply spectacular—reaching a full charge in 90 minutes and lasting up to 1000 shots.

NOTE: *Some high-end pro cameras, such as the Nikon D2H, even keep track of the percentage of battery charge in the menu display, how many pictures that battery took, and if it needs reconditioning.*

- **NiMH.** Nickel metal hydride batteries are probably the most popular choice for rechargeable batteries used in many consumer-level digital cameras. They come in the standard AA size and can be found at any good electronics store. If your camera did not come with a charger, you'll have to purchase one. The main drawback to NiMH batteries is that they do not provide the capacity of lithium-ion, and if your camera has a lot of features to power, they won't last as long. They are also notorious for failing in cold weather. NiMH batteries are good for approximately 500 charge /discharge cycles. While the power charge that NiMH batteries can hold is not as much as with lithium-ion, they are more robust than equivalent NiCd batteries. Contrary to popular belief, NiMH batteries can also be affected by the "memory" issues that are more common in NiCd batteries (see the next paragraph). The effect is not as pronounced, but it can still be an issue.

- **NiCd.** Pronounced "Ni-Cad," nickel cadmium batteries are the most common type of rechargeable battery, though not necessarily for digital camera use. Although they are good for an average of 700 charge/discharge cycles, they do not hold as much power as NiMH or lithium-ion batteries, so they're not a great choice for a full-featured camera. Additionally, a phenomenon known as *memory effect* means that they should be fully discharged before they can be recharged. If a NiCd battery is charged before it has been fully exhausted, this will reduce the maximum capacity of subsequent charges. The effect is cumulative and becomes greater the more the battery is improperly recharged, hence the term *memory effect.* Because of this, we recommend that you use either lithium-ion (the first choice if available for your camera) or NiMH batteries and save NiCds for emergency backup, if you use them at all.

NOTE: *You should never just throw away any old batteries, even rechargeable ones. Batteries decay and break down, and the toxic chemicals contained inside them can leak out and seep into the soils, so you should take them to a designated center for proper disposal. Many camera and consumer electronics stores provide a free recycling service for small batteries (but don't try taking old car batteries to them!). It's much easier, of course, to just toss them in the trash, and we suspect this is what most people do, no matter how good their intentions may be. That being the case, using rechargeable batteries means fewer batteries will end up in landfills, and that's good news for everyone.*

Battery Grips

Many SLRs have optional accessory battery grips that provide extra battery life. A battery grip typically holds two of the camera's standard proprietary battery packs and is used in place of the camera's regular battery. The grip effectively doubles the amount of shooting time available to you. Although the extra power is great, the only potential downside is that you'll be adding extra weight and bulk to what is probably already a substantial camera body. If those factors are already an issue, or if your camera bag is too small to accommodate an extra grip, then you may want to check out a camera that's already equipped with a battery grip to see if it will be too heavy for your tastes. Most makes of battery grips have a duplicate shutter release, which makes taking vertical shots more convenient. Prices for extra battery grips vary but an informal survey at the time of this writing shows you can expect to pay between $175 and $250 (**Figure 5.2**).

Figure 5.2 Battery grips extend your camera's battery life by providing more power. The BG-ED3 grip for the Canon EOS 10D holds two rechargeable lithium-ion battery packs.

Batteries: In a Pinch

Some cameras allow the use of either disposable or rechargeable batteries, and having this additional option can come in handy if you find yourself in a situation where you run out of power on your rechargeable batteries. In such a case, you might be able to find a nearby store where you could purchase a battery that fits your camera. Cameras that do not provide a rechargeable option generally use either standard AA batteries, or special lithium

batteries that have been common in point-and-shoot cameras for many years. Of these two, the AA batteries are more ubiquitous, but their power capacity is lackluster. A set of two AA batteries on a modern digital camera won't last much longer than a few hours, if that. The lithium camera batteries will provide more power capacity, but in the end they run dry and can't be recharged. At an average price of about $13 a pop, disposable lithium batteries can get very expensive.

> **NOTE:** *Despite the temptation of super cheap batteries you can buy in bulk at discount stores, you should only use the batteries that the camera manufacturer recommends. You also should not mix different types or brands of batteries. When you change batteries, change all of them at the same time and replace with batteries that you know to be new and fresh. Finally, don't try to coax an extra shot or two out of an exhausted battery by turning the camera off and on. It can confuse and damage your camera's circuitry as well as interfere with the saving of the last file to the memory card. In some situations it can even damage the memory card.*

High-Capacity Batteries

For those times when you need a lot of power for a long period of time, you might consider a high-capacity battery such as those sold by Digital Camera Battery (www.digitalcamerabattery.com) and Quantum Instruments (www.qtm.com). These high-capacity power packs are external batteries that can be worn at the waist, either attached to a belt or dropped into a pant pocket. A cord connects the battery to your camera's AC power connector. Although these are certainly bulkier and heavier than the internal battery your camera normally uses, they are very useful for event photography where you need to be on-site for a long period. The high power capacity means that you can use the camera for many more shots and for a longer period of time than normal. An additional benefit for photographers using an external flash is that the same battery can power both the camera and the flash.

Charging the Batteries

Even if you don't plan on going out to take pictures the next day, get into the habit of removing the batteries from the camera after you return from a photo shoot, and hooking them up to the charger and the wall outlet. Fortunately, most proprietary batteries that come with cameras will fully recharge in anywhere from 60 to 90 minutes. Having your batteries charged up whenever you pick up the camera and head out the front door will mean you're as ready as possible for any photographic opportunity that may come your way.

NOTE: *Many batteries will continue to discharge a low electrical current even when the camera is turned off. This can lead to excessive discharging and could potentially shorten the overall service life of the battery. If you won't be using the camera for several days, it's best to remove the battery and store it with the protective cover on (if it has one).*

We also recommend always using a separate charging unit and not recharging the battery while it's in the camera using the camera's AC power cord. For one thing, if you're using the camera as a charging unit, it means you're not using the camera to take pictures. It's effectively out of service until the battery comes back to life. Another benefit to using a charger is that most units will display an indicator light to let you know what the level of the charge is. Charging in the camera should only be done as a last resort if you realize on the flight to Timbuktu that you left the charger at home. And if it's a longer trip where you'll be shooting a lot, then you should have someone at home or in the studio ship the charger out to your location, as charging in the camera will get old fast.

Quick chargers

Quick chargers are used to recharge NiMH and NiCd batteries in less time than a standard charging unit takes. Charging times vary depending on the type of battery, its capacity, and the type of charger, but standard times given for quick chargers range from 60 to 180 minutes. The proprietary lithium-ion batteries that we use in the Nikon D100 and Canon EOS 10D will fully recharge in 90 minutes, which we find to be a very reasonable recharge time. In most cases, we charge the batteries overnight, so we're not as concerned about keeping track of the little blinking status lights. If you have more than one camera that uses different types of batteries, there are chargers available that will accept a variety of different batteries, from NiCds and NiMHs to the lithium-ion packs used in many SLRs.

Voltage adapters

If you're planning an overseas trip, be sure to look into a voltage adapter to convert the voltage to something that is usable with your charging device. Different countries have different standards, both for the standard power voltage and for the outlet interface that you plug into. Any good travel shop should be able to provide you with a selection of voltage adapters for either individual countries or specific regions. In some cases, the adapter kits not only cover power conversions, but also let you plug your laptop into the local phone system for accessing email when you're on the road.

Power adapters are also useful for tapping into your car battery via the cigarette lighter. If you'll be on an extended trip, away from the conveniences of electrical wall outlets, then your car's battery may be your only option for recharging camera batteries or running a laptop for downloading and archiving purposes.

Portable solar panels

If you will be venturing far from regular access to the electrical power grid or the cigarette lighter in a car, then you may have to take more drastic measures and look to the sun for recharging your camera batteries. Portable solar panels have been around for a long time, but now that batteries are such a vital part of digital cameras, photographers are using these panels when an assignment takes them to remote areas of the earth for extended periods of time.

Photographer Kevin Ames used two folding, notebook-sized solar panels when he ventured to Africa for an extended photo safari. Each 12-volt folding panel provided all the power he needed to recharge his camera batteries, his PowerBook, and the spare battery for the laptop (**Figure 5.3**). The solar panels came with their own cloth cases and when not in use could be zipped closed for easier storage and transport. Of course, his location in Africa was close to the equator and was ideally suited for using solar power. If your expedition is taking you to areas of constant overcast skies or far above the arctic circle, it might not be as feasible a solution.

Photo by Kevin Ames

Figure 5.3 Portable solar panels let you recharge your camera batteries and your laptop computer, even if your quest for a great photo takes you far from an electrical outlet. These 12-volt panels are the size of a notebook and were used by photographer Kevin Ames for an African safari.

MORE STORAGE

After extra batteries, additional storage space is probably the most important accessory you should invest in. Although you can delete bad shots as you go, the time will come when you've erased all the mediocre images you can but you're still running out of room on the memory card. Like the flashing low-battery indicator, a rapidly filling memory card with no spares available is sure to put a damper on your enjoyment of digital photography, especially when you have a lot more that you want to photograph.

Camera Media

Whatever type of removable storage your camera uses, buying additional memory cards is always a good idea. Fortunately, the storage capacities for memory cards is increasing, and finding a card that represents the right balance of storage space and price should be no problem. The number of cards you need to keep on hand will depend on the capacity of the card, how many photos you're likely to take in a given outing, and the format you're shooting in. With JPEG you'll be able to fit more photos on a memory card than if you're shooting RAW, though RAW will give you greater postcapture flexibility in terms of improving the image.

Memory cards are now available in sizes that were unthinkable only a year ago. Cards that can hold up to 4 gigabytes of images mean that, if properly prepared, you should never run out of storage space between download breaks when you can transfer files to a computer or portable hard drive. In our view, 512 MB is the smallest card that makes any sense, especially if you're shooting in RAW format. If you're shooting at the highest quality JPEG format on a 6-megapixel camera, then you should be able to fit approximately 200 images on a 512 MB card. Your mileage may vary depending on how much compression the camera applies and the visual complexity of the images (the more complex the image, the less it can be compressed). Seán likes to use 512 MB cards because the contents of one card will fit nicely onto a CD-R for archiving purposes. If you archive your photos to DVD, then several 1 GB cards or a Lexar 4 GB card will fit perfectly onto a DVD disc.

Although memory cards that hold more than a gigabyte are more expensive, they may be better suited to your needs (depending on the type of photography you do) since they allow you to shoot for longer periods of time without changing cards. We don't feel too comfortable using cards larger than 1 GB because we don't want to place all of our eggs in one basket should the card fail. Although we've never had a single problem with any of our CompactFlash cards, losing a 4 GB card full of images would really hurt.

In our view, you should stick with known brands when purchasing extra memory cards. Your images are important, so paying a little more for an established name brand and a proven product is another way of ensuring that your photos will be safe until you can download them and create a backup copy. Plus, you should consider the speed of the media. The design of the internal controller of some cards means that higher-end cameras can write data to them much faster than to other cards. Although the camera may process the data at the same rate no matter what card is used, at some point it has to hand the data off to the storage media, and the speed with which the media can accept the data will determine when the camera's buffer has emptied enough to be ready for the next shot. Using a cheap but slow card can add a lot of extra time to the write speeds that your camera can handle. Saving an extra $20 or $30 on an unknown maker of memory cards is not worth it if the card receives data at a glacial pace.

Dedicated Card Readers

While these are not storage cards, dedicated card readers and PCMCIA card readers for laptops enable you to easily download images onto a computer, and we can't recommend them enough. Instead of hooking the camera up to the computer to download your photos, which ties up the camera, you plug in a card reader to quickly download your photos from the memory card to your computer. At around $20 to $30, they're inexpensive enough that you can have one for your desktop machine and another for your laptop bag (**Figure 5.4**).

Figure 5.4 A card reader is an essential accessory that lets you download images without tying up your camera or using precious camera battery power. With a card reader and a laptop, you can work on your new images anywhere, even at 35,000 feet.

Pocket Drives and Digital Wallets

As the size of digital camera files has increased over the years, so has the need for compact, battery-powered external storage devices. Digital wallets and portable hard drives are currently available in sizes up to 80 GB, and it wouldn't surprise us to see higher-capacity devices introduced by the time you read this.

Approximately the size of a paperback book, these devices are an excellent solution if you need to be away from a computer and still want to be able to take a lot of photos (**Figure 5.5**). You can insert your storage card directly into the drive and copy the photos with the push of a button. Some even offer a small LCD screen for reviewing images (**Figure 5.6**). Since that feature consumes precious battery power that should be reserved for running the disk drive, however, we recommend saving your reviewing activities for when you're back at the hotel and hooked up to a power cord. A power charge for these devices usually lasts 2 to 3 hours for continuous operation.

Figure 5.5 Portable battery-powered hard drives and digital wallets are great for downloading your media cards when you take a lot of photos but don't have a computer with you. The Kanguru Media X-change 2.0 (www.kanguru.com) shown here is about the size of a paperback book and holds 20 GB of images (80 GB models are available). You simply insert a media card and press the Copy button to start downloading images. Back at your computer, the Media X-change hooks up via a USB cable and shows up as an extra hard drive.

Figure 5.6 The FlashTrax by SmartDisk (www.smartdisk.com) holds 30 GB and also features a 3.5-inch color screen for reviewing your images. For music lovers it also serves double-duty as an MP3 player.

Having a portable drive in your camera bag, or back at the hotel if you're traveling light, means you can take as many photos as you want and simply download them to the drive at night. Seán has used these devices while photographing events and found that it's easy to download one card to a portable drive in his backpack or camera bag, and put a fresh card in the camera to continue shooting. The freedom this gives you to continue shooting is liberating.

Portable CD Burners

Another option for downloading files while on the road is to use a portable CD burner designed for use with common media card formats (**Figure 5.7**). You can burn the full contents of a memory card onto a CD. These devices work on AC power or can be used with AA NiMH rechargeable batteries. The battery life is nothing to write home about, however, topping out at 60 to 70 minutes. And it's not an option that will let you stray too far from the power grid. In a pinch, though, that might be enough time to burn a few CDs. Although this method does provide you with a potentially more stable archive than a hard drive (since it's on a CD, it can't crash), the obvious drawback to this approach is that the capacity of a CD-R disk limits the size of card you can use. For 512 MB cards this type of backup storage will work fine since a single card can fit onto one CD, but it's not suitable for larger cards. We prefer to use a portable compact hard drive instead because it holds more data and has better battery life.

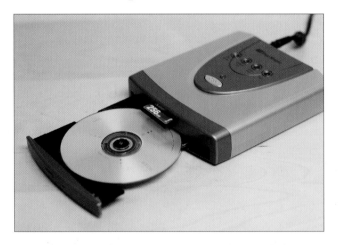

Figure 5.7 Another option for downloading media cards so you can free them up for continued use is a portable CD burner, such as the EZDigiMagic (www.ezpnp-usa.com), that burns a CD-R or CD-RW directly from your camera's flash memory card in about 3 minutes. The only drawback to this approach is that the capacity of a CD-R limits you to using a 512 MB storage card.

Wireless Transfer of Images

How often have you been shooting and found yourself stuck without any space on your CompactFlash cards and without any more cards in your pocket, but you still have more pictures to shoot? Well, you could start to edit images in camera— but we all know how nervous that makes us; you could easily delete the best shot, or miss photographing a decisive moment as you stop to edit. Wouldn't it be great if you could keep shooting while the pictures were transferred via a wireless protocol to a variety of locations? Well, soon you'll be able to.

Wi-Pics was the degree project of Dave Rea, who at the time was an electrical engineering student at the Rochester Institute of Technology. Now being developed by Dice America, Wi-Pics is a network appliance that allows any digital camera with a CompactFlash slot to transmit images via wireless networks, without modifying the camera's firmware or impacting camera performance or power consumption. Wi-Pics units allow images to be sent immediately from the camera to editing stations, servers, FTP sites, or Internet access points. They can be configured with up to 80 GB of built-in storage. In addition to a multimode 802.11a/b/g radio, Wi-Pics units can be ordered with a 10/100 Mbps Ethernet interface for studio use.

Wi-Pics power supply and transmitter is the size of three bars of soap, can be worn on a belt, and contain their own rechargeable power supply—no drop in camera battery life! It's designed with professional photographers in mind; they can shoot events without having to stop and physically transfer image files, and they needn't be limited by the amount of cards they're carrying.

THE IMPORTANCE OF A TRIPOD

For those times when you don't have to be concerned with split-second mobility and traveling ultra light, then using a tripod is an excellent way to improve the sharpness and composition of your images. Trying to handhold a shot with a shutter speed below $\frac{1}{30}$ of a second is a gamble at best. With longer focal-length lenses, the minimum shutter speed is even higher. The slower exposure will record even the slightest camera movement caused by unsteady hands or the downward motion of your finger pressing the shutter button. Even a windy day can buffet you about enough to compromise the sharpness of a photo. A tripod is also necessary for night photography or images where you need increased depth of field (**Figure 5.8**). To render a scene with a great deal in focus from foreground to background, you need to stop down the lens and use a smaller aperture. A smaller aperture will produce a slower shutter speed, which may make a handheld shot impossible.

Figure 5.8 A tripod is mandatory for night photography, where long exposures are commonplace. For this photograph of a Ferris wheel at a county fair, the shutter was open for 20 seconds.

A tripod provides you with a steady platform from which to survey the scene and compose your image. With the camera immobilized, long exposures that are sharply focused are possible. Using a tripod frees your hands from holding the camera, which helps you make your shots more consistent and gives you the time to refine the images. In our experience, slowing down is one of the best ways to take better photographs. When you take a more measured and deliberate approach to the scene you're photographing, you can consider it from different angles and decide if your initial composition is really the best one. Framing the image is a more meditative interaction with the elements you see in the viewfinder and less of a quick grab shot. If you go out and use a tripod all day, even when there's plenty of light to easily handhold the camera, you will take fewer shots, but you may find that they are better images.

Choosing the Right Tripod for Your Camera

There are almost as many different types of tripods as there are cameras, and it's important to choose one that will stabilize your camera and also offer smooth movements, easy controls, and a decent weight. Although none of us likes to lug around heavy photo equipment all of the time, the weight of a tripod is important in ways other than how it feels

slung over your shoulder. Since a tripod's main purpose is to steady the camera during longer exposures, it needs to possess enough mass to counterbalance the weight of the camera and lens that are mounted on top of it. A feather-light compact aluminum tripod may feel great when you heft it in the camera store, but it's not the best choice if you have a sturdy magnesium alloy body SLR with a big zoom lens. Additionally, the farther you extend the legs to raise the tripod higher, the less stable it will become. And if you expect to be photographing outdoors a lot, then factors such as high winds can also thwart your efforts to record a sharp photo.

If you're using a lightweight, compact digital camera, then a lightweight tripod might be sufficient. But buying a model that is slightly larger and heavier than you need may also be a good strategy. Since compact digital cameras are so small and lightweight, even when mounted on a light tripod, the very act of pressing the shutter button could transmit motion vibrations through the camera during the exposure.

For larger cameras, a heavier tripod is better, especially if you'll be using zoom lenses. With a telephoto focal-length, vibration is more noticeable when focusing on distance scenes, and you'll need a sturdy tripod to provide the most stable camera platform you can (**Figure 5.9**). Additional accessories such as an electronic cable release are also recommended for longer exposures in such conditions.

Figure 5.9 A heavy tripod is an asset when shooting in extremely windy conditions such as for this shot of the Suisun Bay Reserve Fleet near San Francisco. High winds at this overlook area are common, and earlier shots taken with a lighter-weight tripod were not as sharp as the ones made with this heavier Bogen tripod.

In the end, you may find yourself with more than one tripod, with each one being used for different situations and different cameras. Seán has four tripods that he uses regularly with his cameras: a tabletop model that works well with compact cameras; a small, lightweight aluminum tripod, perfect for small cameras or those times when he takes his plastic pinhole camera into rivers for water-level shots; a medium-sized tripod he can adjust to eye level or down very low; and a large, heavier Bogen tripod for those times when he needs extra height and real stability. Also keep in mind that a good tripod is not something that you need to replace every year or two. Katrin has a tripod that her husband, John, purchased 30 years ago; it was the best then, and it still is an excellent piece of equipment.

> **TIP:** *When using a tripod, position it so that the "third" leg is facing away from you and not between your legs, where you're more likely to stumble over it.*

Aluminum vs. carbon fiber

The two primary materials that are used in the manufacture of tripods are aluminum and carbon fiber. While the former is more common and less expensive, a carbon fiber tripod is the way to go if you'll be doing your photography far from the convenience of a parked car. The carbon fiber material is up to 30 percent lighter than aluminum and just as sturdy and durable. As an additional bonus, the legs of a carbon fiber tripod do not get as cold as those on an aluminum tripod—something to consider if your work takes you into cold climates. If you're a backpacker who enjoys hiking into remote areas in search of the photographic muse, then a carbon fiber tripod is a good choice. If you've never shopped for one before, however, be prepared for sticker shock. Good carbon fiber tripods usually start at around $400 for the legs only; a head is extra. If you do spend a lot of time hauling all your gear, however, then the investment may be well worth it. Bogen and Gitzo each offer a carbon fiber line in addition to their standard aluminum tripods.

Tripod heads

The tripod head is the part of the tripod that actually supports the camera and allows you to move it into position to compose your shot. There are two types of tripod heads commonly used today: ones that are controlled by three levers or knobs, and ballheads that control movement via a ball that rotates in a socket. Both move the camera into various positions and keep it immobile while the exposure is made. As both types provide this basic function, which one you choose is largely a matter of personal preference—and both types have their fans. For studio-based photography, the control handles on a standard head are better suited to the more methodical approach that is common with still life and tabletop photography. Some photographers don't like handle-based heads because the

handles can get in the way of your face. Some heads come with optional knobs instead of handles, which solves the problem and lets you get close to the tripod without endangering your eyes (**Figure 5.10**). If you've never used one before, a ballhead is initially harder to work with; but once you become used to it, many photographers feel that it offers faster movement and allows a faster response to changing situations, such as wildlife photography. Among ballheads, the B1 made by Arca-Swiss is highly regarded. Expect to pay $300 to $400 for a good ballhead (**Figure 5.11**).

Figure 5.10 This Bogen 3025 tripod head is a 3-axis, pan-tilt type of tripod head that features low-profile knobs instead of long handles.

Figure 5.11 The Arca-Swiss B1 ballhead is a favorite of landscape photographers. Although not cheap (expect to pay around $400 just for the head), it's beautifully designed and machined, and is well regarded for its reliability and superb functionality.

Quick releases

Most tripods sold today come with some sort of a quick release system. A quick release consists of two parts: a plate that mounts on the base of the camera and a clamp on top of the tripod head that you attach the quick release plate to. Quick releases are definitely an improvement over the old way of mounting a camera on a tripod, which meant tightening a screw with a knurled knob. Although the quick release system is found on nearly every tripod, each manufacturer has its own implementation, and not all quick releases are created equal. Here are a few things to check:

- **Plate stability.** Does the plate on the bottom of the camera feel solid and secure when you tighten it down? Does the screw mount allow for side-to-side movement of the plate if the tension loosens? If so, then this could cause problems with the front of the camera not always being aligned with the front of the plate-clamp.

- **Clamp stability**. When the camera is mounted on the tripod, do the clamp and plate hold the camera firmly in place with no movement? As you examine how the clamp holds the plate in place, does it appear solid and trustworthy? Your camera is an expensive investment, and all that holds it to the tripod is this piece of hardware. You need to be able to trust it.

- **Clamp release mechanism**. How does the clamp open and close? Is it easy or difficult? Does it hurt your hands when you open the clamp? Is there a lever that opens the clamp, and does this stick out so that it might catch on clothing or a camera strap and accidentally open?

Custom quick releases

A few companies have recognized the deficiencies in some of the quick release systems offered by the major tripod manufacturers and have answered the requests of photographers by creating custom release plates that are designed to fit a particular camera body. The primary advantage of these custom plates is that, unlike most standard quick release plates, they feature a raised edge that hugs the front and back side of the camera base and prevents any side-to-side motion of the plate once it has been tightened in place. Since each plate is manufactured to fit a specific camera body exactly, the plate becomes an integral part of the camera, rather than something that is screwed on using only the power of your thumbs.

L-plates

Extending the concept of the quick release, an L-plate is a wonderful accessory for SLRs that we highly recommend. If you use a tripod a lot, then this is definitely worth checking out. The L-plate features a quick release plate on the bottom of the camera and also on the side. This permits you to quickly switch from a horizontal to a vertical orientation without having to adjust the tripod head. With a standard tripod mount, switching camera orientation is less than ideal because it can drastically change your composition. Worse than that, the camera is laterally displaced and its new position is such that its center of gravity and all of its weight is no longer above the center point of the tripod. If you have a heavy camera and lens combination, this can be a cause for concern, since the tripod is unbalanced and more likely to tip over.

Since the L-plate allows you to change the orientation of the camera without moving the tripod head, your framing and viewpoint will be much closer to your original composition (**Figure 5.12**). The tripod head stays in an upright position, which means that the camera's weight is evenly and securely distributed over the center part of the tripod for maximum stability. Seán uses an L-plate from Really Right Stuff (www.reallyrightstuff.com) that's designed to fit his Canon EOS 10D; he likes it so much that he leaves it on the camera all the time. The vertical mounting plate also provides an extra handgrip on the left side of the camera. Like most custom release plates, the ones from Really Right Stuff are designed to fit the clamp on an Arca-Swiss ballhead, which is widely used by landscape photographers. The Arca-Swiss clamp provides a large surface area for a very secure connection between camera and tripod. If you don't have (or can't afford) an Arca-Swiss ballhead, then you can buy adapter clamps to fit onto standard tripod heads (**Figure 5.13**).

> **NOTE:** *A tripod head that's good for a film camera may not work with a digital camera, as it may block assess to the memory card door or a battery door. If you plan to use the camera in a studio tethered to a computer workstation, then check to make sure that the ports for interface cords are accessible.*

Figure 5.12 The L-plate from Really Right Stuff (www.reallyrightstuff.com) is designed to fit the Arca-Swiss ballhead and is custom made for specific cameras, which ensures a perfect fit to the base of the camera. Dual quick release plates mean that you can quickly change from a horizontal to a vertical orientation without moving the tripod head.

Figure 5.13 This adapter clamp is designed to fit standard tripod heads, converting them to accept the quick release plate used on the L-plate by Really Right Stuff.

Monopods

For those situations when a tripod isn't feasible, either due to space constraints or the need to move around quickly, a monopod can bridge the gap between mobility and stability. Essentially a single, telescoping tripod leg, monopods are used regularly by sports photographers, wildlife photographers, and photojournalists. The single leg support is enough to steady the camera for use with slower shutter speeds or when photographing with long, telephoto lenses. Monopods can also help you position the camera into places that you may not be able to get into yourself.

Remote Release and Mirror Lockup

Even though you have the camera mounted on a tripod, you can still transmit motion and vibration to the camera by the simple act of pressing the shutter release button. With a telephoto lens, it's even more likely that the vibration will create an image that is lacking critical sharpness. To maximize the chances for a clear and sharp photo, use an electronic *remote release* to trigger the shutter when using a tripod. If you don't have one, you can use the camera's self-timer feature to take the picture without touching the camera at the instant the shutter opens.

Mirror lockup is not an accessory you can buy, but if your camera has this feature, then it's one more thing you can do to ensure that a shot is sharp. On an SLR camera, when you press the shutter button, the mirror that provides you with a view through the lens flips up out of the way to allow the light to pass through the lens and onto the imaging sensor. In some situations, even when the camera is mounted on a tripod, the motion of the mirror flipping out of the way can cause subtle vibrations in the camera body that can compromise image sharpness. The problem is especially noticeable on telephoto shots with slower shutter speeds.

To address this problem, some cameras allow you to raise the mirror before the shot is taken and lock it out of the way. With the mirror stabilized and motionless, you can make the exposure (ideally with a remote release) secure in the knowledge that you have done everything humanly possible to capture a sharp photograph. On the Canon EOS 10D, you select mirror lockup from the camera's custom function menu. With this enabled, you can focus, compose, and set the exposure and when you press the shutter button, the mirror will flip out of the way (thus blacking out the viewfinder) and remain locked out of the light path. If you wait a few seconds for any vibration to stop, you then have up to 30 seconds to press the shutter button a second time to take the photo. Mirror lockup is another feature that we regard as essential on any pro digital camera.

MORE LIGHT

As we have pointed out before, photography is all about capturing the nuances of how light interacts with the scene in front of you. In an ideal world, you'd always have all the light you need, but this is not the case. Plus, there are some very interesting things you can do when you bring your own light to the party. Most digital cameras come with a built-in flash to cover basic illumination needs, but the light that they produce is less than subtle, and you're limited in what you can do with it. All in all, we're not wild about the built-in flashes that come with most cameras, and in most cases, we use them only as a last resort if we can't find a way to get the shot using existing light (**Figure 5.14**). If you're serious about using artificial light sources in your photography, then you'll soon be considering adding a little extra light to your camera bag.

Figure 5.14 The built-in flash found on most digital cameras is convenient and at times necessary, but if there's any way to use natural light instead (top), we prefer that to the frontal, contour-flattening light from the on-camera flash (bottom).

External Flash Options

Whether or not you can even use an external flash unit with your camera will depend on the camera itself. To synchronize a flash with the camera's exposure, your camera needs to have either a hot-shoe mounting bracket on the top of the camera or a sync-cord outlet, which is usually found on the side of the camera. The hot shoe lets you mount an external flash directly to the top of the camera (**Figure 5.15**), and the sync-cord outlet lets you connect a flash mounted off the camera by means of a synchronization cord. Actually, there is a way to sync an off-camera flash with your camera even if it doesn't have either of those options. We'll get to that in the next section.

Figure 5.15 Mounting a flash on the accessory hot shoe elevates it higher above the camera, which reduces the chance of red eye. The higher the flash, the lower it throws the shadows of your subject down behind them instead of outlining them. It also provides additional opportunities for modifying the light by adding bounce cards or diffusers.

External flashes come in a variety of sizes, and they offer different power output and a variety of features for controlling the light. The main advantage that is common to all external flashes is that they raise the light source higher above the camera, which solves the red-eye problem that is common with built-in flashes that are closer to the lens. If the flash is designed to work with your camera, then you should also be able to take advantage of TTL (through the lens) metering features on your camera. With many modern flashes, the camera uses a preflash that evaluates the scene and sets a proper exposure and output level for the flash. Modern flashes are great at balancing their output to the ambient light levels in a scene or to the background light (**Figure 5.16**).

Photos by Lindsay Silverman

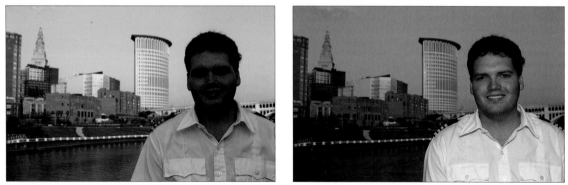

Figure 5.16 Using a full-featured flash mounted on top of the camera opens up new possibilities for using flash creatively and subtly. In the first image of the man, no flash was used. In the second, the flash was balanced to the background ambient light. The depth of field between subject and background is the same, and the soft quality of the early evening light in the background has been preserved. Photographed with a Nikon D2H and an SB-800 Speedlight.

Photos by Lindsay Silverman

For this portrait of the couple, just a hint of flash was used to pop in a little twinkle in the eyes and open up the shadows. The warm sunset tones are still evident on the side of their faces. Photographed with a Nikon D2H and an SB-800 AF Speedlight.

As flashes get bigger and more expensive, they typically offer the ability to swivel the flash head so that the flash can be bounced off of reflector surfaces to soften the quality of the light and extend coverage over a broader area. Other advantages of using the more advanced flash units are that flash power output can be more precisely controlled and wireless features are also available to control other flash units for background or fill lights. Auto zoom is also a common feature: the flash head can zoom within a specified range to fit the coverage angle of the flash to the focal length being used by the camera. A typical flash zoom range is 24mm to 105mm, but it's important to note that this does not take into account the focal-length magnification factor that is at work with most digital SLRs. Since

the flash gets the focal-length information from the camera, which in turn gets it from the contacts on the lens mount, the flash doesn't have a clue about the focal-length magnification factor. It is illuminating the scene based on the full focal length of the lens, but then the sensor crops part of that scene from the image circle.

Off-camera flash

Using the flash in a location other than the top of the camera lets you direct light with more control. One of the drawbacks to a full frontal approach to flash photography is that the light will often flatten out the contours of shapes in the photo, causing them to lose depth and dimensionality. By using a flash bracket and moving the flash slightly off to the side, the flash is still part of the overall camera setup, but its output will not be as harsh (**Figure 5.17**)

Figure 5.17 A Nikon D100 with an SB-80DX Speedlight showing the external sync cord attached to the hot shoe. By removing the flash from the camera, you gain many more creative lighting options. Flash brackets are available so the camera and flash can be carried as a single unit.

An off-camera flash is also effective for adding fill lighting to outdoor shots, even when the primary light source is daylight. Fill lighting can also be used to reduce excessive contrast, and using a flash for this purpose is the only solution when reflector panels are not an option. With a long enough sync cord or IR sync, you can even mount the flash on a separate tripod or light stand for even more control over directional lighting. With this setup, the flash is used more like a studio flash. Unlike a studio flash, however, which has its own power pack for near-instantaneous recycle times, you'll still have to wait a few seconds for your flash to recharge after a shot.

Flash brackets

Flash brackets attach to either the camera or the lens (for telephoto lenses that have a collared tripod mount) and allow the flash to be mounted off the camera's hot shoe. If you want to explore using off-camera flash, then you'll need to get one of these. The most common type is a bracket that mounts to the base of the camera with the tripod mount, extends an arm out to one side, and then provides a vertical arm for mounting the flash. Event photographers use this type of bracket constantly to minimize red eye and provide a more flattering light source. It also puts the shadow down behind the subject. If you use a quick release plate on your camera for a tripod, you will probably have to remove it to mount a flash bracket.

Another flash bracket that's used by wildlife, sports, and macro photographers is one that attaches to the collared tripod mount on a telephoto lens. This is used for the same reasons that you would use any off-camera fill flash: contrast reduction, adding catch lights to eyes on overcast days, and brightening colors. By mounting it to the tripod collar on the lens, the flash stays with the lens and the camera can be used in either a vertical or a horizontal format. Lens-mounted flash brackets from Really Right Stuff (www.reallyrightstuff.com) feature a tilting hot shoe for further control over the direction of the light—a feature that comes in handy for close-up photography (**Figure 5.18**).

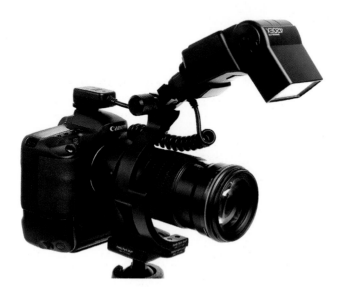

Figure 5.18 A Canon EOS 10D with a custom B85 flash bracket manufactured by Really Right Stuff. The B85 is designed to attach to the collared tripod mount found on some longer lenses. It provides more flexibility for using flash with telephoto lenses. The mounting plate for the flash unit can be swiveled downward for more directional control, making it ideal for macro work.

Ring lights

For very close-up, macro photography of very small objects, standard flashes can't illuminate the area that the camera is focusing on. (*Macro photography* uses special lenses, called macro lenses, to get extremely close-up shots; think of a *Honey, I Shrunk the Kids* type of close-up of a flower or a bug.) For these situations, a ring-light flash is essential. *Ring lights* fit onto the end of the lens and provide flash coverage from a circular flash tube. Since the flash originates right above the subject matter of the macro shot, the scene is given bright and even illumination (**Figure 5.19**). Canon also makes a flash unit with two small flash heads that mount at the front of the lens and can be positioned independently (**Figure 5.20**). The power output of each flash can be separately controlled to add more dimensional lighting to macro compositions. With different output levels, for example, you can easily configure a "main" and a "fill" light for even the smallest of subjects. That's the kind of control we appreciate!

Figure 5.19 Ring lights are attached to the end of the lens and are used for macro photography.

Figure 5.20 Canon makes the MT-24EX Macro Twin Lite for photographers who want the most control possible over flash lighting for macro photography. The dual flash heads attach to the end of the lens, and each can be positioned independently and set to varying power output levels.

Sync cables and slaves

If you want to explore the wonderful world of off-camera flash, then a sync cable is the least expensive way to do it. These come in a range of lengths, from the very short, designed for flash brackets where the flash is still close to the camera, to cords that are many feet in length.

Slaves are small sensors that trigger a flash unit when another nearby flash goes off. They are used in situations where you have a main flash at the camera position and want to use another flash for fill lighting. Slaves usually have a hot-shoe mount for attaching the secondary flash and can then be mounted on a tripod or a light stand. Using slaves is one way to get around the need for a sync cord, and they're helpful in places where flash placement may exceed the length of the sync cords in your camera bag.

IR wireless flash control

Infrared (IR) wireless technology lets you use multiple flashes without the hassle of running sync cables all over the place. A transmitter device is mounted to the camera's hot shoe and can trigger other wireless-compatible flashes placed nearby. Reception will vary depending on the individual unit, the arrangement of the location, and whether you are indoors or outdoors; but common working distances range anywhere from 25 to 50 feet. You can also buy IR remote devices that you can use from the camera position to control the output of different flashes.

Diffusers, bounce cards, and colored gels

We often complain about the harsh quality of the light from the standard pop-up flashes on most cameras. Even with an external flash unit, the illumination, while much better than the small on-camera flashes, can still have a hard edge to it. Fortunately, adding a softer touch is relatively easy to do, either through a little do-it-yourself ingenuity or with the following types of commercially manufactured products:

- **Diffusers.** These can be purchased at photo supply stores and usually consist of a white translucent fabric cover that slips over the head of the flash unit. The light from the flash passes through the diffusion material and is significantly softened by the time it reaches the subject. Small mini–soft boxes can also be purchased for flashes that have a silver reflective interior and a large white translucent front panel for diffusing the light. Please note: Diffusers and bounce cards decrease the amount of light the flash effectively produces, and we recommend you test any flash modifiers before taking important pictures, for example, at your best friend's wedding.

- **Bounce cards.** Another way to soften the light from a flash is to use a bounce card. These are white cards that are angled forward and attach to the vertically raised flash head in a variety of ways, from rubber bands to adhesive materials. When the flash goes off, the light bounces off the angled white surface of the card and then continues its journey down to the main subject of the photo. The bounce off the card creates a larger surface area of light with a softer quality. Since the light is coming from slightly above the subjects, the harsh, in-your-face floodlight quality of most on-camera flash is avoided. Although you can purchase bounce cards at camera stores, they're also one of the easiest accessories that you can make yourself, using a large white index card, or a custom cut piece of poster board and a sturdy rubber band (**Figure 5.21**).

- **Colored gels.** The light from a flash is balanced for a color temperature that approximates daylight (5500K). Even so, it can appear cool and unflattering at times, particularly with fair-skinned people. To warm it up, you can use colored gel material that's available from camera stores or professional photo supply shops. This material usually comes in large sheets and can be found in standard photo filter ratings, such as 81A, which is a common warming filter. All you have to do is cut a piece down to size so it can wrap over your flash head and be secured in place with a rubber band.

Figure 5.21 Flash accessories don't have to be expensive. You can rig a very effective bounce card simply by using a thin piece of white poster board or an oversized index card, and attaching it to the flash with a rubber band.

If you're using a custom white balance, please note that you'll need to set the white balance without the colored gel over the flash, or the warming effect (or whatever effect you're trying to achieve) will be cancelled out. You could also use the electronic flash white balance preset. We cover white balance issues in Chapter 7, "Seeing the Light."

LENSES

If you have an SLR camera that accepts interchangeable lenses, then buying a new lens could be considered an essential accessory. A new lens can give you a fresh viewpoint. In addition to the obvious choices of zooms and *prime* (fixed focal length) lenses, there are other factors to consider with digital SLRs in determining the right lens for the type of images you want to create.

For cameras that don't have interchangeable lenses, you can often buy accessory lenses that attach to the front of the existing, fixed lens. Although these do not offer high optical quality in comparison to SLR lenses, they do allow you to explore different fields of view, from telephoto and magnified close-ups to the superwide angle of a fish-eye lens.

Focal-Length Magnification

In Chapter 3, "How a Digital Camera Works," we explained that digital SLRs that accept interchangeable lenses tend to have image sensors that are much smaller than a frame of 35mm film, while most lenses being used on SLRs were designed to project an image that fills a 35mm frame. This results in the image circle that is formed by the lens being cropped to the smaller area of the image sensor. Visually, the effect is the same as if you had simply cropped a photo to only the center section. Since the camera is using the entire pixel count to capture this "cropped" version of what the lens projects, however, you won't see the loss of quality that would normally occur with such a crop in a film image.

In terms of focal length, this cropping of the image circle means that the standard focal lengths that apply to a 35mm film camera are different when the same lens is used on a digital SLR. This is commonly known as the focal-length magnification factor, but it is technically more accurate to refer to it as a field of view (FOV) crop since the image circle, and thus the field of view, is being cropped rather than magnified. In terms of the final image you end up with, the cropped image circle gives you the same result as if you had used a lens with a longer focal length, hence the common usage of the term *focal-length magnification factor*. On the Nikon D100, D1X, D1H, and D2H, the magnification factor, or FOV crop, is 1.5x while on the Canon EOS 10D and EOS Digital Rebel (known as the 300D in Europe and Japan) it is 1.6x. In translation, this means that a standard 28mm to 85mm zoom lens would function as a 42mm to 128mm on the Nikon digital bodies, and as a 45mm to 136mm on the Canons.

Pros and cons of focal-length magnification

In terms of buying a new lens, the perceived lens magnification imposed by the FOV cropping issue means you have to weigh the purchasing decision a bit differently than if you were buying a lens for a film camera. First, you need to determine what you really want to do with the lens. If you need an all-purpose zoom that you also want to use for portraits, or a telephoto lens for sports or wildlife photography, then the magnification/FOV crop issue will actually have a positive effect. This is because you are essentially getting a free boost on the telephoto end of the focal length. Instead of a 300mm lens, you're actually getting a 450mm or a 480mm, depending on the actual magnification factor on your camera. We know some wildlife photographers who really appreciate this aspect of digital photography and revel in the fact that a 500mm lens with a 2x teleconverter can magically be transformed into a 1500mm lens.

The downside of this aspect of digital SLR photography comes into play if you want to photograph with a wide-angle lens. Where telephoto lenses are extended at no extra charge by focal-length magnification, the other end of the focal-length spectrum suffers in comparison and has the *wide* unceremoniously removed from the words *wide-angle*. On the Nikon cameras mentioned previously, a wide 24mm lens is turned into a 36mm lens and the ultra-wide-angle 20mm is downgraded to only a moderately wide 30mm lens. For the photographers who consider the wide-angle view as an integral part of the way they see the world and capture it in photographs, focal-length magnification is a raw deal.

The wide-angle blues

To effectively reclaim the wide-open views of wide-angle lenses, you need to purchase lenses with a much wider field of view than you would normally consider. For example, if you're using a Canon EOS 10D, then to restore the field of view of a 24mm lens (or as close to what a 24mm lens would look like on a 35mm film camera), you need to buy a 14mm lens. Unfortunately, superwide lenses in those focal-length ranges don't come cheap. At the time of this writing a Canon EF 14mm f2.8L lens costs about $1800. For a little less, you can have the advantage of variable focal length with an EF 16mm to 35mm f2.8L zoom lens. On the Canon EOS 10D this translates to a 25mm to 56mm zoom. The price is about $1400. For many photographers, this aspect of digital SLRs is simply unacceptable and is one of the primary reasons that some photographers have not given up film entirely.

> **NOTE:** The focal-length magnification dilemma only affects cameras where the image sensor is smaller than a frame of 35mm film. Unfortunately, at the moment, that is most digital SLRs. For cameras with "full frame" sensors (i.e., the same size as a 35mm film frame), there is no magnification factor and the lenses behave just as they do on a film camera. As we write this the two cameras that offer a full-frame sensor are priced well beyond the range of most non-professional photographers; the Canon EOS-1Ds (msrp $7999), and the Kodak DCS Pro 14n, which uses Nikon lenses (msrp $4995).

Dedicated Digital SLR Lenses

Nikon DX series

In the spring of 2003, Nikon released a new 12mm to 24mm f4 lens that was the first in a new series of lenses specifically designed to fit the image sensor of all of its D-series digital SLRs (D1, D1X, D1H, D2H, and D100). Later in 2003, Nikon released additional lenses in this new line. Distinguished from their regular lenses by the addition of the letters *DX,* these new lenses represented a significant step forward in addressing the problem of focal-length magnification, especially with wide-angle lenses. They also signified a serious commitment on Nikon's part to the existing size of the image sensor in its digital SLRs.

Although these new lenses provide more traditional wide-angle capability, there is still a little focal-length smoke and mirrors going on in terms of the equivalent 35mm focal length (the common standard that most photographers are familiar with). The 12mm to 24mm, for example, is equivalent to an 18mm to 35mm zoom on a 35mm film camera. The other lenses that are available as we write this are a 17mm to 55mm f2.8 (25.5mm to 82.5mm equivalent), and a 10.5mm f2.8 fish-eye, which provides an equivalent field of view of 15.75mm. This is obviously good news for owners of Nikon cameras, but it also benefits photographers who shoot with the Fuji FinePix S1 and S2, as well as the Kodak DCS Pro 14n, since both of those camera systems use Nikon mount lenses.

Canon EF-S lenses

In August 2003 Canon announced the Digital Rebel (300D) SLR and broke the $1000 price barrier for a digital SLR. Along with this camera the company also released the first in a new series of lenses that are designed to be smaller, lighter weight, and less expensive than standard zooms. The reason for this is that the lens has a rear element that fits further into the camera than a regular lens (the *S* in EF-S stands for *short back focus*), allowing it to be closer to the imaging sensor. With the rear element closer to the sensor, the image circle produced by the lens doesn't need to be as large as with a film camera, and lens elements can be manufactured smaller and lighter. Smaller lens elements translate into a lower cost. As of this writing, however, the EF-S 18mm to 55mm f3.5 to f5.6 zoom can only work on the Digital Rebel, since that's the only camera that has been designed to accommodate this new type of lens.

Zooms vs. Prime Lenses

When you buy a lens, you can either purchase a zoom lens that offers a range of focal lengths, or you can buy a prime lens, which is also known as a fixed-focal-length lens. Many photographers feel that prime lenses are inherently sharper than zooms since fewer glass elements are used in their manufacture. Modern zoom lenses are generally quite good, however (unless you're buying a real rock-bottom cheapie) and may offer you a better blend of convenience and image quality than you get with a fixed-focal-length lens.

In our opinion, the reason to buy a prime lens has less to do with sharpness (though that debate continues to rage among optical purists) and more to do with the speed of the lens.

Lenses with a fixed focal length always have a wider maximum aperture than zoom lenses in a comparable price range. A wider aperture means three things in terms of how it affects your photography. The first is that since the lens lets in so much more light at its widest aperture, you can take photos handheld in much less light than you could with a standard zoom lens. Second, the additional light coming into the lens means that it yields a brighter view of a scene in low light, which makes it easier for the camera's autofocus system to detect and lock onto a focus point. Finally, a wider aperture allows you to create images that have a very shallow depth of field (**Figure 5.22**). Depth of field is the area of the image that is in focus from foreground to background and is one of the most effective ways to direct the viewer's attention in a photograph.

Figure 5.22 Prime lenses with a fixed focal length are more likely to have a wider maximum aperture than zoom lenses. Wider apertures mean you can create photographs with very shallow depth of field. This image was made with a 50mm f1.4 lens.

Zoom Lens Aperture Considerations

When speaking of lenses, the common standard for identifying their capabilities is to specify the focal length (or range of focal lengths if it's a zoom lens) and the maximum aperture. On many zoom lenses, however, you will find not one, but two apertures listed. This simply means that as the lens zooms, the widest aperture setting is not available at all focal lengths of the zoom. In effect the maximum aperture will shift to a smaller opening (less light entering the lens) as the focal length changes.

On the Canon EF 28mm to 135mm zoom for instance, the maximum apertures are given as f3.5 to 5.6. By setting the camera to Aperture Priority mode (which means that the chosen aperture is given priority over the shutter speed) and choosing f3.5 at the lens's widest zoom, the following tale was told as we slowly zoomed the lens and monitored the aperture setting: From 28mm to about 35mm, the aperture was f3.5; from 35mm to 50mm the aperture was f4.0; when we zoomed above 50mm, the maximum aperture was reset to f4.5; from 70mm to approximately 85mm the aperture was 5.0; and at any focal length above 85mm, the widest aperture available was f5.6 (these focal lengths refer to the markings on the lens and not the actual focal length as determined by the FOV crop factor).

If the speed of a lens (in other words, how much light it gathers at the widest aperture) is important to the type of photography that you do, then you might want to consider looking into a more expensive grade of zoom lens that offers a much wider, fixed maximum aperture.

Accessory Lenses for Non-SLR Cameras

If your camera doesn't offer interchangeable lenses, then you can still change the lens by using accessory lenses that attach to the front of the existing lens. Although optical purists may feel that a solution that involves adding an extra chunk of glass onto the front of the primary lens will degrade the quality of the image, these lenses actually work pretty well. Given the alternative, which involves not being able to modify the lens at all, these accessory lenses can be a lot of fun to use and may even rise to the occasion and help you create a really good image, or solve a particular problem. Not all cameras can accept these optional lenses, and you usually have to purchase ones that are manufactured specifically for your camera. They come in a range of sizes and focal lengths, and vary from wide-angle converters and telephoto converters to the extreme view of a fish-eye lens (**Figure 5.23**).

Figure 5.23 This image was taken with a Nikon Coolpix 950 with an accessory fish-eye lens that attaches to the front of the existing lens. Although not the type of lens you'd use for every shot, it creates a pretty cool image!

Leave Your Lens at Home:
Exploring Digital Pinhole Photography

Digital imaging allows for precision and perfection. Sometimes we get so caught up in investigating the tiniest feature of a digital camera or tweaking a pixel that we forget about having fun, letting go, and seeing what will happen when the creative process has free rein. So if you ever feel burnt out by all the numbers, facts, and figures of digital imaging, try what many professional photographers do when they want to recharge their creative batteries. Take off the lens, set the camera to manual, and screw on a pinhole and see what happens, as shown in **Figure 5.24**.

Figure 5.24 A digital pinhole photo of an old car taken with a Nikon D100.

Pinhole photography is photography without a lens and has been an insider art form for decades. Many photography students' first project was to take a picture using a oatmeal canister that had a tiny prick of a pinhole twirled through a piece of aluminum foil and a sheet of black and white film taped to the inside. The images were fuzzy, full of flare, and crooked—all of which added to their appeal and idiosyncratic quirkiness. If pinhole photography appeals to you, then you'll have to accept the following: long exposures from one-half to many seconds, not being able to compose the image through the viewfinder, images that are soft and low in contrast, and rainbow flare whenever sunlight falls directly onto the pinhole (**Figure 5.25**). On the intriguing and positive side, you're never quite sure what you're going to get, and the images have an unlimited depth of field, giving a "Mars rover" feeling to the images.

Figure 5.25 When sunlight enters the pinhole at certain angles, colorful rainbow flares appear in the image.

To enjoy digital pinhole photography you need a camera with removable lenses, such as a digital SLR by Nikon, Canon, Fuji, Kodak, or Olympus, and a pinhole (**Figure 5.26**). The one Katrin used to create the images in Figure 5.24 and Figure 5.25 is a modified camera body cap and was purchased online at www.pinholeresource.com. You can also make your own.

If you decide to make your own, you'll need a black plastic camera body cap, a drill to drill a one-half - inch hole in the body cap, thin metal flashing (found at home improvement stores), and a sharp needle to spin carefully through the flashing in as fine a spot as possible. After spinning the needle through the flashing, use fine sandpaper to smooth any ragged edges down, attach it to the outside of the body cap with black photo tape, and head out on a bright, sunny day.

Figure 5.26 A pinhole body cap from The Pinhole Resource (www.pinholeresource.com) on a Nikon D100.

To take pictures with a pinhole, set your camera to manual mode, use 400 ISO or higher, start with a 1-second exposure, and either use a tripod or make do with stabilizing the camera on surfaces such as walls, stairs, or a car. At first use the best JPEG setting to experiment with. Once you feel confident, you can use the RAW format for additional control over the captured image. Being able to post-process the RAW file can be very beneficial for improving exposure, contrast, and brightness. Point the camera at your subject—you can get within inches of the subject—and press the shutter button. Check the exposure on your LCD. If the image is too dark, increase exposure by 50 percent; or if the picture is too light, decrease the exposure by 50 percent. Repeat. Varying shutter speed and ISO is the only way to control image exposure. The most important thing to keep in mind is that pinhole photography is full of surprises that can create beautiful and painterly images that can be wonderful, inspiring, and just plain fun.

ESSENTIAL FILTERS

Although for some people programs such as Adobe Photoshop have reduced the need for filters (say farewell to the trusty old starburst filter!), there are still some filters that we regard as being essential items in a well-stocked camera bag. Others that we'll mention here may not be totally essential, but they help modify the light in specific ways and let you create images that would be difficult or impossible without them. Not all digital cameras can accept filters and some can only use proprietary filters designed by the manufacturer. To accept standard screw-on filters, the front of the lens will have to have a threaded ring. If your lens has this feature, then there should be a number indicating the size of the filter that will fit on the lens. Here are filters to consider:

- **Skylight and UV filters**. These filters are clear glass and are mainly used as protective covers for the lens. The idea behind this is that if there is an impact to the front of the lens, or contact with a scratchy item such as a bramble bush, the filter will take the brunt of the punishment and spare the front glass lens element from being damaged. We suspect that there's also a certain amount of add-on selling here by camera shops and online dealers, but the basic premise makes sense and we use them as lens protection. A $20 to $40 filter is less painful to write off than an expensive lens costing hundreds of dollars. UV filters can also help to cut down on atmospheric haze to yield a clearer shot.

- **Polarizing filter.** Of all the filters that we carry in our camera bags, we'd have to say that a polarizer is the one filter we just wouldn't want to be without. Like all filters, a polarizer modifies the light as it enters the lens. Chief among these modifications is

a polarizer's ability to remove some of the glare and reflections from the surface of glass and water. It also excels at darkening blue skies and boosting color contrast and saturation. The quality of light in a scene can be made clearer and less hazy. The amount of polarizing effect you get will depend on a few variables, including the time of day, the angle of the light relative to the scene you are photographing, and the reflective properties of a given surface (**Figure 5.27**).

Figure 5.27 A polarizing filter can dramatically improve landscape images by reducing glare on water, darkening a blue sky, and increasing color saturation. On the left, a high-country lake with no filter; and on the right the same scene improved with a circular polarizer.

The best type of polarizing filter to use on an autofocus SLR camera is a circular polarizer. Don't use a linear polarizer with an SLR, because it can confuse the camera's autofocus and metering systems. A circular polarizer allows you to rotate a circular ring on the front of the filter and adjust the level of polarizing effect until you get it just right. Polarizers are darker filters that will cut down on the amount of light entering the lens and this usually means using a wider aperture or a slower shutter speed. Since they reduce the light entering the lens, they are easiest to use on cameras that use TTL metering (through the lens) so you don't have to calculate a compensating adjustment. For rangefinder cameras (see Chapter 4, "Buying a Digital Camera") that also feature an LCD screen that shows you a live preview of what the lens sees,

circular polarizers can be used in much the same way as you would with an SLR, by rotating the ring until the effect looks best. The only drawback is that these screens can be somewhat hard to see in bright light, which makes it more difficult to evaluate the polarizing effect. Seán has been able to use his larger circular polarizing filter on a Nikon Coolpix 5400 by simply holding it against the front of the lens (**Figure 5.28**). Since the preview on the LCD is sometimes hard to see, to judge which rotational angle is best, he first holds the filter up to his eye and turns it until the effect looks good. Then he places it in front of the lens, making sure to keep the filter rotation the same. Fortunately, his Tiffen (www.tiffen.com) circular polarizer has a small handle for turning the ring that makes it easy to use as a positioning marker.

Figure 5.28 On non-SLR digital cameras, the polarizing effect can sometimes be hard to see on the LCD screen. It helps to hold the filter up to your eye first, to establish the correct rotation position, and then take note of that and mount it on the camera, or simply hold it tight against the lens, as we did here for the shot on the right, taken with a Nikon Coolpix 5400.

If you're using a polarizer on a rangefinder camera that does not also have an LCD screen showing what the lens is seeing, then you won't be able to see when the polarizing effect is best, so your success will be somewhat hit or miss. For this type of camera, especially if it does not use TTL light metering, a linear polarizer is best. You'll also need to factor in a plus-1 or plus-2 stop exposure compensation to adjust for the darker filter letting less light through the lens.

Few things liven up an outdoor shot like a polarizing filter. Although you can use Photoshop to darken a blue sky and add some saturation into the colors of an image, it doesn't replace a good polarizing filter. We regard this one as a must-have accessory.

- **Neutral density filters.** These filters reduce the amount of light that enters the lens. Since they are neutral, they do not affect the color balance of a scene. Neutral density (ND) filters are used for times when you want to achieve a certain effect, such as shallow depth of field produced by a wide open aperture, or a motion blur from a slow shutter speed, but the lighting conditions are too bright to allow the necessary settings. Flowing water is a classic subject for a slow shutter speed treatment, as is long grass blowing in the wind. By placing a dark ND filter on the lens, you cut down on the amount of light, making the wider apertures and slower shutter speeds accessible (**Figure 5.29**). ND filters are commonly available in 1-, 2-, and 3-stop increments, and darker ND filters can also be ordered that will cut back as much as 5 stops of light (**Figure 5.30**).

Figure 5.29 Even though this image was made on a brightly lit day, by using a tripod and a special neutral density filter that cut back 5 stops of light from entering the lens, Seán was able to use a very slow shutter speed of 20 seconds to render the rushing water as a silky blur.

Figure 5.30 A Singh-Ray 5-stop Neutral Density filter shown in a Cokin P-series filter holder, and a Tiffen ND 0.9 filter that cuts back 3 stops of light.

For times when you need a really strong ND filter, you can stack them together to increase the darkening effect.

- **Graduated neutral density filters.** Graduated ND filters are dark on the top half and then gradually fade to transparent along the middle of the filter. They are used in situations where the sky area of a landscape shot is much brighter than the terra firma below the horizon. By using the filter to darken the sky, a more balanced exposure

can be made for both the earth and sky portions of the image. Standard graduated ND filters that screw onto the front of the lens are less than ideal since you can't adjust the placement of the horizon line; it's always right through the middle of the filter. A better approach is offered by Singh-Ray (www.singh-ray.com) with their Galen Rowell Graduated ND filters. Designed by the late, renowned nature photographer, these filters come in a range of densities and also feature either a hard-edged or soft-edged gradient transition from dark to transparent. Since the filter is a rectangular piece of acrylic that fits into a standard Cokin P-series filter holder, the photographer can adjust the graduated edge of the filter up or down to match the location of the horizon in the image. This makes them ideal for compositions where the horizon line is not centered (**Figure 5.31**).

A

B

C

Figure 5.31 (Images A & B) A graduated ND filter can help to hold back the light of a bright sky and create a more balanced exposure, as shown in the second image.
(Image C) Galen Rowell 2-stop graduated ND filters with hard and soft transition edges, from Singh-Ray.

The advent of digital cameras has introduced a new way of achieving this effect that involves shooting two (or more) exposures on a tripod, with each one exposed for a specific area in the image. In the digital darkroom, these exposures will line up perfectly (if the f stop is constant) and the best parts of each one can be used in the final image to create the balanced exposure that was not possible to capture in the field. Still, it does require some skill with Photoshop to do this well, and for those who haven't reached that part of the learning curve, or simply prefer to do as much as possible in the camera and on location, then graduated ND filters are an elegant solution to a common photographic problem. We'll cover the layered multiple exposure method in Chapter 11, "Digital Darkroom Expert Techniques."

Seeing the Invisible: Digital Infrared Photography

Black and white infrared photos are hauntingly beautiful images with dark skies and ethereal, glowing white foliage. With certain digital cameras and an infrared filter, you can photograph this "invisible" light and create your own infrared images (**Figure 5.32**).

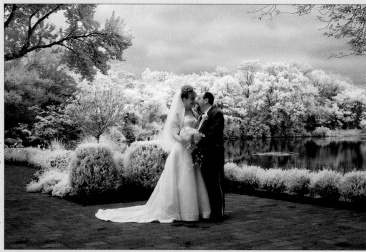

Figure 5.32 Photographer Bill Shaw made this digital infrared photograph with a Fuji FinePix S2 and a Hoya R72 infrared filter.

Figure 5.33 You can test your camera to see if it's sensitive to infrared by pointing a remote control at it and pressing one of the buttons. If you can see the light on the LCD screen, then your camera can take infrared photos.

To do this, you first need to determine whether your camera's image sensor can record the infrared portion of the spectrum. Infrared light can cause image quality issues, and as cameras have improved, many manufacturers have added infrared cut-off filters over the image sensor to block the infrared light. An easy test to see if your camera can photograph infrared is to point the front end of a TV or VCR remote control at the lens, hold down one of the remote's buttons, and take a picture. If the infrared light shows up in the photo, then that's a good sign that your camera will be able to take infrared images (**Figure 5.33**).

To make the most of your camera's infrared capability, you have to use a special infrared filter that blocks all of the visible light from entering the lens. With the visible light cut off, only the infrared portion of the spectrum

is revealed to the camera's image sensor. Since these filters are so dark, they require long shutter speeds ($1/4$ to 1 second), so you will need to use a tripod if you want your images to be sharp. It's best to set up the tripod and compose your shot before adding the filter (since you won't be able to see much once it's on). Focusing needs to be done with the filter on the lens, however, since filtered light focuses differently than the normal, visible spectrum. You can help the camera out by framing the image so that there is detectable contrast on one of the autofocus zones. Set the exposure to auto and try an exposure compensation adjustment of plus-1 to plus-2 stops (exact exposures will vary from camera to camera and also depending on the type of filter used). After you take a shot, the image can be proofed on the LCD screen and additional exposure adjustments can be made if necessary. Although a screw-on filter works best since it blocks all of the visible light, in a pinch you can get by simply by holding a filter tightly against the front of the lens. This works if you already have an existing filter that is too large for your compact digital camera (**Figure 5.34**).

Figure 5.34 This infrared image was made by simply holding a Hoya RM90 tightly against the lens of a tripod-mounted Nikon Coolpix 5400.

Several infrared filters are available and all may produce slightly different results, depending on the amount of infrared light your camera's image sensor can record. Common filters for infrared are the Kodak Wratten 89B, 87, and 87C filters. Hoya makes an RM90 filter and its Infrared R72 is roughly equivalent to the Kodak 89B. Harrison & Harrison also sells an 89B filter.

What about Color-Correcting Filters?

With film cameras, photographers often relied on special filters that were designed to correct for the color characteristics of common light sources so that the image recorded on film would not have an unwanted color cast. The reason that such filters were necessary is that most color film is balanced for the approximate color temperature of daylight, which is 5500K. When daylight-balanced film was used with other light sources, such as indoor tungsten lamps or fluorescent office lights, the result was an unpleasant color cast. Most notorious of these light sources is the yellow tone from household lightbulbs, or the sickly pale green cast from fluorescents. Color temperature correction filters were designed to handle this problem.

With digital cameras that offer user-defined white balance options, the need for these filters has all but evaporated because color temperature can be set for different light sources, and custom settings can also be created based on the actual lighting at the location. These white balance controls also work for more aesthetic concerns such as adding a warming or cooling effect to an image. The only instance where warming or cooling filters still have a place is when used as gels over flashes or studio lights. A warming effect created in the camera with a specific color temperature setting will affect the entire image. Since lights are directional, placing a warming gel on a light means that not all areas of the scene may be receiving the warming effect. If you're using colored gels over a flash or studio lights, you should set a custom white balance to the illumination of the light without the colored gels. That way, when the gels are added to the lights, you will still receive the coloring or warming effect that you want. We'll address color temperature and custom white balance issues in Chapter 7.

Stepping Rings

Lenses come in many sizes, and not all filter rings are the same size. Instead of having to buy duplicate filters for each lens in your bag, which could be an expensive proposition, stepping rings are used to adapt a filter to a specific size of lens. Rings that adapt a larger lens size to a smaller filter are known as step-down rings, while those that adapt a smaller lens size to a larger filter are known as step-up rings. When Seán bought a 28mm to 135mm zoom for his Canon 10D, he didn't have a polarizing filter that would fit the 72mm filter thread on the end of the lens. But he did have a 67mm polarizer that he used for a medium-format camera lens. Instead of buying a new polarizing filter specifically for the new zoom lens, he simply spent about $6 on a step-down ring to adapt the 67mm filter to the 72mm lens thread.

Normally, when adapting a smaller filter to a larger diameter wide-angle lens, you would have to be concerned about *vignetting*. This effect is caused by the wide angle of view "seeing" some of the metal filter ring and causing the corners of the image to be darkened. If you are using a digital SLR that has a full-frame sensor that is the same size as a frame of 35mm film, or a special digital lens like the Nikon DX series, then you still need to be concerned about filter rings or step-down rings causing a vignette effect when used with a wide-angle lens. For standard lenses on digital SLRs that have a focal-length magnification factor, however, the cropped image circle means that vignetting will not show up, even on a wide-angle lens.

DEALING WITH DUST

Digital capture opens up a world of new possibilities for photography, but there can be pitfalls. One of those is dust. Dust has been a problem for photographers since long before the first digital camera was invented, but digital cameras with interchangeable lenses introduce a new reason to be concerned about dust. Unlike film that moves with each frame, the imaging sensor stays where it is. If dust or other contaminants get on the sensor, they can produce spots in every picture you take. Fortunately, although the problem is very annoying, special cleaning accessories exist to help you remove dust from the image sensor. See the sidebar "Cleaning the Image Sensor" in this chapter.

The old saying that an ounce of prevention is worth a pound of cure holds especially true when it comes to keeping the sensor on your digital camera clean. You can start by always keeping a lens or body cap attached to your digital SLR. When changing lenses, work quickly to minimize the time the camera body is open to the elements. We recommend having the new lens out of the camera bag and ready to go, with its rear cap already off so that you can mount it as soon as possible once the first lens is removed from the camera. If you are in conditions with considerable moisture and flying dust, or there's some other risk of getting contaminants inside your camera, make every effort to shield the camera while changing lenses.

If the sensor on your digital SLR is dirty, you'll probably notice it as soon as you review your images. The spots will be quite visible in areas of similar tone and color, such as large areas of sky. Even if you can't see the spots, it's good to check your sensor periodically to see if it needs cleaning. This isn't something you can do by simply looking at the sensor, because even tiny spots you can't see with the naked eye can still show up in the final image.

To check for a dirty sensor, it is best to use a wide-angle lens stopped down to the minimum aperture so the depth of focus at the sensor plane is maximized. Take a properly exposed image of the open sky while moving the camera so the image won't be sharp. Then bring the image into your photo-editing software and zoom in for a close look. Increasing contrast with a feature such as Auto Levels in Photoshop will help make any spots more visible. It is unlikely that you'll ever have a sensor with no spots at all, but if there are more than you can count, it's certainly time to clean your sensor. See the sidebar "Cleaning the Image Sensor" for more on this procedure. We'll cover techniques for using Photoshop to remove dust spots from images in Chapter 10, "Essential Image Enhancement."

Cleaning the Image Sensor

When we refer to cleaning an imaging sensor, we're really talking about cleaning the filter in front of the sensor. As you can imagine, the interior of a digital SLR contains many delicate components. It is critical that you exercise care if you clean the sensor on your camera. If you aren't comfortable doing it yourself, then you should have the work performed by an authorized repair facility.

To help protect your camera, it is important to use the Sensor Cleaning mode to access the imaging sensor, which is hidden behind the mirror. In Sensor Cleaning mode the mirror will be raised out of the way. Some cameras require you to power the camera using the AC adapter to prevent the risk of the mirror dropping down if the battery gets low. Others will allow you to work from battery power. Refer to your camera manual for specific instructions on activating this mode.

For cleaning larger spots from your sensor, particularly those that can actually be seen, the SpeckGrabber from Kinetronics (www.kinetronics.com) can be helpful. The SpeckGrabber is a small wand with a tip made of a special material that is sticky but doesn't leave any residue behind.

For a more thorough cleaning, lens cleaning solution used with special swabs is the best solution. One of the best products for this purpose currently available is the Sensor Swab from Photographic Solutions (www.photosol.com). This swab can be used with lens cleaning solution to swab the full surface of the filter in front of the imaging sensor in your digital SLR (**Figure 5.35**).

Figure 5.35 Cleaning the image sensor on a Canon EOS 10D using a Sensor Swab from Photographic Solutions (www.photosol.com).

Photographic Solutions is also developing a new swab that will provide better contact while cleaning, ensuring a cleaner sensor.

Using swabs to clean the sensor requires a bit of finesse, and we think a little practice is required to get the best results. The technique involves placing a small amount of lens cleaning solution on the swab, and wiping the swab across the sensor in one motion. Then use the other side of the swab to swipe the sensor in the opposite direction. You need to apply enough pressure to clean stubborn dust specks, but not so much that you leave excess solution on the sensor.

Keeping your sensor clean will save you a great deal of time down the line.

ODDS AND ENDS

Some accessories defy easy categorization, yet that doesn't diminish their importance. In this section we dig through the pockets of our camera bags and see what other handy items we can find.

Exposure Tools

- **A white card.** This is the least expensive accessory you'll ever use. In digital photography, a white card, or simply a white piece of paper, is used to set a custom white balance for the lighting of a given location. Using this you can configure the camera to account for any color variances that may be present in the light you are shooting in. The card does not have to be large, since you just need to be able to fill the viewfinder frame with it in most cases. We've found that a sturdy piece of white poster board that is 4 by 6 or 5 by 7 inches works well and fits nicely in our camera bag. We use a plastic bag to keep the white surface from getting scuffed. If the card does get a bit beat up over time, it's easy enough to replace. We cover how to set a custom white balance in Chapter 7.

- **18 percent gray card.** A gray card can be used to help determine exposure settings in tricky conditions that might otherwise fool the camera's built-in light meter. It can also be included in a shot and used for setting a custom white balance (if your camera accepts a gray target for that purpose), or for providing a target tonal value that can be neutralized in Photoshop to remove any color casts present in the image. We discuss exposure situations that might fool a camera's light meter in Chapter 7.

- **GretagMacbeth ColorChecker.** Like an 18 percent gray card, the ColorChecker has been a standard in the photographic industry for many years. With digital photography, it helps you set a neutral color balance in an image after you've opened it in

Photoshop. By including it in a control image taken under each lighting setup, it provides a known reference of what the colors should look like and you can use Photoshop's eyedropper features to set a specific neutral tonal balance using one of the neutral patches on the ColorChecker (**Figure 5.36**). Color checkers come in two standard sizes; the smaller one is ideal for carrying in the camera bag. Neutralizing an image in Photoshop is covered in Chapter 10, "Essential Image Enhancement."

Figure 5.36 A Macbeth ColorChecker (www.gretagmacbeth.com) has been a standard reference in the photographic industry for many years. By placing one in a shot that you take in the same lighting as the rest of your photos, you can create a "control image" that can be used in Photoshop to help neutralize any color casts that may be present in your images.

• **GretagMacbeth Gray Scale Balance Card.** This card has precise tones of black, gray, and white and can be used like the ColorChecker card to help determine a neutral black, white, and middle gray (**Figure 5.37**).

Figure 5.37 The Gray Scale balance card from GretagMacbeth can be placed in test images and, similar to the ColorChecker, used to create a neutral black, white and gray balance in a photo.

General Camera Care

- **Lens cleaning supplies.** You can't take sharp photos with a big smudge on the front of your lens. If you have to photograph in wet weather, drops and small splashes on the lens are common occurrences. A stash of lens cleaning tissues, as well as a bottle of lens cleaning fluid, will keep your camera's view of the world clean and clear.

 NOTE: Although they are always available and easy to use, we don't recommend using mouth fog and the edge of your shirt to clean a quality optical lens. Rather, purchase a dedicated lens cleaning cloth from a professional camera store, store it in a small plastic bag, and only use it for your lenses.

- **Sensor cleaning supplies.** If you use an SLR with interchangeable lenses, the very act of changing lenses will introduce dust onto the image sensor, and sooner or later you'll have to clean the image sensor. The SpeckGrabber from Kinetronics (www.kinetronics.com), the Sensor Swab by Photographic Solutions, and the LensPen miniPro (www.clamperpod.com/lenspen.html) are three very good accessories designed for this purpose.

- **Blower brush.** In addition to the special sensor cleaning products mentioned earlier, this is also useful for removing dust off the image sensor. See the sidebar "Cleaning the Image Sensor" earlier in this chapter.

- **Plastic bags.** We find that it's good to have a few large "zippered" plastic bags stashed in an out of the way compartment of our camera bag for those times when we need to photograph in wet weather. You can cut a hole in the bottom of the bag for the lens and use the open end to hold the camera and work the controls. While this won't protect you from all water splashes, particularly on the part of the lens that extends out of the bag, it can keep most of the camera nice and dry.

- **Toolkit.** Let's face it, things break. Screws work their way loose. A tripod's legs develop an annoying habit of slowly collapsing, rendering it unusable. Having a few key tools in your camera bag can mean the difference between fixing a problem on location and continuing with your photography, or waiting until you get back home. Here are a few useful items that have served us well in the past: a multitool, such as a Leatherman, with a screwdriver, a sharp knife, a pair of scissors, and pliers; or a Swiss army knife with several of the previous items, plus tweezers; small screwdrivers for lens screws (or those on your eyeglasses); and a special set of tools designed to make adjustments to tripods.

"Assistants"

No, we're not talking about an actual human assistant (although they're great to have on a complicated project if the budget supports it), but about a collection of seemingly random items that often come in handy for certain photographic tasks. While hardly high up on an "essential" list, for some situations they can save the day and at the very least, make your photographic journey a little less bumpy:

- **A small flashlight.** Sometimes we're up before dawn or out after dark in the pursuit of interesting images. Having a bright light to help you see is essential. For night photography, a penlight is critical for changing some camera settings. Since autofocus does not work in the dark, this can illuminate the distance scale on the lens so that you can focus manually. Flashlights can also be used as an additional light source for night photos, allowing you to "paint" with light onto a foreground object. For hands-free work, consider a battery-powered head lamp that fits on your forehead with an elastic strap. Don't forget extra batteries for the flashlight. For additional considerations for night photography, see the companion Web site for this book.

- **A small notepad.** Sure, digital cameras have EXIF data that records all the vital settings of a shot, but sometimes you need to take extra notes about details that the camera doesn't record. Like how long you "painted" the foreground subject, such as an interesting rock, with your flashlight. Or what species of bird you photographed in shots 12 through 24. In the same vein as a notepad, many photojournalists carry a mini-cassette recorder to gather details for their stories or to interview the people in their photos. If you want the ability to edit such tapes, then consider a digital recorder.

- **Small bubble level.** These are designed specifically to fit onto a camera's hot shoe, and they're a great way to make sure that your tripod-mounted camera is level (**Figure 5.38**).

Figure 5.38 A small bubble level that is designed to fit onto the hot-shoe mount on your camera can assist you in leveling the camera.

- **Velcro.** If you had enough of this material, you could probably move the world. While we're not suggesting such a Herculean feat, this material can be incredibly useful for routine tasks such as tying back small branches that get in the way of the perfect landscape shot; or helping to position impromptu reflectors for a macro shot. We like the kind that's about an inch wide and comes on a roll with peel-off adhesive backing.

- **Copper wire.** This can be used for any number of purposes and is a very useful item to have tucked way in your camera bag. You can find it in the electrical department of any good hardware store. The best kind can be easily bent into shape as a prop to hold up small reflectors.

- **Aluminum foil.** This can be neatly folded and slipped into a side compartment where it doesn't take up much space. It can be used as small reflectors for macro work, and small, wadded pieces can be used as props for slight adjustments to everything from an external flash unit or a recalcitrant still life subject (**Figure 5.39**). For a larger "reflector" that is lightweight and can be folded into a very small package, try using a space blanket. If you're ever stranded, it'll also keep you warm!

Figure 5.39 Aluminum foil has many uses and is a handy item to keep in your camera bag. Here, it's being used to prop up and position an external flash unit.

- **Creature comforts.** Don't forget some personal items that might come in handy after a long day out with the camera. Katrin likes to carry aspirin, a few plastic bandages, lip balm, and some extra cash in her camera bag.

WHAT'S IN YOUR PHOTO STUDIO?

Photo accessories, whether they are for film or digital cameras, are designed to let you do different things with your cameras, or simply make certain tasks and procedures easier and faster. In the end, though, it all boils down to photographing the best images possible. In the first part of this chapter, we concentrated on accessories that you take with you on location. In this part, we'll shift our focus indoors to accessories that are designed to make shooting in a studio more effective.

Setting up a studio for digital photography is really not very different than setting up a studio for conventional film photography. Other than the fact that you might choose to have a computer workstation near the shooting area, the basic elements are the same. There's a subject to photograph, a setting in which that subject is placed, light to illuminate the scene, and a camera to capture the image. If you're already familiar with studio photography, there won't be many surprises here.

This section of the chapter is designed to cover useful items and strategies for those photographers who are interested in setting up a small studio. Our focus will be on smaller setups for still lifes, people photography, and tabletop work; we won't be covering large coves or cycloramas for photographing full-body fashion shots or car ads. Although larger subjects require more space, there's a lot of studio work you can do even in small studio areas.

Lighting

Lighting is a key issue for an indoor studio setup, because unless you have a skylight, you can't rely on natural daylight to illuminate your set. Even if you do have a wall of large windows, or a skylight, that type of lighting is only appropriate for certain types of image making, and you'll still need to be able to provide light on demand.

Flash

This is the most common and versatile type of studio lighting. If you're just starting out, you can do a surprising amount of work with just two flash units; one for the main light and the other for the fill or backdrop light. Using sync cords, slaves, or an IR wireless setup, the flashes can easily be connected and synchronized. With a third, inexpensive flash unit, you can have a backdrop light as well as a fill light.

A step up from using multiple camera flashes is a compact studio strobe system either with lights that feature a built-in power source on each strobe head or with lights that are powered by a separate power pack. On both types of systems, the lights or the power pack is plugged into a grounded electrical outlet. Studio flashes provide more power and much faster recycle times than typical flash units, and the power output for individual lights can be adjusted, either on the light itself or from the power pack. Depending on the setup, power packs can power from two to four lights. The camera is synchronized with the lights via a sync cord connected to the power pack. While systems with the power source contained in the strobe head (uni-lights) are typically less expensive than those that are run from power packs, the latter system offers more flexibility if you will need to use more than two strobe heads for your work.

Since the light from a flash system is a short burst delivered in a fraction of a second, working with it is not as easy as with lights that are on all the time. To help you visualize shadows and highlights, studio flash systems usually provide a modeling light so you can see how the light falls on the subject. Studio strobes do not interface with the camera's TTL light meter, so using them means that you'll need to invest in a good flash meter. Flash meters start at around $70. More and more photographers rely on the camera LCD screen or computer monitor review to fine-tune their lighting and exposure.

Continuous light

Where flash or strobe systems emit their light in a fraction of a second, a continuous light system is on all the time, which can make it easier to see how the light is illuminating the subject. The drawback is that certain lights can generate a lot of heat, which warms up your shooting space. There are different types of continuous light sources:

- **Photo floods.** These lights are very similar to standard household lightbulbs. They tend to be very warm in color and generally don't provide enough light in the blue region of the spectrum to give accurate color rendition. With digital, of course, this is not a problem, since a custom white balance reading can be taken and the camera's color temperature can be "calibrated" to the specific light source. On the negative side, these bulbs have a fairly short lifespan of 3 to 5 hours, and their color shifts as they age. Although they're very inexpensive, we don't recommend them for any type of serious studio work.

- **Tungsten-halogen lamps.** These are much more useful for photographic purposes and are common in professional still-life studios. They provide a broader spectrum than photo floods and are more consistent in their output over their lifetimes. Halogen lamps can be used with a wide variety of light-modifying fixtures, including focusing spotlights and fiber-optic illuminators to create special effects.

- **HMI.** HMI (hydrargyrum medium-arc-length iodide) lights are the Rolls Royce of the continuous-light-source family. Normally used to light movie sets, these lights give a very bright, cool light with the same color temperature as daylight (5000K to 5600K). Although they are ideal for photographic applications, they are *very* expensive. A 125-watt HMI light (which is equivalent to a 650-watt quartz light) will cost over $1000 and replacement bulbs are about $225 apiece.

- **Fluorescent lighting.** Also known as "cool lighting" fluorescents, once shunned by photo studios for their ghastly color casts and uneven, flickering light, have improved dramatically and have become quite popular in some digital studios because they are so easy to control and handle. Because they operate at much cooler temperatures and power levels than "hot" lights like HMIs and tungsten lamps, fluorescents are more economic and provide a much more comfortable environment to work in, especially for models and portrait subjects. They are best suited for providing a uniform, even light source over large areas, and they work well for flat copy work and fine art reproduction. Modern photographic fluorescents are available color corrected for both daylight (5500K) and tungsten (3200K), which makes it easy to mix fluorescent with other lighting systems, both natural and artificial. Although there are many modifiers and accessories available for controlling the light, fluorescents are not as versatile for directional light as tungsten-halogen and HMI lights.

Reflectors

Reflectors are important tools for controlling where the light falls on your set. They can be as simple as a large piece of white foam-core board, or they can consist of professional photo umbrellas mounted to studio strobe heads. Fortunately, reflectors are one of the easiest items to make yourself, and a little ingenuity can go a long way in creating an inexpensive system that will work just as well as the more expensive commercial offerings.

- **Foam-core board.** This is about as simple as it gets, yet it can create the same effect as a product you would pay a lot of money for at a professional photo supply shop. Start with a basic 30-by-40-inch sheet of ¼-inch white foam-core board. This will provide a bright surface for soft fill light. You can also cover another sheet with the shiny side of common aluminum foil to create a reflector that is brighter and provides a fill light with more contrast.

<div style="text-align:right"><small>Photo by Mark Beckelman and John Parsekian</small></div>

- **Fabric reflectors.** These reflectors consist of reflective fabric panels that stretch around a collapsible frame made of PVC pipe. The main advantage over foam-core reflectors is that these can be collapsed for easy storage or travel, and different types of fabric can be used on a single frame. A gold reflective fabric will provide a warm fill, while a silver fabric will add a neutral fill light. Opaque white fabrics add a soft, even fill light, and translucent fabrics can be used as a large diffuser when the light source is directed through them at the subject. These are available from a variety of vendors. We like the panels and fabrics made by LightForm (**Figure 5.40**).

- **Umbrellas.** Reflector umbrellas are mounted to a studio light—either a strobe or a hot light—and serve to broaden the light coverage and diffuse the quality of the illumination. They are available in several reflective surfaces, including white, gold, silver, and translucent white.

Figure 5.40 Fabric reflector panels are lightweight, easy to move, and can be fitted with a variety of different fabrics, either reflective or translucent. The PVC frame collapses down for convenient transport and storage.

Backdrops

Many photographers plan their photos from the back to the front—deciding on a background first and then working their way forward. A backdrop can be anything, of course, from artfully draped fabric to an old piece of weathered wood. There are some common conventions used in photo studios, however, such as the seamless backdrop that creates a seamless transition from the floor to the background. Several products help you achieve this effect, and in many cases, you can also apply a little do-it-yourself energy and create something for much less money:

- **Seamless paper.** Photo supply stores sell large rolls of sturdy seamless backdrop paper in a variety of widths and colors. Common widths are 5 and 9 feet. You mount the paper above the set and pull down enough to cover the shooting area to create a gentle, curving transition between the vertical and the horizontal. When the paper gets scuffed and messed up (common when photographing people), you just cut off the damaged portion and pull down some new paper. For hanging the seamless paper, you can purchase special backdrop stands that consist of two stands and a pole between them to hold the roll of paper (**Figure 5.41**). If you don't need the portability of backdrop stands, you can mount a pipe to the wall of your studio space and hang the backdrop paper from it. For tabletop photography, you can also create a smaller version of the seamless paper look by clamping a piece of poster board onto the edge of your table and curving it up against the wall.

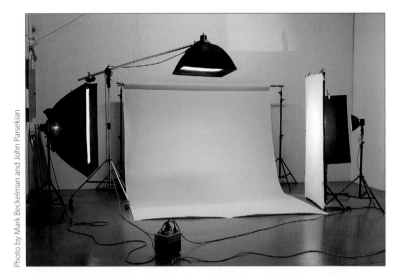

Photo by Mark Beckelman and John Parsekian

Figure 5.41 Seamless photographic backdrop paper is used to create a gentle transition from foreground to background. It is available in a variety of colors and comes in 5 and 9 foot widths.

- **Cloth.** Cloth backdrops add a classic, traditional look to a photograph. They work especially well with formal portraits. You can buy backdrops of plain cloth, which can be draped into artful, flowing folds, or painted versions in a range of designs and colors, from professional photo supply shops. Muslin and canvas are the two main materials that are used for cloth backdrops. Muslin is much lighter than canvas and can also be draped around a model or shaped to a prop or a set. Canvas is better suited for backgrounds where a flat, even look is desired. For location work, muslin is the way to go since it can be folded and transported much more easily than canvas. You can also wad painted muslin up into a tight bundle so that the creases and folds from this treatment make interesting patterns the next time you use the backdrop. If you want to try doing it yourself, you can buy large quantities of muslin from theatrical supply houses and cut to size. You can either leave the muslin in an unaltered state (just the fabric) or it can be painted. Seán used this approach for two of his backdrops, with one that is plain muslin and the other that has been heavily painted. He uses these backdrops outdoors in the open shade for an open-air natural light portrait studio (**Figure 5.42**).

Figure 5.42 Cloth backdrops create a more formal, classic look for portraits. They can be used in the studio, or outdoors for natural light portraits.

TIP: When buying or painting a cloth backdrop, you have to realize that you're likely to have it for a long time and will use it in a lot of photographs. Although interesting patterns and bold designs may seem tempting, experience has shown us that it's the simple backdrops and the more muted tones that give us the most mileage.

From behind, a well-crafted still life often looks like a science experiment gone wrong, resting on a blob of Silly Putty with pins sticking out of it and wires holding it just so. But through the camera's viewfinder, it looks perfect—all the pins, wires, tape, and glue are hidden from view either behind the subject itself or blocked by other props. Here's a brief sampling of some of the humble yet essential studio "assistants" that can help prop up the façade of a carefully arranged studio shot.

- **Clamps.** No studio, either a professional one or the one in your garage, should be without a good selection of clamps of various sizes. They can be used for everything from holding backdrops and reflectors to propping up otherwise recumbent objects in the photo. Spring clamps are perhaps the most useful, but C-clamps also come in handy from time to time. And let's not forget that most humble of clamps for delicate items, the clothespin.

- **Hot glue gun.** The ultimate weapon of photographic persuasion is the electric hot glue gun. Use it to make objects defy gravity and guarantee that your subjects remain motionless.

- **Silly Putty.** Yes, we do mean the very same Silly Putty that you got stuck in your hair when you were a kid. Such tenacious sticking properties may not be appreciated when you're trying to get it out of the rug or a child's hair, but it works wonders for helping to position items in a tabletop still life. Another product that works well for this is the household putty that you can buy to hold items in place in areas of the country that are prone to earthquakes.

- **Wire, gaffer's tape, and Velcro.** Wire of varying rigidity and sturdy tape always come in handy on the set of any photo shoot. Like the hot glue gun, Velcro is also quite helpful for adding that "lighter than air" touch to certain objects.

 NOTE: Gaffer's tape is not just expensive duct tape—but special cloth-backed tape that holds firmly yet comes off without leaving that sticky duct tape residue. You can purchase it at film and video production supply shops or online at www.filmtools.com.

- **Cloth.** Cloth backdrops add a classic, traditional look to a photograph. They work especially well with formal portraits. You can buy backdrops of plain cloth, which can be draped into artful, flowing folds, or painted versions in a range of designs and colors, from professional photo supply shops. Muslin and canvas are the two main materials that are used for cloth backdrops. Muslin is much lighter than canvas and can also be draped around a model or shaped to a prop or a set. Canvas is better suited for backgrounds where a flat, even look is desired. For location work, muslin is the way to go since it can be folded and transported much more easily than canvas. You can also wad painted muslin up into a tight bundle so that the creases and folds from this treatment make interesting patterns the next time you use the backdrop. If you want to try doing it yourself, you can buy large quantities of muslin from theatrical supply houses and cut to size. You can either leave the muslin in an unaltered state (just the fabric) or it can be painted. Seán used this approach for two of his backdrops, with one that is plain muslin and the other that has been heavily painted. He uses these backdrops outdoors in the open shade for an open-air natural light portrait studio (**Figure 5.42**).

Figure 5.42 Cloth backdrops create a more formal, classic look for portraits. They can be used in the studio, or outdoors for natural light portraits.

TIP: When buying or painting a cloth backdrop, you have to realize that you're likely to have it for a long time and will use it in a lot of photographs. Although interesting patterns and bold designs may seem tempting, experience has shown us that it's the simple backdrops and the more muted tones that give us the most mileage.

- **Blue screen.** Any time you see a process shot in a movie where an actor is interacting with something that it obviously a special effect (as in *Forrest Gump,* when Tom Hanks is shaking hands with President Kennedy), it was undoubtedly created using a process called blue or green screening. A character is photographed acting on an empty stage in front of a giant blue or green screen. In postproduction, the blue or green areas are replaced with special effects or computer-generated backgrounds. You can use the same principle for photographing people or objects that you plan to collage into a different image. Photographing against a flat, colored backdrop makes it much easier to extract the element from the background in Photoshop and add it to the other image. For this approach, you can buy seamless background paper in any number of bright colors. It doesn't necessarily have to be blue or green, but those are the traditional colors that work well for this effect. One thing to be aware of, however, is that if the backdrop is too close to your subject, there can be color spill from the colored paper than can contaminate the main subject. To avoid this it's best to have several feet between the subject and the backdrop. If you are photographing a person, use paper that is the opposite of the color of their clothing.

- **Large inkjet prints.** Another way to take advantage of current technologies for your special projects is to print images onto large watercolor paper and use the print as a photo backdrop. For small tabletop still lifes, even a 13-by-19-inch print can be used to create an interesting backdrop.

- **Textures.** For small product photography or still lifes, any textured surface can be used as a backdrop. Stone slabs from a landscape supplier, Formica tiles from the floor shop, and handmade paper from the art store are all fair game when you need to create an image with a textured background. Once you get your mind set on it and the more you look for creative backdrop solutions for the small set—the more you will find them.

Tables and workstation carts

- **Sweep tables.** If you plan to do a lot of product photography, then you might consider the benefits of a *sweep table.* These are adjustable tables with a shooting surface made of a single sheet of translucent frosted Plexiglas that curves upward in the back to create a seamless "cove." The table can be lit from either above or below, or both, providing a range of lighting options for different assignments. Sweep tables are durable and provide a consistent set for product shots (**Figure 5.43**). For the do-it-yourselfer, a sweep table can be rigged without too much hassle. All you need is a sturdy frame to which you can attach a curved sheet of Plexiglas.

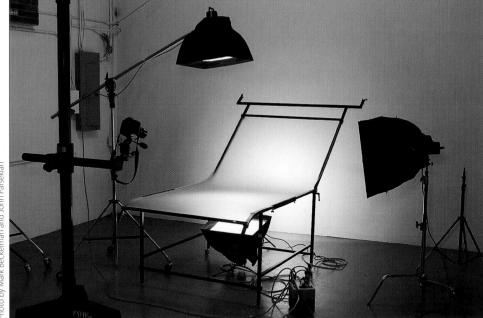

Photo by Mark Beckelman and John Parsekian

Figure 5.43 A sweep table is a studio accessory that is commonly used for product photography. You can purchase these in different sizes from photo supply companies, or if you're talented with tools, you can make one yourself using frosted Plexiglas and a wooden frame.

- **Photo workstation cart.** If you have a larger studio space and want to have the convenience of a computer nearby, wheeled workstation carts are available that can hold a tower computer, a monitor, and some extra room for miscellaneous accessories. For studio cameras that are operated through the computer, this is almost a necessity, since you can easily wheel it to different locations in the studio.

Essential Studio Odds and Ends

Commercial and fine art photography is all about image and has very little to do with reality. Anyone can press a shutter button, but what distinguishes a good photographer is the ability to craft a shot. If you watch food photographers at work, you'll see that they spend an inordinate amount of time looking for the perfect subject and props. For example, they sort through a five-pound basket of brussels sprouts to find just the right ones, then glue each sprout into place, and arrange the leeks and the tarragon with wires, pins, and gaffer's tape to make the shot look like a home-cooked meal.

From behind, a well-crafted still life often looks like a science experiment gone wrong, resting on a blob of Silly Putty with pins sticking out of it and wires holding it just so. But through the camera's viewfinder, it looks perfect—all the pins, wires, tape, and glue are hidden from view either behind the subject itself or blocked by other props. Here's a brief sampling of some of the humble yet essential studio "assistants" that can help prop up the façade of a carefully arranged studio shot.

- **Clamps.** No studio, either a professional one or the one in your garage, should be without a good selection of clamps of various sizes. They can be used for everything from holding backdrops and reflectors to propping up otherwise recumbent objects in the photo. Spring clamps are perhaps the most useful, but C-clamps also come in handy from time to time. And let's not forget that most humble of clamps for delicate items, the clothespin.

- **Hot glue gun.** The ultimate weapon of photographic persuasion is the electric hot glue gun. Use it to make objects defy gravity and guarantee that your subjects remain motionless.

- **Silly Putty.** Yes, we do mean the very same Silly Putty that you got stuck in your hair when you were a kid. Such tenacious sticking properties may not be appreciated when you're trying to get it out of the rug or a child's hair, but it works wonders for helping to position items in a tabletop still life. Another product that works well for this is the household putty that you can buy to hold items in place in areas of the country that are prone to earthquakes.

- **Wire, gaffer's tape, and Velcro.** Wire of varying rigidity and sturdy tape always come in handy on the set of any photo shoot. Like the hot glue gun, Velcro is also quite helpful for adding that "lighter than air" touch to certain objects.

 NOTE: *Gaffer's tape is not just expensive duct tape—but special cloth-backed tape that holds firmly yet comes off without leaving that sticky duct tape residue. You can purchase it at film and video production supply shops or online at www.filmtools.com.*

Adding Flexibility and Creativity

The list of photo accessories goes on and on. What we've covered here is only a small portion of what may be available for your camera system, but it represents what we feel are some of the most important things to consider as you begin to branch out and add items to your camera bag or photo studio. Photography is a huge field, of course, so we can't cover everything under the sun and still fit it within the page count of this book. Every photographer has different requirements for the type of work that they do and the images they like to create.

Accessories extend the capabilities of your camera, increase your efficiency and productivity, and most important, open up new avenues for crafting successful photographs. By investing in them, you're not just adding new gadgets to your camera bag or photo studio; you're adding new possibilities for image-making flexibility and creativity.

PART TWO
Digital Photography Techniques

Chapter Six **Digital Photography Foundations**

Chapter Seven **Seeing the Light**

CHAPTER SIX
Digital Photography Foundations

Before you take your first photograph, it's important to familiarize yourself with the different settings contained in your digital camera's menus and submenus. Human nature being what it is, of course, you've probably already taken a few images with your new camera. Most digital cameras have a fully automatic mode that handles every decision for you except where to point the camera. This is great for those times when you need to take a picture quickly and don't want to think about which setting to use. But to achieve the photograph you're after, you'll more often need—and want—to take the camera off autopilot. Understanding the core concepts outlined in this chapter will make the difference between using your digital camera as a nifty gadget and using it as powerful creative tool.

In the first part of this chapter, we'll go through a list of settings and menu options and get to know your camera better. In addition, because film and digital photography differ, sometimes subtly and sometimes substantially, it's helpful to take a little time to review some fundamentals of photography and how they relate to digital imaging. In the second part of this chapter, we'll take a look at some of the important concepts and practices that form the foundation of making good photographs.

SETTING UP YOUR DIGITAL CAMERA

NOTE: *We highly recommend that you either read your camera manual from cover to cover before proceeding or have it within reach as you dive into this chapter.*

The path to a camera's menu system differs from one camera to the next. With some, such as the Canon EOS 10D, you may be able to access it by simply pressing a Menu button on the back of the camera. With others, you might have to rotate a dial to a special position

before you can bring up the menus. Some cameras, such as those in Nikon's Coolpix line, separate the menus into two sections: one for overall setup configuration that you access via a dial, and another with options that are available in the shooting modes and that you access with a button. Depending on the camera you have, the order of the settings may vary, and some of the ones mentioned here might not be available to you, but many of them are standard on most digital cameras. We'll start with the items that are the most important for image quality.

Image Size and Compression

Of all the settings you can make at the camera level, arguably the most important in determining final image quality are image size, compression (or lack of it if you have a camera that shoots in TIFF or RAW format), and ISO. In fact, if you shoot in RAW capture mode, as we recommend, then ISO is the only setting that will affect image quality as recorded by the camera, since RAW files are captured at the largest size and without compression (see the sidebar "The Case for RAW" later in this chapter). We'll cover ISO settings later in this chapter.

The image size a camera captures is the primary determinant of how large a print you can make, and the compression level affects the quality of the image once it's written to the memory card in the JPEG format. Other settings, such as sharpening and contrast adjustments, can also affect image quality, of course, but they usually show up farther down in the menu system, so we'll cover them a bit later in this section.

Image size

Most cameras offer a number of size settings to choose from. Cameras may identify image sizes in their menu as large, medium, and small; or they may use terms like *full,* or specify an exact pixel size, such as "5M 2592x1944" (used by the Nikon Coolpix 5400 to indicate the largest size available). *Large* or *full* is typically the largest image size that the camera can produce (**Figure 6.1**) and in most cases reflects the actual size of the camera's sensor in terms of pixel resolution. Some cameras may also offer a resolution that is slightly different than the largest size in order to provide a different aspect ratio. If the menu choices don't list a specific pixel dimension, then you'll have to resort to your camera's manual to determine the exact pixel dimensions of each setting. If you're shooting in a RAW format, then you do not have a choice of image size, since RAW is always recorded at the largest size the camera can produce. What you plan to do with your image, as well as how many images you want to fit onto the memory card, will determine which settings you use.

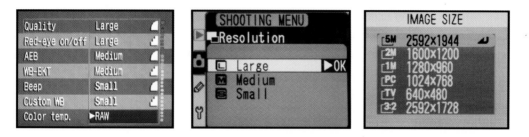

Figure 6.1 Cameras specify image size options using different terms. From left to right, the image resolution menus from the Canon EOS 10D, the Nikon D100, and the Nikon Coolpix 5400. Unless storage space is a concern for you, we recommend always using the largest image size your camera can produce.

If you're used to shooting with a 35mm film camera, where 36 exposures is the most you can fit onto a roll, then the intoxicating prospect of storing hundreds of images on a single memory card might tempt you to choose a smaller image size. The only circumstances in which we would advise this approach is if you know you'll never need to make larger prints or if you find yourself pressed for space on the storage media and have no choice at that moment. If making high-quality fine prints is your main concern, however, then we recommend always setting the image size as large as the camera will allow. More pixels equal a larger file size, but more important, they also mean more detail and more flexibility if you have to make adjustments to the photo at a later time. As the saying goes, "It's better to have it and not need it, than need it and not have it" (**Figure 6.2**).

Figure 6.2 Shooting with a larger image size (more pixel resolution) gives you greater flexibility and better quality if you need to crop the image later (right).

Since we enjoy making fine digital prints, using a larger image size is crucial. But we realize that you're not always shooting photos with printmaking in mind. If you were only using the image for email or to advertise an item on eBay, you might choose a smaller size. Photographs for online catalogs, or other uses that have a short shelf life, are also candidates for a smaller image size. Even if your image is only destined for the Web, however, there's a lot to be said for photographing it at a larger size than may be indicated by your immediate needs. This allows you to crop or enlarge it, as well as zoom in close to do fine detail work in an image-editing program. Another reason to shoot at larger image sizes is so that you can use the image for other purposes at a future time where you may need a higher resolution. Shooting at a larger size gives you more options.

> **TIP:** *Because digital cameras allow you to change image size (as well as file format, compression, ISO, white balance, and so on) on a shot by shot basis, it's easy to select a small image size and then forget about it. If you move on to new images that require a larger image size, you may not realize that you've been shooting lower-resolution images until it's too late. To avoid such calamities, get in the habit of doing a quick "preflight" check of the camera settings each time you start photographing a new assignment or you move your location. Some cameras provide a summary of all the critical settings in a single screen (**Figure 6.3**). Better yet, check whether your camera allows you to save settings as a user-defined preset. The Nikon D100, for example, lets you save a group of settings as either Bank A or Bank B (**Figure 6.4**). Any changes to the settings will be saved to whichever bank is selected, however, so you still have to be careful when making modifications. If your camera does let you save customized settings, we recommend designating one group as the one with settings for maximum image size and quality and a second saved group as the one you'd modify for specific purposes. In this way, you could always return to settings that are configured for maximum image quality—which for us would mean using a RAW format.*

Figure 6.3 Check to see if your camera provides quick access to an info summary screen so you can see all the important settings in a single screen. This screen is from the Canon EOS 10D. The file format and image size settings are not included here, since they're always visible on the top LCD control panel for this camera.

Figure 6.4 The Bank Select menu from the Nikon D100 lets you configure two groups of settings into a preset that you can easily recall.

Compression: JPEG

When saving your files in the JPEG format, you decide how much compression to apply. The decision is always a compromise between image quality and the number of files you can fit on the memory card. Unless you need to cram as many images as possible onto the card, or the final quality is not that crucial, we recommend always using the setting that

A

B

C

delivers the highest image quality (lowest compression level). JPEG compression degrades the image, and when applied at higher compression levels, the artifacts and flaws it introduces can wreak havoc with the fine details of an image (see the sidebar "The Lowdown on JPEG Compression"). In most cases, a high-quality compression setting produces excellent image quality and generates compact file sizes that will allow you to fit many images onto a storage card.

Remember that the level of compression works hand in hand with image size in terms of final image quality. Seán once had a student in a basic digital photography class who conscientiously set the compression to high quality for her first trip through Europe. When she returned from her vacation, however, she realized that she had forgotten to check the camera's image size settings and all of her pictures had been recorded at 640x480 pixels. She was dismayed to discover that she could not make good-quality 8-by-10 prints (**Figure 6.5**). Even Photoshop couldn't help in this case; she had to be satisfied with slightly soft 5-by-7s instead of the 8-by-10s she was hoping for. Cultivating an awareness of your camera's settings and checking them often will ensure that you're always capturing the image quality you need.

Figure 6.5 Three detail views of an image that has been resized to make an 8-by-10 print at 300 pixels per inch illustrate how the camera's pixel resolution can affect image quality if you want to make a larger print. Image A was captured at 640x480 pixels. Image B was captured at 1024x768 pixels. Image C was captured at 2592x1944 pixels (5 megapixels).

In both digital cameras and Photoshop, choose the best or maximum JPEG setting to produce the best quality files, which are compressed the least. The higher the actual compression is, the lower the image quality becomes.

The Lowdown on JPEG Compression

JPEG achieves its incredibly small file sizes by using a clever compression scheme that modifies the pixels in an image so they can be described using less data. At the heart of this procedure is the way the JPEG format "sees" your image by breaking it up into sections. JPEG analyzes the pixels in the file in 8-by-8-pixel blocks (64 pixels at a time) and compares the color variation between pixels in the block to identify the average color. Once it determines the average, it examines the rest of the pixels in the block and throws out information that will be imperceptible to the human eye. If a pixel is close to the average color, for example, then its color will be changed to match the average. Those pixels that are far from the average will be adjusted to make them a closer match. Taking advantage of the fact that human visual perception is less sensitive to changes in color than in luminance (brightness), the color values in the 8-by-8 blocks are changed more than the luminance levels. By averaging colors in this way, JPEG can write the file using less information, resulting in a much smaller file size.

In the magnified view of eight levels of JPEG compression (**Figure 6.6**), you can see how the color values have been altered from quality level 12 down to level 2. It should be noted that these JPEG samples were prepared using an uncompressed file in Photoshop to illustrate how JPEG compression affects the pixels in an image. Digital cameras do not offer this many levels of compression.

Figure 6.6 Eight detail views showing how JPEG compression changes the colors of pixels in an image. View A is the uncompressed image, and views B through H show progressively higher amounts of JPEG compression.

(Continued)

For some people, the specter of *lossy* compression (meaning color information is irreversibly changed) is enough to steer them away from the JPEG format. Digital cameras, however, do a very good job of compressing their images as long as you select the best quality setting (the lowest level of compression). At high quality settings, most digital cameras will produce images indistinguishable from an uncompressed shot of the same scene (**Figure 6.7**). With a properly exposed photo, high-quality JPEG can be an excellent format that provides good quality and convenience for the average photographer. For those who demand the ultimate in control over postexposure adjustments, however, then the RAW format offers much more flexibility.

Figure 6.7 A high quality JPEG from a digital camera (left) will produce great results for most people and is nearly impossible to distinguish from a shot that hasn't been compressed (right).

Choosing a File Format

JPEG

Most consumer-level digital cameras offer only one "choice" of file format: JPEG. If this is the case with your camera, then your choice is easy. (Again, just be sure to choose the lowest compression level available—best or fine quality.) As you move up the camera food chain into the deluxe point-and-shoot and prosumer models, two additional formats become available: TIFF and RAW.

The Case for RAW

When faced with a choice between using JPEG and RAW for our photographs, we almost always choose RAW. Our bias here has less to do with compression (as we've said, high-quality JPEGs can be surprisingly good), and more to do with the "no turning back" nature of JPEG. Once an image is captured and recorded in the JPEG format, all of the camera settings, such as sharpening, saturation, contrast, white balance, and exposure compensation, are irrevocably applied to the photo. With RAW, the image is left untouched by the camera, leaving you to apply these settings at your discretion in a RAW conversion program. This means, essentially, that you get a second chance to evaluate the image on a large monitor and decide which settings suit it best. And you can do this repeatedly, since the original RAW image remains untouched. We really appreciate this flexibility. It's not that we have commitment issues, but few things in life are as flexible as a RAW digital capture combined with all the possibilities that Photoshop offers, and since that flexibility is there for us, we like to take advantage of it. With JPEG, you can never go home again. With RAW you can go home as often as you like, and are always welcomed with open arms.

Despite our bias toward RAW, we do realize, however, that this format is not ideal for everyone or every situation (for instance, fast-action photos that require shooting multiple frames per second for a sustained period, or product shoots that involve hundreds of images and controlled studio lighting). But for most images, RAW is our format of choice.

TIFF

The only difference between a JPEG and a TIFF is that the former is compressed and TIFFs are not. Both are full-color images that are photographed at the pixel dimensions you've specified. For purists and those who are concerned about maintaining maximum image quality, the main advantage to TIFFs is the lack of compression. The primary

disadvantage is that since the file is not compressed, it occupies far more space on the memory card, which means you can take fewer photos before having to download the contents of the card. If you happen to have the luxury of a studio setup, where the camera is directly connected to a computer, and you want maximum quality in a file format you can open immediately in a number of programs, then TIFF is a viable choice for your particular workflow. For a more spontaneous photographic experience that doesn't require you to be tethered to a computer, JPEG and RAW are better choices.

RAW

The other format you're likely to encounter on some cameras, and one that is gaining importance as digital photography matures, is RAW. As we saw in Chapter 3, "How a Digital Camera Works," a RAW file isn't really an image file format, but rather contains the data gathered by the camera's imaging sensor *before* any postcapture processing is applied to it. In this way it's similar to an image on film before it has been developed. With a film image, choices you make during development, such as the temperature of the photo chemicals and how long the film sits in the developer, can affect how the image is processed. If you realized that you had the ISO set incorrectly, for example, and had underexposed the entire roll, you could "push-process" the film by leaving it in the developer for longer than usual. The longer development time would compensate for the fact the film was underexposed.

Similarly, with RAW format you can compensate for many deficiencies in the capture later during processing—in fact, RAW gives you even greater control and flexibility than film. A RAW file is also a great compromise between JPEG and TIFF, as it will be one-third the size of a TIFF on most cameras. Although RAW offers unprecedented flexibility in how you can process the captured image, for some people RAW's primary disadvantage is that it adds additional steps to the workflow. You can't simply open the image in Photoshop or another program. You must convert the RAW file to a common image file format, using either the camera manufacturer's proprietary software or other products such as the Camera Raw feature in Photoshop CS, Breeze Systems' BreezeBrowser, or Phase One's Capture One DSLR. We feel this extra step is a small price to pay for the considerable flexibility and creative choice that RAW provides.

If your camera supports a RAW format, and maximum quality and control over the image processing are important to you, then we recommend choosing the RAW format over TIFF. In-camera TIFF file sizes are simply too large and inflexible, when compared to the advantages of the RAW file format, to justify using TIFFs as a digital camera file format. For more on integrating RAW images into your imaging workflow, see Chapter 9, "Download, Edit, and Convert."

ISO

Just as with film photography, the ISO setting determines a digital camera's sensitivity to light. As the ISO rating doubles, the light sensitivity of the imaging sensor also doubles—or it can be considered twice as fast. Unlike with film, however, where the ISO is the same for an entire roll, digital cameras let you change the setting on a shot-by-shot basis. This also gives you tremendous flexibility in your photography. You could shoot at ISO 100 in the bright sunlight for most of the day, for example, then quickly to switch to ISO 400 or higher if you suddenly found yourself in heavy shade or went indoors.

With film, the chemical recipe used to create the light-sensitive emulsion determines the ISO sensitivity. As we saw in Chapter 3, however, a digital camera's imaging sensor has a specific sensitivity that can't be changed. To increase the effective ISO setting, the sensor's signals are amplified as they are handed off for internal processing by the analog-to-digital converter. In this respect, the ISO setting on a digital camera has more in common with the volume control on your stereo, since it just "turns up" the signal from the CCD or CMOS sensor, allowing the camera to be more sensitive in lower light levels.

Choosing an ISO setting

Most compact and point-and-shoot cameras have ISO settings that range from 100 to 400. Many also offer an auto-ISO feature as the default setting. This setting is usually equivalent to 100 or 200 in well-lighted conditions, but it automatically rises when light levels are low. More advanced cameras offer a wider range of ISOs, up to 1600 and 3200. Keep in mind that using a higher ISO setting, especially in low-light conditions, increases the likelihood that noise will appear in the image. Like film grain, noise tends to rear its ugly head more often in darker areas of the image. To see how image quality is impacted by ISO on your camera, take some test shots at different ISO settings and evaluate them on a computer to determine your personal tolerance for image noise (**Figure 6.8**).

Since the ISO setting you choose will be influenced by the type of photographs you're taking and the lighting conditions in which you find yourself, there's no "right" ISO setting, but there are some guidelines you can follow:

• If your main concern is capturing the best image quality with the least amount of noise, then you should use the lowest ISO (usually 100) your camera has to offer. If you find that the shutter speed is too slow for a handheld shot, choose a wider lens aperture, or use a tripod. If you can't get your hands on a tripod, stabilize the camera by resting it on a table, the roof of your car, a tree stump or wall, or another object. When all else fails, try bumping the ISO up to 200.

ISO 100 ISO 200 ISO 400

ISO 800 ISO 1600

Figure 6.8 Noise levels from images shot with different ISO settings. There's not much difference between 100 and 200. With ISO 400, noise begins to appear in the shadows. At 800 ISO the noise levels noticeably increase, and at 1600 they are excessive.

- For photography where you need to react fast to changing conditions, and where using a tripod is not an option, a higher ISO of 200 to 400 will provide you with a wider range of exposure options, especially in lower light, or if you need to use a certain shutter speed or aperture. Most prosumer and professional SLRs produce excellent results with surprisingly low noise levels at ISO 400. Higher ISOs are appropriate for times when you have to use a fast shutter speed that's not available with a lower ISO, or if there simply isn't enough available light for handheld photography.

- If you're shooting indoors or at night without a flash, or if you need fast shutter speeds in low-light conditions, then you'll need to venture into the outer reaches of the ISO scale and select 800, 1600, or 3200. These higher speeds are not available on all cameras, and some settings on the high end can be used only when you enable an ISO expansion or boost feature.

Using Noise for Creative Effect

Some photographers have developed an appreciation for the look of certain film grain and will often use a particular film stock not only for its increased sensitivity to light, but also for the aesthetic qualities of its grain pattern. Unfortunately, digital noise is not quite as attractive as film grain, and the presence of too much noise in an image may prove disappointing, especially if you're used to the look of film grain. We find it's better to capture images with little or no visible noise and then add a grain effect later in Photoshop, where we have more control. Noise in a digital capture can be minimized to a certain extent using Photoshop and some third party plug-ins, but the result is never as satisfying as if the noise levels were low or nonexistent to begin with. The best noise-reduction strategy we can advise is to try and avoid it in the first place. For those times when circumstances beyond your control leave you with no choice in the matter, however, we do cover noise-reduction strategies in Chapter 11, "Digital Darkroom Expert Techniques."

White Balance

Photography is all about light (the Greek word it derives from means "light writing"), but not all light is created equal. Different sources of light produce illumination with different color characteristics. A digital camera's ability to record an image with an accurate color balance is largely determined by the *white balance* setting. Before we delve into the nuances of white balance and digital photography, however, let's take a quick look at the science behind it.

Color temperature

The term *color temperature* is used to describe the color of light, but it doesn't refer to the thermal value of the light itself (in other words, heat), but rather to the visual appearance of the light. Color temperature is always measured in Kelvins, or K, a unit named for Lord William Thompson Kelvin, the 19th-century Scottish physicist who first developed the absolute temperature scale. In photography, the Kelvin scale describes the relative intensity of red to blue light. Lower temperatures describe light that is warmer, or redder in appearance; midrange temperatures refer to light that is white, or neutral; and the highest readings indicate light that has a cooler, or bluer, appearance (see the sidebar "Color Temperature: Don't Try This at Home"). On the warm end of the scale, you might find light created by candles or standard lightbulbs (1000K to 2500K). In the middle of the scale you would have typical daylight and electronic flash (5000K to 5500K). And on the cool side, you would have open shade and overcast days (7000 to 10,000K). **Table 6.1** lists different lighting conditions and their approximate color temperatures.

Table 6.1 Approximate Color Temperatures for Common Light Sources

1000K	Candlelight, firelight, oil lamps
2000K	Sunrise
2500K	Standard household lightbulbs
3200–3400K	Tungsten photo lights: studio hot lights, photo floodlights
5000K	Typical daylight, electronic flash
5500K	Daylight-balanced films; electronic flash
6000K	Bright sunlight, clear skies
7000K	Slightly overcast skies
9000K	Open shade on a clear day
10,000K	Heavily overcast skies

NOTE: Some light sources are by their nature nonspecific and subject to influence from other factors (altitude, atmospheric conditions, and so on), therefore, the color temperatures given here are approximate.

Although different sources produce light with varying color temperatures, the amazing thing about human vision is that our eyes and our brain continuously balance the colors, no matter what the lighting may be, so that we see a scene with a reasonably accurate color balance. If you leave an office building that is lit with fluorescent lights, which are really in the green spectrum, and walk out into the sunlight, you don't notice any major changes in the color balance of the objects you're viewing. Even with such a sophisticated visual system, however, there are still situations where we will notice that some light sources produce illumination that's noticeably "warmer" (dawn or candlelight) or "cooler" (shade or twilight).

Film and imaging sensors, unfortunately, are not nearly as advanced as the human visual system. You've probably seen photos that were taken inside under typical household lighting with no flash. An image made under those conditions usually exhibits a strong yellow color cast (**Figure 6.9**). The reason for this is that film emulsions are manufactured to produce a response that matches a general category of illumination, such as daylight. If daylight-balanced film is exposed in normal household lighting, the color balance tips toward yellow because the film is designed to produce a balanced response at 5500K, whereas the illumination indoors is a cooler color temperature (and has a warmer appearance) of about 2500K.

Indoor

Outdoor

Figure 6.9 In an indoor shot with no flash, typical household light bulbs create a strong yellow color cast. When the same subject is photographed outside, the color balance is more neutral.

Color Temperature: Don't Try This at Home

One of the most confusing aspects of color temperature is that light with a warmer appearance has a lower temperature, while light that exhibits cooler, bluer characteristics is said to have a higher temperature. This is, of course, completely counterintuitive to our normal association of cooler with lower temperatures and warmer with higher readings, but there is a method to this madness.

The key to this seemingly backwards scale can be traced back to 1899 and German physicist Max Planck's experiments with thermal radiation and black body radiators. In physics, a black body is a theoretical object that absorbs all wavelengths of thermal radiation falling upon it, reflecting no light and appearing totally black at low temperatures. When heated, however, a black body emits thermal radiation. At lower temperatures, this radiation is invisible to the human eye, but as the temperature increases, the radiation becomes visible as the black body begins to glow and give off its own light.

To bring this discussion into the realm of common experience, imagine a darkened kitchen and a black, cast iron frying pan on the stove, with the burner turned up to high. When the temperature of the iron pan reaches 1000K, it will begin to glow a dull reddish color. As the temperature increases, the color of the glowing metal will shift to orange and then yellow (2000K – 3000K). As the pan becomes hotter still, rising above 3000K, the color of the superheated metal will transform into a yellowish-white. By the time the frying pan reaches 5000K, it will be glowing white-hot. Continued temperature increases past 7000K will shift the color of the glowing iron pan into the blues of the higher frequency regions of the visible spectrum.

By this time, of course, if you have a smoke detector in your kitchen, it's probably a dripping mess of melted plastic, and the fire department is breaking down your door with an axe. The incendiary nature of this experiment moves us to caution you against trying it out in your own kitchen. It's much safer as an imaginary exercise to help you understand where color temperature comes from. Real experiments with black body radiators are better left to trained professionals who possess the necessary equipment and stylish blast furnace fashions to protect themselves.

With film, the choices for color balance are limited to daylight and tungsten lamps. If you need to make further adjustments, you have to rely on color-correction filters. These filters are manufactured with a very precise coloration that compensates for the light source or film emulsion being used. A bluish 80A filter, for instance, will convert a standard 3200K tungsten light source to 5500K for use with daylight-balanced film. If you're using tungsten-balanced film, then you can use a more orange 85B filter to modify daylight or

an electronic flash so that it will be recorded as neutral by the tungsten film. Other filters compensate for the unpleasant greenish cast produced when you use daylight film with fluorescent lighting. Not all color-correction filters are designed for exact conversions between light source and film emulsions. One of the more useful of these filters is an 81A, which adds a slight warming effect and is commonly used by photographers when photographing people under overcast skies or in shady locations.

Digital cameras, on the other hand, make no assumptions about the type of light you're shooting in until the image data is processed by the camera's software. The decision the camera makes about how the colors in an image should be rendered is determined by the white balance setting. At the most basic level, the camera uses white balance to accurately reproduce white. If you get the white balance right, then all of the other colors should also be accurate.

Choosing a white balance setting

By setting the white balance in a digital camera, you're specifying the type of light source that's illuminating the scene.

- **Auto White Balance.** All digital cameras offer an automatic white balance (AWB) feature. With Auto White Balance, the camera evaluates the scene and tries to find the brightest point, which it assumes is white. Some AWB systems perform a much more advanced evaluation that factors in many different areas of the scene and performs complex calculations to arrive at a white balance decision.

 Automatic White Balance works quite well in most situations, although this can vary depending on the quality of the camera and the type of lighting. The main advantage of using AWB is the convenience of not having to remember to change the setting when the lighting changes. Tim has grown to trust the AWB feature on his Canon EOS 10D and finds that it's very effective under most lighting conditions. Seán also uses AWB, and since he shoots using the RAW format for most of his images, he can always fine-tune the white balance of a shot as he opens the image into Photoshop.

 As with any auto feature, however, there are times when it can be fooled, especially if the image is dominated by one particular color, or when you're photographing in low-temperature illumination, such as with tungsten lightbulbs (**Figure 6.10**). Subtle white balance color shifts can be hard to see and evaluate on the small LCD monitor on the back of the camera, particularly in bright sunlight. A number of studio photographers we spoke to reported that in the studio Auto White Balance may shift and that they prefer to use a custom white balance to fine-tune color temperature settings.

Figure 6.10 Auto White Balance can be thrown off by bright colors that fill most of the frame, or by very low temperature lighting, such as with tungsten lamps. In this image, the auto white balance feature could not handle the illumination from a single household lamp very well and the photo still has a strong yellow color cast.

- **White balance presets.** Many cameras offer a choice of white balance presets that are designed for specific lighting conditions. Standard choices include Daylight, Shade, Cloudy, Tungsten (often labeled Indoors or Incandescent), Fluorescent, and Flash. Although settings such as these are useful for those times when they match the lighting in which you find yourself, we have found that the auto white balance feature on most cameras does an excellent job of figuring out the approximate color temperature of the lighting and adjusting the camera accordingly. The one exception to this is tungsten lighting. Even with AWB the shot is likely to turn out too yellow for most people's tastes. In this case, choosing the tungsten white balance preset will give you a more balanced shot. The main drawback to using white balance presets is that it's easy to forget to change it back to auto if you move to another location where the lighting is different.

If you find yourself shooting in tricky lighting, you can always make a few test shots with the camera set to the white balance preset that most closely matches the existing light. Fluorescent lights are likely to have the most variance from the setting your camera offers simply because so many different types of lights fall under this general category. As with any camera setting that can affect image quality, we recommend testing the white balance presets in the appropriate lighting before you find yourself on an actual shoot. By making test photos and then evaluating them on your computer, you'll be better able to predict how a certain preset may perform under different lighting conditions (**Figure 6.11**).

Auto White Balance

Daylight

Shade

Cloudy

Tungsten

Fluorescent

Figure 6.11 Besides Auto White Balance, some of the standard color temperature presets included on cameras are Daylight, Shade, Cloudy, Tungsten, and Fluorescent.

- **Custom white balance.** Some deluxe point-and-shoot cameras and nearly all pro-sumer and professional cameras provide the capability to set a custom white balance based on the lighting at any given location. You usually do this by photographing a white object, such as a sheet of paper, under the specific lighting conditions you want to adjust for. Some cameras, such as the Nikon D100, can also perform a custom white balance by using a photographic gray card or another object that is a neutral gray. The goal is to shoot a normal exposure, since an under- or overexposed shot can give an incorrect white balance. In the camera's custom white balance mode, you then select this image as the source, and the camera will calculate the custom white balance. The exact steps for determining a custom white balance may vary depending on your camera and you may need to select custom white balance first and then point the camera at a target object and press the shutter button. If you find yourself without a handy sheet of white paper or a gray card, then you can also get by using something that is a neutral tone, such as a gray sidewalk. Custom white balance is highly useful if you find yourself in situations where the scene is illuminated by mixed light sources, such as daylight coming in through a window to blend with tungsten and fluorescent lights (**Figure 6.12**).

Figure 6.12 The image on the left was photographed using the camera's Auto White Balance setting. For the image on the right, a custom white balance setting was used based on the illumination at the location and the image is more accurate.

- **Setting a manual color temperature.** Some higher-end cameras let you select a specific color temperature. This can be useful if you're using a color meter to determine the accurate color temperature of the lighting in a scene and want to be sure that the camera matches it exactly. At high altitudes, for example, the color temperature of the light is likely to be much higher, which produces photos with a cooler, or bluer appearance. Although the automatic or custom white balance feature may handle this condition with ease, if you're precisely measuring the color temperature using a color

meter, then you may find it useful to set a specific temperature. Even if you're not using a color meter, you can still make test shots and experiment with manual settings to determine which one gives you the color balance you need.

- **Using white balance as a filter system.** Once you become familiar with how different white balance settings affect the image, you can also use them as a creative filter system to add a warming or cooling effect to images. Just remember to return the setting to AWB, or you may end up with a memory card full of images with the wrong color balance. We prefer to apply such color enhancements in Photoshop, where we have more flexibility.

Sharpening, Saturation, and Other Enhancement Options

Since some consumers may find the initial image as delivered by the camera as too "soft," camera manufacturers have added a sharpening option to produce images that look sharper and more finished. Fortunately, some cameras allow you to choose the level of sharpening applied, or even to turn it off completely. Our view on the sharpening feature is unanimous: If your camera provides you with a way to disable it, turn it off for good.

The reason for our impassioned view is that sharpening is a destructive process that permanently alters the color and contrast of edge pixels—areas of the image where light and dark colors are adjacent to each other. The camera just sees a bunch of pixels and applies a sharpening amount based on canned formulas that are hard-wired into it. A camera doesn't know what your photograph requires, or how you might want to use sharpening, so the sharpening it applies may not be appropriate for the image. This is especially true if you plan to make prints, since the amount of sharpening that you apply is influenced by the subject matter and the size of the final print.

We have the same philosophy when faced with options to alter contrast, brightness, and color saturation: Turn these features off! All of these decisions are best applied later in an image-editing program, where you can apply them in a way that complements the specific image and in a flexible manner that doesn't harm the original (**Figure 6.13**).

A B C

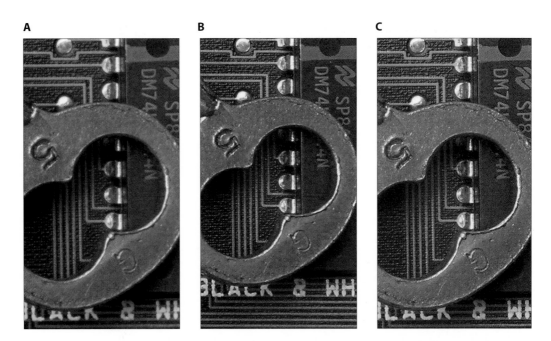

Figure 6.13 Image A is a detail view showing a photo with no in-camera sharpening applied. Image B is the same subject with in-camera sharpening turned on. Since sharpening is an irreversible process, we prefer to turn off the camera's sharpening feature and apply the effect later in Adobe Photoshop, where we have more control over the process (image C).

Color Space Settings

Digital cameras, monitors, scanners, televisions, and even the human eye all create color using the RGB color model, which is based on red, green, and blue, the three additive primary colors of light. Within the range, or gamut, of RGB colors that the human eye can perceive, there can be different subsets of colors, known as *color spaces,* that describe different gamuts within the overall RGB color model. A simplified way to think of this is to imagine a large container that holds all of the colors we can see. Within this container are several smaller containers, or color spaces, with each one describing a slightly different range of colors. Some of the containers might have more greens and cyans in them, for instance, while others have more oranges and reds. Some containers may also have more intense, or *saturated,* colors than others. Color spaces with a larger gamut can contain more colors than smaller-gamut color spaces.

Most entry-level and deluxe point-and-shoot digital cameras do not offer a choice of color space settings. They create color based on an industry standard color space known as sRGB. Microsoft and Hewlett-Packard developed sRGB, basing it on the color gamut of

the average, inexpensive monitor (aka the lowest common denominator). More and more, however, higher-end prosumer and professional cameras are offering a choice between sRGB and Adobe RGB. The difference between these two color spaces is primarily one of gamut size, with Adobe RGB having a much larger gamut than sRGB (**Figure 6.14**).

Figure 6.14 These two views from the 3D gamut-graphing feature of the program ColorThink (www.chromix.com) compare the gamuts of sRGB, shown as a solid color shape, with Adobe RGB (1998), shown as a wire frame. Adobe RGB has a larger color gamut than sRGB and, if available on your camera, is more suited to professional photography.

If your camera offers you a choice, then the best choice depends on what you ultimately need to do with the image. If you're only concerned with emailing photos to friends and family, creating images for the Web, or making casual prints on desktop inkjet printers, then there's nothing wrong with choosing sRGB. If, on the other hand, your work consists of creating professional, exhibition-quality prints, or if you're shooting images destined for reproduction on a printing press, then Adobe RGB will give you more colors and let you retain more color information. In reality, all color spaces involve compromise and there is no single ideal color space. But if you have to decide between the two, we recommend Adobe RGB.

> **NOTE:** The question of which color space setting to use on your digital camera is moot unless you have a calibrated monitor with an accurate monitor profile and you use reliable printer-paper-ink profiles when you print. Selecting Adobe RGB in the camera's settings is not a magical cure-all for color problems you may be experiencing further down the image-editing pipeline. We cover calibration and printing issues in Chapter 12, "From Capture to Monitor to Print."

Additional Camera Settings

Besides the basic settings we have already discussed, you should be aware of a few others:

- **LCD brightness.** More recent cameras feature an LCD brightness control that allows you to increase or decrease the brightness level of the LCD screen. If you find yourself in bright sunlight trying to review your images, bumping up the brightness of the LCD may help you to see the display better, although this can also throw off your perception of the actual tonal values in the scene. We think it's better to keep the LCD brightness at a set level and use other methods to get a better view of the LCD screen, such as using an LCD hood or your body—or the jacket off your back—to create shade.

- **LCD/system sleep.** This determines the length of inactivity (in other words, not pressing any buttons) required before your camera enters a sleep or standby mode. If you want to conserve your battery, then you'll want to choose a relatively short amount of time such as 15 to 30 seconds; but if you want the camera to be always at the ready, then you may want to set a longer interval. If your camera has a separate setting for LCD standby, we recommend choosing the shortest time available. If you find that you don't use the LCD for framing the image but rather rely on the optical viewfinder, then see if you can turn the display off for all but reviewing purposes. The less the LCD is on, the longer your batteries will last.

- **Setting the date.** This is pretty straightforward, but it's definitely something you want to do before you take any photos. Digital cameras record the date and time of day you created an image, as well as other information, and include it with the image file (see the section "Metadata," later in this chapter). Computers can also use dates to sort images, so having an accurate date and time attached to your images is important.

- **File-numbering options.** Digital cameras name their files with a combination of letters and sequential serial numbers (such as DSCN2051 or CRW_0406). Although this file-naming scheme is hardly useful if you have to sort through countless folders of your digital photos, it does provide a starting point. We can expect a lot from digital cameras, but at the moment, creating meaningful filenames such as EmpireMine_Metal-Textures_0024 is not an option. On many cameras, however, you can specify how you want to handle the numbering sequence.

 Continuous Numbering continues the number sequence even after you've changed storage media. This setting ensures that all of your shots will have discrete numbers, preventing you from accidentally overwriting an earlier image with the exact same file number. Cameras will usually assign an upper limit to the numbering scheme, such as 9999, beyond which they'll start over again at 0001.

Auto Reset, or Auto Renumber, automatically resets the file number to 0001 whenever you replace the storage media card. If you're shooting with several different memory cards and want to keep track of how many shots you've taken on each card, this can be a useful numbering convention. If you store your images from each session in separate folders, then you don't have to worry too much about conflicting filenames. However, if you ever rearrange your files into groupings by subject (such as falconry, or San Francisco), then you could inadvertently replace earlier files that have the same filename. If you use auto-renumbering on your camera, then some system of batch renaming will not only provide insurance against accidental overwrites, but will also attach some meaning to all those folders of images you're generating. We'll cover file naming and file management in greater detail in Chapter 9, "Download, Edit, and Convert," and Chapter 14, "Archive, Catalog, and Backup."

Formatting the Storage Card

When you first use a memory card, you should format it using the camera's formatting option to prepare the card for use with that camera. And you should reformat each time you need to erase a card—for instance, when you want to reuse it and take new photos. Just as with a hard drive, formatting a card erases all the existing data and directory structures on the card. Since this action is irreversible (there's no undo command), be sure you're not wiping out important images that have not been backed up yet. Although some cameras will let you shoot with an unformatted card, certain camera-specific features may not function properly until the camera has formatted the card. Seán discovered this firsthand when the Continuous Numbering setting he had selected for file naming on his Canon EOS 10D wasn't working. After double-checking that it was indeed set to Continuous Numbering, he realized he hadn't yet formatted the memory card. A quick card format by the camera solved the problem.

In certain circles there is some debate about whether it's better to format the card in the camera or on your computer. Currently, most cameras format the card using the FAT16 system (File Allocation Table, 16-bit addressing), while most computers use the FAT32 (32-bit addressing) system. A File Allocation Table describes how a computer structures the data on a memory card or hard disk. This system is changing, of course, and some newer cameras use FAT32 for formatting the memory cards. Computers are evolving, too. Apple's G5 PowerPC processor uses 64-bit addressing. Although there is no harm in formatting a card on your PC or Mac, we recommend formatting the card in your camera. Since the card is in the camera most of the time, it makes sense to let the camera do it so that the card is optimized for use in that device. In case you have more than one type of digital camera, we recommend having dedicated media cards for each one. We've noticed that not all cameras can

read cards formatted in other cameras, so rather than risk losing images, we opt to dedicate media cards to each camera to simply avoid the card formatting issue.

When you hook the card up to your computer, either via a card reader (highly recommended) or directly from the camera, you may be tempted to delete the files you've already transferred by dragging the folders on the card to the computer's trash can or recycle bin. We caution against this and recommend returning the card to your camera and formatting it there to delete the files. We also suggest that you reformat the card after every use, instead of simply deleting the files using the camera's erase command, because the FAT is regenerated with each new format. As with any computer file system, data corruption can slowly build up over time; formatting the camera media card after confirming that you have safely downloaded the images and before each use ensures that you'll start with a clean slate.

EXPOSURE MODES

Digital cameras usually provide several exposure modes for your photographing pleasure. Although most cameras do an excellent job when left on autopilot, you gain a great deal more technical control and opportunity for creative image making when you explore the other exposure modes. Although the modes vary, some are common to nearly every camera. Typically, these include a semiautomatic mode, where you make certain exposure choices while the camera handles the rest; a full manual mode; and possibly a selection of scene modes that are designed for specific situations. Before we consider what each of these exposure modes is and what they have to offer you, let's take a look at the basics of photographic exposure.

What Is Exposure?

Simply put, *exposure* is the moment when the light strikes the film or sensor and the image is recorded. Three factors combine to determine the correct exposure for a digital image: the amount of light in the scene that strikes the CCD or CMOS sensor, the length of time that the sensor is exposed to the light, and the sensitivity of the sensor. Aperture is measured in f-numbers, and each number (commonly referred to as a stop) represents a factor of two in the amount of light admitted. The importance of a good exposure cannot be overstated. If an image is overexposed, the highlights will be completely white, without any tonal information (**Figure 6.15**). If an image is grossly underexposed, the image will be dark and lack shadow detail (**Figure 6.16**). All three of us are well versed in Photoshop, and while it can rescue us from slight exposure mistakes, no amount of Photoshop magic can

save a picture that is extremely over- or underexposed. Fortunately, camera light meters are very sophisticated instruments and do an excellent job of determining the settings for a proper exposure in most common photographic situations. However, by changing any of the three main settings, you can gain control over certain characteristics that can influence the look of the image. We examine how light meters see the world in great detail in the next chapter.

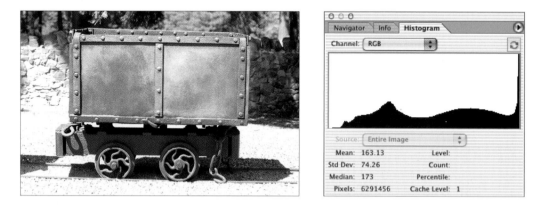

Figure 6.15 When an image is grossly overexposed, the brightest highlights will be rendered as a white with no detail. In the histogram for the image, the vertical bars representing the tonal values for the highlights will be pushed up against the right side of the graph, indicating lost highlight detail.

Figure 6.16 When an image is severely underexposed, the darkest shadows will be rendered as black with no detail. In the histogram for the image, the vertical bars representing the tonal values for the darker parts of the image will be pushed up against the left side of the graph, indicating lost shadow detail.

Aperture

Aperture refers to the opening of the iris, or diaphragm, in the lens that can be adjusted to let more or less light hit the CCD. One way to think of aperture is to imagine a funnel in which the large end is the lens gathering the light and the small end is the aperture that controls how much light reaches the imaging sensor in a given period of time. Aperture is measured in f-stops, and each stop represents a factor of two in the amount of light admitted. Thus, "opening up" a lens from f5.6 to f4 will admit twice as much light, and "stopping down" from f11 to f16 will cut the amount of light in half (see the sidebar "What's in an F-Stop?").

Apart from controlling how much light passes through the lens, the aperture is also one factor that affects depth of field (the others are the focal length of the lens and the size of the imaging sensor). *Depth of field* is the area of the image that appears in focus from foreground to background and is one of the main ways that you can change the appearance of an image (**Figure 6.17**). We'll cover depth of field in more detail later in this chapter.

Figure 6.17 Depth of field is the area of the image that is in focus from foreground to background. You can achieve a shallow depth of field (less area in focus) by using a larger lens aperture, and deeper depth of field (more area in focus) by using a smaller aperture.

What's in an F-Stop?

If you've ever been confused as to the origin of the term *f-stop*, or what the numbers refer to, you're not alone. Although those numbers engraved on the lens ring (or illuminated on the LCD panel) may seem arbitrary, they really do mean something. The f-stop is the ratio of the focal length of the lens to the diameter of the opening in the aperture. On a 50mm lens, for example, when the aperture is opened up to a diameter of 12.5mm, this would result in an f-stop of f4 (50/12.5 = 4). Standard f-stops used on lenses for film cameras are f1.2, f1.4, f1.8, f2, f2.8, f4, f5.6, f8, f11, f16, and f22 (**Figure 6.18**). Depending on the lens, the actual range of f-stops may vary. Large-format cameras typically have f-stops that go down to f-64.

Each change in f-stop either halves or doubles the amount of light that enters the lens. In this admittedly unintuitive numbering system, smaller numbers indicate a larger opening and larger numbers indicate a smaller opening, and the presence of fractional numbers only complicates the matter. If you wanted to adjust the aperture one stop down from f4, to let in half as much light, then common sense would tell you that the next stop should be f8, and not f5.6. The reason for this seemingly odd number thrown in between f4 and f8 is that apertures are circular openings and the mathematical realities of dividing the area of a circle in half sometimes produces a fractional number instead of a whole number.

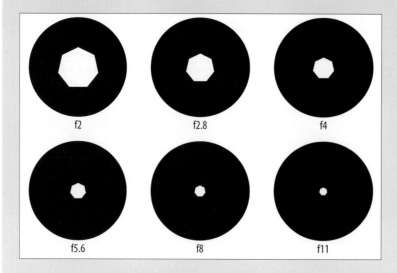

f2	f2.8	f4
f5.6	f8	f11

Figure 6.18 An aperture consists of a bladed iris with an opening that can be made larger or smaller to let in more or less light. This illustration shows several standard lens apertures.

Shutter speed

If we continue with the same funnel analogy that we used to explain the aperture, then the shutter is the valve that controls how long the light flows through the lens and onto the CCD. The smaller the aperture, then the longer it will take a given amount of light to flow through the funnel and the longer the required exposure will be. Shutter speeds are measured in extremely small fractions of a second and speeds range from incredibly fast ($\frac{1}{16,000}$ of a second on the Nikon D1x and D1H) down to several seconds or even many minutes. The function of the shutter is similar to aperture in that each successive change in the shutter speed will either halve or double the exposure time. Using standard shutter speeds as an example, $\frac{1}{125}$ of a second is half as much exposure as $\frac{1}{60}$, but twice as much as $\frac{1}{250}$ (**Figure 6.19**).

Figure 6.19 In the photo on the left, the exposure was f5.0 at $\frac{1}{60}$ of a second. For the photo on the right, the aperture stayed the same, but the shutter speed was increased to $\frac{1}{125}$ of a second. Since the shutter was open for half as long as the previous shot, this resulted in half as much light entering the lens, creating a darker exposure.

The beauty of reciprocity

Aperture and shutter speed work together to create a proper exposure in a given lighting situation. Because of the way they function, you could take several shots, each with a different aperture and shutter speed, and produce several images that all had equal exposure. You could use a wider aperture for a shorter amount of time, for instance, or a smaller aperture for a longer amount of time to admit equivalent amounts of light. Another way to look at this is that opening up the lens aperture by one stop is exactly the same as decreasing the shutter speed by one setting; each doubles the amount of light for the exposure. And increasing the shutter speed by one setting has the same effect on exposures as stopping down a stop to a smaller aperture. This give-and-take nature of the aperture-shutter speed relationship is known as *reciprocity,* and it's one of the most effective exposure tools available to photographers (**Figure 6.20**).

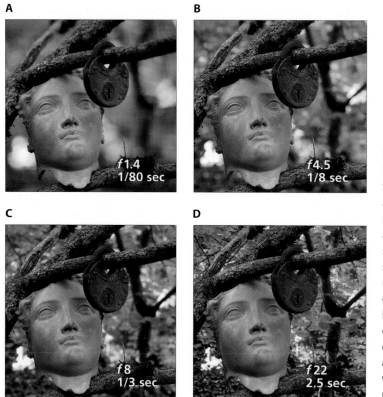

Figure 6.20 Reciprocity in action: Four photos of the same scene, each with a very different shutter speed and aperture, yet all have the same exposure (in other words, the same amount of light reached the sensor). The only noticeable difference in these images is greater or less depth of field, depending on the aperture. All images were photographed using a tripod.

NOTE: *Many photographers who are familiar with film exposure know the term reciprocity from a phenomenon called reciprocity failure. This is essentially a breakdown of the normal reciprocal relationship between aperture and shutter speed that tends to occur at either very fast or very slow shutter speeds. This has nothing to do with the actual aperture or shutter speed in the camera, but rather how the film emulsion reacts to very short or long exposure times. On the fast end of the shutter speed dial, reciprocity failure is usually not a problem unless the speed is more than $1/10{,}000$ of a second. Typically, the problem is more an issue of longer exposures, such as those that are more than a second in duration. With film, reciprocity failure can create exposure problems and color shifts, due to the chemical nature of film emulsions. Digital cameras create images based on an electrical response as opposed to a chemical one, and although we can't speak for every CCD or CMOS sensor, now or in the future, in the tests that we have made, we haven't noticed reciprocity failure with long digital exposures.*

The benefits of reciprocity come into play when your camera meter recommends a certain exposure, but you need to change either aperture or shutter speed to produce a desired creative effect. Let's say you're photographing a flower, and the camera's light meter indicates that it will use a shutter speed of ½ of a second and an aperture of f11. Although this might yield a correctly exposed image, an aperture of f11 would produce too much depth of field, making the background details too sharp and distracting. If you were using a manual camera, you could take advantage of the reciprocity principle to quickly (well, reasonably quickly) calculate an equivalent exposure that would give you a wider aperture and throw the background out of focus. If you decided that an aperture of f2.8 would produce the desired shallow depth of field, you'd increase the aperture by 4 stops (f8, f5.6, f4, f2.8); that would require an equivalent adjustment of the shutter speed. Opening the lens aperture to f2.8 lets in more light (16 times as much in this case), so to balance out the exposure you would need to shorten the amount of time the shutter is open by 4 stops—to ⅓₀ of a second. For the final exposure of the flower, the shutter speed is at ⅓₀ and the aperture is at f2.8. This produces exactly the same exposure (in other words, the same amount of light reaches the sensor) as the initial camera meter's suggestion of ½ at f11, but the differences between the two images is significant (**Figure 6.21**).

Figure 6.21 In the photo on the left the exposure is a ½ second at f11. The small aperture renders too much of the background in focus. In the photo on the right, the exposure is ⅓₀ of a second at f2.8. The amount of light reaching the imaging sensor is exactly the same for both images, but by taking advantage of the reciprocal relationship of aperture and shutter speed, a more appropriate aperture was used to blur the background details.

NOTE: *In an effort to make this example more straightforward, we have chosen to use an aperture-shutter speed scale similar to what you might find on a traditional film camera. In addition to standard 1-stop exposure adjustments, many cameras, film and digital, offer adjustments in increments of ½ to ⅓ of a stop. Computer-driven shutters on digital cameras can also generate unconventional shutter speeds, such as $1/729$ of a second (try calculating reciprocity with that!).*

Fortunately, unless you're operating on full manual mode or you just enjoy the intellectual challenge, when used in Aperture or Shutter Priority mode cameras will automatically calculate the reciprocal aperture and shutter speed values for you. This makes it easier to concentrate on the image and choosing the settings that will give you the right creative look. We'll cover exposure considerations in greater depth later in this chapter and also in Chapter 7, "Seeing the Light."

Full Auto Mode

Nearly all cameras provide a fully automatic mode that does everything for you but compose the shot and decide when to press the shutter button. Full Auto mode evaluates the lighting; selects the ISO, white balance, aperture, and speed settings; and even decides whether the scene needs a little extra light from the built-in flash. On some models a green icon on the control dial designates this mode. This is the mode to use when you first get your camera and you still don't know much about it, but you want to take pictures right away—or when you need to hand the camera to someone else so they can take a picture of you. It's also the perfect mode for new parents, even if they already know a lot about cameras. When Seán bought a new compact digital camera a week after his daughter was born, the demands and distractions of a new baby in the house meant that the camera stayed on Full Auto for several weeks (with the exception of turning the flash off now and then) before he found time to explore all of its features.

Keep in mind that some camera features, such as the abilities to change the ISO, adjust the exposure with exposure compensation, and shoot in RAW format, may not be available in fully automatic mode. To gain an extra level of control and customization while enjoying the ease of automatic operation, you may have to use another automatic mode that is commonly called Program.

Program Mode

Program mode is similar to fully automatic mode in that the camera selects the appropriate aperture and shutter speed in order to deliver the correct exposure for the scene you're photographing. You also have the ability to modify the settings the camera has chosen by shifting the aperture–shutter speed combination to select a mix that better serves your creative goals (reciprocity in action). On SLRs you usually make this adjustment by dialing a control wheel until you arrive at a desired aperture or shutter speed, something you can do without taking your eye away from the viewfinder. On compact cameras, or deluxe point-and-shoot models, the procedure may be more cumbersome: You usually have to manipulate a series of buttons, requiring you to take your eye away from the camera. Program modes also offer access to more advanced features of the cameras such as shooting in RAW format, exposure compensation, higher ISO settings, and choosing a custom white balance. Because it offers the convenience of being fully automatic with the flexibility of changing some of the settings, you may find that Program mode works well for most of your photographs.

Aperture Priority Mode

Aperture Priority can be thought of as a semiautomatic mode because it relies on you to decide which aperture to choose, while the camera supplies the appropriate shutter speed. Once you select a given aperture, the camera will constantly adjust the shutter speed in response to changing exposure conditions, but the aperture will remain the same. This mode is an excellent choice for images where depth of field issues take precedence over shutter speed. A wider aperture will cause the background to be more out of focus, and a smaller aperture will yield a photo with more areas of the image in focus. Aperture Priority is excellent both for portraits, where you want only the subject in focus, and for scenic shots, where you want everything clear and sharp.

Shutter Priority Mode

Like Aperture Priority, Shutter Priority is a semiautomatic mode. You decide what shutter speed you want to shoot with, and the camera chooses the correct aperture. Shutter Priority is ideal for situations where exposure time is more important than depth of field. If you need to freeze motion, such as with sports or birds in flight, using this mode will allow you to select an appropriately fast shutter speed. If your aim is to use motion blur creatively, such as the classic rendition of moving water in a stream, then you can also use

Shutter Priority to choose a slow shutter speed (**Figure 6.22**). Depending on the speed of the object you're trying to blur, you may need to use a tripod so that stationary elements in the image remain sharp.

Figure 6.22 By using a slow shutter speed for a longer exposure (in this case ½ second), the water in this river is rendered as a smooth, silky blur.

Manual Mode

As the name suggests, in this mode you have to do all the work. Well, maybe not all the work. The camera does provide a light meter to tell you if your settings will give you a properly exposed image, but you have to turn the dials or push the buttons and make sure that both aperture and shutter speed are set correctly. Although a manual mode is essential for photographic control geeks (like the three of us) and those who want as many creative options as possible, it's not as spontaneous as some of the other modes, and realistically you may only need to control either aperture or shutter speed to achieve the effect you want. For some situations, however, such as night photography and in the studio, having a manual mode is critical. We cover some specific uses for Manual mode on the companion Web site.

Scene Modes

Scene modes are preset configurations that are designed for you to use under specific shooting conditions to achieve good to excellent results without having to think about the optimal camera settings. They're not exposure modes you would use all the time. You'll find these modes on many digital cameras, from compact point-and-shoot models all the way up through advanced prosumer SLRs. The actual names and modes will vary from camera to camera (other terms we've heard include Best Shot and Creative Assist modes), and depending on their features some cameras may offer more sophisticated interpretations. But here's a rundown of some of the most common scene modes:

- **Portrait.** The main feature of this mode is that it will try to soften the focus of the background while keeping the main subject sharp. The degree to which the background is thrown out of focus depends on a number of factors, including the amount of light available, the distance between the subject and the background, and the maximum aperture and focal length of the lens. Some cameras may also use a Center-Weighted metering pattern to give emphasis to the center portion of the frame. Center-Weighted metering is common in portrait situations. See Chapter 7 for detailed coverage of how a camera's light meter works.

- **Night portrait.** This mode is for portraits of people, or any photo where the subject is relatively close to the camera at twilight or at night. If such a scene is photographed normally, the flash will fire and the camera will expose for the immediate foreground subject, leaving the background very dark and underexposed. In Night Portrait mode, the camera will use the flash and also choose a slower shutter speed, creating a balanced exposure between the main subject and the darker background. The exposure for both the main subject and the background will look good. Some cameras have a mode that is similar to this called Slow-Sync Flash (**Figure 6.23**).

Figure 6.23 Night Portrait mode uses a longer exposure (slower shutter speed) to create a good exposure for a dark background, combined with a fill flash to properly expose the foreground. On the left is the photo with regular auto flash, showing the dark background, and on the right is the same image shot using Night Portrait mode.

- **Landscape.** Whereas Portrait mode chooses as wide an aperture as possible for shallow depth of field, Landscape mode uses a small aperture to produce the deep depth of focus commonly associated with scenic images. Be aware, however, that some cameras may be doing a bit more behind the scenes than simply choosing an aperture for good depth of field. The manual for one of Seán's older cameras claims that the Landscape mode will "enhance outlines, colors, and contrast in subjects such as skies and forests." This suggests that the camera is actually applying more aggressive sharpening, contrast, and saturation adjustments when it processes the image—and our subsequent testing proved this to be true. The only problem with this approach is that we found the sharpening, contrast, and saturation adjustments used for this camera's Landscape mode unacceptably harsh and heavy-handed (**Figure 6.24**). Before you rely on any scene mode, it's a good idea to run some tests and see how it affects image quality.

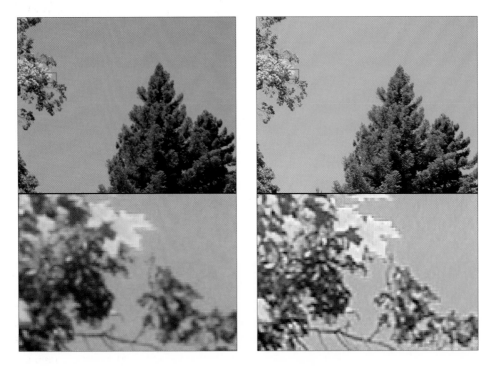

Figure 6.24 On the left is an image that was photographed on regular program mode with sharpening turned off. On the right is the same view photographed using the camera's Landscape scene mode. The inset detail views show that the Landscape mode used what we feel is excessive sharpening and saturation adjustments.

- **Night Landscape.** This is useful when you want to photograph cityscapes at night, or twilight views of grand vistas. It cancels any flash operation, sets the focus distance to infinity and uses slow shutter speeds to gradually build up an exposure of a night scene. Due to the slower shutter speeds, a tripod or other stabilizing surface is necessary.

- **Beach/Snow and Backlight.** These two modes are very similar and are designed to compensate for photographing very bright subjects. When a camera light meter tries to evaluate a scene such as a beach or a snowy field on a sunny day, the brightness reflected from the sand or snow can confuse the meter and lead to an image that is too dark. A mode designed for photographs of beach and snow scenes adjusts the exposure so that the scene will be properly exposed (**Figure 6.25**). The Backlight mode does essentially the same thing but is used for situations where the light is coming from behind your main subject or the background is brightly lit. The Backlight mode chooses a shutter speed–aperture combination that will create a proper exposure for the foreground subject. On some cameras, the flash may fire in Backlight mode in order to fill in the shadows on the person's face.

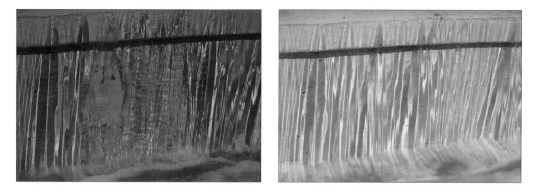

Figure 6.25 The Beach/Snow scene mode on your camera is not just for photos of the seashore or a winter wonderland, but is for any subject that's naturally bright and reflects a lot of light. In this example, the darker photo is a result of the camera's meter being fooled by the bright tones of the fountain and water. When the Beach/Snow scene mode was used, a correct exposure was captured that better represented the real appearance of the scene.

- **Close-Up/Macro.** Depending on the camera, this mode will select a range of settings designed to produce a better close-up photo. On compact cameras, all this may amount to is extending the zoom lens all the way and adjusting the AF (autofocus) sensors for close focusing. On some cameras the flash will go off, while on others it won't. Still other cameras may employ some form of camera-shake reduction to help

with handheld shots. Apart from ensuring that you have a fast enough shutter speed to make up for any camera motion (we recommend using a tripod for macro shots), much of close-up photography depends on the lens, so the Close-Up mode on many SLRs with interchangeable lenses doesn't really do that much. On the Canon EOS 10D, for example, all the close-up feature does is set the metering, ISO, and white balance to auto and turn the continuous-shooting drive off.

- **Sports.** This mode is optimized for photographs where you want to freeze the action on sporting events and fast-moving subjects. The actual functionality that this mode offers will depend greatly on the capabilities of the camera. Features such as autofocus speed, AF servo focus (the ability to track a moving subject), variable-focus sensors, and the speed of the continuous-shooting drive are all put to work when you use this mode on a digital SLR. Compact cameras and deluxe point-and-shoots, which don't have the advanced focus and drive features of SLRs, will generally offer an exposure mode that is biased toward faster shutter speeds and a drive setting for taking a series of multiple shots.

- **Black and White/Monochrome.** For those times when you want to create a black and white photo with no hassle, this is the mode to use (some cameras offer this feature under the color saturation control). But we prefer to take our images in color and convert to black and white using an image-editing program, since that gives us the most flexibility to interpret the file. The only reasons we can think of to use Black and White mode is if you don't have the time or experience to make the conversion in another program, or if you're new to viewing the world in gray tones and actually seeing the image in black and white on the LCD helps with the composition and subject matter you've chosen. Otherwise, we don't recommend shooting in Black and White mode. We talk about the nuances of converting color images to black and white in Chapter 11, "Digital Darkroom Expert Techniques."

- **Other modes.** The variety of scene modes is limited only by the imagination of camera manufacturers. Some of the modes are useful in relatively limited circumstances, such as a Fireworks mode, or a mode designed to copy documents (espionage mode?), while others seem to be no more than marketing gimmicks. The Casio Exilim EX-Z3, for example, offers no fewer than 20 "Best Shot" modes. While some may be quite useful and many people might have a lot of fun with them, we question the need for scene modes such as Pet, Natural Green, Food, and Retro.

METADATA

Metadata is not a setting or mode that you'll find on your camera, and you probably won't see the term in the instruction manual, but your camera is generating lots of metadata every time you take a picture. To use a simple definition, *metadata* is information about information. More specifically, metadata is structured information about a collection of data—such as an image file—that makes accessing and using that file more efficient and productive.

Recent improvements in the digital management of information have underscored the importance of metadata among different professional disciplines, but the concept itself has been around for a long time. Distance scales and legends on maps, for example, qualify as metadata since they are essentially information about the map, which in itself is just information about a specific geographic area. Dictionaries also feature metadata in the form of a dictionary guide that tells you how to interpret the different information you'll find listed in the word definitions.

Until recently, the only experience with metadata that most photographers had was probably keeping written records of their photo sessions, making notes about the exposure or darkroom settings of certain photos, or creating the custom name and copyright imprints on cardboard slide mounts. With the advent of digital photography, however, metadata has become just as important as any other piece of gear in a photographer's camera bag.

EXIF

For most digital cameras, metadata consists of a record of the settings that were in effect when an image was photographed. This information can include data such as the date and time the image was created, pixel resolution, shutter speed, aperture, focal length, ISO, white balance, metering pattern, and whether the flash was used. The information is saved using a standard format called Exchangeable Image File (EXIF) that was created by the Japan Electronic Industry Development Association (JEIDA) in 1995.

At the most basic level, EXIF data can be a useful tool to help you improve your photographic technique. Because it keeps track of basic exposure information, you can study it to learn what the settings were on photos that worked, and what they were on images that had problems. For example, if you notice that several images from a session are slightly out of focus while others have sharp, clear details, a quick check of the EXIF data for the soft images might reveal that the camera used a slower shutter speed for them than it did with the sharp photos (see the sidebar "Accessing Camera EXIF Data"). This knowledge can help you make different exposure decisions the next time you're shooting in similar conditions.

Records of exposure information may be useful, but that's only the beginning of many possible uses for metadata. Once you've downloaded your images to your computer, Photoshop and digital asset management programs currently let you add descriptive keywords to facilitate faster searching and retrieval from an image database. Other uses for metadata could include client and job information, as well as the ability to track image usage for photographers who license the use of their photos. As of this writing, the full potential of metadata for photographers, especially professionals, has yet to be realized, but we expect to see significant strides in this area as the technology matures and new uses emerge. For further discussion of metadata, see Chapter 14, "Archive, Catalog, and Backup."

Accessing Camera EXIF Data

The File Browser feature in Photoshop 7 and Photoshop CS is one of the easiest ways to see the basic EXIF data for an image (**Figure 6.26**). One potential drawback, however, is that not every parameter recorded by the camera can be displayed. This is not due to any deficiency in the File Browser, but to the inclusion of proprietary "MakerNote" EXIF information that is specific to individual cameras. To see everything that the camera records, try using the software that came with the camera. Below is the all of the EXIF data recorded for a RAW capture on a Canon EOS 10D. The data for the image was viewed in the Canon File Viewer utility.

File Name:	CRW_0021.CRW
Camera Model Name:	Canon EOS 10D
Shooting Date/Time:	09/15/03 17:54:17
Shooting Mode:	Aperture-Priority AE
Tv(Shutter Speed):	1/10
Av(Aperture Value):	22
Metering Mode:	Evaluative
Exposure Compensation:	-1/2
ISO Speed:	100
Lens:	28.0 - 135.0mm
Focal Length:	30.0mm
Image Size:	3072x2048
Image Quality:	RAW
Flash:	Off
White Balance:	Auto
AF Mode:	AI Focus AF

```
Parameters:
  Contrast:          Normal
  Sharpness:      Normal
  Color saturation: Normal
  Color tone:      Normal
Color Space:       Adobe RGB
File Size:         5915KB
Custom Function
  C.Fn:01-0; C.Fn:02-0: C.Fn:03-0
  C.Fn:04-0: C.Fn:05-0; C.Fn:06-0
  C.Fn:07-0; C.Fn:08-0 C.Fn:09-0
  C.Fn:10-0; C.Fn:11-0; C.Fn:12-0
  C.Fn:13-0; C.Fn:14-0; C.Fn:15-0
  C.Fn:16-0; C.Fn:17-0
Drive Mode:        Self-Timer Operation
Owner's Name
Camera Body No.:   04202WXYZ
```

Metadata	Keywords	
Camera Data (Exif)		
Make	:Canon	
Model	:Canon EOS 10D	
Date Time	:2003:08:11 20:15:27	
Date Time Original	:2003:08:11 20:15:27	
Date Time Digitized	:2003:08:11 20:15:27	
Exposure Time	:1/200 sec	
Shutter Speed	:1/200 sec	
F-Stop	:f/1.4	
Aperture Value	:f/1.4	
Max Aperture Value	:f/1.4	
ISO Speed Ratings	:1600	
Focal Length	:50.0 mm	
Flash	:Did not fire	
Metering Mode	:Pattern	
Pixel X Dimension	:3072	
Pixel Y Dimension	:2048	
Orientation	:Normal	
X Resolution	:180.0	
Y Resolution	:180.0	
Resolution Unit	:Inches	
Compressed Bits Per Pixel	:3.0	
EXIF Color Space	:Uncalibrated	
File Source	:DSC	
ExifVersion	:0220	
Exposure Bias Value	:-0.3	
Sensing Method	:One-chip color area sensor	
Bits Per Sample	:	
Focal Plane X Resolution	:3443.946	
Focal Plane Y Resolution	:3442.017	
Focal Plane Resolution Unit	:Inches	

Figure 6.26 The EXIF section of the Photoshop CS File Browser displays the standard EXIF information associated with an image.

TAKING THE IMAGE

Once you've taken the time to configure the camera's settings so that the technical quality is assured, it's time to think about what else goes into making an interesting and successful photograph and how to use your camera to achieve those ends. If you're already a seasoned photographer, then some, if not all, of the topics we're about to cover may be nothing new to you. But it's worth noting that although traditional framing and compositional guidelines can be applied to all photos, with digital photography certain aspects need to be treated differently than they would with a film image.

Framing

When we view any scene, no matter what the lighting conditions may be, we have the benefit of the world's fastest and most advanced autofocus, as well as sophisticated light metering and white balance systems that have yet to be rivaled. We're talking about the human eye here, of course. The way a camera sees an image and the way we see it are very different, and what we view with our eyes is never exactly the same as what is recorded by the camera. Predicting how the camera will capture the lighting and the different planes of focus in a given scene is something that only comes with experience and knowing how your camera and lens (or lenses if you have more than one) will respond. In this respect, working with digital is no different than using film. Although you may be somewhat at the mercy of factors such as lighting, focal length, aperture, and shutter speed, one thing that you do have total control over is how to frame the image.

The rectangle of the viewfinder is the canvas where you compose your photographs. It's been said that painters include, whereas photographers exclude. Painters begin with a totally blank canvas, which they proceed to fill in with brush strokes to render the scene that they want the viewer to see. Photographers, on the other hand, begin with the cluttered jumble of reality in their viewfinder and selectively exclude all but the most vital aspects of the photograph they see in their mind's eye. If there is something in a scene that a painter doesn't want in the painting, then she will simply not paint it. But if a photographer is faced with the same situation, then he must employ creative framing to exclude any elements he doesn't want in the final image (**Figure 6.27**).

Figure 6.27 By carefully considering how you frame an image in the viewfinder, you can eliminate distracting details. In many cases, you can do this simply by moving closer to the subject (right).

Horizontal or vertical?

The rectangular or square aspect ratio of most camera viewfinders can be both a blessing and a curse. In some regards, it can make composition easier since it defines the shape where we must compose the image. On the other hand, since our view of the world is not limited by rectangular constraints, we often find ourselves having to work around the narrow window on the world that the viewfinder provides.

If your image format is rectangular, the first choice you face is whether to frame the image horizontally or vertically. Many novice photographers use horizontal framing because most camera designs encourage you to hold the camera in a horizontal orientation. Until you become used to it, using vertical framing requires a conscious effort to rotate the camera. Depending on your photographic experience, and your skill at seeing images amid the visual confusion of reality, deciding on a horizontal or vertical frame may come easily to you, or it may take some practice. Certain subjects will obviously lend themselves to one or the other, of course, but others are not so easy, and some may work well with both methods. Above all, try to be conscious of not falling into the routine of taking all of your images as horizontals (**Figure 6.28**).

Figure 6.28 The image on the left was taken in the standard horizontal orientation that most camera designs encourage. By consciously recomposing the shot as a vertical, however, the end result is a more interesting composition that fits the subject better.

When you look at a scene, put away any preconceived ideas about how it should be framed and try to distill it down to just the basic shapes and colors. Using this approach, you should be able to see whether elements in the image suggest a horizontal or a vertical view. Some scenes, such as landscapes and large group portraits, are obvious candidates for the horizontal frame. The vertical frame is ideal for images where there are strong vertical lines, such as soaring skyscrapers, towering trees, or the classic head and shoulders portrait pose. But even with images where the orientation of the frame seems clear, be open to trying a different approach, as you might find a new and better composition that didn't occur to you at first (**Figure 6.29**). When in doubt which frame orientation will work best, go ahead and take the image as a vertical, a horizontal, and even a diagonal—just to see what happens. If you want your photographs to be published in magazines, many photographers recommend shooting more images as verticals as they will fit the typical page layout much more easily than horizontals, which always are interrupted by the magazine *gutter* that separates the pages of a spread.

Figure 6.29 Don't be afraid to break the rules if that results in a better photo. Some subjects are obvious candidates for a vertical composition, such as the photo on the left. But they might also work well as a horizontal. You'll never know unless you try!

Experiment with angles and different points of view

And don't think that just because the camera presents you with a rectangle that you are just limited to horizontal and vertical. Remember that you have 360 degrees of rotation available to you. Can you find anything interesting when you tilt the camera so you view the scene at a diagonal? Such a view may give the scene more of an abstract feeling, but there's nothing wrong with that if it creates an interesting image (**Figure 6.30**).

Change the point from which you view the scene and you may discover new images that weren't apparent in your initial composition. If you first took the image from an eye-level standing position, get down low and see how it looks from closer to the ground. Look around you and try to imagine how the dynamics of the composition might change if you moved to the left or right. It's even easy for experienced photographers to fall into a visual rut and automatically compose an image a certain way, or in the way we've done it in the past. If your first idea is to take the photograph with a specific composition, go ahead and do it, but then try to find at least two other compositions for the scene.

Figure 6.30 When composing a photo in the viewfinder, don't settle for the first composition that comes to mind. Explore different framing to see if you discover any images you hadn't thought of. How does the scene look by moving to the left or the right? Get closer. Crouch down for a low-angle shot. Tilt the camera and view the scene as a diagonal. Sometimes, the most rewarding images are the ones you weren't expecting.

And if you're traveling through a scene, especially if you're on foot, don't forget to look back every so often to see how the view changed while you were walking away from it. There's an old saying: "You can't know where you're going unless you first know where you've been." We think this is great advice for life in general, but it also works well for photography. It's natural to concentrate on where you're going, and to anticipate the new views and images you may see around the next bend in the road. But we have found many great and often unexpected images simply by looking back over the path we have already

walked. For one thing the lighting is likely to be different, and in many cases, that alone is enough to create a compelling new image. The dynamics of the scene will also change, and you may see new relationships between certain elements in the image, or between the foreground and background that create an entirely different photograph than what you saw when you were only looking ahead.

The Importance of Cropping in the Camera

Make every pixel count

With film cameras, it is sometimes common to frame the image a little loose so you can have some extra room to apply a specific crop later when the image is printed. For example, when framing an architectural photo with a traditional film camera, a photographer may frame the initial composition and then step back one or two steps to allow for some darkroom straightening and cropping. With digital photography, however, this is not a practice we recommend. The reason for this is that cropping a digital photograph means that you are throwing pixels away and effectively lowering the megapixel resolution for that particular shot. If you shoot a horizontal photo with a 6-megapixel camera, for example, and then decide later on that it works better as a vertical, the act of cropping it to the different orientation will turn the original 6-megapixel image into approximately a 3-megapixel image. By halving the resolution of the image, you also halve the file size and drastically affect how large that image can be printed. To avoid this, don't waste any of the viewfinder area. Take advantage of every pixel that the imaging sensor has to offer and fill the entire frame with the image you want to capture.

If you're shooting image elements that will be composited into a separate multi-image collage, consider framing your shots to take advantage of the diagonal width of the viewfinder. This will give you more useable pixels than if you had filled the frame either horizontally or vertically. The difference is a small one, admittedly, but if you're trying to maximize pixel resolution and the image will be used in a collage where the diagonal orientation won't be an issue, then this is one way to increase the pixel count (**Figure 6.31**).

Figure 6.31 By framing the Statue of Liberty so that she filled the diagonal width of the viewfinder, we maximized the number of pixels used to capture the statue. Although this is not an option for a "straight" photo of the statue, the diagonal slant to the image is no problem for photos that will be used in multi-image collages.

Get closer

Robert Capa, the famous war photographer who covered many of the major conflicts in the middle part of the 20th century, once said, "If your pictures aren't good enough, then you're not close enough." We think this is excellent advice, although if you're seeking the job title of combat photographer, you have to exercise caution at how literally you apply this motto to your own photography: Capa died in 1954 when he stepped on a landmine while he was covering a small regional conflict in a country called Indochina (later to become Vietnam).

If you are not in a combat zone, however, and you need to move closer to the scene, then by all means do so. One of the most common mistakes that even serious amateur photographers make is including much more in the frame than is necessary. Get close to your subject, and then move closer still. Try to fill the frame with only the elements that are essential to the image. Pixels are precious in digital photography; so don't waste them on things that dilute the main subject (**Figure 6.32**).

Figure 6.32 Get closer! The number one way you can improve your photos is to move closer when you take them. Use as much of the viewfinder as possible and distill the composition down to the essential elements.

Don't be lazy and rely on the camera's zoom lens to do the job for you (unless you're standing at the edge of the Grand Canyon, or some other equally formidable precipice). Move yourself closer first. If you are photographing people, of course, then there's a limit to how close you can get before the moment is ruined, or the person you are photographing becomes ill at ease or downright annoyed. Once you are as close to the scene as you can get, then use the zoom lens for fine-tuning the composition to exclude any extraneous elements that detract from the primary image.

Details, details, details

Getting physically closer to what you're photographing will also help you see details more clearly, and that, in turn, may lead you to discover new photographs and new relationships between different elements in the scene. One exercise you can do to remind yourself to look for the details in a subject is to take the initial shot and then make a point of moving much closer for a second shot, and then closer still for a third shot. Since you're shooting digital, if you chance to discover more interesting compositions from your close-up

vantage point, there's nothing to stop you from taking even more photos (apart from a full memory card). **Figure 6.33** shows a photograph of two old tow trucks that have both seen better days, and **Figure 6.34** shows a close-up detail view of one of the trucks.

Figure 6.33 This image of two old trucks is already a good, tight composition that doesn't waste pixels on any extraneous elements.

Figure 6.34 By moving in close to examine the fine details of one of the trucks, we found some intriguing patterns and textures in the rusted metal and peeling paint that created an interesting abstract image.

The closer you get, of course, the more abstract the image may become, but that's a big part of the discovery process that makes photography so rewarding. Finding an interesting image where you weren't expecting it is one of the great joys of creating photographs.

Image Relationships

Most photographs are pictures of scenes we view with our eyes, whether that's a child playing, a still life, an African landscape, kayakers on Lake Tahoe, or a busy street scene in New York City. We say "most photographs" because extremely fast or slow shutter speeds can also reveal images that we can't see, such as star trails in the night sky, or Dr. Harold Edgerton's ultra-high-speed photograph of a speeding bullet shooting through an apple. Beyond the concept of photography as a representation of what we can see, however, a photograph is also an arrangement of elements within a square or rectangular area (the frame). The relationship of these elements to one another—whether they are actual objects, or simply areas of light, shadow, and color—is one of the things that separate a photograph with a good, visually interesting composition from a photograph that's just another picture. Consider the following:

- **The importance of the frame.** The frame is the stage on which you present the performance of your image. How you use the stage can take an ordinary picture and turn it into a creative photograph. The frame can be busy and cluttered, with lots of activity that gives it an edgy sense of tension, or it can be quiet and orderly, imparting a feeling of calm and balance. How elements interact with the edges of the frame can also be very important to the composition, as can the use of white space or "empty" areas that can be used to create a frame within the frame.

- **Balance.** The rectangle of the viewfinder gives you a frame that contains the image. Within this frame the arrangement of image elements can be balanced using either a symmetrical or asymmetrical approach. Symmetrical balance is apparent in images where the subject is centered, or where different areas of equal size, whether they are actual objects or simply areas of light and shadow, create a balanced arrangement within the frame. One way to use asymmetrical balance is to create a triangular arrangement that juxtaposes two smaller elements with a larger one. The two smaller elements create the counterbalance for the larger object or image area (**Figure 6.35**).

Figure 6.35 In the image on the left, the symmetrical design of the lifeguard tower lends itself to a formal, balanced composition. In the image on the right, a close-up of a hammer dulcimer creates asymmetrical balance with the two ornate hammers forming a visual counterpoint to the round sound hole of the dulcimer.

- **Foreground/background.** How the foreground and background elements relate to each other is one of the key factors in a photo. Does the background inform, or comment on what is happening in the foreground? Or is it a distracting element that is unrelated to the foreground subject? The relationship between the foreground and the background can be subtly changed through effective use of depth of field. Whenever you compose a shot that has a distinct foreground element, take a moment to survey what is happening in the background. This is good practice just to be sure that there is nothing in the background showing up that you don't want in the photo, but in some cases you may see something that would work well if it was included.

- **Size, position, and point of view.** The size of image elements and the way they are viewed contribute to their importance in the overall image, as does how they relate to each other. By composing an image so that certain elements are larger, for instance, you focus attention on those areas and give those elements more importance in the final image. This approach can often be successful in images that focus on smaller or more mundane objects that we usually don't pay much attention to (**Figure 6.36**).

Figure 6.36 The size of image elements, and their relationship to each other, can be used effectively in a composition to draw the viewer's attention to a specific area, make a visual comment, or simply to give importance to ordinary objects that we may see every day.

- **Line, form, and color.** The camera is ideally suited to examine the world and isolate intriguing compositions of form and color. In some photographs, the subject is not necessarily any specific object in the image, but the lines, shapes, and colors that exist within the frame (**Figure 6.37**). Lines can be employed to direct the viewer's attention within the image, and they can also be used as a subject themselves, creating abstract patterns. Cities are great places to look for images with strong lines (**Figure 6.38**).

Figure 6.37 In this photograph of a swimming pool at night, the image is not so much about the pool itself, as it is an exploration of the lines, shapes, and colors the photographer saw.

Figure 6.38 Lines can be used to direct the viewer's attention within an image, and they can also create interesting abstract patterns such as in this architectural study.

- **Light and shadow.** Photographs exist because of light, so the interplay of light and shadow can often make for compelling images, even with subject matter that might be thought of as ordinary (**Figure 6.39**). Whether the shadows are cast by recognizable objects, or represent only a close-up detail of a larger shadow, you can usually find interesting images lurking in the shadows. High-contrast lighting, normally the bane of digital photographers, can be highly useful for creating intriguing relationships between light and shadow.

Figure 6.39 Harsh, high-contrast light, normally a very challenging condition for digital cameras, can be used to great effect when concentrating on the images found in the shadows. Even the most ordinary subjects can be transformed into a compelling image by the presence of harsh light and deep shadows.

- **Use of motion.** Movement, either in the subject being photographed or in the camera itself, can affect an image in intriguing ways. If you cherish the idea of serendipity or random chance in the image-making process, then incorporating the trails of movement as seen by a slower shutter speed is a great way to create images whose final appearance is a mystery until after the shutter has closed. For images where the motion of a moving subject is recorded as a blur but the background is sharp, you'll need to make use of a tripod, since these effects generally entail slower shutter speeds that are not appropriate for handheld photography. If you're using the camera to create the movement, however, then no tripod is needed. Even images that

would not be remarkable when photographed in sharp focus with no motion can be transformed into surprisingly beautiful abstract compositions by using a slow shutter speed and moving the camera during the exposure (**Figure 6.40**).

Figure 6.40 Using a slow shutter speed and moving the camera during the exposure (also known as *drag shutter*) can create striking abstractions of color and light. Even a scene that would normally be pretty boring can yield an interesting image when photographed using a drag shutter technique.

- **Use of focus.** For the photographic purist, crisp, sharp focus, is one of the standards by which any photographic image is measured. In the 1930s Group f64, which included such visionaries as Ansel Adams, Edward Weston, and Imogen Cunningham, promoted "straight" photography (as opposed to the soft focus "painterly" or pictorialist photographs that were still popular at the time). One of the hallmarks of this new approach was sharply focused images with great depth of field. But images with incredible depth of field and tack-sharp focus represent only one type of photograph among many possible interpretations. The use of shallow depth of field, for instance, is one of the most effective ways to direct the viewer's attention to specific areas in a photo. Selective focus also is particularly well suited for visually conveying the vague and subjective sense of memory or emotion. And even though an image with crisp, sharp focus can be a thing of beauty, don't feel compelled to worship at the altar of precise image clarity if it doesn't serve your creative vision for an image (**Figure 6.41**).

Figure 6.41 Sharp focus certainly has its place in photography, but the use of soft focus, or even an image with no obvious point of focus, is especially effective at conveying the sense of memory or emotion. In the case of this image, an unsharp, motion-blurred view of a praying mantis out for a twilight stroll is more an interpretive abstract than a representational study.

- **Breaking the frame.** The first item in this section referred to the importance of the frame. Just as important, however, is realizing that the frame is not sacred. You should push the edges now and then to see what you find. Try composing an image that consciously violates all the principles of "good composition" and see if the results intrigue you enough to follow that road a little further. The immediate feedback of the LCD, as well as the cost-free nature of digital exposures, gives you a safety net as you experiment with a radical framing idea. Do all portraits have to be centered? No. Do you even have to include the entire face of your subject? Not necessarily. By going out of your way to push and break the boundaries of the traditional frame, you may discover a new way of composing images that works quite well for certain subjects (**Figure 6.42**).

Figure 6.42 By "breaking the frame" and trying a composition that violates all of the traditional rules of photographic exposure, you might discover an image that works well for a particular subject, or that helps to create a certain feeling or emotion for a photo.

- **Taking risks.** Chance, serendipity, and fortunate accidents are all important to any creative undertaking, whether that process involves industrial design, poetry, sculpture, painting, or photography. It stands to reason that if you always follow the same routine when taking pictures, chances are good that you will consistently make

images that look similar. While this is not negative in any way, and consistency is advantageous when learning any new discipline, there is much to be gained by trying new photographic techniques. When you change or, better yet, discard your routines, you unlock the potential for discovering something new and fresh. True, by taking risks with your image making, there is the very real possibility of a card full of disappointing images that never quite got off the ground, but there's also the chance that you'll find an outstanding image where you least expected it, or create a cool visual effect out of the ordinary ingredients of daily life. Besides, it's digital—it doesn't cost anything to experiment except a little of your time!

HOW DIGITAL PHOTOGRAPHY DIFFERS FROM FILM PHOTOGRAPHY

The fundamental principles involved in photography are essentially the same whether you use a camera loaded with film or one that captures the image digitally. Light is reflected from the scene and focused through a lens onto a light-sensitive area that records the image. Beyond that, though, some important and sometimes subtle differences can affect how you use the camera. Knowing how these differences can affect the final photograph is key to translating a prior understanding of film photography into a comfortable working knowledge of digital photography.

Lens Focal Length

The focal length of a lens refers to the distance (usually measured in millimeters) from the rear nodal point of the lens to the image plane where the light from the lens is focused into the image and exposed, either onto film or onto a digital imaging sensor. For those who have been living and breathing film photography for many years, there is a comfortable familiarity with the focal lengths that are associated with your film format of choice. With most digital cameras, however, those familiar focal lengths have different meanings.

Digital vs. 35mm equivalents

Because the CCD or CMOS imaging sensor on most cameras is usually much smaller than a 35mm film frame, the focal lengths that you're used to with 35mm are not the same. With compact cameras, the listed focal lengths may seem impossibly wide-angle at first glance. For example, the Nikon Coolpix 5400 has a zoom lens with a focal length that ranges from

5.8mm to 24mm. In an effort to provide a standard reference point that most people are familiar with, camera manufacturers usually give the equivalent 35mm focal lengths to help you envision just what type of field of view is possible. For the Coolpix 5400, a 5.8mm to 24mm lens translates to a much more comprehensible 28mm to 116mm.

Focal-length multiplier

If you use a 50mm lens on a 35mm film camera and a 50mm lens on a medium-format camera that produces negatives measuring 6 by 6 centimeters, the angle of view will differ because the physical area the lenses are focusing onto is different. On a 35mm camera, a 50mm lens is considered "normal," while on a medium-format camera such as a Hasselblad, 50mm is a wide-angle lens. On most digital SLRs with interchangeable lenses, a similar concept is at work, due to the fact that the imaging sensor is smaller than the size of a 35mm film frame. Since the lenses were designed to be used with 35mm film but are focusing the image onto a smaller area, the result is a magnification of the stated focal length of the lens. On the Canon EOS 10D, for example, a 28mm to 135mm zoom lens is subject to a 1.6X magnification factor, which means the true focal length of the lens is 45mm to 216mm. Though this results in a free boost on the telephoto end, the loss of a true wide-angle field of view can be disappointing for photographers who like or need to shoot wide-angle. For additional information, see the section on Lenses in Chapter 5, "Essential Accessories."

Depth of Field

How sensor size affects depth of field

In film photography, the size of the film you're shooting with impacts not only the field of view, but also the depth of field. With the smaller imaging sensors used on most digital cameras, this same principle will influence how depth of field appears in your photos. This effect is usually more apparent in situations where you want an image to have less depth of field. On most compact and deluxe point-and-shoot digital cameras with a built-in lens, the small imaging sensors combined with shorter focal lengths means it's much harder to create photographs with a shallow depth of field. If you are trying to take a photo where the background detail dissolves into a soft, featureless blur, you may be disappointed with the results, even if you've set the camera's aperture to wide open (**Figure 6.43**).

Figure 6.43 Both photos were photographed using an aperture of f2.8. Note the difference in the depth of field apparent in the softness of the backgrounds. The image on the left was taken with a digital SLR Canon EOS 10D and the image on the right was taken with a prosumer Nikon Coolpix 5400. Since the CCD imager on the Nikon is physically smaller than the imager in the Canon DSLR, the Nikon has an inherently greater depth of field.

Shallow depth of field: optical vs. software enhanced

If the images you like to create depend on shallow depth of field, there are two approaches you can take. You can use lens-based optical methods to create shallow depth of field, or you can use software such as Adobe Photoshop to selectively blur portions of the image in the digital darkroom.

For shallow depth of field that's created optically, compact digital cameras are not a good choice. As mentioned previously, because of the smaller CCDs in these cameras, even a wide aperture is insufficient to produce the kind of shallow depth of field where focus falls off rapidly into a heavily blurred background. If this is the only kind of camera you can afford, then you'll have to do some tests before you buy to determine the minimum depth of field. Arranging several objects on the camera store counter and shooting toward them at the widest possible aperture will give you a good idea of a camera's shallow depth of field capabilities.

SLR cameras with interchangeable lenses will typically offer shallow depth of field effects that are very close to their 35mm film counterparts. Remember that a lens with a wider maximum aperture will be better at creating shallow depth of field. Many zoom lenses, for example, have a maximum aperture of f3.5 to f4.5, while prime (fixed focal length) lenses offer much wider apertures that are better suited for shallow depth of field. Other ways that you may be able to decrease the depth of field include using a lens with a longer focal length, placing the subject closer to the camera, and increasing the distance between the subject and the background.

Using software to enhance or add a shallow depth of focus effect is a lot more work, of course, and requires that you have some proficiency in the program you're using. Seán loves to use shallow depth of field in his photographs, for instance, and he's also very accomplished at using Photoshop, but he prefers to achieve the effect in camera with a 50mm f1.4 lens because it's easier, more natural, and saves him a lot of time. For the purist, it's also important to note that a software-created blur will not produce the exact same visual effect as an optical blur that's created using a camera lens.

If you do decide to pursue the software approach, you'll need to make an accurate selection around the foreground element so that you can protect it from the blurring effect that will be applied to the background. And keep in mind that optical blurring that occurs along a distance is not the same as throwing everything out of focus uniformly—a mistake a lot of people make. To create convincing depth of field, you need to apply the blur gradually, with the blur starting out very subtly and becoming gradually stronger as the distance from the subject increases. Shallow depth of field may also mean that some areas of the image in front of the main subject are out of focus, as well. We cover image-blurring techniques in greater detail in Chapter 11 (**Figure 6.44**).

Figure 6.44 In the image on the left, the blurred background was created optically in the camera using a lens with a wider aperture. The background of the image on the right was blurred using software techniques in Adobe Photoshop.

Exposure latitude

Exposure latitude is the range of tones between the brightest highlights and the darkest shadows that can be recorded by a camera's CCD or CMOS sensor. This may also be referred to by other names, such as *dynamic range* or *contrast range*. Digital cameras have an exposure latitude similar to that of color slide films, and high-contrast scenes, such as those in bright sunlight, may exhibit a contrast or dynamic range that is beyond the exposure latitude of your camera. When that's the case, without careful exposure technique you're likely to end up with some highlights that are "blown out" to an absolute white with no detail. Deep shadows may also be rendered as a black with no detail, but these are not nearly as noticeable as blasted white highlights.

Since the camera's light meter is measuring the overall reflected brightness of a scene (see Chapter 7 for more on light meters), any bright sources of highlight reflection will fall outside the range of the average exposure that the camera chooses, resulting in areas of totally white highlights devoid of image detail. This is not something that can be fixed in any image-editing program. You can certainly darken the white areas so they are no longer white, but you cannot bring back detail that was never recorded by the camera (**Figure 6.45**).

Figure 6.45 The highlights in the water lily are blown out to a total white with no detail.

With digital cameras, especially in situations where there's a wide contrast range between highlights and shadows, it's best to expose so that the image is as bright as possible without blowing out the highlights. This also helps to minimize noise and maximize the amount of tonal detail captured in the most important parts of the image histogram (see the Chapter 7 sidebar "Left, Right, or Center? Exposing for the Best Possible Histogram"). It's much easier to adjust the midtones and shadows than it is to try to salvage highlights without any image information in them (which is nearly impossible). We usually achieve this by using an exposure-compensation setting on our cameras to automatically underexpose the recommended camera meter setting in situations where contrast may be a problem (**Figure 6.46**). The histogram for a shot is then reviewed and adjustments are made to the exposure compensation to maximize the exposure in the highlights without pushing them into a total, featureless white. If the lighting is soft and even, such as in open shade, then we can always turn the exposure compensation adjustment off. Using the camera's histogram feature to evaluate the tonal quality of images after you have taken them is essential for identifying areas where extreme contrast may be causing exposure problems. If you are shooting on a tripod, you can also take multiple exposures with different settings and then combine them in Photoshop to create an image that is made up of the best areas of each shot. See Chapter 7 for more detailed information on both exposure compensation and using the histogram, and Chapter 11 for camera and Photoshop techniques for shooting and compositing multiple exposures to extend contrast range.

Figure 6.46 By using exposure compensation to let in less light, an exposure was captured where the detail in the bright highlights on the flower were not overexposed to a total white.

Black and White Photography

Many digital cameras offer a Black and White mode for capturing monochromatic images. If you don't want to have to import your images into an additional program to convert color into grayscale, then this is certainly an acceptable method of shooting black and white for many people. One interesting side effect of such an approach is that there is none of the normal color interpolation that takes place with a color image. If you remember from Chapter 3, the vast majority of digital cameras do not capture an image in full color. Instead, they record an alternating pattern of pixels using the three different primary colors of red, green, and blue. The camera's internal processor then *interpolates* (otherwise known as making a really good educated guess) what the missing colors are by looking at the colors that were recorded. With no color interpolation needed, the camera can record the full number of pixels in gray values. Some feel that this yields a sharper image, since the camera is not forced to make guesses about the color in order to assemble the final photo, but other than convenience, we've never seen any compelling advantages to this approach. The other reason we do not favor using a camera's Black and White mode is that you are stuck with what the camera thinks is a good grayscale interpretation. Cameras may do a fine job of making basic exposure decisions, but they're not designed to make creative interpretations, and making a good black and white image certainly falls into the latter category.

As mentioned previously in this chapter, we prefer to take all of our images in color, and convert to black and white using Photoshop. Capturing the photograph in color affords us the most flexibility in how we deal with the image. We may have originally had a black and white image in mind when we pressed the shutter button, for example, but upon seeing it displayed at full size on our computer monitor, we may change our mind and decide to leave it in color, or explore a combination of both. Having the original in color gives us the freedom to entertain such creative second thoughts.

If we do decide that the image will work best in black and white, then starting with a color original gives us more choices as to how to translate the color values into gray values. We're not forced to accept what the camera gives us, but can come up with our own recipe of tones that suits our interpretation of the image (**Figure 6.47**). Using the main red, green, and blue colors of an image, this approach is similar to exposing black and white film with different color filters to redistribute the tonal values in the scene. The digital version of this technique, however, is far more flexible, providing instantaneous feedback and, if applied properly, the ability to make subtle changes long after the initial conversion has taken place. Since we have so much control over how we create our grayscale images, we rarely use actual black and white film anymore.

Figure 6.47a The scene photographed in color.

Figure 6.47b A black and white interpretation created by a digital camera.

Figure 6.47c The grayscale view of the red channel of the color image.

Figure 6.47d The grayscale view of the green channel of the color image.

Figure 6.47e The grayscale view of the blue channel of the color image.

Figure 6.47f A custom grayscale conversion created in Photoshop using different blends of the grayscale tonality found in the color channels.

For those photographers who are dedicated to working only in black and white and printing their images in a traditional darkroom, there is a potential advantage to using black and white film. Since the exposure latitude of digital cameras is smaller than it is with black and white negative film, it's conceivable that with careful exposure and custom developing you could end up with a negative with a greater tonal range than you could achieve with a digital capture. For static scenes such as landscapes and still lifes, however, a digital photographer can use two or more bracketed exposures and then combine them into a single image, choosing the best areas from each exposure to create a final image with a tonal range that was not possible from a single shot. Chapter 11 covers a variety of techniques for converting from grayscale and for combining different exposures of the same scene. Another reason to stick with black and white film is if you like to shoot Kodak High Speed Infrared film. Although a black and white infrared effect can be crafted with Photoshop, it's just an effect and doesn't represent a true infrared rendering of a scene.

Changing Settings on a Per Shot Basis

A roll of film is 12, 24, or 36 exposures on a long strip of film. Once you load it in the camera, you can't change the film speed (ISO), or alter the color temperature that the film was designed for without the use of special filters or sacrificing previous images. With digital photography, each shot can be treated independently to create an exposure that is best suited for the needs of a particular image. You are free to change not only ISO and color temperature, but also image resolution, image size, and file format. Of all of these, the ability to choose a new ISO setting on a per shot basis is probably the one that will have the most impact on your photography. Using ISO 100 for photographing in the bright sunlight and then being able to effortlessly switch to ISO 400 or higher when you move into lower light levels is one of the great benefits of digital photography.

Taking Advantage of the LCD Monitor

For the most part, digital cameras don't look all that different from film cameras. The one thing that does identify a camera as digital, however, is the presence of the LCD monitor on the back of the camera. The LCD screen lets you relate to the image in a new way, in that it represents a quantum leap over shooting with a film camera. For a photographer, being able to see an image immediately after it's been captured is a wonderful addition, both technically and creatively, to the photographic process. Apart from the obvious benefit of reviewing shots you've already taken, making the most of the camera's LCD can enhance your photography in ways that might not have occurred to you:

- You can use the LCD like a sketchbook to explore new ideas or work on composition and exposure technique. Seeing the genesis of an idea and watching it develop over the course of many exposures can lead to interesting insights into your own creative process. With a digital camera, you'll be more open to shooting a lot of images as you ponder the compositional possibilities of your subject. Even if you decide to delete many of the less-than-perfect shots soon after taking them, the initial review can help you hone your eye for framing and image relationships.

- You can use the LCD to verify proper exposure and framing; this can often mean having a chance to retake an important shot. The histogram feature (discussed in more detail in Chapter 7) on the LCD lets you evaluate an image for overexposed highlights and modify your exposure settings to capture a shot with a better tonal range.

- On cameras where the LCD shows you a live image as you compose the photo, this lets you see differently than looking through an optical viewfinder. Being able to view

the scene on the LCD may lead to different ideas about camera viewpoint and composition. The LCD also allows you to explore new photographic perspectives that would be either impossible or downright uncomfortable using a traditional viewfinder. New views become possible, such as extreme low-angle images looking up from beneath a flower, or shots of tight spaces that would not accommodate both the camera and your head (**Figure 6.48**).

Figure 6.48 LCDs that swivel out from the camera allow for shots that would be very difficult (or at the very least, uncomfortable) with a standard viewfinder. In this image we've taken a shot of the underneath side of a sunflower plant without disturbing the planter box or any of the other flowers.

- The real world we live in is three dimensional. Even the very best photographs we make of the real world are, at best, only a two-dimensional representation of a scene that we can not only view with our eyes but also move through with our bodies. Often, a 2D photograph of the 3D world is disappointing because certain aspects do not translate well into the flat plane of an image on paper. Having the LCD screen on your camera lets you review an image and make changes to framing and composition that can improve the translation from 3D to 2D.

- LCDs allow you to pan with motion or see a drag shutter effect as the image is being exposed (a drag shutter effect refers to moving, or dragging, the camera during a longer exposure while the shutter is open). In short, your visual relationship to the photo is enhanced because you can now see things that in the past would have had to wait until the film came back from the lab (**Figure 6.49**).

Figure 6.49 Drag shutter can be effective for adding visual interest to shots where it's too dark to take a shot without the flash but flash is not allowed. In this photo taken in the Lisbon Coach Museum, Katrin knew that the slow shutter speed would result in a blurry image, so she rotated the camera during the exposure and was able to create a more controlled and interesting blur effect.

DIGITAL PHOTOGRAPHY IS PHOTOGRAPHY

In the previous section, we pointed out some of the differences between using a film camera and using a digital camera. In the end, however, those differences are really no more than technical and procedural details. Photography is point of view, framing, and timing. In that regard, digital photography is fundamentally no different than film photography. Only the tools have changed.

The new tools are changing not only the technical aspects of photography, but the personal as well. For many people, digital photography has reignited their interest and passion for photography. With digital photography, it's much easier to explore the world visually with a camera. Instant feedback, and the ability to delete bad shots, translates to a perfect learning environment for improving your photographic skills. If the capacity of your memory cards is up to the task, explore a subject from all possible angles and in different light. Although you may not be keeping all of your photos, don't be too quick to delete the bad shots. Take time to study the failed images so you can see why they didn't work. Everyone can recognize an image they are disappointed with, but knowing what went wrong is the key to taking better photos in the future.

Just as you can learn from the bloopers, you can also learn a lot from the photos that do work, so study your successful images as well. Remember what worked in those images as you look through the viewfinder. Make more images like them, and make better images, too. Above all, take more pictures! Photography is all about seeing, and the more you look, the more you will see. A practiced eye is one of the best things a photographer can have. If you are used to looking for images, you'll find them. Give your eyes plenty of practice. Digital photography makes this easier than ever.

CHAPTER SEVEN

Seeing the Light

John Muir, the eminent naturalist and wilderness explorer, recognized the important part that light played in creating a memorable scene. In his book, *The Mountains of California*, he wrote, "It seemed to me the Sierra should be called not the Nevada, or Snowy Range, but the Range of Light." During his many years of travels in the Sierra Nevada, he had numerous opportunities to see how the high country light could transform a landscape. He recognized that, as powerful as the mountain vistas were, the light, ever changing, filtered by mist, clouds, rain, and snow, added mystery and majesty to the jagged peaks and sheer walls of granite.

In photography, light is everything. It brings a scene to life. It establishes a mood and influences the emotional impact of an image. Even photos made in the dark of night, far from artificial light sources, are the result of moonlight or starlight building up over time to form an exposure. The character and quality of light can have a great influence on a photograph, and understanding how a camera "sees" light is fundamental to producing a good image.

One of the most important skills a photographer needs is the ability to visualize the photograph—seeing the picture in your mind's eye and understanding how the camera will interpret the scene. Beginners see what they *know* is there and are often disappointed that the picture doesn't convey the mood or meaning that they saw when they took it; photographers learn to see what the camera sees and to work with the light and camera controls to craft the image they see in their mind's eye.

Digital cameras offer an impressive array of automatic features and can almost always be relied on to produce a decent picture, but making a *good* photograph requires an understanding of the principles of photography and knowing how a camera translates the light in the scene into the photo captured by the image sensor. The difference between an ordinary picture and a good photograph is the difference between just pointing and shooting, and consciously working with composition, light, and camera controls to create a memorable image.

MEASURING THE LIGHT

As we saw in Chapter 6, "Digital Photography Foundations," the proper exposure for a photograph is achieved through a combination of aperture, shutter speed, and the ISO sensitivity of the image sensor. A light meter, either in the camera or an external, handheld model, is used to determine the optimal exposure settings by evaluating how much light is being reflected back from the scene being photographed. Most cameras have built-in light meters that do a good job of calculating an adequate exposure setting, and higher-end cameras offer more sophisticated meters that produce excellent results. For photographers, this feature is definitely a case of "better living through technology"; you can concentrate more on the composition of the scene, while knowing that you can rely on the camera's light meter to do a good job in most lighting situations. Although you may trust your camera's light meter when it comes to exposure decisions, it's still important to know *how* the light meter evaluates light, so that you can better anticipate how the exposure settings it recommends will affect the image.

How Light Meters "See" Light

The light meters found in modern cameras are very good at analyzing the light in a scene and selecting an aperture and shutter speed combination that will yield an image that is neither drastically under- nor overexposed. In most cases, the exposure may actually be quite good, but it's not necessarily the best exposure for a given scene. A light meter doesn't know what you're photographing, nor can it determine if you're using it the right way, or even pointing it at the right place. A light meter doesn't give you the correct settings to use; it just gives you the settings to create a certain type of exposure based on its very narrow interpretation of the scene before your lens. This limitation of the device is due to the fact that all light meters see *luminance* (or how light is being reflected from a scene, also called *brightness*), but they can't see color, evaluate contrast, or even tell the difference between black and white, so the reflected light from every scene they analyze is averaged into a shade of medium gray. A light meter's view of the world is so limited that the gray tone seen by light meters is not just any gray, but a very specific, 18 percent gray. This precise percentage comes from the fact that most scenes tend to reflect 18 percent of the light that falls on them. When you point a light meter at a scene—no matter if it's a snowy hillside, a dark cave, or a casual portrait—and you take a reading, the meter assumes that it's pointed at something that is 18 percent gray; the meter is calibrated to give an aperture and shutter speed that will record the overall reflected luminance of the scene as a middle gray (**Figure 7.1**).

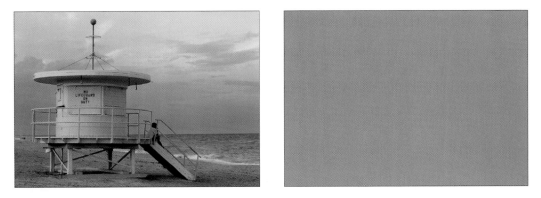

Figure 7.1 When you look through the viewfinder to compose an image, you may see a colorful scene, but light meters interpret the world as having an average reflectance value of 18% gray and recommends an exposure that will render the overall tonal values in a scene as a middle gray.

The meter's 18 percent gray "tunnel vision" works surprisingly well most of the time, especially if the reflected values in your image really should be rendered as a medium tone, as is the case with most "normal" scenes. But it can cause problems if you're photographing something that contains a preponderance of either very dark or very light tones. If you fill the viewfinder frame with a dark object and use the recommended setting, the image will turn out to be much lighter than you expect, and with a light-toned object it will be much darker than you expect. This is because the light meter is just doing what it has been programmed to do (**Figure 7.2**). Real-world instances of this can be seen in photographs taken at the beach or in brightly lit snow scenes, or in shots that have a lot of dark values, such as photographs taken at night. We'll address how to deal with those situations a little later in this chapter.

Figure 7.2 In the image of the black 1937 Nash Lafayette coupe, the light meter took the reading from the black areas of the car and the resulting exposure rendered the car as a washed out gray instead of a rich black. In the close-up detail of a white Bentley, even though the car was white and it was a bright day, the meter's recommended exposure settings recorded the car as a dull gray.

Types of light meters

There are two types of light meters used in photography, those that are built into the camera and external, hand-held units. Hand-held light meters usually can be set up to measure the light as either incident or reflective light. *Incident* refers to the light falling onto the subject, and *reflected* is light reflected off the subject. When used in reflective mode, handheld light meters are very useful for taking precise reflected light readings in landscape photography. Special spot meter attachments with viewfinders can be fitted onto some handheld meters to provide the capability to take measurements from very small areas in a scene (**Figure 7.3**). This allows a photographer to precisely calculate the contrast range in a scene and make an exposure that will contain the tonal information needed to make a good print.

Figure 7.3 A handheld light meter with a 5˚ spot attachment.

With an incident light meter, you take a reading of the light illuminating a scene by pointing the meter at the light source. Taking an incident light reading is used in situations where you do not want the meter to be fooled by dramatic reflectance differences between your main subject and the background. Incident light meters are also common in studio situations to measure the output of professional off-camera flash systems, and for portraiture, both in the studio and on location (**Figure 7.4**).

Figure 7.4 A handheld light meter with an incident dome measures incident light (light falling on the subject).

The light meters found in digital cameras are reflective meters, and that's the type we'll concentrate on in this book. Depending on the type of camera you have, the light meter will measure either the light that comes *through the lens* (also known as TTL), or via a small metering cell located on the front of the camera. Although the basic principle of rendering the world as 18 percent gray has not changed over the years, light meters have become more sophisticated by increasing the number of different

areas that they evaluate; in addition, the way the camera interprets the information collected by the meter has improved.

To see how your in-camera meter works, try this exercise:

1. Gather three pieces of cardboard approximately 8 by 10 inches in size. One needs to be white, one gray, and one black.

2. Set the camera to Program mode, and make sure that there's no exposure compensation turned on. You should also try to use Program rather than Full Auto mode, because the camera may want to fire the flash in Auto mode.

3. Fill the frame with the white cardboard, and take a picture without adjusting the exposure (in other words, let the camera figure out what exposure to use). Repeat with the gray and the black pieces of cardboard.

4. Download the three files to your computer. What do you see? If you followed the directions correctly, you should be looking at three gray pictures—approximately 18 percent gray to be precise (**Figure 7.5**).

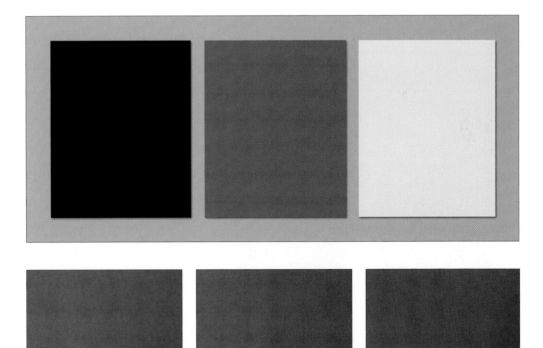

Figure 7.5 When a black, gray, and white card are photographed in Program mode, the resulting exposure for each is a middle gray.

Metering Modes

With the exception of entry-level compact models, most digital cameras offer a choice of metering modes. Metering modes tell the light meter to analyze the light in different ways. The three most common are Matrix, Center-Weighted, and Spot (**Figure 7.6**). Working with the appropriate metering mode allows you to get the best exposure in a variety of situations. You usually select metering modes either from within the camera's menu system or from a control button or selector switch located on the camera body.

Figure 7.6 From top to bottom, Matrix (pattern), Center-Weighted, and Spot metering modes.

- **Matrix.** Depending on your camera, this mode may be called Multisegment, Pattern, or Evaluative metering. Matrix metering has been used in film cameras for many years. We feel it's the best mode to use for most situations, and it's the one that we use most often.

The Matrix metering pattern divides the image into sections, or zones (anywhere from 30 to well over 200), and takes a separate reading for each zone. The camera then analyzes the different readings and compares them to information programmed into its memory to determine an optimal exposure setting. High-end digital SLRs that offer a range of different autofocus (AF) zones will also factor the active autofocus zone into the metering pattern, giving that area of the image more weight in the final exposure calculation. In most cases, Matrix metering works very well, and we use it for most images simply because it does such a great job of calculating an optimal exposure, letting us concentrate on image making. Matrix metering may not be the best choice in all situations, and recognizing when it's not can help you decide whether it's time to use another metering mode or adjust the exposure. Common situations where matrix metering may be fooled include heavily backlit scenes, bright areas such as snow or the beach, and dark subjects that you want to record as dark. We'll address how to handle these types of exposure situations later in this chapter (see "Knowing When to Override the Meter").

To get a sense of how your Matrix metering system responds to different lighting situations, you should take a series of pictures in as many different lighting conditions as possible—a sunny day, a cloudy day, dawn, heavy shade, open shade, high contrast, low contrast, indoors—and carefully evaluate the results. Pay particular attention to the shots you take in very bright daylight, where there is an extreme contrast range between deep shadows and bright highlights. This is the type of lighting that's most likely to cause problems for a Matrix metering system. To be fair, we should point out that this type of lighting could cause problems for *any* metering system, but since Matrix metering bases its exposure on many different areas of the scene, it may not be able to distinguish which area of a high-contrast scene is important to you (remember that a light meter has no idea what you're photographing). Your goal with these exposure tests is to try to determine how the meter handles the bright highlights and deep shadows. Does it tend to preserve good shadow detail at the expense of blown-out highlights? Or does it do a good job at controlling bright highlights but fail when it comes to capturing detail in the deep shadows (**Figure 7.7**)? Using the histogram feature on your camera (covered later in this chapter) can help you evaluate problems on the highlight end, and to some extent, you can also use it to evaluate the shadows. To properly assess the integrity of very subtle shadow detail, however, you should view the images in an image-editing program on a calibrated monitor.

Figure 7.7 Even though a Matrix metering pattern measures the light from many different areas in the scene, it sometimes has trouble with high contrast scenes that contain both deep shadows and bright highlights. In this image, the sunlit part of the road has been overexposed to a total white.

Different camera manufacturers have developed different metering systems over the years and any two cameras may interpret the same scene differently. By familiarizing yourself with the nuances of how your camera's Matrix meter responds to different scenes, you can develop your own "metering intuition" that will help you determine when to modify the exposure settings or use a different metering mode.

- **Center-Weighted.** This metering pattern has been used in cameras for years and was around long before Matrix or Pattern metering came on the scene. The mode meters the entire frame, but as the name implies, it gives more emphasis to the center area of the frame. The ratios will vary among different cameras, but typically a Center-Weighted meter will base 60 to 75 percent of its metering decision on the center circle (this is usually shown in the viewfinder), and the remainder on what's happening in the rest of the frame. Center-Weighted metering is common for use in portrait situations, where it preserves background details while letting lighting at the center of the frame determine the exposure.

Although this is the most common type of light meter in more consumer-oriented digital cameras (if your camera doesn't offer a choice of metering patterns, then it probably uses a Center-Weighted meter), the main drawback is that it makes the assumption that your subject is centered. While that may be the case for general snapshot photography, it certainly isn't true for all images, especially if you're a photographer who's already familiar with the major tenets of photographic composition—one of which emphasizes not placing the subject in the center of the frame. For this reason, Center-Weighted metering often produces results that are adequate, but nothing to write home about (**Figure 7.8**). Of the three most common metering modes discussed here, this is the one we use least of all.

Figure 7.8 The image on the left was photographed with Matrix metering, which took the entire scene into account. This resulted in an image in which all areas, even the dark background, have received good exposure. In the image on the right, Center-Weighted metering was used, which based most of the exposure on the little girl's shirt, making the background areas much darker.

- **Spot (Partial).** Whereas Matrix metering looks at many different areas of the image in order to evaluate the lighting in a scene, a Spot meter is designed to measure only the light in a very small area. The exact size of the spot may vary from camera to camera, but it's typically a 3-to-10-degree circle in the center of the frame (*degree* refers to the angle of view—3 degrees is about as large as a dime looks on the sidewalk between your feet). This can encompass anywhere between 2 to 10 percent of the entire scene. The Canon EOS-1Ds offers two Spot choices: a partial mode, which covers 13.5 percent of the viewfinder area, and a Spot mode, which covers 3.8 percent of the frame. Some pro cameras, such as the Nikon D2H, also have Spot meters that link the metering spot to the active autofocus zone for more precise control where the metering will follow the subject that's in focus. On cameras that feature user-selectable AF zones, this allows an incredible degree of control for metering and focusing using the same area of the viewfinder.

 Spot metering is appropriate when you want to measure a specific part of the scene and you want the camera's exposure to be based on the luminance (brightness) of that area. Since meters want to place everything into a zone of 18 percent reflectance, keep in mind that a Spot meter is no different in this regard; it just measures from a much smaller area. A classic situation where you might use Spot metering is for a scene where a relatively small foreground subject is juxtaposed against a very bright or dark background. Matrix or Center-Weighted metering would factor a bright background into its calculations, causing the foreground subject to be underexposed. By framing the image so that the spot area is on the subject, a correct meter reading could be obtained for that area of the image (**Figure 7.9**).

Although we use Matrix metering for most images, we always try to pay attention to how the lighting is affecting the scene that the meter is evaluating, in case a different metering mode may be more appropriate for a given scene. **Table 7.1** provides some recommendations for when to use different metering modes.

Table 7.1 When to Use Different Metering Modes

Mode	When to use
Matrix	"Average" scenes where you want all areas of the image to be factored into the exposure
Spot	Any time the camera might be fooled: backlit scenes, main subject off center (used with exposure lock), dark subjects against light backgrounds, light subjects against dark backgrounds, or light on light and dark on dark compositions
Center-Weighted	Portraits; backlit scenes; main subject off center (used with exposure lock)

Figure 7.9 The image on the left was photographed using Matrix metering, and the exposure is a balance between the bright highlights and the dark shadows. In the image on the right, Spot metering was used. Because the meter reading was taken from the bright side of the building, it is well exposed, but the shadows are much darker than in the shot made with Matrix metering.

Using the In-Camera Light Meter

The ease with which you can take good pictures in automatic mode on most digital cameras often seems to relegate the light meter to the role of a supporting player. A camera's light meter operates silently in the background, and unless you make a point of paying attention to what it's telling you about the scene, it's easy to forget about it. But apart from more obvious image aspects such as composition, focus, pixel resolution, and file format, the light meter—and the exposure it chooses—affects the final image quality more than any other camera setting. As we mentioned previously, a light meter has no idea what you are photographing or how you want the photograph to look, so an important skill is knowing how to use it properly, understanding what it's telling you, and knowing whether to follow the meter's recommendation or modify the exposure settings.

What to meter

The first thing to consider is what area of the image to meter. This decision will be influenced by what your main subject is, how the existing lighting conditions are affecting the scene, and how you want the image to look. Understanding how your camera's metering system responds to different lighting situations is also key to deciding what area of the photo to meter.

If the average tonal reflectance in the scene you're photographing is similar to a medium gray, then relying on the built-in meter's recommendation is probably a safe bet. Humans view the world in color, of course, so if you're not used to making that conceptual tonal translation in your mind, evaluating the reflectance in a colorful scene may take some practice. One way to practice is to imagine the scene as a black and white photo (**Figure 7.10**). Would it be primarily middle gray tones, or are there large areas that would translate as dark grays or very bright tones approaching white? The beauty of digital cameras, of course, is that you can take a shot and immediately preview how the meter's interpretation affected the overall exposure and make on-the-spot decisions about modifying the camera settings to achieve a different result.

Figure 7.10 We see the world in color (left) but light meters only see brightness and then translate the tonal reflectance values in a scene, light and dark, to an 18% gray average. To predict how a light meter might interpret the reflected light in a scene, it is helpful to imagine the scene in black and white.

In lighting situations that contain a good deal of contrast between shadows and highlights, or when the background is significantly darker or lighter than your main subject, then you may have to override the meter. A photograph taken from a distance, showing a woman in a white dress standing before a very dark background, is a classic case where the meter is likely to be misled by the large expanse of darker tones in the image. True to its mission, the meter will choose an exposure that will render the dark background as middle gray, which in turn may overexpose the skin tones of the person and the white fabric of the dress (**Figure 7.11**). As you view the composition through the viewfinder, apply some of your own metering skills, together with what you've learned from testing your camera's meter, and evaluate the scene for areas that may confuse the meter and yield a less-than-optimal exposure.

Figure 7.11 In the image on the left, the meter was thrown off by the large expanse of dark tones that make up the trees, and the exposure is too light for the main subject. The woman's white dress is overexposed and the image does not represent what the scene really looked like. In the image on the right, an exposure compensation adjustment was used to underexpose by 1½ stops to render the trees darker and prevent the highlights in the dress from being overexposed.

TIP: One thing to keep in mind when using SLR cameras that allow you to choose a specific autofocus zone is that the area of focus may be influencing the decisions the light meter makes. Even if you are using the default center focus zone, this can be an issue, because many SLRs, even when using Matrix metering, give more importance to the area of the scene in the active AF zone. If that part of the image is exceptionally light or dark, this can adversely affect the meter's choice. When photographing scenes that contain a significant brightness or contrast difference, try taking different shots using points of focus in different brightness areas to see how that affects the exposure the meter gives you (**Figure 7.12**).

Figure 7.12 In many cameras, the meter reading is influenced by the autofocus zone used to focus the image, as shown in these examples. In the image on top, the autofocus point was the handle at the bottom of the window. This biased the meter to yield a good exposure for the bright areas of the window frame. In the image on the bottom, the autofocus (and meter reading) was taken from the items on the desk. This yielded a good exposure of the desk, but the bright areas of the window are hopelessly overexposed.

If the average tone of your scene is quite different from a medium gray, such as would be the case with a snow scene, a sunny day at the beach, or a dark, rocky outcropping, there are strategies you can adopt to override the meter, or coax it into giving a reading that will give you great results.

One approach is to meter a gray target and use that light meter reading to calculate the best exposure. This technique works for any type of metering pattern. On most cameras, the light meter is roused into action by pressing the shutter button down halfway. On some models, you can also lock the exposure by keeping the shutter button at that halfway point and then recomposing to take the picture. Other methods of locking exposure also exist; we'll address them in the next section.

One approach, which works for any type of meter reading, is to meter a gray target and use that light meter reading to calculate the best exposure:

1. Fill the viewfinder with something that is close to 18% gray. Ideally this would be a standard photographic gray card, but since many photographers don't carry one all the time, you can also use other items with similar reflectance properties such as a pair of faded jeans, a gray sidewalk, or a concrete wall. The object you are metering, known as the *metering target,* has to be in the same light as your subject.

2. Press the shutter button halfway down to activate the light meter and hold it at that position to lock the exposure settings.

3. Frame the scene as desired, and carefully press the shutter button down the rest of the way to take the picture.

The only time you'll have a problem with this approach is if your proxy metering reference target is at a different distance from your camera than your subject. In addition to activating the light meter, pressing the shutter button halfway down on most cameras also turns on the autofocus system, and holding the shutter button halfway down to lock the exposure may also lock the focus. Unless you take this into account, metering off of a gray target may result in an excellent exposure of a blurry subject. For this technique to work best, you really need to have an exposure-lock function on your camera.

Exposure lock

Some cameras offer an exposure-lock button, or a menu command, that is separate from the shutter button. With a dedicated exposure-lock feature that's independent of the focusing controls, you don't have to worry about metering off of a gray reference that is a different focus distance than your subject. We view this as an essential feature if you are interested in more than casual photography with your camera (**Figure 7.13**).

Figure 7.13 By taking a meter reading from the subject's jeans, the exposure was locked and the portrait recomposed. Since the jeans are very close to a middle gray, the final meter reading and exposure is not influenced by the dark areas of foliage behind the woman.

Exposure lock, sometimes called AE Lock, can be found on many deluxe point-and-shoot cameras, and is a standard feature on most prosumer and pro digital cameras. On SLR cameras, the AE lock is usually a button that locks the exposure for as long as you hold it down. This allows you to take a meter reading, lock the exposure, and then reframe and focus the image to take the shot. On smaller cameras that don't offer as much physical area for additional buttons, exposure lock is more likely to be found in a menu command. Some exposure-lock controls will let you lock the exposure for the first shot and use that

setting for all subsequent shots until the AE lock is turned off. This can be very useful if you're taking several shots for a panoramic image that you will stitch together later in an image-editing program (**Figure 7.14**) We cover creating panoramas in Photoshop in Chapter 11, "Digital Darkroom Expert Techniques."

Figure 7.14 Exposure lock, or manual exposure, can be useful when photographing multiple images that will be later blended together into a single panorama. By locking the exposure across all the exposures, you can be sure that the meter will not react to different reflective areas within each scene, and the individual images will match better when merged together.

If your camera doesn't have an exposure-lock feature but does have manual exposure, then you can use that in place of exposure lock. In manual exposure mode, you would take a meter reading from an appropriate reference in the same lighting as your subject, adjust the settings to what the meter recommends, and then reframe, refocus, and shoot. When doing this, get close to the subject, so that it fills the frame, excluding any areas in the scene that contain significant tonal differences, and then take your meter reading. If you have a zoom lens, you can also use that to fill the viewfinder with your main subject. The one drawback to this approach is that it's hardly suited for fast, spontaneous photography, or situations where the light is changing rapidly, but it does suffice as a workaround if no other methods are available. Remember that with a digital camera you can always check the LCD screen and histogram to verify a correct exposure after taking the shot. This aspect of digital photography is a wonderful "safety net" that makes experimentation and taking chances with your photography much easier. Evaluating the histogram will be addressed later in this chapter.

Knowing When to Override the Meter

A good way to interpret the readings a light meter provides is to think of the meter as an advisor or a consultant. When you hire a consultant, or rely on the counsel of an advisor, you are making use of their expertise and experience in a specific field to help inform your own decision. They offer suggestions and advice, which you can then choose to follow, or not, based on the nature of each situation. There will be times when their recommendations are sound, and other times when you will choose to ignore their advice, or use it as a point of departure for a more customized approach. Knowing when to use the settings

recommended by the meter, and when to override them, is an important difference between just snapping pictures and consciously creating good photographs. Although you can read about when to override the meter in books such as this one, developing a real sense of when to modify the meter's settings will only come from practice and experience.

Although each scene is different, some situations have become known as classic examples of when to take the camera off of autopilot. We have alluded to some of these previously, but now we'll take a look at them in greater detail.

- **Backlight.** In extremely high contrast lighting situations, it's impossible to expose correctly for both dark and light areas of the image. Backlit conditions, where the dominant light source is coming from behind the subject, can be very difficult for even the "smartest" cameras. A good example of this situation is a portrait with a bright window in the background, or a scene with the main subject in the smooth, even lighting of open shade, but with a large expanse of sunlit area or dazzling sky behind them. The bright light in the background will fool the camera's meter and the resulting exposure will be too dark for the main subject (**Figure 7.15**). To correct for this, you can turn the flash on so that it fills in the darker areas of the image, or you can use exposure compensation to manually override the meter and give the shot additional exposure.

Figure 7.15 In the first image, shooting upward toward the sun and the bright sky has caused the statue to be underexposed. By using exposure compensation to let in more light, the camera settings are adjusted for a better exposure of the statue.

- **Snow and beach scenes.** These subjects tend to reflect a lot of light and are often underexposed, with the snow and sand showing up as a disappointing dull and dingy tone (**Figure 7.16**). A common rule of thumb is to use exposure compensation to override your meter's recommendation, and increase the aperture by a half to a full f-stop to compensate for the meter's 18 percent gray tunnel vision. This will brighten

up the light areas in the scene so that they look like they should, and not like the muddy gray that the typical meter exposure will deliver. This type of exposure problem is such a common occurrence that many cameras offer a scene mode designed specifically to address photographs taken in the snow or at the beach. You can also use exposure compensation controls, which we'll cover later in this chapter, to add the additional stops of exposure and arrive at a more appropriate setting.

Figure 7.16 Snow and beach scenes, or any image containing large, bright areas that reflect a lot of light, confuse a light meter and result in bright tones being underexposed (left). By using an exposure compensation setting to add a half to a full stop of exposure to the scene, the bright areas are properly exposed (right). Many cameras also have scene modes that are designed for this situation.

- **Nighttime.** Taking photos in low-light conditions, such as twilight and nighttime, represent a special challenge for light meters. When set to automatic, the default behavior on most cameras will trigger the built-in flash, which will flood the scene with the harsh flash illumination that we love to hate. The problem with built-in flash at night, however, is that the effective distance range of the flash is dependent on the ISO setting and is usually limited to 8 to 12 feet on most cameras. So what you typically get is a foreground that has received enough light for an adequate, if uninspiring, exposure, and a background that is dark and underexposed. If you're taking night photographs and want to preserve the feel and mood of the existing light at the scene, the first step to take in overriding the camera's exposure system is to turn the flash off.

 Even with the flash disabled, however, the meter's default inclination to try and place the tonal values in the scene at a reflectance level of 18 percent gray will overexpose any bright points of light in the image (such as twinkling city lights), and leave the dark areas, which should be dark, as an unsatisfying muddy tone that reveals too much noise. The same principle that works with snow and beach scenes can also be applied when photographing at night. Take your camera's meter reading as a starting point, and use it as a base from which to explore other exposure settings. Since the

camera tells you an exposure for reproducing a middle gray, the first thing to do is compensate for this by giving the shot less exposure than the meter recommends. You can achieve this by manually using a shorter exposure time, or by stopping the lens down to a smaller aperture (**Figure 7.17**).

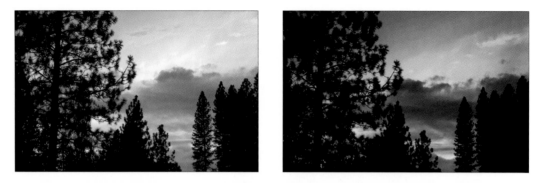

Figure 7.17 Night or twilight scenes can be especially challenging for a light meter, which will normally try to place the reflected tonal values at 18% gray, overexposing what should be a darker image (left). By consciously underexposing using a minus exposure compensation setting, the photograph will be more faithful to the true nature of the scene (right).

Some night shots may be too dark for the meter to accurately calculate an exposure. If this is the case, then you'll need to experiment with different exposure settings to find one that works for what you want to photograph. We cover long exposures and low-light photography in more depth on the companion Web site for this book.

EXPOSURE COMPENSATION

Exposure compensation is a great feature that lets you take the meter's recommended exposure setting and then consciously over- or underexpose the photograph to achieve a better result that is more customized for each individual scene. The wonderful thing about exposure compensation is that it frees you from having to calculate a specific f-stop or shutter speed in your head, letting you simply specify that you want more or less exposure than the recommended setting. Although you can certainly accomplish what it does by manually adjusting the exposure settings, the presence of an exposure compensation control is easier and faster than making changes in manual mode, and it's one camera setting that we use all the time (**Figure 7.18**).

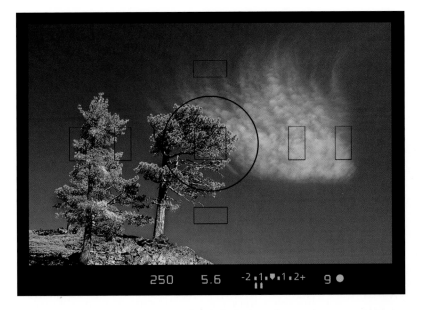

Figure 7.18 Exposure compensation is being used to underexpose this image by 1½ stops, so the large areas of dark blue will not cause the meter to make an exposure that is too washed out. The exposure compensation adjustment can be seen in the viewfinder information display.

How and When to Use Exposure Compensation

Fortunately for digital photographers, many cameras, even if they do not offer manual or semi-automatic modes, do provide the capability to use exposure compensation. The ease of use and accessibility of the controls will vary from camera to camera. On some compact models you may have to go into the camera's menu system and use the input buttons to select the desired setting. Other cameras provide buttons on the exterior body that may be easier to use than the menu, but you still may have to take the camera away from your eye in order to see which setting you're choosing. Such usability bottlenecks may make taking advantage of this feature too cumbersome when you need to react quickly to a spontaneous photo opportunity. For slower-paced photography, however, this is not a problem.

Our favorite exposure-compensation controls are the ones found on our DSLRs that we can quickly access by manipulating a rocker switch or a wheel without taking our eye away from the viewfinder. This allows us to respond quickly to changing situations, and it feels more natural and intuitive than stopping to cycle through a selection of menus.

Know thy light meter

The key to using exposure compensation properly is knowing how your camera's light meter will treat the scene in front of the lens. You need to evaluate the image in your viewfinder and then evaluate what the light meter tells you before deciding whether an exposure compensation adjustment is appropriate. Although the light meter may recommend a good setting for an adequate exposure of the scene, you may decide that you will get a better result if you underexpose slightly to deepen the shadows and improve the contrast and color saturation. Making a test shot and then evaluating the histogram can also tell you if such an exposure modification is warranted (see "Evaluating Exposure: Using the Histogram," later in this chapter).

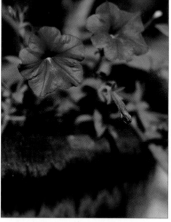

Figure 7.19 The image on the top was photographed at the meter's recommended settings. The image on the bottom was underexposed by 1½ stops using exposure compensation, which improved the contrast and color saturation.

The main thing to look for when deciding whether exposure compensation is needed is to compare the brightness levels of your main subject with those of the rest of the scene. If you notice a big difference in brightness, then the scene could probably benefit from some exposure tweaking or from a recomposition of the picture. If the background is substantially darker than your subject, underexpose a bit, and if it is significantly lighter than your subject, overexpose a bit.

But you don't need to restrict your use of exposure compensation to scenes with discrete foreground and background elements. Any scene that is predominantly bright and reflects a lot of light can be greatly improved by controlled overexposure. Keep in mind that the meter sees everything as 18 percent middle gray. If you are photographing something that is substantially darker or lighter than middle gray reflectance, then using an exposure compensation setting can make the difference between an average exposure and an outstanding one (**Figure 7.19**). A good general guideline to follow is that if the scene you're photographing is bright, you should use exposure compensation to add exposure of ½ to 2 stops so that the meter won't expose it as a middle gray tone (**Figure 7.20**). If the scene is dark, then you should subtract exposure of ½ to 2 stops so that the darker tonal characteristics are preserved (**Figure 7.21**).

Figure 7.20 With no intervention on the photographer's part, bright white subjects, such as this classic white Bentley, photographed in full sun, will be underexposed by the camera's light meter (left). To ensure that the bright white areas are being recorded as bright white, use exposure compensation to purposefully overexpose the image (right). In this example, the brighter image was overexposed by two stops to capture the clean white tones of the classic car.

Figure 7.21 When photographing very dark subjects, use exposure compensation to subtract exposure and preserve the dark characteristics of the scene. The image on the left was shot at the meter's default normal setting, and the image on the right was purposefully underexposed by two stops to faithfully capture the deep black tones of the plane's tail.

Taming digital exposures: underexpose rather than overexpose

If you're used to making images with film, then you may be familiar with the advice that says, when in doubt, it's better to slightly overexpose negative film than underexpose it. This stems from the fact that with an underexposed negative, the light-sensitive silver crystals have not received enough exposure to form a good image on the film. A print made from an underexposed negative is marked by lack of detail in the shadows, flat contrast, dull color saturation, muddy dark tones, and more noticeable film grain. An underexposed negative is difficult to print in the darkroom, and while an experienced printer can make definite improvements, the print will never be as good as one made from a negative that was properly exposed, or slightly overexposed.

With slide or transparency film, the opposite is true; when in doubt about exposure, it's better to slightly underexpose than overexpose. An overexposed slide appears too bright, with low contrast, blasted highlights, and washed-out colors. Slide film, however, has a much narrower exposure latitude or dynamic range than negative film, and while underexposure may yield good contrast and punchy color saturation, it may come at the cost of lost shadow detail in the darkest areas of the image.

In terms of *exposure latitude,* or the ability to capture a specific range of contrast in a single exposure, the image sensors on current digital cameras have a dynamic range that is similar to that of color slide film. Since this is the case, the exposure recommendations for slide film actually work fairly well for digital captures, with a little adjustment. When in doubt about the camera's ability to record detail in bright highlight areas, it's generally safer to underexpose the image by ⅓ to 1 stop than to expose normally and risk blown-out highlights. If the bright highlights are overexposed in a digital capture to the point where they are a total white with no detail, there's no way to recover detail that was never captured in the first place (**Figure 7.22**). Controlling the highlights by slightly underexposing may leave the overall image looking too dark, but you can easily adjust this in Photoshop or another program (**Figure 7.23**)

> **NOTE:** *Although slightly underexposing to preserve highlight detail is a commonly repeated digital exposure "rule," if you have the time for exposure testing and tweaking, it is actually much better to expose so that the image is as bright as possible without totally overexposing the bright highlights. This means making sure that the recorded tonal values fill as much of the right side of the histogram as possible, without falling off the right edge into a total white. This exposure practice ensures that there is maximum data in the most important areas of the tonal range (the right side of the histogram) and will help keep noise to a minimum. The midtones and shadows will almost certainly appear much too light for your tastes, but you can adjust and darken them later as needed. This approach is best suited for RAW images, where you can fine-tune the exposure before opening up the image in Photoshop. See "Left, Right, or Center? Exposing for the Best Possible Histogram," later in this chapter.*

Figure 7.22 The white umbrellas in this photo have been overexposed and the highlights are blown out to a total white with no detail (level 255). If highlight detail is never recorded in the original exposure, then it's gone for good.

Figure 7.23 Controlling bright highlights by slightly underexposing the image is one way to prevent lost detail in the brightest areas of the photo. Though this often results in a dark photo, the image can be brightened later in an image-editing program. This practice works best when photographing in RAW mode so you can take advantage of the high-bit data. A better way to approach this is to use the "expose to the right" method (See "Left, Right, or Center? Exposing for the Best Possible Histogram" later in this chapter).

The easiest way to accomplish any intentional underexposure is to use your camera's exposure compensation feature to enter a minus exposure value that's appropriate for the lighting conditions you're shooting in. The tendency of digital exposures to record very bright highlights as totally white is most noticeable under bright sun and high-contrast situations, especially if the camera's meter is calculating its exposure based on darker areas of the scene. The white foam of surf and waves on a sunny day at the beach, for example, or blonde hair under a bright sun are common situations where blown-out highlights are a possibility. In such conditions, an exposure compensation setting of –1 to 1 ½ stops will help prevent the loss of highlight detail. In scenes where the lighting is soft, diffuse, and low contrast—such as images made on an overcast day or in the open shade—the problem is much less likely to occur, but it can still rear its ugly head, even when you least expect it. Underexposing by ⅓ stop on cloudy days can provide a little extra room at the bright side of the histogram in the event that highlights are causing problems. Taking some test shots at the start of your photo shoot and evaluating the histogram is a good way to be sure you're getting the best exposure for all areas of the scene.

EVALUATING EXPOSURE: USING THE HISTOGRAM

The histogram is the primary tool for evaluating exposure, allowing you to check exposure either before or after (depending on your camera's features) you take the picture. This tool is incredibly useful for deciding whether or not you need to retake the shot with corrected exposure settings. Although the histogram is typically not offered on the least expensive digital cameras, it is available on all digital SLRs, many prosumer models, and even some deluxe point-and-shoot cameras as well. For serious image making with a digital camera, the histogram is an essential tool for making better pictures. In fact, on the few occasions that we do shoot film, we tend to find ourselves taking the picture and then looking at the back of the film camera—only to be disappointed not to see an LCD and histogram display.

The histogram shows how the tonal values in the image are distributed along the camera's grayscale tonal range. If you're new to the concept of a histogram, it's not really as mysterious as it seems. Essentially it's just a bar graph, with the horizontal axis representing the tones from total black on the left (level 0) to total white on the right (level 255). The vertical bars indicate the number of pixels at a given location on the tonal scale. With underexposed or dark images, the vertical bars tend to bunch up on the left side of the graph, while with photos suffering from overexposure, the vertical bars congregate on the right side. An exposure that exhibits a good tonal range with neither under- nor overexposure has data that covers the full range of the histogram (**Figure 7.24**).

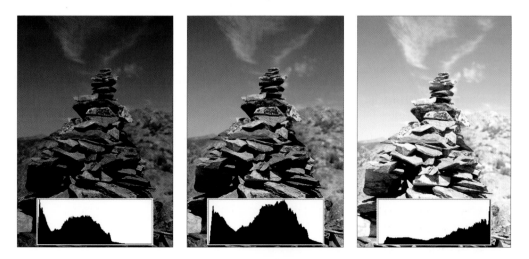

Figure 7.24 Learning how to interpret your camera's histogram feature is essential to capturing a good exposure. From left to right, the three images of the rock cairn are underexposed with lost shadow detail, a good exposure that fills the tonal range, and an overexposed shot with blown-out highlights.

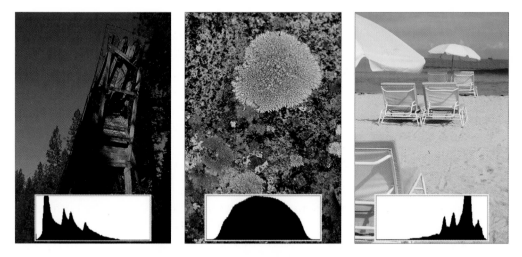

Every photo will have a different histogram shape that is appropriate for it based on the tonal values present in the scene. In darker images, for example, it is natural for the values to be grouped on the left side, while on bright images, they will be grouped on the right side of the histogram.

The histogram usually displays only on the luminance (brightness) values of the image rather than showing individual histograms for the red, green, and blue color channels. If the colors in a single channel are getting blown out (such as in the red channel), the luminance histogram may not show this. Or it could show up at the far right side of the luminance histogram as a spike that is caused by an extremely bright red value from a specular highlight in the image (*specular* highlights are the only highlights that are appropriate to be recorded as totally white).

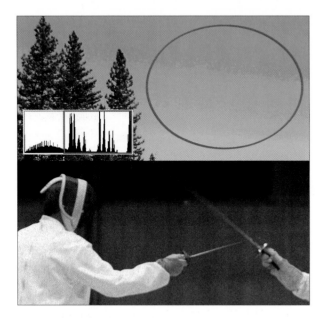

Figure 7.25 The top image shows heavy posterization in the sky (and this does show in the inset histogram), and the bottom image was photographed at ISO 1600 under low light and is very noisy. Subtle posterization and severe noise cannot be evaluated by looking at the histogram.

Other qualities, such as color saturation, accuracy of the color rendition, *posterization* (banding) along color transitions, and noise levels, are not addressed by the histogram and are generally too subtle to notice on the camera's small LCD screen, even with the ability to zoom in on the image. In extreme cases posterization may be revealed in the histogram, but you have to know what to look for, and it still may not show up well on the LCD (**Figure 7.25**). To properly evaluate these, you'll need to download the image onto a computer and review it on a good monitor in a program such as Photoshop.

Left, Right, or Center?
Exposing for the Best Possible Histogram

With digital cameras, especially those that can capture RAW high-bit files, not all tonal values are created equal, and some areas of the tonal scale are more important than others. Michael Reichmann, the publisher of The Luminous Landscape (www.luminous-landscape.com), told us of a conversation that he had on this subject with Thomas Knoll as the two drove across Iceland during a photo workshop in the summer of 2003. Thomas Knoll, and his brother John, are the original creators of Adobe Photoshop; Thomas is the author of the Adobe Camera Raw plug-in for Photoshop.

According to Knoll, the far right side of the histogram that represents the brightest tones in the image is by far the most important, because it contains most of the image's tonal data. To create the most optimum exposure, therefore, the

tonal values should be as far to the right side of the histogram as possible, without being jammed up against the edge of the scale (which would indicate overexposed, blown-out highlights). To understand the reasoning behind this theory, let's take a look at the dynamic range of a digital SLR and examine the behavior of the image sensor.

Reichmann points out that the typical digital SLR has a dynamic range that's between 5 and 6 stops. For the purposes of this discussion, however, we'll round it down to 5 stops. When shooting in RAW format, most cameras record a 12-bit image. A 12-bit image can contain 4096 separate tonal values (as opposed to the relatively meager 256 tones that you get with an 8-bit image). If you spread 5 f-stops across the 4096 tonal values of a 12-bit image, the natural inclination would be to divide them evenly across the histogram, so that each f-stop of the 5-stop dynamic range would contain 850 (4096/5) tones. Unfortunately, this is not how it works out. In reality, the first, and brightest, stop contains 2048 of the tonal steps, which represents half of the total tonal values available in the image!

The reason for this lies with the fundamental behavior of an f-stop, as well as the behavior of the image sensor in your camera. If you remember how f-stops work, you know that each f-stop records half as much light as the previous one. CCD and CMOS image sensors are linear devices; half as much exposure translates into half of the remaining data slots on the tonal range. So if the histogram were divided into fifths, the far right-hand section representing the first f-stop and the brightest tones, would contain 2048 values, and the next section, representing the 2nd f-stop, would contain half that many, or 1024 values. The third f-stop, representing the middle tones would contain 512 tonal levels. The fourth, 256 levels, and the fifth f-stop, representing the darkest tones in the image, would contain only 128 tonal values (see **Table 7.2**).

Table 7.2 Linear Tonal Distribution in a 12-Bit Image with a 5-Stop Dynamic Range

1st f-stop/ brightest tones	2048 tones
2nd f-stop / bright tones	1024 tones
3rd f-stop / midtones	512 tones
4th f-stop / dark tones	256 tones
5th f-stop / darkest tones	128 tones

The moral of the story, Reichmann concludes, is that you need to be using as much of the far right of the histogram as possible. If not, then you're squandering fully half of the available recording levels of your camera. To achieve this, check the histogram after taking a shot. If it's a bright day and you have shot your image slightly underexposed to ensure that the highlights don't blow out

(continued)

(see the next section "Controlling the Highlights"), check to see how much empty space is on the far right of the histogram. If there's a gap between the data and the right side (**Figure 7.26**), then increase your exposure, take another shot, and review the histogram again. The goal here is to have the data bars grouped as closely as possible toward the far right edge without actually running into the end of the scale (**Figure 7.27**).

Figure 7.26 A "normal" histogram with plenty of empty space in the vital right side.

Figure 7.27 A histogram that has been "exposed to the right" to take advantage of the most important part of the tonal range.

When the image is opened using Photoshop's Camera Raw, or another RAW conversion program, the tonal values can be redistributed to achieve the overall brightness and contrast that you desire (**Figure 7.28**). The main benefit to exposing and then adjusting the RAW image this way is that it will maximize the signal-to-noise ratio and minimize the possibility of posterization (banding) and noise that can occur in darker areas of the image.

Figure 7.28 The same histogram from Figure 7.27 after the 16-bit values were modified in Photoshop to fill the entire tonal range.

Reichmann points out that while this exposure practice is great for capturing the best collection of tonal data in an image, it may not be ideal for photographing fast-moving subjects, for handheld shooting in low light, or for shooting in quickly changing conditions, as photojournalists and sports photographers do. Because of the need for larger apertures and slower shutter speeds, the practice of "exposing to the right", as he calls it, will effectively lower the ISO that is

used to capture the image. However, for slower-paced subjects such as land-scapes, still life, and portraiture, where you can adopt a more considered approach, this technique is an excellent way to improve your exposure to capture the best possible information.

Controlling the Highlights

If you review the histogram after taking a shot, and you see the mountain silhouette of the histogram running smack up against the right side of the display, this is a sign that the bright highlights have been clipped, or recorded as a total white with no detail (**Figure 7.29**). Some cameras will even display the image with a flashing overlay to indicate where the overexposed highlights are in the photograph (**Figure 7.30**). If you notice clipped highlights in the histogram, then you need to retake the photo and adjust the exposure to prevent the highlights from being rendered as a total white.

If your camera offers a full range of exposure modes, you could modify the settings several ways, but exposure compensation is usually the quickest way to achieve this end and it's the method we use most often. Based on experience, we recommend leaving the exposure compensation set at a minus exposure of ⅓ to ½ stop all the time, even on cloudy days. At the very least, this should insulate you from blown-out highlights, especially if you're working fast. You may not think there is a contrast problem, but remember that the camera's eye sees the world differently than you do. Taking a test shot and checking the histogram will reveal whether there is a problem If the photographic situation allows for more contemplative and considered exposure, then you can use the "expose-to the right" practice recommended previously.

Katrin's exposure compensation formula is usually ½ stop underexposed for a low-contrast day with no hard shadows, 1 stop under for a bright day with shadows, and 1 ½ stops under for exceptionally bright days with deep, sharp shadows (and if that doesn't do the trick, then it's time to go home!). These settings are subject to review, of course, as we are photographing and checking the histogram for each shot. Although these exposure compensation settings can serve as a starting point, we never totally rely on a rigid formula and are always modifying our exposure to get the best possible histogram. We recommend that you check the histogram frequently as the lighting, composition, subject brightness, or metering method changes, to ensure that you're capturing a good tonal range in your photographs.

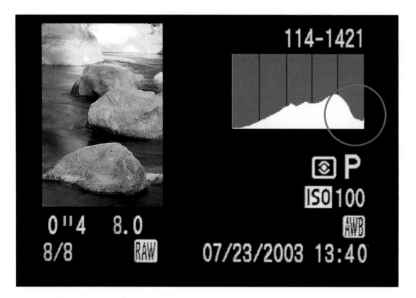

Figure 7.29 The highlights at the top of this image are overexposed to absolute white with no detail. The histogram shows this where it runs up against the right side.

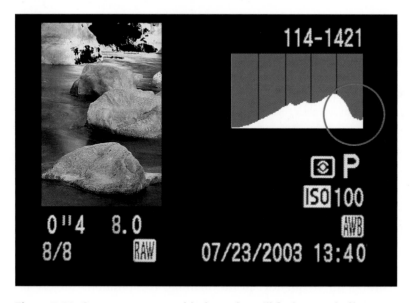

Figure 7.30 On some cameras, a black overlay will flash on and off over the areas on the image where highlight clipping occurs.

For most photographic images, the only highlights that should be recorded as a total white are specular highlights, such as bright reflections on glass, water, or polished metal (**Figure 7.31**). Highlights with detail, such as a white jacket, or the puffy, white textures of clouds on a summer day, are usually better when placed slightly darker than total white. By making sure the tonal levels are grouped as far to the right edge of the histogram as possible without running right up against the edge, you can be sure that the highlights are not being recorded as total white and that you're utilizing the vital right-hand fifth of the histogram (see the sidebar "Left, Right, or Center? Exposing for the Best Possible Histogram"). The tonal value of a blasted highlight can be reduced and slightly darkened in Photoshop, but if the detail was not captured in the original exposure, it is lost forever.

Figure 7.31 Specular highlights, such as the bright reflections in the headlights of this classic car, are the only photographic highlights that are appropriate to be totally white.

Preserving shadow detail

Although histogram displays do not usually have a flashing overlay feature for underexposed areas of the image that have been rendered as a total black with no detail, you can still see how shadow detail is being exposed by how the histogram bars look on the left side of the graph. As with the highlights, if the vertical bars run right up against the left side and appear cut off, this is a sign that the dark shadows do not have a gradual progression from

dark to total black. Since shadow tones are darker than highlights, *shadow clipping* (which is when detail is cut off and rendered as a total black) is harder for the eye to see. Zooming in on the LCD screen may tell you if detail has been captured in important shadow areas, but you'll probably need to throw your jacket over your head or use an LCD viewing hood to properly evaluate this. In any case, the zoomed view that you see on the LCD either is rendered on the fly or is a separate thumbnail image and does not represent the full resolution data of the photograph, so evaluating shadow detail this way is questionable. However, if your photo does contain subtle shadow details that you want to be sure are recorded so that you can work with them in the digital darkroom, the histogram can help you keep track of these tones as you photograph. Using exposure compensation is the easiest way to increase exposure so that the shadows are not too dark. In **Figure 7.32**, the darkest tones on the plane's tail section are being recorded as a total black. In this case, we would gradually increase the exposure with a plus exposure compensation setting and review the histogram after each shot until we saw that the shadows were not clipped to black.

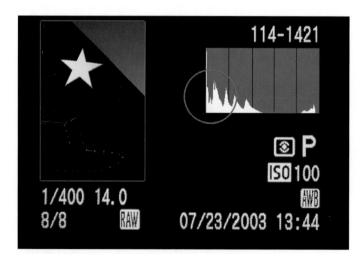

Figure 7.32 When the tonal data runs up against the left side of the histogram, it means that there is clipping (tones forced to a total black with no detail) in the shadows.

Dealing with impossible contrast

If you're photographing under harsh, bright lighting, you may face a situation where the contrast range in the scene exceeds what your camera is able to capture in a single exposure. If you can only take a single shot under these conditions, such as with photojournalism, sports, or wildlife subjects, then you have to decide which area of the tonal range is more important to the shot. Generally, it's preferable to expose so that the highlights are not blown out. As stated previously, darker midtones and shadows can be lightened, but there is no good fix for a blasted highlight. If the subject can be moved, such as with a portrait, try to find a place where the lighting provides more even coverage with no harsh extremes. For subjects where you don't have that luxury, you can try to reframe the shot so

that a different composition provides an image with less challenging contrast. As with all good photographic composition, search for the view that distills the image down to the essentials. In excluding extraneous and distracting elements, you might also end up with a contrast range that is easier for the camera to deal with.

For photographs such as landscapes, where shooting quickly is not a major factor, you may be able to take two shots of the same scene with different exposure settings. One shot would be created to capture the bright highlights, and the other would be given more exposure to capture an image with better detail in the midtones and shadows. You could then merge the two exposures together in Photoshop to create an image with the extended contrast range you couldn't capture in one shot. This approach works best when the camera is mounted on a tripod to ensure that both images will line up precisely (**Figure 7.33**). We'll cover this procedure in more detail in Chapter 11, "Digital Darkroom Expert Techniques."

Figure 7.33 By making two separate exposures on a tripod, one for detail in the brightly lit pool (A), and the other for the darker tiles around the pool (B), the two images were combined into a single, perfect exposure (C).

In search of the perfect histogram

Keep in mind that there is no "perfect" histogram shape that is appropriate for all images. The histogram is merely a graphical picture of how the tones in the photo are spread out from black to white, and it will be different for each image and also for how you want to portray each scene (**Figure 7.34**). The perfect

histogram for a landscape photo is not the same as for a dark and mysterious portrait. For some photos, such as night shots that contain large areas of dark sky, it's natural to have the shadows appear clipped, since significant areas of the image are black with no detail. On flat, low-contrast images, such as fishing boats in the early morning fog, it's also natural for the histogram to contain very few tones in the brighter highlight areas.

The important thing to glean from reviewing a histogram is that it captures a full range of tones, especially in the all-important right-hand fifth of the scale, and that highlight values are not being clipped, or recorded as a total white. If detail in the deep shadow values is important to the image, you should check that they are not being recorded as a total black (values slammed up against the left side). Don't worry if the image appears a bit flat or low contrast on the LCD screen; you can fix this later in Photoshop. It's better to have a slightly flat photo than one with excessive contrast that suffers from clipping in either the shadows or the highlights.

Figure 7.34 These three photographs all have good exposures, yet their histograms are very different. There is no perfect histogram shape that is appropriate for all images. Every scene will generate its own individual tonal signature.

TIP: Using the camera's RAW format is another way to maximize the exposure possibilities of any lighting situation you might find yourself in. With RAW you typically have an additional plus or minus 2 stops of exposure that you can take advantage of in the digital darkroom after the photograph has been taken. Although this won't help you in cases where the highlights are definitely blown out, or shadow detail is nonexistent, it can provide great flexibility for adjusting the majority of the tonal range. RAW also gives you access to the high-bit-depth data of the digital capture, and the additional tonal levels offered by a 12-bit capture can be very useful when trying to perform complicated adjustments on images with exposure problems.

WHITE BALANCE

The white balance setting tells your camera what type of light (for example, tungsten, fluorescent, daylight, flash, and so on) is the primary source of illumination for the scene. We covered the technical aspects of choosing a white balance, as well as the scientific background behind color temperature, in Chapter 6, but because this chapter deals with seeing the light, and because the color characteristics of light are something that affects the look of the image, we'll revisit it here so we can view it from a different perspective.

At the most basic level, the white balance setting determines how the camera interprets the light in a scene as it relates to color balance. All digital cameras offer an Auto White Balance option, and many others provide several presets that are designed for specific lighting conditions such as standard household lights, fluorescents, electronic flash, cloudy days, open shade, and so on. Understanding what setting to use depends on the type of lighting at hand, as well as on how you may want to record the scene.

For most situations, we find that Auto White Balance works quite well. For some scenes, however, you may want to consciously choose a specific white balance that is more appropriate to the existing lighting, or even ignore the "correct" white balance in favor of one that will produce a desired effect. If you're taking a photo meant to convey a nostalgic feeling about childhood memories of home, for example, and only the light of a single table lamp or a fire crackling on the hearth lights the scene, the color balance of the image will tend to be very yellow. To correct for this you could rely on the camera's Auto White Balance, or even choose a tungsten setting, to shift the colors to a more neutral color balance. Depending on the mood you want to establish, however, you might want to preserve that yellow light to convey a feeling of warmth and contentment (**Figure 7.35**).

TIP: If you do decide to experiment with the preset white balance settings, get into the habit of reviewing all camera settings every time you turn on the camera, or when you move to a different location. It's very easy to choose a white balance setting that works well indoors, for instance, and then forget about it when you move outside, which would result in miscolored images that may or may not be correctable in the digital darkroom.

Figure 7.35 Not all color casts are undesirable, and sometimes you need to turn off Auto White Balance in order to capture a particular type of lighting. In this image, the light is coming from two lamps and the fire in the fireplace. The strong yellow cast conveys a sense of warmth and nostalgia, which works for this particular image.

Creating a Custom White Balance

Most high-end digital SLRs, many prosumer models, and even some deluxe point-and-shoots, offer the ability to create a custom white balance by reading the light that is reflected from a white or neutral gray object. The camera then uses that as the basis to calculate the custom white balance setting. Essentially, what you are doing is telling the camera that the object should be white or neutral gray, and the camera is compensating for the color characteristics of the light that is striking the object. With most custom cameras, any custom setting you create will be used for all custom white balance shots until you create a new setting. Measuring a new value will delete the previous setting from the memory. Choosing a custom white balance, though not something you'll do every day, can come in handy, particularly in situations where the light sources are mixed, or when you need to compensate for any artificial light source that has a strong color cast (**Figure 7.36**).

Figure 7.36 The lighting for this diner scene was a mixture of fluorescent and tungsten. In the image on the left, Auto White Balance was used. In the image on the right, a custom white balance setting was used. As you can see, the image on the right has neutral tones and will require less digital darkroom work.

If you're shooting RAW files (see the sidebar "White Balance and the RAW Image"), using a custom white balance setting in the camera is not that useful, except perhaps as an initial starting point. For those photographers who need to shoot JPEGs, however, and who find themselves working in locations where the lighting is a blend of different sources, such as office fluorescents combined with large areas of window light, then using a custom white balance setting can provide an excellent way to match the exposure to the color temperature of the available light.

White Balance and the RAW Image

White balance settings are only applied to the image if you are using JPEG or TIFF formats. If you shoot in a RAW format, then the white balance setting at the camera level doesn't matter, since the RAW data from the image sensor is not altered in any way before it's saved to the memory card. With a RAW file, white balance is just another setting that you can apply when the image is converted into a more standard format using RAW conversion software. You can still measure the light at a location and use a custom setting while shooting RAW if you want to be able to apply the white balance "as shot" or further customize the setting in the conversion software. Placing a GretagMacbeth ColorChecker in the scene you are photographing gives you a good reference to use in a "control image." By clicking on the light gray patch in the GretagMacbeth ColorChecker in Camera Raw, you can use that as a reference for neutralizing the image. The same settings can then be used for other shots photographed under the same light. We cover techniques for neutralizing color casts in Chapter 10, "Essential Image Enhancement."

Shooting RAW also protects you from forgetting to reset the white balance if you change locations and find yourself outdoors after shooting inside in artificial light. Along with additional latitude in exposure, we feel that this is another compelling reason to shoot in the RAW format (**Figure 7.37**).

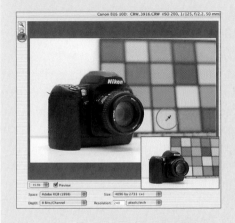

Figure 7.37 Another advantage to shooting in RAW is that you can use the eyedropper in the Camera Raw dialog to neutralize colors in an image. This is essentially creating a custom white balance after the image has been captured. For a target tonal value, you can use something that should be a neutral gray, or include a Macbeth ColorChecker chart in a test shot and click on the light gray square.

White Balance Auto Bracketing

If you find yourself in tricky lighting and are unsure which setting will work best, white balance bracketing may provide an elegant solution to the problem. This feature, which is usually only found on higher-end cameras, will automatically shoot a single image and then create two additional copies of the shot and apply a different white balance to each one. The primary white balance is based on the current setting, or if Auto White Balance is in use, on what the camera determines to be the best setting. The bracketed settings are derived from the main color temperature and range from a cooler, bluish tone to a warmer reddish tone. Like exposure bracketing, the differences in the white balance can be fine-tuned, usually ranging from +3 to –3 in whole-stop increments; some cameras may offer adjustments in fractions of a stop (**Figure 7.38**).

It should be noted that the use of the term *stop* for adjustment in white balance is just a convenience, since that is a means of expressing exposure modifications that most photographers are familiar with. In exposure terms, a full stop means that the image is receiving half as much or twice as much exposure—and this has no real correlation when applied to white balance. Cameras that offer white balance bracketing usually apply the modifications in units of *mireds* (pronounced "my-reds"). Since the calculation of mireds is far more complicated than thinking in terms of simple exposure stops (see the sidebar "Once Upon a Mired"), the latter method is generally how the changes in color temperature are expressed for bracketing white balance. The conversion factor from mireds to stops that a camera uses will vary by manufacturer, and also according to whether an exact preset color temperature or Auto White Balance is being used. On the Canon EOS 10D, each full-stop bracket increment is equivalent to 5 mireds, while on the Nikon D100, each stop equals about 10 mireds in Auto White Balance mode. For specific color temperature presets such as those for fluorescent, tungsten, daylight, flash, shade, and cloudy, the D100 applies precise color temperature adjustments. In the fluorescent setting, for example, the size of the increments is greater than the other presets. This is designed to accommodate the wide variation in color temperature among different types of fluorescent light sources, which include low-temperature stadium lighting, standard office lighting, daylight-balanced fluorescent tubes, and high-temperature mercury-vapor lamps.

White balance auto bracketing is best used when you are unsure if the camera's color temperature setting is the same as the light source. You might choose a fluorescent setting when photographing inside a warehouse, for example, but you may be faced with a situation of mixed lighting consisting of different brands and ages of fluorescent tubes, tungsten or halogen desk lamps, and perhaps even some daylight coming from large, open areas on a loading dock. In such a location, using the camera's custom white balance setting would also be another option. One thing to remember about white balance bracketing is that it will drastically decrease the number of shots you can fit on a memory card (it writes three files for each shot you take). This feature is also not available if you are shooting in a RAW file format.

Figure 7.38 These images were taken using an Auto White Balance bracketing sequence. The image on the top is the closest to how the scene looked in reality.

Once Upon a Mired

As discussed in Chapter 6, color temperature is measured in degrees Kelvin. Another unit of measure that is used when talking about color temperature is the *micro reciprocal degree*, more commonly known by the term *mired*. A mired is an approximate unit that represents the smallest change in color temperature that is perceptible by the human eye.

Mireds are used to express the differences between color temperatures in order to convert from one to another using photographic filters, such as when shooting under a tungsten light source (3200K) with daylight-balanced film (5500K). Digital cameras use the term to specify how differences in color temperature translate into the exposure stop system that most photographers are familiar with.

The mired value for a given color temperature is obtained by dividing 1 million by the color temperature. Using this formula, the mired value for standard tungsten light is 312 (1,000,000 / 3200 = 312). The reason for this complicated method of conversion is that changes in color temperature will produce a more noticeable color difference at low-color temperatures than at high-color temperatures. A 1000K difference between 2200K and 3200K, for instance, is 142 mired, but the same difference between 5000K and 6000K is only 34 mired. The mired is a way of measuring color temperature that takes this into account; because of this, it is the unit that is used for calculating differences in color temperature compensation filters.

To return to the earlier example of using daylight-balanced film (5500K = 182 mired) under a tungsten light source (3200K = 312 mired), the difference between the two is approximately 130 mired. A standard filter that would be used in this situation is an 80A, a light blue filter that is designed to increase the color temperature of the light from 3200K to 5500K. For film photography where actual filters are used, the downside is that the filters decrease the amount of light that enters the lens and must be compensated for by an additional $2/3$ to 1 stop of exposure. With digital photography, you can adjust for differences in the color temperature of the light source with no impact on exposure settings.

Breaking the Rules:
White Balance as a Creative Tool

Just because certain white balance settings exist for specific lighting situations, there's no reason that you can't depart from those guidelines and employ them for artistic effect. When used this way, the white balance settings are similar to warming or cooling filters that have long been used in traditional photography. If you use a tungsten or incandescent setting outside, for example, the scene will be rendered in cool, blue tones. This can be useful for suggesting the cold light of winter, or a certain time of day such as early dawn (**Figure 7.39**). Although using the white balance presets as digital "filters" is very convenient and easy to do, we prefer to capture the image without any creative interpretation applied in the camera. Just as a film negative does not necessarily contain all of the interpretations that may be inspired by it, we like to keep our digital original unaltered in terms of color filtration and use Photoshop to apply such effects where we have more flexibility and control.

Figure 7.39 This portrait was photographed outdoors using a tungsten white balance setting for creative effect to suggest a cool tone or the look of early morning.

EVALUATING IMAGE QUALITY ON THE LCD SCREEN

After making sure that you are metering the light properly, using exposure compensation when appropriate, and checking the histogram to verify that you have captured a good exposure containing all the tonal information necessary to make a fine print, you need to review the image to check for various aspects of image quality. The camera's LCD screen is a window onto the images you have already made and as such, it is a valuable tool for evaluating exposure, checking how the light in the scene has been translated into the digital image, and how flattening the 3D world we live in into a 2D surface is working. Seeing the image within seconds of pressing the shutter button gives you the opportunity to retake the shot with a different exposure setting, explore a new angle of view, or move on to a different scene. Of course, a 1-inch-tall screen on the back of your camera is no match for a good desktop monitor, but you should be able to look at the image thumbnail on the camera and get a good sense of the overall exposure and colors in the image.

Although the LCD certainly represents a wonderful development for photographers, enumerating all the great things it can do is pointless unless you also remove the rose-tinted glasses and take a hard look at all the things it can't do. As with any other feature on a digital camera, the LCD monitor has its limitations, especially when it comes to evaluating subtle exposure and focus differences, and knowing these limitations can give you a better understanding of what the little images on the screen are showing you.

Keep in mind that the angle at which you view the LCD can drastically affect the quality of the display. You can try this out by tilting the camera up and down or left to right to see this effect in action. In this respect, the monitors on digital cameras have the same problems as LCD screens on laptop computers. The ambient light level is also a factor in how well you can evaluate the image, with brightly lit, outdoor conditions making it very difficult to get a good view of the image.

What Are You Really Seeing?

In most cameras, the image you see on the LCD is not the actual full-resolution photo, but a separate low-res thumbnail image, or a low-res display that is generated on the fly from the actual image data. When shooting in the RAW format with a Canon SLR, for example, the camera generates a low-resolution .thm (thumbnail) file that is used for the LCD display and also for viewing in the Canon File Viewer utility. This can be critical, especially when zooming in on an image to check for fine focus. Since you are never seeing the actual, full-resolution image that the camera has captured, certain things, such as shadow detail, noise, and the smoothness of color transitions, can be difficult or impossible to evaluate on the LCD screen.

Configuring LCD Settings

Many cameras offer controls that affect the behavior of the LCD screen. Some are more significant than others, but all the controls influence how you interact with the LCD as a photographic tool for evaluating image quality:

- **Brightness Control.** For reviewing images, one of the most useful of the LCD settings is a brightness control. Although this option was less common on older cameras, more of the newer models are shipping with an LCD brightness control, and some even display a gray step bar so you can see how changes to the brightness are affecting a standard tonal reference. For most situations, we have found that the default brightness level is adequate for reviewing the thumbnails, but in outdoor situations where there is a lot a bright light, increasing the brightness of the display may make it easier for you to see the image. Just remember that increasing the brightness of the display has no effect on the image itself, so you shouldn't rely on this for reviewing the tonal characteristics of a photo. Evaluations of tonal levels, especially highlights and shadows, should be made using the histogram.

- **Image Review.** With an image review feature turned on, the camera will automatically display a thumbnail of the photo immediately after it has been captured and as it is being recorded to the memory card. This is a great way to quickly check the image before moving on to the next shot. The duration of the display can often be changed, usually ranging from 2 to 8 seconds. Once the display time ends, the LCD will either turn off if the camera is a DSLR, or if the camera is a non-SLR, it will switch back to a live-feed image of what is being seen through the lens. You may also be able to leave the display on until the next shot is taken, though we don't recommend this because it drains precious battery power.

- **Image Review with Histogram.** Cameras that provide a histogram display may also have the capability to display an immediate image review that includes a histogram for the photo. If the photography you do requires fast reactions, you can use this feature to take a shot: Quickly glance down to check for highlight overexposure, then return the camera to your eye, dial in an exposure compensation setting, and be ready for the next shot. Cameras that display a flashing overlay on overexposed areas make these kinds of quick evaluations even easier.

- **Monitor Off.** Any decent camera should also have the ability to turn the monitor off, either through a dedicated button on the camera, or with a timed setting that can be selected in the camera's menu options. The LCD display is one of the main drains on the camera's battery, so using it only when you need to will give you more mileage from a single battery charge.

Checking Focus and Sharpness

The LCD screen can be used to check overall focus in an image, including how depth of field appears, but it is typically not ideal for determining fine levels of sharpness, particularly on areas in the image where details should be crisp. Many cameras provide the capability to zoom in on the thumbnail image and even scroll around to check on different areas of the magnified view. Even with this feature, however, we have found that it is difficult to truly judge the sharpness of a shot based solely on the LCD, because the zoomed view is not the actual high-res photo, but a scaled-down rendering for the LCD display. In most cases, the view on the LCD will look less sharp than on a large monitor. Turning off the camera's built-in sharpening feature (a move we recommend) is another reason that zoomed-in views of the image may look slightly soft. If you are shooting in RAW format, the image is not sharpened by default, no matter what the sharpening options in the camera's menu may be set at.

Although not extreme, this slight visual disconnect between the sharpness you see on the LCD and what you see on a large monitor can be an issue, especially if you find yourself at a location where sharp focus is critical, and you can't easily return to retake shots where the sharpness is less than satisfactory (**Figure 7.40**). Sometimes, you just have to take for granted that the shots are sharp, and use time-tested photographic practices (use a tripod, manual focus) to do all you can to capture an image that has sharp focus where you need it. Knowing how your lenses perform, especially at different focal lengths and at various apertures, is critical to ensuring that you come home with images that have good focus. Shutter speed affects sharpness—more so with longer, telephoto lenses—so try to use a shutter speed that is appropriate for the focal length you're using. The common rule of thumb for handheld photography is to use a shutter speed at least as fast as the focal length of the lens. For a 250mm lens, for instance, you would not want to use a shutter speed of less than $\frac{1}{250}$ of a second. Remember to factor in any focal length magnification that may be taking place. For example, if you have a 28mm to 135mm zoom lens on a camera with a 1.6x focal length magnification factor, at 135mm the focal length is really 216mm. If the need for greater depth of field forces you to use a slower shutter speed, use a tripod to ensure that the camera is steady. An electronic cable release will prevent movement from your hand from affecting the camera as you press the shutter button, and in some situations, especially with longer exposures and telephoto lenses, using the mirror lockup feature will further reduce the possibility of focus-killing vibrations from resonating through the camera body. We cover tripod photography, mirror lockup, and long exposures in greater detail on the companion Web site for this book.

Figure 7.40 At the time this photograph was made, the preview on the LCD seemed to be in focus. However, when seen in an enlarged view on a computer monitor, the fine details lack critical sharpness.

Editing in Camera

Apart from evaluating images for quality, the main utility and appeal of the LCD screen is the ability to edit images in the camera and share them with your companions. Your editing practices at the camera level will vary depending on how well you can rely on what the LCD is showing you, the availability of extra memory cards or other portable storage solutions, and how comfortable you feel deleting something that you haven't had a chance to view on a large monitor.

- **Reviewing thumbnails.** On some cameras, you have to turn a switch to enter a separate review mode to see the thumbnails, while on others a quick press of a button will show you the most recent photo. Most SLRs are shooting-priority cameras, which means that as soon as you lightly press the shutter release button, the camera is returned to capture mode, ready to take the next photo.

In addition to letting you review each of the images you have taken as a full-screen thumbnail, most cameras offer an index view, which lets you see four to nine shots on one screen and quickly scroll through them (**Figure 7.41**).

Figure 7.41 Most cameras allow you to view multiple thumbnails on the LCD screen for easier editing.

- **Scrolling and zooming.** While in thumbnail review mode, you should be able to press the lens zoom control, or other buttons, to magnify the thumbnail view and zoom in for close inspection. The zoom factor will vary among different cameras, but a 6x to 12x magnification is common. DSLRs typically allow for greater thumbnail magnification than their more compact cousins. The camera's control wheel or multiselector switch is used for scrolling left to right, or top to bottom on the magnified image. The thumbnail scroll and zoom feature is essential for photographs where you need to check on details that are hard to see in normal view. A good example of this is a group portrait, where you want to verify that everyone has their eyes open before calling an end to the session

- **Flagging/protecting images.** Another feature we like is the ability to flag certain images as keepers. In many cameras, this also serves double-duty to protect a photo from accidental deletion. This can be quite helpful, because no matter how careful you are, on some cameras there's a very fine and dangerous line between deleting a single image and erasing all of the images on the card.

- **Deleting images.** Whether you choose to delete photos using the camera controls or to save that decision for later when you can view them on your computer will depend on a number of factors. One approach you can use to maximize space on the memory card is to delete any clearly bad shots as you go. Sooner or later, however, we all face the unpleasant reality of a full memory card. If you find yourself running out of room and you have no spare cards in your camera bag, then you may have no choice but to cull and delete right on the spot. In this case, we suggest reviewing all images on the card and then deleting the ones that are obvious candidates for the trash bin. This may buy you some extra shooting time, but the shrinking number of shots left to you is sure to cramp the normal feelings of spontaneity and freedom to experiment that are usually part of the digital photography experience.

> **TIP:** In addition to extra memory cards, portable battery-operated storage devices known as digital wallets are incredibly useful for times when you want the freedom of lots of storage space. Available in sizes of a few gigabytes all the way up 80 GB (and probably more by the time the ink dries on these pages), these portable hard drives are designed for downloading the contents of memory cards. Once the images have been transferred to the digital wallet, you can format your cards and start filling them up again. See Chapter 5, "Essential Accessories," for more information on portable storage solutions.

Some people prefer to do significant editing in camera. If the purpose for your images is clear and you know exactly what you need, then editing in the camera can be an efficient way to save only the shots you need while preserving space on the card for new photos. Although this is certainly a viable option if you have faith in what the LCD shows you and your ability to understand it, we usually like to save major editing decisions for later when we can review our shots on the larger monitors in our digital darkrooms. Katrin is especially reluctant to edit out even questionable images while they are still in the camera, because she never knows if there might be a group of pixels or an interesting abstraction that she might find useful later. If your work includes collages or more abstract visual interpretations, then even shots that other people might consider bad can be grist for the creative mill. Interesting blurs, exposure flaws, subject movement, unexpected expressions, or relationships between foreground and background elements that you didn't notice when you pressed the shutter button are all legitimate reasons to postpone deleting images until you've had the chance to see them displayed on a larger monitor (**Figure 7.42**).

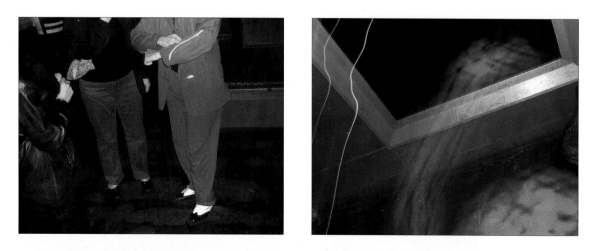

Figure 7.42 Don't be so quick to delete less-than-perfect shots from your memory card! These two "bad" images were later combined into a whimsical illustration.

The Range of Light

Good photographs are a mixture of many elements all coming together in a perfect instant at the time of exposure. Composition, viewpoint, timing, subject matter, technical control, and creative interpretation all play important roles in the final image, but the one element that can transform a scene like no other is light. By making changes to how the camera's image sensor is exposed to the light, you can exercise a great deal of control over your digital exposures. The key to this creative control lies in understanding how the camera's view of the world differs from your own view and knowing how to use the camera's settings to create the image you want. Once you develop this understanding and mastery of the technical controls on your camera, you'll never again have to settle for the default exposure that your camera gives you. Instead, you can evaluate the range of light in a scene, know how the camera's meter will react to it, and make the necessary adjustments to craft the image you see in your mind's eye. Your images will improve and your enjoyment of digital photography will increase. Every photograph you take will teach you more about making photographs and working with the light to create the best image possible.

PART THREE

THE DIGITAL DARKROOM

Chapter Eight **Building a Digital Darkroom**

Chapter Nine **Download, Edit, and Convert**

Chapter Ten **Essential Image Enhancement**

Chapter Eleven **Digital Darkroom Expert Techniques**

CHAPTER EIGHT

Building a Digital Darkroom

The darkroom is where the photographic image is transformed from a mere photograph into a masterpiece. With film photography, the process involves working with a variety of chemicals and changing the exposure and contrast of the light-sensitive paper in order to interpret the image in a variety of ways. Using an enlarger, the photographic paper can be selectively blocked to *dodge* (lighten) or exposed to *burn* (darken). The photographer can vary the timing of both exposure and development to achieve the desired result, or use contrast filters when exposing the paper, to create effects ranging from the subtle to the dramatic.

All of these film development processes are time-consuming and difficult to reproduce consistently. Just setting up a "wet" darkroom for producing prints is a challenge. It requires a room that can be completely darkened, with good ventilation and running water. Then, of course, the photographer needs chemicals, an enlarger, and a wide range of accessories. Working in the traditional darkroom allows the photographer to control the process of

creating the final image, but without much convenience or comfort (**Figure 8.1**). In truth, most film photographers don't develop the pictures themselves, instead leaving the process of creating the final print to a lab technician who played no role in the creation of the image.

Enter the world of digital photography. Besides the instant gratification and other advantages of digital, it's much easier to exercise extensive control over the processing and printing of your images. In addition, once you've perfected an image, you can create as many exact duplicates of that original as you want. We can only imagine how much Ansel Adams would have enjoyed being able to dodge and burn to perfection just once, and then produce as many prints as he wanted without having to reproduce the painstaking process involved in creating the first print. Granted, the tools of the digital darkroom aren't always inexpensive, but they are readily available and they provide much more flexibility and utility than the traditional darkroom tools. In this chapter we'll guide you through the process of selecting the right tools and configuring your digital darkroom so you can get the best results with your images.

Photo by Reed Estabrook

Figure 8.1 The "wet" darkroom of film photography offers a great deal of control for the film photographer, but at the expense of convenience and comfort.

THE DARKROOM

We've often been asked why we refer to the *digital darkroom*, since you don't need to work in a darkened room with digital photography. It's not just because we're borrowing the term from film photography. We like to use *digital darkroom* because it reinforces the importance of the environment in which we work on our images (**Figure 8.2**).

Figure 8.2 The digital darkroom provides a more comfortable working environment for the photographer, while at the same time offering more control than the wet darkroom allows.

Lighting

Digital darkroom lighting is an important factor when you're evaluating images on your monitor as you optimize them. Your monitor emits light to produce the image you see, and other light sources can influence your image as well. *Ambient* light—the light that fills the room from a variety of sources both artificial and natural—interferes with the brightness and color of the monitor's display (see the sidebar, "Going Gray"). Too much ambient light will cause the display to appear more faint. This distortion will tend to cause you to adjust your images to make them too dark. The color of the ambient light can also influence your monitor's display. For example, early morning or late afternoon light can impart a warm cast to the image on your monitor, causing you to overcompensate by adjusting the color balance of images too far toward the cooler hues of blue and green.

Ideally, your digital darkroom should allow you to dim both ambient and artificial lighting. By using blinds or curtains on your windows and a dimmer switch on your lights, you can minimize the amount of light in the room. The ambient light should never be brighter than your display.

Sometimes, you just may not be able to adequately darken your digital darkroom. In that case, we highly recommend using a *monitor hood* to block excess light so it won't reduce the contrast of your monitor and distort your perception of the images (**Figure 8.3**). You can buy one from any source that sells monitor accessories, or you can make your own by cutting black foam core to fit and then attaching it to your monitor with some sort of adhesive material.

Figure 8.3 A monitor hood helps block ambient light that would otherwise interfere with the image displayed on your monitor.

Going Gray

In addition to dimming the lighting as you optimize your images, it's helpful to avoid brightly colored walls. We also recommend not wearing clothing that is too bright or colorful, as this will reflect back onto the monitor. Having said that, you needn't take this to an extreme. As much as Tim loves the color gray, he's not about to paint the walls in his digital darkroom with 18 percent gray paint. And as much as Katrin is not enamored of gray—she did. Either you can buy expensive neutral gray paint from the Graphic Arts Association, or you can do what Katrin did—take an 18 percent Kodak gray card to a local paint store and have a gallon or two of 18 percent gray paint mixed. While you don't need to change your clothes or put on a neutral smock before working on your images, be aware that that chartreuse sweater your aunt gave you isn't the best item to wear while doing critical color correction. Most important, keep in mind that your working environment influences your visual decisions and therefore influences the quality of your images.

When it comes to evaluating your prints, you can forget these rules. Because prints depend on reflected light to be seen, you don't want to evaluate them in a darkened room. If you want to use your existing overhead lights, replace the bulbs with daylight-balanced 5000 Kelvin bulbs. We recommend those from SoLux (www.solux.net) because they have a high *color-rendering index*, which is a measure of how accurately colors are rendered under the illumination of a light source.

In addition to replacement bulbs, you can also purchase stand-alone lights for the evaluation of prints, and simply leave your other light sources turned off. For this purpose we recommend the lamps available from Ott-Lite (www.ottlite.com) (**Figure 8.4**).

Courtesy of Ott-Lite.

Figure 8.4 A lamp with a 5000 Kelvin illumination source, such as this Ott-Lite lamp, ensures the most accurate evaluation of your prints.

THE COMPUTER

Your digital camera may be the cornerstone of your photography, but when it comes to perfecting your images, your computer is the foundation. Although it's possible to produce prints using only a digital camera and a photo inkjet printer that supports direct printing, a computer allows you to optimize your images.

Platform Issues

We've all heard the advice to avoid discussing religion or politics in mixed company. We'd like to add to that list of forbidden topics: Avoid the debate over Windows versus Macintosh.

Frankly, we're tired of hearing the often-venomous debates about which computer platform is better. The simple fact is that you can produce excellent images using either platform. Regardless of which platform you choose, you can count on having the tools you need to produce the best-quality prints.

If you're buying a new computer and need help deciding between Windows and Macintosh, ask people who are doing the kind of work you would like to do which platform they're using and consider following suit. A side benefit: You'll have someone who's familiar with your setup to call if you ever need help.

So what do we use? Katrin is a longtime Macintosh user, but she's perfectly comfortable working with a Windows computer when necessary. Tim uses Windows simply because that's where he got his start and that's where his expertise lies. Seán straddles the fence, working with both platforms, although he tends to favor his Mac most of the time.

Other Issues to Consider

The key issues to consider when buying a new computer or upgrading an existing system all revolve around performance. Digital images contain a lot of information, especially if they're sized for large output. It takes a lot of horsepower to process those images with reasonable speed.

Still, no matter how much money you spend on your computer, you're going to be left waiting when you apply a complicated adjustment to a big image. Far too many photographers compound this problem by worrying more about their budget than about the capabilities of the computer. You certainly need to consider your budget, but whenever possible buy more computing power than you think you need, because—believe us—you'll need that power before you know it.

Processor speed

The processor is the "brain" of the computer, handling the number crunching involved in all tasks the computer performs. When you apply a filter, crop an image, or adjust contrast, the processor is doing the intense math behind the scenes. A faster processor means everything gets done faster. Of course, a faster processor also means a higher price.

Processor speeds are measured in gigahertz (GHz), which is a measure of the billions of cycles per second the processor undergoes. The speed at which a processor operates is referred to as its *clock speed*. Keep in mind that clock speed is only a relative measurement and must be understood in the context of the overall system architecture. For example, Macintosh computers achieve better performance than their clock speed indicates, because the architecture includes a larger cache, faster bus speeds, and other factors that improve overall system performance. Clock speed is useful only for comparing systems that use the same architecture, such as two Intel Pentium 4 computer systems. Apple maintains performance benchmark information on its Web site (www.apple.com/powermac/performance/); you can also get the results of third-party tests on various other Web sites, such as MacSpeedZone (www.macspeedzone.com). For Windows-based computers, you'll need to consult broader benchmark tests. *PC Magazine*, for example, frequently performs benchmark tests on new computers, and publishes the results in the magazine and/or on its Web site (www.pcmag.com).

We recommend buying the fastest processor available for your computer. At this writing the fastest Macintosh is a Power Mac G5. For the Windows platform the fastest processor is currently the Pentium 4 at 3.2 gigahertz (GHz). You can save hundreds of dollars by opting for a slower processor, but consider the time lost during the life of the computer.

Staying under budget may require that you make a compromise on processor speed, but the fastest processor your budget will allow makes the most sense for digital photography.

Bus speed

The bus is the "highway" inside the computer that information uses to travel between the processor and the other components.

As you can imagine, the faster that information moves, the better. So you want to buy a computer that matches a fast processor with a high-speed bus. Unfortunately, many manufacturers don't make it easy to find out the bus speed a particular computer uses, so you may have to do some homework.

At this writing, bus speed is measured in megahertz (MHz), which is a measure of the millions of cycles per second the bus performs. Soon we'll cross the threshold into the billions of cycles per second, and bus speeds will be measured in gigahertz.

When comparing different computers, be sure to consider the bus speed as a factor in overall performance. For example, a Pentium 4 processor operating at 3.06 GHz with a 533 MHz bus actually performs slower than the same processor type at 3 GHz but with an 800 MHz bus.

RAM

The key word when it comes to RAM is *more*. We consider 512 megabytes (MB) to be an absolute minimum for imaging work. If you're working with large images, composites, or panoramas, you should consider 1 gigabyte (GB) as a minimum instead. If your images are giving new meaning to the word *huge*, then you may want to opt for 2 GB or more of RAM. Adding more RAM to your computer is the easiest and most effective way to increase computer performance (**Figure 8.5**).

Photo by Jeff Greene / ImageWest.

Figure 8.5 Adding more RAM is an easy upgrade that significantly boosts your computer's performance.

Hard drive

Tim likes to compare hard drive capacity with money: You can never have too much. If you've owned more than one computer, at some point you've probably had a hard drive you thought you'd never be able to fill. Then you filled it. Digital photography provides countless opportunities to fill all available storage space with your images.

Fortunately, hard-drive prices have continued to plummet, so you can get significant storage space for a modest sum. We recommend having more hard drive space than you think you need. For one thing, you'll probably end up taking more pictures than you think. Also, not all the space on the drive can be used for your images. You need to anticipate the considerable space your software programs will eat up, as well as the space your operating system and applications will use for *virtual memory*. This term refers to the hard-drive space used for temporary storage when the computer is working on a task—sort of like the scratch paper you'd use to figure out a complicated math problem.

Hard-drive space is currently measured in gigabytes. We still remember when 100 MB was a lot of storage space; now several hundred gigabytes is easy to fill. We recommend getting the largest hard drive available when you buy your computer, but remember that you can also add a hard drive later. The current maximum hard-drive capacity for desktop computers is 250 GB, but that number is increasing all the time. You might even consider adding more than one hard drive to your computer for additional storage capacity.

> **TIP:** Some users prefer to split their hard drives into more than one partition, so that they have a logical division between program files and image files, for example. This also provides potential benefits in capacity because the packets of data are smaller when you split a large drive into multiple partitions. However, we prefer to keep the drive as one cohesive block of storage, even if we're giving up some space in the process, so that our images aren't spread across multiple drive letters. We're willing to give up some capacity in exchange for a cleaner organizational system.

Besides capacity, you need to consider the speed of the drive. Several factors impact the overall drive speed. One factor is the rotation speed of the hard drive platters that store data. Drives typically spin at 5400 rpm, 7200 rpm, or 10,000 rpm. We recommend looking for a drive that operates at 7200 rpm or faster.

Two other important factors related to hard-drive performance are the *throughput rate*, which measures the maximum speed data can be moved on or off the drive; and *average seek time*, which measures how fast on average the drive can access a specific piece of data on the drive. The maximum throughput is determined primarily by the drive's interface. At this writing most hard drives offer an Ultra ATA/100 interface, which moves data at 100 MB per second. The newer Ultra ATA/133 increases that performance to 133 MB per second. Current hard drives offer seek times below 10 milliseconds. Look for the lowest possible seek time.

Network

If there is more than one person in your office and they all need access to your photos, a network can be invaluable. It also allows multiple users to share a printer. A network helps you create a more organized workflow: For example, you can use a single computer to download and store image files, and then allow other computer users to access those files through the network.

It's increasingly common for network support to be included as a standard feature on many computers. There are many network types to choose from.

Sneakernet

This term refers to the lack of a computer network. If you don't have a network for sharing files across multiple computers, the only way to get those files from one computer to another is to put them on removable media, lace up your sneakers, and walk the files over to the other computer.

In the old days, a sneakernet used floppy disks, back when those were still common and the files could actually fit on them. These days, if you don't have a true network, you can transfer files from one computer to another in a pinch using the digital media cards you use for storing the pictures on a digital camera, along with a card reader.

Ethernet

"Wired" networks use wires to connect computers to each other so that data can be shared. The most common type of wired network is Ethernet.

With Ethernet, all computers connect via data cables to a central hub that controls the flow of data from one computer to another. Each computer connects to the hub, and each has access to all shared resources on the other computers on the network.

Figure 8.6 A network hub is the central connection point for all the computers on an Ethernet network.

Most new computers now come standard with an Ethernet port, so they are *network ready*. All you need to do is add a hub and cables to connect the computers, and you'll be able to share files and printers among the computers on the network (**Figure 8.6**). If your computer doesn't come with an Ethernet port, you can add one by installing an Ethernet card.

When setting up an Ethernet network, you'll have a choice of speeds supported by the hardware involved. The speed of the network determines the maximum rate at which information can move from one computer to another. This speed is measured in the millions of bits of data that can be transferred each second (megabits) or even in the billions of bits (gigabits). At this writing, 100 megabits per second (Mbps) is the most common speed. A higher-speed option, gigabit Ethernet, is becoming more common. It offers a tenfold increase in performance over 100 Mbps Ethernet. For most networks, 100 Mbps will yield tolerable transfer times for large files and is more than adequate for sharing a printer over the network. But if you need to move large files on a regular basis, you might opt for gigabit Ethernet.

Ethernet is a widely used networking standard that offers high performance, and most desktop and laptop computers today come with a built-in Ethernet port, which is why we recommend it as the best solution for most digital photographers.

Wireless

It may be a wired world, but people are getting increasingly tired of the tangle of wires under their computer desk and are happy to do without as many of them as possible. Networking has been slow to adopt wireless opportunities, but wireless is becoming more and more common.

Wireless networking operates just like a wired network, except that data is sent via radio signals rather than through wires. You can typically communicate indoors with other computers that are within a couple hundred feet. For most studios and small offices, this should be more than adequate to provide seamless connectivity.

When you look at the names of wireless networking standards, you quickly realize that they were dreamed up by computer engineers rather than by marketing geniuses. At the moment, the most common standard is referred to as 802.11, with the 802.11b and 802.11g updates providing higher speeds. The "b" version offers up to 11 Mbps, making it comparable to 10 Mbps Ethernet. The "g" version offers speeds of up to 54 Mbps. These standards are also often referred to collectively as *Wi-Fi*, short for *wireless fidelity*.

If you're planning to make use of a wireless network, you can generally have a wireless network interface card included when you buy your computer. Or you can purchase a wireless card after the fact and add it to your computer.

Wireless is certainly an attractive solution, but keep in mind that the speeds are not as high as those available with a wired network. Every bit of performance can help when you're moving large image files to another computer.

Monitor

When it comes to digital photography, the monitor is the most important component of your digital darkroom. You'll spend a lot of time looking at your monitor while working on your images, and having a high-quality, accurate display is crucial.

Display size

It would be easy for us to simply tell you to get the biggest monitor available, but that may not necessarily be the best solution, considering your budget and the amount of space you have available on your desk. We will say that the more space available on your monitor, the better. We consider 17-inch displays to be a bare minimum, with a 19-inch monitor being an ideal starting point. If the size of your desk and wallet will allow, opt for a 21-inch or larger monitor.

LCD vs. CRT

It seems that the choice between an LCD and a CRT monitor is a choice between sexy and practical. Many photographers hope for the former but settle for the latter (**Figure 8.7**).

Photo by Jeff Greene / ImageWest.

Figure 8.7 Most photographers would prefer to have an LCD monitor on their desk, but settle for a CRT display because it costs less and usually offers superior image quality.

Experts have told us that the CRT monitor will be the professional standard for the next five years; they predict it will be that long before LCD monitors offer the same level of quality at a reasonable price. The potential advantages of a CRT monitor are image quality, vibrant colors, pure blacks, a wide viewing angle, a wide choice of calibration options, and a relatively low cost. The major disadvantage of a CRT monitor is that it weights up to 70 pounds, produces heat, and hogs space on your desktop.

It used to be that buying an LCD monitor represented a compromise. You gained desk space and had a really cool looking monitor, but the quality wasn't very good and you paid a lot more for it. Now LCD display technology has advanced to the point that there are many LCD monitors available that come close to matching the quality offered by CRT monitors. In addition to being less of a space invader, an LCD uses less power and therefore produces less heat, and it's easier on your eyes (an LCD doesn't refresh 85 times or more per second the way a CRT does). The disadvantages with some (but not all) LCDs are a reduced viewing angle, less vibrant colors, and less visible detail in the shadowed areas of your images.

CRT specifications

CRT monitors have been around for a long time, and the technology has developed to the point that most CRT monitors are of very good quality. The most important qualities photographers tend to look for in a monitor are the crispness of the display, its refresh rate, its color fidelity, and the ability to accurately calibrate the monitor.

The dot pitch defines how crisp a monitor's display is. *Dot pitch* is a measure of the distance between pixels of the same color on a monitor. The smaller the dot pitch, the better the monitor will display fine detail. We look for a monitor with a dot pitch below 25mm.

The *refresh rate* measures how frequently the display is updated. When the monitor doesn't refresh quickly enough, it appears to flicker slightly, which can fatigue your eyes. (The easiest way to detect flicker is by looking at the display using your peripheral vision.) The refresh speed is measured in hertz (Hz), which is the number of times per second the display is refreshed. We recommend looking for a monitor with a refresh rate of 85 Hz or higher at all resolutions.

Another issue to consider is when selecting your monitor is the range of resolutions the monitor supports (*resolution* measures the number of pixels used to produce the full display). Because of the way CRT monitors produce images, you can run them at a variety of resolution settings with excellent quality. We also recommend getting a monitor that supports a higher resolution than you think you'll need, so you have some room to grow.

We also prefer flat-screen CRT monitors to the standard curved CRT displays. The flat surface helps minimize distortion in the display and is more pleasing to look at because of reduced glare. All three of us currently use Sony Artisan 21-inch flat-screen CRT displays, which provide a distortion-free flat display.

LCD specifications

LCD display technology has improved to the point that the newer LCD monitors offer excellent quality. And prices have fallen to reasonable levels, even if they're still more expensive than CRTs.

The areas where LCD monitors still tend to fall short are the viewing angle and the contrast ratio. You'll want to pay close attention to those specs when shopping for an LCD monitor. *Viewing angle* is a measure of the range in front of the monitor from which you can still see the image clearly. A 180-degree viewing angle would be impossible, because it would allow you to see the display on the monitor when viewing it from the side. A 90-degree viewing angle would mean you could see an accurate picture when viewed from 45 degrees either side of center (**Figure 8.8**). Once you look outside the viewing angle range, the display gets darker and colors may shift. You should look for a display with a viewing angle of 120 degrees or more.

Photo by Jeff Greene / ImageWest.

Figure 8.8 Many LCD displays have a limited viewing angle, making the image appear dark when not viewed from directly in front.

Contrast ratio measures the range of tones the monitor can display, from the brightest white to the darkest black. A lower contrast ratio means the monitor can't display some tonal values, and this generally translates into a loss of detail in shadowed areas of your images. CRT monitors offer a contrast ratio of 800:1 or higher, which means they can display a wide range of tonal values. Typical LCD monitors offer a contrast ratio of around 450:1, which we recommend as a minimum value.

Because of the way an LCD monitor's internal elements are designed, these monitors produce the highest quality display when operating at their "native" resolution. To ensure the best quality, look for an LCD that offers a native resolution you intend to use. For 17-inch displays or smaller, we recommend a native resolution of 1024 by 768 pixels for most

users. For larger displays, a resolution of 1280 by 1024 is best, and you might even opt for 1600 by 1200 for a 21-inch or larger monitor. Personal preference plays a role here, so if possible visit a retail location that has a wide range of LCD monitors on display, so you can see which produces the most pleasing image to your eye.

Black Is Beautiful

The best monitors are able to distinguish between all shades of black, rendering excellent detail in the deep shadows of your images. Many monitors, particularly LCD displays, fall short in this area. Andrew Rodney (a color management expert and Photoshop consultant) and Bruce Fraser (a self-confessed "color geek" and coauthor of *Real World Color Management*, Peachpit Press, January 2003) shared with us a technique for testing the shadow detail and neutrality (lack of color cast) of your monitor:

1. Launch Photoshop.
2. Select Edit > Color Settings from the menu, and set the RGB Working Space to Monitor RGB so that RGB values get sent directly to the monitor.
3. Select File > New to create a new document. Size isn't important, but be sure Color Mode is set to RGB.
4. Fill the document with black by selecting Edit > Fill from the menu and setting the color to black.
5. Maximize the document window and zoom in so it fills the screen.
6. Create a selection with no feathering using the Rectangle Marquee, and make it big enough that you can clearly see the selected area (perhaps a quarter of the total screen area).
7. Hide the selection by pressing Ctrl-H (Command-H on Macintosh).
8. Press Tab to hide the palettes, and then press the F key twice to go to full-screen mode so that you see only black, with no palettes or menus.
9. Press Ctrl-M (Command-M on Macintosh) to bring up the Curves dialog, and move the dialog so you can see the central area where your selection is.
10. Click on the anchor point that represents black (either top-right or bottom-left, depending on how you have Curves set up), taking care not to move the point.
11. Use the arrow keys on your keyboard to carefully move the anchor point vertically to change the output value, one point at a time.
12. Continue pressing the appropriate arrow key (up or down) to change the value of the black point for the selected area in the center, and watch to see when you are able to detect a difference from the surrounding area. With a high-end monitor such as the Sony Artisan, you should be able to see a difference with just one press of the arrow key.
13. Also check for the neutrality of the center area as you change the tonal value. It should remain neutral rather than exhibiting a color shift.

The Value of a Second Monitor

When you're optimizing your images in the digital darkroom, the monitor is your viewfinder into the image. We are firmly of the opinion that if one monitor is good, two must be better. In fact, we're confident that once you've worked with multiple monitors, you'll never go back to working with just one again.

A second monitor enables you to double your working area on the computer, although you'll sacrifice working area on your real desktop. To us the advantages are well worth the lost space. With more room on your display, you can work more efficiently. For instance, you can display your image full screen on your primary monitor, and then move all of your toolbars, palettes, and other controls to the second monitor so they don't get in the way of the image (**Figure 8.9**).

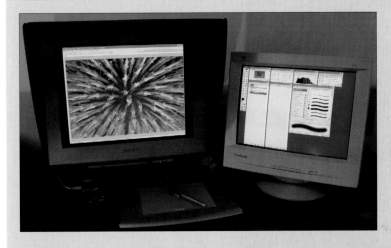

Figure 8.9 Setting up multiple monitors on your computer allows you to work much more efficiently.

Adding a second monitor is pretty straightforward. You'll need a second monitor, of course, plus an available video output on your computer (you can add another video card to provide that additional output). With Windows systems, you can replace your existing video card with one that supports dual monitors. For example, Tim uses a Matrox Millennium P750 video card, which provides the ability to connect up to three monitors to the computer. Of course, three monitors eat up a lot of space on the desktop, so Tim has opted to stick with two monitors. To have two monitors running on an Apple, Katrin added a second video card to her desktop Mac and configured the position of each with the Apple operating system, which is easily done in both OS 9 and OS X. Seán sometimes uses his G4 PowerBook as his primary editing computer and hooks his Sony Artisan into the laptop to use as his primary image display monitor. He then uses the laptop screen to hold all the Photoshop palettes.

Calibration

Just buying a great monitor doesn't guarantee that the images displayed on that monitor will be accurate. If the display isn't accurate, the image adjustments you make in response will also be inaccurate. To ensure that the image you're seeing is accurate, you need to calibrate your display.

The calibration process consists of two parts. One is the actual calibration, in which you adjust the display to get it as close as possible to established standards for luminance and color temperature. The second part is creating a custom profile for the monitor, which provides a formula for determining the adjustments necessary to produce an accurate display (**Figure 8.10**).

Figure 8.10 Calibrating your monitor on a regular basis ensures that the images you're seeing are as accurate as possible.

Over a period of weeks or months, the monitor's color and tone will shift, due to the gradual deterioration of the monitor's internal components. Therefore, you should recalibrate your display regularly. It is often recommended that you calibrate your display every two weeks, but we feel this is more frequent than necessary for a relatively new display. For new monitors, once a month is more than adequate. As your monitor ages, you'll need to calibrate it more frequently. Be sure to let your monitor warm up before you calibrate it, as the color display doesn't stabilize until after the monitor has reached its normal operating temperature.

Some high-end monitors such as the Sony Artisan (www.sony.com) or the Barco Reference Calibrator (www.barco.com) come with tools for calibrating and profiling them. If your monitor doesn't include these tools, we recommend purchasing the

appropriate tools, such as the GretagMacbeth Eye-One (www.gretagmacbeth.com), the MonacoOptix (www.monacosys.com), or the Spyder Colorimeter and PhotoCAL software from ColorVision (www.colorvision.com). These tools allow you to calibrate your monitor to known standards and then generate an accurate profile that describes the color behavior of the monitor. For a more detailed look at the calibration process and the full color-managed workflow, see Chapter 12, "From Capture to Monitor to Print."

BACKUP

With film photography, your images are relatively safe. Provided you could protect them from high humidity, fire, and other threats, your images would last for decades. With film, you don't really have a viable option for backing up, because film duplicates don't retain the quality of the original. You could scan the images to produce digital images, but then you have the same issues to contend with as images that were digital in the first place.

With digital photography, you have to guard against harm to your images in a number of ways. Besides keeping your computer and media safe from physical harm, you run the risk of periodic hardware failures that can cost you a heavy price in lost images. Fortunately, unlike with film, you can back up digital images with no loss of image quality. You can produce an exact duplicate that's identical in every way to the original image file. In fact, digital redundancy can be an advantage—not a burden—if well managed.

Backing up images is like paying for health insurance. We often would rather not bother, but it sure is nice to have it there when you need it. To paraphrase Murphy's Law, the only time you'll ever need a backup is when you don't have one. We recommend taking the safe approach: Always back up your work.

For in-depth information on hardware, software, and developing a backup strategy see Chapter 14, "Archive, Catalog, and Backup."

PRINTERS

If you're using a digital darkroom to work on your images, you probably want to make the final prints yourself. This allows you to produce prints to your specifications and to fine-tune the output. Doing it yourself also gives you the satisfaction of perfecting your image from the time you snapped the picture all the way to the final print.

When selecting a printer for your digital darkroom, you need to consider a variety of factors:

- The type of printer
- The size of prints you plan to produce
- The type of paper you want to print on

Once you made these essential decisions, you'll be ready to produce prints of the highest quality, which we'll discuss in Chapter 12.

Inkjets

Inkjet printers are the most affordable and most convenient method of printing high-quality photos in the digital darkroom. Of course, there are a wide variety of excellent printers to choose from (**Figure 8.11**).

Photo by Jeff Greene / ImageWest.

Figure 8.11 There are many excellent photo inkjet printers that offer exceptional print quality at a very reasonable price.

Inkjet printers spray ink in microscopic droplets with precise positioning onto the paper. There are two basic techniques for spraying the ink onto the paper. Printers from Canon, Hewlett-Packard, and others use thermal technology, where the ink is heated until enough pressure builds up to splatter an ink droplet onto the paper. Epson, on the other hand, uses

a patented technique where an electrical charge is used to create a vibration that effectively "shakes" the ink droplet onto the paper. Neither way sounds like a very precise way to put ink to paper, but they actually function with incredible precision. Both methods are perfectly capable of producing excellent images.

Because of all the marketing efforts to promote inkjet printers, choosing the best model can be daunting. Most of today's photo inkjet printers produce exceptional-quality prints, so you need to consider additional factors when making a decision.

You should be sure to purchase an inkjet printer specifically designed for photographic output. That means it will use at least six inks to produce images of photographic quality, or possibly more to extend the tonal range. We also highly recommend that you visit a store that can provide print samples from each of the printers you're considering.

Inkjet inks

There are two types of inks available for inkjet printers: dye based and pigment based. Most printers can only use a single type of ink, so the type of printer you choose will usually determine the type of ink you'll be printing with. More to the point, the types of inks that meet your needs will determine which printers to consider. Dye-based inks provide the most vibrant colors, at the cost of reduced print longevity. Some dye-based inks will last only a couple of years under typical display conditions, while others can last as many as a couple of decades. Pigment-based inks offer extended longevity, but with colors that aren't quite as vibrant as dye-based inks.

If you are selling prints of your images, print longevity is a critical factor. When someone buys a print, they expect it to last when they hang it on the wall. At the very least the print should last as long as the best "traditional" print from a wet darkroom. That means you'll need to use pigment-based inks. The latest pigmented inks, such as the UltraChrome inks from Epson, provide vibrant colors that come very close to matching what is possible with dye-based inks. According to tests conducted by Wilhelm Imaging Research (www.wilhelm-research.com), the recognized leader in image permanence testing, prints using UltraChrome inks will last from 34 to 145 years under normal display conditions, depending on the paper type used.

If you need prints to look as good as possible but you don't need them to last (say you're printing the images as proofs or for short-term display), then dye-based inks are your best option because they offer the most vibrant colors at a lower price than pigment inks.

Those caveats aside, our general recommendation is to use pigmented inks for all inkjet prints. The color vibrancy of the latest pigment inks is very good, and you'll have longevity on your side.

Third-Party Inks

You can use a variety of third-party inks in place of the manufacturer's inks in many inkjet printers. Third-party inks tend to be less expensive than those from manufacturers. We prefer not to use third-party inks, however, since they typically have a greater tendency to clog the printer nozzles, and in most cases they don't offer the same longevity as the manufacturer's inks. We feel it's best to use the inks specifically designed for your printer.

Another way to save money is by using a continuous inking system (CIS). These systems replace the ink cartridges in your printer with special connections to large ink tanks that you can refill at any time. So you can continuously operate the printer without ever having to change cartridges, and you save money by buying inks in bulk. If you produce a large volume of prints, a CIS solution might be worth considering (**Figure 8.12**). Be aware that using third-party inks may void your printer warranty.

Courtesy of InkJetArt.com / NoMoreCarts.com

Figure 8.12 A continuous inking system (CIS) lets you save money by buying ink in bulk, and you'll never have to change the cartridge.

Specialized inks

Certain specialized inks provide potential benefits in quality and possibly even longevity. These products are of particular interest when it comes to printing black and white images. Most inkjet printers don't do a great job of printing black and white images, instead producing prints that have a strong color cast with weak contrast. Third-party inks, such as those available from Cone Editions (www.coneeditions.com) and Lyson (www.lyson.com), produce excellent black and white output that's perfectly neutral. These black and white inks are generally referred to as *quadtone* inks, because they include several shades of black ink to produce a full tonal range with no color cast. The original ink sets include four tones of black ink; and the quadtone name has stuck even though recent ink sets feature even more shades of black.

If you're interested in using specialized inks, make sure the printer you're considering (or the printer you have) will support those inks. Research the types of inks you plan to use, and confirm that they work with the printer you own or plan to buy.

If you're interested in using third-party inks, review the options available from Cone Editions, Lumijet (www.lumijet.com), Lyson, and MIS Associates (www.inksupply.com), among others.

Dye Sublimation

Dye-sublimation (or *dye-sub*) printers have long been promoted as being superior to inkjet printers because they offer "continuous tone" output. This means that the colors on the paper aren't produced with discrete dots, but rather that the colors continuously blend into one another. The problem with this claim is that in recent years the droplet size and spacing on photo inkjet printers has been reduced to the point that they can also be considered, for all intents and purposes, continuous-tone output devices.

Dye-sub printers operate by heating a colored "ribbon" so that the dyes are converted to a gaseous state and impregnated into the surface of the paper. The dyes then become solid and are permanently bonded to the paper. The result is a print that looks almost indistinguishable from a traditional silver print; it's very durable and is virtually waterproof (**Figure 8.13**).

Courtesy of Olympus America.

Figure 8.13 Dye-sublimation printers produce durable prints with continuous-tone output.

While dye-sub printers can produce excellent output, they are usually quite a bit more expensive than inkjet printers, and they don't offer the precise control of output color that is generally possible with inkjet printers. While the dye-sub's final output results can be impressive, we recommend opting for a photo inkjet printer.

Print Longevity

After print quality, we consider print longevity to be the most important issue to consider when buying a printer. Unfortunately, it can be difficult to get accurate information about the longevity of the inks used in a particular printer. Printer manufacturers will make their own claims, but we prefer to trust an impartial third party that uses consistent criteria and conditions to test print longevity for a range of printers. As mentioned earlier, the most respected lab for image permanence testing is Wilhelm Imaging Research. Its testing is the most precise in the industry.

On the Wilhelm Imaging Research Web site (www.wilhelm-research.com) you can view archived longevity data for a variety of printers, and new testing is being conducted constantly. As the results of new tests emerge, they are posted to the Web site. This is an excellent reference to use when determining which printer will best meet your needs if longevity is a primary concern.

Print Size

A particular printer can only produce prints up to a maximum output size, so you'll want to be sure to anticipate your future needs when buying a printer. At the lower end are printers that can print up to a maximum of 8.5 by 11 inches. A step above that are the larger desktop printers capable of producing prints up to 13 by 19 inches. Many photographers start out with a printer that can print up to 8.5 by 11 inches, but quickly decide they'd like to be able to print larger. A 13-by-19-inch print may seem huge when you're just getting started making your own prints, but in time you'll probably start wanting to produce large prints of your best images (**Figure 8.14**). Keep in mind that you can always make small prints on a large printer, but you can't make prints larger than the printer will allow.

Figure 8.14 As your skills improve in the digital darkroom, you'll likely find yourself wanting to produce larger prints of your photos.

If even a 13-by-19-inch print doesn't seem big enough for your needs, then you may want a wide-format inkjet printer. These printers will commonly support paper widths of either 24 or 44 inches. They will accept both cut-sheet and roll paper, providing tremendous flexibility. With a 24-inch-wide printer you can produce prints up to about 20 by 30 inches, and with a 44-inch-wide printer you can print up to about 40 by 60 inches. Note that many printers, including most wide-format printers, will also allow you to produce panoramic prints that are as wide as the printer will allow and as long as the software will allow.

Big prints can certainly create a big impact. For example, nature photographer George Lepp frequently produces large, 90-inch-wide panoramic prints with his Epson Stylus Pro 9600 printer. For single-frame photographs he commonly produces 40-by-60-inch prints. When even bigger is better, you can take your image to a commercial printing service. George has had panoramic prints produced as large as 52 feet wide for trade show display.

If you won't be producing large prints very often, it might make sense to buy a desktop printer that will handle the largest prints you anticipate producing on a regular basis and then to send your image files to a print lab when you need a larger print. We'll discuss preparing your files for printing by a lab in Chapter 12.

Print Media

This is what we'd otherwise call paper, but of course the material you print on isn't necessarily paper. When buying a new printer, you'll want to consider the types of media it can print on. You may expect to print only on standard glossy or matte papers, but having the flexibility to print on different surfaces will let you get creative with a variety of materials later if you wish.

Glossy papers provide higher contrast and saturation, giving more "snap" to your images. Matte-surface papers will mute the colors and reduce contrast, providing a softer final image. Semigloss papers fall somewhere in between, though they behave more like glossy papers than like matte. Specialty print materials can add an artistic touch to your image. These include textured papers, silk, canvas, or other materials.

Several issues affect a printer's ability to print on a particular type of media. One is the ability of the printer to feed the media type through in the first place, since each printer has a minimum and maximum thickness it can handle. Another factor is the texture of the media. For example, some canvas material lacks traction, leaving the printer's rollers unable to properly feed it into the printer.

And even if a printer can feed a particular media type, that doesn't mean it can successfully print on it. To produce a good print, the inks must properly bond with the paper. Some inks simply won't bond properly with certain papers or other materials, causing them to puddle up or migrate on the media.

To play it safe, use media specifically designed to work with your printer. Many papers will work with virtually all inkjet inks, but some will work only with dye-based or pigment-based inks. Most third-party paper manufacturers indicate which types of printers their papers are best suited for.

Cost of media

Printer manufacturers make most of their profits not by selling printers (which they practically give away), but by selling the paper and ink. Since these costs can be considerable, you'll want to factor them into your printer purchasing decision.

For example, consider the cost of replacement ink cartridges for your printer, taking into account the (incredibly optimistic) estimates provided by the manufacturer of how many pages per cartridge you can expect to print. These estimates are generally based on printed text, even for photo printers. Photographic prints require much more ink than a typical text document, so you'll only want to use the estimates as an approximate indication of the relative cost of inks among printers.

Many photographers seem to fixate on the price per print with inkjet printers. Keep in mind that an inkjet print is less expensive than a traditional chemical print. Still, you'll want to have some idea of what your prints are costing you. You can calculate your own ink costs by keeping track of how many square feet of prints you are able to produce before replacing the ink cartridges. A typical sheet of 8.5-by-11-inch paper costs about $1, so making a series of test prints can certainly add up.

You may be tempted to produce test prints on less expensive paper, and then produce the final image on your favorite paper. However, proper proofing is best done on the media you'll use for the final print. Therefore, we encourage you to get the image perfected on the monitor before attempting to make the final print. Appropriate color management can also help avoid wasted paper, which we'll cover in Chapter 12.

ESSENTIAL ACCESSORIES

In addition to the computer components, there are additional accessories we consider essential equipment for an efficient digital darkroom.

Card Reader

You can connect your digital camera directly to your computer and transfer your images using that connection, but that's an inconvenient approach because it turns the camera into an oversized card reader that isn't as easy to work with. Instead, we recommend getting a card reader that will allow you to connect your digital media cards directly to the computer (**Figure 8.15**). This way, you can keep your camera in the bag safe and sound. We'll talk about how to actually transfer your images in Chapter 9, "Download, Edit, and Convert." But while you're setting up your digital darkroom, a card reader is an excellent accessory to add.

Figure 8.15 We recommend that you use a card reader to transfer your images to the computer, leaving your camera safely in the camera bag.

When choosing a card reader, the two issues to consider are the type of media the reader supports and the speed of the reader. Many card readers support only one type of digital media card, and since most cameras also only accept one type, you can just buy a reader whose card type matches your camera's. If you want to play it safe, there are some card readers that read multiple digital media card formats.

The speed of the card reader is determined by the connection it uses to the computer. Most card readers use either a USB or a FireWire connection. For USB, we recommend getting a card that supports the USB 2.0 standard (assuming your computer has a USB 2.0 port), as this provides considerably faster transfers than the previous USB 1.1 standard. To achieve the speeds USB 2.0 offers, both the card reader and the port it plugs into must be USB 2.0 compatible. USB 2.0 sends data at up to 480 Mbps, while FireWire card readers currently support up to 400 Mbps.

Optical Mouse

There aren't many computer users who would go without a mouse these days, and you'd be hard-pressed to find a computer for sale that didn't automatically include a mouse or similar pointing device. So we don't really need to tell you to get a mouse. What we do recommend is that you make that mouse an optical mouse. Many of the operations you'll perform to optimize your images will require precise movement of the mouse.

The traditional mouse that uses a ball to measure movement tends to accumulate dust that hardens along the rollers inside the mouse. An optical mouse uses a light beam projected from the bottom of the mouse to measure movement along the surface your mouse sits on. That means the movement is always smooth and precise, and you don't need to clean any parts to keep it moving smoothly.

Wacom Tablet

When you think of editing images, you probably don't think of drawing, so you may not think you need a drawing device. Think again. A tablet and stylus allow you to perform the same tasks as a mouse, and then some. The major advantage is that you use a stylus much like a pen, holding it in your fingers to draw on the tablet (**Figure 8.16**). This allows much

more precise control compared with using a mouse that you hold with your whole hand. In addition, a stylus is pressure sensitive, so it will respond differently depending on how hard you press down when drawing.

Photo by Jeff Greene / ImageWest.

Figure 8.16 A Wacom tablet is an invaluable tool for working with your images in the digital darkroom.

We all use a stylus extensively when performing image adjustments such as dodging and burning, when creating selections, and for other tasks where finesse is important. While using this tool can require some adjustment for those who have grown accustomed to using a mouse, we think that after you've worked with it for a few days you'll agree that a tablet is a must-have accessory.

We strongly recommend the Wacom (pronounced "WOK-um") brand because it gives you more control over your adjustments. These tablets are available in several sizes. We consider the 4-by-5-inch size too small for photo editing. The 6-by-8-inch is a comfortable enough size when desktop space is a concern. The 9-by-12 is our favorite, big enough to be effective but not so big that it's unwieldy. The 12-by-12 and 12-by-18 sizes tend to be cumbersome for many users.

We'll talk more about some of the adjustments a tablet is useful for in Chapter 10, "Essential Image Enhancement," and Chapter 11, "Digital Darkroom Expert Techniques."

SOFTWARE

The most powerful computer in the world isn't much good without software, and when it comes to optimizing your photos you'll need specialized software. There is no shortage of options, but you'll want to make sure the software you choose meets your needs before you spend the time learning to use it.

Basic Photo Editing

If you're just getting started with digital imaging, you want software that's easy to use, and you probably don't want to spend a lot of money. Many affordable software packages will enable you to edit your images, with some providing simple, easy-to-use adjustment options.

Jasc Paint Shop Photo Album

Paint Shop Photo Album (Windows only) from Jasc Software (www.jasc.com) lets you easily enhance your images. The basic enhancement options allow you to perform minimal cleanup and correction of your images, including basic tonal and color adjustments. You can even have the software adjust your images automatically. You can also add borders, fancy edges, and filter effects to your images.

The adjustment options in Paint Shop Photo Album don't provide the tools needed to perfect your images, but they do provide a good set of tools that are easy to use.

Ulead PhotoImpact

PhotoImpact (Windows only) from Ulead (www.ulead.com) started as a relatively simple program that provided only basic image-adjustment tools, and was primarily suited for preparing images for the Web. It has since been updated numerous times and now includes many features that provide excellent control over images.

PhotoImpact includes excellent tools for creating sophisticated selections: You can then edit selected areas, working with each one on its own image layer.

Its interface is relatively uncluttered considering the wealth of tools and adjustment options it contains. The program uses palettes to present information and options about the various tools, and lets you hide the palettes to maintain a clean interface.

While many of PhotoImpact's adjustment features are advanced, they aren't as refined as those found in Adobe Photoshop. Most of the adjustment options are easy to use, although the layer support is a bit clunky.

While PhotoImpact isn't the most sophisticated photo-editing software available, it offers an excellent selection of tools at a very reasonable price. It's a good choice for those who want to be able to exercise full control over their images with software that's relatively easy to use.

Microsoft Picture It! Digital Image Pro

Microsoft Picture It! Digital Image Pro (Windows only) is targeted at the serious amateur and professional photographer, but it lacks many of the refinements that make it suitable for that audience. It does allow you to create selections and work with multiple layers, but using these features can be cumbersome.

While not ideally suited for the advanced user, Digital Image Pro really shines for the beginner. It offers a variety of wizards that guide you through the process of adjusting your images, and the interface makes it easy to use. A wide range of artistic effects and projects can add creativity to the images you want to share with others. Tim finds the software a bit frustrating to use at times, but his wife is a beginner at digital imaging and she loves to use this software for creatively enhancing her snapshots of the family dogs.

For users who don't plan to upgrade to Photoshop later, and who want software that's easy to use and will guide them through challenging tasks, Digital Image Pro is an excellent choice.

Jasc Paint Shop Pro

Paint Shop Pro (Windows only) from Jasc Software (www.jasc.com) provides many features you might not expect to find in an inexpensive photo-editing package. It allows you to selectively adjust certain areas of your image, use multiple image layers in a single document, and perform many advanced adjustment and touch-up tasks.

While Paint Shop Pro lacks some refinements and advanced capabilities that would make it appropriate for professional photo editing, it does offer some excellent tools and is a great choice for photographers who need to exercise full control over their images but don't have any plans to move up to Photoshop.

Adobe Photoshop Elements

Photoshop Elements (Windows and Macintosh) is offered as a feature-limited version of industry-standard Photoshop. Unlike previous "LE" versions of Photoshop, Elements has

an excellent set of features and provides a great solution for those just getting started with digital imaging (**Figure 8.17**).

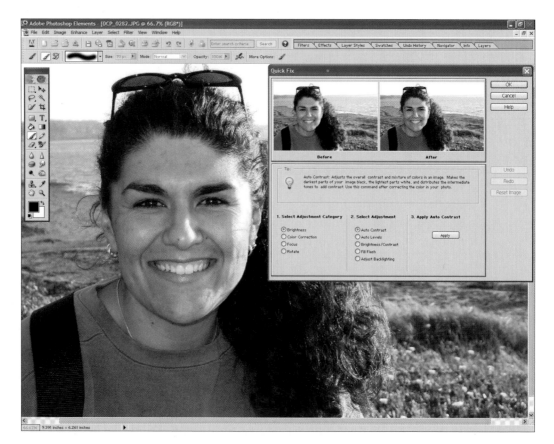

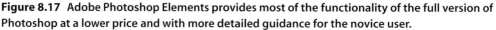

Figure 8.17 Adobe Photoshop Elements provides most of the functionality of the full version of Photoshop at a lower price and with more detailed guidance for the novice user.

Elements includes the most important features of Photoshop, such as advanced selection tools, the ability to work with multiple image layers in a single document, and a variety of filters. While the program is missing some of the most advanced features, it adds usability enhancements to make learning the program easier. It features an enhanced help system, including "recipes" that guide you through complex tasks step by step.

The tools that Elements is missing can be found in the full version of Photoshop, but they are tools only advanced users would miss. These include curves adjustments, layer masking, quick mask mode for selections, CMYK support, and other features. We'll talk about these in more detail in Chapters 10 and 11. We consider Elements an excellent choice for photographers just getting started with digital imaging, especially if you plan to move up to the full version of Photoshop later.

Professional Photo Editing

If you need to produce professional results with your digital images, you need software that provides opportunities rather than limitations. You need the broadest selection of tools with the maximum amount of control possible. In this category of software, there is only one product.

Adobe Photoshop

If you're serious about your photo editing, you'll want to use Photoshop. This is the software we use most of the time, and we recommend it for making the most of your digital images (**Figure 8.18**).

Figure 8.18 Photoshop is the photo-editing tool of choice for the serious photographer.

Photoshop provides incredible power and flexibility. You can exercise full control over the process of optimizing your images, with advanced selection tools, adjustment tools, and other options that provide virtually unlimited possibilities.

Besides the features built into Photoshop, there are other reasons to choose it as your photo-editing software. For one thing, it has become the industry standard, which means you'll find many sources of information on how to use it. If you have a problem, you can consult books (such as this one), magazines, online forums, workshops, seminars, conferences, and other resources to answer your questions and learn the best techniques.

Of course, Photoshop's immense power doesn't come cheap, either in price or in the time investment required to learn it. Be prepared for a steep learning curve. We'll be guiding you through the most important image optimization tasks in Photoshop in Chapters 10 and 11, and for even more advanced techniques we recommend that you pick up a copy of *Real World Adobe Photoshop CS*, by David Blatner and Bruce Fraser (Peachpit Press).

Photoshop Plug-ins

As if the software available didn't offer enough options for working with your images, there are also a number of plug-ins that extend the capabilities of your software. Most of these plug-ins are designed for Adobe Photoshop, but they can often be used with other software as well.

We really don't use too many plug-ins, preferring to find a way to achieve the same results with the tools available in Photoshop. Our reasons are many: We like the challenge; we have enough knowledge of Photoshop that we can do it ourselves; we prefer not having to purchase the plug-ins; and we can exercise more control over the processes. However, plug-ins can often simplify otherwise difficult tasks, and they provide features not found explicitly in Photoshop, so we want to direct you to some that we consider most useful.

nik Dfine

As we discussed in Chapter 3, "How a Digital Camera Works," digital cameras often produce images with some degree of noise, particularly when you're using higher ISO values or longer exposure times. The process of optimizing the image can often exaggerate this noise, resulting in an image of less-than-ideal quality.

Dfine from nik Multimedia (www.nikmultimedia.com) provides a solution to this problem for many images. It locates and reduces noise in your images, while maintaining and enhancing detail, thereby maximizing the final image quality. The program also helps minimize JPEG artifacts in images you've captured in JPEG mode.

Dfine provides automated tools to quickly fix your images, as well as more advanced tools to help you analyze and optimize your images.

nik Sharpener

Another plug-in from nik Multimedia, nik Sharpener provides an alternative to using the Unsharp Mask filter in Photoshop. It optimizes the sharpening applied to the image based on the image's intended use. For example, the plug-in would apply different sharpening for an image that will be displayed on the Web than it would for one printed on an inkjet printer. The size of the print and the approximate viewing distance also factor into the sharpening that's applied to the image.

We prefer to fine-tune the settings in Photoshop's Unsharp Mask filter to sharpen our images, sometimes using other advanced techniques within Photoshop to perfect the process. We feel we get better results by using the tools within Photoshop rather than the nik Sharpener plug-in. However, nik Sharpener does provide a simpler approach to sharpening for those who aren't yet familiar with the subtleties of working with Photoshop's Unsharp Mask filter.

Image Doctor

As the name implies, Image Doctor from Alien Skin Software (www.alienskin.com) provides a variety of tools for fixing problems in your images. It allows you to remove blemishes and defects, repair artifacts caused by JPEG compression, and replace unwanted elements of your images without leaving a trace. Image Doctor provides all of these options within an easy-to-use interface.

As with other plug-ins, we prefer to use creative techniques within Photoshop to achieve the same results. However, Image Doctor is an excellent tool for seamlessly replacing unwanted details in your images, particularly if you aren't comfortable making these corrections manually in Photoshop.

Quantum Mechanic

Quantum Mechanic from Camera Bits (www.camerabits.com) is another powerful plug-in that allows you to reduce noise and JPEG artifacts in your digital images. It comes in a Lite version that uses a simplified interface, as well as a Pro version that offers greater control over the process. The Macintosh version of Quantum Mechanic Pro also includes a plug-in to remove color moiré patterns.

PhotoKit

PhotoKit and PhotoKit Sharpener were developed by a group of respected digital experts, including Martin Evening, Bruce Fraser, Seth Resnick, Andrew Rodney, Jeff Schewe, and Mike Skurski, for Pixel Genius (www.pixelgenius.com). They provide over 100 effects for digital images that replicate film effects. These include black and white toning, dodging and burning, colorizing black and white images, and other effects. The wide range of tools provides automated ways to create effects that would otherwise be time-consuming to produce with Photoshop.

Optipix

Optipix is a suite of plug-ins from Reindeer Graphics (www.reindeergraphics.com) that allows you to enhance the contrast and content of digital images. It includes tools for blending multiple exposures by selectively blending two images and for averaging the tonal values of multiple exposures. These techniques allow you to capture more detail in scenes that present very bright highlights and dark shadows.

Optipix also offers various tools to automate tasks that would be difficult to accomplish in Photoshop. These include edge enhancement, noise reduction, and other tools that offer a high degree of control over the process of improving image quality.

PhotoFrame

PhotoFrame is a plug-in from Extensis (www.extensis.com) that lets you put an artistic edge around the outside of your image (**Figure 8.19**). The plug-in comes with a library with thousands of edge shapes, enabling you to quickly and easily add a creative look to your image's edge.

Figure 8.19 Extensis PhotoFrame allows you to put creative edges on your photos that are sure to grab the viewer's attention.

Photo/Graphic Edges

Auto FX Software (www.autofx.com) offers Photo/Graphic Edges, a plug-in with a unique interface that provides the same basic edge-effects capability as Extensis PhotoFrame. It, too, comes with an extensive library of edge effects that you can apply to any image.

nik Color Efex

Color Efex is a collection of plug-ins from nik Multimedia that offers a comprehensive set of filters for image enhancement, optimization, special effects, and replication of traditional darkroom techniques. The plug-ins provide powerful options for adjusting the lighting and color of digital images.

Many of the filters available in the Color Efex suite of plug-ins simulate effects that could otherwise be obtained with traditional photographic filters. These include such effects as adding warmth to an image, enhancing blue skies, and adding softness to existing light.

Besides the photographic filters, another set of filters in the Color Efex collection simulates effects from the traditional "wet" darkroom. These include sepia toning and solarization, among others.

But wait, there's more!

What we've presented is a mere handful of the most popular plug-ins for Photoshop (or for other software supporting Photoshop plug-ins). In addition to these products, there are dozens—if not hundreds—of filters available offering workflow enhancements, advanced editing capabilities, and creative ways to change your images. If you're looking for new ways to work with or interpret your images, take a look at the many plug-ins available to extend the capabilities of your photo-editing software. As a start, visit www.thepluginsite.com, which maintains a list of plug-ins for Photoshop in its Resources section.

Digital Asset Management Software

In addition to photo-editing software, you'll need software to help you sort and organize your images. There are two basic categories here, although some software covers both categories. The first is software to help you browse and sort through your images, deleting those that aren't in sharp focus or properly exposed. The other category is software that maintains a database of your images, often with keywords or categories to allow you to quickly and easily find just the image you need.

We'll discuss software for browsing your images during the sort and editing process in Chapter 9, and we'll look at software for managing your growing collection of images in Chapter 13, "The Digital Portfolio."

READY FOR IMAGES

Getting your digital darkroom set up correctly from the start will ensure that you're able to work more efficiently and with better results. Now that we've guided you through the process of selecting the appropriate equipment and setting up your digital darkroom, you're ready to start working with your images. In the next chapter we'll show you how to get all your digital photos into the computer so you can sort and edit them before moving on to optimizing those images.

CHAPTER NINE
Download, Edit, and Convert

Whether you work in a professional photo studio or you've just returned from a family weekend, the first thing you have to do is download your images to your computer. Of course, you can review your digital photographs with the camera's LCD screen, but that can be tedious when you're working with a lot of images (not to mention a drain on the battery). So it's always better to transfer your images from the camera media to the computer as the first step. With the images safely on the computer, you can delete the ones you don't want, and organize your best images so you can optimize them for output.

You may be tempted to skip the organization stage and move on to editing your images in Photoshop. Don't. Digital image files add up quickly, so you want to establish an organized file system from the start. After downloading images to your computer, you can edit them and then convert RAW image files into a Photoshop-compatible file format. At that point, you can move on to perfecting your images, which we'll cover in the next two chapters.

DOWNLOAD

There are two ways to get images from the camera to the computer. The first way is to connect your camera directly to the computer with a data cable. This method has several disadvantages. It requires that your camera be out on the desk with a cable dangling from it, rather than safe in your camera bag. It also consumes the batteries in your camera, and we'd rather save that power for photography. Also, during the time your camera is connected to the computer, you can't use it to photograph with.

The other method is to use a card reader to read the images directly from the digital media, without the need to connect the camera to the computer. We prefer using a card reader, but we'll address both methods and let you choose for yourself (**Figure 9.1**).

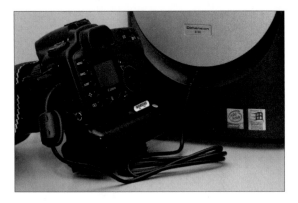

Figure 9.1 While it's possible to connect your digital camera directly to the computer for downloading your images, we prefer to keep the camera in the bag and use a card reader for downloading.

Direct from Camera

Digital cameras have a data port for connecting the camera to the computer. This method is convenient because you don't need a card reader. Once you hook up the camera and install the drivers, you can download directly from the camera. How fast the images download depends on the type of connection you are using between your camera and computer.

USB

Virtually every computer now includes at least one USB (Universal Serial Bus) port, making this a ubiquitous standard for connecting a variety of devices to your computer (**Figure 9.2**). The original USB standard was USB 1.1, which provided a maximum data transfer speed of 12 megabits per second (Mbps). That translates to around 1 MB per second, which means a typical JPEG image file would take 1 to 2 seconds to transfer to the computer, and a typical RAW image file would take about 10 seconds.

Figure 9.2 A USB connection is standard on virtually all new computers and is one way you can connect a digital camera to your computer to download your images.

The USB 2.0 standard raises the transfer speed to 480 Mbps, or about 50 MB per second. That means you can transfer about 50 times as many images in the same amount of time as you can with a USB 1.1 connection. To achieve those speeds, however, both the camera and the computer must support USB 2.0. If one or the other does not, the transfer speed reverts to USB 1.1 performance levels.

More and more cameras that use a USB connection are supporting the USB 2.0 standard, and most new computers now come with one or more USB 2.0 ports. You can also add a USB 2.0 card to your computer if it doesn't include USB 2.0 ports.

FireWire

FireWire (also known by its technical name, IEEE 1394) is a connection standard originally developed for digital video cameras, which means it was designed for speed. Many digital cameras, particularly the higher-end cameras, offer a FireWire connection (**Figure 9.3**).

Figure 9.3 A FireWire connection offers high-speed data transfer and is supported by many of the higher-end digital cameras.

The first FireWire implementation, FireWire 400, supported speeds of 400 Mbps. Although it offered connections that were tremendously faster than USB 1.1, it was surpassed by USB 2.0 speeds. However, even though the USB 2.0 standard theoretically offers a faster maximum speed, it devotes some of that bandwidth to data-transfer "housekeeping" chores that we won't bother going into. But the upshot is that this additional overhead means that USB 2.0's effective transfer rate is slower than FireWire's.

More recently, a new standard called FireWire 800 has emerged, offering speeds of up to 800 Mbps. While digital cameras are not yet supporting this standard, we expect that they will in the near future, particularly as resolution and storage capacities increase.

Most non-Apple computers don't come with a FireWire port, so to take advantage of a FireWire connection on a digital camera you need to install a FireWire card. All Apple computers have built-in USB and FireWire capabilities.

Bluetooth

Bluetooth is a wireless networking standard developed primarily to provide simple connections for small consumer devices. It's primarily used for cell phones, personal digital assistants (PDAs), and similar devices. It's also being used to provide a simple wireless method for transferring images from digital cameras.

It hasn't had a significant impact because it provides a very slow connection. The maximum data transfer rate is about 1 to 2 Mbps, but overhead limits the actual data transfer speed to about half that level. This speed limitation makes Bluetooth pointless for high-end digital cameras. Instead, it's used primarily for low-end cameras so that you can transmit images to others on their cell phone, PDA, or any other device supporting Bluetooth.

Currently, digital cameras that support Bluetooth are available in Europe and Japan. At this writing there is only one digital camera manufacturer—Concord Camera Corporation—that offers digital cameras with Bluetooth support in the United States.

Card Readers

Due to the drawbacks in using the camera cable-connection method to download your images directly to the computer, we recommend using a card reader (**Figure 9.4**).

You can buy an accessory card reader for less than $30. You simply insert the digital media cards into the card reader to download your images—similar to the way you'd copy files from a floppy or a CD—while your camera rests safely in its bag.

Figure 9.4 A card reader provides a convenient method of downloading your images from multiple digital media cards while leaving the camera safely out of harm's way.

External

External card readers connect to either a USB or a FireWire port on your computer. On Windows systems they're assigned a drive letter just like a hard drive; on a Mac they appear on the desktop as an additional drive icon. This allows you to easily access the files

and transfer them to your computer. If you have multiple digital media cards with images, simply transfer the images from one card, then swap in the next card, and so on.

PC Card Adapter

If your computer has a PC Card slot (formerly known as PCMCIA), you can use a PC Card adapter to connect your digital media card directly to the computer (**Figure 9.5**). Most desktop computers don't have a PC Card slot, but virtually all notebook computers do. If you're on the road with your camera and need to download your image files, a PC Card adapter is a convenient, inexpensive solution. Simply plug the digital media card into the adapter, and slide the adapter into the PC Card slot. You'll then be able to access your image files as if you were using an external card reader.

Figure 9.5 A PC Card adapter allows you to plug your digital media directly into a PC Card slot, which is standard equipment on laptop computers.

Downloading the Images

The process of downloading your images is straightforward. You can use the file management tools provided by your operating system or specialized software to download images, regardless of whether you are connecting the camera directly to the computer or using a card reader.

Keeping your digital images organized from the beginning will allow you to find just the right image when you need it. You know how easy it is to accumulate a huge number of digital photos, so when downloading we recommend that you create a master folder on your hard drive for the images. You can then embed folders within that master folder to organize your images. The best system for you will depend on which criteria are most

important when looking for images later. You could create a hierarchy of folders organized by subject matter, place, date, or any number of other schemes (**Figure 9.6**).

> **TIP:** *If you wanted to organize images by date, you could create a folder called Photos to contain all your images. Within that folder you could create a new folder for the date using the format yymmdd, which specifies the year, month, and day you took the images. By putting the date in this order, your folders will be in chronological order when you sort them alphabetically.*

> **TIP:** *Whatever system you use to organize your photos, be consistent in using it for all of your images to make the task of finding the right image that much easier.*

Figure 9.6 Creating a consistent folder structure to organize your images is a good way to provide a basic image management solution.

Copy First

We've seen many photographers insert their digital media cards into the card reader and immediately start editing the images directly from the camera card. We strongly recommend that you first copy the images to your computer, for three reasons.

First, copying the images provides a redundant copy, so you have an immediate backup in case you accidentally erase images. Second, it's much faster to edit your images when they are directly on your hard drive. Even the fastest card reader is still much slower than the hard drive on your computer. Third, working with images directly from your camera card may damage the card.

Our recommendation is to copy the images from the card onto the computer, and not erase them from the card until you actually need to use that card again to capture new images. When you do need to use the card again, it's best to reformat it in the camera rather than simply erasing all the images. Doing this reinitializes the card, which helps minimize the chance of data corruption on the card.

Windows

On a Windows system, you first should navigate to the folder where you want to save your images. For example, if you store your images in a master folder called Photos on your primary hard drive, you would double-click My Computer on the desktop, then double-click the primary hard drive (C:), and finally double-click the Photos folder. Once inside this folder, right-click and select New > Folder from the pop-up menu. A blank folder appears, ready for you to type a name; when you're done, press Enter.

Next, you would navigate to the images on your digital media and copy them to the folder you just created: With a direct camera connection, you would double-click My Computer and then double-click the camera icon. With a card reader, you would double-click My Computer and then double-click the shortcut to your external card reader.

At this point you should have windows open for both the source and the destination folders for your files. In the source folder (the digital camera or external card reader), you would select all the files to be copied. Initially you should copy all images (deciding which ones you really want to keep comes later), so choose Edit > Select All or press Ctrl-A to select all files. Then drag and drop the files from the source folder to the destination folder (**Figure 9.7**).

Figure 9.7 Using the file-management capabilities built into Windows, you can copy images from your digital media to your local hard drive.

Macintosh

On a Macintosh you first want to navigate to the location where you want to save your images. For example, if you store your images in a master folder called Photos on your local hard drive, you would double-click that hard drive on your desktop, and then double-click the Photos folder. Once inside this folder, Control-click and select New > Folder from the pop-up menu. A folder appears, ready for you to type a name; when done, press Return.

Next, navigate to the images on your card reader and copy them to the folder you just created: With a direct camera connection, you would double-click the camera icon on the desktop; with a card reader you would double-click the drive icon for that device.

At this point you can see windows for both the source and the destination folder for your files. In the source folder (the digital camera or memory card), you'll want to select all of the files to be copied. Initially you want to copy all images (deciding which ones you really want to keep will come later), so choose Edit > Select All from the menu or press Control-A to select all files. Then drag and drop the files from this source folder to the destination folder you have open and the files will be copied.

On some versions of OS X, depending on how your system is set up, the Apple Image Capture utility may launch when you connect a card reader to the computer. This program allows you to select a destination folder on your system or create and name a new folder, it shows you thumbnails of the images on the card, and it lets you download either all of the images or just selected photos.

Camera Software

Another, easier way to download your images from a camera or card reader is to use software provided with your digital camera. The advantage to using the software that comes with your camera is that all images on the card appear as a single group of images rather than as miscellaneous files scattered throughout multiple folders; this makes the copy process a simple one-step affair.

Canon ZoomBrowser

The Canon (www.usa.canon.com) ZoomBrowser is Windows-only software included with Canon's digital cameras that that lets you download images from your digital media cards (**Figure 9.8**). (Canon offers similar software, called ImageBrowser, for the Mac.) You can configure ZoomBrowser to launch automatically when you connect your digital camera to your computer or when you insert a card into a card reader, or you can launch the software manually. All of the images on the digital media card will appear as thumbnails, letting you easily select which images to download. (We recommend downloading all of the images and then sorting them using other image-management software that provides more flexibility for organizing and browsing your images.) To select all images, simply click the Select button, then choose the Select All option. Then click the Download Image button to bring up the Download Settings dialog. You can create a new folder for your images if you haven't already and add a prefix for all of the images to help keep them organized. Then click OK to start downloading your images.

Figure 9.8 Canon's ZoomBrowser software provides a convenient way of downloading images from your digital camera or card reader to your computer.

Once you've downloaded your images, ZoomBrowser switches to the folder view so that you can view them. You can also convert RAW image files using ZoomBrowser, but we recommend using the Adobe Camera Raw plug-in because it is convenient (built right into Photoshop CS; just open files and adjust settings) and because it is very fast at RAW conversions.

Nikon View

Nikon View (Windows and Macintosh) lets you download and manage image files captured with Nikon cameras (**Figure 9.9**). It's mainly designed as an image browser, but you can also download images: Select Launch Nikon Transfer from the Tools menu to call up the Nikon Transfer dialog, which shows you the default destination and naming to be used for the files. You can click the Change button to change either of these options. You can also change the specific transfer options by clicking the Transfer Options button in the top-right corner of the dialog. Once you've set the transfer options, click the Transfer button on the Nikon Transfer dialog to begin downloading the images.

Figure 9.9 Nikon View provides an excellent solution for downloading and managing your images captured with Nikon digital cameras.

Olympus Camedia Master

Most Olympus (www.olympusamerica.com) digital cameras include support for USB Auto-Connect, which allows you to access the camera as another drive letter on your system. This allows you to download images manually by copying files from the camera to the computer.

The Olympus Camedia Master software (Windows and Macintosh) offers a simpler option for downloading images from your camera or a card reader. In the Get Images area of the Camedia Master main window, select either From Camera or From Media. Click on the Media tab at the top right of the Get Images window to display a folder view, and select the destination folder for the images you're downloading. You can create a new folder by clicking the New Folder button at the bottom of the folder view. Then click the Get Images button to download the images.

Sigma Photo Pro

Sigma's (www.sigma-photo.com) SD9 digital camera only captures in RAW capture mode. Therefore, all images must be converted to a Photoshop-compatible image format before you can use them. The Sigma Photo Pro software (Windows and Macintosh) enables you to both download your photos and convert them to image files in one step.

If you're connecting your camera directly to the computer, select the camera in the navigation pane of Photo Pro's main window. (If you're using an external card reader to download your images, select the external card reader instead.) Next, select the images you want to transfer and click the Copy Camera Images button. A dialog will then present options for the transfer. You can choose whether to transfer all images or only those you've selected, and whether you would like to delete the images from the digital media card after they are transferred (we don't recommend this option, as it eliminates a backup that you'll need if the download goes awry). Select a destination folder by clicking the Choose button, then click OK to begin downloading.

Stand-alone Software

Several software tools allow you to download images from a variety of cameras, giving you an alternative to the software included with your camera. These stand-alone programs support a wide range of cameras and card readers.

Downloader Pro

Breeze Systems' (www.breezesys.com) Downloader Pro software (Windows only) enables you to automate the process of downloading images (**Figure 9.10**). Downloader Pro currently supports only Canon digital cameras if you're connecting your camera directly to the computer. If you use an external card reader, it handles any camera type.

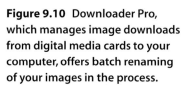

Figure 9.10 Downloader Pro, which manages image downloads from digital media cards to your computer, offers batch renaming of your images in the process.

Downloader Pro automatically detects a connected camera or digital media card in an external card reader at startup. You can also specify a source for Downloader Pro to download files from. You select the images you want to transfer and click the Download button. Downloader Pro creates a folder automatically and lets you assign a prefix to the batch of files, to help you organize them. For example, if you just photographed a wedding, you might use the prefix "HartWedding."

Breeze Systems is actually best known for its BreezeBrowser image editing and conversion software, which we'll look at later in this chapter.

iPhoto

Apple Computer's iPhoto (Macintosh OS X only) also enables you to download and organize your images. It comes with Mac OS X computers, and updates are available as a free download from Apple's Web site (www.apple.com). To download your images, launch iPhoto, connect your camera to the computer or insert a digital media card into an external reader, and click the iPhoto Import button. The Import panel shows you how many photos are on the card and displays a thumbnail of each as it imports them (iPhoto can deal with a number of different image formats, but it doesn't support RAW image files). You can also configure iPhoto so that it automatically launches any time a camera or card reader is attached to the computer.

iPhoto is more than just a way to import pictures into your computer; it also serves as a basic yet very capable tool for organizing, editing, sharing, archiving, and publishing images. You can import photos from cameras or from existing folders on your hard drive. You can arrange your images into different albums, add keywords to locate images more easily, and perform basic image-editing tasks such as cropping, adjusting brightness and contrast, converting to black and white, and fixing red eye (Seán's wife loves iPhoto's red-eye retouching tool and wishes that Photoshop's was as easy to use). You can even easily create slide shows with musical soundtracks, and burn an image backup on CD or DVD.

Apart from iPhoto's main role as a tool to organize your digital photos, the one feature that really stands out is its ability to design a custom presentation book of your images that you can have professionally printed and bound in a handsome linen cover. You can choose from a number of page layout templates, arrange photos on each page, and add custom titles and comments. You place the book order online from within the iPhoto interface (the cost is $3 per page for a book from 10 to 50 pages). About a week after you place the order, your custom hardback photo album arrives at your door.

ImageStore

ImageStore (Windows only) from TTL Software (www.ttlsoftware.com) provides a powerful workflow for downloading images from multiple digital media cards to your computer, helping you organize your images in the process (**Figure 9.11**).

Figure 9.11 ImageStore is a flexible image-management package for downloading images from multiple digital media cards.

A program wizard walks you through the process of downloading the images. You can opt to rename the images as they download, and to make a backup CD to protect your images immediately. Once you've defined how you want the download to be processed, clicking the Get Photos button begins the process. Once all the images have been downloaded, you will be asked if you have additional cards to download from—which means you can quickly download all images from a particular photo shoot in one easy process.

Choosing the Right Software

Deciding the best solution for downloading your images depends on your own preferences. We prefer to simply download images using an external card reader and the file-management options provided by the operating system. If you're already familiar with your operating system's basic file-copying operations, you may find that the software that comes with the camera, while friendlier, is also more cumbersome.

You'll want to consider ease of use, cost, and additional features when deciding which download method will provide the most efficient and convenient solution for your needs. In many cases, you'll want to make use of advanced third-party software that provides both a downloading and an image-management solution in one robust package. We'll talk more about these solutions both later in this chapter and in Chapter 14, "Archive, Catalog, and Backup."

Now that you've downloaded your bounty of images to your computer, it's time to evaluate what you've got.

> **TIP:** Once your downloaded images are safely on your computer, be sure to burn a backup CD or DVD to protect your assets from a possible hard drive crash.

EDIT

In the realm of digital photography, the term *edit* is often used to describe the process of adjusting your images in Photoshop (or a program like it) to produce the best possible results. We'll get to *that* kind of editing process in the next two chapters. But first you need to "edit" your batch of images, which means to go through the images, discard those that have problems, and find the ones that you want to focus your attention on.

While it may be tempting to start right in on working with your favorite images and making sample prints, we recommend going through this editing process to keep your collection of digital images under control. If you neglect this task, it won't be long before you fill up your hard drive with unneeded images and you are unable to find the images you do need.

The Digital Light Table

For many years photographers edited their images by laying them out on a light table with a loupe in hand (**Figure 9.12**). When it comes to editing digital images, we try to simulate the light table approach on the computer. Obviously the digital version of the light table experience involves some significant differences, but the basic approach is the same.

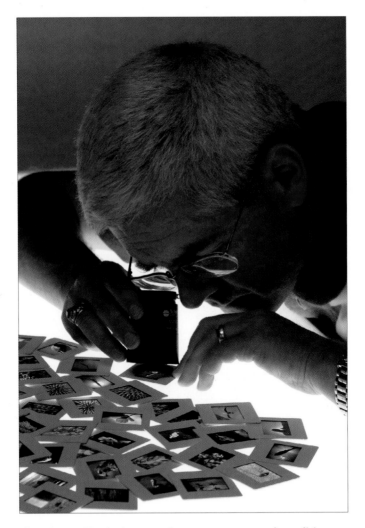

Figure 9.12 Many photographers are accustomed to editing their images on a light table. In the digital darkroom, software attempts to mimic this experience.

Digital's Dirty Little Secret

It's time we came clean. Camera manufacturers and other proponents of digital imaging will often talk about how much time you'll save with digital photography compared with film. This is simply not the case. Editing a collection of digital images is not nearly as fast as editing a batch of slides on a light table. That isn't to say you can't efficiently work your way through your digital images, but you can probably count on it taking longer than it would to edit a batch of slides.

This issue causes many photographers to have second thoughts about going digital (**Figure 9.13**). Consider, for example, nature photographer John Shaw's experience:

"When I'm in the field, I do a rough edit every night. Still, when I get back to the office I'm faced with a monumental task. I shoot in RAW format, so every image has to be opened, tweaked with a RAW converter, then opened in Photoshop for final touches before it can be sent to a client. Plus every image has to be captioned— thank heavens for batch actions—and assigned a unique file number for tracking and retrieval purposes. All in all, a lot of work."

Photo by John Shaw

Figure 9.13 Professional nature photographer John Shaw loves capturing images such as this one with a digital SLR camera, but he is concerned about the extra work required to manage images in a digital workflow.

Many software programs provide a virtual light table for you to review your digital photos. They run the gamut from basic image browsers that offer the capability to view your images and possibly perform some simple adjustments to programs that also provide advanced controls such as image management and the ability to convert your RAW captures to image files.

Basic image browsers

These image browser programs make it easy for you to edit your batch of images. You can view thumbnails of all images, view individual images full screen and zoom in for a close look, rotate images as needed, sort the images into folders, and rename the images.

The Windows platform offers many options, and these are some of our favorites:

- Ulead Photo Explorer (www.ulead.com) provides an uncluttered interface while still providing all the basic features needed to edit your images. The simplicity of the software has kept it a favorite of ours.

- ACDSee from ACD Systems (www.acdsystems.com) provides all the basic features and a host of more advanced features. It's an excellent tool but the huge number of toolbars clutters the interface. We prefer to turn off most of the toolbars to simplify the working environment.

- Photodex CompuPic Pro (www.photodex.com) is another excellent choice that offers all the basic features needed for editing.

The Macintosh platform has somewhat fewer choices. Here are some options:

- Apple's iPhoto, if you're using OS X, can be downloaded for free from the Apple Web site (www.apple.com), and it provides basic image browsing, organizing, and editing features (see the "iPhoto" section earlier in this chapter).

- ACDSee is also available for Macintosh, but it doesn't offer all of the features available in the Windows version.

- iView Media is another popular program for Macs that is OS 9 and OS X compatible.

Advanced light table programs

These packages take basic image browser software a step further, offering image-management features including the ability to categorize images, add keywords, and convert RAW captures to true image formats.

- ImageStore (Windows only) from TTL Software (www.ttlsoftware.com) provides an interface for editing your images that mimics the light table process many film photographers are accustomed to (**Figure 9.14**). It presents your images as thumbnails, and allows you to adjust the size of the thumbnails with a slider so you can optimize the image size to your needs. You can also view the images full screen and navigate through them for a closer examination.

Figure 9.14 ImageStore provides an interface that closely matches the way most photographers work with their images on a light table.

ImageStore takes a unique approach to removing images from the batch. With actual film slides on a light table, you might stack the slides you don't want into a separate area of the light table rather than throwing them away immediately. Similarly, ImageStore allows you to move images that you don't want into an "outtakes" section of the light table. You can decide later whether you really want to get rid of them or recall them to the full batch of images.

As you view and edit the images, ImageStore allows you to categorize them so you can keep your images organized from the beginning. You can even sort an image into multiple categories. This provides an excellent solution for sorting through and organizing a large number of images after a photo shoot.

- Digital Pro from Pro Shooters (www.proshooters.com) provides much more than the ability to simply edit your images (**Figure 9.15**). It provides a workflow solution that allows you to download images from your digital media card, then edit and sort the images. You can categorize your images and assign keywords, as well as fine-tune the

images directly. If you capture in RAW mode, Digital Pro enables you to convert RAW files from a variety of camera models to "real" image file formats. Digital Pro also offers a "digital loupe" feature that makes it easy to zoom in to evaluate sharpness and other aspects of your images. If you're looking for the ability to manage your images in the process of editing them, along with a host of other features to stream-line your workflow, Digital Pro is worth considering. We'll take a closer look at Digital Pro's ability to manage your image library in Chapter 14.

Figure 9.15 Digital Pro is advanced software that provides tools for downloading images, converting RAW captures, and organizing your photos.

- iView Media (Windows and Macintosh) from iView Multimedia (www.iview-multi-media.com) provides features for editing as well as organizing your images. Its easy-to-use interface lets you quickly view your images both as thumbnails and full screen, delete unwanted images, and rotate images as needed. The Pro version of iView Media

(Macintosh only) provides additional features, including support for RAW capture formats, advanced search capability, image conversion, and more. The real strength of iView Media lies in its ability to organize your images. We'll look at those features in Chapter 14.

- BreezeBrowser (Windows only) from Breeze Systems (www.breezesys.com) is primarily designed to enable you to convert RAW files from Canon digital cameras. It also provides a very basic interface for editing your images. This browser really only provides the ability to view your images, delete outtakes, rotate as needed, and sort into folders. If you only need minimal editing capabilities and use the RAW capture mode with a Canon digital camera, BreezeBrowser may meet your needs.

Editing with Photoshop

We know what it's like to come back from a photo trip with hundreds of digital images. Our first impulse is to leap in and print some of our favorites. But we hope that by now we've convinced you of the wisdom of editing your images first. Let's take a step-by-step look at how you would actually perform that editing in Photoshop. First, however, you should get acquainted with Photoshop's File Browser.

Photoshop's File Browser

We frequently find ourselves using the File Browser for our editing. It's convenient because it's built into Photoshop, so once we've edited and sorted our images, we can quickly and easily open them in Photoshop to make adjustments.

Another benefit of the File Browser is the ability to quickly view thumbnails of RAW files in addition to other image file formats. Note that for Photoshop 7 you need to purchase the Adobe Camera Raw plug-in to be able to view and convert RAW files. This capability is built into Photoshop CS. Besides handling RAW files, the File Browser also provides accurate previews of layered Photoshop and TIFF files, which many other file browsers have a problem with.

The File Browser provides a folder view so you can select the folder that contains the images you want to review. Navigate to the folder of images you wish to edit to view thumbnails of all the images. Once you've selected the appropriate folder, you'll be focusing on the images, so you can hide the palettes on the left side of the File Browser window

by clicking the Toggle Expanded View button (**Figure 9.16**). In the File Browser for Photoshop CS, you can add folders to a Favorites list and view recently accessed folders for easy selection. You can also rank images to distinguish "keepers" from other images that might not be as good.

Unfortunately, you aren't able to zoom in on the image in the File Browser's preview, but you can quickly and easily open the image in Photoshop to examine it more closely. Tim would like to see the File Browser add the ability to navigate through full-screen previews of each image, as you can with other file-browsing software. This would be especially useful when comparing sharpness and subtle expressions in portraits.

Toggle Expanded View button

Figure 9.16 The File Browser in Photoshop provides a convenient solution for editing your images and provides all the basic tools you need.

Image overview

The first step in the process is to get an overview of the images you are editing (**Figure 9.17**). We find it helpful to view the full batch of images before beginning the editing process, to help determine how many images there are, how much redundancy there is, and perhaps to get a basic idea of which images are our favorites.

> **NOTE:** *If you shot in RAW format then you'll need to use software here that allows you to view thumbnails for those images. The software must convert the RAW file on the fly to be able to provide a preview of the image, but fortunately there are many programs that are able to do this. We'll review some of the options available in addition to the Photoshop File Browser later in this chapter.*

> **TIP:** *If you have a folder that contains a large number of images that you want to browse, it's a good idea to let Photoshop build the thumbnails while you work on another task away from the computer—it'll take a while because the background process consumes lots of resources. Be sure to select the option to "Allow Background Processing" in the File Browser section of Preferences, and also select the folder in the File Browser. Photoshop will then generate thumbnails for the images even if other tasks are being performed.*

Figure 9.17 Before you start deleting images after a photo shoot, get an overall look at the images to get a sense of how many there are, how much duplication exists, and which are your favorites.

Delete outtakes

Once you have an overview of the images you're editing, it's time to delete the outtakes. We start with the most obvious images. For example, bad exposures will usually be quite obvious, and many images with other technical problems can also be eliminated with a quick review (**Figure 9.18**).

Figure 9.18 The obviously bad exposures should be deleted early on in the editing process.

Now you're ready to take a closer look at the images. If the photo was taken without a tripod or the subject was moving, check for any sign of unintended motion blur. Confirm that images that were intended to show fine detail exhibit sharp focus. To really verify that an image is sharp where it needs to be, don't rely on a file-browsing program that doesn't allow you to zoom in; open up the image in Photoshop and examine it at a 100 percent view. And

in addition to deleting images that exhibit technical problems, you should also remove images that have aesthetic problems. Compare the image's composition with that of photos of the same scene taken from different perspectives, and decide which works better.

The process of deleting outtakes can be incredibly subjective. When you get started, the images with obvious problems can be deleted quickly. But after that it gets more challenging to decide which to keep and which to throw away. You want to edit the batch of images down to a manageable number, representing only the very best images. However, you don't want to eliminate any options you might want in the future. Consider what would be involved in fixing the image. Is it possible that only minimal adjustments will be required to produce a final result you're happy with? When in doubt about a particular image, we recommend keeping it and making your final decision after you start working with your images and producing prints.

Not So Fast!

The tendency with digital photography is to take many more pictures than you would if you were working with film, because there isn't the sense that you're wasting film. As long as you have enough storage capacity for the photos you're taking, there's no need to limit the number of pictures you take.

When you start to edit the large number of images you captured digitally, however, you may become more aggressive in deleting images that aren't the best, so that you don't waste time working on them and so they don't consume space on your hard drive. This can be a good thing in terms of staying organized. However, consider what you may ultimately miss out on.

Have you ever gone through a shoebox full of old prints years after they were taken? If so, you may have found a photo that stirred your emotions but lacked good image quality. Maybe it's a photo of a dear friend caught with a humorous expression. It could even be an important historical moment that wasn't appreciated at the time.

When editing your images, consider the potential value of the images beyond their aesthetic qualities, and don't be too quick to delete photos that don't meet your standards now, but may be among your favorites later.

To delete outtakes in the File Browser, select them and either click the Delete File button at the top of the File Browser or press the Delete key. You can also right-click on a file and select Delete from the shortcut menu. If you have the palettes visible on the left of the File Browser window, you can click on an image to get a preview for closer evaluation.

TIP: Don't forget that if you choose to delete images in the File Browser you really are deleting the photograph, not just the thumbnail. Be sure you're ready to part with the image before you delete it.

Rotate

Many of the latest digital cameras include sensors to determine the orientation of the camera at the time the picture was taken. This information is then stored in metadata that is added to each image file so that the image can be automatically rotated by software that is able to read this metadata.

If the images aren't rotated automatically, you'll want to rotate the vertical shots so they appear with the proper orientation (**Figure 9.19**). However, since you may end up deleting many of these images, you'll save time by waiting until after you've deleted the outtakes to do the rotation. On the other hand, it's often easier to review the images when you can see them in their proper orientation. Tim swears he has some sort of disconnect in his brain that makes it impossible for him to evaluate an image if it isn't in the proper orientation, so he prefers to rotate all verticals before deleting outtakes. If you are comfortable deleting the outtakes without rotating the images, you can do so. Some images will have such obvious problems that there is no need to rotate them.

Figure 9.19 It's helpful to rotate your images so they're all in the proper orientation before you get too involved in the editing process.

Rotating the images is again a matter of selecting those that need to be rotated and then clicking the button to rotate clockwise or counter-clockwise at the top of the File Browser window. You can also rotate by selecting the appropriate option from the Edit menu: Either right-click on an image and select the appropriate rotation option, or use the keyboard shortcuts. In Windows, Ctrl-[will rotate left and Ctrl-] will rotate right, each in 90-degree increments. On Macintosh, the keyboard shortcuts are Command-[and Command-].

You can also select multiple images and rotate them at once. To select multiple images in a series, click on the first image to select it and then hold the Shift key and click the last image; all images in between the first and last will also be selected. If you need to select images that are not contiguous, hold the Ctrl key (the Command key on the Macintosh) while clicking on an image. This allows you to toggle the selection of an image on or off as needed.

Sort and organize

Once you've edited your batch of images down to the very best, we recommend sorting and organizing them right away. Keeping your images organized requires discipline, but it certainly pays off.

You can use a variety of methods to organize your images. To start with, you can split them up into folders that represent various categories. We have already recommended creating a folder for the images for each photo shoot or trip, but you can also further divide your images up to better manage them. For example, if you have just photographed a wedding you would have all of the images in a folder identifying the bride and groom along with the date. You could then create subfolders within this main folder to separate pictures of the happy couple, the extended family, the wedding party, and candid shots of the event. This will make it easier to find just the right photo when the bride calls looking for a picture of her new father-in-law doing the "funky chicken" on the dance floor.

Besides creating a folder system, you can also use a variety of software tools to categorize your images and assign keywords (which we'll discuss later in this chapter). These tools involve work and time up front but offer a more organized way to track and find your images later. If you are a wedding photographer, you aren't likely to need this ability, since once family and friends have placed their orders for prints shortly after the wedding you aren't likely to need to find a particular image again. If, on the other hand, you license your images for stock, it could be very valuable to spend the time up front to assign keywords, so that you can locate an image for a client quickly when needed. We'll discuss some of the software for organizing your images later in this chapter, and take a more detailed look in Chapter 14.

Rank

The ranking option in the File Browser allows you to assign a rank to each image, identifying its relative importance for you. For example, all your favorite images could be given the rank of "A," with second-best images getting a "B." This feature has improved in Photoshop CS to offer more flexibility. Instead of assigning a single letter grade to your image, you can assign any code you want (**Figure 9.20**). Since you can sort images by rank, we recommend using a numeric or alphabetical ranking, but you can use words or any other code system you like.

Figure 9.20 Ranking images in Photoshop's File Browser provides an additional way to sort and organize your images, keeping your favorites at the top of the list, for example.

> **TIP:** We also recommend keeping your ranking system as simple as possible. While it might be tempting to score your images on a scale of 1 to 100, this adds tremendous complexity. Instead, we recommend using a simple system with limited choices. For example, you could rank on a scale from 1 to 5, with 1 being best.

The ranking feature in the File Browser provides an excellent way to fine-tune the editing of your images. You can then use the rank to sort your images and simplify the process of grouping your favorite images.

Rename

Another way to keep your images organized is by naming the individual images. Because you can search for files by name, choosing an appropriate one will make it easier to identify the right image when you need it. There are as many approaches to this as there are photographers, but some basic concepts can help you decide which approach works best for you.

The simplest approach is to name all files with a common prefix and numerical suffix. The prefix can be either a number that identifies the group of images based on your own system, or a name that identifies the images. For example, you might assign job number 0123 to the latest photo shoot, and then assign a number for each image, so that the file names would be 0123-0001, 0123-0002, and so on. If you prefer to use a name to identify the photo shoot, the names might be Yellowstone-0001.psd, Yellowstone-0002.psd, and so on.

Renaming can also be helpful because the final batch of images can be numbered sequentially with no gaps. This is great for a variety of situations, such as when providing image files to a client when you don't want to emphasize the fact that some images were deleted.

The other approach is to name the individual images so that the name tells you a bit more about each photo. For example, from a Yellowstone National Park photo trip, you might name some images with the prefix *mammal* and a number, others with *geysers* and a number, and so on.

You could also be much more specific, and identify particular information about the image based on the filename. For example, you might name images of the Old Faithful geyser at Yellowstone as "YNP-GY-OF" representing Yellowstone National Park, geysers, and Old Faithful, respectively.

Another important practice when creating a file-naming system is to document it. While you may have developed a perfectly logical system that makes perfect sense, down the road you may forget some of the details of your system. Create a document on your computer, or keep a written record, that describes your naming system in detail, so that you can decipher the names of your images and know exactly how to name new images.

The File Browser's Batch Rename feature allows you to build complex filenames and then either rename the files in the current location or move the renamed images to a new folder that you specify (**Figure 9.21**). To use it, select the files you wish to rename, and then select the Batch Rename option from the Automate menu.

Figure 9.21 The Batch Rename feature in Photoshop's File Browser allows you to change the filenames for a group of images with flexibility and convenience.

The Batch Rename dialog allows you to select up to six parameters for the filename. Since you'll want to include an extension for the file, you have five parameters to devote to the filename itself. For example, you can specify a prefix based on the photo trip, such as "Yellowstone" or your client's name. You can then add the date of the image by specifying one of the date format options. For the third parameter you can place a dash or underscore character, followed by a serial number ranging from one to four digits in the fourth parameter. You might also add a code after the number indicating a classification for the images, such as "P" for personal, "C" for client, and so on.

Note that you can rename the images where they are, or you can copy the images with a new name to a new folder, preserving the original files.

Metadata

Metadata is additional information about the photo that's stored with the image file (**Figure 9.22**). Digital cameras include a tremendous amount of information about the capture conditions in the metadata for each image. While we don't generally use metadata for editing our images, it can be helpful for deciding between two images. For example, for action subjects we might select the image with the fastest shutter speed, all other factors being equal. It's also helpful to see what camera settings were used to capture a particular image. The data recorded includes the camera used, the lens focal length, the metering mode, and whether the flash fired, among other data. The information is displayed on the Metadata palette in the left pane of the File Browser window, and reflects the capture data for the currently selected image.

Figure 9.22 The metadata stored with digital image files provides useful information about the image, such as capture settings.

Keywords

You use keywords to identify the subject matter and theme of a photograph so that you can search for the image later.

If you assign keywords to your images, it's best to do so early in the editing process. Assigning keywords is a science in itself. It's nearly impossible to anticipate every possible keyword you might use to identify an image. Since these are your own images, you'll have a good idea of the image you are looking for; so the keywords can be rather straightforward. However, in some cases you may need to find an image that represents a particular concept—which is a little trickier.

Basic keywords are relatively easy to come up with. These should identify any important details about the image, including orientation, camera, location, and details about the nature of the image. Assigning keywords for concepts can be a bit more complicated because many words can be used to describe the same concept. For example, if you have a picture of a person laughing, would you add keywords for "joy," "happiness," "laughter,"

"humor," and "funny"? Each image will convey particular emotions and ideas, and these are incredibly subjective. Each viewer may interpret an image with different emotions.

The File Browser provides a basic keyword feature that allows you to assign keywords to images and search for images that have one or more keywords assigned to them.

The Keywords palette allows you to categorize your keywords into keyword sets, and then create keywords within those sets (**Figure 9.23**). For example, under the Event category you could include the Birthday, Graduation, or Wedding keywords. You can create new keyword sets by clicking the New Keyword Set button at the bottom of the Keywords palette. You can create new keywords within a keyword set by clicking the New Keyword button at the bottom of the Keywords palette.

Figure 9.23 Photoshop's File Browser provides a basic keyword feature that helps you further organize images into categories.

To assign keywords select the images in the File Browser. Then click on the box to the left of the keyword you want to assign, and a checkmark will appear to indicate that the keyword has been assigned to the selected images. If you want to view the images that have been assigned a particular keyword, right-click on the keyword in the Keywords palette and select Search from the shortcut menu. Because the search criteria will automatically be set to look for images with the keyword assigned, clicking the Search button will locate the images with that keyword assigned.

We'll discuss strategies for applying keywords to your images when we discuss image-management software in Chapter 14.

Export Cache

If you use the File Browser for editing your batches of images and you eventually put the final images onto CD, you'll want to take advantage of the Export Cache feature. When you select Export Cache from the File Browser's File menu, the thumbnail data for the current folder is exported to the same folder the images are in. If you then move the folder or put the files onto a CD, you won't need to wait for the thumbnails to be generated when you browse the images in File Browser. The data files will provide instant access to the thumbnails for faster review when finding the image you need.

CONVERTING RAW FILES

Once you've edited and sorted your images, you're ready to optimize them. If you are capturing images in the RAW format—and we strongly recommend that you do—you'll need to convert the RAW files into a true image file format before you can work with them.

Converting your RAW images is in fact the first step in optimizing them. During this process, you will make a number of important decisions about how to produce the best quality from the high-bit data the camera recorded. You can choose one of several tools to help you effectively convert your RAW files.

BreezeBrowser

As mentioned earlier in this chapter, BreezeBrowser only allows you to convert RAW captures from Canon digital cameras. Once you've navigated to the RAW image you want to convert, simply click the RAW button on the toolbar. This brings up the Convert RAW Image dialog, where you can adjust the settings for the RAW conversion.

You can set the following options: the white balance preset mode or a specific color temperature, tonal adjustments, saturation adjustments, and specific output settings. Unfortunately, most of the controls offer only specific options with limited choices, rather than a slider that allows finer control. When you're done, click OK and the image will be converted and saved in the location you specified.

If you don't need fine-tuning control when converting your RAW images, BreezeBrowser offers an acceptable solution. If you do, however, we recommend that you consider other, better options.

PhaseOne Capture One DSLR

Capture One DSLR from PhaseOne (www.phaseone.com) provides an excellent solution for converting RAW files. It currently supports most Canon and Nikon digital SLR cameras.

Capture One DSLR includes a file browser that allows you to navigate through the folders (or the connected digital camera) on your system and then select images to convert. When you select an image, you can adjust the various settings to be applied in the conversion by selecting from available controls on a series of tabs.

The Capture tab provides information about the original file. This tab includes a histogram display that helps you evaluate the original, as well as basic EXIF (EXchangeable Image File Format) data showing exposure and camera settings.

The Gray Balance tab allows you to tweak the white balance and color adjustments for the image. You can adjust the color temperature of the image, as well as its color cast, by using either a color wheel control or individual Hue and Saturation controls.

The Exposure tab includes the common Levels and Curves adjustment options. These allow you to set specific white point, black point, and middle tone values in Levels, as well as adjust any tonal range in the image with the Curves control. We discuss these adjustment options in Chapter 10, "Essential Image Enhancement," and Chapter 11, "Digital Darkroom Expert Techniques."

The Focus tab provides settings to adjust sharpening of the image. Keep in mind that—despite the name of the tab—these settings don't allow you to fix images that were captured out of focus to begin with. Rather, they allow you to compensate for the loss of sharpness that occurs when an image is converted to digital data. The settings here provide excellent control over the sharpening process.

Finally, the Develop tab allows you to set output settings, and then set the image to be processed. This way, you can batch-process images: While one image is being converted you can move on to another image to adjust and convert it. As you complete the adjustments on an image, it goes into a queue to be processed. You can continue working on a series of images while those in queue are processed in the background, providing a very efficient way to convert your images. You can also set an option to automatically open the images in their associated software after they are converted.

Although Capture One DSLR is an excellent tool for converting RAW files, we prefer to use the conversion option built into Photoshop for workflow efficiency. However, if you will be converting the images and sending them to someone else for final adjustment, then the advantage of working with Camera Raw in Photoshop is minimal. In that case, Capture One DSLR is an excellent solution.

Adobe Camera Raw

Our preferred method for converting RAW captures is the Camera Raw interface in Photoshop (**Figure 9.24**). This was offered as an optional plug-in for Photoshop 7.0.1 and is now included as part of Photoshop CS. Camera Raw gives you extensive control over the image conversion and also provides an efficient workflow. To convert RAW files, you simply open them in Photoshop as you would any other image file, and the Camera Raw dialog automatically pops up so you can fine-tune the image adjustments. Note that Camera Raw supports RAW captures for most, but not all, cameras.

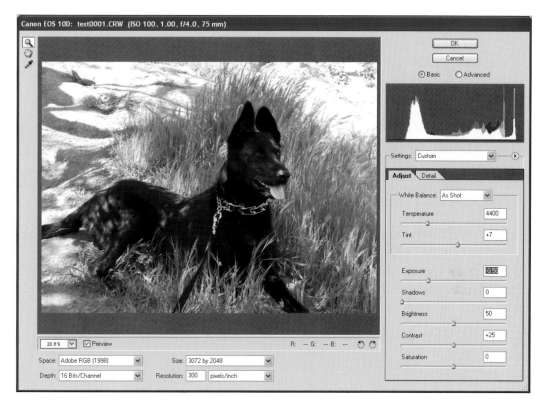

Figure 9.24 Photoshop's Camera Raw interface is our preferred method of converting RAW captures.

Navigation

The navigation controls in Camera Raw provide the same functionality as the Zoom and Hand tools in Photoshop, making it easy to focus on particular areas of the image as you fine-tune the adjustments to be applied in the RAW conversion process. You can double-click the Zoom tool to view the image at 100 percent, and double-click the Hand tool to

size the image to fit the window. You can also select a specific zoom setting from the drop-down list at the bottom left of the Camera Raw dialog. It's important to view the image at 100 percent scale so you can see all the fine detail; this will allow you to make a better decision about the relative merits of the image, in addition to providing an overall look at the complete image.

Histogram

The histogram provides critical information as you adjust the settings in the Camera Raw dialog (**Figure 9.25**). Just as the histogram is invaluable when capturing images to ensure proper exposure, the histogram in the Camera Raw dialog is critical for ensuring that you aren't clipping highlights or shadows. We strongly encourage you to review the histogram as you make adjustments to your images with Camera Raw.

Figure 9.25 The histogram display in Camera Raw allows you to make more informed adjustments to your images.

In addition to watching the histogram as you adjust your image, you can also use a *clipping display* for the Exposure and Shadows sliders in the Camera Raw dialog. This allows you to get a much better idea of where you are sacrificing detail in the image based on the adjustments you are making. To get the clipping display, hold the Alt key (Option on Macintosh) while moving the Exposure and Shadow sliders.

White balance

Digital cameras provide a white balance setting to compensate for the color cast created by various types of lighting. For example, incandescent lighting produces a yellow color cast, so the camera will compensate by shifting the color toward blue.

If you used the wrong white balance preset in the camera, you can select another option from the drop-down list. This will change the appearance of the image so that it looks as if you had used that new white balance setting during capture. The default is to leave the settings as they were photographed. Because of the control provided during the conversion, we capture all images with the camera's automatic white balance setting and then fine-tune them as needed during conversion.

If a white balance preset doesn't provide the perfect adjustment for the image, you can fine-tune the Temperature and Tint sliders. The Temperature slider controls the overall

white balance setting for the image. Moving the slider to the right will give you an image with warmer colors (yellows and reds), as though it had been captured at a higher temperature setting. Moving the slider to the left will produce an image with cooler colors (blues and greens), as though it had been captured at a lower temperature setting. You can also fine-tune the overall color in the image with the Tint slider, which shifts the image between green and magenta.

Tonal and color adjustments

The Camera Raw dialog offers a number of excellent tonal adjustment that let you control the brightness, contrast, and saturation of the final image.

The Exposure adjustment allows you to produce a linear shift in brightness, where all pixels in the image are brightened or darkened to a similar degree. The unit of measure is Exposure Value, which is what photographers would think of as the number of stops of exposure compensation. Because this is a linear adjustment that affects the brightness of all pixels in the image, it's possible to clip highlights or shadows in your image. It is important to watch the Histogram display as you adjust this setting. You would typically use the Exposure control to adjust images that are significantly over- or underexposed.

The Shadows slider functions the same way the black-point slider in the Levels dialog does. It allows you to define a black point for your image, so that you can maximize contrast in the final image. You can get a preview of where detail is being clipped by holding the Alt (Windows) or Option (Macintosh) key while moving the slider. As you move the slider, you can see which color channels are losing detail based on where the color appears. When black appears, it's an indication that those areas of the image have been clipped to pure black.

The Brightness slider allows you to adjust the overall brightness of the image, similar to the control provided by the Exposure slider. The only difference is that the Brightness slider will not clip highlights or shadows, but will instead compress the tonal information at the ends of the tonal range as you make adjustments. It's therefore a safer adjustment tool, although it doesn't provide the range offered by the Exposure slider. Think of it as behaving like the middle tone slider in the Levels dialog.

The Contrast slider adjusts the contrast in the middle tones of your image. Highlights and shadows will not be clipped by this control except with extreme adjustments.

The Saturation slider allows you to fine-tune the saturation of colors in the image. As with the Hue/Saturation dialog in Photoshop, you shouldn't increase saturation too much or you'll produce artificial-looking colors and lose detail in highly saturated areas of the image. In fact, we prefer not to adjust saturation at all in the RAW conversion, leaving those adjustments for Photoshop.

Detail settings

In addition to the tonal and color adjustments, you can adjust detail settings for your images. The Sharpness setting allows you to apply some sharpening to compensate for the loss of sharpness that occurs in the digital capture process. We find that the default value of 25 is excessive for most images. Our preference is to set this to zero and apply our own sharpening using the Unsharp Mask filter.

Luminance Smoothing and Color Noise Reduction both target noise in your image. Luminance Smoothing reduces noise where the variation is monochromatic, and Color Noise Reduction cleans up noise where there are color variations. If you have noise in your images due to a high ISO setting, a long exposure, or other factors, these controls can help minimize that noise. The Color Noise Reduction setting can also be used to minimize moiré patterns, such as those you might capture in finely woven fabric patterns.

Output settings

At the bottom of the Camera Raw dialog are settings that affect the output of the final image file. The Space option allows you to select the color space for the image. We recommend using the Adobe RGB (1998) color space here, as it's the most appropriate color space for images that will be printed to an inkjet printer. We'll talk more about color spaces in Chapter 10.

The Depth drop-down allows you to choose either 8 Bits/Channel or 16 Bits/Channel. We strongly recommend working with 16 Bits/Channel, as it provides the maximum amount of information in the final file. If you immediately convert the image to 8-bit, you are eliminating much of the benefit of capturing in RAW mode to begin with. If you convert the image to a 16-bit file, you will be able to maintain much smoother gradations of tone and color.

The Size option lets you change the size of the image in the conversion process. This may sound like a job for Photoshop's Image Size dialog, but resizing the image in the RAW conversion will produce better image quality than if you sized the image in Photoshop later. This is because the RAW conversion involves interpolation of the image's color data—the imaging sensor captures only luminosity values, so color information must be interpolated. If you also interpolate the image to a different size in this process, you maximize quality. The difference is subtle, but we do recommend adjusting the size in Camera Raw if you plan to resize the image later. In most cases, that means increasing the size of the image in the conversion.

The Resolution setting will not affect the actual output size of the image—only the default output resolution setting for the file. This can simplify your workflow if you need to prepare

images for print. For example, you can set this to the resolution you use for printing your images, and the file will be set to that output resolution.

Lens settings

When you select the Advanced option in the Camera Raw dialog, the Lens tab is added to the available controls that include options for correcting chromatic aberration and vignetting.

We discussed *chromatic aberration* in Chapter 3, describing it as color fringing around high-contrast objects. There's another type of chromatic aberration where the size of the image for each color channel is slightly different. This doesn't produce color problems in the center of the frame, but it does create color fringing away from the center of the image. This second type of chromatic aberration is the only type Camera Raw allows you to control.

The controls for adjusting this chromatic aberration are split into an R/C slider that controls fringing between red and cyan, and a B/Y slider that controls fringing between blue and yellow. These controls will not affect the center of the image, but will affect the area outside the center, with the maximum effect in the corners.

The *vignette* controls allow you to compensate for images that have outer edges—particularly the corners—that are darker than the rest of the image. The Vignetting Amount setting determines how much lightening or darkening is applied to the edge of the image, and the Vignetting Midpoint slider determines how large an area will get adjusted.

Calibrate settings

The Calibrate tab is also only visible when the Advanced option is selected. This section provides a variety of controls designed to compensate for inaccurate camera profiles. Camera Raw includes profiles for supported cameras, which describe the color behavior of the cameras. If you feel the profile is inaccurate because it consistently shifts the color in your images toward particular hues, you can fine-tune these controls to compensate. They include controls for the Shadow Tint, which controls the color temperature in shadow areas, as well as hue and saturation adjustments for each of the color channels. These controls are only recommended for advanced users who are very familiar with camera profiles.

Convert

Once you have set all of the options for the RAW conversion, you can click the OK button. The image will be processed and converted based on the settings you applied, and the image will be opened in Photoshop, ready for you to save and optimize. The original RAW capture, however, is left untouched.

Batch processing with Camera Raw

You can also batch-process a group of images that you want to convert using the same settings with Camera Raw. This is an excellent way to speed up the process of converting a series of images shot under the same conditions, as would be the case for a studio shoot. To batch-convert, first open one image and apply the settings desired in the Camera Raw dialog. Then go to the File Browser, select the files you want to convert with the same settings, and from the File Browser menu select Automate > Apply Camera Raw Settings (or right-click and choose the same option). In the dialog that appears, select the option to apply settings from "Previous Conversion" and click Update. Then hold the Shift key while selecting File > Open from the File Browser menu, or while pressing Enter, to open the images. Holding the Shift key prevents the Camera Raw dialog from being displayed, and the images will all be converted using the same settings.

Note: For detailed instructions on working with Adobe Camera Raw, visit the book's companion Web site at www.digitalphotobook.net.

Sigma Photo Pro

Because the Sigma SD9 digital SLR camera only captures in RAW mode using the Foveon full-color sensor, you need to use the Sigma Photo Pro software to convert your photos to image files. We recommend converting these files after you have downloaded the images to the computer, as explained earlier in this chapter.

The Photo Pro software provides excellent control over the conversion process. Double-click on the image to preview it at a larger size. Then click the Adjustment Controls button to fine-tune the image. You can apply a variety of tonal adjustments and adjust color balance, while keeping an eye on the image and the histogram to make sure you aren't clipping highlight or shadow detail. Once you've optimized the image, click the Save Image As button to set file options and save the image file.

You can also batch-process a group of images if you don't need to individually adjust them. Select a folder that contains RAW capture files, and select those you wish to convert. Then click the Save Images As button. The resulting dialog will let you set options for the batch conversion, including the option to convert all or only selected images, as well as processing options and a destination folder. When you click OK, the images will all be processed and saved to the destination folder you specified.

ON TO OPTIMIZATION

During the process of downloading and editing your images from a photo shoot, you'll have an opportunity to determine which images are the best. While looking for the images you want to delete, you'll also figure out which are your keepers. Now you're ready to start working with those gems. In the next two chapters we'll guide you through the process of optimizing the images and suggest creative ways to interpret them.

CHAPTER TEN
Essential Image Enhancement

For many people, seeing their pictures immediately is the main attraction of digital photography. No longer must you drop the film off at a processing lab and wait. Once you get back to your computer, you can download the photos and view them immediately in full size. What's more, with the exception of RAW files, which require a brief conversion detour, digital images are already "developed," so you can start working with them right away, whether you're going to upload them to a Web page, email them, or make prints.

Still, as good as digital cameras are, we've never met a collection of pixels that we didn't want to tweak, adjust, massage and finesse into a better image. And that represents another aspect of the allure of digital photography: the ability to retain total creative control over the image, from concept to capture, through editing and the final print. For creative photographers who enjoy such levels of control, this is heady stuff. Most digital photographs can be improved with a little TLC, and images that you would have written off as a total loss if you were shoot-ing film can often be coaxed and cajoled into a spectacular recovery with the right techniques.

After you take pictures with your digital camera, the next stop on the learning curve is becoming comfortable with working on your photos in an image-editing program. With the requisite skills, you can create practically anything with a digital image that you can imagine. Yet there are certain essential improvements that all images can benefit from, including overall color, tonal, and contrast adjustments; modifications to specific areas of the image; simple retouching; and preparing the image for the final print. In the next two chapters we'll discuss techniques and strategies for improving your images in the digital darkroom. The software we'll be using for this discussion is Adobe Photoshop CS. Photoshop is the premier application that the overwhelming majority of professional and serious photographers use for their digital image editing. Although some of the features that we mention may be specific to this version of Photoshop, most of the techniques can be used in earlier versions of the program, and even in different programs such as

Photoshop Elements or Ulead PhotoImpact with only minor adaptations on your part. In some cases, other programs offer similar features and let you do the same things to your images; it's just the interface that looks a little different. We should point out, however, that these chapters are not meant to be an introduction to the program if you're totally new to Photoshop. We assume that you have at least a basic familiarity with the general layout of the program's interface. We only have two chapters in this book that are devoted to Photoshop. There are plenty of very good resources available for learning the basics of the program and beyond. We've included a list of some of our favorite Photoshop titles at the end of Chapter 11, "Digital Darkroom Expert Techniques."

In the first part of this chapter, we'll look at some of the more important program preferences and then take a tour of the very important Color Settings dialog that serves as mission control for Photoshop's handling of color. In the second part of the chapter, we'll address some essential image-editing techniques for improving your digital photographs.

PHOTOSHOP PREFERENCES

Before you start working on your images in Photoshop, you need to configure some of the settings that work behind the scenes and control how different aspects of the program behave. We like to think of this routine as being similar to picking up a rental car at the airport. There are always a few adjustments we like to make, such as positioning the mirrors, adjusting the seat, making sure we know where the headlight switch is, checking the gas level, and finding a decent radio station, before we drive out of the parking lot and hit the open road.

Photoshop provides numerous ways for users to customize the program. From actions that record commonly performed tasks to user-defined keyboard shortcuts and saved workspaces, there are different avenues to setting up the program just the way you like it. The first place you should start, however, is the Preferences. On Windows systems, these can be found under the Edit menu; on Mac OS X, they're located under the Photoshop menu. There are a lot of preference settings, but we won't discuss each one in detail. Many of them are specific to tasks and workflows that are intended more for graphic design and Web-related work. Instead, we'll address the most important preferences that pertain to the overall operation of the program in general, and more specifically, to those items that have the most impact on the type of work that digital photographers do.

TIP: You can use the keyboard shortcut Command-K for Mac or Ctrl-K for Windows to bring up the Preferences dialog. The entire Preferences dialog is divided into nine panels. The first panel you see will be the General Preferences. You move through the panels by using the Prev and Next buttons, via the pop-up menu in the upper-left corner of the dialog, or from the keyboard, by pressing Command-1 through -9 (Mac), or Ctrl-1 through -9 (Windows).

General Preferences

The General Preferences panel contains options that are not specific to any particular area of the program. Although some may seem trivial (and some are), there are some important settings on this panel (**Figure 10.1**).

Figure 10.1 The General Preferences dialog in Photoshop CS.

- **Color Picker.** This should be set to Adobe. The Adobe Color Picker offers far more functionality, control, and subtlety than either the Apple or the Windows system color pickers. Plus, it's a great place to learn about color!

- **Image Interpolation.** *Interpolation* refers to the method by which new pixels are created or existing pixels are thrown away when an image is sized up or down. Choosing an interpolation method here will affect how interpolation is done in other areas of the program, such as when you scale an image or transform an image element. The change is immediate and does not require you to restart the program. If you're using Photoshop 7 or earlier, then you should set this to *Bicubic*, as that is the most accurate algorithm for photographic images.

Photoshop CS has two additional interpolation methods: *Bicubic Smoother* and *Bicubic Sharper*. For *upsampling* images (making them larger) Smoother is almost always the better choice. Sharper will often provide the best results for *downsampling* (making an image smaller), although how good can vary from image to image, so it's not as clear a choice as Bicubic Smoother is for upsampling. All of the interpolation options are available in the Image Size dialog, and can be chosen for specific images as the need arises. For general use, we recommend setting Bicubic as the default interpolation method.

> **NOTE:** *One area where interpolation choices are not available, however, is when you're performing a transformation in size or proportion using the Free Transform command. For this reason, leaving the general interpolation preference set to Bicubic is the safest setting for general usage. If you know you'll be using Free Transform to scale an image larger or smaller, then you'll have to use the Command-K/Ctrl-K shortcut to make a quick detour into the Preferences and select the appropriate interpolation method. Unfortunately, you'll have to return to the dialog after the transformation to set it back to regular Bicubic. Depending on the type of work you'll be doing in Photoshop, this is a bit of a workflow issue at the moment that could be improved in a future version of the program.*

- **History States.** At the most basic level, the History feature in Photoshop is a super-undo command that lets you move backward through the editing steps to undo changes. Photoshop refers to each separate change as a *history state*. A history state can be anything from a tonal correction to a paintbrush stroke to an image-resizing operation. As you might imagine, this provides great flexibility and insulation from "no way out" mistakes that occur during the editing process. The default number is 20 history states, and the maximum number is a whopping 1000. Whether you'll actually be able to get by with the maximum amount will depend on a number of factors, including the size of your image, how much RAM you have, and how much free disk space is available for Photoshop to use as a Scratch Disk. We'll address Scratch Disk issues later in this chapter. Until you get a better idea of how many history states is a good number for you, we suggest starting at 50.

 > **TIP:** *If you will be doing a lot of retouching using either the Clone Stamp or the Healing Brush, then it's a good idea to use a higher number of history states. Since retouching typically involves many small applications of these tools, the more available history states you have, the more flexibility you have recovering from retouching mistakes.*

- **Dynamic Color Sliders.** This setting affects the behavior of the color bars in the Color palette. When the option is turned on, the colors will update as you move the control sliders. We feel this is a very useful feature, and we recommend selecting this check box.

- **Save Palette Locations.** This preference is self-explanatory. We generally leave this turned on. A better way to handle palettes is to save specific palette arrangements as workspaces. You can do this through the Window menu.

- **History Log.** Photoshop CS allows you to save a record of your activity in Photoshop, or the specific steps you applied to an image. You can choose to save this information to a file's metadata, to a separate text file, or both. The details can be restricted to Session, which simply records when you open and close a file; Concise, which tracks session info plus keeps a record of every step you perform; and Detailed, which tracks session info and keeps an extremely detailed record of every thing you do to an image, including specific settings used for filters, color correction, and other tools. If you want to remember what you've done to an image, the Detailed option can be very useful.

File Handling

This section of the Preferences contains settings that control how Photoshop saves a file (**Figure 10.2**). Some are fairly minor and inconsequential, while others, such as the Maximize PSD File Compatibility option, are very significant.

Figure 10.2 File Handling preferences.

- **Image Previews.** If you want Photoshop to save small versions of the image for your operating system to use as icons or preview thumbnails, this is the preference that controls it. Note that this has nothing to do with the thumbnail previews that are generated by Photoshop's File Browser. If you're generating images for the Web, then you usually don't want to save either previews or icons, since no one visiting a Web page will see them and they just needlessly increase the file size. To be able to choose on a per-image basis whether these items are generated, select the Ask When Saving option.

- **Ignore EXIF profile tag.** Color tags are used to give meaning to the color numbers in a digital image (which is all just a bunch of numbers anyway) so that the appearance of an image will be consistent on different color-managed computers. Some digital cameras will automatically tag their images with an sRGB color profile, even if you've specifically chosen Adobe RGB in the camera's setup menu. While the sRGB profile may represent a correct interpretation for the images a camera produces, it's just as likely to be no more than a "default" tag by the camera that doesn't necessarily reflect the best way to interpret the colors in an image. If you determine that another color profile, such as Adobe RGB or ColorMatch RGB, works better with the images from your camera, you can use this preference to tell Photoshop to ignore the sRGB tag contained in a camera's EXIF data. If you're using Photoshop 7, you can add this functionality to the program by downloading a special Ignore Color Space plug-in from the Adobe Web site (www.adobe.com/products/photoshop).

- **Ask Before Saving Layered TIFF Files.** Prior to Photoshop 6, only Photoshop's native PSD format could save layers. Now the club is not so exclusive and as the TIFF specification has matured, it too has developed the ability to support layers. This is really only an issue for those who may be using TIFF files in page-layout programs. In the past, some layout applications would get downright cranky if they encountered a layered TIFF. Although the ability of programs like Adobe InDesign to handle layered TIFFs and PSDs is allowing modification to the previous workflow of only using non-layered TIFFs, such changes are being adopted slowly. If you want a reminder that you're saving a layered file in TIFF format, turn this option on. We leave it off.

 > **TIP:** *Due to the lossless compression employed by the PSD format, it used to mean that the same file saved as a PSD would always be smaller on disk than if it was saved in the TIFF format. Since Photoshop 6, however, the lossless ZIP method of compressing a file has been available as a part of the TIFF format. In some cases, you can actually end up with a smaller file by saving as a TIFF with ZIP compression. Combined with the fact that TIFF supports layers and pretty much everything else that a PSD does, the native Photoshop format is not as exclusive as it used to be.*

- **Enable Large Document Format (.psb).** This Photoshop CS preference allows you to save very large files that were not possible in earlier versions. These large files can be saved in either TIFF (up to 4 GB) or the new PSB format, or in Photoshop RAW (which is not the same as Camera RAW, and we recommend that you avoid this format) with no file size limit. This new format and the new image size limits (300,000 by 300,000 pixels) are not backward compatible with earlier versions of Photoshop. The number of people who have a need for such gargantuan files is very small, and we recommend that you leave this option off, just as protection against accidentally

creating a file this big. If you feel compelled to stitch together 97 six-megapixel photos into a single, monumental image, however, then this is the option you need to use to make that possible.

- **Maximize PSD File Compatibility.** This option has been around in Photoshop under a variety of names for several versions, and it controls whether Photoshop will include a hidden, composite layer along with the regular layers when you save a file. The composite layer is essentially just a single layer that represents what the image would look like with all the visible layers flattened. This preference is primarily for people who need to use their layered PSD images in other applications that read PSD files but really need the composite layer in order to do so. The main problem with this option is that the extra composite layer will make your file size much larger— up to 33 percent larger—than it needs to be. While this is not much of an issue with small files, it can quickly become a big problem with larger documents. If you're working on your images only in Photoshop, then we feel that you should leave this off and save some disk space.

 The only marginally persuasive reason to turn this option on was given to us by Mark Hamburg, Photoshop's chief software architect at the time, during an earlier version of the program. He suggested that in the future some of the math for the layer blending modes may be updated, and that this could cause the interaction of the layered data to change, which in turn could result in your image looking a bit different than when you last saved it in an earlier incarnation of Photoshop. Saving a composited layer with the file would provide a visual reference of how the image should look. As logical as this sounds, we still prefer to archive a separate flattened file for this purpose and to keep the file size of our layered, master image as trim as possible.

Display & Cursors

The Displays & Cursor's section contains options that govern the display of the pixels on the monitor and the appearance of the mouse cursor (**Figure 10.3**).

- **Color Channels in Color.** We feel strongly that this should left unchecked. When turned on, it displays the individual color channels in brightly colored red, green, or blue. If you're new to the idea that digital photos are made up of separate red, green, and blue versions of the image, then this may make that concept somewhat easier to grasp. But the channels are still labeled red, green, and blue, and the colored overlays actually make it much harder to evaluate the tonal detail in the channels. You're better off leaving this unchecked and viewing the default grayscale versions of the color channels.

• **Painting Cursors.** This is probably the most important setting in this panel. By setting the painting cursors to Brush Size, it allows you to see a circular cursor that represents the actual size of the brush you're painting with. If the cursor is the default brush symbol icon, then you won't know how large your brush is until after you've painted on the image. The Other Cursors preference lets you choose between standard, which is the tool icon, and a precise crosshairs.

Figure 10.3 Display & Cursors preferences.

TIP: You can access a precise crosshairs cursor at any time by activating the Caps Lock key on the keyboard. To return to your regular cursor, simply press Caps Lock again.

Transparency & Gamut

These preferences are not that important in the big picture, and we've rarely had to select different options here, but sometimes you do need to change them (**Figure 10.4**).

Figure 10.4 Transparency & Gamut preferences.

- **Transparency Settings: Grid Size & Colors.** When you have an image element on a separate layer, it can either fill the entire size of the image or occupy only a portion of the image area. If the pixels on the layer do not fill up the full image area, then Photoshop uses a checkerboard pattern to represent the transparent pixels that surround it. You'll only see the pattern if you turn off the eye icons in the Layers palette of any underlying layers. If you're new to Photoshop, or Photoshop Elements, then the checkerboard pattern may be confusing at first. Essentially, the program needs to have something there so that you can *see* there's nothing there. We have found that the default colors and grid size work fine for most images. Clicking in the colored swatches will take you to the Photoshop Color Picker, where you can choose new colors for the grid. Be careful, though—some color combinations can be painful to look at!

- **Gamut Warning.** When the Gamut Warning is activated (from the View menu, choose Gamut Warning), Photoshop will place an overlay tone over any colors in the image that are out of gamut for the current CMYK setup as specified in the Color Settings dialog. You can also use it to display the out-of-gamut colors if you have selected an inkjet profile as the current proofing space. The default battleship gray at 100 percent works pretty well for most images…unless you have a photo of a battleship on a foggy day, that is, in which case lime green or shocking magenta might be a better choice.

Units & Rulers

Like the previous Preferences panel, this one is not too exciting, but it does allow you to decide which units you'll be using for rulers, as well as specify a couple of other important "under-the-hood" settings (**Figure 10.5**).

Figure 10.5 Units & Rulers preferences.

- **Units.** We prefer to change the ruler units out in the main Photoshop interface, either by right-clicking (PC) or Control-clicking (Mac) inside the rulers, or by accessing the units in the XY section of the Info palette (**Figure 10.6**). If you'll be printing most of your images, then use the measurement system you are most familiar with—inches or centimeters. If you need to prepare images for the Web, then pixels are the unit of choice.

 > **TIP:** *The measurement unit that is set in the Preferences is used by default when you enter custom values in the Crop tool's options. Be on the lookout for this to be sure that you are not inadvertently about to crop an image to 8 by 10 pixels!*

Figure 10.6 You can change the ruler units in Photoshop by clicking on the crosshair in the lower-left section of the Info palette.

- **Column Size.** If you are working on a publication such as a newspaper that uses columns for arranging text on a page, then specifying the exact size of your columns here will allow you to resize images, or create new files, based on the column width used in your publication. If you want to resize a photo so that it's two columns wide, for instance, the Column Size preference tells Photoshop how wide to make your image.

Plug-ins & Scratch Disks

These preferences control how Photoshop interacts with your computer in the vital areas of virtual memory and the location of accessory plug-ins (**Figure 10.7**).

Figure 10.7 The Plug-ins & Scratch Disks preferences.

- **Plug-ins.** Photoshop normally looks for filters in its own plug-ins folder (located inside the Photoshop application folder). If you have third-party plug-ins that you want to keep in a different folder, this is where you tell Photoshop where that folder is so that the additional plug-ins show up.

- **Scratch Disks.** When Photoshop runs out of RAM in which to do its calculations, it commandeers empty hard drive space on your computer and uses that as temporary RAM. This is also known as *virtual memory*. This option lets you assign a first, second, third, and fourth choice for which hard disks Photoshop should use as scratch space. You should always assign your fastest drive, with the largest amount of free space, to be the primary scratch disk drive.

 > **NOTE:** Adobe recommends that you have at least five times the size of your image in available RAM. This means RAM that is left over after your operating system, Photoshop, and all other active applications have taken what they need just to operate. Of course, with Photoshop, more RAM is always better.

Memory & Image Cache

This Preferences area controls more options for general memory allocation and the speed at which Photoshop updates the display of images (**Figure 10.8**).

Figure 10.8 The preferences for Memory & Image Cache.

- **Cache Settings.** The image cache is a way that Photoshop increases the apparent speed with which it deals with large images. Using the number specified here, Photoshop saves several smaller versions of the image at different zoom percentages (such as 25 percent, 33.3 percent, 50 percent, and 66.7 percent). When viewing the image at a zoomed-out view, the program can apply the changes to a smaller, cached version first and update your screen preview faster. The default setting is 4 cache

levels, which works just fine for most images from digital cameras. If you find that you're working on really large images and you have a good allocation of RAM, then you might try increasing it to 6 cache levels.

- **Use Cache for Histogram in Levels.** This option should be turned off! Its sole purpose is to speed up the rendering of histograms in the Levels dialog when working on your image at views other than 100 percent. Although the speedier histogram may seem like a good thing, you're not getting the real histogram from the full image, but rather a histogram rendered from whatever cached version happens to be presently in use. We feel that if you're going to make the effort to understand what the histogram is telling you, then you should be getting the accurate data.

 > **NOTE:** In Photoshop CS, the Histogram palette will always use the cached data until you tell it to do otherwise. It has its own interface and menu controls to render a new histogram from noncached data.

- **Memory Usage.** This section shows you how much available RAM you have and how much of it should be assigned to Photoshop. Both Windows and Mac OS X use dynamic memory allocation so the number is not necessarily as specific as it may seem in this preference. We generally use 75 percent of our available RAM for Photoshop. If you are running a lot of programs, or you find your system getting cranky, then you may need to lower this amount, install more RAM (always a good idea), or try closing some applications. Of those three possible options, getting more RAM is the best one. You can never have too much RAM with Photoshop.

File Browser

This group of preferences is specific to Photoshop CS and influences various aspects of the File Browser behavior (**Figure 10.9**). Most are pretty self-explanatory, but we'll go over a few of the more important ones here.

Figure 10.9 The File Browser preferences are specific to Photoshop CS.

- **Do Not Process Files Larger Than…** If you have certain folders that contain really large image files and you don't want the browser to get bogged down in generating high-res previews and thumbnails, then you can specify a file size cap here. The default is 100 MB.

- **Allow Background Processing.** This tells Photoshop to grab any extra available processing power and use it to generate previews and thumbnails for the selected folder of images, even when you're not currently working in the File Browser or in Photoshop. This is very useful for setting the File Browser up to work on a large folder of new images before you actually start browsing the files. We like to target the folder in question and then work on other tasks (or just go have dinner); then, when we come back, all the thumbnails and high-quality previews are ready for us.

- **High Quality Previews.** As the name implies, this directs the File Browser to build a higher resolution preview. We think this is an essential feature for evaluating images before you open them, and we recommend that you turn this on.

- **Render Vector Files.** If you have files created with Adobe's Illustrator, InDesign, or Freehand, or Corel's CorelDRAW, and you want to see previews of those files in the File Browser, turn this one on.

- **Keep Sidecar Files with Master Files.** The sidecar files contain the additional information about images that is generated by the File Browser. The default setting is for this to be turned on and it allows that such data be moved, copied, deleted, renamed, or batch-renamed along with the associated image files. We suggest leaving this on.

COLOR SETTINGS

The Color Settings dialog is mission control for Photoshop's handling of the display and conversion of color in your images. Understanding what is happening here and choosing the appropriate settings is key to controlling color in Photoshop, and it's essential to maintaining the color fidelity of your photographs. Although the Color Settings dialog operates in the background, it's one of the most important areas in the program. The settings you choose affect how images are opened, what happens to pixels when you paste from one image into another, how colors are displayed on your monitor, and how much notice you get if a particular process might change the colors in an image. It's well worth your time to get to know the different options in this dialog and understand how they impact your image-editing workflow.

How Photoshop Handles Color

Before we get into the details of the Color Settings dialog, let's pause for a moment to get an overview of the terrain we'll be exploring. It does no good to just tell you which settings to choose, which check boxes to check, and which radio buttons to enable if you don't have a decent understanding of the conceptual foundations of the Color Settings dialog and of Photoshop color management in general.

Painting by numbers

When distilled down to its most basic components, a digital image is nothing more than an electronic paint-by-numbers kit. The image is made up of a grid of pixels, with each pixel's color, or tone if it's an grayscale image, represented by a number. In the case of an RGB image, each pixel has three values, one each for red, green, and blue (**Figure 10.10**). True, when you're working on an image in Photoshop, it probably feels a lot more high-tech than a paint-by-numbers kit, but all you're really doing when you edit a digital image is changing the color of pixels. The numbers that are assigned to the pixels tell Photoshop how to display a given pixel on your monitor, or they tell an output device such as a printer what color that pixel should be when the image is printed.

The problem with this arrangement is that it comes with a certain amount of ambiguity. A paint-by-numbers picture would look very different depending on whether you used watercolors, oils, acrylics, colored pencils, or chalk pastels. With digital color, the actual color you get, whether displayed on a monitor or printed by an inkjet or photographic printer, will vary from device to device, simply because different devices interpret the numbers and render color in different ways.

In an effort to standardize how digital color is displayed and printed, color management in Photoshop revolves around three key principles:

1. Having a properly calibrated monitor with an accurate profile that tells Photoshop how your specific monitor displays color.

2. Using an RGB Working Space that's device independent; that is, its interpretation of how a given set of color numbers should be displayed is not constrained by the limitations of a particular device, such as a monitor, printer, scanner, or camera.

3. Adding ICC (International Color Consortium) profiles, or color tags, to your image files that tell Photoshop and other ICC-aware applications how the color numbers in your file should be displayed. These color tags give meaning to the color numbers in your image.

Figure 10.10 A color digital image is the ultimate paint-by-numbers kit, with every pixel having a value for red, green, and blue.

Monitor calibration and profiling

While all of the previously mentioned components are crucial, the importance of having an accurately calibrated and profiled monitor cannot be emphasized enough. Simply put, if your monitor has not been properly adjusted (calibrated) and the profile that describes it is not accurate, then no amount of color management diligence and use of image color tags farther down the line will give you predictable color. If you have never created a profile for your monitor (at the very least you should use the calibration utility that comes with your computer's operating system—or Adobe Gamma, which comes with Photoshop), then we recommend postponing any serious printing of your images until you've dealt with that vital piece of the puzzle. We address profiling your monitor, as well as the general process of shepherding your image from camera to monitor to final print, in Chapter 12, "From Capture to Monitor to Print."

> **NOTE:** The Adobe Gamma monitor calibration utility is included with the Windows versions of Photoshop CS, but not the Mac version. This is because Adobe Gamma does not run on Mac OS X. If you are not using a third-party calibration package to calibrate and profile your monitor, then Adobe recommends using the ColorSync calibration utility that is included with OS X.

The importance of working spaces

A *working space* defines how Photoshop interprets the color numbers in a file and gives some visual meaning and consistency to the numbers that make up a digital image. The working space affects any new images you create in Photoshop and also images that do not already have a profile associated with them (as is often the case with files from a digital camera).

The RGB working spaces that are available in Photoshop do not represent color as defined by a particular device, such as a monitor or printer. As long as you're using an accurate monitor profile and saving an image with a color profile (more on that in the next section), then the display of the image will be consistent when viewed on other calibrated and color-managed systems as well as when printed.

The importance of color profiles

If you gathered five people in a room and asked everyone to close their eyes and think of the color purple, it's doubtful that everyone would imagine the exact same color. Apart from obvious brightness difference such as light purple and dark purple, there are also subtleties of hue and saturation to consider. Is it a deep bluish purple, or a purple with traces of intense magenta? With no way to precisely define the color, the range of imagined purples would be all over the map. To accurately convey a more specific idea of what type of purple you were talking about, you would need to provide some additional information. In a digital image, an ICC profile contains this additional information to ensure that the colors in the image are being interpreted properly.

A *color profile* describes how the colors in an image should be displayed or printed. Along with a monitor profile and a device-independent working space, it represents the third, crucial component in Photoshop's strategy for handling the colors in your images. Any file you work on in Photoshop should be saved with an embedded color profile (this option can be found in the Save As dialog). The presence of a profile tells Photoshop and other ICC-aware applications how the colors should look. We can't stress enough the importance of having a profile associated with your image. Without an embedded profile Photoshop has no idea how to display the colors, so it just displays them according to the working space, which may represent a correct interpretation, but then again it may not.

Configuring the Color Settings

Let's now turn our attention to the actual Color Settings dialog (**Figure 10.11**) and discuss some of the choices there. In Windows, this is found in the Edit menu, and on Mac OS X it's under the Photoshop menu (Command-Shift-K on Mac and Ctrl-Shift-K on Windows).

Figure 10.11 The Color Settings dialog in Photoshop CS.

The Settings pop-up menu is at the very top of the Color Settings dialog and contains a collection of preset configurations that are tailored for different purposes (**Figure 10.12**). If you've never changed these settings, then it's likely they are still set at the defaults, which, while not catastrophic, are certainly not the best for serious photographic work with Photoshop. In Photoshop 6 and 7 the default settings are configured to Web Graphics Default unless you opt to customize them when you first open the program after installation, or you customize them later. In Photoshop CS, the default settings have been changed to North America General Purpose Defaults, which for all practical purposes regarding digital photography are no different than the previous set of defaults. Again, while use of these default settings doesn't herald the end of the world in terms of color quality, they're not ideal.

Figure 10.12 You can use U.S. Prepress Defaults as a shortcut to most of the correct settings for working with digital photographs.

As a shortcut to get to most of the settings that we recommend for photography, you can choose U.S. Prepress Defaults from the Settings menu. In the following section, we'll address what these settings mean, explain why we think you should use them, and cover situations where using a different setting might be a better option. In addition, we'll show you how to save a particular group of settings (such as those we'll recommend here) so that you can easily access it from the Settings menu.

Working Spaces

RGB

Photoshop provides you with four choices for RGB Working Spaces in the pop-up menu, and of these, only two are serious contenders for photographers who care about good color reproduction. Unfortunately, neither of them is included in the default settings. Let's take a look at them in greater detail. We'll list them in order of our preference, rather than how they appear in the Working Spaces pop-up menu (**Figure 10.13**).

Figure 10.13 Of the four standard RGB working spaces in Photoshop, we recommend using Adobe RGB (1998).

- **Adobe RGB (1998).** This is our preferred working space, and with few exceptions it's the one we recommend for digital photographers. If you chose U.S. Prepress Defaults from the Settings menu, Adobe RGB (1998) is already selected for you. This RGB working space has the largest color gamut of any of the four spaces provided by Photoshop (**Figure 10.14**). More specifically, many digital cameras now let you choose a color space for your images, and Adobe RGB is one of them. If you're producing images for reproduction on a printing press, the gamut of Adobe RGB includes nearly all of the colors that can be found in the most commonly used CMYK gamuts. The only potential drawback of using Adobe RGB for prepress work is that it extends pretty far out into the brightly saturated greens, which in most cases would be impossible to reproduce on a press.

Figure 10.14 On the left, the gamut of Adobe RGB (wireframe view) compared to sRGB (solid view). On the right, Adobe RGB (wireframe) compared to Color Match RGB (solid). ColorThink 3D graphing software courtesy of Chromix (www.chromix.com).

For any printed output of your photographs on RGB devices, whether on inkjet printers or photographic printers such as a LightJet 5000, Adobe RGB (1998) encompasses most of the color gamuts of those devices and is the best choice of the available RGB working spaces in Photoshop. If you're preparing files for specific output devices, however, it's always a good idea to check with your output provider to see if that vendor has different recommendations. Many consumer digital photo printers, such as the Fuji Frontier, use sRGB as their target output profile.

- **ColorMatch RGB.** This working space is based on the gamut of an actual device, the Radius PressView monitor that was once ubiquitous in prepress shops. After Adobe RGB, this is the other logical choice to use, especially if you're preparing images for press reproduction. Although the gamut of ColorMatch is much smaller than that of Adobe RGB (1998), it does include most of the common CMYK gamuts. Since it does not include as many intense, saturated colors as Adobe RGB (1998), some people prefer this space for work that will end up on press because the saturation of some of the colors they see on their monitor will more closely resemble what the image will look like when it is finally converted into CMYK.

- **sRGB.** This is Photoshop's default RGB working space, so if you've never changed it, or if you just accepted the defaults when you installed the program, it's probably still set to this. If we had to describe this working space in a few words, it would be *lowest common denominator.* In an effort to place some reference on what they felt most of the world was seeing on their monitors, Microsoft and Hewlett-Packard developed the sRGB space to represent the gamut of the "typical" monitor. Since most people are probably using inexpensive monitors that are not designed for imaging work,

sRGB is less than ideal for people who are concerned about working with color in images. If your work is destined for a printing press, sRGB is not advisable since it produces considerable *clipping* of colors (it can't reproduce them), especially in the cyan range.

With prints made from desktop inkjet printers, which is arguably what many digital photographers are most concerned with, sRGB is similarly gamut-challenged. When using Chromix's excellent ColorThink program to compare the profiles for the Epson 2200 on both Enhanced Matte and Premium Luster papers to the sRGB gamut, it's clear that sRGB produces significant clipping in the cyans, as well as in some of the deep greens and blues that are adjacent to cyan (**Figure 10.15**). A large amount of clipping also occurs in the very bright yellows and oranges, and some of the magentas and purples are also affected.

Figure 10.15 On the left, when the gamut for sRGB (wireframe view) is compared to Enhanced Matte paper on an Epson 2200 printer (solid view), clipping of the cyans, greens, and blues is apparent in the solid area that extends beyond the sRGB wireframe. On the right, sRGB is compared to Premium Luster paper on the same printer and even more clipping of the cyans, greens, and blues is noticeable.

Because most cameras use a variation of sRGB as their internal space for creating photos from the data produced by the CCD, you might think that it makes sense to simply use sRGB in Photoshop as well. While not catastrophic for casual use (such as emailing photos, dropping them into a PowerPoint presentation, Web graphics, or hobby printing), sRGB is not ideal for printed output, and if you care about color quality you can do much better. We recommend Adobe RGB (1998) over sRGB any day.

- **Apple RGB.** We're not sure why this is still offered in Photoshop. In computer terms, it's something from the fossil record (the polite way of referring to it would be to call it a "legacy" working space). In Photoshop 4 and earlier, the default color space (it didn't

let you choose your own back then) was based on an Apple 13-inch monitor, hence the inclusion of Apple RGB in the list of choices here. Unless you're just nostalgic for the past (before color management), there's no reason for digital photographers to choose this as a working space.

> **NOTE:** *Many people assume that the best working space to use is one that describes their monitor, camera, scanner or the printer that they will be using to print the final image. This is a false assumption; you should never, ever use a device profile as a working space in Photoshop. For one thing, a working space that is based on a specific device, especially a monitor, may not contain all the colors that your output device can render. Another reason this is a bad idea is that device profiles are rarely neutral (also known as gray-balanced), which means that equal amounts of red, green, and blue yield a neutral color. Photoshop makes this critical assumption in color correction and blend mode calculations. To play it safe, stick with one of the four working spaces that ship with Photoshop, with our recommendation being Adobe RGB (1998).*

Advanced RGB working spaces

The four RGB working spaces mentioned in the previous section are the default ones that ship with Photoshop. You can also use other spaces. Some, such as Kodak ProPhoto RGB and EktaSpace RGB, are popular with photographers who are well versed in editing high-end color scans in Photoshop. These additional working spaces, known as *wide-gamut spaces,* are fairly specialized and have been written to meet specific image-editing needs, most notably to capture the entire color gamut that was recorded on color transparency or negative films.

Since they have been developed to deal with the extended gamuts and saturated colors that are possible with E6 transparency films, these wide-gamut working spaces are best used for scanning and archiving purposes and are not at all appropriate for digital camera files. Although we strongly advise against using these spaces for your digital photographs (their color gamuts are much larger than what your camera can capture or your printer can reproduce), they do merit mention, especially since you may already have heard of them and might be wondering whether you should use them. Unless you're working with high-end scans of transparencies, and you're already accomplished at color correction in Photoshop, you don't need to go here.

> **NOTE:** *These advanced working spaces are not installed with Photoshop. If you're interested in using them, you have to download them from the Web, and then put them in the correct location on your system.*

Accessing additional RGB working spaces

To access a list of every RGB profile installed on your computer, or to find the wide-gamut spaces if you've installed them, simply check the Advanced Mode check box in the upper-left corner of the Color Settings dialog. If you're like most people, seeing that many choices for an RGB working space and feeling that you have to choose one can be a daunting prospect, and you'll probably want to immediately uncheck the Advanced Mode option and retreat to the comparative safety of the four default working spaces (**Figure 10.16**). The good news is that nearly all of the Advanced Mode options are entirely inappropriate as an RGB working space because they are device profiles. As previously mentioned, using a device profile for a working space is a bad idea because it's usually not neutral, which is key to performing good color correction in Photoshop. We do not use any of these other spaces since we prefer to stick with a neutral and perceptually uniform working space such as Adobe RGB (1998).

Choosing a CMYK working space

Before we get into the different factors that determine which CMYK working space you should choose, keep in mind that you only need to be concerned with this setting if the images you're working on will be reproduced on a commercial printing press. Even though desktop inkjet printers use cyan, magenta, yellow, and black inks, they are considered to be RGB devices because they do such a great job of taking the RGB data you give them, converting the RGB information into the color of ink they use, and most important, making nice prints. If you don't need to convert images to CMYK for prepress purposes, then you don't need to trouble yourself with this setting.

While RGB working spaces are device independent, CMYK is output specific, and the settings are influenced by the type of inks and paper being used, and in some cases, the characteristics of the individual printing press. So it's not as easy to give a one-size-fits-all recommendation for the best space to use. For general purposes, using the default U.S. Web Coated (SWOP) is probably as safe a choice as any for

Figure 10.16 When the Advanced check box in the Color Settings dialog is selected, every RGB profile on your system will show up in the RGB workspaces pop-up menu. We recommend leaving the Advanced box unchecked.

a default setting. Since CMYK settings are so tied to how the job will be reproduced, however, any setting you choose here should be thought of as no more than a placeholder that will suffice for the most common printing situations. Depending on the work you do and the type of publications in which it appears, one of the supplied presets may be just fine, but you should always maintain good channels of communication with your publisher or printer and verify if you are using the right setting. We highly recommend *Real World Adobe Photoshop CS* by David Blatner and Bruce Fraser (Peachpit Press, 2004) as an excellent resource for anyone who needs to use Photoshop with CMYK.

Gray working space

Gray working spaces can be selected to reflect specific dot-gain characteristics or display gammas. *Dot gain percentages* refer to the fact that when printed on a press, a dot of ink will increase in size, and therefore become darker, as it is imprinted and absorbed into the paper. The gamma settings are designed for images that will be viewed on a monitor, but they also work well for images that will be printed on an inkjet printer.

If your primary output is to a printing press, then choose a dot gain that matches the same figure in your CMYK setup. A setting of 20 percent is a common percentage for coated paper stock, for instance, and is the default in Photoshop CS. As with CMYK, however, dot gain may vary depending on the particular inks and paper being used, so consult your printer to get as much information as possible.

If you're printing black and white images to a desktop inkjet printer, we recommend setting the Gray working space to Gray Gamma 2.2. This is true even if you're on a Mac, which still uses a default display gamma of 1.8. A gamma of 2.2 (here and in your monitor calibration) will produce smoother gradients than a gamma of 1.8. If you're on a Mac and will be opening earlier grayscale files created using a gray gamma of 1.8, you will be notified that the embedded profile does not match the current Gray working space of 2.2. In that case, just choose the Convert to Profile choice, and the tones in the photo will be converted with an eye toward preserving the appearance of the image.

Spot working space

This setting refers only to specialized prepress situations where custom inks (those other than the standard process colors of CMYK) will be used. It does not apply to working on your digital photographs. Since you'll probably never use it, the default setting of 20 percent is fine. If you need to use it at all, then check with your printer about the specific dot gain characteristics of the ink, paper, and press that will be used to print the job.

Color Management Policies

This section of Photoshop's Color Settings dialog tells the program how to behave when it encounters either images that don't have a profile (untagged) or images that have an embedded profile that does not match the currently selected working space (mismatched). This is the place that controls those annoying warnings that appear when you open an image in Photoshop. Well, some people feel they're annoying, but once you understand what they're telling you, they're not so bad.

There are three separate pop-up menus for setting the policies for RGB, CMYK, and Gray working spaces (**Figure 10.17**). All contain the same three choices: Preserve Embedded Profiles, Convert to Working RGB (or CMYK, or Gray), and Off. These choices are the same ones that appear in the warning dialogs when you open images (though the exact wording is a bit different). What you select here just determines which radio button is selected by default when the warning dialog pops up. Let's take a close look at exactly what these choices mean. We'll look at them in order of our preference, rather than how they appear in the menu:

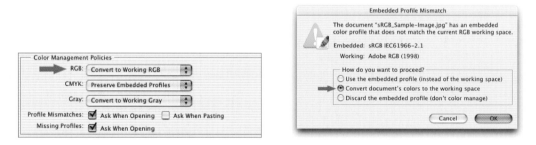

Figure 10.17 The Color Management Policies section of the Color Settings dialog controls the behavior of the warning notices that sometimes appear when you open a file. The three choices in the CM policies pop-up menus determine which radio button is preselected for you when a warning notice appears.

- **Convert to Working RGB.** When a file is opened that has a different color tag than your working space, this choice will convert the image from the embedded space into your currently selected RGB working space. If you're using Adobe RGB (1998) as your working space and all your images are generated by your camera, and you know that they have accurate profiles, then this is the best choice for digital photographers.

- **Preserve Embedded Profiles.** When opening a file with a color tag that is different from your working space, any embedded profile (like sRGB or ColorMatch) and the color numbers in the file are left unchanged. The image opens into Photoshop, and you can work on it in its own color space without having to convert to your working space. Assuming that you have a properly calibrated and profiled monitor, the display of the image should be correct. This setting is useful if you get files from different sources and only want to make a conversion to your working space after you've had a chance to inspect the file.

- **Off.** If you open a file that contains an embedded profile, Photoshop will discard the profile and regard the image as untagged. The color numbers in the file will be interpreted according to the currently selected working space, even though that may not be a correct assumption. Since we believe that profiles (if they are accurate) are a good thing that can help you take control of the color in your digital images, it's probably no surprise that we think this is a really bad idea. By stripping the profile from the image, you are flying blind as to the true meaning of the color numbers and Photoshop can only display the file as if it matched your working space. There is no good reason to choose this setting.

Profile mismatches and missing profiles

These three check boxes control whether or not you see those pesky "missing profile" or "mismatched profile" notices when you open a file. If you never want to be bothered by them again (and we hear this sentiment a lot!), you can turn them off here. We recommend that you leave at least two of them on, however, since we feel it's always good to be informed about what's happening with the color in our file or how it's being interpreted. The most important are the two Ask When Opening check boxes that trigger a notice if you open a file that either has no profile or that has a profile that doesn't match your working space. The Ask When Pasting option we feel you can safely turn off (it drives Katrin crazy). This triggers a notice when you paste from one image to another and the profiles of the two don't match. In nearly all cases you will want to convert the color numbers so that the image appearance is preserved. Since that is the default choice for this warning, we feel it's fine to leave this option unchecked and let Photoshop do the conversion without bugging you about it.

Opening Files: How to Deal with Profile Warnings

One of the most common questions we get from students and new Photoshop users is what to do about the missing profile and profile mismatch warnings that seem to pop up every time you open a file. If you don't know what they're telling you, or what the right answer should be, encountering these can be very frustrating. To make matters more perplexing, they use language that is slightly different from that used in the Color Management Policies section. In an effort to clear up some of the confusion surrounding these warnings, here are some recommendations on what choices are appropriate when you run into them.

Profile Mismatch

These are the easiest to deal with because Photoshop detects that there is a profile associated with the image and this gives it the necessary information to convert the color numbers from the image's existing profile to match your current RGB working space. Of the three choices presented to you, only the first two are really an option (**Figure 10.18**):

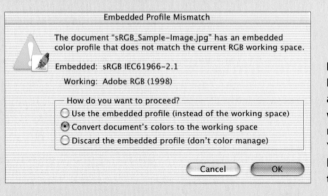

Figure 10.18 The Embedded Profile Mismatch warning appears when you open a file with a color tag that does not match your working space. You have three choices for how to handle color information in the file as you open it.

- **Use the Embedded Profile** will honor the existing color tag and you will be able to edit the image in its native space, as if your working space had been temporarily changed to match the profile of the image. This choice is the same as the Preserve Embedded Profiles menu option in the Color Management Policies.

- **Convert Document's Colors to the Working Space** is probably the more logical choice for most digital camera owners. The most likely scenario you will encounter is opening a digital capture where the camera has tagged it with an sRGB profile. Since it's far better to edit an image in the Adobe RGB (1998) space than in sRGB, converting to the working space makes a lot of sense. The conversion will preserve the image's appearance, so while actual color values in the image may change, it should look exactly the same as if you had opened it by choosing to preserve the embedded profile. This choice is the same as the Convert to Working RGB option in the Color Management Policies.

(Continued)

- **Discard the Embedded Profile (Don't Color Manage),** the final choice, should not be used. This is the same as the Off option in the Color Management Policies. The profile is removed from the image and the colors in the file are interpreted according to the working space, which is essentially just Photoshop shrugging and saying, "I dunno, let's try this". The only reason we can think of to ever use this is if you know for certain that the embedded profile is wrong and you want to remove it so you can assign a new one.

Missing Profile

If you open an image that has no embedded profile, Photoshop has no reference to go on and so it asks you how you want it to interpret the color numbers in the file (**Figure 10.19**). If you are only opening files from your digital camera, then you can usually figure out the right choice with a little testing. For one thing, most consumer-level digital cameras create files that look pretty good when opened as sRGB files. If your camera lets you shoot into the Adobe RGB (1998) space, then you can always select that, or simply convert into the working space if you're using Adobe RGB (1998). Here are your three choices:

Figure 10.19 The Missing Profile warning appears if you open a file that has no embedded color profile. Photoshop gives you three choices to determine how it handles the color information as it opens the file.

- **Leave As Is (Don't Color Manage)** is similar to Off in the Profile Mismatch warning dialog, with the exception that, since there is no profile to start with, nothing gets stripped from the image. Photoshop leaves it alone and opens it up, interpreting the colors according to how the working space thinks they should be displayed, whether that is correct or not. We use this option quite a lot in conjunction with Photoshop's Assign Profile dialog, when we want to explore how an untagged image might look when interpreted through a different profile.

(Continued)

- **Assign Working RGB** essentially does the same as the previous choice, with the only difference being that it slaps the profile of the working space onto the image. Since no color numbers have changed, and the image is being displayed based on the specification of the working space, the appearance of the image will be identical to how it would look if you had chosen Leave As Is. The only difference is the addition of the working space profile. This choice is appropriate only if you know that the file matches your working space.

- **Assign Profile** lets you choose a specific profile if you know what it is and also allows you to then convert to the working space after the profile has been assigned. This is a good choice if you know, for example, that sRGB works well for your camera's images but they still open up as untagged. You can choose sRGB from the pop-up menu and then click the Convert to Working RGB check box. The momentary presence of the sRGB profile gives Photoshop enough information to make a correct conversion to the working space. The only thing missing for this choice is a preview so you can see how a different profile is affecting the image. But since the image isn't even open yet, there's no way to see a preview (Photoshop can do a lot, but even that is beyond its capabilities!). To access this same functionality with a preview of how the new profile will affect the display of the image, choose Leave As Is and after the image is open go to Image > Mode > Assign Profile.

Advanced Mode

This area of the Color Settings dialog is available if you click the Advanced Mode check box in the upper-left corner. But many people feel that the normal Color Settings are advanced enough. We don't want to appear to be shirking our duty here, but our advice, based on a lot of experience working in Photoshop with our images, is that the default settings are fine for most situations and there's no need to change them. If you want to delve deeper into this part of the color settings, or Photoshop's handling of color in general, then *Real World Adobe Photoshop CS* is a great place to start.

Saving Your Color Settings

After you've gone to all the trouble of customizing the color settings, you can save them so that they appear in the Settings pop-up menu as a choice you can easily select later on. This is useful if you need to change color settings to work on different projects, such as specific CMYK jobs. To do this, click the Save button in the Color Settings dialog and give your settings a descriptive name, such as Photo Settings. In the Color Settings Comment dialog you can enter some text to give further information about the settings that will show up in the Description area at the bottom of the dialog as you roll your mouse over a settings option.

When you've finished configuring and saving the color settings, you're ready to go to work in Photoshop (**Figure 10.20**).

Figure 10.20 The Color Settings dialog in Photoshop CS, with all of the settings configured as we recommend here.

DEVELOPING AN IMAGE-EDITING STRATEGY

Photoshop makes it easy to start adjusting and changing your images right away. For someone who enjoys image making, it can be a little like finding yourself at a crossroads, with several paths leading off to different and creatively intriguing possibilities—exhilarating, but also a bit intimidating. Where should you start? What's the best path to take?

In this part of the chapter, we'll take a look at some essential image-enhancement techniques that can be used with nearly all images. Our focus here is not to cover all the myriad things you can do to an image, but to concentrate on the core techniques to improve any digital photograph. Before you jump in and start working on your images in Photoshop, though, it's good to take a step back and consider just what you might need to do to them.

Evaluate the Image

In Chapter 9, "Download, Edit, and Convert," we covered how to use Photoshop's File Browser to get an overview of all of the images in a given folder and edit them down to the best ones. In this chapter, we'll address evaluating each image individually after you've

opened it in Photoshop. Before you even think of modifying or enhancing a photo, the first step is to take a look at your image and try to consider it as objectively as possible. By subjecting it to a realistic evaluation, you'll have a much better idea of what you need to do to it in Photoshop. This can help you decide which step comes first, and can make it easier to know how to proceed once that first step is completed. To get a clear view of just your photograph, we suggest taking advantage of one of Photoshop's screen-viewing modes. If you click the middle icon of the three view buttons near the bottom of the Tool palette, or just press F on the keyboard, your image will be presented to you centered on a background of neutral gray (**Figure 10.21**). Pressing the Tab key will hide the Photoshop palettes and give you a view of your image without any desktop clutter in the background. More important, the gray background will let you evaluate the colors in the image without being distracted by any colors that may be present in your usual desktop pattern or wallpaper. Press F a second time and the image will be centered on black, and the menu bar will be hidden. Pressing F a third time will return you to the standard, multiple-window view.

Figure 10.21 In Full Screen Gray mode, your image is centered on a background of neutral gray, which makes it ideal for evaluating the colors in the photo.

Once we have our image in the full-screen gray version of the screen view, we evaluate our images for exposure, color balance, and focus:

- **Exposure.** This is usually one of the first things we evaluate. Is the image well exposed? Are there problems with under- or overexposure? If the image is underexposed, then you may have a challenging time lightening up the dark shadows without revealing too much noise, which usually hides in underexposed areas of an image. If the exposure is overexposed, then you need to check that the highlight values still retain detail. We'll cover techniques for evaluating the tonal integrity of an image in "Global Tonal Correction," later in this chapter.

- **Color balance.** In addition to overall exposure, how does the color balance in the image look? Is it warm or cool? Was the photograph taken under indoor lighting such as tungsten or fluorescent lamps? If so, even though your camera may do a good job on Auto White Balance, you still may need to make slight adjustments to the color balance to fix any casts that may be lurking in the image. If the image was photographed in the shade, it may be close to neutral (without a color cast), but it might still benefit from a little warming touch. We'll cover more precise methods of evaluating the color in an image later in this chapter.

- **Focus/sharpness.** To check the sharpness on the image, zoom in to 100 percent view (View > Actual Pixels). There's a vital keyboard shortcut for this: Command-Option-0 (zero) for Mac, or Ctrl-Alt-0 for Windows (see "Essential Photoshop Shortcuts" later in this chapter). Once you're zoomed in, hold down the spacebar and the mouse button to scroll around the image and look for the area in the photo that has the sharpest detail.

Keep in mind that images that have not been sharpened in the camera may appear a bit soft, but they can still be successfully sharpened using Photoshop (**Figure 10.22**). If you find that the image is more than a little soft, however, either through subject motion, camera motion due to a slow shutter speed, or just bad focusing, then there's not much you can do to bring it back into a state of crisp sharpness. Keep in mind, however, that just because an image is tack-sharp, it doesn't mean it's a good image, only that it's a sharp image. If you still find a slightly soft and blurry image to be a compelling photograph, then don't give up on it so quickly. We cover sharpening images in Chapter 11.

Figure 10.22 On the left a detail section from an image with no in-camera sharpening applied. On the right, the same image after sharpening in Photoshop.

NOTE: Any time you want to see the clearest, sharpest display of your image, you need to be looking at it at 100 percent. Photoshop calls this Actual Pixels (View > Actual Pixels), since there is a direct 1 to 1 ratio between a pixel in your image and a pixel that the monitor is using to display it. The image display will always be smoother at even multiples of 100 percent (in other words, 50 percent, 25 percent), but the best way to inspect fine details— such as how sharp the photograph is—is to be viewing the Actual Pixels and working in 100 percent view.

Make an Editing Plan

When working on images in Photoshop, knowing what you will do to the image and how you will accomplish it can save you a lot of time and frustration. The process of what you do to your image and in what order you do it is commonly referred to as a *workflow*. Establishing a protocol for a logical and known workflow can make editing your digital images both easier and more predictable. Although there may be variations in your treatment of different images, many of the steps and the general order in which they occur will be the same for most images. Having a workflow means you know what step comes next and can proceed to it with more confidence.

Technical considerations

Regardless of what you plan on doing with your image, there are a few basic steps that are usually applied to all images. These include setting a black and white point, neutralizing highlights and midtones, adjusting overall brightness and contrast, sharpening, and preparing for output. After you have evaluated the image, you'll be in a better position to know what areas need to be improved. Consider making a list of items that need to be addressed, or even use text layers, or the annotation feature in Photoshop to add editing comments to the image (**Figure 10.23**). Knowing the main steps you need to take on the technical end can make it easier to approach other aspects of the image that are not as easy to pin down, such as what the mood of the photo should be, and how to achieve this.

Figure 10.23 You can use the Text tool to make editing notes on a copy of your image and they will be kept on separate layers. The Pencil tool is handy for making quick circles around areas that need attention. In the second image, we're using the Annotation tool to add a comment to the area of the image that needs specific editing.

Interpretive considerations

For many people this is harder to put into words. Images are records of a certain subject at a specific moment in time. How you chose to photograph the scene has a great deal of effect on conveying a particular feeling or mood. Beyond that, how you decide to enhance the image in Photoshop can also be instrumental in creating the image in your mind's eye, either the way you imagined it when you pressed the shutter button or as you sit at your computer and sort through the latest download from your memory card.

Look at the image and try to imagine how you want the final version to look. For many photographers, the goal is to create a final photograph that accurately represents the scene they saw when they took the picture. Others are not as concerned with strict fidelity to what was captured by the camera and enjoy modifying and enhancing the image so that it conveys a particular thought or feeling they have about a place or a person. Color and tone can be used to great effect to impart mood and emotional nuance to a photograph. Consider whether the image should be brighter and more colorful, with increased saturation and contrast, or darker, with subdued colors and low contrast. Or perhaps a monochromatic approach would work well for a certain photo; you may find that a black and white or toned treatment best conveys what you feel about the image. Brightening certain areas while darkening others can also highlight specific areas in an image to direct the viewer's eye and alter the mood.

Photoshop Reality Check

Before you get started editing your image, we recommend taking stock of what you need to do to it, considering what steps are involved and what your skill level is, and coming up with an estimate of how long it will take to accomplish. What we're getting at here is that some tasks may take a long time, especially if you're relatively new to the program. You need to weigh the time invested to fix a problem in the image versus the return on that investment. If you need to remove an element from the photo and then replace a complicated area of the background, for instance, or do heroic color and tonal rescue to salvage a severely underexposed image, the end result may not be worth it. You might be better off looking for a similar version of the image that doesn't have so many problems. Or, if the opportunity exists, consider reshooting the image under better light and more controlled conditions. This last option is actually one of the best, since you will be returning to a familiar scene or concept, and having already photographed it once, you'll be better prepared to revisit the image a second time.

Safe image handling

One of the great things about digital photography is having total control over your image, from the time you press the shutter button until you make a nice print. But once you're working on your image in the digital darkroom, you have to use this control carefully. Our philosophy when we edit our photographs is to structure everything we do so that it's flexible and not permanent. In the sections that follow on basic and essential image enhancement, we'll show you how to work on your images so that you don't burn any bridges

behind you. It's not that we have commitment issues, but since Photoshop gives us this flexibility, it makes sense to take advantage of it. Here are some good practices:

- **Work on a backup copy.** The easiest way to accomplish this is to open a file and immediately choose File > Save As. This lets you give the file a new name and save it in a specified location on your hard disk. By giving a new name, it creates a copy of the file that remains open in Photoshop. The original image is closed and not modified. We view the original captures from the camera as our digital "negatives" that serve as the source for any creative explorations we may make with the photo. We think of the saved copy of the image file as our master image, where all of the enhancements are applied.

- **Never use JPEG as a working format.** If you are using the JPEG format in your camera, you should never use it for working on your file in Photoshop. As we've mentioned before in this book, the JPEG method of compression is *lossy,* which means that information is eliminated in order to make the file smaller. This loss of data is cumulative, so every time you save the image in JPEG format, a little more data gets discarded. To be safe, when you use Save As to rename a copy of your file, open the Format pop-up menu and use either Photoshop format (PSD) or TIFF. Both support layers and both use lossless compression to make the file smaller when it's stored on your hard disk.

- **Save, Save As, and Save As a Copy.** These commands all save your image, but each does so in a slightly different way and it's good to know the subtle differences. The normal Save command simply saves all the changes to the open file. Once you've generated a copy of your file to serve as a working version, this is probably the command you'll be using most often. As mentioned previously, Save As will let you rename the file and will generate a copy of the open file, closing the original image without saving any changes. Save As a Copy is available as an option in the Save As dialog. This is similar to Save As, except that it creates a new copy of the current version of the file and saves it to a specified location on your hard drive. The newly saved file is not open in Photoshop.

 Of course, the other thing we can recommend is that you save your file often. Although this is not as critical as in past versions before the advent of the History palette (more on that in a bit), it's still a good strategy for protecting your work in the event of a sudden power failure.

- **"Layers are your friends."** Lee Varis originated this saying, and we can't agree enough. Working with image adjustment layers and retouching layers allow you to work nondestructively on an image. In fact, we never touch the background layer, as it's our original reference and something that is useful to refer back to in order to double-check that what we are actually doing to an image is helping or hindering the final results.

- **Using the History palette.** When you realize that you've made a mistake in editing your image, sometimes you don't catch it until you're several steps beyond the single level of Undo found in the Edit menu (Command-Z/Ctrl-Z). Enter the History palette, which keeps track of every move you do in Photoshop (up to the limit set in the General Preferences) as separate history states, with the oldest state at the top of the list and the most recent at the bottom. If you find you've done something you need to undo, but the Edit > Undo command is not working, look to the History palette for the ability to back up several steps to the point just before you made the error (**Figure 10.24**).

Figure 10.24 In the History palette, the most recent history state is at the bottom of the list. If you find you've made a mistake, click back several states in the History palette until you undo the error.

Essential Photoshop Shortcuts

Quick keys and shortcuts are not just for power users. If you spend a lot of time with Photoshop, then using them can help you be more efficient and work faster. While you certainly don't need to memorize every single Photoshop shortcut (even we don't know them all), there are a few that we think of as being essential.

Mac/PC Conventions

The two main keys on the Mac keyboard for shortcuts are Command and Option. On Windows, those same keys are equivalent to Ctrl and Alt. We will be using these abbreviations when mentioning keyboard shortcuts.

Zooming and Scrolling

Zoom to 100 percent (actual pixels):
Command-Option-0 (Mac); Ctrl-Alt-0 (Windows)

Fit the entire image on screen:
Command-0 (Mac); Ctrl-0 (Windows)

Incremental Zoom In:
Command+(plus key) (Mac); Ctrl+(plus key) (Windows)

Incremental Zoom Out:
Command–(minus key) (Mac); Ctrl–(minus key) (Windows)

Zoom In using any tool:
Command-spacebar-click (Mac); Ctrl-spacebar-click (Windows)

Zoom Out using any tool:
Option-spacebar-click (Mac); Alt-spacebar-click (PC)

Double-click the Zoom tool in the Tool palette to switch to a 100 percent view.

Double-click the Hand tool to fit the image on screen.

Use the spacebar to switch to the grabber hand, and click and drag to scroll through your image.

Tool Palette Shortcuts

Every tool in the Tool palette can be selected using a single letter keystroke. For example, M is for the marquee tools; S for the Clone Stamp, B for the brush, and so on. A quick reference card comes with the program and lists these shortcuts. Another way to see them is to let your mouse cursor hover over a tool for a second; a tool tip label will appear, and you will see the shortcut listed in parentheses.

Brush Size and Opacity Shortcuts

When working with any of the painting tools that use a brush to apply color or tone, there's a much faster way of choosing a different size brush than moving your mouse up to the Options bar and opening the Brush Picker. The left bracket key [will make your brush tip get progressively smaller, and the right bracket key] will make it get larger.

For changing the opacity of the color that the brush is applying, use the number keypad on the right side of an extended keyboard, or any of the numbers on a laptop keyboard. For example, 5 sets the opacity to 50 percent; 8 to 80 percent; 25 to 25 percent, and so on. Pressing 0 (zero) resets the opacity to 100 percent.

If you do not have a brush tool active, then the number keypad shortcut will change the opacity of the active layer in the Layers palette.

Create Your Own Shortcuts

In Photoshop CS you can create your own custom keyboard shortcuts for any item in the menus. Go to the Edit menu and choose Keyboard Shortcuts. For example, you can assign a shortcut to a commonly used command for which no shortcut currently exists, such as the Image Size dialog.

Photoshop Help

If you launch Photoshop's built-in Help system (Help > Photoshop Help), you can find a large list of standard keyboard shortcuts categorized into different sections.

GLOBAL TONAL CORRECTION

Now that we've laid the foundation for working with images in Photoshop, we'll address some of the important, fundamental techniques that can be used to improve any image. Chief among these is *tonal correction,* or adjusting the brightness levels of your images. The modifications made to the tonal range are often simple, yet the change in the image can be quite dramatic.

Before we get into the details of manipulating the tonal levels in your images, however, we want to talk about the best way to apply any color or tonal change in Photoshop so that the change is flexible and not permanent. The importance of this approach cannot be overstated.

The Importance of Adjustment Layers

The cold, hard truth of editing digital images is that any change you make to an image's tonal range results in tonal data being thrown away. By shifting the image tone, you're changing the tonal distribution. You can see this effect by viewing the Histogram palette as you adjust tonality: Gaps will appear in the histogram, representing loss of data on the tonal scale. Although such loss of information is a normal part of the digital editing process and is not a problem when kept to a minimum, excessive data loss and wide gaps in the histogram can result in an uneven progression from tone to tone, which usually shows up as *posterization,* or banding in tonal transitions. Even worse, this data loss is cumulative, and when tonal manipulations are repeatedly applied to an image, it can result in tonal erosion of the histogram, with each successive adjustment causing additional data loss (**Figure 10.25**). The effect on your image is similar to rubbing coarse sandpaper on a delicately carved piece of wood; with every pass of the sandpaper, more of the finely carved details are sanded away. It can be very difficult to try and salvage an image that has been thoroughly worked over with coarse tonal correction sandpaper.

Fortunately, Photoshop provides a way around this dilemma in the form of adjustment layers and we strongly recommend that you use them for all tonal manipulations you apply to your images. *Adjustment layers* are nonimage layers (meaning

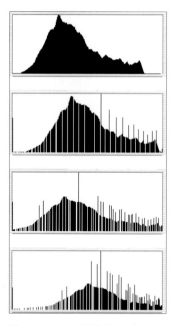

Figure 10.25 This histogram shows some serious tonal erosion after just three Levels adjustments applied directly to the image. The white gaps indicate areas where tonal values have been lost and there is not an even progression from tone to tone.

they don't contain actual pixel-based image information) that apply a set of tonal correction instructions to the layers below them (**Figure 10.26**). In a way, they function somewhat like an ever-flexible photographic filter that modifies the appearance of your photo, without adversely impacting the actual image data. Better yet, as long as they remain as separate layers, they are not permanent, and can be modified at any time simply by double-clicking on the adjustment layer's thumbnail in the Layers palette. The effect that an adjustment layer adds to an image, and any data loss that might result from it, is not permanently applied until the layers are flattened. This gives you a great deal of flexibility in correcting your images and is especially useful if you're just starting out on the Photoshop learning curve. Adjustment layers act like a safety net, allowing you to explore how different changes and tonal modifications work with your image without having to worry about irreversible data loss.

Figure 10.26 Adjustment layers let you apply tonal and color corrections to an image so that they are not permanent and can always be edited as long as you don't flatten the layers. We recommend using adjustment layers for any tonal or color correction work you do in Photoshop.

But wait…there's more! Adjustment layers boast an impressive array of additional features and functionality that make them one of the best things about working in Photoshop. Their flexibility extends beyond being able to modify their settings and having those settings remain "live" and not permanent (already a significant advantage). Some of the other available perks that adjustment layers provide include the following:

- **Opacity.** Every layer can have its opacity modified, and adjustment layers are no exception. By lowering the opacity, you can reduce the strength of the correction applied by the layer.

- **Layer masks.** With a layer mask, you can specify where in the image you want an adjustment to show up. You can either hide or reveal the tonal correction by using the painting tools and other techniques to define which areas of the mask are black and which are white. Layer masks also work with selections and are very useful for applying local area adjustments.

- **Blending modes.** Blending modes affect how the values on one layer interact with the layers underneath it. When used in conjunction with masks and opacity, they provide a great deal of control and flexibility in retouching and tonal modifications.

- **Resolution independence.** Since adjustment layers are merely instructions for how to change the layers underneath them, they do not contain pixel data that is a part of your main image. This means that they are not tied to a specific size file and can be moved to another image simply by dragging from the original file and dropping onto the new image.

To add an adjustment layer to an image, go to the Layer menu and choose New Adjustment Layer, or use the shortcut button at the bottom of the Layers palette (**Figure 10.27**).

Figure 10.27 Click the adjustment layer shortcut button at the bottom of the Layers palette to add an adjustment layer.

Photoshop Elements

We feel that it's important to note that you can use many of the same tools and techniques that we demonstrate here, including adjustment layers, even if you don't have the full version of Adobe Photoshop. Photoshop Elements 2 has been called Photoshop "Lite," but there's really nothing lightweight about this program. For $99 you get about 70% of Photoshop's core functionality, delivered in an interface that is nearly the same as its professional counterpart, but designed for the nonprofessional user. For the average person who wants to edit digital photos, Photoshop Elements may be all that you'll ever need.

The Tonal Range: A Closer Look

Throughout the book we've made references to the histogram feature on many digital cameras that you can use to evaluate the exposure of your images immediately after they've been captured. The histogram is a graphic representation of how the tones in the image are distributed along the tonal scale, with dark tones on the left and highlights on the right. When distilled down to the basics, it's just a bar graph, with the height of the bars indicating the relative number of pixels that are found in a certain location on the tonal scale. Higher bars simply mean more pixels in that area of the tonal range. The values in the scale range from 0 (total black with no detail) to 255 (total white with no detail) (**Figure 10.28**). In the middle is value 128, which represents the exact midtone point between black and white.

Photoshop CS provides you with two ways to view the histogram data for your image. The Levels dialog provides a histogram where you can also manipulate its tonal values; and the Histogram palette lets you see the histogram at all times when you're editing your image. See the sidebar "The Histogram Palette" for more on this feature.

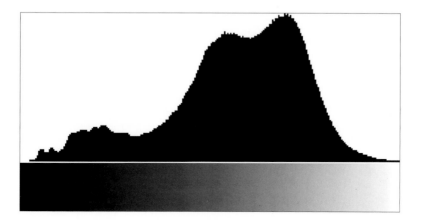

Figure 10.28 A histogram is a bar graph that shows how the tonal values in an image are distributed across the tonal range. At the far left is total black (level 0), and at the far right is total white (level 255).

The Histogram Palette

The Histogram palette is an important tool for editing digital images, because you can keep it in view at all times and see how your edits are affecting the histogram in real time (**Figure 10.29**). Tonal information can be displayed for the entire image, for a selected layer, or for an adjustment composite. In the latter mode, you can click on each layer in your layer stack, and the Histogram palette will display a different histogram for each adjustment layer, representing the effect that each layer is having on the image.

Depending on the size of your monitor, or whether you have dual monitors, you can choose to display a compact version of the palette that just shows the mountain-scape of the histogram itself; an expanded view that shows a larger histogram along with more detailed information; or a full view that shows separate histograms for the RGB or CMYK composite and either the individual red, green, and blue, or cyan, magenta, yellow, and black color channels. Since the Histogram palette is always basing its display on the current cached version of the image (see the "General Preferences" section earlier in this chapter), it also provides a convenient button so you can update the histogram from that actual image data (**Figure 10.30**).

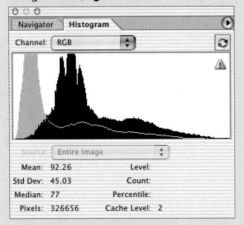

Figure 10.29 The Histogram palette provides live updates as you perform adjustments on the image. The black histogram shows how new tonal adjustments are affecting the image. The light gray histogram shows the tonal data before the new adjustment was applied.

Figure 10.30 By default, the Histogram palette will always build the histogram based on the cached image data, which may not be totally accurate. To see a correct display based on the actual image information, you can click an update button in the upper-right corner.

Measuring tonal values with the Info palette

To keep track of the tonal values in your image and to measure specific areas, Photoshop provides several tools, the primary one being the Info palette. As you move your cursor through an image, the values of the pixel under your cursor are displayed in the Info palette (**Figure 10.31**). By default this palette displays the colors using what it calls Actual Color, which is based on the color mode of your image. For RGB images, which are mainly what you'll be dealing with from digital cameras, it displays the RGB values. If you convert to Grayscale mode, the values are displayed as a K percentage, which refers to the amount of black ink that would be used if the image were printed. By clicking on the small eyedropper icon next to the Info displays, you can choose from several different ways of displaying information about the image (**Figure 10.32**). If you need to prepare images specifically for press reproduction, then you may find it useful to set the secondary Info readout to display values in CMYK or Grayscale.

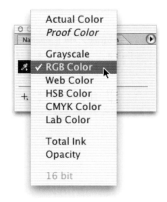

Figure 10.32 Click on the small eyedropper icon in the Info palette's display areas to select a different method for measuring the tonal information in an image.

Figure 10.31 The Info palette is Photoshop's built-in densitometer, which allows you to measure color and tonal values throughout your image.

Using the Eyedropper tools

You don't need to specifically choose the Eyedropper tool to see the values displayed in the Info palette; wherever you move your cursor, no matter what the tool, the cursor also functions as a means of sampling tonal or color values. But the Eyedropper tool does offer some options and expanded features that are very useful for measuring tones:

- **Sample size.** This determines how large an area the Eyedropper is sampling from. To set this, select the Eyedropper in the Tool palette and open the Sample Size pop-up menu in the Options bar (**Figure 10.33**). The default setting for the Eyedropper is for a point sample, which means it only samples color or tone from a single pixel. We recommend using a 3-by-3-pixel average. In digital camera images, dust spots on the sensor, noise, or even faraway objects may result in "rogue pixels" that may not represent the tone you think you're clicking on. Sampling a 3 by 3 Average will prevent the Eyedropper from being misled by rogue pixels.

Figure 10.33 The sample size for the Eyedropper tool can be set in the Options bar, or you can right-click (PC) or Control-click (Mac) and set it in a context menu. We recommend a 3 by 3 Average for working on photographic images.

NOTE: The sample size of the Eyedropper also affects tools that create selections by sampling the color or tonal value of pixels, such as the Magic Wand and Select Color Range. By sampling from a 3 by 3 Average value, instead of a single pixel, this can influence which pixels are selected by these tools.

- **Color Sampler points.** The Color Samplers are nested with the Eyedropper tool and you simply click, hold, and drag down on the Eyedropper in the toolbar to access them. They are used for keeping track of specific tonal areas throughout the entire time you're working on an image. You can place as many as four Color Sampler points in an image and use them to monitor important tonal values such as highlights, shadows, and midtones. The information for each point is displayed in the lower portion of the Info palette. Since they are always in the same place, you don't

have to worry about whether or not you're moving the Eyedropper over the right location as you try to track changes to a specific tonal level (**Figure 10.34**). When you're performing any tonal or color correction to the image, the display in the Info palette shows you a before and after comparison of the values. This is highly useful for evaluating whether a certain manipulation is adversely affecting either the shadows or the highlights. In **Figure 10.35**, as the contrast is being increased in the image of the airplane tail, the second set of numbers in the readout for point #1 tells us that we are still retaining detail in the bright highlights of the white star.

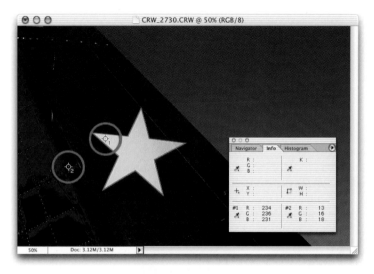

Figure 10.34 In this example, two Color Sampler points have been placed on the highlights and the shadows of the airplane's tail. The color and tonal information for these points is displayed in the bottom of the Info palette.

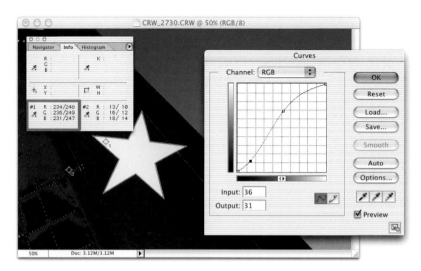

Figure 10.35 The second set of numbers for Color Sampler point #1 show that highlight detail is not being compromised by the Curves adjustment.

To place a Color Sampler point in your image, you can either select the Color Sampler tool from the Eyedropper group in the Tool palette (**Figure 10.36**) or use the easy shortcut of Shift-clicking with the Eyedropper tool. We prefer using the shortcut method since it's faster and it also works with tonal correction dialogs such as Levels or Curves.

Figure 10.36 Click and hold on the Eyedropper icon in the Tool palette to access the Color Sampler tool. You can also set sample points with the Eyedropper by Shift-clicking.

TIP: To move a Color Sampler point, place the Color Sampler cursor directly over it and Shift-drag to move it to another location. To delete a point, Option-click (Mac) or Alt-click (Windows), or Shift-drag it out of the image window. You can also Control-click (Mac) or right-click (Windows) on the point and choose Delete from the context menu that appears. Color Samplers will disappear in the image when you select any tool other than the Eyedropper, but their readout is still visible in the Info palette.

Improving the Tonal Range Using Levels

Tonal and color correction in Photoshop is all about shifting the tonal values around and making them darker or lighter depending on what you need to do to the image. Understanding what the tonal levels mean and how they manifest themselves in the image is key to getting the tones and colors you want. In terms of adjusting the overall tone of a photograph, as well as seeing the all-important histogram so you can evaluate the tonal integrity of the image, Levels is the first place we go when we're editing our images.

The Levels dialog is found in the Image menu under Adjustments, but for maximum flexibility we recommend applying it as an adjustment layer. Working with Levels allows you to control three areas of an image's tonal range: the shadows, midtones, and highlights. The main portion of the dialog contains the histogram for the image and sliders you can use to set the black point, white point, and midtone levels (**Figure 10.37**). You can also set black, white, and neutral points using the eyedroppers in the lower-right corner of the dialog. We'll discuss the functionality of the eyedroppers later in "Using the Levels Eyedroppers to Set Black and White Points."

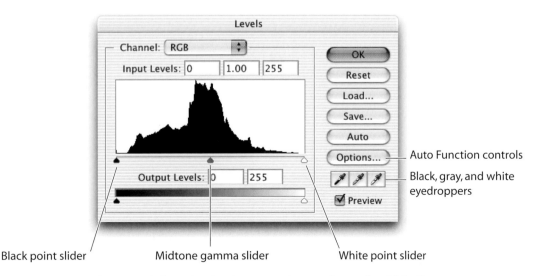

Figure 10.37 Levels is one of Photoshop's primary tonal correction tools, which allows you to set a black and white point, and adjust the midtone level to remap tonal values and improve the appearance of the image.

Adjusting shadows and highlights with the endpoint sliders

Directly under the histogram in the Levels dialog are three sliders that control the black, midtone, and white points in the image. With just these three sliders you can do quite a lot to improve the overall tonal balance of the image. The first thing to evaluate is whether your image has a full range of tones that span across the entire histogram (**Figure 10.38**). If it does, then there's not much you can do with the shadow and highlight slider without introducing clipping (forcing tones to black or white) into the image.

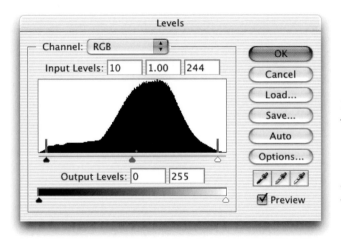

Figure 10.38 This histogram shows a full range of tonal values ranging from black to white. Any adjustment of the black and white point sliders, as shown here, would cause clipping in the shadows and highlights. Clipping refers to when tones are forced to either a total black or white.

If you see empty space on either end of the main histogram data (**Figure 10.39**), however, then a few quick moves will dramatically improve your image. By moving the black and white input sliders in to where the data begins, you will brighten the highlights and deepen the shadows. This alone can work wonders for the image (**Figure 10.40**).

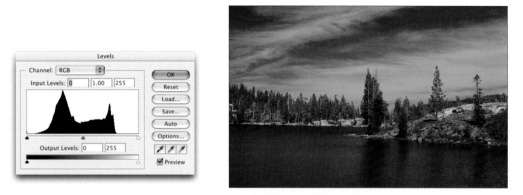

Figure 10.39 The empty space on either side of the tonal data in this histogram means that the image does not have any bright highlights or dark shadows. Since those tonal values are unused, the photo is flat and dingy.

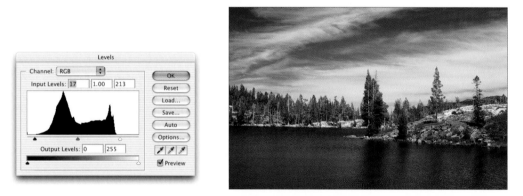

Figure 10.40 By moving the black and white point slider in to where the tonal data begins, those tones are remapped to black and white. This has the effect of stretching the existing tonal values to cover the entire tonal range, which gives the photo a full range of tones and greatly improves it.

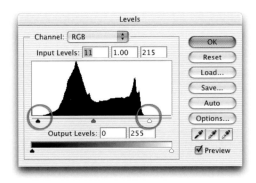

Figure 10.41 Leave a little extra space between the endpoint sliders and the tonal data to allow for some flexibility during adjustments later in the editing process.

*TIP: When moving the black and white endpoint sliders in to where the histogram data starts, it's a good idea not to move them in all the way (**Figure 10.41**). Leaving a small amount of space between the slider and the tonal bars in the histogram will give you a little extra leeway in case any additional tonal adjustments you may make brighten or darken these areas some more.*

The main thing you want to remember about using the shadow and highlight sliders is that you don't want to move them past where the histogram data starts. Since these sliders control the black and white point, respectively, their position will change corresponding tonal values to either 0 or 255. If you move them in too far, you can lose tonal detail in the image.

Adjusting the midtones

The middle slider for the input Levels controls where the midtone (level 128) is located. You may have noticed already that when you move either the shadow or the highlight slider, the midtone slider moves as well. By moving it independently of the shadow or highlight slider, you can set this yourself and make your image either lighter or darker, without affecting the endpoints.

If after adjusting the endpoints your photo seems too dark, simply moving the midtone slider to the left will shift more tones to the bright side of the midtones, brightening the image overall (**Figure 10.42**).

If the photo seems too light and washed out, move the midtone slider to the right to shift more tonal values to the dark side of the midtones. This will darken the image overall (**Figure 10.43**).

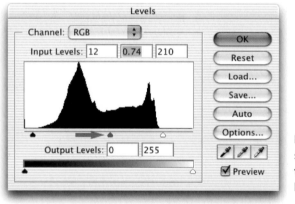

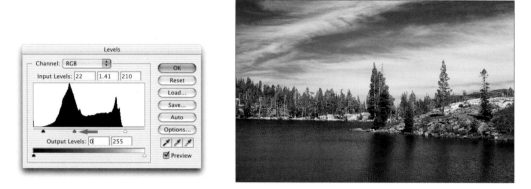

Figure 10.42 Moving the midtone slider to the left will shift more of the tones to the lighter side of the midtone level and lighten the image overall.

Figure 10.43 Moving the midtone slider to the right will shift more of the tones to the dark side of the midtone level and darken the image overall.

Controlling clipped tones with the output levels sliders

The output levels sliders do the opposite of the input levels sliders; they make black values lighter and white values darker. They can be useful if you have an image where the highlights are irretrievably blown out to a white with no detail. By moving the output-levels highlight slider toward the left, any value that is white will be lowered to the value you choose, which will darken that tone and all other tones in the image. This will ensure that when the image prints, that bright highlight will not print as total paper-white, but will have some ink coverage (**Figure 10.44**). It's important to note that this adjustment is only for controlling the brightness of a white tone or the darkness of a black tone; it will not restore detail that was never captured in the first place.

Figure 10.44 The Output Levels sliders reassign a total black or white to a lighter or darker value respectively. In this example, the highlight on the white horse was blown out to 255. By moving the Output Levels highlight slider slightly to the left, it was remapped to 245, which ensures that when the image prints, the highlight will not be rendered using the white of the paper surface.

Setting white and black target colors

The eyedroppers in the Levels dialog are very useful for setting precise values for the white, black, and midtone gray values in an image. We use this most often for setting a specific shadow and highlight value for the darkest and brightest areas in an image, as well as for neutralizing color casts by targeting tones that we know should be neutral and remapping their tonal values to a neutral color. Before you can do this, you first need to enter correct target values for the eyedroppers:

1. Open up the Levels dialog (for just setting the target values it doesn't need to be on an adjustment layer) and double-click the white eyedropper in the lower-right corner. Photoshop's Color Picker appears.

2. For images that are destined to an inkjet printer, or a direct photographic printer such as a LightJet 5000, use the RGB section and set the values to 245, 245, 245. You can also enter 96% for brightness in the HSB section and this will set the RGB numbers correctly. When all the RGB values are the same, the result is a neutral tone. If you will be printing CMYK to an offset press, then use C=5%, M=3%, Y=3%, K=0% (**Figure 10.45**). Click OK.

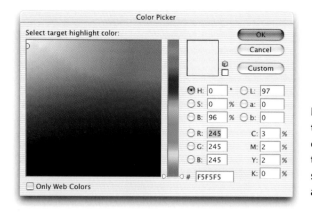

Figure 10.45 Setting the highlight target color to R 245, G 245, B 245, or 96% Brightness ensures that the brightest highlights will retain some light tonality and not print as paper white.

3. Double-click the black eyedropper and set the RGB values to 12, 12, 12. You can also enter 5% for Brightness in the HSB section (**Figure 10.46**). Click OK.

Figure 10.46 Setting the shadow target color to R 12, G 12, B 12, or 5% Brightness ensures that the shadow information will be maintained, even in the darkest areas of the image.

4. Double-click the gray eyedropper (not available on grayscale files). The default for this is 128, 128, 128 for RGB, or 50% for the Brightness of HSB, which represents an exact middle tone that is neutral. Leave this as is and click OK.

5. Click OK in the Levels dialog to close it. As you do this, you will be asked if you wish to save the new target colors as defaults. Click Yes. These defaults are fine for most purposes involving making prints on inkjet or direct photographic printers. We still recommend checking the values of these eyedroppers before using them, just in case you have to restore to a default set of preferences, or if someone else is likely to set different values. You should also check any time you are targeting colors for images that will be reproduced on an offset press.

Finding the brightest and darkest points: Levels

To use the Levels eyedroppers, you first need to identify the brightest and darkest points in the image. The shadow and highlight sliders in Levels, combined with a keyboard shortcut, provide an easy way to do this; you can download the photo used in this example, Star_Tail.jpg, from this book's companion Web site (**Figure 10.47**).

Figure 10.47 The "Star Tail" photo.

1. Open an image you wish to work on and add a Levels adjustment layer. To find the brightest point in the image, Option-click (Mac) or Alt-click (Windows) on the highlight slider and hold down the mouse button. The entire image will turn black. Keeping the mouse button pressed down, slowly move the slider to the left. As the slider approaches the main data of the histogram, you will see parts of the image begin to appear in stark, posterized colors. If you see red, it means that in that area of the image, the values in the red channel are being clipped to 255; green or blue means clipping in their respective channels. If you see yellow, it means that in both the green and the red channels those tones are being forced to 255 (green and red produce yellow). Cyan is an indicator that there is clipping in the blue and green channels, and magenta shows the clipping in the red and blue channels. When adjusting the exposure and shadow sliders in Camera Raw, you can also use the same keyboard shortcut to show the clipping display in that dialog.

When you see white appear in the image, that indicates the brightest point in the image in all three of the color channels. As long as this is not a specular highlight, but an area that should be bright white with detail, it's a good area to target for the highlight (**Figure 10.48**). Sometimes, especially if you're zoomed out, it can be difficult to distinguish between white and yellow. If that is the case, zoom in closer by pressing Command-spacebar (Mac) or Ctrl-spacebar (Windows) and clicking in the image. When you take your finger off the mouse button, the clipping display will be turned off. Once you've zoomed closer, simply Option-click or Alt-click the highlight slider again to relocate the brightest point.

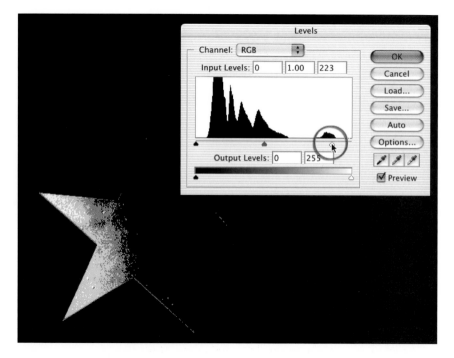

Figure 10.48 By holding down the Option or Alt key and moving the highlight slider to the left, you can find the brightest point in the image, indicated by the white areas on the left point of the star.

To place a Color Sampler point, you have to take your finger off the mouse button and the Option or Alt key, which of course turns off the clipping display. If the white point is in a spot that's easy to remember, then it should be no problem to place a Color Sampler point there. For images where it's not so clear, Seán likes to move the Levels dialog box and use a corner of it to point to the area where he's going to place a Sampler point. With the dialog box in place, he brings back the clipping display and double-checks the position (**Figure 10.49**) and Shift-clicks to place a Sampler point. After you have used this technique to identify the brightest point and have placed a Sampler point, it's important to slide the highlight slider all the way back to the far right side. This was not a tonal adjustment in and of itself; only a way to locate a point for targeting with the highlight eyedropper.

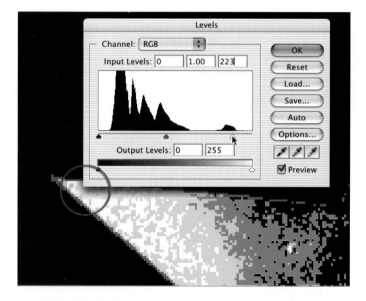

Figure 10.49 Moving the Levels dialog and using one of its corners as a pointer can be helpful when you need to precisely place a Color Sampler point.

> **TIP:** *The Caps Lock key will change the standard eyedropper cursor to a precise crosshairs target, which is infinitely more useful for this purpose than the standard eyedropper icon. Pressing Caps Lock again will change the cursor back to the regular eyedropper icon.*

2. To locate the darkest point in the image, Option-click (Mac) or Alt-click (Windows) on the input shadow slider and move it toward the right until you see black areas begin to appear. As with the highlight clipping display, the different colors you see indicate which channels are clipping to black first. When the display shows black, it means that is the darkest point in all three of the color channels (**Figure 10.50**). Shift-click on the target area to place a Color Sampler point for the shadows. Return the shadow slider to the far-left side of the histogram.

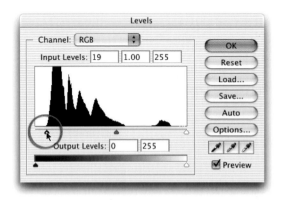

Figure 10.50 Hold down the Option or Alt key and move the shadow slider to the right to find the darkest tones in the image.

Using the Levels Eyedroppers to set white and black points

Once you have identified the bright and dark points in your image and have set Color Sampler points so you can easily track the values of those important areas (**Figure 10.51**), it's time to use the Levels eyedroppers to remap those areas to the target values that you specified earlier. Once again you should be using an adjustment layer for this correction. Let's start by tackling the highlights in the Star Tail image:

1. Click the highlight eyedropper to make it active. If your cursor is the standard eye-dropper icon, use the Caps Lock key to turn it into a precise crosshairs cursor. Move the cursor over the highlight Color Sampler point. When the two line up exactly, the cursor will dim slightly. Click once to remap that point to the target highlight values. If you check the readout for that point in the Info palette, you should see two sets of numbers. The numbers on the left are the values before the adjustment, and the numbers on the right are the new, remapped values (**Figure 10.52**).

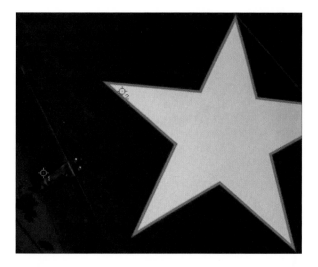

Figure 10.51 The highlight and shadow Color Samplers in place.

Figure 10.52 The display for Color Sampler #1 in the Info palette shows the before and after values of the highlight after it has been targeted with the white eyedropper. It is now a brighter and neutral highlight with values of 245, 245, 245.

2. Click the shadow eyedropper to make sure it's active, and repeat the procedure using the shadow eyedropper. After you have set the shadow point, be sure to click on the shadow eyedropper one more time to deactivate it.

Our final adjustment for the airplane image was to move the midtone gamma slider to the left to lighten up the middle tones and show some of the detail in the plane's tail. Since this also lightened the darker parts of the tail, we also brought the input shadow slider to level 5 to add a little richness back into the darkest tones (**Figure 10.53**). As we made this final adjustment to the shadows, we kept an eye on the Shadow Color Sampler in the Info palette to make sure that the darkest tones were not getting too dark. The change to the image made by these adjustments is subtle, but the whites are brighter and more neutral, the sky is brighter, more detail is visible in the metal surface of the tail, and the darkest tones are still a deep, rich black (**Figure 10.54**).

Figure 10.53 Adjusting the midtone slider.

Figure 10.54 A before and after view of the Star Tail photo showing how highlight and shadow targeting has improved the image.

Improving Contrast with Curves

The Curves dialog is the next stop on our magical mystery tour of Photoshop's tonal correction capabilities. This is a powerhouse feature that many find intimidating at first, but it's definitely a worthwhile investment to learn it if you want to do serious work in Photoshop. Many power users and some pundits scoff at Levels and advocate doing all tonal and color correction work in Curves. Although we feel this view is a bit elitist, there are some valid reasons for this approach. For one thing, every adjustment that you can make to the image in Levels can also be done in Curves. And where Levels gives you three sliders for adjusting three points—highlights, shadows and midtones—in a linear fashion, Curves lets you adjust as many as 16 points at different locations along the tonal range. Although we've never had to use that many in one adjustment, it's nice to know that we can if we ever need to!

A closer look at Curves

Unlike Levels, which shows you a reasonably clear histogram when you enter the dialog, Curves is somewhat enigmatic and presents you with only a grid of squares bisected by a diagonal line. But it's really not so mysterious once you know how it operates.

The line on the Curves dialog controls a tonal value's input and output (before and after) relationship. When you first enter the dialog, the diagonal line represents the current tonal values in the image. Because Curves is all about the numbers, there's no histogram to give you a "picture" of the tonal landscape of your image. Once you start to manipulate the curve, however, then the changes you make do provide a picture of how you're reshaping the tone curve of the photograph.

> **TIP:** *The default appearance of the Curves graph is a 4x4-pixel grid. You can change this to a 10x10 grid simply by Option-clicking (Mac) or Alt-clicking (Windows) anywhere inside the grid. Repeating this shortcut changes the grid back to 4x4 grid (**Figure 10.55**).*

Figure 10.55 Option-click or Alt-click inside the Curves grid to change it from a 4x4 to a 10x10 grid.

The Curves dialog provides you with two different value systems to use when making your adjustments. You can work with ink dot percentages of 0 to 100, or the standard tonal values of 0 to 255 that are also found in Levels. Switching between the two is as simple as clicking on the small black and white triangles in the lower horizontal gray bar (**Figure 10.56**). If you are starting with an image in Grayscale mode, the dialog will be in dot percentage mode by default. If you have done a lot of work in prepress, then you will probably be more familiar with the dot percentages system, which refers to how much ink is laid down on paper. Once they get used to working with the digital tonal values, photographers are generally more comfortable with the 0 to 255 scale. This is the method that we prefer to use, simply because it uses the same values as Levels, and it gives us a common standard for measuring and manipulating the tones in our image.

A B

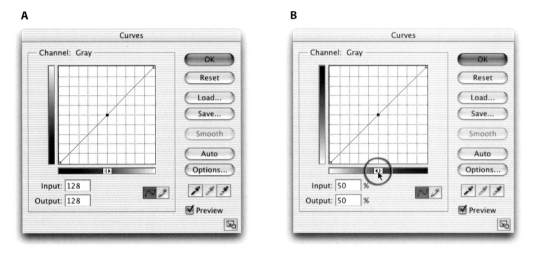

Figure 10.56 Image A shows the Curves dialog using digital values (0–255). Image B shows ink percentages being used. To switch between the two modes, click the black/white arrows in the middle of the lower gray ramp.

In the 0 to 255 scale, the top portion of the curve (also known as the *shoulder*) represents the highlights, while the shadows are found in the lower left part (also known as the *toe*) (**Figure 10.57**). Another reason we like using this method is that the left-to-right relationship of the shadows to the highlights matches how those values are arranged in the histogram. Katrin finds this to be a familiar way of working since it's the same way a film dH log curve is represented. With the dot percentages method of manipulating the data, this relationship is

backwards and the highlights (representing less ink coverage) are in the lower-left part of the curve, with the shadows (representing more ink coverage) in the upper-right part. It doesn't really matter which method you use, but unless you're already very familiar with specifying contrast changes in ink percentages, we recommend that you stick with the 0 to 255 scale. We will be using that scale for our Curves discussion here.

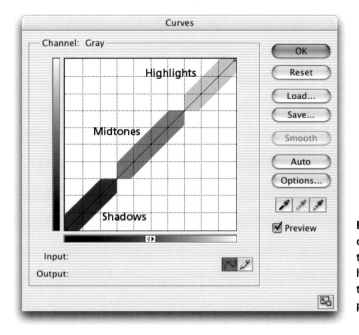

Figure 10.57 When set to use digital tonal values (0–255), the top part of the curve controls highlights, the middle controls the midtones, and the lower part controls shadow values.

Working the curve

To place a point on the curve to manipulate, click anywhere on the line. To remove a point, click and drag it out of the graph area. If you want to see where a specific tonal area in the image is found on the curve, move your cursor over your image and hold down the mouse button. You'll see a small ball appear on the curve line. If you keep the mouse button held down and move the cursor through your image, the ball will slide up and down the curve to reflect the location of the tone you're sampling (**Figure 10.58**). If you Command-click (Mac) or Ctrl-click (Windows) on a tone in the image, Photoshop will place a point on the corresponding curve location for you.

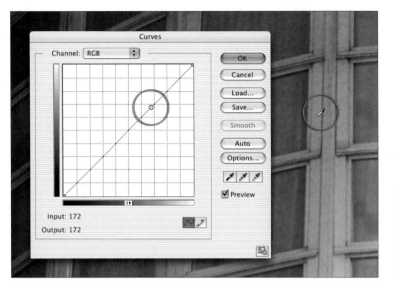

Figure 10.58 Click in the image and a ball will appear on the curve to show you where that specific tone is located on the curve.

The vertical axis in the graph represents the current, or input, tone values in the image. To see what tone a specific location represents, follow one of the vertical lines (or draw an imaginary line) down to the horizontal gray ramp below the graph. The horizontal axis represents the adjusted, or output, values. To see what tones they line up with, follow the

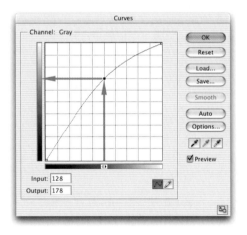

Figure 10.59 The vertical lines in the Curves grid indicate the current tonal values and the horizontal lines represent the adjusted values. In this example, the midtone of 128 is being raised to 178. If you follow the imaginary line as it exits the Curves grid, you can see the new lighter tone that 178 represents.

horizontal lines to the left side of the graph and the vertical gray ramp. When you click on the curve and place a point and then raise that point up, you are taking the current value, indicated by the corresponding tone on the lower gray ramp, and raising it up to a higher number and a lighter tone, indicated by the position of the point relative to the vertical gray ramp on the left (**Figure 10.59**). In the lower-left corner of the dialog, input and output values show you the numerical results of the adjustment. For instance, if you take the midtone value of 128 and raise it up to 178, you are telling Photoshop to reassign the current 128 tonal level to 178. As a result, all tones in the image are remapped in proportion. Since higher values indicate lighter tones, the net result of such an adjustment is that the entire image becomes lighter (**Figure 10.60**). Lowering the curve will make the entire image darker.

Figure 10.60 The right side of this image shows the results of raising the midtone from 128 to 178.

Since Curves provides more control over tonal adjustments than Levels (as we'll see in a moment), we often will use Levels only to set the highlight and shadow points, and then do the rest of our tone correction in Curves. For example, moving the midtone slider to the left in Levels is the same as raising the 128 point upward, as in the previous example. Where Curves really shines, however, is in its ability to make separate adjustments to different parts of the tonal range. This comes in handy for making very precise modifications to the contrast of an image and can be used to create small bumps in the curve to bring out detail in very specific areas of the photo. This flexibility and greater accuracy is something that Levels can't offer, and is one of the reasons why many Photoshop users prefer to do most of their work using Curves.

Adding contrast with an S-curve

Many images, particularly if they were photographed in the shade or under overcast skies, can benefit from a little increase in contrast. This is especially true if you have followed our recommendations for turning off the contrast setting in your camera. We feel it's better to have an image that's a little flat than to have one that has too much contrast that we can't do anything about. Fortunately, a subtle contrast boost is very easy to achieve in Curves with the application of a classic S-curve (**Figure 10.61**). Let's explore this essential image-enhancement technique (the image used in this example, Waterflower.jpg, can be down-loaded from this book's companion Web site):

1. Add a Curves adjustment layer (Layer > New Adjustment Layer > Curves) to an image that you feel could be improved by a bit more contrast. We're using a photo of a water flower taken in a shaded area of a garden pool.

2. Place your cursor in the image over an area that you feel needs to be a bit lighter and Command-click (Mac), Ctrl-click (Windows) to place a point on the curve. We used the underneath side of one of the flower's petals (**Figure 10.62**).

A B

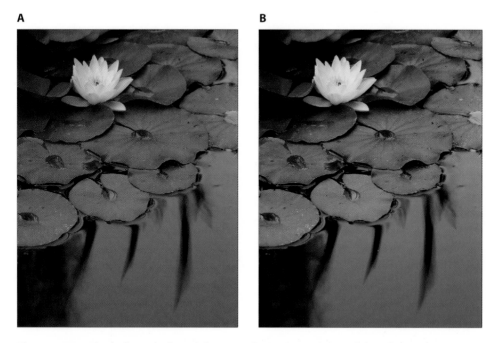

Figure 10.61 The before version of the water flower image (A) and the after version (B).

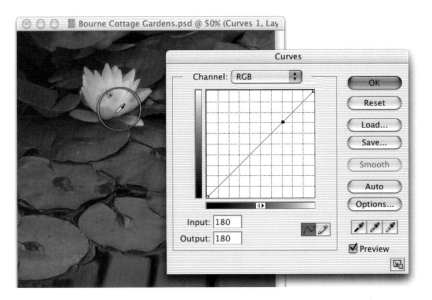

Figure 10.62 Clicking on the flower to find that tone on the curve.

3. Next, find a darker tone that you want to make darker, and repeat the procedure from the previous step to place a point on the curve. We chose a shadow area on the water (**Figure 10.63**).

Figure 10.63 Clicking on the dark water to find that tone on the curve.

4. Click on the highlight point and move it upward slightly, then click on the shadow point and move it downward a bit (**Figure 10.64**).

Adding contrast can be tricky because some tones become lighter while others get darker. The object here is for the change in the curve to be subtle, not drastic. We're only adding in a slight contrast increase. If you move the points too far, this can lead to an adjustment that is obviously too much. Shadow detail gets lost and highlights blow out to a total white. Keep an eye on darker tones to be sure that they don't get too dark and hide important detail. In the highlights, make sure that the brightest whites are not creeping too close to 255 (we recommend keeping them below 248). Use the Info palette to monitor these important tonal areas. In extreme cases, severe curve changes can cause posterization or banding where the steeper section of the line transitions to a flatter part of the curve.

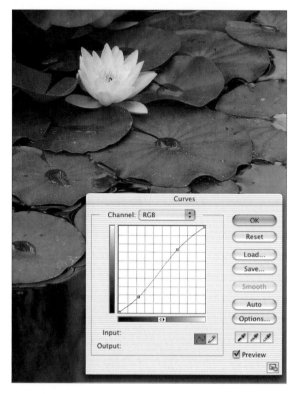

Figure 10.64 A subtle S-curve to increase contrast.

Reducing contrast with a reverse S-curve

If you have an image that suffers from too much contrast, often a problem with digital camera photos taken in harsh, bright sunlight, then a reverse S-curve can often help bring the tones back under control. The basic procedure for applying this is the same as with a normal S-curve: Add an adjustment layer and place points on the curve in the highlight and shadow areas that you want to adjust. The difference is that the highlight point is lowered and the shadow point is raised (**Figure 10.65**). Since the numerical gap between these tones is lessened, the contrast is reduced, as seen in the before and after views of the garden steps (**Figure 10.66**).

Figure 10.65 A reverse S-curve can be used to reduce contrast in photos taken in harsh, bright sunlight.

A B

Figure 10.66 Image A shows a photo with too much contrast. Image B shows the results of using a reverse S-curve to bring the contrast under control.

Although a reverse S-curve can work wonders for photos that have too much contrast, it can't fix images where there is clipping (in other words, values that are either a total white or black) in the highlights or the shadows. If the camera did not record that information at the time of exposure, there is no getting it back in Photoshop. In such cases, harsh bright whites with no detail can be darkened slightly so they're less objectionable, but the detail is gone for good. This is another reason to be careful with your exposure technique, particularly on bright, sunny days, when you're out with your camera. In **Figure 10.67** the white areas of the plane's fuselage are blasted out to total white (255). Although we can't recover any detail there, we can lower the white point located in the upper-right corner to bring them down to level 241, which is darker and less glaring than 255. This is the same as moving the output levels highlight slider to the left in the Levels dialog. We have also added S-curve points to improve the contrast of the rest of the image, which was a little flat due to the overall overexposure.

Figure 10.67 By lowering the 255 point on the curve, you can compensate for a highlight that has been blasted out to a total white. Although this lowers the brightness level of the clipped highlight, it does not restore detail. This is the same as moving the Output-Levels highlight slider to the left in the Levels dialog.

Using a lockdown curve

By now it should be obvious that you can place points at different locations on the curve to adjust tonal ranges independently of each other. For some images, however, two points is not enough to control the rest of the curve from being influenced by the changes you're making. In such a case, you need to create a lockdown curve so that you can move the curve very precisely in specific areas. Here's how to do it:

1. Add a Curves adjustment layer to an image. For greater precision in placing the points, click the grow button in the far lower-right corner to enlarge the Curves dialog.

2. Carefully position your cursor over the first intersection of a horizontal and vertical graph line on the curve, and click to set a point. Move to the next intersection and place a second point. Continue until you have a point placed at every intersection (**Figure 10.68**).

Figure 10.68 A lockdown curve.

3. In the Curves dialog, click the Save button and save this curve as "Lockdown Curve" so you can use it again on future images.

4. Click on the tones in your image that you want to adjust, and find their location on the curve. With the lockdown curve in place, you can now manipulate small areas of the curve without affecting the rest of the curve. In the example in **Figure 10.69,** we are lightening the shadows without affecting the midtones or the highlights.

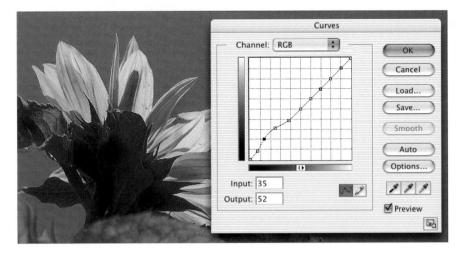

Figure 10.69 Using a lockdown curve to only adjust the shadow tones.

Now that you have saved the basic lockdown curve, you can quickly recall it when you need it by adding a Curves adjustment layer and clicking the Load button in the dialog. Navigate to the folder where you saved the curve, click OK and it will be loaded into the Curves graph. Lockdown curves really let you take advantage of the full power that Curves has to offer. As with a regular curve, however, make your lockdown "bumps" as smooth and gradual as possible for the best effect in the image. Bumps that are too steep and shelflike can cause unnatural tonal transitions and posterization (**Figure 10.70**).

Figure 10.70 Keep your curve adjustments smooth and subtle. As shown, changes to the curve that are too abrupt or steep can cause unnatural tonal transitions that show up in the image as posterization (banding between tones) and strange color shifts.

The Case Against Brightness/Contrast

Although we feel that Curves is the best tool to use when you need to adjust the brightness and contrast of an image, Photoshop does provide a command called Brightness/Contrast, and many new Photoshop users are drawn to it because its controls are much easier to understand than those found in the Curves dialog.

Our very strong recommendation, however, is to ignore Brightness/Contrast and spend your time learning Levels and Curves. The reason? Brightness/Contrast applies its changes to the image's tonal range in a linear fashion, which means that it does the same thing to every pixel in the image. Compared to fine control of Levels or Curves, it's somewhat like doing antique watch repair with a mallet.

When you lighten a photo using Brightness/Contrast, it just shifts all the pixel values up or down. If you increase brightness by 15, it adds 15 to the value of every pixel in the image, even if all you really wanted to adjust were the midtones. This becomes a problem, because an addition of 15 will push every pixel with a tonal value higher than 240 over into clipped whites with no details. The contrast adjustment is similarly logic-challenged and can wreak havoc with the tonal values in your image, particularly on the endpoints. Simply put, Brightness/Contrast is not worth the effort for tonal adjustments, and you can harm your image by using it. Take the time to learn Levels and Curves, and you'll be much better off.

Shadow/highlight correction

The Shadow/Highlight Correction in Photoshop CS is an amazing feature that applies tonal correction in the shadows or highlights, or both, without significantly sacrificing contrast in other tonal areas. It can be found in the main menu under Image > Adjustments > Shadow/Highlight. The dialog is initially a small one with only two sliders that control the amount of the effect being applied to the shadows and highlights. But by clicking on the Show More Options check box, the dialog expands to fill up most of your screen with no fewer than 10 separate controls (**Figure 10.71**).

For controlling the Shadows and the Highlights, there are three sliders: Amount, Tonal Width, and Radius:

1. **Amount.** This controls how much change to make, but it does so in a way that affects different parts of the image in different ways. Larger amounts provide greater lightening of the shad-

Figure 10.71 The Shadow/Highlight dialog in Photoshop CS.

ows or greater darkening of the highlights. Essentially, the program is creating a darkening or lightening curve, and the Amount setting determines how steep the curve is. The settings for the Radius and the Tonal Width determine where in the image this tone curve is applied.

2. **Tonal Width.** This slider controls how much modification to apply to different tonal regions. For instance, you might choose to lighten only the deepest shadows, or you may need to brighten up some of the midtones as well. When adjusting shadows, for example, smaller values will place more emphasis on the darkest areas of the photo, while larger values will increase the tonal width to apply the effect to midtones and highlights.

3. **Radius.** The Radius controls how far out from a given pixel the Shadow/Highlight Correction is looking to determine what tonal "neighborhood" that pixel is located in: shadows, highlights, or midtones. The Radius slider determines the size of this area. The extent to which every pixel is modified depends on how dark or light its neighbors are.

This is definitely one of the most impressive features in Photoshop CS (**Figure 10.72**). Since the command functions more like a filter than a typical adjustment layer (the radius setting occurs in many filter dialogs), you do not have the ability to put it on an adjustment layer. We recommend making a copy of the background layer and applying the Shadow/Highlight command to the copy layer. You should always preserve your original image.

A B

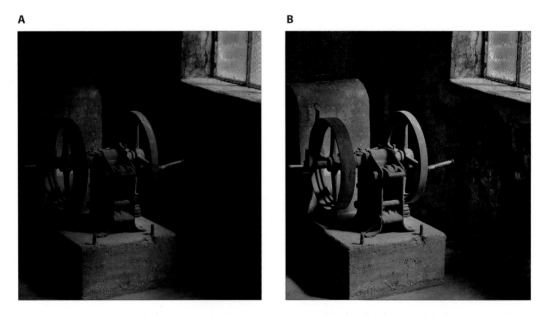

Figure 10.72 An image before (A) and after (B) correction with the Shadow/Highlight command.

BASIC COLOR CORRECTION

The importance of color in images cannot be overstated. Whether it's soft and muted or bold and vividly saturated, color plays a profound role in the visual arts and in visual communication. Color is one of the most important aspects of photography for many photographers. Even if you prefer a subtle palette of pale and muted earth tones in your images, that is a conscious choice you make to communicate your vision of how your photographs should be interpreted.

Human vision is incredibly sensitive to minute changes in color, so working with color in a digital image can have a great impact on whether an image just sits blandly on a page or comes to life with a sensitive and effective use of color. In this section, we'll provide you with an overview of how to perform basic color-correction adjustments on your images in a way that leaves you with flexibility for future fine-tuning. Before we start showing you some examples, however, we need to take a brief look at some important background information so you can build a good foundation for your explorations with color correction.

Color Theory

The two primary models for color are *additive* and *subtractive*. The color we see with our eyes, the images you photograph with your digital camera, and the display of your computer monitor are all examples of the additive color model of RGB. Additive color is created by combining the three primary colors of light (red, green, and blue) to form all the other colors that we can see. When these three colors blend together at maximum intensity, the result is pure, white light. When they blend together in equal amounts, the result is a perfectly neutral tone. The absence of all three colors (which is the absence of light) results in black. These concepts form the essence of color theory (**Figure 10.73**).

Figure 10.73 The additive color space is formed by the red, green, and blue primary colors.

Subtractive color deals with the secondary colors of cyan, magenta, and yellow, and our first experience with it was probably mixing paints together in grade school art classes. Today, you see it any time you pick up a magazine, or a book, such as this one. The colors reproduced in printed materials are created using cyan, magenta, yellow, and black inks. This color model is called *subtractive* because, unlike RGB where all the colors blending together create white, with CMY the result of the colors mixing together is a dark, muddy brown. To correct for this less-than-satisfying color, pure black ink is introduced in the

printing process to create deep, rich shadows and bold, striking black tones. Subtractive colors are created when certain lightwaves are absorbed and others are reflected. When you take an image on your computer and make a print on your inkjet printer, you are translating the additive color of light into the reflective color of ink on paper (**Figure 10.74**).

Figure 10.74 The subtractive color space is formed by the cyan, magenta, and yellow primary colors.

One of the most important things to understand about color is the relationship between the different colors. A mixture of two colors creates every primary and secondary color and every color has an opposite, or a complementary color. Red is made up of yellow and magenta, for example, and its opposite, or complement, is cyan. Cyan is created from the mixture of blue and green, and its opposite color is red. To help you understand this, study the illustration of the color wheel in **Figure 10.75.** Colors that are opposite each other on the wheel are complements. The two hues on either side of a color are the component colors that create that color. When you know these vital pieces of the color puzzle, color correction becomes less mysterious.

Figure 10.75 The color wheel.

Understanding Color Correction with Variations

To properly color-correct an image, first you have to be able to recognize that an image has color problems and then you have to be able to identify what is causing the problem. In many respects this is a learned skill that comes from viewing lots of photographs. In photo labs, it's customary to print a *ringaround* to help evaluate difficult images. A ringaround consists of 6 to 12 prints, usually 4-by-6s, that are printed on a continuous strip of paper using the main color corrections representing different color filtrations. With broad corrections of the main color filters applied, the technician can then make a much better decision about how to color-correct the image.

Photoshop provides its own version of the ringaround in the form of the Variations command (Image > Adjustments > Variations), which shows you several versions of the photo, each one with a different color correction applied representing the six main colors (**Figure 10.76**). In the main pane of the Variations dialog, there are six images with color corrections grouped around a central image that represents your current pick. If you look at the arrangement of the color-filtered photos, you'll see that the colors correspond to the arrangement on the color wheel. Red is opposite cyan, green is opposite magenta, and blue is opposite yellow. If you feel that the image is too green, then you need to add green's

opposite to remove the offending color. By clicking the magenta version of the image, you will add magenta and subtract green. If you feel that's not working, then you need to click on green to undo the magenta addition.

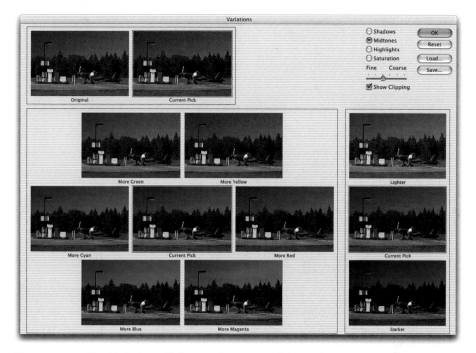

Figure 10.76 The Variations dialog can be very useful as a diagnostic tool for helping you identify if there is a color cast in your image and what colors might be helpful in correcting it.

Although we think that Variations is a wonderful tool to help you identify what color is causing a problem in your image and which colors may assist you in fixing the problem, it has some essential drawbacks that temper our enthusiasm for it as a color correction tool for serious use. The primary reason for this is that it can't be applied as an adjustment layer. Due to the nondestructive flexibility that adjustment layers offer, we believe that, if at all possible, you should use them for all color and tonal corrections. The second reason we don't favor Variations for "real" color correction is that it offers fairly blunt controls. The slider at the top of the dialog ranges from Fine to Coarse, and you have to apply changes separately to the shadows, midtones, and highlights. Variations is useful to help evaluate your image and craft a plan of action for fixing it, but we feel that for making actual modifications to the image, your time is better spent learning how to use adjustment layers with Photoshop's major color correction tools such as Levels, Curves, Hue/Saturation, and Color Balance.

Using Color Balance

Photoshop's Color Balance command is similar to Variations in that it features controls for adding or subtracting opposite colors in order to balance the colors in an image. Unlike Variations, however, it can be applied as an adjustment layer, which makes it much more flexible. Another benefit of Color Balance is that, like Variations, it serves as a very good instructional tool if you are new to color correction. The color sliders are arranged so that you can clearly see the opposite for a given color. Adjusting the sliders also makes these relationships and their effect on the image very clear. The one thing that Seán doesn't care for in Color Balance is that, like with Variations, you have to create separate adjustments for the shadows, midtones, and highlights. This is certainly not the end of the world, however, and for many people the user-friendly controls in the Color Balance command probably outweigh that minor inconvenience, especially if the idea of doing color correction in Curves sends shivers up your timbers. You may also need to use only two of the tonal ranges because in most images, correcting a color cast in the highlights and midtones will take care of the shadows.

The image we're using for the Color Balance example was taken using a tripod during the twilight hours of early evening (**Figure 10.77**). Nearby, a street lamp was providing most of the illumination, which gave the image a reddish yellow color cast. You can download this image (Family.jpg) from the companion Web site if you want to follow along using this image.

1. Open the Family.jpg image or use one of your own images that has a color cast. A good candidate for this exercise is a photo that was taken under artificial lighting. Photos taken outdoors in open shade may also have a cool, bluish color cast. Add a Color Balance adjustment layer to your image.

A B

Figure 10.77 The Family image before correcting with Color Balance (A) and the image after (B).

2. First the midtones were adjusted. To counteract the red cast from the outdoor lights, a −10 was entered for the reds, which added cyan, red's opposite color. Then the blue was increased by +10 to tone down the yellow cast. Finally, to correct a remaining reddish magenta cast on the sculpture, the green was increased by +10. This also had the effect of removing some red that was hiding in the green foliage (**Figure 10.78**)

Figure 10.78 Correcting the midtones.

3. Next the highlights were adjusted. The red slider was moved to −10 to remove any traces of the red cast on the sculpture by adding cyan. There was still a trace of magenta on the light clay, however, so green was increased by +5 (green is the opposite of magenta). Finally, blue was increased to +15 to leave the carved heads with more of a cool tone (**Figure 10.79**).

Figure 10.79 Correcting the highlights.

Color Correction with Levels

In addition to being an excellent way to adjust overall image tone and brightness, Levels is also one of Photoshop's best color correction tools. In our first outing with Levels, we used it to set a precise black and white point and improve the global tone of an image. In this section, we'll explore how to use it to apply basic color correction to an image.

Neutralizing highlights and shadows

The ability to specify a precise point in the image and use the Levels eyedroppers to change that tone to a neutral is one of the main reasons to start any color correction here. In a standard color correction workflow, after first evaluating the photograph to determine what it needs, the next step would be to be sure that the highlights and shadows are neutral. A neutral tone, remember, is one that has no color cast and where the RGB values are equal. If you do have an image that has a slight, or not so slight, color cast, much of the problem is often taken care of when the highlights and shadows are neutralized. In many cases you can just fix the highlights and the midtones, and that will take care of the shadows.

Specifying a neutral white and black point in Levels for color correction purposes is essentially the same procedure that we used when adjusting the overall tone of an image. To be able to make the most effective use of the highlight and shadow eyedroppers, this technique works best on images where there is an area that should be a neutral highlight. Such items might include puffy white clouds, a white shirt collar, a napkin at the dinner table, or anything that is white, or close to white. Using this procedure would not work well, for example, on photographs taken in a jazz club under the colored stage lighting. Although you could certainly use the eyedropper to neutralize the colors, doing so would take away all of the mood and ambience that was created by the colored lights. In short, you have to decide for every image if this approach would work, based on the subject matter and the lighting used to illuminate it.

The image used in this example, SierraLake.jpg, is available for download from the companion Web site. Here's how to specify a neutral shadow and highlight point:

1. Open an image that has not been color corrected yet, and add a Levels adjustment layer. As in the previous Levels example, Option-click (Mac) or Alt-click (Windows) on the highlight slider and move it toward the middle of the histogram to locate the brightest tone in the image that should be a highlight with detail. Remember that specular highlights (bright reflections) are not good candidates for highlight targeting. In many cases they are already pure white, or close to it, and clicking on them with the eyedropper will not do anything to neutralize colors in the rest of the image.

2. Once you've identified a highlight target area, Shift-click to set a Color Sampler point there. For the photograph of Sierra Lake in our example, we chose a bright area on the rocky side of the mountain. Be sure to return the highlight slider to the far-right side of the histogram when you're done.

3. Double-click the highlight eyedropper to verify that the RGB values for the target color are set to 245, 245, 245. Click OK to close the Color Picker. Use the Caps Lock key to get a precise crosshairs cursor, and zoom in close so you can see what you're doing (Command-spacebar-click for Mac, or Ctrl-spacebar-click for Windows, will let you zoom in closer). With the highlight eyedropper active, line up your cursor over the Color Sampler point and click once to set a neutral highlight (**Figure 10.80**).

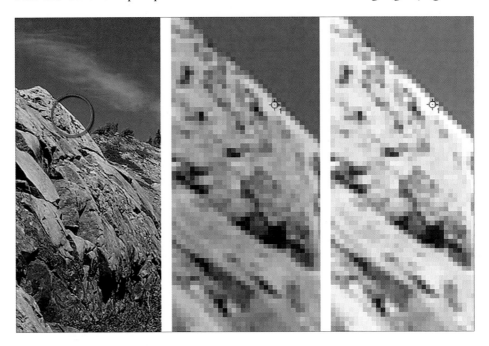

Figure 10.80 Neutralizing the highlights on the Sierra Lake photograph. The center view shows the detail of the target area before the adjustment, and the view on the right shows the result after clicking with the white Levels eyedropper.

4. Next, use the Command-0 (zero) or Ctrl-0 shortcut to zoom out and fit the entire image on screen. Using the clipping display method described in Step 1 (but using the shadow instead of the highlight slider), locate the darkest point in the image. Set a Color Sampler point so you can track the shadow values, and then return the shadow slider to the left side of the histogram.

5. Double-click the shadow eyedropper to open the Color Picker and verify that the RGB numbers are 12, 12, 12. Click OK to close the Color Picker, make sure the shadow eyedropper is active, and carefully line up your cursor over the shadow Sampler and click once to set a neutral shadow point (**Figure 10.81**).

Figure 10.81 Neutralizing the shadows on the Sierra Lake photograph. On the left is the before view, and on the right is the result after clicking with the black Levels eyedropper in the shadows of the trees on the far shore.

This simple procedure is one of the foundations of basic color correction, and it's something that works well on most images. Even if you don't think there's anything wrong with a photo, this should be one of the adjustments you do. In a color image it accomplishes two important things at once: It sets a black and a white point, which preserves bright highlight and dark shadow details; and it makes those tones neutral, removing any color cast that might be lurking there (**Figure 10.82**). Although it might seem pretty labor-intensive at first, once you get used to it, you can apply this technique to an image in a minute or two.

Figure 10.82 Sierra Lake, before (left) and after neutralizing the highlights and shadows using the white and black Levels eyedroppers (right).

Using the gray eyedropper to neutralize midtones

Gray is a very powerful color in color correction because it can be used to neutralize colors throughout the entire image. To remove a color cast from a midtone, you can use the middle gray eyedropper in the Levels dialog. Since the gray eyedropper will turn anything you click into a neutral gray value and shift all the other colors in the image proportionately, you need to make sure that you choose an area in your image that should be a neutral middle gray. Sidewalks, concrete walls, a gray sky, or metal objects are examples of places where the gray eyedropper can be used. You can download this sample image, Gray Eyedropper.jpg, from the companion Web site for the book (**Figure 10.83**).

Figure 10.83 In this image we used the gray Levels eyedropper to click on the metal surface of the kitchen timer (circled in red) to neutralize the color cast.

Activate the gray eyedropper by clicking on it and then click on the designated area in the image that should be gray. If you have chosen the target area well, then any color cast throughout the rest of the image should be removed. If you click on an area that does not represent a true gray value, you can end up with some startling color shifts being introduced. Try clicking on a colored object and you'll see what we mean (**Figure 10.84**).

Figure 10.84 When using the gray eyedropper, be sure that what you click on is a neutral gray. In this example, we inadvertently clicked on a cyan fringe on the bright reflection on the center of the timer. Clicking there with the gray eyedropper caused Photoshop to add red to try to neutralize the cyan.

Working with individual color channels in Levels

Levels gives you direct access to the individual red, green, and blue color channels in your image. This is very useful for correcting color casts that might not be addressed by using the Levels eyedroppers. In cases where you have an image that has no obvious highlight and shadow point, or an area that should be a neutral gray (such as the Sierra Lake photo from earlier in this chapter), the eyedroppers are of little use and you have to adjust the color manually as well as the individual color channel controls in Levels. In some ways, this is similar to the Color Balance dialog in that you have a slider control and moving it in different directions either adds or subtracts color based on the relationship of color opposites. The main difference between Levels and Color Balance is that with Levels you can adjust shadows, midtones, and highlights at the same time (although you do have to access the colors separately). It also helps to know the basic color wheel relationships. Since the different channels are only for red, green, and blue, for example, if you feel that an image is too yellow, then you need to know that blue is the opposite of yellow and you'll probably need to start in the blue channel to reduce the dominance of yellow in the photo.

It's easy to find out which way to move the midtone sliders simply by pushing them drastically in either direction. The effect in the image will tell you that the blue channel controls blue and yellow, the green channel affects the balance between green and magenta, and the red channel works with the opposites of red and cyan. Though the different sliders control the color balance in different parts of the tonal range, you do not have the precise control that you do in Curves. **Table 10.1** shows a list of typical Levels slider movements and the effect they have on the image.

After the highlights and shadows were neutralized in the Sierra Lake photo (see "Neutralizing Highlights and Shadows" earlier in this chapter), there were still some color casts that needed to be addressed. The middle slider in the RGB Levels was moved a little to the left to lighten the midtones a bit. Then the pop-up Channel menu at the top of the Levels dialog was opened and the green channel was selected. The middle green slider was moved to the right a small amount to add some magenta, which is the opposite of green. This slightly enhanced the reddish color of the rocks. Finally, in the blue channel the middle slider was moved to the left to add a bit of yellow to bring out more of the greens in the trees and counteract the blue/magenta cast that crept in when we added magenta to the rocks (**Figure 10.85**).

Table 10.1 How Levels Sliders Affect Color in an Image

Red Adjustments	Effect
Move Red midtone slider left	Adds red to the midtones
Move Red midtone slider right	Adds cyan to the midtones
Move Red shadow slider right	Adds cyan to the shadows
Move Red highlight slider left	Adds red to the highlights
Move Red Output shadow slider right	Adds red to the shadows
Move Red Output highlight slider left	Adds cyan to the highlights

Green Adjustments	Effect
Move Green midtone slider left	Adds green to the midtones
Move Green midtone slider right	Adds magenta to the midtones
Move Green shadow slider right	Adds magenta to the shadows
Move Green highlight slider left	Adds green to the highlights
Move Green Output shadow slider right	Adds green to the shadows
Move Green Output highlight slider left	Adds magenta to the highlights

Blue Adjustments	Effect
Move Blue midtone slider left	Adds blue to the midtones
Move Blue midtone slider right	Adds yellow to the midtones
Move Blue shadow slider right	Adds yellow to the shadows
Move Blue highlight slider left	Adds Blue to the highlights
Move Blue Output shadow slider right	Adds blue to the shadows
Move Blue Output highlight slider left	Adds yellow to the highlights

Figure 10.85 After the initial correction that set the black and white points on the Sierra Lake photo there was still a slight blue-magenta color cast lurking in the midtones. This was fixed by adjusting the individual Levels for the green and blue channels.

Auto color correction (with manual override)

In times past, we have not been huge fans of some of Photoshop's automatic color correction features, such as those found in the Image menu under Adjustments. While Auto Levels, Auto Curves, and Auto Color certainly have their place in some quickie workflows and provide an easy way for the new user to get fairly good color correction results on many images, we have never liked the fact that we could not control the adjustment and even worse, could not place it on an adjustment layer. In addition to those deficiencies, the auto features do not work well on all images. If an image has just the right distribution of certain tonal values, then sometimes they can be used to great effect, but it's just as likely that the adjustment will miss the mark, sometimes by a little and sometimes by a lot.

Our view of the Auto features, or at least, one in particular, changed with the release of Photoshop 7 and the appearance of the Auto Color Options feature, which can be accessed in the Levels or Curves dialog. When you press the Auto button in those dialogs, the default settings are applied, which may or may not work well depending on the image. If you do not click the Auto button and instead press the Options button in those dialogs, an auto effect is applied, but a dialog opens that allows you to experiment with a number of different ways that the auto correction is configured (**Figure 10.86**). It's a little like having separate recipes based on certain core concepts of color correction. If you like to tweak the setting as we do, then it's essentially an auto feature with some built-in manual override. We've found that in many cases it does a surprisingly good job, and even if it's not perfect, then it's reasonably close to the mark and can be improved with some manual adjustments in the main Levels dialog.

Figure 10.86 In either Levels or Curves, click the Options button to gain access to the Auto Color Options.

The Auto Color Options gives you six different ways to influence how the color correction is applied. Let's explore each of these settings:

- **Enhance Monochromatic Contrast.** When this option is selected, Photoshop will clip all color channels identically, using the clipping values that are specified in the dialog (we feel the default values are too heavy-handed, but more on that a little later in this section). As you can see from the tool tip that appears if you hover the mouse over this choice, the effect is essentially the same as the Auto Contrast feature found in the Image>Adjustments menu. You can achieve this same effect manually by moving the Levels endpoint slides to where the information starts in the main RGB histogram. This adjustment will address overall contrast while leaving color balance alone. As you can see from the photo of the polyphemus moth, the reddish yellow color cast has not been removed (**Figure 10.87**).

Figure 10.87 Using the Enhance Monochromatic Contrast option has not removed the reddish yellow color cast from the image.

- **Enhance Per Channel Contrast.** Photoshop will make a separate adjustment for each channel and this option is the same as choosing Auto Levels in the Image> Adjustments menu. You could do this yourself by moving the sliders in each individual channel to where image information starts on the histogram, which is one way to try to neutralize the colors in a photo, especially if you have no clear highlights or shadows to target with the eyedroppers. With this choice, you are more likely to see a

color balance change, especially if your image has a noticeable color cast (**Figure 10.88**). With some images, such as our moth here, this option also works very well when combined with the Snap Neutral Midtones option, which we'll discuss in more detail in a moment (**Figure 10.89**).

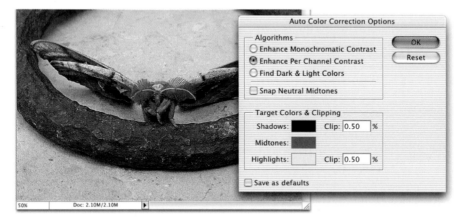

Figure 10.88 Using the Enhance Per Channel Contrast option has done a much better job of removing the color cast from the image, but it has replaced it with a faint green cast.

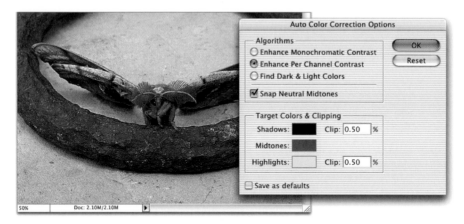

Figure 10.89 When Snap Neutral Midtones is added to Enhance Per Channel Contrast, the results look much better for this image.

- **Find Dark & Light Colors.** With this option selected, Photoshop will find the darkest and lightest pixels in the image and use them for the shadow and highlight values. The results for this option are harder to predict and are dependent on each individual image. We have noticed that sometimes this tends to add an unwanted color cast to the image. This effect is the same as using the Auto Color command found in the Image>Adjustments menu. For our sample image, the effect is similar to Enhance Per Channel Contrast, but a little more blue and less greenish yellow. Combining this with Snap Neutral Midtones has a barely noticeable effect that removes the faint blue cast and makes the image more neutral (**Figure 10.90**).

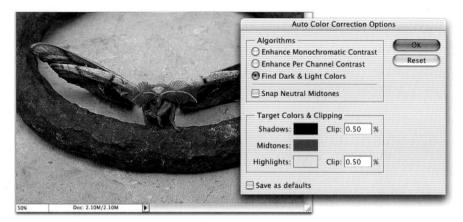

Figure 10.90 The Auto Color correction when Find Dark & Light Colors is selected.

- **Snap Neutral Midtones.** This option can be combined with any of the previous three choice options. With this selected, Photoshop will locate a color in your image that is as close to neutral as possible, and then force it to gray. Although actual results vary from image to image, we have found that it seems to work best when combined with the Enhance Per Channel Contrast option.

- **Target Colors & Clipping.** These values tell Photoshop how much of the very ends of the tonal range to ignore when figuring the color correction. We feel that the default clipping values of 0.50% are much too high. We recommend changing the defaults to no more than 0.05%.

By clicking on the color swatches for the shadow, midtone, and highlight, the Color Picker will open and you can choose a different target color to tweak the calculations so that they are based on non-neutral colors. In the example in **Figure 10.91**, the initial adjustment of Enhance Per Channel Contrast combined with Snap Neutral Midtones worked well, but there was still a hint of a reddish yellow cast in the image. To address this, we clicked on the midtone swatch and reassigned the midtone values to R=122, G=126, B=132, which gives the image a slightly cooler tone.

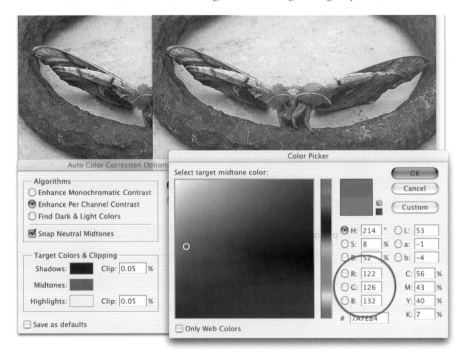

Figure 10.91 By clicking on the black, gray, or white swatches, you can choose a different color mixture for these tones. Although in most cases it makes sense to leave them at the defaults, in some situations, changing them slightly might help. In this example, we've chosen a cooler midtone color to compensate for the lingering yellow cast in the image. The image with the adjusted midtone is shown on the right.

- **Save as Defaults.** This saves the current settings as the defaults so that they will be selected the next time you use Auto Color. One potential gotcha is that any changes you have made to the shadow, midtone, or highlight target colors will also be saved as the default. For safety's sake, we recommend only saving a new default configuration that uses the standard neutral target colors.

For an "automatic" feature, the Auto Color Options provides a great deal of control for subtly influencing how the corrections are applied. We find that they're very useful and often find ourselves clicking the Options button in Levels and trying different settings to see what the effect will be. In many cases, these options will get you very close to where you need to be, and you can then apply some additional manual corrections using the main Levels or Curves dialog. One thing that you cannot do, however, is return to the Auto Color Options and see which settings you used for the initial adjustment. The effect that is generated by the settings is applied to the adjustment layer, so you can see how the Levels sliders have moved, but if you click the Options button again, it reverts to the default setup, removing the previous correction and replacing it with the default.

Color Correction with Curves

Adjusting color balance with Curves works on the same principles that are used in Levels and most of Photoshop's other color correction tools. The primary red, green, and blue colors interact together and with their secondary cyan, magenta and yellow opposites. The major difference in terms of actually applying those adjustments is that in most of the other color correction dialogs, you use sliders to change color balance, whereas with Curves you are manipulating a flexible tone curve. When you enter the Curves dialog, you can access the individual color channels just as you can in Levels. The color relationships are the same as well. Raising the red curve will add red, while lowering it will subtract red by adding cyan, the opposite of red. Dragging up on the green curve will increase the green in the image and lowering it will add magenta, which is the opposite of green. In the blue curve, raising the curve will add blue and lowering it will add yellow, the opposite of blue. In addition to dragging the middle portion of the curve, you can place a point anywhere on the tonal curve where you need to change the balance of color in the photograph. This localized precision is what sets Curves apart from Photoshop's other color correction tools.

Figure 10.92 shows a quiet portrait of a little girl by a swing set. The photo was taken in the early evening in the full shade of tall redwoods and pines. As a result it had a cool tone to it that we wanted to warm up. It's also a bit dark and lacks contrast. First we'll explore how to do this in Curves (**Figure 10.93**) and in the next section, we'll try a similar warming effect using the Photo Filter adjustment layer in Photoshop CS.

Figure 10.92 This portrait was taken in the shade in the early evening and is too cool and blue.

Figure 10.93 In the final version the cool color cast has been removed and the image now has a warmer color balance that is more pleasing.

Here's how we adjusted the color balance with Curves:

1. As always, our first step was to add a Curves adjustment layer. Since this image didn't include any obvious candidates for the neutral eyedroppers, we made our adjustments by eye.

2. Since we felt the image was too cool and blue in overall color balance, we started our adjustments in the Blue curves channel. We pulled down on the upper portion of the blue curve a bit to add yellow to the photo (**Figure 10.94**).

Figure 10.94 Adding yellow by lowering the blue curve.

3. We then went to the Red curves channel and added red to the same approximate portion of the curve by raising it up. Since we only wanted to warm up the lighter areas of the image such as the girl's face, her hair, and the tan bark in the background, we also added two other points further down the red curve to prevent those areas from being affected (**Figure 10.95**).

Figure 10.95 Adding red by raising the red curve.

4. We investigated making some changes in the Green curves channel, but decided to leave it alone because it did nothing to help the image. The last thing we did was to return to the RGB composite Curve and add a subtle S-curve to increase the contrast a little (**Figure 10.96**).

Figure 10.96 Adding a touch of contrast with an S-curve.

Photo Filter adjustment layers

In Photoshop CS, you can use a Photo Filter adjustment layer (Layer>New Adjustment Layer>Photo Filter) to apply some of the standard warming and cooling effects that have been common to photographers for years in the form of 85A and 81A (warming) and 80A and 82A (cooling) filters. As shown in the previous example, subtle corrections in Levels and Curves can also produce a similar effect. But for those who are new to Photoshop and like their effects within easy reach and conveniently named, Photo Filter adjustment layers are worth looking at (**Figure 10.97**).

Like its real world counterpart, the warming 85 filter is a deep amber color and is effective at accentuating the warm colors of sunrise or sunset, or for adding a rich warmth to skin tones. The 81 filter is a pale amber and not as strong as the 85. It works well for adding a slight trace of warmth to portraits, bluish exterior shadows photographed in the bright midday sun, or images made on overcast days or in the open shade (**Figure 10.98**). The default opacity of 25% works well for

Figure 10.97 The Photo Filter dialog.

reproducing the subtle effect the real filters have when you hold them up to your eye. Of course, you can adjust that setting up or down until you find the right setting for a particular image. In addition to the warming and cooling properties of the 80-series filters, you can also choose from a list of basic colors. The magenta Photo Filter, for instance, is useful when you need to counteract the ghastly greenish hue introduced into images by fluorescent lighting on exposures that have not been properly white balanced.

Figure 10.98 To warm up this portrait, an 81 warming filter was used at a density setting of 40%.

BASIC IMAGE CLEAN-UP

Once you've finished with the main color and tonal correction in your image, you should thoroughly check your image for any flaws that you may want to remove. This can include anything from touching up dust spots on your image sensor to removing a crumpled soda can marring an otherwise perfect grassy lawn. Some items that you choose to remove may not necessarily be as objectionable as a piece of trash in the image, but after you've had a chance to consider your image for a while you may notice that they're just as distracting.

Photoshop provides several tools for applying essential retouching, repair, and finishing touches to your images. Here's a look at them with some tips and techniques for using them effectively.

Cloning

The Clone Stamp tool works by copying pixel data from one place in an image (or from another image) and "stamping" it onto another place in the image. One of the original "guilty pleasures" in Photoshop, it's also been the tool of choice for retouching for many years. Only with the release of Photoshop 7 and the introduction of the Healing Brush did the Clone Stamp's luster fade a bit (more on the Healing Brush in the following section).

While the Healing Brush may have stolen some of the Clone Stamp's thunder, cloning is still something you will have to do from time to time, and there remain many retouching tasks that are better suited to the Clone Stamp. Here's a brief summary of how this tool works:

1. Open an image that contains an object or defect you would like to remove. Be realistic in your expectations and try to choose something small and not too difficult. Removing your reflection from the glass of a museum display case is a bit beyond the scope of this introductory tutorial.

 For our image, we've chosen a photo of a park with two stately trees that are held together by a large steel bar. Although we don't question the strength and necessity of the steel bar, we think it mars an otherwise lovely park setting, so we'd like to remove it. You can download this image, Park_Trees.jpg, from the companion Web site if you want to try these techniques on the same image (**Figure 10.99**).

Figure 10.99 The Park Trees image. The two trees on the right side of the path have a steel bar between them that needs to be removed.

2. Create a new, empty layer by clicking the New Layer icon at the bottom of the Layers palette, or by going to the main menu and choosing Layer>New>New Layer. The reason we're making an empty layer is that we will place any cloning work on this separate layer so that the original image is not harmed. This is a core principle in our image-editing philosophy: structure your file so that any changes you make are flexible and nondestructive.

3. Select the Clone Stamp tool from the toolbar (make sure you don't select the Pattern Stamp tool—they look very similar). In the Options bar for the Clone tool, select the Use All Layers check box. This allows the Clone tool to sample data from the main image beneath the empty layer where we will place our retouching work **(Figure 10.100).**

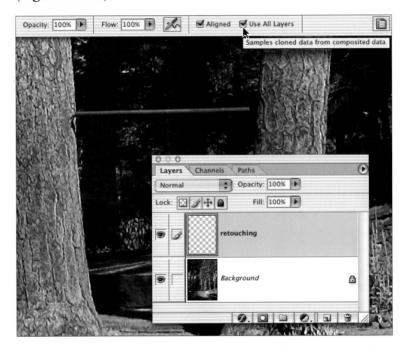

Figure 10.100 The Use All Layers check box in the Clone Stamp Options bar lets you sample pixels from one layer and place them onto an empty layer to keep your retouching work separate from the main image.

4. Zoom in close to the area you will be retouching by using the Command-spacebar-click (Mac) or Ctrl-spacebar-click (Windows) keyboard shortcut. From the Options bar for the Clone Stamp, select a brush that is the right size for the area you need to cover up. A smaller brush that you can use with more precision is preferable to a larger brush that will get the job done faster. Ideally, the brush should be just slightly larger than the area you need to cover up (**Figure 10.101**). You may also need to use a harder brush edge, since the normal brush tip has a soft, feathered edge. To choose a different hardness setting, click the Brush button on the left side of the Options bar for the Clone Stamp tool and use the Hardness slider. You can also use Shift-left bracket ([) to decrease hardness and Shift-right bracket (]) to increase hardness. The hardness can be previewed in the small thumbnail of the brush in the Options bar (**Figure 10.102**).

Figure 10.101 Click the brush size icon in the Clone Stamp Options bar to open the brush picker and select a brush size.

Figure 10.102 The hardness of the Clone Stamp brush can affect the effectiveness of your cloning. In the top example, the brush hardness is set at 0% for a soft, feathered edge. In the bottom example, the hardness is set at 80%, for a brush with a harder edge.

5. To create a source sample point for the Clone Stamp to copy data from, try to find an area of tone, color, and detail that is as close as possible to the area you need to blend with when you cover the undesirable item. We like to consider what would be visible in that space if the steel bar (or whatever) was never in the photo in the first place. This brings up one of the truths of digital retouching. Removing an objectionable

item from an image is easy. The tricky part is reconstructing what would have been there in the background.

6. Once you have found an appropriate area to copy data from, place your cursor in the area and Option-click (Mac) or Alt-click (Windows) to create a sample point. With a sample established, release the mouse button and move your cursor over the area to be repaired or replaced. Then click and hold the mouse button to paint using the cloned information. When you have covered up a small area, stop and find another place to sample data from. Option-click or Alt-click again and return to covering up the item (**Figure 10.103**). Sampling from several different areas as you clone will help prevent tracks or echoes from showing up and revealing to the world that you were there with the Clone Stamp.

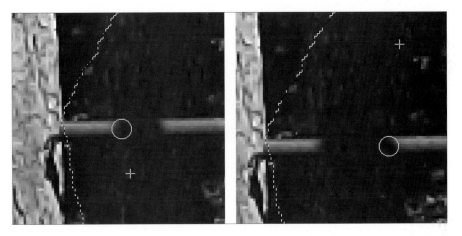

Figure 10.103 Option-click or Alt-click to sample some of the background, paint with the Clone Stamp to cover up a bit of the steel bar, and then make a new sample point from elsewhere in the image. By varying the sample points you can avoid repeating patterns that call attention to your retouching work.

In our image of the trees, we used the Lasso tool to make a selection to prevent us from accidentally cloning onto the hard, sharp edge of the tree trunks. This can be a useful strategy to keep your cloning work only where you want it, though it is only necessary for working around delicate edge areas.

Keep an eye open for repeating patterns creeping into the areas where you are working with the Clone Stamp tool. To avoid this, try creating a new sample point often and use it for only a few clicks or strokes of the Clone tool before creating a new sample point in a different area. Don't use the tool like a roller brush for painting a wall! If you've ever used a tiny brush and retouching dyes to remove dust specks from photographic prints, then this is a much better metaphor to have in your mind than painting with a paintbrush.

With the advent of the Healing Brush, the Clone Stamp tool is used less often for spotting images, simply because the Healing Brush does a much better job. The Clone Stamp tool is best for times when you need to copy actual image detail and move it to another location in an image (**Figure 10.104**).

Figure 10.104 The image after removing the steel bar.

Healing

The Healing Brush is an amazing tool for repairing images, retouching wrinkles, or dealing with the bane of the digital photographer, image sensor dust spots on your otherwise pristine photograph. As with the Clone Stamp, you have to Option-click (Mac) or Alt-click (Windows) to create a source sample point and then move the cursor to brush over the areas you want to retouch. But that's where the similarities end and the magic of the Healing Brush takes over.

Not only does the tool copy the texture and detail of the area where you sampled, but it preserves the color and tone (brightness) of the area where you are applying the retouching. This makes it ideal for spotting out dust specks from your images, retouching portraits, or removing jet contrails from remote wilderness landscapes. With the Clone Stamp tool, you

need to be very careful about where you sample data from to be sure that it is the same brightness and color as the area where you're copying it to. With the Healing Brush, you only need to be concerned that the detail texture is the same, since the color and tone will be sampled from the destination area.

To try this out, find an image with some dust spots or flaws, or a portrait image that has some facial blemishes that you'd like to remove. You can also download the example used here, HealingBrush-1.jpg (**Figure 10.105**) from the companion Web site. Select the Healing Brush from the Tool palette and try the following to retouch the flaw:

Figure 10.105 This image shows several dust spots from the image sensor. The Healing Brush is the perfect tool to remove these.

1. Option-click (Mac) or Alt-click (Windows) to create a source sample in an area of the image that has suitable detail to cover up the flaw. It doesn't matter if you sample in a place that is different in tone (brightness) than the area where you are going to retouch. As long as the detail texture is the same, the Healing Brush can handle it.

2. Move the cursor over to the top of the flaw, press and hold the mouse button down, and paint over it with the mouse to cover it up. As you do this you may notice that the new pixels you put down are a different brightness and do not blend in at all. Once you let go of the mouse, however, Photoshop does some quick calculations and then blends the two areas together, taking the detail and texture from where you sampled, and preserving the color and brightness of the area you retouched (**Figure 10.106**).

Figure 10.106 Option-click or Alt-click to sample some detail and then paint over a spot to remove it with the Healing Brush.

If you need to use the Healing Brush in areas that are adjacent to regions that are much darker, lighter, or of a different color than the area you are retouching, you may need to make a lasso selection that excludes that darker or lighter area. This will prevent the Healing Brush from "looking" outside its brush tip for data to use when it calculates how to heal the area you're working on (**Figure 10.107**).

As great as this tool is, it's not the answer to all of your retouching problems. There will still be times when you need to use the Clone Stamp tool, or other procedures such as copying elements and moving them onto separate layers.

In Photoshop CS, the Healing Brush can be used on an empty retouching layer with the Use All Layers option selected. This is how we recommend using it. In Photoshop 7, however, the Healing Brush can only be used on the layer where the image data is. If you are using Photoshop 7 and are concerned (and you should be) about preserving the original image, create a duplicate layer of the background and do all the retouching on that copy layer. To keep the file size as small as possible, you could also copy a selection of the

retouch area onto a new layer (with a selection active, Edit > Copy, Edit > Paste) and then lock the position of that layer using the lock position icon at the top of the Layers palette (**Figure 10.108**). You can then use the Healing Brush and have it on a separate layer.

Figure 10.107 If you need to use the Healing Brush close to an edge that contains different color or brightness from the area you are retouching, make a selection to exclude that area so the Healing Brush will not consider it for its healing operation.

Figure 10.108 In Photoshop 7, you cannot heal onto an empty layer. To keep your retouching flexible and not increase your file size, copy only the areas you need to retouch onto a separate layer and lock its position.

Patching

The Patch tool produces an effect that is similar to the Healing Brush, but it is designed to work on larger areas. The functionality of the Patch tool is similar to a lasso. If you click and draw in your image, you'll end up with a lasso selection. This is the first step: defining the area you want to patch. You can also use any of the selection tools to create a selection. When you're ready to apply the patch, you need to be sure that the Patch tool is active. Here's how it works:

1. Using either the Patch tool or the regular lasso, trace a rough selection around the outside of a scratch or large flaw.

2. If you used the regular lasso, or another selection tool, to create the selection, you now have to switch to the Patch tool.

3. The Patch tool works by defining a selection around a damaged area and then moving that selection over to an area that contains good data that you'll use to make the patch. If your initial selection surrounds the damage, then you need to select Source in the Patch tool Options bar. This tells Photoshop to apply the patch to the source (your selected area) and not to the area where you are dragging the selection.

4. With the Source option checked, drag the selection onto an adjacent undamaged area that contains detail that is suitable for covering up the flaw. In Photoshop CS a preview will appear as you drag that shows how the new, copied pixels will look when patched over the source area. Release the mouse button and Photoshop applies the patch by blending the data from the area where you dragged the selection onto the damaged area that you wanted to fix (**Figure 10.109**).

 > **NOTE:** *If you drag the selection too close to areas that contain other detail or darker or lighter tones than the area you are patching, then that detail may blended in to the final patch and it may not ruin the effect. Keep in mind that, like the Healing Brush, the Patch tool "looks" slightly outside the selection edges in order to calculate how to blend the patch onto the existing data.*

A

B

C

Figure 10.109 The initial Patch tool
selection over the shadow of the reed (A);
dragging the selection onto an area with
detail to use for the patch (B); the finished
patch (C).

Spotting

All images need to be spotted (retouched to eliminate tiny flaws). Fortunately, digital camera images need less spotting than a scan from a slide or a negative, especially if your camera does not have interchangeable lenses. All images should be closely examined toward the end of the editing process to see if there are any tiny flaws, spots, or even faraway birds that look like spots, that need to be retouched.

The tools of choice for this procedure are the Healing Brush and the Clone Stamp. For most spotting situations, we prefer the Healing Brush. Since we've already covered the basic functionality of the Healing Brush, we'll talk about the best way to inspect your images and how to spot them to make sure that you don't miss a single pixel.

First, spotting needs to be done at 100%, or Actual Pixels view (View > Actual Pixels). Second, once you are zoomed in for a close view, bring up the Navigator palette, click the little red box in the proxy preview of your image, and move it to one of the corners of the preview area. Next, make sure that you are in the first screen view mode, so that you can see the edges of your document window with the scroll bars (**Figure 10.110**). If you are in one of the two full-screen modes, simply press the F key once or twice until you return to multiple-window screen mode.

Figure 10.110 The image is at 100% (View > Actual Pixels) and the proxy preview box in the Navigator palette is positioned in the upper-left corner prior to a final check for dust spots.

With the Healing Brush, retouch any spots or flaws that you want to remove from the image. When you have finished spotting the first panel of the image, move your mouse down to the horizontal scroll bar track and click in the empty area of the track just beyond the scroll handle (**Figure 10.111**). This will advance the image one exact panel to the next section. By using this method, you can be sure that you do not miss any pixels in the image. Spot this panel and move on to the next by clicking in the empty part of the horizontal scroll bar track. Continue until you reach the other side of the image. Now click in the vertical scroll bar track to advance the panel down (or up) one exact section. Spot this panel and then move back in the direction from where you started. When you reach the other side, move down one row and come back. Repeat this procedure until you have finished spotting the entire image (**Figure 10.112**). Seán likes to call this process "mowing the lawn."

Figure 10.111 Clicking in the empty scroll track will shift the image over one exact screen view.

You can review an image that will not fit entirely on your monitor using only the keyboard. Starting in the upper-left corner, these shortcuts will adjust only the viewing area one screen width or height at a time:

1. Press the Home key to jump to the upper-left corner.

2. Press the Page Down key to move down one full screen view.

3. Press the Page Up key to move up one full screen view.

4. Press Command/Ctrl-Page Down to move to the right one full screen view.

5. Press Command/Ctrl-Page Up to move to the left one full screen view.

Figure 10.112 A final search for dust spots using the "mowing the lawn" method.

Nikon Dust Off

Every bit of dust removal that we don't need to do in Photoshop is time that can be used for taking more pictures or making better prints. To our delight Nikon has developed an ingenious software solution that is very easy to use.

If you use any of the following Nikon digital cameras, the D1, D1X, D1H, D2H, D100 and Coolpix 5700 and Coolpix 5000, you can take advantage of the Dust Off Removal feature in Nikon Capture 4 software.

The entire process takes two simple steps. While you're out taking pictures you need to shoot a Nikon Dust Reference file. To do this you navigate to the Dust Removal menu in the camera, where the camera instructs you to photograph a featureless white surface from 10 centimeters away. The camera will automatically change the lens focus to infinite so all you end up with is a very blurry white picture. Then you can go back to taking pictures as usual.

After you've downloaded the camera files, launch Nikon Capture 4 and browse to your images. As you can see in **Figure 10.113** the dust is especially prevalent in the clear blue areas of the sky. Open the Dust Off palette and click Change to navigate to the folder with the Nikon Dust Reference file you shot. Click Choose, and then sit back and let the software do the work. In a few seconds Nikon Capture 4 will have compared the open photograph with the Dust Reference file and removed all of the nonimage dust from the file as shown in **Figure 10.114**.

(Continued)

Figure 10.113 A dusty sky image seen in the Nikon Capture 4 software.

Figure 10.114 The dust removed using the Dust Off Removal feature in
Nikon Capture 4.

The software is so savvy that if it "thinks" that you've chosen the incorrect dust
reference file, it will ask you to choose another one. Because dust can move on
the sensor, we recommend that you shoot a reference file at the beginning and
end of every photo session. It only takes a few seconds but boy, it can save many
hours of tedious cloning or healing.

Retouching Recommendations

The field of retouching is vast, and we only have room to cover the most basic techniques for everyday touch-ups on your images. If you are interested in delving deeper into this fascinating area, then we can enthusiastically recommend the second edition of Katrin's excellent book *Photoshop Restoration & Retouching, 2nd Edition* (New Riders Publishing, 2003) as a good source of practical and inspiring information on this topic.

> **NOTE:** For techniques on removing red eye from your photos, as well as other retouching tips, check the companion Web site for this book.

Cropping

The right crop on an image can take an ordinary photo and elevate it into a more interesting and compelling image. By excluding all but the most vital aspects of the photo, you distill the scene down to its visual essence. Of course, with digital cameras, we feel it is best to do most of your cropping in the viewfinder to maximize every precious pixel that the image sensor has to offer. Still, there are times when you have no choice and you must crop the image in an editing program.

Using the Crop tool

Here's how the Crop tool works:

1. To define an area to crop off of your image, select the Crop tool from the toolbar. Double-check the Options bar to make sure that a previous dimension is still not selected. If there are existing crop values that you would like to get rid of, click the Clear button to clear all values from the crop options.

2. Click and drag across your image to define a crop box. To constrain the proportions to a square, hold down the Shift key as you drag. When you let go, the areas outside the crop box will be covered in a semitransparent black overlay. This is to help you visualize how the crop will affect the image. Click on the small square "handles" to reposition the placement of the sides of the crop box. To move the entire box, click inside the box (but not on the center, pivot point) and drag it into a new position.

3. To apply a crop, you have three choices: Click the Checkmark button on the far-right side of the Options bar; press Enter; or double-click inside the cropping box. To cancel a crop, click the No button on the far-right side of the Options bar, or press the Escape key (**Figure 10.115**).

You can also use the Crop tool to resize an image. Simply enter the dimensions you want the image to be and drag a new crop box. If you are preparing an image to make a print, you can enter a resolution here as well. Pay attention to what the units are after you enter the sizes for your crop. If your ruler units are set to pixels, then you will be cropping your image in pixel dimensions. If you have entered 8x10, but didn't see that the abbreviation was "px" instead of "in," then you will have a really tiny image after the crop is done! You can change the ruler units by clicking the crosshair in the Info palette, or you can also type in the "in" abbreviation in the Crop Tool Options bar.

Figure 10.115 Cropping an image with the Crop tool.

Perspective cropping

If you have an image where the perspective needs correcting, such as a photo looking up at a building, you can use the Perspective check box in the Crop tool Options bar to turn on some additional functionality of the tool. To follow along with this example, download Hotel_Webster.jpg from the companion Web site (**Figure 10.116**).

1. Activate the full-screen gray view by pressing the F key. To apply the perspective crop, you need to adjust the crop box handles close to the edge of the document window. Having the image in full-screen view makes this easier to do.

2. Drag a crop box around the entire image. In the Options bar for the Crop tool, click the Perspective check box. Starting on the left side of the image, move the center crop handle into the photo and line it up with the bottom of the first vertical edge of the frame on the front of the building (**Figure 10.117**).

Figure 10.116 The Hotel Webster needs a new perspective.

Figure 10.117 Drag the center handle on the left side in until the edge of the crop box aligns with the lower corner of the white frame, as shown in the circled area.

3. Click the top-left corner handle and slide it across the top edge of the image until it is aligned with the slanted side of the frame (**Figure 10.118**). You may need to readjust the lower-left corner handle to make it line up perfectly with that edge.

Figure 10.118 Drag the top-left corner handle in until the edge of the crop box aligns with the upper side of the white frame, as shown in the circled area.

4. Repeat steps 3 and 4 for the right side of the crop box. Once the edges of the crop box are aligned with what should be a vertical in the image, grab the center side handle of both the left and right sides and move it back until the lower-left and lower-right handles are just at the edge of the image (do not extend it past the edge of the image). Moving the sides in makes it easier to line up the edge of the crop box with lines in that image that should be vertical (**Figure 10.119**).

5. Press Enter or use the Checkmark button on the right side of the Options bar to apply the perspective crop (**Figure 10.120**).

This feature works well for making moderate corrections to perspective, but there are some situations, such as looking up at an object at a very steep angle, that are beyond its capabilities. If you extend the crop handles outside of the image, Photoshop will fill those areas with whatever your background color is set to and you'll then have to either crop them again, or try to retouch them. For most images, we try to keep the handles inside the image boundaries.

Figure 10.119 The final crop box just before the crop is applied.

Figure 10.120 The Hotel Webster after perspective cropping.

DIGITAL DARKROOM FLEXIBILITY

Editing and improving your images in Photoshop or another program can be a lot of work, but it can also be a lot of fun. Once you become familiar with the basic steps, you'll be able to work more efficiently and do a better job. The most important factor is to structure your file so that everything you do is nondestructive and flexible. This allows you to revisit your corrections and improve them at a later date.

This chapter has covered some of the core fundamental techniques for improving your photos. In the next chapter, we'll move on to explore additional techniques, including important procedures for sharpening digital images, dodging and burning for precise tonal adjustments, and merging two exposures to extend dynamic range.

CHAPTER ELEVEN
Digital Darkroom Expert Techniques

The digital darkroom, especially when powered by Adobe Photoshop, is a wonderland for photographers and visual artists. You can do so many things to an image, that unless you have a clear goal in mind, it's easy to get sidetracked by all of the possibilities. In the last chapter we concentrated on some fundamental concepts and techniques that can be used on most digital images. In this chapter, we'll start off with essential sharpening skills and then expand our discussion of Photoshop to include some more in-depth image-enhancement techniques such as light-altering adjustments, interpretive modifications, custom black and white conversions, toning and tinting, multiple exposures, panoramas, and the importance of working with 16-bit images.

SHARPENING

Just as all digital images need spotting to touch up dust specks or other tiny imperfections, all digital images also need sharpening. The act of taking a scene from the real world and translating it into a mosaic of millions of tiny, square pixels will inevitably introduce some softening into an image. Images from high quality digital cameras typically are sharper than scans, but even they can often be greatly improved with some sharpening applied (**Figure 11.1**). Many cameras deal with this by applying a sharpening pass as the image is processed after the initial capture. Because sharpening permanently alters the contrast and color of pixels, and because you have little control over how the camera applies the sharpening, we recommend turning this feature off in the camera if at all possible. If you're shooting in the RAW format, then the camera doesn't apply sharpening, although it's common for RAW conversion programs to offer controls for applying a sharpening effect as the image is processed and converted from the RAW file.

Figure 11.1 Detail of an unsharpened image from a digital SLR (left), and a final sharpened version (right).

We prefer, for a number of reasons, to defer any sharpening until we bring the image into Photoshop. First, we have more control and can even decide to selectively apply sharpening to only certain areas of the image using selections, layers with layer masks or by targeting individual color channels. Second, the amount of final sharpening you apply is influenced by how large the final print will be. For this reason, we never apply our final sharpening pass until after we've saved and resized a copy of our master image at final output size.

The Truth about Sharpening

Sharpening is really just an optical illusion, designed to fool our eyes into thinking that the image is sharper. It does this by increasing the contrast of pixels where there is an "edge," or a natural difference in contrast, brightness, or color (**Figure 11.2**). Although all digital images, whether from scanners or digital cameras, benefit from sharpening, this process can't help images that were photographed out of focus, either from an improperly focused lens or because a slow shutter speed caught the subject or camera moving. Sharpening the image may help a bit, but it will not turn an out of focus image into a sharp photo.

Figure 11.2 Sharpening a digital image involves increasing the contrast along color or brightness edges in order to fool the eye into thinking the image is "sharper."

When to Apply Sharpening

Sharpening is a destructive process since it's applied directly to the image pixels and permanently alters pixel contrast values. Too much sharpening, or repeated sharpening, can cause significant degradation in the image. With this being the case, you need to have a plan for applying sharpening to your images.

In the past, conventional wisdom recommended that major sharpening be applied toward the end of the image-editing process. The idea was that since the sharpen values you use are determined by the size of the image, sharpening should take place after you've sized the image to final output size. In our own workflows, we use a three-step approach developed by Bruce Fraser (see "Sharper Is Better" later in this chapter) that lets us sharpen to correct for softness introduced by the capture device, creative sharpening that we may apply to different areas of the image, and final sharpening that is targeted to the output device that will print the image.

We keep our master image with layers intact and apply any sharpening to a copy of the background layer. This lets us use layer masks and layer opacity to further refine the sharpening effect. For the final file that we will send to our printer, we create a flattened copy of the file and then resize it to the desired output dimensions and resolution. Then we apply final sharpening to compensate for any softness that will be introduced by the act of translating the pixels into inkjet or halftone dots. The last thing we do is make a final spotting pass in case the sharpening has enhanced any defects we may have missed the first time around. This approach preserves our original master layered image in a flexible state so we can always use it to generate new copies that may have different sharpening needs.

When we're ready to sharpen our images, we prefer to use Photoshop's Unsharp Mask filter (Filter > Sharpen > Unsharp Mask).

Unsharp Mask Controls

The Unsharp Mask dialog has three controls that affect how the sharpening is applied to the image (**Figure 11.3**). These settings are all interrelated so that you can have different numerical combinations of the three and still end up with very similar results:

- • **Amount.** The Amount setting increases the contrast of pixels by either lightening or darkening them. It's like a volume control for the contrast. At its extremes, the setting can force pixels to either a solid black or a solid white, or to the maximum amount of a given color. If the amount is too high, you will notice halos or fringing at the tonal edges in the image. To start out, you can set the Amount fairly high, say around 300 (some advocate an even higher initial setting) and then use the Radius and Threshold settings to back off the intensity until you start to get something that looks good.

Figure 11.3 The Unsharp Mask dialog.

- • **Radius.** This setting determines the width of the sharpening halos. Obviously a wider halo results in a more pronounced sharpening effect. If the halos are too wide, however, then the image is likely to look over sharpened, which is generally something to avoid (**Figure 11.4**). Radius and Amount work together in a seesaw relationship; when you increase one, then you usually need to decrease the other to maintain the same level of sharpening.

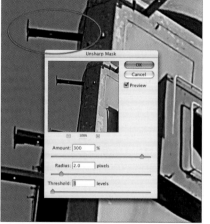

Figure 11.4 If the Radius is set too high, it will cause halos or light fringes to appear around edges. In this example showing an unsharpened version of the image (left), and a sharpened one (right), the one on the right has a Radius setting that is too high, which is causing the light halo around the metal brackets on the sign.

- **Threshold.** This setting controls which pixels the Unsharp Mask filter considers as candidates for sharpening, depending on the value you enter. Its range is 0 to 255, so if you enter a value of 8, the filter will sharpen a pixel only if there's a difference of at least 8 tonal levels between it and neighboring pixels. Threshold is very useful for minimizing sharpening in areas such as the smooth, even areas of skin tones on a person's face, still water, or skies (**Figure 11.5**). Aside from creating a special selection or mask, the Threshold setting is the easiest way you can tell the filter to ignore certain parts of the image. We usually start out with the Threshold set at 3 and then gradually increase it to see how it affects the areas in the image we don't want to sharpen. We rarely go over 8 with the Threshold setting.

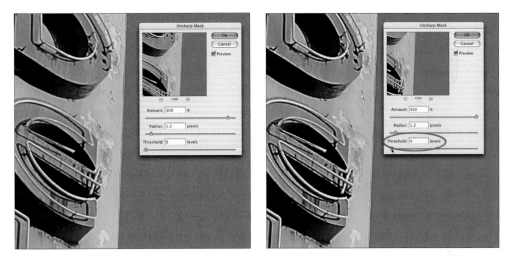

Figure 11.5 A Threshold setting of 0 will sharpen areas that should remain smooth, such as the blue sky in this image (left). By raising the Threshold setting to 3, the sky does not receive any sharpening effect (right).

How Much Should You Sharpen?

Since sharpening takes place at the pixel level, the amount of sharpening you apply depends on the number of pixels in the image, how sharp the original image was, and whether you are sharpening to compensate for capture softness or targeting a specific output device. An image with a larger pixel dimension, for instance, can take more sharpening than an image with a smaller one. Images scanned from film originals typically require more sharpening than do images from good-quality digital cameras. This being the case, there is no set of magic numbers that we can hand down to you as the one, true combination of sharpening values that works in all cases.

Typically, with our digital camera files, we start off at around 250 to 350 for the Amount, with the Radius set to 0.7. If the image needs more sharpening, then we will try increasing the

Radius; if it needs less sharpening, then we'll decrease the Amount. Be careful when using the Radius slider and make sure that that obvious halos and edge fringing are not apparent. The sharpened edge should increase the perceived sharpness without looking like it's glowing (see Figure 11.4). The Threshold slider is used when there are areas in the image, such as even facial tones, skies, still water, or anything that should remain smooth. A higher Threshold setting will restrict the sharpening effect to areas with obvious contrast edges.

> Note: When you are applying the sharpening to your image, you can zoom in to 100% to see how it is affecting the fine details, but be sure to zoom out to 50% to get a better impression of how it is affecting the image as a whole. Instead of the super close-up that 100% view provides, viewing at 50% gives you more of an idea of how the image will look when it is printed.

Sharper Is Better

The very sharpest your images will ever be is when you look at the actual scene with your own eyes, especially if you have 20/20 vision and it's a crystal-clear, well-illuminated day. When you focus your lens on a subject and push the shutter button, the light going through the lens is compromised; the resulting image will always be softer than the original scene. Using high-quality lenses with a lens hood and a tripod will help reduce softness caused by light scattering, internal lens flare, and camera shake, but no matter what you do, you just can't fight optical physics. Then to add insult to injury, when you make a print, the physical interaction of ink on paper adds softness to an image as the inks or dyes diffuse into the paper. In between taking the photograph and making the print, we often sharpen and soften image areas selectively: We like to add softness to less important image areas and sharpness to the essential image areas to guide the viewer's eye.

Since the pure physics of light moving though a camera lens and ink hitting paper causes softness, should we just give up and all become impressionistic photographers? Satisfied with soft, mushy images? Of course not. An arsenal of Photoshop sharpening filters and techniques and many third-party plug-ins can help you sharpen your images and make them as crisp as the day they were taken.

One of our favorite sharpening strategies was developed by Pixel Genius (www.pixelgenius.com) and packaged as PhotoKit Sharpener, a three-step approach to sharpening that addresses sharpening for the softness caused by lenses and CCD grids, sharpening for creative interpretive reasons, and sharpening for a variety of output including Web, inkjet, and offset printing. As Bruce Fraser (super pixel genius) explains the sharpening workflow:

If we try to use a single round of sharpening on a digital image, we immediately encounter a problem. The image source requires one kind of sharpening, the image content requires another, while the output medium needs still another sharpening treatment. Why is this?

(continued)

1. Different capture mechanisms—film formats and digital cameras—have their own signature combinations of detail and noise. The challenge is to sharpen the detail without also exaggerating the noise, so successful sharpening needs to take into account the relationship between image detail and the noise signature of the image source, whether it's film grain or a digital camera filter mosaic.

2. Different subjects need different treatments. Apparent sharpness depends on the contrast along what we see as edges. A close subject with soft detail has wider edges than a high-frequency image, so each requires a different treatment in terms of sharpening radius. Incorrect sharpening either obscures small details, or oversharpens textured areas such as skin tones.

3. Output processes differ in the way they convert pixels to printed dots, so sharpening that works well for an inkjet printer may fail miserably when sent to a halftone output process such as a web press, or to a continuous-tone process such as a film recorder. Incorrect sharpening either produces insufficiently sharp results, or makes obvious, objectionable sharpening haloes along high-contrast edges.

Rather than try to address all the factors that influence sharpening in a single edit, the sharpening workflow splits sharpening into three stages:

1. Capture Sharpening is applied early in the image-editing process, and aims simply to restore any sharpness that was lost in the capture process. Capture sharpening compensates for the image source and image type, without having to worry about output issues.

2. Creative Sharpening is usually applied locally to accentuate specific features in an image—for example, we often give eyes a little extra sharpness in headshots. Creative sharpening applies directly to the image at hand without having to worry about image sources since they've already been addressed by the capture sharpener.

3. Output Sharpening is applied to files that have already had capture and creative sharpening applied, after they've been sized to final output resolution, and is tailored to a specific type of output process. Output sharpening can then concentrate solely on the needs of the output process since the image has already been sharpened adequately in the two previous phases.

At the very least, a workflow approach to sharpening gives us all a much better conceptual framework in which to cast sharpening issues than simply trying to find a one-size-fits-all approach. But the real payoff is that sharpening becomes a creative tool: the capture sharpen addresses the defects of the capture, the output sharpen addresses the defects of the output. In the middle, there's lots of room to play.

The Other Sharpening Filters

- **Sharpen.** For small images such as those for the Web or email, Seán will often use the regular Sharpen filter instead of Unsharp Mask, because it's faster and, for those small images, it often does a really good job. There are no options for the Sharpen filter; it just applies a sharpening pass.

- **Sharpen More.** This filter does exactly what it advertises, applying a stronger dose of the Sharpen filter; however, you have no control. We rarely use this filter, since we prefer to make our own decisions on the appropriate amount of sharpening.

- **Sharpen Edges.** This filter is also aptly named, as it finds areas where significant color or contrast changes occur and sharpens only those areas while preserving the overall smoothness of the image. There is no control that lets you determine the specifics of the edges that are targeted.

> **TIP:** Many routine Photoshop tasks that you perform on all images, such as sharpening, can be easily automated using the Actions palette. Visit the companion Web site for this book to learn how to program your own Actions for automating frequently used procedures.

Blurring Effects

Sharpness is one of the popular benchmarks for evaluating the quality of a photographic image, but sometimes sharpness can be a disadvantage, and for some subjects, it's possible that a photo can be too sharp. For years, photographers have sought to take the edge off of their tack-sharp lenses by using diffusion or soft-focus filters for subjects like portraits and pastel, painterly landscapes. Lenses with a very wide maximum aperture are also popular for their ability to record a very shallow depth of focus.

With Photoshop in your digital darkroom, you have plenty of options for adding a digital soft-focus effect on a separate layer that does not permanently affect the underlying quality of the image. If too much of the background is in focus, you can apply a blurring effect to certain areas after that image has been captured. The advantages to this are that you have great control over exactly how the effect is introduced into the image. The disadvantages are that it's a lot more work than simply using a fast lens with a wide aperture.

Photoshop has several ways of blurring an image, some more useful than others. The blur filters are all found in the main menu under Filter > Blur. Here's a short survey of the most interesting ways to take the edge off a sharply focused image:

Gaussian Blur

This filter is used to blur details in the image, either slightly or dramatically. You can use this to throw backgrounds out of focus or to blur something so much that it turns into an abstract image. In the Gaussian Blur dialog, there is a single slider to adjust. If you click and hold down the mouse button inside the small preview box, it will show you the image without the blur. Let go of the mouse button and it previews the blur (**Figure 11.6**).

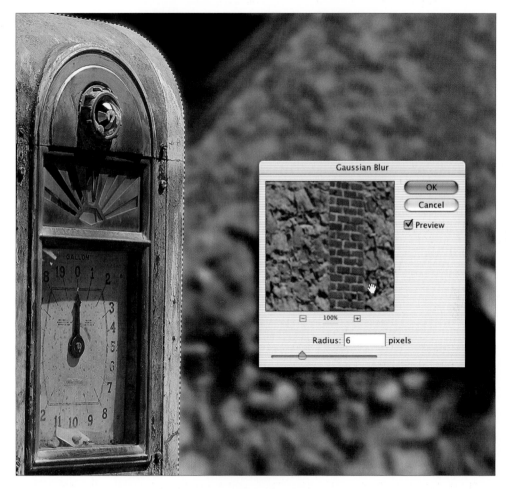

Figure 11.6 In this example, we are using a selection to only apply the blurring effect to the background. By clicking the mouse button in the small preview in the filter dialog, we can see the unblurred image.

In addition to blurring regular image pixels, Gaussian Blur is a useful tool for modifying channels and masks, and this is where we find the most use for it. Blurring a mask will soften

the edges and let you apply an effect gradually. Blurring a mask is the same thing as feathering a selection; for example, a 5-pixel blur is the same as a 5-pixel feather (**Figure 11.7**).

Figure 11.7 Mask edges frequently need to be blurred to soften the transition between what is masked and what is not masked in the image. Blurring a mask is the same as feathering a selection.

If there are only selected areas in an image that you want to blur, such as a background, then we recommend applying the filter to a duplicate layer and then controlling its visibility with a layer mask. This is an effective way to add a selective focus effect or to add the look of shallow depth of field. See "Selection-Based Layer Masks" later in this chapter for more on the basics of using layer masks (**Figure 11.8**).

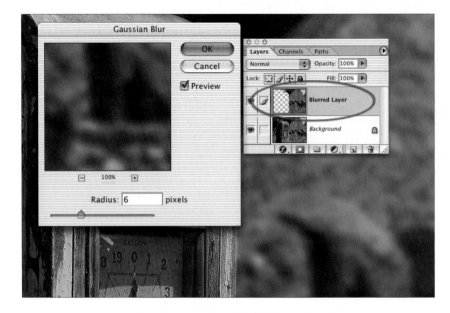

Figure 11.8 One flexible method for applying a blurring effect is to copy the pixels you need to blur and place them on a separate layer as we have done here. To do this, make a selection of the area you want to blur and then choose Layer > New > Layer via Copy.

Lens Blur

This filter is specific to Photoshop CS. It attempts to duplicate the look of an optically created blur, where the highlights take on the softened shape of the lens iris. The filter has settings for iris shape, number of blades, blade curvature, and rotation. If definitely creates a much more believable blur than Gaussian Blur, which in comparison seems to turn the image into mush.

First you need to define an outline around the object or element that you want to keep in focus. This can be accomplished by a variety of methods (see "Selection Tools" later in this chapter). Once you have a selection, save it (Select > Save Selection) so that you can use it as a depth mask in the Lens Blur dialog. To make the blurring effect flexible, we recommend loading the selection again (Select > Load Selection), inverting it (Select >Inverse) and adding a 2- or 3-pixel feather to the edges (Select > Feather). Then create a copy layer of the background by choosing Layer > New > Layer via Copy.

Make the duplicate layer active, and from the main menu choose Filter > Blur > Lens Blur. At the top of the dialog, you'll see two options for the preview rendering, Faster and More Accurate. Since Lens Blur requires a lot of processing power, we recommend that you use the Faster previews initially unless you have a powerful computer. In the Depth Map section, choose the saved alpha channel that was based on your selection. The Blur Focal Distance slider controls the depth of the areas that will remain in focus based on the tonal values in the mask, with the white areas receiving more blur and the darker areas less blur. As you move the slider to the right, less blurring will be applied (**Figure 11.9**).

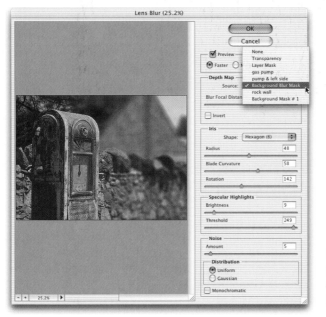

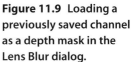

Figure 11.9 Loading a previously saved channel as a depth mask in the Lens Blur dialog.

In the Iris section of the dialog, you can control the maximum amount of the blur (Radius), as well as the shape, softness, and rotation of the blurred highlights. In images made with a camera and a lens, blurred highlights take on the shape of the lens's aperture iris. To really see how the highlights will be affected, set the Specular Highlights Threshold to just under 255 and adjust the brightness until it looks good. The Specular Highlights setting determines how bright a highlight must be before it is affected by the Iris settings (**Figure 11.10**).

Once you've established a blurring effect that you like, try placing your mouse cursor in the preview area and clicking at different points in the image from foreground to background. The location and distance of the blur will change based on where you click. This is another technique for fine-tuning the appearance of the blur (**Figure 11.11**).

Figure 11.10 Lens Blur: choosing a lens iris shape.

Figure 11.11 The Lens Blur filter, before and after.

The other blur filters

Additional blur filters are the succinctly named Blur and Blur More. Like their counterparts in the sharpening department, neither of these gives you any control. Blur can be useful with selections for smoothing transitions by averaging pixels next to hard edges and defined lines. Blur More applies the same effect, but with the strength increased.

Motion Blur creates a blur along a straight line, the angle of which you can determine. Radial Blur creates a blur that radiates in a circle, with the center being more in focus and the sharpness decreasing as the circle goes outward. In Zoom mode you can add the effect of zooming the lens during a slower exposure (**Figure 11.12**). Click inside the Blur Center box to choose a different center point for the blur.

A B

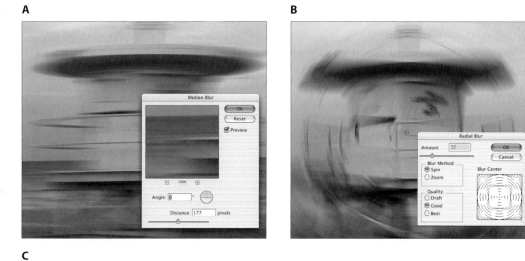

C

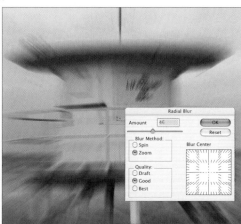

Figure 11.12 The other blur filters:
(A) Motion Blur; (B) Radial Blur, spin;
(C) Radial Blur, zoom.

IMPROVING THE LIGHT

Lighting is one of the most important aspects of any photograph. The illumination helps shape the scene and gives definition to the subject. It can render an image flat and two dimensional in low-contrast light, or it can carve out distinct depth and dimensionality with high-contrast light that lets the image pop off the page. In most cases, once you've pressed the shutter button and exposed the image, you have to live with the general quality of the light that the Fates gave you when you were making your photographs, as it determines overall structure of shadows, highlights, and dimensional depth for the elements in your image. You can't, for instance, take an image that was photographed in the low-contrast lighting of overcast skies and use Photoshop to transform it into a sun-drenched scene accented by strong, deep shadows and bright, sparkling highlights. You can, however, make substantial modifications and improvements by selectively manipulating the existing tones within your image to add depth, place emphasis on certain areas, and suggest an emotional interpretation. It is through this manipulation of the light and dark areas in the image that you can improve or alter the quality of the light in the image.

The Importance of Luminosity

If you take an image and break it down into its most fundamental components, you are left with the brightness values of the pixels, also known as *luminosity,* and the color values. In a black and white photograph, of course, you only have luminosity, the varying tonality of the gray values, to describe the image. Of these two components that make up your images, luminosity is by far the most important. If you remove all of the color from an image, you still have the brightness values, the mosaic of light and dark and middle-toned pixels that give form to the image. We see this image as black and white, but all of the intricate detail is still present, and with the exception of the color, the image looks the same. But if you could somehow remove the brightness from an image, leaving only the color values, then it would look much different, and in many cases, it would be difficult to even tell what was pictured in the photo.

In **Figure 11.13**, we've illustrated this concept by placing an image layer of a leaf in the rain over a background filled with 50 percent gray. In one version we set the blending mode for the leaf layer to Luminosity. This takes the brightness values from the leaf layer and the color values from the underlying layer. Since there are no color values in the background, only the brightness, or luminosity values from the leaf are seen and it is still an easily recognizable image of a leaf covered with summer raindrops. In a different version, we set the blending mode of the leaf layer to Color. This mode tells Photoshop to take the color values from the leaf layer, but use the brightness values from the underlying layer.

Since the background layer is a single uniform brightness of 50 percent gray, all of the delicate details that shaped the image of the leaf disappear, leaving only somewhat indistinct color values that are hard to interpret, especially if you've never seen the image before.

A **B** **C**

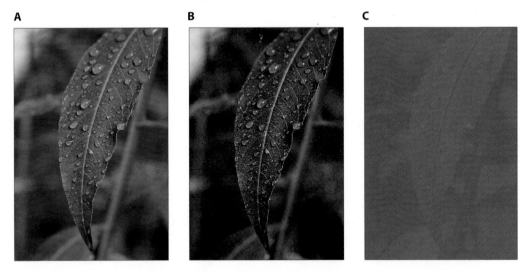

Figure 11.13 **The luminosity, or brightness values in a photo, gives it form and makes it look like what it is. When all of the color is removed from the original color photo (A), the result is a black and white image, still clearly recognizable as a leaf in the rain (B). But when the brightness values are removed and replaced with a uniform 50% gray luminosity, it's hard to tell what the image is (C).**

Guiding the viewer's eye and establishing a mood

When you look at a photograph, you initially take a quick overview "snapshot" to establish the basic scene in your mind, but then your eyes enter the image and move around within it, pausing to view and enjoy the key areas and details. Part of good composition, whether in painting or in photography, revolves around the concept of establishing a flow, or a path for the viewer's eye to enter and then move through the image. Apart from composition, which is mainly established in the camera viewfinder, you can also draw the viewer's eye to the essential areas of the image by using brightness and shadow to light a path for their eyes to follow.

In the editing stage of working on your photograph, the term *light* refers not to sources of illumination within the image, but the luminosity of specific areas of the tonal range. To draw the attention of the viewer, it is common to brighten areas of the image that you want to place emphasis on and darken other areas that are less important. This has been a common practice in traditional photo darkrooms for many years. In portrait photography, for instance, the outer edges of the print are darkened, or burned-in, which causes the center portion to be lighter and more noticeable to the viewer. The brighter center area draws the viewer in and helps to focus their attention on a specific area (**Figure 11.14**).

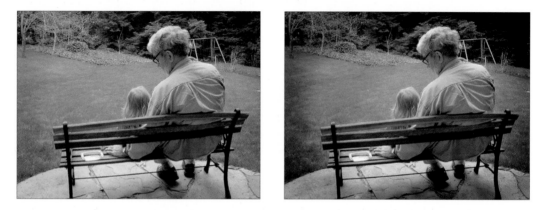

Figure 11.14 By darkening the corners and edges of an image, you can focus attention on the main subject. This technique has been around almost as long as photography.

The brightness of an image, and how it is controlled across different areas, can also affect the mood of the piece and how the viewer interprets it. Art is subjective; it's a dialogue between the artist who creates the work and the viewer who brings their own experiences, opinions, beliefs, and emotional history to the act of viewing it. While it is impossible to instill a specific emotion or feeling in an image that will be felt by everyone who sees it, you can use light and tonal variation within the image to suggest an overall mood.

Dodging and Burning

In a traditional photographic darkroom, *dodging* and *burning* refer to lightening and darkening specific areas of a print. To "burn" an area of the print, means to give it additional exposure to the enlarging light, while to "dodge" means to block light from the photo paper. In a traditional darkroom, working on a print often involves using pieces of wire with small cardboard circles taped to the end for dodging, pieces of cardboard with holes cut in them for burning, and carefully rehearsed hand gestures for wielding those tools. You won't know how successful your efforts are until the image is developed a few minutes after exposure, and since the elaborate hand maneuvers have to be done for each print, the results for complicated manipulations are difficult to repeat with consistency from print to print. Fortunately, dodging and burning in Photoshop is much easier, you can see the results immediately, and it's very repeatable.

The Dodge and Burn tools

Photoshop does have two tools that are designed specifically for lightening and darkening specific areas of a photo, but they're not our preferred method for making tonal modifications. Reflecting their traditional darkroom origins, these tools are called the Dodge tool and the Burn tool, and they can be found in the Tool palette midway down on the right side (**Figure 11.15**). Their icons are also derived from the darkroom, with the Dodge tool represented as a wire dodging tool, and the Burn tool showing a hand cupped into a circle to let more light onto the image. They both use a brush-type interface, and settings in the Options bar let you adjust the exposure (similar to opacity in other painting tools) and decide whether to target shadows, midtones, or highlights. The darkening or lightening effect can build up pretty fast, so starting out at a relatively low opacity, such as 20 percent and gradually building up the effect is better than starting out with the default setting of 50 percent (**Figure 11.16**).

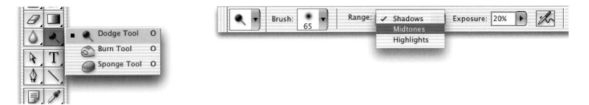

Figure 11.15 The Dodge and Burn tools and their options.

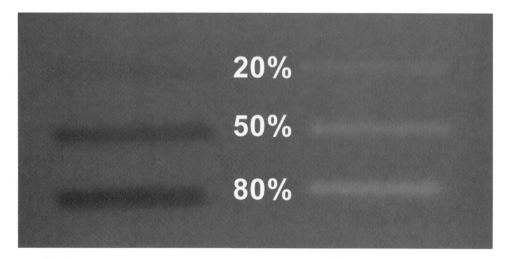

Figure 11.16 The Burn (left) and Dodge (right) tools at 20%, 50%, and 80% exposure settings.

Although these tools do exactly what they say, we don't recommend using them because they are designed to apply their effect directly to image pixels. Any change that is made directly to the pixels can't be easily undone and should be approached with caution. If you darkened an area, for example, and then decided two days later that it was too dark, you would have to go back over that area with the Dodge tool in order to lighten it up a bit. As we discussed in Chapter 10, "Essential Image Enhancement," repeated tonal changes made directly to the pixels can lead to severe tonal erosion and compromise the quality of those areas if you need to return to them and make additional changes. We prefer to apply such tonal changes by using adjustment layers. The results are identical, and we have the additional options of using layer opacity, blending modes, and layer masks to refine our modifications.

Dodging and burning with adjustment layers

As we saw in the previous chapter, an adjustment layer is simply a set of instructions for applying a tonal or color change to the pixels beneath it. When you create an adjustment layer, by default it applies the change to the entire image. To use an adjustment layer for dodging and burning, you have to take advantage of layer masks, which allow you to control where in the image the adjustment shows up.

Fortunately, with adjustment layers you don't have to do anything special to create a mask since they already come with one. The small white rectangle next to the main thumbnail for the adjustment layer is its layer mask. White areas in a mask mean that any change made in the adjustment layer will be applied throughout the entire image. Black areas

indicate areas where the change will not show up. Since the layer mask is white by default, it means that the adjustment will affect the entire image. To use it for dodging and burning, you first have to invert the white areas to black (Command-I for Mac/Ctrl-I for Windows), and then use the Paintbrush tool to paint with white in the areas where you want the adjustment to be visible. Here's a quick rundown of the essential steps, using a dodging adjustment as an example:

1. Add a Levels or Curves adjustment layer. Lighten the image by either moving the Midtone Levels slider to the left, or by dragging the curve upward. Don't worry that the change affects the whole image. We'll fix that in the next step. You also don't have to be too precise in how much you lighten the image since the final dodging effect can be applied gradually. Click OK when you're satisfied with the adjustment (**Figure 11.17**).

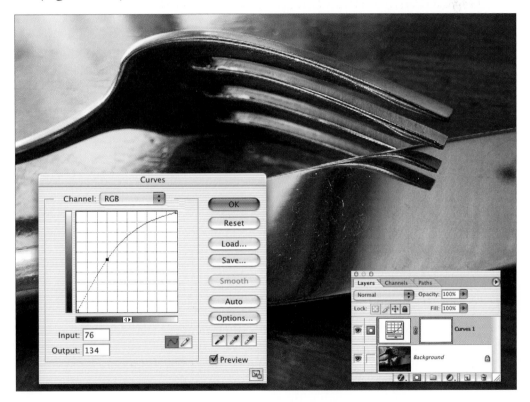

Figure 11.17 A Curves adjustment layer has been added, which lightens the image. Since the layer mask for the adjustment layer is white by default, the lightening is visible throughout the entire image.

2. Invert the white layer mask to black by using the Command-I/Ctrl-I shortcut (or
 select Image > Adjustments > Invert). When you do this, the lightening effect will
 be hidden (**Figure 11.18**).

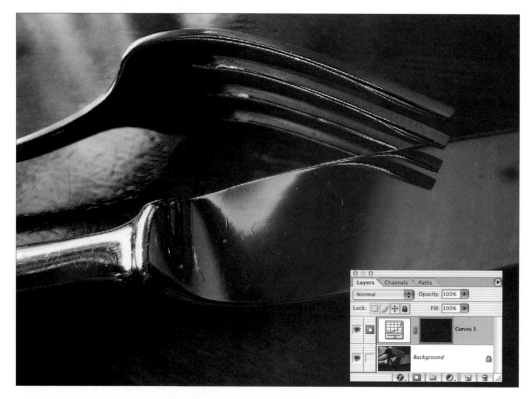

Figure 11.18 When the layer mask is inverted to black (Command-I, Control-I), the lightening
adjustment from the Curves layer is hidden.

3. Select the Paintbrush tool, and from the Brush Picker in the Options bar, choose a
 brush size that is large enough to cover the area you wish to dodge (lighten). The
 numerical brush sizes refer to the diameter of the brush tip in pixels, so the correct
 size will vary depending on the size of your image. You should also choose a soft-
 rather than a hard-edged brush as this will help blend the edges of your brush strokes
 more convincingly (**Figure 11.19**). Press D on the keyboard to get the default mask
 colors, which makes white the foreground color (when an image layer is active the
 default colors are reversed and black is in the foreground).

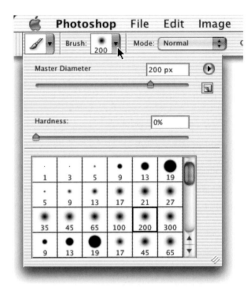

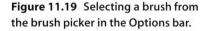

Figure 11.19 Selecting a brush from the brush picker in the Options bar.

Before you start dodging with the brush, there are two more settings to double-check. In the Options bar for the Paintbrush tool, set the Blend mode to normal and the Opacity to 50 percent. This means that you'll be painting with a 50 percent gray, which, in the case of a mask, means that 50 percent of your adjustment will be visible in the photo.

4. In the image window, begin painting over the areas where you want the lightening effect to be visible. As you add gray areas to the mask in the form of brush strokes, the adjustment will show up in those areas of the photo. If you think that the adjustment makes the image look too light, you can set the opacity of the brush to a lower setting. If you need to increase the effect, paint over an area a second time to build up the amount of white that is applied to the mask (**Figure 11.20**).

Figure 11.20 The adjustment layer dodging effect, before (left) and after (right).

To undo the dodging effect, simply press X on the keyboard to exchange the foreground and background colors so that black is in the foreground swatch and paint over the areas where you want to tone down the lightening adjustment. Using this method of painting on a layer mask using white, black, or some level of gray, any dodging or burning adjustment can be edited and refined with great precision—and it's not permanent.

The same steps apply for adding a burn adjustment layer except that your Levels or Curves modifications would darken instead of lighten the image.

> **TIP:** To see what the mask actually looks like, Option-click (Mac) or Alt-click (Windows) on the thumbnail of the layer mask in the Layers palette. Repeat to return to the regular image view (**Figure 11.21**).

Figure 11.21 Option-click or Alt-click on the layer mask thumbnail in the Layers palette to see the mask in the main document window. Black areas do not show the lightening, white areas show it at 100%, and gray areas partially show it. Option-click or Alt-click on the layer mask thumbnail again to return to the regular image view.

Burning in the corners of an image

This is a simple, yet effective adjustment that focuses the viewer's attention on the central part of the image by bringing down the tone of the corners and edges. As in the previous example, this can be applied with an adjustment layer, inverting the mask to black, and painting with white or gray (via a lower brush opacity) to control where you want to darken the edges.

1. Apply an adjustment layer that darkens the image overall. Since the opacity of the Paintbrush can be varied and the effect can be easily taken away or minimized, it's fine to go a little darker than you need. Click OK.

2. Invert the mask (Command-I/Ctrl-I), make sure white is the foreground color, and choose a large, soft-edged brush. To keep the effect subtle, it helps if the brush can cover a good portion of the image's corner with one stroke; on an 18-MB 6-megapixel file, for example, a brush size of 600 to 800 pixels works pretty well (**Figure 11.22**). You won't see a brush thumbnail that large in the Brush Picker, so you can choose the largest one you see and use the Master Diameter slider to increase the size.

Figure 11.22 For a large brush to burn in the corners of a 6-megapixel image, a size of 600 to 800 pixels usually works quite well. You can use the Master Diameter slider to create a custom size for your brush, as shown in this example. Make sure that the Hardness slider is set to 0% to ensure a soft, feathered edge.

3. Set the brush opacity to 20 percent to start with, and begin to slowly brush over the corners of the image to bring down the tone in those areas. For a subtle approach, keep your brush strokes in the corners of the photo. If you want a more pronounced effect, come as far into the image as you feel is necessary. You can feather the brush strokes by applying more on the outer edges and progressively less as you move in toward the center (**Figure 11.23**).

A

B
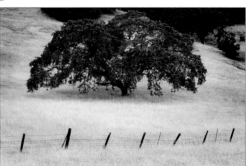

C

Figure 11.23 The oak tree image before the corners are burned in with an adjustment layer (A); after painting on the layer mask with a large, soft-edged brush (B); the view of the layer mask (C).

Dodge and burn with an overlay layer

Another way to apply dodging and burning takes advantage of the neutral color of one of the layer blend modes. In a blend mode, a neutral color is ignored by the blend mode as if it doesn't exist.

1. In the Layers palette, Option-click/Alt-click the new layer icon at the bottom of the palette (not the adjustment layer icon, but the regular layer icon that looks like a dog-eared page on a notepad). Holding down Option or Alt as you do this brings up the New Layer dialog.

2. Open the Mode pop-up menu and choose Overlay. A new option appears at the bottom of the dialog: Fill with Overlay-neutral color (50 percent gray). Turn on this check box and click OK (**Figure 11.24**). A new layer is added to your layer stack filled with 50 percent gray and set to Overlay. Since 50 percent gray is an Overlay-neutral color, however, it means that it does not show up in the image (**Figure 11.25**).

Figure 11.24 In the New Layer dialog box, set the blend mode to Overlay and then click the Fill with Overlay-neutral color (50% gray) check box.

Figure 11.25 The Overlay blend mode does not "see" 50% gray, so even though the layer is clearly filled with gray, it does not appear in the image.

3. To apply dodging and burning, all we need to do is darken or lighten the gray tones, and any deviation from 50 percent gray will show up in the image. With the Paintbrush tool, choose an appropriate brush size and set the foreground color to white if you want to lighten, and to black if you want to darken. In the Options bar, set the opacity to a lower number like 15 percent or 20 percent, and begin painting in the image on the areas you wish to dodge or burn. As the gray tone becomes lighter, that area in the image will get lighter and as the gray tone gets darker, the image gets darker (**Figure 11.26**). Just as with the adjustment layer approach, if you go too far, simply press X on the keyboard to exchange the colors and paint back over the area in question to scale back the effect.

A

B

C

Figure 11.26 The oak tree image before burning and dodging on the 50% gray Overlay layer (A); after painting on the Overlay layer with black, white, and gray (B); a view of the modified 50% gray layer (C).

The one advantage to performing dodging and burning with this method is that both adjustments can be handled on the same layer. The primary disadvantages are that the level of lightening or darkening can't be controlled with the same flexibility as with an adjustment layer, and since it's an actual image layer, this method will make your file size larger than an adjustment layer will.

Selection-Based Layer Masks

Local adjustments to tone and color can also originate from a selection. Although you could simply make a selection and then apply a change, we believe that any such changes should be made as an adjustment layer. Fortunately, Photoshop will take any active selection and turn it into a layer mask for you when you add an adjustment layer. It makes the logical assumption that you want to apply the adjustment to the area that you have selected, so your mask is ready to go the minute you add the adjustment layer.

Selection tools

Making selections can take on many forms and use different approaches. Indeed, the options, tools, and techniques are so wide-ranging that this topic could be the subject of an entire book in itself (**Figure 11.27**). For this section we'll concentrate on making general selections for areas in your images that you need to modify. We will not be going into great depth on making super-accurate masks, although a few of the tools and techniques do a surprisingly good job of making precise selections of specific areas in the image that can be identified through color or tonal values. We'll also cover the all-important step of *feathering,* or softening, the edges of the selection so that any adjustment will fade off gradually.

Figure 11.27 The Marquee and Lasso selection tools.

- **Rectangular and Elliptical Marquee.** These tools are helpful for making very general selections that will be heavily feathered to disguise their edges. The Elliptical Marquee is useful for creating a selection that can be used to burn in the edges of an image.

- **Lasso.** This tool is useful for making very general selections that will be used to apply adjustments with soft, feathered edges, such as the earlier example of burning in the edges of a photo. Although the Options bar for this tool does have a feather setting, we prefer to feather the selection or the eventual mask using other means, which we'll get to shortly (see the section "Feathering a Selection with Quick Mask and Gaussian Blur" later in this chapter).

- **Polygonal Lasso.** With this tool, you click to set a corner point, drag a straight line segment, click again to set a corner point, drag a line, click again, and so on. Since this tool creates polygons, it's ideal for quickly selecting objects that have straight sides, such as boxes, buildings, stop signs, and so forth. As with the regular Lasso, and most of the selection tools, we think of this as a valuable tool for making "starter selections." Starter selections get you going, but they almost always require further modification before they're ready to be used for image adjustments.

- **Magnetic Lasso.** The Magnetic Lasso makes selections based on the amount of contrast it finds in an edge between light or dark areas, or adjacent areas of different colors. Since it uses contrast and color to help define an edge, this tool is useful when you need to make reasonably accurate selections of objects that have clear differences from the rest of the image. In the Options bar (**Figure 11.28**), Width controls how large an area it samples as you move your cursor along an edge; Contrast determines how sensitive the tool is at seeing tonal variation along an edge, and Frequency controls how often the tool will place an anchor point down to help it snap to an edge. Click once along an edge of an area you wish to isolate, and slowly trace around it. You have to completely enclose the object with the lasso and come back to the point where you started to close the selection. Double-clicking at any point in the selection process will close the selection by drawing a straight line from the current location back to where you started the selection.

Figure 11.28 The Options bar for the Magnetic Lasso.

This tool can do a wonderful job at making complex selections of objects that have well-defined edges, with no ambiguity in terms of what is and isn't an edge. It can be frustrating to use, however, until you become familiar with its eccentricities. Most of the time it becomes confused by another contrast edge that's close to the one you're selecting and wants to snap over to the other edge. If you encounter this behavior, you can click to manually insert anchor points at close intervals until you've moved past the area that's confusing the tool. As with all of the lasso tools, selections made with the Magnetic Lasso should be thought of as starter selections.

- **Magic Wand.** Like the Magnetic Lasso, this also creates selections based on tonal and color values, and it works best on areas where there is a clear difference between what you want to select and what you don't want to select. The Tolerance setting in the Options bar controls how sensitive the tool is, and Contiguous will limit the selection to pixels that are connected to the initial sample point (**Figure 11.29**). When Use All Layers is selected, it makes the selection based on the composite data from all visible layers. The Anti-Aliased option should always be turned on to add a slight smoothing to the edges of the selection. Click once inside the area you wish to select, and the tool will build a selection based on the tonal values where you clicked.

Figure 11.29 The Options bar for the Magic Wand.

Select Color Range

This is not a selection tool in the Tool palette, but a command found under the Select menu. It is one of the best methods for selecting areas in an image. Like the Magic Wand, it creates a selection based on color or tonal values in the image. Unlike the Magic Wand, however, it gives you a preview of which areas will be selected and lets you make adjustments to the proposed selection before it is created. Here's how it works:

1. From the main menu, choose Select > Color Range. With the pop-up menu at the top of the dialog set to Sampled Colors, you can click in an area of the image that you want to select. A preview window shows you the image as a mask, with white representing areas that will be selected and black showing the areas that will not be selected (**Figure 11.30**).

2. The Fuzziness slider tells Photoshop to increase or decrease the percentage of color or tone used to make the selection on a pixel-by-pixel basis. Fuzziness is often confused with Tolerance, but the two concepts and results are not the same. The Magic Wand tool is "an either/or selection tool" meaning an area is either selected or it isn't. The Color Range allows you to choose a percentage of a color or tone based on the Fuzziness setting. When you are first starting out with Color Range it's easier and more accurate to leave the Fuzziness set to the default value of 40 and Shift-click with

the eyedropper in the image to add areas to the selection mask (**Figure 11.31**). If you add too much to the selected areas, Opt-click or Alt-click to remove them. Selecting colors using this method allows you to partially select very subtle transitions between colors that is not possible with the Marquee and Lasso tools, and much harder to predict with the Magic Wand.

Figure 11.30 The selection preview (the black and white mask) in the Select > Color Range dialog shows only a partial selection of the yellow wagon wheel after clicking once with the eyedropper on one of the spokes.

Figure 11.31 After Shift-clicking on different areas of the wagon wheel and watching the selection/mask preview update, a better selection mask is created.

3. Another method that works quite well if there is a specific region of the tonal range that you need to adjust is to open the pop-up menu at the top and choose from Highlights, Midtones, or Shadows (**Figure 11.32**). This is very effective if, for example, you just need to lighten up the shadows a bit, or tone down a bright highlight, and you do not want the tonal adjustment affecting other parts of the image. When you click OK, the selection is created (**Figure 11.33**).

Figure 11.32 You can easily create a selection of an image's highlights, midtones, or shadows in the Color Range dialog.

Figure 11.33 The wagon wheel selection was generated from the Color Range dialog by selecting Highlights from the pop-up menu.

Feathering Selections

All selections used for color or tonal adjustments need to be feathered to create a softer transition between selected and unselected image areas (**Figure 11.34**). Sometimes this feathered transition area needs to be large, while other times just a slight softening will do the trick. There are various ways of adding a feather to a selection, either before you make it or after it has been created. The feather setting in the Options bar for the Marquee and Lasso tools applies to any new selection that you make with those tools. Once you have a selection active, you can go to Select > Feather and enter a value. The problem with both of these methods is that they do not give you a preview so you can see how much feathering will actually be applied to the selection. Fortunately, there are workarounds for this.

Figure 11.34 Two selection mask edges showing an unfeathered edge (left) and a feathered edge.

There are two ways to handle feathering a selection that let you see how much the feather will affect the selection. Both involve using the Gaussian Blur filter, but they apply it at different points in the process. The end result is exactly the same.

Feathering a selection with Quick Mask and Gaussian Blur

1. With a selection active in your image, press the Quick Mask button (**Figure 11.35**) or simply press Q on the keyboard to enter Quick Mask mode. This shows you a temporary mask based on your selection. The semitransparent red areas represent the black, or unselected, areas in the mask. The clear area shows the part that is selected.

Figure 11.35 Quick Mask turns a selection into a temporary mask that you can edit with the Gaussian Blur filter to create a feathered edge you can see.

2. From the main menu, choose Filter > Blur > Gaussian Blur. Move your mouse into the image and you'll see that it's now a small square. Click on an edge that you want to observe as you adjust the blur amount. By clicking, you prompt Photoshop to jump the preview to where you clicked. Enter a value, and you can see how the blur will

affect the edges of the selection mask (**Figure 11.36**). The preview in the filter dialog shows the grayscale version of the mask, while the main preview shows that mask as a red overlay on your image. In either preview, you get a much better sense of how much of a feather will actually be created by the settings you choose. The important thing to note here is that a blur setting will have the same effect as the equivalent feather setting. So choosing a Gaussian Blur value of 20 in the filter dialog will create a blurred edge that will be identical to feathering a selection by 20 pixels. The crucial difference is that here, you can *see* the difference. Blur to taste, and click OK.

Figure 11.36 With the selection temporarily in Quick Mask mode, a Gaussian Blur filter is applied to slightly soften the edges of the selection/mask. On the left is the unblurred preview, and on the right is the preview showing the softening effect of a 3-pixel blur on the Quick Mask.

3. Press Q on the keyboard, or use the Standard Selection mode button in the toolbar, to exit Quick Mask and return to the selection view of the image.

4. With the selection edges now feathered, you can add an adjustment layer and the selection will automatically be turned into a layer mask that will control which areas of the image are affected by the adjustment (**Figure 11.37**).

Figure 11.37 The Quick Mask was returned to Selection Mode and then an adjustment layer was added, which turned the selection into a layer mask. With this Curves adjustment, we are darkening the yellow highlights. The softened edges of the mask mean there will be a gradual transition between areas that are lightened and the rest of the image.

Blurring the layer mask

You can also accomplish the same feathering technique as in the previous example by making a selection and adding an adjustment layer. The selection will be turned into a mask, but the edges will be much too hard. With the adjustment layer active, choose Filter > Blur > Gaussian Blur and blur the edges until the blending between the adjusted area and unchanged areas in the image is smooth and undetectable. We'll cover this technique in the next example.

Burning the edges with a selection-based layer mask

Earlier we showed you how to use the Paintbrush tool to burn in the corners or edges of a photo. The same effect can be achieved using an elliptical selection.

1. Select the Elliptical Marquee tool from the toolbar. Click down in the approximate center of the image and begin to drag outward. Hold down the Option or Alt key to drag the selection from the center out. Enlarge the selection until you have most of the center part of the photo selected, with only the corners and edges left unselected. Release the mouse button.

2. Invert the selection by pressing Command-Shift-I/Ctrl-Shift-I (or choose Select > Inverse). Now just the corners and edges are selected, and the center is not selected (**Figure 11.38**).

3. Add a Levels or Curves adjustment layer. Darken the edges by dragging down on the curve or by moving the middle slider to the right. Don't be concerned about the hard edge of the layer mask; we'll fix that in the next step. You can also darken it more than you might need, since you can use the opacity slider in the Layers palette to fine-tune the effect. Click OK (**Figure 11.39**).

Figure 11.38 The elliptical selection after using the Select > Inverse command.

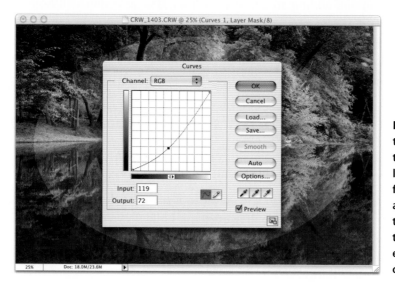

Figure 11.39 Since the initial selection that created the layer mask was not feathered, there is a hard and abrupt transition between the darkening effect and the rest of the image.

4. From the main menu, choose Filter > Blur > Gaussian Blur. Move your cursor into the image and click on an edge of the mask to show that area in the filter preview. Increase the amount of blur until the mask edges can't be seen and the darkening effect begins gradually (**Figure 11.40**) (**Figure 11.41**).

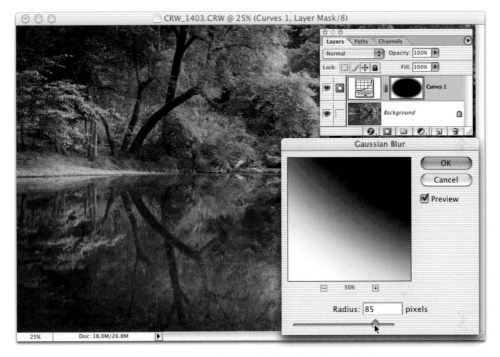

Figure 11.40 Using Gaussian Blur to soften the edge of the layer mask.

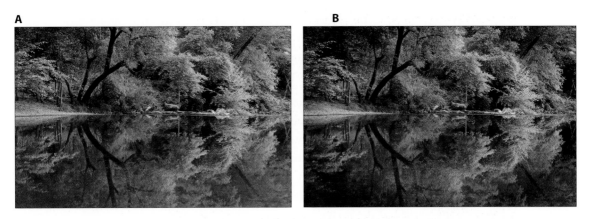

Figure 11.41 The final feathered mask that burns in the corners, before (A) and after (B).

Using Levels and Curves to modify a mask edge

Since a layer mask is just a grayscale document, it can be edited using any of the tools you would use on a regular grayscale file. Chief among these are the painting tools to precisely add areas of black, white, or gray in areas of the mask that need touching up. But you can also use Levels, Curves, or any of the standard tonal correction tools that you might use on a regular photograph.

Since Levels and Curves both remap tonal values in an image, they can be used to apply subtle edits to the edges of mask that can help the mask conform more closely to the object in the image. This works especially well if you have already feathered the edge of the mask. Since feathering introduces a blur, which is nothing more than a transitional border of gray pixels between the black and the white pixels, these gray pixels can be easily changed by applying Levels or Curves directly to the layer mask:

1. Start with an adjustment layer that has a layer mask. If you have not already blurred the edges of the mask, do so using the Gaussian Blur filter as described previously. So you can see what this effect is doing, Option-click/Alt-click on the thumbnail of the mask so you can view just the mask. Zoom in closer (Command-spacebar-click/Ctrl-spacebar-click) so you can clearly see the edges of the mask.

2. With the adjustment layer active in the Layers palette, bring up Levels (Command-L/Ctrl-L). Move the middle slider to the left to add more white into the gray pixels (in Curves you would raise the curve up). This has the effect of spreading the mask away from the image element it's masking. Since more white is being added to the mask, your tonal adjustment will now also show through these white areas.

3. By moving the middle Levels slider to the right, the gray values along the edge will be darkened, which has the effect of contracting the mask inward, tighter around the image element (in Curves you would lower the curve). In prepress trapping terms, this is know as a *choke,* whereas adding white to the gray areas is known as a *spread* (**Figure 11.42**).

4. The ideal way to apply these modifications is to be viewing the actual image at the same time. We only suggested viewing the mask so you could see how the gray values of the edge were being manipulated. Click Cancel in Levels and Option-click/Alt-click on the mask thumbnail to turn off the mask view. Try modifying the layer mask with Levels or Curves while viewing the image, and you'll see how the edges of the mask can be expanded and contracted with great control to create a better fit between the mask and the image.

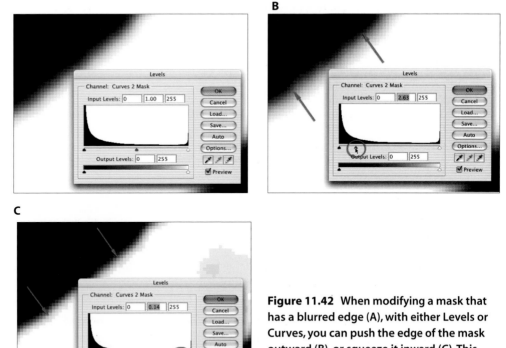

Figure 11.42 When modifying a mask that has a blurred edge (A), with either Levels or Curves, you can push the edge of the mask outward (B), or squeeze it inward (C). This provides great flexibility for fitting the edges of a mask precisely against the image element that it is masking.

Using a gradient mask

Photoshop's Gradient tool comes with an impressive collection of bright and colorful gradients. Although we do use the Gradient tool quite a bit, we pass by those colorful candy shop gradients most of the time in favor of the simple black to white and foreground to transparent gradients. The straightforward black to white gradient is ideal for creating a smooth gradient transition on an image or on layer or channel masks. This provides subtle changes from one area to another, and when used on skies, for example, it's the Photoshop equivalent of a graduated neutral density filter that you would use on your camera to balance the exposure between the sky and terra firma.

Although gradient masks can be very powerful tools for adjusting image tonality, they're not as difficult to create as you might think. To try this out, open up an image that has a sky that is too light, or a foreground that is too dark.

Our second most loved gradient is the foreground to transparent gradient, which allows us to add density or color to an image but with the advantage of going from opaque to clear.

We use this all the time in conjunction with layer masks, as the transparency allows us to add multiple gradients to a single layer mask. In **Figure 11.43** you see the original photograph taken with a Fuji S2 by John McIntosh, and in **Figure 11.44** you see the final modified image.

Figure 11.43 The original image.

Figure 11.44 The final image after the addition of a gradient mask to darken the sky and lighten the center.

To interpret the image, John took advantage of Photoshop's image adjustment layers, blending modes, and layer masks with the Gradient tool:

1. To darken an image, or in traditional darkroom parlance *to burn the image down,* add a Levels or Curves image adjustment layer and simply click OK without changing a thing. Seán refers to these as "empty" adjustment layers because no adjustments have been made with the controls in the dialog. Please note that either Levels or Curves will yield the exact same results with this technique.

2. As you can see in **Figure 11.45** absolutely nothing has changed in the image.

Figure 11.45 After adding a Levels adjustment layer without making any changes in the Levels dialog.

3. Now change the blending mode of the image adjustment layer to Multiply, and the image will darken down by almost 3 stops (a 38 percent multiply equals one *f*-stop in exposure) as seen in **Figure 11.46**.

Figure 11.46 By changing the blend mode of the "empty" Levels adjustment layer to Multiply, the image becomes much darker.

4. Take a look at the Layers palette; do you notice that the layer mask is white? That means that the full effect of the multiply darkening is taking place. To control the effect of where the darkening takes place, you need to start with a black layer mask, which will block the darkening effect from taking place. Use Image > Adjustments > Invert to flip the mask values from white to black as seen in **Figure 11.47**, which turns off the entire effect.

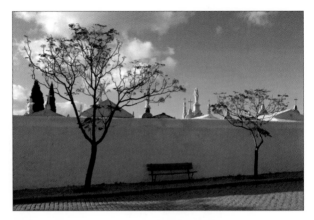

Figure 11.47 Inverting the Levels layer mask to temporarily hide the darkening effect.

5. Now the magic begins. Set the foreground color to white, activate the Gradient tool, and select the second gradient from the Gradient palette, which is white to transparent as seen in **Figure 11.48**. In the Options bar, double-check that the first gradient icon (Linear) is selected.

Figure 11.48 Select the Gradient tool and choose the second gradient swatch (foreground to transparent) from the gradient picker in the Options bar.

6. Working in full-screen mode start the gradient well outside of the image and drag from the upper-right corner toward the center of the image. Repeat on all four corners as shown in **Figure 11.49**. The beauty of working with a white to transparent gradient is that you can repeat gradients and work the individual corners without overwriting previous gradients.

Figure 11.49 Dragging diagonally into the image with the Gradient tool will add white to the layer mask. Repeat as many times as necessary until the sky looks good.

7. In case the corner darkening is too heavy or noticeable, adjust the layer opacity to fine-tune the effect.

8. To lighten the wall, John started by selecting the wall with the Magic Wand and feathering the selection by 3 pixels as seen in **Figure 11.50**. He then added a Levels adjustment layer as seen in **Figure 11.51**. The mask reflects the selection, in that wherever there was an active selection the mask is white, and whatever was not active is now black.

Figure 11.50 Selecting the wall with the Magic Wand.

Figure 11.51 The Magic Wand selection is turned into a layer mask when the Levels adjustment layer is added.

9. By simply changing the image adjustment layer blending mode to Screen, the wall area is lightened by 3 *f*-stops. John adjusted the opacity of the adjustment layer to 66 percent to make the change a bit subtler (**Figure 11.52**).

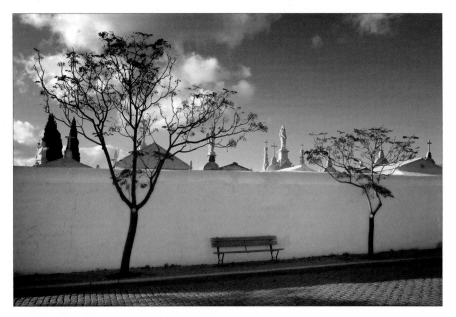

Figure 11.52 The effect of the Screen blend mode is lessened by lowering the layer's opacity to 66%.

All in all, working with gradients, adjustment layers, layer masks, and blend modes gives you a wide world of image-enhancement control that can make the ho-hum image really sing.

CONVERTING COLOR TO BLACK AND WHITE

There are several methods you can use to turn a color original into a grayscale image in Photoshop. Some give you no control over how the conversion is made, while others let you brew a custom grayscale mix that gives you exactly the black and white look you want:

- **Desaturate.** This is probably the least useful of all the conversion methods. We'll mention it here just so you'll be aware of its shortcomings. As its name implies, the command desaturates all the colors in the image. When a color is desaturated by 100 percent, the result is a neutral gray value. The problem with this approach is that it doesn't always preserve the contrast between colors that you see in an RGB image. It also doesn't treat all brightness values the same; some bright values, particularly if they are highly saturated colors, tend to be rendered much too dark (**Figure 11.53**).

Figure 11.53 Desaturate is not the best way to convert a color image to grayscale, particularly if it has brightly saturated colors. Notice how the brightness and contrast relationships between the yellow neon tubing and the rusty sign have been totally lost in this conversion.

- **Standard Grayscale Conversion.** The Image > Mode > Grayscale method creates the grayscale file by blending the grayscale versions of the color channels together into a single gray channel. In an RGB file, the mix is Red: 30 percent; Green: 59 percent; Blue: 11 percent (**Figure 11.54**). Although this method makes acceptable grayscale conversions in some cases, for images you really care about it can be a bit disappointing, and other methods will serve you better.

- **Channel Mixer.** With Channel Mixer, you can create a custom blend of the existing grayscale tonal information that is found in the red, green, and blue color channels. This method is similar to using colored filters with black and white film to change the tonal rendition of colors in a scene. Orange and red filters are often used with black and white to darken the sky. Orange and red absorb their own color but block any opposite colors such as the blue or cyan in skies, causing those areas to be underexposed and darker in the final print.

Figure 11.54 The standard Grayscale conversion method does a pretty good job on most images, but it's not the best one to use if you want total control over the process.

Using Channel Mixer

Channel Mixer gives you the most control over the conversion process by allowing you to take advantage of the color values in an image and use them to make the best grayscale conversion for a particular image. Here's how it works:

1. Open a color image. To really see the differences between the channels, it helps if the image has bright colors. Muted or pastel images will not exhibit that much difference between the channels. Take a look at the individual color channels by clicking on their names in the Channels palette (**Figure 11.55**). Each channel is a different grayscale version of the image. Lighter tones of gray indicate more of that color, and darker tones indicate less of that color. When you've finished checking out the channels, click back on the word RGB at the top of the Channels palette.

Figure 11.55 A color photo (A), and its three color channels: Red (B); Green (C); and Blue (D). In Channel Mixer you can blend your own custom mixture of the different grayscale tonalities found in the color channels.

2. Add a Channel Mixer adjustment layer. In the Channel Mixer dialog box, click the Monochrome check box in the lower-left corner. This will give you a version of the image that is made up of 100 percent of the red channel (**Figure 11.56**). Now you can change the mixtures of each channel until you arrive at something you like. Until you get used to it, Channel Mixer may seem a bit perplexing. One guideline to follow, however, is that your totals for each channel should ideally add up to 100 percent. Mixtures that total more than 100 percent could lead to blown-out highlights, and blocked-up shadows are a risk with totals well below 100 percent.

Figure 11.56 The Channel Mixer dialog.

As you are adjusting the sliders in the Channel Mixer dialog, use the eyedropper (automatically selected for you once you enter a color correction dialog) and the Info palette to check that highlight or shadow areas are not being clipped by your adjustments—meaning your highlights should not be higher than 248, 248, 248 and the shadows not lower than 10, 10, 10. You could also place Color Sampler points at these important areas before you apply the channel mixer so that their information readouts are always visible in the Info palette.

The Constant slider lightens or darkens the image based on percentage. This is a linear adjustment, however, which means that all areas of the tonal range receive the same brightening or darkening amount. Since the tonal range contains 256 levels, an adjustment of 10 percent will raise or lower every tonal level by 25 levels throughout the entire image. In most cases, this is not very useful; in fact, it can be destructive, and we always leave it set to 0.

In the example shown in **Figure 11.57**, the red is at 50 percent and the green is at 60 percent, which adds up to 110 percent. To compensate for that greater-than-100-percent total, the blue has been set to –10 percent, which adjusts the total to 100 percent. The reason for minimizing the blue influence is that the only blue tones in the image are the sky and the slight blue cast on the sheet metal of the sign where the paint has peeled away. Since we want the sky to be very dark, we don't need much of the blue channel in the final mixture.

Figure 11.57 The final Channel Mixer settings. The custom grayscale conversion retains the dark sky from the red channel, but the tones in the sign are more even. Since this is applied through an adjustment layer, we can return to these settings to try out different variations.

NOTE: *When you use the Channel Mixer to create a custom grayscale conversion, even though it looks like a black and white photo, your file is in RGB mode. We recommend leaving the master working version of the image in RGB mode so that you can explore toning options, which we'll cover in a bit.*

Gradient Map

Another way to convert an RGB image to grayscale tones is to use the Gradient Map feature. This maps the brightness tones in the image to the corresponding location on a gradient. For a color to black-and-white conversion, the best choice is a standard black to white gradient, although you can use other subtle colors if you want to explore a tinted effect.

Open an RGB image and add a Gradient Map adjustment layer. In the Gradient Map dialog, click on the small triangle on the right end of the gradient preview bar to open the Gradient Picker. Click the third gradient swatch from the left. This is always a black to white gradient and is not dependent on having the correct foreground and background colors selected in the Tool palette. As you view the gradient in the preview bar, black should be on the left and white on the right, just like in the Levels histogram. If it's not,

then you'll be seeing a negative version of the image. If that is the case, make sure that the Reverse check box is not enabled in the lower-left corner of the dialog (**Figure 11.58**).

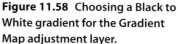

Figure 11.58 Choosing a Black to White gradient for the Gradient Map adjustment layer.

Gradient Map doesn't work for all images. It tends to boost the contrast in a scene, so if the image already has a fair amount of contrast, this may push it over the edge; you need to monitor the highlight and shadow values closely with the Info palette. For more even-toned images, however, it often does a great job of translating the scene into black and white, as well as injecting a necessary shot of contrast that helps when a color image becomes monochromatic. Although it doesn't provide the full tonal flexibility that Channel Mixer does, using Gradient Map for grayscale treatments is fast and easy, and works quite well for a more contrasty black and white interpretation (**Figure 11.59**).

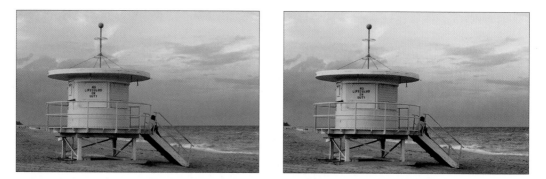

Figure 11.59 The original color image (left), and the grayscale version created by a Gradient Map adjustment layer.

> **NOTE:** If you are photographing digital infrared images using a special infrared filter, then you will need to apply an adjustment such as the Channel Mixer grayscale treatment mentioned earlier in order to end up with the classic look of black and white infrared. The images straight out of the camera often have a strong magenta color balance to them. Although any of these grayscale conversion methods will work, you'll probably get the best results from the Channel Mixer. In many cases, simply using the red channel is all you'll need to do. For additional information, refer to "Seeing the Invisible: Digital Infrared Photography" in Chapter 5, "Essential Accessories."

TONING AND TINTING TECHNIQUES

There are numerous ways that you can add a toning or colorization effect to a grayscale image in Photoshop. We'll explore a few of them here. If you're working with an image that's in grayscale mode, the first thing you need to do is convert it to RGB mode. You can find this command in the main menu under Image > Mode > RGB.

Toning with a Hue/Saturation Layer

1. Add a Hue/Saturation adjustment layer to your image. In the lower-right corner of the dialog, click the Colorize check box. This adds a color tint throughout the image. The color you get will be based on whatever your foreground color was when you entered the dialog, or red (0° on the Hue color wheel slider) if the foreground color was black, white, or gray.

2. Move the Hue slider until you arrive at the basic hue of the tone you wish to apply (if you're after a sepia tone, for example, you can achieve that by moving the Hue slider to 40). The effect will probably be too saturated initially, so adjust the Saturation slider until you find something more to your liking. Alternately, you can leave it saturated in the Hue/Saturation dialog and then use the layer Opacity slider to tone down the saturation later. This will also blend in some of the original colors from the image, which can also be a very interesting effect (**Figure 11.60**).

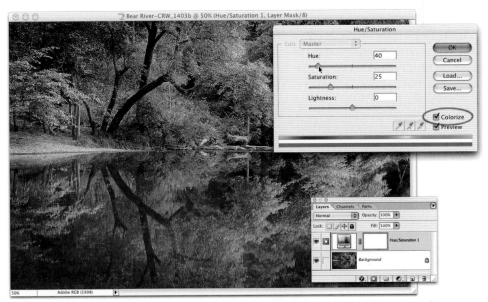

Figure 11.60 Adding a sepia tone with a Hue/Saturation adjustment layer set to Color.

Toning with Levels and Curves

Once you're familiar with the basic color relationships that exist on the color wheel, you can also use Levels or Curves to apply a color tone to a photo. In the following example, we'll add a sepia tone effect. Before you start, you just need to identify what the component colors of sepia are. Sepia is a brownish tan, and if you looked at the basic colors of RGB and CMY, the two that are mixed together to create brown are red and yellow.

1. Start with a Gradient Map or Channel Mixer adjustment layer to give a grayscale appearance to the color image. If you're starting with an image in grayscale mode, you'll have to convert it to RGB first (Image > Mode > RGB).

2. Add a Levels adjustment layer. To create a sepia tone you need to work in the red and blue channels (blue is the opposite of yellow). In the red levels, move the middle slider to the left to add red. Next, switch to the blue levels and move the middle slider to the right to add yellow. Continue adjusting until you find a tone that you like. Click OK (**Figure 11.61**).

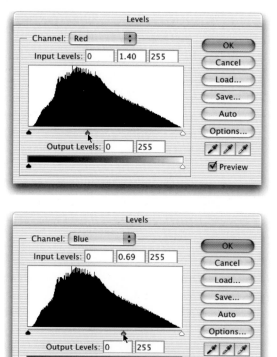

Figure 11.61 Adjusting the red and blue midtone levels sliders to create a sepia tone.

3. The same basic effect can be created using Curves. Move the red curve up and the blue curve down to create a sepia effect. With Curves, however, you can add the tone more in one area of the tonal range than another (**Figure 11.62**).

Figure 11.62 The final sepia effect from the Levels and Gradient Map adjustment layers.

Split-toning

In the traditional black and white darkroom, a procedure called split-toning is used to add different a tone to specific areas of a print's tonal range. A common effect is a split sepia/selenium tone, or simply a split tone of sepia combined with the normal cool neutrals of the photo paper. Seán used to do split sepia-selenium toning back when he had a darkroom, and he definitely thinks that the Photoshop approach is less hazardous to his health and the environment and much safer and easier to clean up.

The tonal effects can be varied in any number of ways depending on the look you're trying to achieve, but the basics steps include two techniques we have already mentioned in this chapter: using the Color Range command and then adding a Hue/Saturation layer.

1. Starting with a grayscale image or an RGB image with a grayscale effect added, choose Select > Color Range. From the pop-up menu, select Highlights near the bottom of the list. Click OK to load a selection of the highlights (**Figure 11.63**).

2. Add a Hue/Saturation adjustment layer. Click the Colorize button in the lower-right corner of the dialog and use the Hue slider to find a hue that you want to use to tone the highlights. We used sepia again, which is approximately 40 on the Hue slider. Adjust the saturation level as desired (**Figure 11.64**).

Figure 11.63 Using Color Range to create a selection of the highlights.

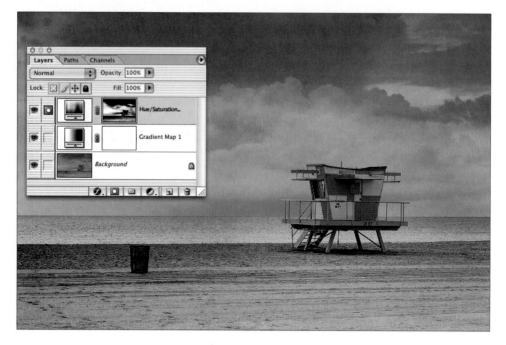

Figure 11.64 Adding a sepia tone to the highlights with a Hue/Saturation adjustment layer.

3. To soften any hard edges that might be lurking in the layer mask, make sure the adjustment layer is active and choose Filter > Blur > Gaussian Blur. Add a slight blur of about 1 pixel (the actual blur amount you use will vary depending on the size of your image, but the goal is to just slightly soften the mask).

This result by itself is often a very cool interpretation of an image. The highlights will be a warm tan color, and the rest of the photo retains the neutral tones of the grayscale effect. If you want to experiment with adding a different hue to the midtones, choose Select > Color Range again and load a selection of the midtones (**Figure 11.65**). With the selection active, add another Hue/Saturation layer and try out a different color. In our example, we went with a classic sepia-selenium tone that combines the warm sepia with the purple tone of a strong selenium mixture (**Figure 11.66**). If you do add another adjustment layer, don't forget to slightly blur the mask. Command-F/Ctrl-F will apply the most recent filter with the previous settings. Command-Option-F/Ctrl-Alt-F brings up the filter dialog with the previous settings but allows you to adjust the filter settings.

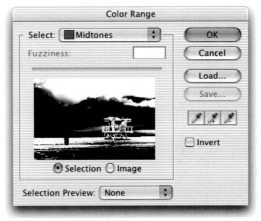

Figure 11.65 Loading a selection of the midtones.

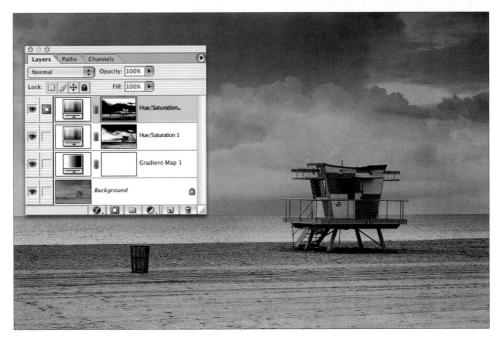

Figure 11.66 Adding a selenium tone to the midtones to create the final split sepia-selenium toned effect.

Global and local tinting with original image colors

In Photoshop, there are often several ways to accomplish a given effect, and this is certainly true for toning and tinting. Instead of showing how to apply the more detailed, labor-intensive color tinting that involves adding different colors to the image using a paintbrush, however, we're going to share two ways to get a hand-tinted look by using the original colors in an image: global tinting and local tinting.

Global tinting is very quick and creates a soft, muted color palette throughout the entire image:

1. Using one of the methods previously discussed, add an adjustment layer that applies a grayscale effect to a color image.

2. Once the grayscale layer is in place, start lowering the opacity until you get something you like.

Local tinting is quite similar to the technique we showed you earlier for dodging and burning with an adjustment layer and a layer mask, except that instead of lightening or darkening, you can paint in an image's original colors in selected areas:

1. As before, add an adjustment layer that applies a grayscale treatment to the photo.

2. Select the Paintbrush tool from the Tool palette and use the Brush Picker in the Options bar to choose a soft-edged brush size that is appropriate for the areas you want to paint over.

Figure 11.67 By adding a Gradient Map layer that turned the image grayscale and then painting on the layer mask with gray where we wanted the color to slightly show through, we were able to tint this image with its own colors.

3. In the Options bar, set the Opacity of the Paintbrush to a low setting, such as 20 percent. This will let you add the color slowly and you can gradually increase the coverage and intensity if you want to. Press D on the keyboard to load the default colors, and then press X to exchange them so that black is in the foreground swatch.

4. Begin painting over your image in areas where you want the original color to show through (**Figure 11.67**).

MERGING IMAGES

Digital photography makes it easier than ever to blend different images together. An obvious use for this is in the creation of multi-image collages. Although such collages are certainly fun to make, and in the right hands the results can be truly stunning, in this section we're going to concentrate on a couple of techniques that are less flashy, but from a photographer's standpoint the results can be just as satisfying.

Combining Exposures to Extend Dynamic Range

In some situations, the range of contrast in the scene exceeds what the camera's CCD or CMOS image sensor is able to capture in a single exposure. This is not a problem exclusive to digital cameras; the exposure latitude of film also exhibits the same limitations under extremely bright lighting conditions. Fortunately, digital cameras provide an elegant way to solve this problem by using two exposures to artificially extend the camera's contrast range. In one exposure, the camera is set to record good detail in the highlights, while the second exposure is used to capture detail and a good tonal range in the midtones and shadows.

We feel that this is a technique that every digital photographer needs to know. It combines an aspect of traditional photographic practice—use of a tripod—with the new technology of digital capture. The key to this procedure is that when the camera is mounted on a tripod and two different images are taken without moving the camera, those two images can be combined in Photoshop on separate layers and they will line up in perfect pixel-for-pixel registration. Using layer masks to selectively show or hide portions of each layer lets you take the best parts from both shots and combine them into a single, perfect exposure. And the beautiful part is that the steps involved are not that complicated!

To start with, you'll need two exposures that have been made using a tripod. Ideally they have been photographed with one exposure targeted toward capturing good highlight detail, and the other for recording a good tonal range in the midtones and shadows (it doesn't matter if the highlights are blown out in this second image).

> **TIP:** *When taking pictures to combine them later in Photoshop, you will achieve the best results if you vary the exposure by changing the shutter speed versus adjusting the f-stop. Changing the f-stop will affect the depth of field and in finely detailed scenes may cause problems when you're aligning the images in Photoshop.*

What about Handheld Shots?

Although images photographed without a tripod could conceivably work for this technique, it's much trickier to get them lined up, and the masking usually takes longer because of this. Even if you were very careful to brace your arms against your sides and do your best to not move the camera, it is virtually impossible to take two shots like this and have them line up perfectly. We're not saying that the combining exposure technique can't work with handheld shots—we're just saying it's not nearly as easy.

NOTE: We have placed JPEGs of these example files on the companion Web site for this book if you want to download them and follow along. They are called Pool_Highlights.jpg and Pool_Shadows.jpg.

The photographs that we are using for this example were made using a tripod and are long night exposures of a lighted swimming pool. The contrast range was so extreme that there was no way to record both the copper-colored tiles in the top part of the image and the illuminated blue interior of the pool in the bottom part in a single exposure (**Figure 11.68**). As long as you can recognize such a situation when you are photographing it, however, then it's relatively easy to take two exposures and combine them in Photoshop. The following steps refer to the images that you can download from the companion site, but should be easy to translate to your own images.

Figure 11.68 The Pool Highlights image (left) was exposed for the interior of the pool, and the Pool Shadows shot (right) was exposed for the tile above the pool.

1. Start with the Pool_Highlights photo (the one with the blue pool interior) as your active image. Position both images so you can see them at the same time on your monitor. Select the Move tool from the Tool palette. Click down on the Pool_Highlights photo and drag it over on top of the Pool_Shadows image. Hold down the Shift key and keep that key held down as you let go of the mouse button.

 The addition of the Shift key here centers the new layer over the existing photo. Since both images have the exact same pixel dimensions, this ensures that the image you are adding will line up perfectly with the existing photo.

2. To avoid confusion, rename each layer by double-clicking on its name. Call the shadows layer (the one with the lighter top half) Shadows, and the highlights layer (the one with the blue pool water) Highlights (**Figure 11.69**).

3. Click on the Highlights layer to make it active. Add a layer mask by clicking the Add Layer Mask icon at the bottom of the Layers palette (**Figure 11.70**).

Figure 11.69 The two pool layers together in one file.

Figure 11.70 Adding a layer mask to the pool Highlights layer.

4. Press D on the keyboard to set the default foreground/background colors to white and black and then press X to exchange them and place black in the foreground swatch. Select the Paintbrush tool and from the Brush Picker in the Options bar, and choose a soft-edged 300-pixel brush.

5. Begin painting with black on that layer mask over the top portion of the image. This will gradually reveal the lighter version of the copper tiles from the layer below. As

you add black to the layer mask, it hides the darker, underexposed tiles on the Highlights layer (**Figure 11.71**).

6. When you get close to the edge where the tiles and the water intersect, you'll probably need to switch to a smaller brush; we used a 65-pixel brush for the finer detail work along the waterline. Don't forget that you can (and should) zoom in close whenever you are performing subtle work along the edge of a mask. If you reveal too much of the Shadows layer and cause some white to appear along the edge where the blue pool water should be, simply exchange the foreground and background colors by pressing X on the keyboard, and paint over the mistake with black until the error is removed (**Figure 11.72**).

Figure 11.71 Painting with black on the layer mask of the pool Highlights layer causes the lighter tiles to show through from the layer underneath.

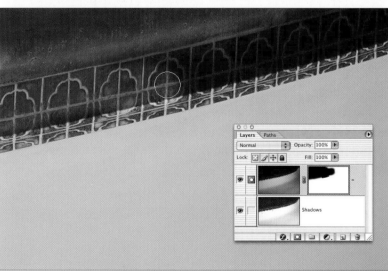

Figure 11.72 We used a smaller brush to mask out the edge where the water and the tiles meet.

These are the basic techniques for combining two exposures into a single image. We have chosen to illustrate the concept using an image with a relatively simple edge between the two exposures. The more complex and intricate the areas that require masking, either through selection or painting techniques, the more in-depth this procedure might be on certain images. The important thing to remember, however, is that, with the exception of the masking details, the core concepts and steps are exactly the same (**Figure 11.73**).

> **NOTE:** *When you are photographing the two exposures, keep track of your shutter speed and aperture for each shot. If there is motion in the shot that is important to capture, then you need to use a shutter speed that is similar for each image. Likewise, if the depth of field is important, then you need to use the same aperture so that depth of field matches between the two images.*

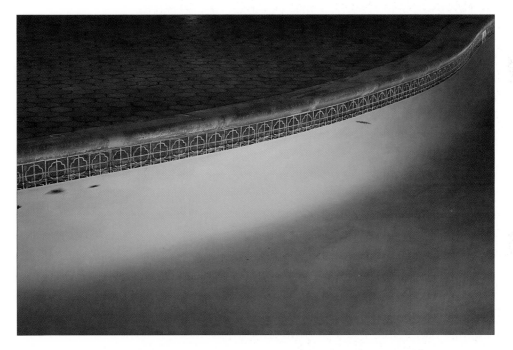

Figure 11.73 The finished merged composite.

Combining Exposures to Extend Depth of Field

The same technique that we demonstrated for merging two exposures to extend dynamic range can also be applied if you need to extend depth of field. Obviously, if the camera is on a tripod, then there is no problem about stopping down the lens to get as much depth of field as you need. But you might find yourself in a position where the need to capture movement means that a faster shutter speed takes priority over depth of field. In such a case, then taking two shots, one focused on the foreground and the other focused on the background, can solve this problem quite nicely (**Figure 11.74**).

Figure 11.74 Two exposures with different areas in focus.

Although the basic Photoshop steps are the same for combining the two exposures, there are certain factors to consider when taking the actual photographs. The easy images to combine are ones that provide a clear demarcation line between foreground and background; because the background is obviously *behind* the foreground element, it is much easier to create a mask to reveal the

in-focus background layer (**Figure 11.75**). Where it becomes tricky is when you look at the scene on location and you can see details gradually receding from the foreground into the background. Depending on the focal length of the lens and the aperture being used, you may actually need to take three or four mages that are focused on various portions of the scene as it recedes into the distance. This then requires more intricate masking using gradient masks, such as we demonstrated earlier in this chapter.

Figure 11.75 The finished composite extending the depth of field in the image.

Stitching Panoramas

One of the limitations of the rectangular format of most cameras is that they do a poor job of capturing the width of scenes that we see in our everyday experience. Even with a wide-angle lens, the effect is not the same as being in a place and seeing it with your own eyes. For many years, photographers have sought to remedy this by creating panoramic photographs that are much longer or wider than they are tall. While this is obviously still no substitute for our visual experience in the real world, panoramic images have been popular since photography's earliest days. In addition to being able to record more of a scene along the horizontal axis, the format is naturally pleasing to our eyes.

Digital photography is ideally suited for exploring the panoramic format due to the tremendous flexibility offered by programs like Photoshop. Multiple images can be taken and then "stitched" together in the comfort of your digital darkroom. This procedure involves some of the same mask and layer techniques used to combine two exposures for extending dynamic range, as well as the tonal and color correction skills that were covered in Chapter 10, "Essential Image Enhancement." Photoshop CS and Photoshop Elements 2 also feature a Photomerge feature that will do all the work for you. The success of any

panoramic image, and how much work it involves, depends a lot on how the photographs were taken. See "Photographing Panoramas" for more information on the camera side of this technique.

Photographing Panoramas

Preparations made in the field when photographing panoramas can pay off back in the digital darkroom when it comes time to stitch your images together. Here are a few factors to consider the next time you venture out to capture a wide-open view.

1. **Use a tripod.** It is possible to photograph panoramas handheld (much more so, for instance, than when photographing two exposures to combine into one), but your results will be better if you use a tripod. For one reason, it will slow you down and make you concentrate on alignment issues and exposure more than with a handheld shot.

2. **Overlap images by at least 20 percent.** Consciously framing the different panels of the panorama so that they overlap by approximately 20 to 30 percent is crucial to provide you with enough room to blend the images using layer masks. If you will be using a program to assist in the assembly of the panorama, this overlap will make for better merges between images.

3. **Look for uncomplicated seams.** Although some subjects, such as urban views, do not lend themselves to this, as you look through the viewfinder, try to think ahead to how the images will fit together. An uncomplicated area will be easier to blend than one with a lot of busy detail.

4. **Keep the horizon level.** As you pan the camera from side to side to capture the different panels, try to use the autofocus markings in the viewfinder to help you keep the horizon in alignment from shot to shot.

5. **Use exposure lock or manual exposure.** If the camera's exposure system is set to auto or program, then the meter will recalculate exposure as the brightness levels change. This can result in skies and other areas where the exposure does not match across the different shots, making it more difficult to blend the images together. Take a single meter reading off of a good middle tone reference, such as faded jeans, wet sand, or anything that can stand in as a middle gray reference (of course, if you happen to have a gray card with you, then use that). Make a note of what the meter reading is, set your camera to manual, and then dial in the same settings. If your camera does not have a manual exposure mode, then see if it has an exposure lock feature. Many compact cameras can lock the exposure for the first shot and several shots thereafter, until you turn it off. This is ideal for photographing panoramas.

6. **Keep the focus consistent.** If you use an SLR that refocuses every time you lightly press the shutter button, take an initial focus that will work for the entire scene and then turn the autofocus off when taking the photos.

7. **Don't worry about the focus.** Yes, we know that sounds contradictory with the previous point, but sometimes you can get very interesting results by mixing up the focus zones in a panorama. The final image may be more interpretive than literal, but it also might be really cool.

8. **Think outside the horizontal.** Even though the majority of panoramas are of landscapes, and they are almost always horizontal, that doesn't mean you can't make a vertical panorama, or a close-up detail panorama, or even a panoramic portrait. Look for unexpected relationships between foreground and background, left and right, and top and bottom. Push the boundaries of the rectangle and see what you find.

Manual stitching

Manually stitching more than one image together to create a panorama can be a lot of work. Therefore, we recommend you begin your panoramic journey with modest aspirations. If you've never tried this before, then it's probably best to start with a composition that is made up of only two photographs. This will let you become familiar with the basic techniques and workflow. Later, when you have mastered, or at least are more comfortable with, the process, you can head for the more challenging terrain of panoramas made up of several images.

What follows, in broad strokes, are the basic steps for making a panoramic collage. We'll be using two images taken on the beach in Miami. If you want to follow along with this exercise, you can download these photos from this book's companion Web site. They are called beachpano_left.jpeg and beachpano_right (**Figure 11.76**). If you want to try using your own images, you may need to adjust some of the settings to achieve pleasing results:

Figure 11.76 Beach Pano Left, and Beach Pano Right.

1. The first thing to do after you open up the images is to see how well they match in terms of color and brightness. The Miami shots match pretty well, so we don't need to make any adjustments to them at this point. If you find that your images do need some tweaking to get them to match better, you can either try to correct them now, before stitching them together, or wait until they are both in the same file. The only advantage to correcting them once they are together in the same image is that it might be easier to see when the tones and colors match, since one will be overlaid on the other.

2. Starting with the left image, you'll need to add some extra canvas so there is room to bring in the new image. First, press D on the keyboard to set the default colors to black and white. The default color for new canvas is always the color of the background swatch, but you can change it inside the Canvas Size dialog if necessary. From the main menu, choose Image > Canvas Size. Set the units to percent and enter 200 for the width and 120 for the height. Make sure that the Relative check box is not checked. In the position grid, click the center box on the left to add the new space to the right side and the top and bottom. This gives plenty of room on the right for the new photo to be placed, as well as providing some extra space on the top and bottom so you can move and position the image pieces freely (**Figure 11.77**). Click OK.

Figure 11.77 The Canvas Size dialog and the new canvas added to the image.

3. Make the image on the right (with the man on the trailer) active and use the Move tool to drag it onto the expanded canvas. You can hold the Shift key down as you release the mouse button, and the photo will be centered in the destination file. Use the Move tool to drag the right-side photo into an approximate position (**Figure 11.78**).

Figure 11.78 The two beach images together in approximate placement.

4. Show the Rulers (View > Rulers, or Command-R/Ctrl-R). Click inside the top horizontal ruler and, keeping the mouse button down, drag a guide down into the image. Position the guide so that it lines up with the horizon line on the left side of the image.

5. Press the number 5 key on the numeric keypad to set the opacity for the right image to 50 percent. This allows us to see through the photo and will help us line up the horizons.

6. From the Edit menu, choose Free Transform. A bounding box is placed around the active layer. If you place your cursor outside the box on the right side of the layer, it becomes a curved, doubled-sided arrow. Click and drag slowly counterclockwise to begin rotating the layer. If you pause, you can click inside the box and drag to reposition the layer. The goal here is to line up the horizon where the two images overlap (**Figure 11.79**). An approximate match is close enough for now. To apply the transformation, press the Enter/Return key. To cancel the transformation, press the Escape key. Then press 0 to reset this layer's opacity to 100 percent.

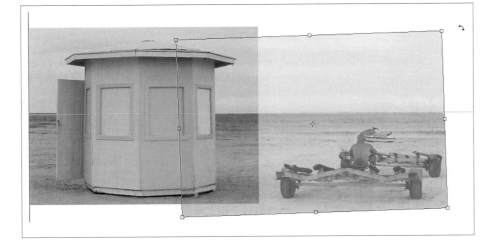

Figure 11.79 With the right side layer set to 50% opacity, it can be rotated, allowing us to see how well it lines up with the image on the left.

7. Click the Add Layer Mask icon at the bottom of the Layers palette to add a layer mask to the right side image. Select the Paintbrush tool and choose a soft-edged, 150-pixel brush. Press D on the keyboard and then press X to set the default colors and move black to the foreground swatch. Zoom in for a closer view and begin painting with black on the layer mask to hide portions of the right image where they overlap with the beach hut. For fine detail work along the edge of the hut, you should probably zoom in to 100 percent (View > Actual Pixels).

The goal is to have all of the hut in the left image, and to have the blend between the two be an uneven edge in the empty area of the sand and ocean (**Figure 11.80**). As you make further refinements to the mask, you may have to use the Move tool to nudge the right image up or down to line up the horizon between the two photos. When you're satisfied with your work, save the file under a different name and preserve the layers in case you want to go back and work on it some more (**Figure 11.81**).

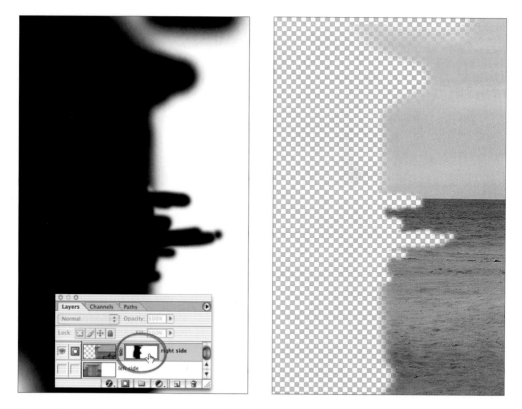

Figure 11.80 A view of the mask that blends the two layers together (left); the edge of the right-hand photo (right).

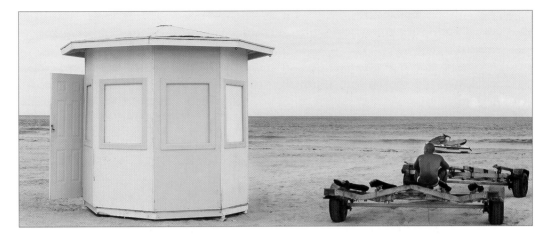

Figure 11.81 The finished panorama.

8. The final step is to use the Crop tool to crop the panorama and remove the white canvas and any uneven edges where the two do not line up. For our final version, we used the Clone Stamp tool to fill in some white areas in the sky that remained after our crop. This is also the time when you might experiment with additional color or tonal correction, either for each layer individually or for the entire collage. For example, we added a Curves layer to slightly increase contrast and a Hue/Saturation layer to bump up the color saturation a bit.

The individual steps for making a panorama can vary greatly, depending on the number, quality, and exposure consistency of the images involved, how many there are, how well they line up, and how easily they blend together, but these are the basic steps. When distilled down to the essentials, they can be summed up like this:

1. Add canvas size to accommodate all images.

2. Group images together as layers on the enlarged canvas.

3. Place layers in approximate positions. Use 50 percent opacity to help line up edges and horizons. Use the Free Transform command to rotate images for fine-tuning. Return opacity to 100 percent.

4. Add layer masks and paint in masks to blend the images together. Zoom in close for detail work along the edges.

5. Crop panorama and apply additional color correction and retouching as needed.

Expanding Your World with Photomerge

When you're looking through the camera viewfinder, take a moment and look to the left, to the right, and up and down. Often, trying to frame an expansive or interesting scene with a single exposure may not do the subject justice. In fact photographers have been using wide-format, panoramic cameras since the 19th century to capture large groups of people or to record impressive landscapes. With a digital camera you can expand your horizons and create spacious images simply by taking a number of overlapping images and then using Photoshop CS's Photomerge function to, as the name implies, merge them together.

1. After shooting and downloading your source images you can access the Photomerge command by selecting File > Automate > Photomerge; but our preferred method is to highlight the targeted images in the File Browser and select Automate > Photomerge from the File Browser menu.

2. Photoshop will open previews of all the selected images into the Photomerge interface and do its best to overlap and merge the images into a panoramic scene (**Figure 11.82**)

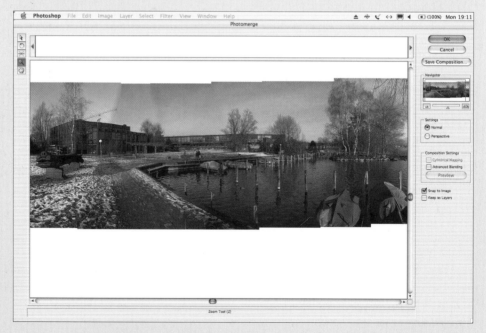

Figure 11.82 The Photomerge dialog.

3. If Photoshop has a problem or can't find enough overlap, a warning message will pop up that saying the program couldn't complete the task. But you can drag files into the Photomerge window from the image hopper at the top of the Photomerge interface and visually align files by rotating them with the rotate (R) and arrow (A) tools.

(continued)

4. On the right you have a number of settings options for using Normal or Perspective. Normal will create a flat image as seen in **Figure 11.83** and clicking on perspective make the closer sides larger, as seen in **Figure 11.84**.

Figure 11.83 The Normal option produces flat panoramas.

Figure 11.84 The Perspective option creates a slight warp, making the sides that appear closer to you a bit larger.

5. We recommend keeping Snap to Image checked, and also Advanced Blending, which uses a sophisticated color-matching process to blend the images that can't be duplicated with layer masks. Snap to Image is helpful when you have to manually align pieces. Although it may sound counterintuitive, leave the Keep as Layers box unchecked, as this will defeat the advanced color-matching blending that is built into Photomerge.

(continued)

One last hint: your panoramic images do not have to be rectangular, as seen in **Figure 11.85**, or even panoramic in subject, as seen in **Figure 11.86**. Photomerge is a great way to blend and create realistic panoramas, as well as abstract and surprising images.

Photo by John McIntosh

Figure 11.85 There is no law that states that panoramas need to be rectangular...

Figure 11.86 ...or even of a panoramic subject, for that matter. Think outside the rectangle and have some fun!

IMPROVING IMAGE STRUCTURE

Reducing Digital Camera Noise

In an ideal world we would only take pictures in well-lit situations and use the camera's lowest ISO possible. But we don't live in a perfectly illuminated world and many important events take place in less-than-ideal lighting conditions. Sunset scenes, candlelit dinners, and theater presentations are all examples of where the low light will force you to increase the camera's ISO. As we discussed in Chapter 3, "How a Digital Camera Works," you can increase the ISO or light sensitivity of the image sensor, which adds a gain to the signal, which is often visible as increased noise. Sometimes we also make exposure mistakes and underexpose the image. When you lighten the image up in Photoshop, the noise of the weak signal often becomes unpleasantly apparent. No matter what causes the noise, we feel that it is much less attractive than film grain can be.

To reduce digital camera noise you can use a number of third-party plug-ins, such as PhotoKit by Pixel Genius, Dfine by nik Multimedia (www.nikmultimedia.com), Grain Surgery by Visual Infinity (www.visinf.com), and Digital Gem by Applied Science Fiction (www.appliedsciencefiction.com). Or you can use the following Photoshop technique, which although it has been around for many years still works very well.

1. Start by inspecting the three image channels by clicking on the words *red, green,* and *blue* respectively in the Channels palette (**Figure 11.87**). As you can see, the blue channel shows a significant amount of noise, which will degrade the print quality.

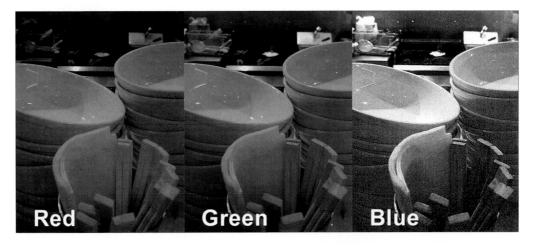

Figure 11.87 When we compare the red, green, and blue channels, the blue channel is the obvious cause of most of the trouble.

2. From the main menu, select Image > Mode > LAB, which separates the tonal information from the color information, as seen in **Figure 11.88**.

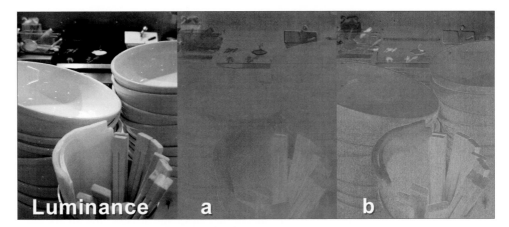

Figure 11.88 The three LAB channels. The "b" channel.

3. Now click on the "a" channel and select Filter > Noise > Median. In this example we started with a setting of 3. If your images are noisier, use a higher setting. Click on the "b" channel as shown in **Figure 11.89** and once again select Filter > Noise > Median or use the short-cut Command-Option-F/Ctrl-Alt-F to bring up the last-used filter. In most cases the "b" channel needs a higher dose, and in this case we used 5, as shown in **Figure 11.90**.

Figure 11.89 Selecting the "b" channel so that only it will receive the Median filter.

Figure 11.90 Applying the Median filter to the "b" channel.

4. Click on the "L" channel and use an aggressive Unsharp Mask filter setting. By *aggressive,* we mean sharpen the image so that it looks uncomfortably crisp on screen; when it's printed it will not look this crunchy. Refer to the section on sharpening techniques at the beginning of this chapter for more on sharpening.

5. From the main menu, select Image > Mode > RGB to bring the image back to RGB, or if you are going to offset print, you would select Image > Mode > CMYK.

Please note: There are numerous variations on this method; some photographers prefer to use Gaussian Blur on the "a" and "b" channels, while other use the Dust and Scratches filter. We say, whatever works the best for your images is the right answer. The primary issue is that it's important to separate the noise out of the image, and in the great majority of cases the LAB technique works well.

Retouching Chromatic Aberration and Color Fringing

Chromatic aberration shows up in images as a purple color fringing along a dark edge that is right next to a very bright area (**Figure 11.91**). Image sensors react differently to this challenging situation, so the amount of chromatic aberration will vary among different camera models. Retouching it so that it's not as noticeable is fairly easy to do, though a bit tedious depending on how much of the image needs to be fixed.

Figure 11.91 Chromatic aberration often shows up as a colored fringe along a bright and dark edge.

Since chromatic aberration manifests itself as unwanted color fringing around light and dark edges, the easiest way to get rid of it is to simply replace the offending color fringe with the color that should be there. This can be done using the Clone Stamp tool with a special blend mode. To try this technique out, open a file that has chromatic aberration, or you can download out example image, Chromatic_Aberration.jpg, from the companion Web site:

1. Zoom in for a very close view of the images so you can clearly see the color fringing (Command-spacebar-click/Ctrl-spacebar-click will let you zoom in on a specific area).

2. Select the Clone Stamp tool from the toolbar. In the Options bar, change the mode to Color. This will allow you to sample and copy color and leave detail untouched. This is a fairly benign retouching technique, but if you want to keep your work on a sepa-

rate layer, click the New Layer icon at the bottom of the Layers palette to add an empty layer. Set this layer's blend mode to Color, and in the Clone tool's Options bar, click the Use All Layers check box (**Figure 11.92**).

Figure 11.92 Setting up the correct options for the Clone Stamp tool.

3. Navigate to a place in the image where you can see unwanted color fringing. Option-click/Alt-click on an area of good color adjacent to the fringe (that is, a natural image color and not the aberration halo). Now move your cursor over the fringe and click to begin painting with the good color from your sample point. Because you are using Color Blend mode, the brightness detail will be untouched, but the nasty color fringing will be removed (**Figure 11.93**).

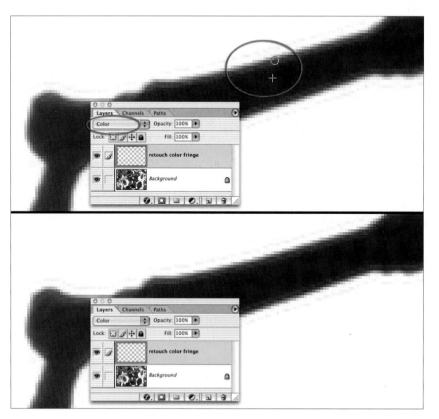

Figure 11.93 Retouching chromatic aberration with the Clone Stamp tool set to Color mode.

4. Continue through the rest of the image and retouch where the chromatic aberration is noticeable.

WORKING WITH HIGH-BIT FILES

Many higher-end digital cameras are capable of capturing a 12-bit image. This translates to 4096 tonal levels per color channel instead of the 256 levels in an 8-bit file. That represents quite a bit more tonal information. In Photoshop a file with more than 8-bits per pixel is classified as a 16-bit image. Since digital color correction involves selectively discarding information in order to get the existing data looking the way you want, more individual tonal levels means more room, or a bigger stage, on which to perform your corrections. When you start out with many more tonal levels in your file, it's not as critical if some levels are lost in the quest to make the image look better (**Figure 11.94**). The ability to apply broad corrections and not sacrifice significant amounts of the tonal range in the process represents a huge advantage for preserving the highest possible quality in your images. The advantages of working with high-bit data mean much more control and quality throughout the color correction process, especially for images that need a lot of work.

A

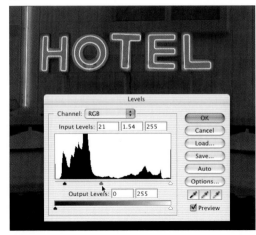

B

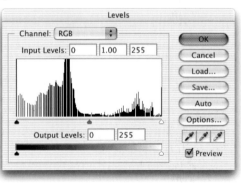

C

Figure 11.94 The same Levels tonal correction was directly applied (no adjustment layers) to two versions of this image, one 8-bit and one 16-bit. After running Levels on the images, their histograms can tell us a lot. In the 8-bit file (B) significant tonal erosion has occurred, but the histogram for the 16-bit file (C) is not damaged.

Working on 16-bit images used to require a lot of elaborate workarounds to get around the fact that layers were not supported in this mode. Even with these constraints, we felt it was still worthwhile to do our major global tonal and color correction in 16-bit mode. If there were other tasks that required layers, we would create a copy of the file and convert down to 8 bits per channel and continue with all of the program's functionality available to us. If you're using Photoshop CS, then you can use adjustment layers (and most of the application's core functionality) on 16-bit files.

Working on high-bit images is not for everyone. For one thing, it's only an option if you have a camera that shoots in RAW format. A JPEG file is always 8 bit, so if your camera doesn't offer RAW, this is one question you don't have to worry about. Second, depending on what you need to do with your digital images, working in 16-bit mode may be overkill. Although we shoot in RAW format most of the time, we decide on a per-image basis whether or not we need the extra control and flexibility that 16 bit offers. For images with good exposures that do not require large, high-quality output, we leave them in 8-bit mode simply because it makes sense for that particular image. Here are a few things to consider:

- **File size.** 16-bit files are at least twice as large as 8-bit files. So an 18-MB 6-megapixel image will be 36 MB in 16-bit mode. Additionally, in Photoshop CS, the layer compression on 16-bit files is not as efficient as with 8-bit files, so even adding a few adjustment layers can cause your files to quickly balloon in size.

- **Processing speed and RAM.** Large, 16-bit files require a lot of processing power. Unless you have a very fast (and we do mean *very* fast) processor with lots of gigabytes of RAM, and a substantial amount of free disk space for Photoshop to uses as a scratch disk (virtual memory), then working on a 16-bit image can be painfully slow.

- **Image requirements.** Not all images need to be edited in 16-bit. If we're making large prints and we need to do a lot of work to correct the tonal range, then 16 bit is a viable option, simply because it allows us to preserve as much of the tonal range as possible without doing damage to the image. But we don't use it on every single image we work on.

> **NOTE:** *In Photoshop CS you can set the Info palette to display the tonal values in an image as 16-bit values. Although we definitely evangelize the benefits of working in 16-bit mode, we feel that the 16-bit Info display is just too confusing for mere mortals (like us). We recommend leaving the Info display set to 8-bit values, which are much easier to comprehend.*

A good compromise approach to use with the high-bit data that your camera provides you with is to make as many of the adjustments as possible in Camera RAW and then import the image into Photoshop as 16 bit. Address the rest of the major tonal and color correction issues in 16-bit mode so that you have the flexibility of the expanded tonal range. Once you get the image looking perfect, save a copy of the adjusted 16-bit file for archive purposes and then go to Image > Mode > 8 Bits/Channel to convert the file to 8-bit mode. Now you can continue to work on an 8-bit master file with none of the file size slowdowns that are common with large 16-bit images. The adjusted 16-bit master file is safely archived in case you need to return to it again.

CREATING BETTER IMAGES

Photoshop continues to evolve and offer us more and more options for editing and enhancing our images. By learning a few essential skills and some advanced techniques, you can do amazing things to improve your images or take them in extraordinary directions that stretch the limits of reality. In the end, however, remember that most good photographs have a strong visual foundation before they are reworked in Photoshop. In addition to improving your Photoshop skills, it is just as important, if not more so, to develop good photography skills as well. Being proficient in both areas is essential for creating better images with digital photography.

Photoshop is a big program. Like the ocean, it is very deep. Learning it well requires dedication, lots of practice, patience, and the advice of people who know the program well. In this book we have barely uncovered the tip of the iceberg, but fortunately there are many good Photoshop books on the market.

Real World Adobe Photoshop CS by David Blatner and Bruce Fraser
(Peachpit Press, 2004)

Photoshop Color Correction by Michael Kieran
(Peachpit Press, 2003)

Professional Photoshop by Dan Margulis
(Wiley, 2002)

Photoshop CS Artistry by Barry Haynes, Wendy Crumpler, and Seán Duggan
(New Riders, 2004)

Photoshop Restoration & Retouching, 2nd Edition by Katrin Eismann
(New Riders, 2003)

Adobe Photoshop Master Class, 2nd Edition by John Paul Caponigro
(Adobe Press, 2003)

Adobe Photoshop CS for Photographers by Martin Evening
(Focal Press, 2004)

Adobe Photoshop CS Studio Techniques by Ben Willmore
(Adobe Press, 2004)

The Photoshop CS WOW! Book by Linnea Dayton and Jack Davis
(Peachpit Press, 2004)

Making Digital Negatives for Contact Printing, 2nd Edition by Dan Burkholder
(Bladed Iris Press, 1999)

PART FOUR
Output, Manage, and Present

Chapter Twelve **From Capture to Monitor to Print**

Chapter Thirteen **The Digital Portfolio**

Chapter Fourteen **Archive, Catalog, and Backup**

CHAPTER TWELVE
From Capture to Monitor to Print

Once you've photographed and optimized your image, the moment of truth arrives. It's time to put ink to paper to produce a print. For many photographers, the look and feel of the final print is in their mind's eye as they are pressing the shutter release button. The final print completes the experience of the image. If it isn't just right, the photographer won't be happy, and won't be enthusiastic about sharing the image with others. What defines that perfect print? If you've optimized the image, a perfect print matches what you see on your monitor and conveys what you envisioned when you took the picture.

Many photographers get frustrated when they can't produce prints that match the image on their monitor. Fortunately, there are tools to help you achieve a close match between the monitor image and the final print. Even with the variations our choice of print media imparts—such as changes in contrast, saturation, and texture—we want the colors in our prints to be consistent and accurate. These issues all fall under the category of color management.

THE IMPORTANCE OF COLOR MANAGEMENT

Color management is a critical aspect of digital imaging because it provides the tools to produce predictable, accurate, consistent, and repeatable output, whether on a monitor, on the printed page, or in a gallery exhibit. When you spend time and effort getting your image just right, you want the final display to present exactly what you intend the viewer to see. Color management provides a way to achieve this goal while cutting down on test prints, wasted media, and frustration.

Each device that deals with your image has its own unique characteristics. Every monitor and printer displays color differently. Color management enables you to bridge the differences between these device, through the use of *profiles*, which describe the color behavior of a device so that color can be reproduced accurately. (See the "Profiles" section later in this chapter.)

Keep in mind that an effective color management system includes an appropriate working environment and methods for evaluating your results. We discuss the working environment in Chapter 8, "Building a Digital Darkroom," and we'll discuss the evaluation of prints in a later section in this chapter.

UNDERSTANDING LIMITATIONS

The most important thing to understand about color management is the inherent limitations of monitors, inks, paper, viewing conditions—even our own moods as we work on an image. We're all looking for prints that perfectly match our monitor display, but that goal is unattainable. Monitors and the printed page use very different methods of displaying an image. Monitors glow with light, producing an incredibly luminous image, similar to what you see when you view a slide on a light table. Prints, on the other hand, depend on reflected light for their illumination, and they will never have the same colors and luminosity as a monitor.

You also need to consider how the specific ink and print media you're using will affect the final appearance of the print. For example, glossy materials allow the inks to sit on the surface, enhancing color saturation, contrast, and sharpness. The images simply have more snap to them. Matte papers, on the other hand, will absorb the inks and reduce the vibrancy of the colors and contrast, resulting in an image with a more muted look. Color management will help you get consistent and accurate output, but prints of the same image on different materials will still look different.

Comparing a print to the image on your monitor also involves a certain amount of interpretation. You need to be able to look past the differences between the two mediums, and evaluate how closely they match in terms of tone and color. Before we dive into the wonderful world of color-management profiles, it is essential that you understand how the color settings in Photoshop will affect your work and your images. To access these settings, select Edit > Color Settings. For information on setting up the Photoshop color settings, see Chapter 10, "Essential Image Enhancement." Do not pass Go. The Photoshop color settings are a critical component in developing a color-managed workflow.

PROFILES

A *profile* describes the color behavior of a particular device, so that the behavior can be translated into a known standard. Once the behavior is standardized, another device profile can translate that information again in order to reproduce the image to match the original. Katrin likes to use the analogy of the United Nations to describe profiles. The printer speaks German, the monitor speaks French, and the digital camera speaks English. The profile is the universal translator that allows Photoshop to understand all of the "languages"—color behavior—spoken by each device.

Later in this chapter we'll look at how to create or obtain profiles for digital cameras, monitors, and printers. First, let's look at some of the issues related to the actual profile files that will be saved on your computer.

Where Do Profiles Go?

When you create your own profiles, they will in most cases be saved automatically to the correct location by the software you use to build them. When you create, purchase, or download a profile for your digital camera, monitor, or printer, you need to save it in the correct location yourself, so that applications that need to use it can find it.

For Windows 98 and earlier, profiles should be saved in the Windows\System\Color directory. For Windows XP, Windows 2000, and Windows ME, profiles should be saved to Windows\System32\Spool\Drivers\Color. For Windows NT, the profiles belong in Windows\System32\Color.

For Macintosh OS 9, profiles should be saved in the ColorSync Profiles folder in the System folder. For Mac OS X, profiles can be saved in the System/Library/ColorSync/Profiles/ folder.

Can You Share Profiles?

Before you consider whether you can share a profile, you need to consider whether you'd actually want to. The only situation where you would possibly want to share a profile is for a printer. Monitor profiles are specific to the individual monitor. Each monitor's display will gradually *drift* (meaning the color will shift) over time. Therefore, even if a friend has the exact same model of monitor as you, you wouldn't want to share your profile with them. Instead, they'd want to create a custom profile for their own monitor.

While the same issues theoretically apply to photo inkjet printers, in reality printers of the same model are usually very consistent in their output. Similarly, paper and ink are manufactured within very strict tolerances so that a custom printer profile will remain accurate

even with different batches of the same type of ink and paper. Therefore, sharing printer profiles is of much more interest to photographers.

Whether you can share profiles depends on how the profiles were created. If you build a profile yourself with the commercial software tools designed for that purpose, you can almost certainly not share those profiles. The licensing agreement of every software tool we've seen for building profiles specifically forbids sharing the profiles you build with that software, regardless of whether you are offering them for sale or for free. The software marks the profiles to indicate which tools were used to create them, so if you start distributing the profiles, the manufacturer might well take notice.

If you obtain a profile from a third party, you'll need to check with them to see if you can share the profiles with others. If you obtained the profile for free from a paper manufacturer, for example, you can probably distribute it freely. If you obtained the profile from a service provider who builds custom profiles, the agreement you have with them may prevent you from legally sharing profiles.

We'll address some of the sources for building or purchasing custom printer profiles in the "Printer Profiling" section later in this chapter.

High-Quality Epson Profiles

Photographer and color management expert Bill Atkinson (www.billatkinson.com) has developed profiles for the Epson Stylus Pro 7600 and 9600 printers using software he wrote himself. He has generously made these profiles available free of charge, and Epson provides them as free downloads from the "Drivers and Downloads" section of its Web site (www.epson.com). We have found these profiles to be extremely accurate and recommend them for any photographers using the Epson 7600 or 9600 printers. For other printers you may be able to find similar profiles available.

DIGITAL CAMERA PROFILING

For digital photographers, the image starts with the digital camera, so it would seem to make sense to profile your camera to provide the most accurate color from the beginning. The challenge of building profiles for a digital camera, however, is that the lighting conditions can vary dramatically unless you are using the camera in a very controlled, studio environment. We prefer to control color in the camera by photographing in RAW capture mode and adjusting the white balance settings, which we find offers more. Even if you were capturing in JPEG mode, in most situations you could use a custom white balance setting in the camera in place of a custom profile. This doesn't provide exactly the same thing, but it does provide more consistent color in the images you capture.

We recommend that only photographers working in a studio with consistent conditions create custom profiles for their digital cameras. Even in this situation, you'd want to build a custom profile for each specific lighting situation. Once you've established the lighting for a particular photo shoot, you can simply photograph the color target. You can then build the custom profile as part of your workflow when processing the images for that shoot.

Creating the Profile

Creating a digital camera profile is a relatively straightforward process. First you photograph a color target under the exact lighting conditions of the photo shoot so that you can apply the profile to the images in the photo shoot, and also future shoots if you use the same lighting setup. The specific color target you would photograph is the GretagMacbeth (www.gretagmacbeth.com) ColorChecker DC chart, the first reference chart designed specifically for digital photography (**Figure 12.1**).

Figure 12.1 The GretagMacbeth ColorChecker DC chart is the first reference chart designed specifically for digital photography and digital camera profiling.

Once you've captured the profile target, you'll need to open it with the software for building the profile. We recommend using the GretagMacbeth ProfileMaker software with the Digital Camera Module. This software guides you through the simple process of opening the captured target and creating a custom camera profile for that target. Be sure to name the profile so you'll know what setup it's designed for. This will simplify the process of assigning the correct profile to your photographs.

Assigning the Profile

When you use a custom camera profile, you need to assign that profile to the images you captured before you edit them, so that the color data will be translated based on that profile and the images rendered correctly. Doing this will ensure the most accurate colors possible.

When you open images that were captured based on the use of a custom profile for your camera, you don't want to convert to the working space. Instead, select the Preserve Embedded Profiles option in the Color Settings dialog.

Once you've opened the image, select Image > Mode > Assign Profile from the menu. In the Assign Profile dialog, select the option to assign a profile, and choose the profile you created for this photo shoot. With the Preview check box selected, you will be able to see the change the profile applies to the image. Click OK to assign the profile.

Once you've assigned the profile to the image, you'll want to convert the image to your working space. Assigning the profile causes the image numbers to be interpreted based on a different set of color values, defined by the custom profile you assigned. Select Image > Mode > Convert to Profile from the menu, and select Adobe RGB (1998) from the Destination Space drop-down list. We recommend using the default settings of Adobe (ACE) as the Engine and Relative Colorimetric as the rendering Intent, with the Black Point Compensation and Dither options selected. Click OK, and the image will now be converted to the working space. Note that converting to the working space causes the color numbers in the image to be changed so that the appearance of the colors is preserved.

If you will be processing a large number of images that use a custom digital camera profile, you can record an action in Photoshop to automate the process.

MONITOR PROFILING

We can't stress enough how important it is that you have an accurate display on your monitor, and we highly recommend that you calibrate and profile your monitor about once a month. The monitor is the focal point of the digital darkroom. The final product may be a print from your photo inkjet printer, but the monitor is what you use to evaluate the accuracy of the print, and that same display is how you decide which adjustments are necessary to optimize the image. If your monitor display is inaccurate, every image-editing decision you make will simply be a blind roll of the dice.

Profiling your monitor is a two-step process. First, calibrate the display to adjust the display settings to get the monitor as close as possible to established standards. Then generate a profile that describes the color characteristics of the monitor. This is sometimes referred to as *characterizing* the display.

A variety of tools can help you build a profile for your monitor.

Adobe Gamma

Adobe Gamma is included with Photoshop 7.0 (and earlier) and Photoshop Elements, so it doesn't cost you anything extra. But you get what you pay for. While the price is right, Adobe Gamma produces profiles that depend on your eyes to determine the correct settings—so the profiles may be inaccurate. Unfortunately in this case, the human visual system is too good at adapting to different lighting conditions, and this creates problems when it comes to accurately judging the display on your monitor.

Therefore, we do not recommend using Adobe Gamma to produce a profile for your monitor. It's far more accurate to create a profile using a calibrated sensor—and the accuracy of the image displayed on your monitor is something worth paying for.

Sensor and Software Packages

The best way to calibrate and profile your monitor is with a package that includes software to guide you through the calibration process and that uses a sensor to read the actual values produced by the monitor to create an accurate profile. The profile is then specific to your monitor, ensuring as consistent and accurate a display as possible (**Figure 12.2**).

Figure 12.2 A monitor sensor reads the values displayed by the monitor during the profiling stage of monitor calibration, ensuring the most accurate profile possible.

Several software-and-sensor packages allow you to calibrate your monitor. These include the ColorVision Monitor Spyder sensor with PhotoCAL software (www.colorvision.com), GretagMacbeth's Eye-One Display package, and the MonacoOPTIX package from Monaco Systems (now owned by X-Rite, www.monacosystems.com). All of them include the hardware and software that enable you to produce a profile for your monitor.

Calibration

Monitor profiling software will guide you through the process of optimizing the display settings to get your monitor as close as possible to the established calibration standards. This includes adjusting brightness and contrast to achieve optimal black and white points for the display, as well as configuring the color settings for the monitor.

For most LCD monitors calibration actually doesn't apply. Because LCD monitors use a purely digital signal, they don't exhibit the variation that monitors do. Therefore, an LCD monitor may not even include the ability to adjust the display. When it does, you will generally just want to reset the controls to their factory-default neutral values.

For CRT monitors the calibration process is an important step in configuring the monitor to produce the most accurate profile. You should increase the contrast to the maximum value, to produce the brightest white possible. Next, you should adjust the brightness to achieve a maximum black while maintaining detail in the dark tones. Sensor readings can then determine the luminosity (brightness) of the display, and you will likely need to reduce the contrast to prevent whites that are excessively bright.

Once black and white points are established, you'll need to configure the color settings for the display. The best monitors allow you to adjust the red, green, and blue channels independently, so you can fine-tune the exact color temperature of the display. Other monitors only allow you to select preset color settings that define the color temperature of the display. Lower-end monitors don't offer any adjustment for color temperature, but these are not monitors we would recommend for imaging work to begin with.

Once you've adjusted the physical settings of your monitor, it is very important *not* to adjust them again until the next time you calibrate your monitor. In fact, some photographers we know actually tape over the dials so that their assistants or young children can't fiddle with the settings.

Target values

When you calibrate and profile your monitor, you must specify the target color temperature and gamma values for the process. The color temperature is a measure of the color of neutrals on your display. Obviously, we would normally expect neutrals to lack any color cast, but reality is a bit different.

We recommend targeting a color temperature of 6500K. This is a slightly more blue color temperature, which more closely matches the natural color temperature of a monitor. We find that that this setting produces the most accurate results.

The target gamma setting defines the relative lightness or darkness of the middle tones in the display. A gamma setting of 1.8 is generally considered the standard for Macintosh systems, with 2.2 used for Windows. However, we recommend targeting a gamma setting of 2.2 for both operating systems. This will produce an image with slightly higher contrast, which reflects the typical output more accurately than a gamma setting of 1.8.

Profile building

Once you've calibrated the monitor and set target values, the software and the sensor do the rest of the work. You attach the sensor to the front of the monitor, using suction cups for CRT monitors and a device for hanging the sensor over the top of the monitor for LCD displays. The sensor then reads a series of values displayed on the monitor, measuring the value produced and comparing that to the value requested by the software. By measuring the difference between what the software asked for and what the monitor actually displayed, the software generates a table that defines the color behavior of the monitor. This is the monitor profile. The software will then save the profile in the appropriate folder on your system and set it as the default monitor profile. This profile is used as the basis for adjusting color for the monitor display, ensuring the most accurate presentation of your images possible.

If you have a number of monitors in a studio or office, it is important to calibrate and create profiles for each one. An accurate monitor display is critical, particularly if you'll be sharing images across multiple computers. All monitors should be calibrated to the same standards, preferably by the same person, to help ensure consistency. Also, as we'll describe in the next section, you should calibrate and profile the monitors on a regular basis.

Certain high-end monitors simplify the calibration process considerably by including all of the tools—both hardware and software—that are necessary for building accurate profiles. For example, the Sony Artisan displays that all three of us use for our critical imaging work

include a sensor and software that fully automates monitor calibration (**Figure 12.3**). Simply launch the software, select a calibration target, and place the sensor on the screen. Everything else—the calibration of the monitor and the building of the profile—happens automatically while you wait. Monitors such as the Sony Artisan that offer this calibration option are more expensive, but to us the exceptional image quality and convenience make them worth the higher price.

Figure 12.3 The Sony Artisan monitor includes software and a sensor for performing automated monitor calibration and profiling, which makes the task of maintaining an accurate monitor display a breeze.

Frequency

Profiling your monitor isn't a one-time task. Over time the components of your monitor will deteriorate, causing a shift in the colors produced. Therefore, it's important to build a new profile on a regular basis, allowing your monitor to warm up for about half an hour before doing so. How frequently you need to profile depends in part on your monitor's age. As it gets older, the color will drift. Once the monitor gets to be more than three to five years old, it may no longer be able to achieve the target calibration values.

We generally recommend profiling your monitor once a month to ensure the most accurate display. You shouldn't need to profile more frequently unless the monitor is older and you notice that colors shift relatively rapidly. In that case, rather than profiling more frequently, you should consider buying a new monitor. If you forget to profile your display every month, this isn't something we'd worry about. For most newer monitors, you'd never be able to tell the difference if you only profiled once every few months.

PRINTER PROFILING

Much like the profile for your monitor, a printer profile describes the color behavior of your printer, so that the output will render accurately.

But while a monitor profile is specific to a particular monitor, a printer profile is specific to not only the printer, but also to the paper and ink you use for a particular print job. That means you'll need a separate profile for each printer-paper-ink combination you use. Fortunately, since you'll typically use a single printer and ink combination, the only real variable is the type of paper you use. For the most accurate output, you'll need a custom profile for each type of paper you'll print to.

Fortunately, printers include profiles that are generic for the printer model. These provide reasonable output provided you use the type of paper the profile is built for. If the paper you're using doesn't have a profile, you can often use a profile for a paper with a similar surface type and still get good results.

When the generic profiles included with your printer aren't accurate enough to provide the best results (see the "Evaluating Prints" section later in this chapter), either you can use the printer settings to fine-tune the output through trial-and-error, or you can obtain or build a custom profile that will improve the accuracy of your output.

Generic Paper Profiles

Each type of paper has specific absorption and reflection properties that cause variations in the appearance of colors in the print. Therefore, if you get excellent results with a matte paper from your printer manufacturer, but then switch to a third-party paper, you'll likely get inaccurate output.

To remedy this problem, many third-party paper manufacturers are providing generic paper profiles for a variety of different printers. These profiles are reasonably accurate, so if you're using a third-party paper, we recommend that you check the manufacturer's Web site to see if profiles are available for your printer. Then test the profile to determine whether it provides accurate colors in your prints.

Profiling Services

If profiles are unavailable or inaccurate for the papers you are using, a custom profile can do the job. For example, Integrated Color Solutions (ICS) offers its ProfileCity service (www.icscolor.com) that allows you to purchase a custom profile specific to your printer, ink, and paper combination for $99 each.

To obtain a profile, you simply download a target image and print it using specific settings outlined in the instructions. The printed target is then sent to ICS, where it is scanned using a spectrophotometer to accurately read the color output. ProfileCity then produces a profile that describes the color behavior of your printer-ink-paper combination and provides you with the information necessary to recalibrate your settings.

Purchasing profiles from an outside service is certainly convenient, and the results can be very good. If you only need profiles for a few paper types for a single printer, then this is an excellent way to go.

Build Your Own

If you print on a wide variety of materials, particularly with several different printers, you may want to invest in a solution that allows you to generate accurate profiles whenever you need them. These solutions are more expensive than buying a few custom profiles from an outside service, but they allow you to produce an unlimited number of custom profiles.

Building a custom profile involves printing a test target that includes patches of a variety of colors. These color patches are then read into the computer so that their values can be compared to what was expected. The patches can be read using a flatbed scanner or a calibrated spectrophotometer (which is a specialized device for reading color values very accurately). The flatbed option is much less expensive but not usually as accurate; we prefer not to recommend it, because the flatbed scanner adds its own color idiosyncrasies. An exception to this is the MonacoEZcolor package that effectively calibrates the scanner in the process of building the profile.

When printing the print target that is the basis of building the profile, it's critical that you do not apply a profile or any printer adjustments to the output. That means you should set the Print Space profile in the Photoshop Print with Preview dialog to Same as Source, and then set the appropriate options in the Printer Properties dialog so that no adjustments are applied to the printed image. We also recommended that you allow the print target to dry for 24 hours to allow the inks to fully cure before reading the patches and building a profile. The following software packages allow you to create custom profiles for your printer:

- **PrintFIX.** ColorVision (www.colorvision.com) offers a package called PrintFIX ($339) that includes a small print scanner for reading the target print. It produces

profiles that are accurate for some colors but less accurate for others. For example, the magentas and yellows tend to be oversaturated. This is a good solution for building profiles for third-party papers, and serious amateurs will find the color accuracy acceptable. However, professionals will want to hold out for solutions that use a spectrophotometer for reading the color patches.

- **DoctorPRO.** ColorVision also offers the DoctorPRO software package ($169) for fine-tuning the custom profiles you've built with PrintFIX. DoctorPRO has you adjust your monitor image to match the inaccurate print and then looks to see how the image changed. It then uses that information to fine-tune the profile so that the next print will match the original file. You won't save the settings—you'll only use them to adjust the profile. This method does provide a way to get more accurate profiles, but it can be a challenge for users who are not familiar with advanced adjustment techniques in Photoshop.

- **MonacoEZcolor.** Monaco Systems (www.monacosys.com) offers another option with their MonacoEZColor package ($299). This package does not include any scanner or spectrophotometer for reading the color patches, but rather requires that you scan the print target on a flatbed scanner. While we panned the idea of using a flatbed scanner earlier, this company has developed a clever solution for producing accurate profiles: When you scan the print target containing the color patches, you include in the scan a target (provided with the software) for evaluating the accuracy of the scanner itself (**Figure 12.4**). This method provides a user-friendly way to generate profiles that are quite accurate.

Photo by Miranda Grey.

Figure 12.4 MonacoEZcolor uses a flatbed scanner for scanning print targets (something we normally advise against), but this product has a clever solution for producing an accurate printer profile.

- **GretagMacbeth Eye-One Photo.** The way to create the most accurate profile is by scanning the print target's color patches using a calibrated spectrophotometer. That usually puts the price out of reach for most photographers, as a good spectrophotometer can cost thousands of dollars. However, GretagMacbeth's (www.gretagmacbeth.com) Eye-One Photo package ($1495) includes a spectrophotometer—at a price that photographers serious about the accuracy of their prints can justify. It includes everything you need to calibrate your monitor and produce highly accurate printer profiles, even if you buy a new printer or switch papers.

Evaluating Prints

Whether you're fine-tuning printed output with the adjustments provided with your printer driver or you're using custom profiles to get the best prints, you need to be able to evaluate the print's accuracy. Several factors can impact that evaluation process.

Lighting conditions

Every light source has a particular color cast that influences the appearance of the print. Existing color-management solutions revolve around a standard illumination of 5000 Kelvins, so using a 5000K illumination source will allow for the most accurate evaluation of your prints. You can replace your existing lightbulbs with 5000K bulbs, such as those available from SoLux (www.solux.net) and other sources. Or you can use special lamps with 5000K bulbs, as well as special viewing booths that utilize 5000K light sources (**Figure 12.5**).

Figure 12.5 Special viewing booths that utilize a 5000 Kelvin light source provide a perfect method for evaluating your prints more accurately while still doing so in close proximity to your monitor

Of course, just because color-management systems revolve around a 5000K illumination source doesn't mean that's the best solution for you. If you know what type of lighting your images will be displayed under, evaluate the prints under that lighting. It's the final result that matters.

Memory colors

When testing the accuracy of your printed output, using the right image to test with can make all the difference. If you don't, then if the print doesn't match your image on the monitor, you won't know whether it's the printer or the monitor that's to blame. Using an image that that you know to be accurate and that includes memory colors is a solution.

Memory colors are colors that you can easily identify as accurate based on your personal experience. For example, virtually everyone knows the yellow of a banana, the red of an apple, and the green of a watermelon. For example, PhotoDisc provides a target image that includes a variety of objects, many of which represent memory colors. It also includes areas of various tonal values that should be neutral, including white shelves and shadows of those shelves. If you open this image on your monitor, you'll know immediately if the display is accurate. When you print the image, you can also evaluate the accuracy of the print with no reference other than your own memory of what the included colors "should" look like. Because you know the original image file is accurate, you can determine whether your monitor or printer profiles are inaccurate based on how accurate the image appears on each. You can download the PhotoDisc target from a variety of online sources, including www.inkjetart.com/custom/.

When evaluating a print of the PhotoDisc target or other sample image, look carefully at the neutral values. The PhotoDisc target includes a chart with neutral gray blocks of varying tonal values, as well as white areas and shadows that should likewise be neutral. It requires practice to develop an eye for detecting color casts in places where an image should be neutral, and for analyzing the accuracy of memory-color objects within the image.

Fine-tuning profiles

Once you've evaluated your print, you'll want to correct any inaccuracies. If you've built a custom profile, you may be able to fine-tune it with various software tools. This process can be a challenging task, but it does give you excellent control over the final output.

You can also use the generic profiles included with your printer and then use the options available in the Printer Properties dialog to fine-tune the output color. This process can be time-consuming, because you must produce a variety of prints, adjusting the color balance for each, to find compensation settings that produce accurate output. But once you find the right settings, you can reuse them whenever you use the same paper on that printer.

We'll address the use of profiles in the printing process in the following section, including a look at how to use Photoshop's soft-proofing feature to get the most accurate output possible.

> **TIP:** *An exercise that Katrin uses to illustrate printer profiles in the classes she teaches is to print an image first with an appropriate profile and then with no profile. She then compares these two prints to show what the colors should* look like *as well as what the printer thinks they look like when a profile isn't applied. This is a good way to get a better perspective on how the profile is affecting the final output, and it can give you a better sense of how accurate the profile is.*

PREPARING TO PRINT

In Chapters 10 and 11. we showed you how to perfect your image, saving the result as an archival master image. Having a perfect image file is great, but the final print is the defining result for the photographer. An accurate printer profile helps ensure that you will be able to produce the most accurate prints possible.

Printer Types

Preparing your image file for printing involves resizing it for the output dimensions you want, sharpening that final image, and then sending the image file to the printer with appropriate settings that will ensure an accurate, high-quality print. Understanding how the various printer types work will help ensure you get the results you want, and give you a better understanding of how to prepare the image for output on a specific printer. In particular, it can be helpful to understand the resolution capabilities of various output methods.

Offset press

Offset printing is what we would normally think of as using a printing press. It is generally used for high-volume printing, such as for the weighty tome you are now holding, magazines, brochures, and other printed pieces. These presses produce images on the page by laying down ink in lines of halftone dots. Referred to as a *line screen*, those lines are a measure of how many lines per inch (lpi) the press prints.

The general rule of thumb is that the dpi output resolution of your image should be double the lpi of the printing press. Most offset printers operate at a resolution of 133 or 150 lpi, which translates into an output resolution for the image file of 266 or 300 pixels per inch (ppi). This is where the standard output resolution of 300 ppi for printing originates.

Inkjet

Photo inkjet printers have improved remarkably over the past few years, primarily due to improvements in print resolution, as well as in ink and paper quality. Not too many years ago, inkjet printers produced relatively coarse output that was mainly good for pie charts and bar graphs—not exactly something you'd want to hang on the wall.

Inkjet printers function by spraying tiny droplets of ink onto paper. At the lower end of the spectrum are printers that use only four colors (cyan, magenta, yellow, and black). The photo inkjet printers generally add light cyan and light magenta inks to increase the total number of colors they are able to produce. More recent printers also add a "light black" (what we would normally refer to as gray) ink to expand the tonal range the printer can produce.

In the last few years, the resolution and overall quality of inkjet printers has improved to the point that they produce incredibly photo-realistic output. A variety of improvements helped achieve this quality, but resolution is at the top of the list. Today's inkjet printers produce smaller ink droplets and can place them very close together with precision.

To produce photographic-quality output, an inkjet printer needs to be able to put down 1440 droplets of ink per inch. Most printers also offer lower resolutions of 360 dpi or 720 dpi. These resolution settings use less ink, but they also result in lower quality. Values above 1440 dpi really don't provide an improvement in quality, and use more ink, so there generally isn't a benefit to using such a setting. Keep in mind that the 1440-dpi printer resolution is not the same number you'll use to size your image files. The image file will be set to a resolution of between 240 ppi and 360 ppi. A setting of 240 ppi is more than adequate for photographic output, while 360 ppi will help maintain maximum image quality in the final print.

Dye sublimation

Dye-sublimation (dye-sub) printers are continuous-tone printers, which means that their output consists of continuous color gradations rather than individual droplets of ink. These printers function by heating a ribbon so that the solid dyes are converted directly to gas (sublimated) and then applied directly to the paper, where they are absorbed before solidifying.

Most dye-sublimation printers operate at 300 or 314 dpi, which are the ideal image resolution values to be used for this type of printer. In the case of dye sublimation, the output resolution of your image file should match the resolution of the printer.

Photo direct

Photo-direct printers allow you to produce traditional photographic prints from digital files. These printers produce exceptional photo-quality output (from high-quality digital files) that is almost indiscernible from a traditional photographic print. The advantage to these printers is that they can write to traditional photo media including paper, clear film, and translucent materials. However, these printers are also very large and very expensive, so you'll need to work with a photo lab to obtain this type of output.

Because of the way these photo-direct printers function, they can be thought of as producing continuous-tone output. Using a laser, or other precision light source, they use colored light to produce images that continuously blend into surrounding colors, rather than producing discrete dots such as with inkjet output. This gives this printing method a potential advantage in overall quality, although today's photo inkjet printers have improved to the point that their output could almost be considered continuous tone. These printers are good for photographers who need larger output than their photo inkjet printer will allow, or who otherwise prefer traditional photographic prints to inkjet prints. The image files prepared for this output should generally be set to 200 to 400 ppi.

Sizing the Image

To produce a specific size print with optimal quality for the printer being used, you need to set the output size and resolution before printing (**Table 12.1**). The optimal resolution is based on the type of printer you are using, as discussed earlier in this chapter. The output size, of course, depends on how big a print you want, limited only by the printer's capabilities, the paper size you'll be using, and your image quality expectations.

Table 12.1 Output Optimal Resolution Settings

Output Type	Output Resolution
Offset press	266 to 300 ppi
Inkjet	240 to 360 ppi
Dye sublimation	300 to 314 ppi
Photo direct	200 to 400 ppi

It's a commonly held myth that for most printers an image file resolution of 300 ppi produces output of excellent quality. That's why many photographers simply use 300 ppi as a standard setting for all images, regardless of the type of printer being used to produce the final image. A higher resolution setting offers the potential of better detail and quality in the final print, but with most images you would never be able to see the difference.

Once you know what output size and resolution you want to use for your image, you can use one of the many tools available to size the image based on your specifications.

Using Photoshop

Photoshop includes built-in features for adjusting the size of your image to produce high-quality output. You access these capabilities via the Image > Image Size dialog (**Figure 12.6**).

Figure 12.6 The Image Size dialog in Photoshop allows you to resize your images by specifying the output dimensions and resolution for the final print.

The top portion of the Image Size dialog provides the ability to resize your image to specific pixel dimensions. Since this is not helpful for printed output, you'll want to either change the unit of measurement to percentage or focus on the Document Size section of the dialog.

You can simply set the target Width and Height for the image, along with the desired Resolution. Keep the Constrain Proportions check box selected so that the height and width automatically maintain their proportional relationship. At the top of the dialog the new size will be indicated by the Pixel Dimensions label, followed the image's size before resizing. This tells you how significantly you're changing the size of the image.

To actually change the size of the image at a given resolution value, you need to check the Resample Image box. This allows Photoshop to change the number of pixels in the image according to the dimensions and resolution you entered. When you change the number, Photoshop uses interpolation to add or remove pixels as needed.

> **TIP:** Another way to get a better idea of the change being applied to your image is to first change the resolution with the Resample box unchecked. This ensures that the number of pixels in the image doesn't change. You can then set the output Resolution to the setting you wish to use, and the Width and Height values will automatically change to reflect the size of the image at that resolution with no interpolation applied. You can then select the Resample Image box and adjust the output size as needed. By using this two-step approach, you learn what the output size would be with no interpolation, which tells you how significantly you are increasing (or decreasing) the image size.

In addition to the Resample Image check box, there is a drop-down list that provides options for the method of interpolation to be applied. For most photographic images we use the Bicubic option, which provides better image quality than Nearest Neighbor or Bilinear. Photoshop CS also added the options of Bicubic Smoother and Bicubic Sharper. As the names imply, these settings use bicubic interpolation but with additional adjustments to smooth jagged edges or to increase sharpness of the image, respectively. The Bicubic Smoother option is the best choice for enlarging images, while Bicubic Sharper is best for downsampling an image. If you don't have Photoshop CS and therefore can't use the Bicubic Smoother option (the method we recommend), try the approach outlined in the sidebar "Alternative Methods for Sizing Images."

> **NOTE:** You will want to apply sharpening to an image after resizing it, as described in Chapter 11.

Alternative Methods for Sizing Images

- **Enlarge 10 percent at a time.** Many photographers prefer to enlarge an image in a series of steps. For example, you can achieve a slight quality benefit by enlarging the image 10 percent at a time. The difference is usually very difficult to see in the final image. However, you can achieve a more significant improvement if you apply a minimal amount of sharpening during an incremental resizing. To use this approach, enlarge the image in 10 percent increments; when you get to about half the final enlargement factor, apply Unsharp Mask with a modest Amount setting (around 150 percent to 200 percent) and a very small Radius setting (around 0.4 to 0.8). This will help enhance edge contrast in the image as it's resized, producing a final image that has more apparent detail. The Bicubic Smoother interpolation option in Photoshop CS effectively replaces the benefits achieved with this stair-step approach to interpolation.

- **Use the Crop tool.** In addition to using the Image Size dialog, you can use the Crop tool to resize your image to a specific output size. This is particularly helpful if you need to crop the image to a specific aspect ratio—so that it will, for example, fit perfectly within the dimensions of a standard frame. To size the image while cropping it, select the Crop tool from the Tools palette. On the Options bar, set the Height, Width, and Resolution settings based on the desired final print size. Then click and drag on your image to create a crop box that defines the final image area you want to include. When you double-click inside the crop box or press Enter on your keyboard, the image will be cropped and sized to the size and resolution you specified on the Options bar.

- **Use exact percentages.** Katrin also suggests doing Image Size in exact percentages—for example, if she needs to size an image up and then notices that the percentage setting reads 154.75 percent, she'll change the setting to 150 percent, which reduces image softening.

Third-party tools

In addition to the resizing tools built into Photoshop, a number of third-party solutions offer additional benefits:

- **Genuine Fractals.** From LizardTech software (www.lizardtech.com), Genuine Fractals allows you to store your image in a proprietary format that is resolution independent. You can then resize the image using settings optimized for your specific type of output. This produces an image of excellent quality at virtually any size. We have found the results to be only marginally better than those obtained with Photoshop. So we say, why spend the money and take the extra time to encode your image—stick with Photoshop's interpolation engine.

- **pxlSmartScale.** Another option is a plug-in called pxlSmartScale from Extensis. This plug-in provides direct resizing of your images in Photoshop, and produces excellent results. Our testing has shown that it consistently produces results that are slightly better than those obtained through Photoshop. But again, you need to examine the image very closely to see any difference. Unfortunately, it's only able to work with 8-bit-per-channel images.

For most photographers, simply resizing the image with Photoshop's built-in tools is what we recommend, even for producing very large prints.

Adobe Camera Raw

For photographers capturing images in RAW mode (which we strongly recommend for getting the best results), another interpolation option is available in Adobe's Camera Raw interface. (The new version of Photoshop also has this option built in; users of Photoshop 7.0 can buy it as a $99 plug-in.) Remember, the RAW conversion process interpolates the image data anyway (each pixel in the imaging sensor records a value for only one color, so the other color values for each pixel must be calculated through interpolation). Because the interpolation algorithms are optimized to achieve the best results from the RAW capture, you can get a better result if you increase the image file size at the same time. For images that you'll print at sizes larger than the size of the initial capture (which is usually a majority of the images, considering a 6-megapixel digital camera only produces a file that equates to about an 8-by-10-inch print), we recommend always interpolating to the highest available size setting during the RAW image conversion with Camera Raw.

Pushing the Limits with Interpolation

When you take a picture with a digital camera, the image contains a fixed number of pixels and in the most conservative sense this would place a finite limit on the output size possible for a given image. But photographers aren't known for placing limits on the potential of their images! Fortunately, we can increase the output size of our images through interpolation. In fact better than that—since a digital camera file doesn't have a grain structure, the way film does, you can increase the size of a digital camera file more than you can the same-sized file from a film scan.

Most photographers would be surprised at just how much they can increase the size of their image files while retaining excellent print quality. If the original capture is of good quality, you can likely enlarge the image to produce very large prints. Don't be afraid to push the limits of your digital photos.

Digital vs. film

Digital images have considerable advantages over film scans: You can enlarge them to better effect, they're sharper, and they differentiate detail better. The reasons for this are several. As mentioned earlier, film inherently contains a grain structure. This grain structure is visible in the film scan and gets exaggerated when the image is interpolated. In our opinion, film grain is not image information, and enlarging or accentuating it distracts from the actual image.

In addition, since film scans must undergo the additional step of scanning—in which light passes through the scanner's optics to become a digital image file—they are slightly less sharp than a digital image.

An image scanned from film can still be enhanced and interpolated to produce large prints, but a well-exposed digital image (preferably from a RAW capture) can be interpolated to a much higher degree relative to its original size.

When to interpolate

To get the best quality when interpolating your digital photos, you should perform the interpolation later in the image-editing process. The only exception to this suggestion is if you're using a RAW file, it is best done in the RAW state especially when you're using Adobe Camera Raw. Save your master image file for a variety of print sizes, without applying any interpolation. Then you can size the image just before sharpening and printing the image. If you like, you can save this final image as a separate file for making more prints at that size in the future.

Dot gain to the rescue

Sometimes you need to print a file at a relatively large size, but the image isn't of adequate quality to support the interpolation required. In this situation, dot gain can save the day.

Dot gain describes how ink spreads out when it meets paper. Dot gain is more pronounced with absorbent papers such as watercolor paper and other matte varieties.

Dot gain produces a slightly softer image. While it may sound counterintuitive to compensate for the softness of an image by printing it on paper that makes it look even softer, doing so can be a big help. Because of the flat surface of these more porous papers, we don't expect them to look tack sharp. That means you can get away with a slightly softer image by printing it on a porous paper.

Texture can also help to hide quality problems in your images. For example, canvas materials have a rough texture that can mask visible grain, noise, softness, and other issues in your images.

Obviously, you want to work with the best images possible, but sometimes factors beyond your control make that impossible. Choosing the right paper type can make all the difference in those situations. We'll talk more about paper selection later in this chapter.

> **TIP:** *Keep in mind that if you will be printing an image to media with high dot gain, there will be a more significant loss of sharpness in the print than if you had used a glossy paper. For this reason, you may need to apply a stronger amount of sharpening than might otherwise be reasonable for a particular image. Refer to Chapter 11 for details on sharpening techniques.*

PRINTING VIA PHOTOSHOP

To get the best photographic prints, you have to do more than simply press Print and wait for the image to roll out of the printer. You must specify the right settings both in Photoshop and in your printer—and there's more than one approach to getting the best results.

Soft Proofing

Soft proofing in Photoshop uses a custom profile to display an onscreen simulation of what the image will look like when printed with a specific printer, ink, and paper combination.

To preview your image using a specific profile, we recommend that you first duplicate the image by selecting Image > Duplicate so that you can use the original as a reference point when fine-tuning the image. Then select the original image, and choose View > Proof Setup > Custom (**Figure 12.7**). Select the appropriate profile for your printer, ink, and paper combination. Be sure the Preserve Color Numbers option is not selected, or you'll get unpredictable results.

Figure 12.7 The Proof Setup dialog allows you to select the output profile that Photoshop will use to simulate the final appearance of the print on your monitor.

For the Intent option (explained in detail in the next section), select either Relative Colorimetric or Perceptual. Check the Use Black Point Compensation box. You can also select the Paper White and Ink Black simulation options (if you select Paper White, then Ink Black will be selected automatically). These last two settings allow you to preview both the appearance of the paper where it will show through (pure white areas) and the

density of the black being used for the ink. These settings are helpful if you're working with a paper that is not visibly white, but rather has a yellow, cream, or other color cast.

When you click OK in the Proof Setup dialog, the image will be displayed as a simulation of what the final output will look like (**Figure 12.8**). You can toggle the proof display on and off by selecting View > Proof Colors from the menu or pressing Ctrl-Y (Command-Y on Macintosh).

> **NOTE:** If you select Proof Setup options without any images open, the settings you select will apply to all images when you open them.

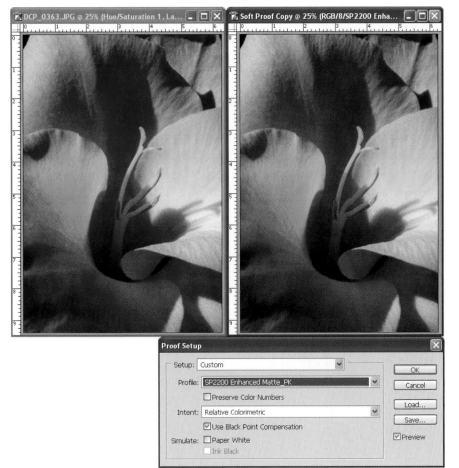

Figure 12.8 Once you've configured the Proof Setup dialog and activated the option to view Proof Colors, you can evaluate the accuracy of the final output.

You can use the Proof Colors option to do more than simulate the final output. Because you are able to see how the image will look in print after you have adjusted it, you can also fine-tune the image *while* using Proof Colors. We recommend using adjustment layers to apply these changes to the image. Even better, create a layer set by clicking on the New

Layer Set button at the bottom of the Layers palette (it looks like a folder). Name this set so you'll know what type of output the adjustments apply to, and then create whatever adjustment layers are needed inside the layer set. You can turn off the layer set if you need to print the image with a different output process.

For most photo inkjet prints, we don't find it necessary to use the Proof Colors option. For files that will be sent out for a direct photo print or offset printing, however, it can be very helpful to proof the output as part of the image-adjustment process.

Gamut Warning

When you are working with the Proof Colors option to preview the output of your images, it can also be helpful to take advantage of the Gamut Warning option, which provides a visual indication of colors that can't be reproduced using the output profile selected (**Figure 12.9**).

It is important to remember that the Gamut Warning option is helpful only when you're using the Proof Colors option with a custom profile. For example, if you are using a generic profile for your printer, or you haven't set a custom profile in the Proof Setup options, the Gamut Warning will warn you only about colors that are outside of the default CMYK profile (color space) currently set in Photoshop's Preferences. So only use Gamut Warning in conjunction with the Proof Colors option.

Figure 12.9 The Gamut Warning option in Photoshop lets you clearly see which areas of the image contain colors that can't be reproduced based on the output profile used with the Proof Colors feature, here shown in magenta.

The Gamut Warning displays a specific color over your image in areas that are outside the color gamut for the profile you've set in the Proof Setup options. You can change the color of the Gamut Warning in the Transparency & Gamut section of Preferences. We recommend setting it to a highly saturated color that doesn't appear in most of your images, such as a fully saturated magenta color.

To activate the Gamut Warning, simply select Gamut Warning from the View menu. The color you set in Preferences will then be shown in areas of the image that represent colors that can't be produced by the printer, ink and paper combination you've profiled. You can then fine-tune the image with adjustment layers so that all colors in the image are reproducible and the image matches the desired final image.

One problem with Gamut Warning is that it doesn't specify how far out of the gamut a color may be, so it may cause you unnecessary anxiety. Therefore, we prefer to rely on a well-calibrated monitor.

Print with Preview

To set the output options and ensure the most accurate output, you'll want to select Print with Preview rather than just Print from the File menu. Print with Preview presents a dialog offering additional print options (**Figure 12.10**):

Figure 12.10 The Print with Preview dialog allows you to set the appropriate output profile to ensure the most accurate print possible.

- **Position.** Position options allow you to control the precise position of your image on the printed page. Many photographers prefer to keep their image centered on the page. This is Tim's preference, even when he knows the image will be matted and framed and the position doesn't really matter. Katrin prefers to keep the lower margin larger than the top margin so that she can float the print in a simple frame. The Position option allows you to adjust this. With the Center Image check box selected, the image will automatically be centered on the page. If you want to change the position, uncheck the box and adjust the Top and Left position values, or simply click and drag the preview image around on the page preview display.

- **Show More Options.** Most important in the Print with Preview dialog are the color-management settings. To access these options you need to be sure the Show More Options check box is selected, and then choose Color Management from the drop-down list. You will then have options for selecting the output profile and output settings.

- **Source Space.** Under Source Space you will want to select Document. Proof, the other option, is used only for printing a proof preview on your printer to simulate the output of a different printer.

- **Print Space.** If you're using a custom profile, even if you have used the Proof Colors option to view a soft proof of your image, select the profile from the Profile drop-down in the Print Space section. If you don't have a custom profile, select the generic profile for your printer.

- **Use Black Point Compensation.** Select the Use Black Point Compensation check box to ensure that black is accurately mapped in the destination profile. If you're using a custom profile in this manner, it is critical that you turn off any color adjustment options in the Printer Properties dialog or you'll get unpredictable results when you print the image.

- **Intent.** The Intent option allows you to select a *rendering intent*, which defines how colors that are not available in the destination profile are dealt with. With the Relative Colorimetric rendering intent, colors that are within the color gamut of the destination profile will remain unchanged. Colors that are outside that gamut will be shifted to the closest matching color within the gamut. The Perceptual rendering intent causes all colors to be compressed to fit within the destination space. This can cause a slight shift in the image, but it maintains the relationships between colors. For most images the Relative Colorimetric rendering intent is the best choice. If you have significant colors that are out of gamut (which you can determine using the Gamut Warning option), then Perceptual may be a better choice.

With the color-management settings established in the Print with Preview dialog, you can click the Print button to select your printer and set the appropriate properties based on the type of output you're producing.

Printer Properties

Once you've clicked the Print button from the Print with Preview dialog, you can select your printer from a drop-down list. Then you must click the Properties button to select additional options for your printer. The right settings in the Properties dialog are essential for getting the best prints both in terms of quality and color accuracy (**Figure 12.11**).

Figure 12.11 In addition to using the appropriate profile settings in the Print with Preview dialog, using the correct settings in the Printer Properties dialog is a critical step in achieving accurate prints.

- **Paper type.** One of the most important settings is the paper type. Each paper type has different absorption qualities and will produce a different color effect as a result. By selecting the correct paper type, the printer will adjust output to produce the most accurate results. If your paper type isn't listed in the options, select the type that is closest in terms of surface type.

- **Output quality setting.** The right output quality setting has a dramatic impact on the quality of the final print. For glossy papers a setting of 1440 dpi or higher is best. For some matte papers a lower setting may be required, but we don't recommend using anything lower than 720 dpi output. With some printers these options are labeled with names such as Photo or Best. Check your printer manual for recommended settings. In many cases, the highest quality setting (such as 2880 dpi) will use more ink and take longer to print, but will not provide a visible improvement in print quality.

- **No Color Adjustment.** If you are using a custom profile, it is important to select the No Color Adjustment or equivalent option in your printer properties. Otherwise, the printer will adjust the output and defeat the purpose of the custom profile.

- **Color adjustment.** If you've selected the generic profile for the printer, then you may want to use the available color-adjustment options. Start with all settings at their neutral values and then produce a test print. Then print again, revising the settings to produce the most accurate print. Through trial-and-error you'll find the settings that give you the most accurate colors. Save those settings so they can be used whenever you use that particular paper.

- **Paper size and adjustments.** Finally, you select the correct paper size, as well as the other available options. For example, most photographers prefer to center the print on the page (even when it's going to be matted later). A variety of options allow you to adjust the way the image prints. The quality and color settings are the most important, but the other available options can be helpful as well.

Black and White

While photo inkjet printers are designed for optimal color output, many of them can be used very effectively for black and white prints. The key thing to remember when printing black and white images is that you want to use the same settings as you do for color prints. Most important, you should set the option in your Printer Properties dialog to print with all of the ink colors, not just the black ink. Even though you don't want any color in the image, using only the black ink will severely limit the tonal range of the final print, producing images without smooth tonal gradations.

Many printers have a hard time producing perfectly neutral black and white prints. A highly accurate custom profile should allow you to produce neutral prints. However, if you don't have an accurate profile, or if you aren't using a custom profile at all, you'll need to use the generic profile for your printer.

When using a generic profile, you'll most certainly need to adjust the output settings to get a neutral print. Create a test print with the settings at their neutral values, and then make adjustments for the next print based on the accuracy of the test print. Through trial-and-error you should be able to produce a neutral print with most printers (**Figure 12.12**).

Unfortunately, when printing with a generic profile, many printers simply can't be adjusted to produce a neutral print. Exceptions are the Epson Stylus Photo 2200 printer and the larger Stylus Pro 7600 and 9600 printers, which often cause a slight magenta cast in the print; however, you can offset this problem using the Color Controls option in the Printer Properties dialog so that the printers produce perfectly neutral black and white prints with excellent tonal range.

Besides working with your printer's existing Printer Properties settings, you can also use other software to help improve the accuracy of your output. Software such as ImagePrint from ColorByte Software (www.colorbytesoftware.com) provides exceptional control over the output process, allowing you to exercise tremendous control over the printing process. This can help you to produce perfectly neutral black and white prints, or to add color tints to those images when desired.

Figure 12.12 With some fine-tuning of the output settings, you can produce perfectly neutral black and white prints with the Epson Stylus Photo 2200.

Inkjet archival issues

We discussed the issue of print longevity as it related to the inks used in various inkjet printers in Chapter 8. The type of ink used—whether dye-based or pigment-based—is the most significant factor affecting the longevity of your print. All prints are sensitive to light, temperature, and humidity levels, and the way the images are stored and presented impacts how long they'll last before noticeable fading occurs.

Of course, you'll get the best print longevity if you put your print in dark storage in a temperature- and humidity-controlled environment. That may sound silly, but consider that you may have important family images that you want to pass along to other family members in print form. In that case, storing them carefully will help ensure that they last for many generations. For pigmented inks, prints in dark storage will generally last for over 200 years, based on accelerated testing conducted by Wilhelm Imaging Research (www.wilhelm-research.com).

We consider the testing conducted by Wilhelm Imaging to be the most accurate assessment of potential print life. While the company doesn't test all printers, it does test many of the most popular models. You can check its Web site for longevity estimates for many printers using a variety of papers.

For images that will be on display, one of the best things you can do to ensure long display life is have the image professionally matted and framed under glass (matting should prevent the image from contacting the glass). This will provide a sealed environment that will block most ultraviolet (UV) light. Hanging the picture where it won't receive direct sunlight also helps.

Fortunately, with digital images you can always open your master image file and produce another print. Still, when you display a print, you want it to last as long as possible, so use care in selecting the best environment for displaying your prints.

OUTSIDE PRINTING

No, we're not talking about taking your digital darkroom outdoors. We're talking about having your prints produced by an outside service. This involves perfecting your image based on your monitor display, and then sending the file to someone else so they can print it for you. Taking this route is particularly useful when you need an image printed at a size larger than your printer allows, or in large quantities.

Direct Photo Prints

A variety of high-end printers such as LightJet and Chromira models (often costing hundreds of thousands of dollars) can expose light-sensitive photographic paper from a digital file, producing a true continuous-tone photographic print from your digital image. These printers are an excellent choice for photographers who prefer photo paper to inkjet paper. They are also an excellent option when you need a print larger than your printer allows.

It's important that you discuss the file preparation requirements for a direct photo print with the lab that will be producing the image. Most labs require an RGB image in the Adobe RGB (1998) color space, sized to the final output size at 300 dpi. It should be a flattened image with all alpha channels and paths deleted, saved in 8-bit-per-channel mode. In most cases you won't need to apply a custom profile yourself for the print. It may be helpful to include a proof print along with your digital image file, although there will probably be an additional charge if your image needs to be adjusted to match the proof print in the final output.

Online Print Services

Digital photography and the Internet have enjoyed a similar rise in popularity at the same time. They seem a perfect match in many ways. Sure enough, there are no shortage of online companies offering photo-printing services, such as Ofoto (www.ofoto.com) and Shutterfly (www.shutterfly.com). These services are best suited for producing quick prints conveniently, or for allowing far-flung family and friends to purchase copies of your images. The print sizes are limited, with some offering a maximum print size of 8 by 10 inches.

Most of the online print services use some form of direct photo printer to produce traditional photographic prints from your digital image files. You'll want to check with them for the most appropriate settings to ensure the best image quality. For many of these services, the Adobe RGB (1998) color space will provide excellent results. However, many of them produce the best results if you first convert your images to sRGB.

While you would typically want to size the image to the final output size at 300 dpi, in some cases the online services will require a lower image size than the final results would normally require. There will also be restrictions on the maximum file size you can upload for printing, and in most cases the image will need to be saved as a JPEG rather than a higher-quality TIFF image.

Even with these restrictions, the prints produced are of excellent quality in most cases, and are particularly good for snapshot photos. Be sure to carefully review the image requirements for the service you're using before uploading images and ordering prints.

Offset Printing

Sending images for output on a printing press requires a bit more preparation to ensure the most accurate output. With offset printing, there are many different printing presses, and even more ink options, which produces a tremendous amount of variation.

There are two basic approaches to offset printing. Ideally, you can provide an RGB image in the Adobe RGB (1998) color space, along with a proof print so the press operator will know what the final output should look like. In this case you would size your images to the final output size at 300 dpi, save them as TIFF images with no layers, and send the image files to the printer along with your proof prints.

If the printer requires that you convert your images to CMYK color, you'll want to obtain a custom profile for the specific output conditions, as well as specific settings to use in the Photoshop Color Settings dialog. In case your printer can't or won't provide a profile, then the basic SWOP 2 setting in Photoshop will provide good results in the United States. It is also a good idea to send a couple of sample images for a test print run if possible.

With the proper settings established in the Color Settings dialog, you can select Image > Mode > CMYK Color to convert the image based on the profile and other settings you've set. The image may look completely wrong on your monitor, but this should not be a cause for concern.

With the right settings, you can prepare your images in the CMYK color mode and be assured of excellent output in the final press run. It is still a good idea to provide proof prints along with the image files, so that the press operator knows what you intend the final output to look like and can either make adjustments as needed or stop the print run if the image files aren't producing accurate results.

The most important thing is communication with the printer. Talk to them about their specific image requirements ahead of time, and follow their instructions carefully to ensure the best output possible.

THE PERFECT PRINT

Once you've expertly adjusted your images so they match the vision you had when you pressed the shutter release, and you've produced excellent prints from your images, it's time to share those images with others. That means creating a portfolio so that others can view your images, whether it for pure enjoyment, for a potential purchase, or for any other reason. In the next chapter we'll show you how to prepare the perfect portfolio.

CHAPTER THIRTEEN

The Digital Portfolio

As photographers, we create images to nurture and to satisfy our creative inspiration, as well as to share our images—our vision—with others. We don't photograph images and then hide them from the world—not our good ones, anyway. We want our pictures to be seen.

In previous chapters we have shown you how to improve your photography, how to optimize your images in the digital darkroom, and how to produce the best prints possible. While prints represent the ultimate goal for many photographers, digital photography offers many other opportunities for creatively sharing images. These include Web galleries, digital slide shows, and print packages.

These additional viewing options enable us to present our images in alternative ways to a much larger audience than we would otherwise be able to reach. Naturally, the Internet represents the widest possible audience, and many photographers are taking advantage of sharing their images with this huge online global community.

PRESENTING PHOTOS ONLINE

With a potential audience numbering in the billions, the Internet gives new meaning to *sharing your photos*. Whether you just want a virtually limitless number of people to be able to see your photos or you want to tap into a huge market to sell prints or license your images, the Internet offers great potential. It also offers an incredibly convenient way to share your images. If a client needs to see and approve images from a photo shoot, if a designer needs to select just the right image to use in an advertisement, or if distant family members want to see the latest pictures of the kids, the Internet allows you to quickly make your photos available to anyone with online access.

Preparing Photos for Online Viewing

Images shared online will naturally be viewed on a monitor, which provides a very different experience than a printed image. Because of those differences, you need to optimize the image for display on a monitor.

- **Sizing images.** First, you'll want to size the image appropriately for online display. Most likely, the Web viewer who's interested in photography and graphics has their monitor set to a display resolution of 1024 by 768 pixels. This measurement provides an outer limit for your image size, but of course the Web browser's interface elements further restrict the available viewing area. Whether your intended audience will likely be more advanced users operating at a higher resolution, or more novice users at a lower resolution, you'll want to change your sizing strategy accordingly.

 Even assuming the average viewer will have their monitor set to 1024 by 768, you don't generally want to create images that will fill the screen. Doing so swells the file sizes, so they take longer to download and display. Instead, we usually aim for an image that fills about one-quarter of the screen, which translates to an image size of about 600 by 400 pixels.

 You can size the images directly in Photoshop by selecting Image > Image Size. Then with the Resample Image check box selected, simply enter a new height or width for the image. If you have the Constrain Proportions check box selected (which we recommend), the other dimension will be automatically adjusted to maintain the proportions of the image.

 > **TIP:** Another helpful trick for sizing your images for the Web is to scale them to a specific percentage of the image's display. Be sure your monitor resolution is set to what you estimate to be the average for most of your Web viewers. Then use the zoom tools in Photoshop to view the image at the size you want it to appear on the Web and note the zoom percentage the image is displayed at. Then select Image > Image Size, and in the Pixel Dimensions pane of the resulting dialog, change the unit of measure drop-down to "percent," and enter the percentage zoom shown on the image title bar (or the Navigator palette) (**Figure 13.1**). Click OK, and the image will be resized accordingly. If you return to a 100 percent view of the image, you'll see how large it will appear for viewers who have their monitor resolution set the same as yours.

Figure 13.1 You can use the zoom percentage to resize your image for the viewer.

- **Converting to sRGB.** In Chapter 12, "From Capture to Monitor to Print," we discussed using color-management techniques to produce the best prints. Unfortunately, on the Internet color management is irrelevant because Web browsers currently don't support color management. To get the best colors possible, we recommend converting images that will be displayed on the Web to the sRGB color space. This color space is designed to match the color display on a typical monitor, so it will ensure the most accurate colors. In Photoshop, select Image > Mode > Convert to Profile, select "sRGB IEC61966-2.1" from the Profile drop-down, and click OK.

- **Sharpening.** In Photoshop CS, in Image Size, choose Bicubic Sharper when downsizing images. With earlier versions of Photoshop, sharpening the final image will improve its final appearance. We recommend using Unsharp Mask with a small Radius setting (about 0.4 to 0.8) and a modest Amount (about 125 percent to 200 percent). Because the monitor display accurately represents what the final image will look like, you can use the preview to determine the best settings to use.

After resizing the image, converting it to sRGB, and sharpening as needed, you're ready to save the image as a JPEG file (the only Internet-compatible format we recommend for photos). We advise using the Save for Web option because it gives you much more control over the options for the image file. Select File > Save for Web to display the Save for Web dialog. We prefer to use the 4-Up tab to preview the image, which will display four samples

at varying quality settings. Select the JPEG High option from the Preset drop-down to provide a good starting point for your images. You can fine-tune the Quality level for any of the four sample images, allowing you to preview the effect of applying more or less compression on the image file (**Figure 13.2**). The content, image size, and target audience will affect how you balance image quality versus file size. Once you've adjusted the image to suit your needs, click the Save button, and enter a filename and location for your image.

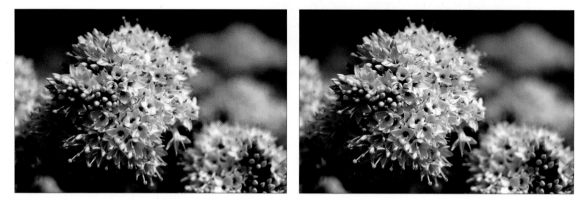

Figure 13.2 A JPEG image's quality depends on how much compression you apply: The higher the compression, the lower the image quality. The image on the left was saved at a low quality setting, producing significant artifacts and image quality problems. The image on the right was saved at a high quality setting, providing an excellent image.

What About GIF?

The GIF (Graphics Interchange Format) file format ensures small files sizes, but it's generally not the best choice for photographic images. The GIF format is specifically designed for images with solid colors (such as navigation elements) that will be displayed on a monitor rather than printed. GIF files support only a maximum of 256 colors, and while you can optimize those colors, 256 simply isn't enough to produce a realistic photographic image.

Sharing via Email

By now I'm sure we've all received a photo from someone who just got a digital camera and couldn't wait to share their first snapshots. You can recognize these email attachments because they take forever to download; and if the pictures are inserted directly in an email, they're so big on screen that you can see only a tiny portion of the image (**Figure 13.3**).

Figure 13.3 If an image is not sized properly before it's inserted into an email message, it takes longer to download and may appear huge to the recipient, with only a small portion of the image visible.

You need to keep in mind the way monitors display images and how fast the recipient's Internet connection is. We'll talk about sizing your images specifically for email in the following section, but the rule of thumb is to keep them relatively small if you're sending them over email, especially to someone with a dial-up connection to the Internet (**Figure 13.4**).

Figure 13.4 An appropriately sized image for email should take minimal time to download and will appear at a reasonable size.

When sending an image via email, you have two options: to insert the image or to attach it. Inserting is an option only if you're sending messages in HTML format. It causes the image to actually appear within the text of your email where it was inserted. This is the most convenient option for the recipient, provided their email software lets them view HTML messages—and these days most email software can. Attaching the image transmits it as a separate element with the email. This method requires the recipient to take an extra step to view the image, but it makes it a little easier for them to save the image if they need to.

Photo-Sharing Services

If you don't have your own Web site, you can still share your images on the Internet. Countless Web sites offer photo-sharing services that let you upload images and make them available to anyone online (**Figure 13.5**). You'll need to prepare your images as described earlier in this chapter, but the process of posting your images is handled easily through the site. Besides posting your images, many sites allow your friends and family to purchase prints or other items such as caps, t-shirts, and calendars featuring your images.

Figure 13.5 Online photo-sharing Web sites provide a convenient way to make your images available to a large audience.

It would be impossible for us to list all of the sites that offer some form of photo-sharing service, but some of the most well known include www.imira.com, www.ofoto.com, and www.shutterfly.com.

Web Gallery Software

Online photo-sharing Web sites provide a simple and convenient way to provide access to your images, but they don't offer the degree of control you enjoy when you create your own Web site. With your own site you can design the pages exactly the way you want them, which means you can customize the presentation of your images.

Even if you're an expert Web designer as well as photographer, using automated software makes it fast and easy to assemble a gallery of images to share. You can then upload the pages and images to your Web site and make them available for all (or just a few, if you password-protect the folder) to see. Besides automating the task of creating the Web pages, these software tools also automatically resize your images so you don't need to prepare them ahead of time. For the best image quality, however, we recommend sizing your images yourself, converting them to the sRGB color space, saving them as JPEGs, and then using them with the following automated Web gallery packages.

Photoshop Web Photo Gallery

Photoshop's Web Photo Gallery automation tool creates a good basic photo gallery for you to display on the Web. It offers a selection of templates and options for fine-tuning the final appearance of the pages and images. Some of the templates even include sophisticated options such as allowing viewer feedback about the images.

We often use Photoshop's Web Photo Gallery to post client review files or to quickly update our Web sites (**Figure 13.6**).

Figure 13.6 A Web photo gallery allows you to quickly make images available for clients and friends to review.

You access the Web Photo Gallery dialog by selecting File > Automate > Web Photo Gallery. The Site section at the top controls the overall appearance of the site. You can select a template from the drop-down, with a preview displayed on the right side of the window to give you a basic idea of the overall appearance of the final layout. You can also enter your email address, which will be incorporated into the page with a link so that viewers can easily contact you.

Creating a Web gallery of your images is a simple matter of setting the following options:

1. **Select a source for images**. You select the source images that will be included in the final gallery pages in one of two ways. If you use the File Browser to select the images you want to include, you choose the "Selected Images from File Browser"

option in the Web Photo Gallery dialog. Otherwise, the Folder option lets you click the Browse button to select a folder on your computer to add all files within the folder to the Web gallery. Images in all subfolders within the selected folder will be included if you select the Include All Subfolders check box.

2. **Specify a destination**. In addition to selecting the source of your images, you also must specify a destination for all the images and Web pages the Web Photo Gallery tool will create. Clicking the Destination button allows you to browse for a folder, adding a new folder in a selected location if needed. Please note: You must choose a different folder for your destination than your source folder.

3. **Fine-tune other options**. Once you've defined the basic structure of your gallery, you can fine-tune the various options. These include general options that control the HTML code for the Web pages, banner settings that allow you to define a name for the gallery and include contact information on the pages, sizing options for both the large images and the thumbnails, options to change the default colors for text links, and a security option that allows you to have some form of copyright text overlaid on each image to help prevent unauthorized use.

4. **Create your Web Photo Gallery**. Once you've set all of the options, click OK to launch the Web Photo Gallery tool into action. It will open each image based on the options you set in the Source Images section, size them as needed, and generate Web pages based on the specifications you have provided. The final gallery will be saved in the location you specified, and the resulting page will display in a Web browser for your review when the process is complete. The last step is to upload the files to a Web site.

5. **Upload the gallery files**. When you create a Web photo gallery with any of the software tools that automate this process, all of the image and HTML files will be saved in one folder, most likely with subfolders to store the various page and image elements.

 To post the gallery to your Web site, launch your FTP (File Transfer Protocol) software and log in to your Web hosting account. Create a new folder on the server for the files. Browse to locate the gallery files you created, and then drag that folder into the folder you created on the Web site and begin the transfer. When the files have uploaded successfully, test the gallery with your Web browser. If everything works properly, you can copy and paste the link to include it in an email to those with whom you'd like to share your images.

Other Web Gallery Options

If you're using Adobe Photoshop Album to organize your images, you can also use it to create a Web gallery with many of the same options found in Photoshop's Web Photo Gallery. Simply select the images you want to post, and select Web Photo Gallery from the Creations menu. The Web Photo Gallery dialog will appear, offering most of the same options as the Photoshop Web Photo Gallery. You can't select a source for your images because the only option is to include images (or a subset of those images) you have selected within Album. However, the other options for page and image layout are available, allowing you to fine-tune the final pages.

In addition, many of the image-management software tools include the capability to create Web photo galleries, with some enabling you to define your own templates. Some of the software that allows you to create your own galleries includes ACDSee (www.acdsystems.com), CompuPic Pro (www.photodex.com), and iPhoto (www.apple.com).

PROTECTING PHOTOS ONLINE

For photographers to maintain the value of their images, they must control the use of those images. In the past, the risks of unauthorized duplication of photographs weren't very high. If someone saw your image, it was likely as a print on the wall, and making a high-quality copy of that print was virtually impossible.

The digital world provides new opportunities for your images to be copied without your permission, and those copies may be of identical quality to the original. Because online digital image files can easily be copied, they need to be protected.

For your own image archive, protecting the images is a simple matter of protecting the devices used to store the images, such as CD, DVD, and hard drives. But when you post the photos online, the risks rise considerably.

> **TIP:** *If you register your images with the U.S. Copyright Office, you'll enjoy additional protection should you need to pursue legal action against an infringer. We'll talk about registering your images for copyright in Chapter 14, "Archive, Catalog, and Backup."*

> **NOTE:** *Commercial photographer Seth Resnick takes an interesting approach: He requires visitors to his Web site (www.sethresnick.com) to acknowledge and accept that his images are protected by U.S. Copyright law and complete a registration form before they can enter the main Web site. This way, if one of those visitors steals an image from the Web site, it will be that much easier to prove their intent to break the law.*

You can't completely prevent unauthorized use of your images if you put them online, but you can certainly do your best to make it as difficult as possible.

Size Restrictions

Keeping the size of your images small won't stop Web site visitors from taking them, but it will limit what they are able to do with them. A relatively large image size of 600 by 400 pixels for the Web translates into an image that would only print at 2 by 1.3 inches with good quality. The image could be interpolated to a larger print, but large prints of excellent quality won't be possible. Saving images in the JPEG format will also leave compression artifacts in the image, further ensuring that large prints won't look good.

We recommend keeping your images sized at 600 by 400 (or smaller) for Web site viewing. For a monitor set to 1024 by 768, a 600-by-400-pixel image will consume about one-quarter of the available space on the monitor. If you need to provide larger images, be aware that someone could print those larger images at larger sizes.

Visible Watermark

A watermark is a visible mark on the image that discourages viewers from using it by making it clear that the image is protected by copyright (**Figure 13.7**). The disadvantage is that a visible watermark adds a visible element to your image that most photographers would rather avoid. The picture was taken to show the scene depicted, not to emphasize who holds the copyright. For this reason, most photographers avoid using a visible watermark.

Figure 13.7 A visible watermark can certainly protect your image, but at the cost of degrading the viewer's experience of the image.

However, if you decide that using one works for your purposes, you'll get the maximum deterrent effect by using a watermark that covers a significant portion of the image. A popular example is to place a partially transparent copyright symbol over the full area of the image. To soften the appearance of the watermark text, simply reduce the Opacity setting on the Layers palette for the text layer. This will allow the underlying image to show through partially, reducing the visual impact of the watermark while maintaining its deterrent effect. The viewing experience is less than ideal, but the image is certainly not likely to be stolen.

Some alternatives are to either put more-discreet text listing the copyright holder in a corner of the image, leaving most of the image clearly visible; or, if you don't want a watermark to block any of the image, you can enlarge the canvas in Photoshop and put the watermark text outside the image area. This is a reasonable solution if you want to allow the viewer to see the whole image but still want to be able to demonstrate that they willfully stole the image as evidenced by the cropping of the watermark, if you pursue legal action. However, it's also easy for an image thief to crop your watermark out of the image, or to clear it with the Clone Stamp in Photoshop.

> **NOTE:** Downloading another photographer's images, whether they're watermarked or not, and cropping them or changing them in any way is against international copyright law.

However you decide to implement your watermark, the basic method for creating it is the same. In Photoshop, select the Type tool from the Tools palette, and click on your image where you want the text to begin. Type the text using an appropriate font size, with a color that contrasts with the image. We tend to use white with most images, unless it's a particularly bright image.

Copyright in Metadata

As a commercial photographer, Seth Resnick is a strong advocate for copyright protections for photographers. He offers the following technique for creating an action (which allows you to record tasks so they can be automatically run later) to add copyright information to the File Info metadata you can store with any image file:

1. Open any image in Photoshop.
2. Under the window menu choose Show Actions.
3. At the bottom of the Actions palette click the Create New Set button, which has a folder icon on it. Call the set something like File Information.
4. Name the set and create a new action within the set. Name the action something like Insert File Info. If you want, you can assign a keyboard shortcut of your choice for the action.
5. Click Record.
6. Go to your open image and choose File > File Info. Then choose Section General.
7. In the Caption box, place "© 2003 (photographer's name) All Rights Reserved." (To get the copyright symbol, press Option-G.) I add my address and phone number, the caption, the copyright registration number, and the license agreement information.
8. Under Copyright Status, Choose Copyrighted Work.
9. Under Copyright Notice place "© 2003 (photographer's name) All Rights Reserved."
10. Under Owner URL, place your URL. Under General, you can also fill out Job, Name, and Title, and fill out the sections under Keywords and Origins as well. I typically insert licensing information in Instructions under the Origin menu, as well as inserting it in the caption section.
11. Choose OK. You'll notice that the copyright symbol is now in front of the image name when you open the file in Photoshop.
12. Close file and save.
13. Go back to the Actions palette and choose Stop Recording (the little black square).

You now have an action for inserting this data into every image. To make this process even easier, set up a batch process so that you can process many images at once with the following method:

1. Set up a folder on your desktop called either Metadata or Copyright.
2. Under the File menu choose Automate and select Batch. Place all your images to be copyright protected in the folder. Choose the copyright action you recorded earlier and the source folder, and choose Play.

Invisible Watermark

If you don't want a visible mark on your images, but you still want to mark them as yours, an invisible watermark provides a possible solution. The most popular option is the Digimarc plug-in from Digimarc Corporation (www.digimarc.com). This plug-in embeds in the image a watermark that holds key information about the copyright holder. This won't deter theft, but it will help you establish that an image is actually yours and was taken without permission.

The Digimarc plug-in actually changes the pixel values of your images slightly, so that information can be embedded into the image. You can use a plug-in that's included in Photoshop to read the watermark so you'll know who the owner is, and the copyright symbol will be included in the title bar of the image. Because pixel values are changed, the image can get a bit soft and grainy if too strong a watermark is applied. The plug-in can vary the strength of the watermark. A more durable watermark causes a more visible loss of quality in the image, but it helps to ensure that even with adjustments to the image the watermark data will remain intact.

To apply an invisible watermark to your images using this plug-in, you must sign up for a subscription service from Digimarc. Prices range from $49 per year and up depending on how many images you need to watermark. Digimarc also provide a MarcSpider service that crawls the Internet searching for images with your watermark, actively seeking Web sites that have infringed on your copyright. While some stock photography agencies have claimed success with this service, our testing has shown that it is not effective for finding images, except those used on very high-profile Web sites.

If you appreciate the benefit of having your images tagged with your information so that those who save your images can view copyright data, then Digimarc provides a solution. For most photographers the actual benefits are minimal—in reality, most people who have a mind to use an image without permission aren't going to bother checking for a Digimarc tag.

Table Method

Many tricks for protecting images online have been developed, and using a table to hide the image is one example. If you're creating your own Web pages, this option will make it more difficult for the casual Web site visitor to steal your images.

To use this method you first need to create a transparent GIF file that's the same size as your image. Then create a table on the Web page and set the background image for the cell to the "real" image. Then insert the transparent GIF inside the cell of the table. If the visitor to the site right-clicks (Control-click on Macintosh) to save the image, they'll save the transparent GIF instead of the underlying image they were trying to save.

This solution involves considerable effort for the photographer, but it will discourage all but the more advanced Web visitors.

A variation on the table method makes use of the Slice tool and ImageReady software that is bundled with Photoshop. With an image open, go to ImageReady (click the Edit in ImageReady button at the bottom of the Tools palette). Use the Slice tool to "cut" the image into multiple pieces. Then select File > Save Optimized As from the menu. In the Save Optimized As dialog, set the Save as Type option to "HTML and Images," choose a destination folder and filename, and click Save. You can then open the saved Web page in your HTML editor, and copy and paste it into the page required. When the user tries to right-click to save an image, they'll only be able to save a small piece of it. This won't prevent more advanced users from stealing your images, but it can certainly deter many users.

Web Programming Protection

For more advanced users who want to provide the maximum protection possible for their online images, there are programming options for your Web site that can help protect your images. These methods include using mouse rollover images, disabling the right-click option that allows viewers to save images, and using plug-ins that limit the ability to view images without permission.

- **Rollover.** Mouse rollovers display a different image when the mouse is moved over an existing image on a Web page. These can be complicated to create directly with HTML, but Photoshop makes it easy with its included ImageReady program. You can create a layered image in Photoshop, then jump to ImageReady and define a rollover state for the image, with a different layer visible for that state. For example, you could create a mouse rollover state that includes text with contact information, a copyright notice, or a blank image (**Figure 13.8**).

Figure 13.8 With a mouse rollover effect, you can prevent unauthorized copying of your images via certain methods. The image on the left is what the viewer will see when the mouse is not over the image. When the mouse moves over the image, it changes to the image on the right.

- **Disable right-click.** For users who don't mind doing a little HTML programming for their Web pages, some JavaScript routines provide several ways to protect your images. The most common disables right-clicking of the mouse, which is a common way for viewers to access the Save Image option of their Web browser. This can deter some users from stealing images, but can be frustrating for visitors who use the right-click option to navigate on a Web site. For example, Tim uses the right-click option to open links he wants to follow into a new browser window, and he gets incredibly frustrated when a Web site disables this functionality. Of course, a savvy user can quickly defeat this security measure by simply turning off JavaScript support in their browser preferences.

- **Plug-ins.** One of the most effective ways to protect your images online is to use some form of plug-in that restricts access to images. To view images a user must download and install a plug-in, although the latest browser versions often handle this chore automatically in the background.

 These plug-ins aren't foolproof, but they will probably deter all but the most advanced users. The best solution we've seen in this category is D-Lock from Partners in Software (www.imageescort.com). It provides excellent protection for your images, except that images can be viewed only in a pop-up window, not on your actual Web pages. The level of protection it offers doesn't come cheap: At this writing, D-Lock will cost you $1895.

Limits of Protection

It is important to keep in mind that you can only do so much to protect your images online.

As mentioned earlier, our recommendation is to keep images small enough that they can't be used to produce large prints of high quality, and to use a subtle watermark to indicate that the images are protected by copyright. While more aggressive methods of protecting your images exist, either they require a significant investment of time and money, or they create an inconvenience for those who visit your Web site to see your images, or both. Actively enforce any violation of your rights as a copyright holder, but understand that sharing your images on the Internet involves a certain amount of risk.

> **TIP:** Katrin has actually received emails from complete strangers telling her that her images were being used or posted without her permission. She followed up with the offending Web site owner and demanded that the images be removed—so far this has worked every time. On a more positive note—she has also sold image usage of images she placed on her Web site that she thought no one would be interested in.

DIGITAL SLIDE SHOWS

Digital projectors allow you to take your images to any audience and share them with great flexibility. When the only projectors available were slide projectors, most photographers settled for showing one image at a time, with no transitions between images. Those who wanted to invest the time and money in more advanced solutions created custom slide mounts and used multiple projectors with a dissolve unit to combine and transition between images.

Digital projectors provide all of the capabilities of slide projectors, and much more. You can include multiple images on each "slide," use remarkable transition effects between images, easily synchronize images with music, and even include video clips in your show.

Preparing Photos for Projection

Getting your images ready for a digital slide show is identical to the process of preparing images to share on the Internet or via email, except that the size of the images will be different. This is because a digital projector behaves essentially the same way as a computer monitor, except that it's projecting an image to be displayed on a screen or wall rather than directly on a monitor.

The size of the images will depend on the resolution supported by the digital projector you'll be using. The computer running the slide show must also support that resolution, but that shouldn't be a problem, since most computers support much higher resolutions than today's digital projectors offer.

Most digital projectors currently offer XGA resolution (1024 by 768 pixels), with some of the lower-end models topping out at SVGA (800 by 600). SVGA is fine for shows being presented to a small audience on a small screen, but XGA will provide a higher-quality and a more detailed image that will translate better on a larger screen. Progress has been relatively slow with digital projectors, especially when compared with the rapid advance of digital camera technology. As with most digital technology, however, future projectors will eventually produce higher resolution, and the prices will continue to drop over time.

Once you know the resolution of the final projected image, you know the maximum dimensions possible for your images. This represents the largest you should size them for optimal display with a reasonable file size. For example, if you're using an XGA digital projector, you'll want to size your images to fit within 1024 pixels wide by 768 pixels tall.

For projected display the output resolution (dpi) doesn't make any difference. Only the pixel dimensions affect the size and detail of the image in the projected display. However, with some of the software used to build digital slide shows, the image will be sized properly

only if it's set to an approximate display resolution. In those situations, you'll want to set the output resolution to 72 dpi for Macintosh and 96 dpi for Windows. We are in the habit of setting this output resolution just to be sure the images are sized properly before we place them in the slide show. You can always resize the image once you've placed it in the software with no loss of quality, since the wrong resolution just means the image will be scaled incorrectly. However, it's much more convenient to have it sized properly to begin with.

We still recommend converting the image to the sRGB color space and sharpening the image to optimize its appearance on your monitor, just as we explained earlier in this chapter for preparing your photos for online sharing.

To help achieve optimal performance for the slide show, you should keep the image file size as small as possible. Large files require more processing, and can cause problems such as transition effects that aren't smooth. We therefore recommend saving the images in the JPEG format, with a quality setting of about 8 to 10. This will provide excellent image quality with a reasonably sized file.

Slide Show Software

With your images prepared you're ready to create the actual digital slide show. Many software tools do this job, all providing the same general capability to create a basic slide show presentation. Where they differ is in the advanced capabilities they offer. Some programs offer advanced features such as showing more than one image on the screen at a time, applying various transition effects between images, synchronizing slides with music, and more. The right software depends in large part on the type of show you plan to present.

We'll share some of the most popular choices (and our choices as well) for creating digital slide shows, but keep in mind that many other options can more than meet your needs. Each of the following options provides an excellent solution for creating slide shows; the best choice for you depends on the type of show you want to create and the features you need.

Apple Keynote

At first glance, Apple Keynote (Macintosh only, www.apple.com/keynote/) may look like it was designed with only the corporate presenter in mind. However, it offers an excellent method for creating photo slide shows. It includes a number of predesigned themes to get you started, and lets you edit those themes or even build your own. You can combine multiple images into one slide, and use its excellent dissolve and 3D transitions to produce an impressive slide show.

Keynote is the application that Katrin uses for her image presentations, and she has received many positive comments on the quality of the fades and dissolves in the shows.

Microsoft PowerPoint

While Apple Keynote looks like it was designed for the corporate presenter, Microsoft PowerPoint (Windows and Macintosh, www.microsoft.com/office/powerpoint/) is indeed designed for corporate presentations. However, it can also be used to produce excellent digital slide shows of your images.

PowerPoint includes many themes and templates to help get you started quickly, and gives you great flexibility as you design your slide layout. You can put multiple images on a single slide, and even have those images slide onto or off the slide based on specific event triggers. In addition, you can add text or shapes and even animate them. You can also add background music to your slide show.

These features are not typical slide show fare, but they do offer a way to add some creativity to your presentations. Photographers who create educational presentations will find these features invaluable. Those wanting to present a simple slide show reminiscent of those prepared for carousel projectors may find that the features add unnecessary complexity to the software.

iView

iView (Windows and Macintosh) is an image-management program from iView Multimedia (www.iview-multimedia.com), but it also lets you generate slide shows from the images you're managing. You can display images full-screen or at varying sizes, and you can adjust the duration for each image and transition effect globally. In addition, you can add a soundtrack to the slide show.

We consider iView to be an excellent choice when you're looking for a simple solution that offers all the basic features for sharing your images in a digital slide show.

Photodex ProShow Gold

ProShow Gold (Windows only) from Photodex (www.photodex.com) provides a simple way to create slide shows quickly using a drag-and-drop interface. Simply drag the images into the show timeline to add them to your show. In addition, you can choose from more than 170 transition effects. This software is geared toward creating shows that consist solely of images, with only one image displayed at a time. These may be seen as limitations, but they also keep the show focused on your images rather than on other effects. For a basic slide show with creative transitions, ProShow Gold is a great choice.

The greatest strength of ProShow Gold is its simplicity. Simply locate the images you want to include in the slide show, drag them to the timeline, and insert transitions to produce a

more creative show. It's even easier to create your slide show if you copy the images you want into a single folder first.

SmoothShow

SmoothShow Imaging's SmoothShow (Windows only, www.smoothshow.com) takes the basic slide show concept to an extreme. It includes over 2000 transition effects and the ability to synchronize two tracks of digital audio with the image transitions. You can also add captions to the images if you like. This package provides an excellent way to build a professional show. And that audience needn't be limited to those who show up for a digital projector display. You can also use SmoothShow to create Web-based presentations that include animated transitions. If you need to create only basic slide shows but want advanced options for those basic features, SmoothShow is an excellent solution.

Remember, though, just because a program such as SmoothShow offers a huge variety of transitions doesn't mean you should use them all. Many photographers are tempted to use as many transitions as possible, never using the same one twice in the same presentation. This can be a distraction, putting more emphasis on the transitions than your images. Instead, focus on a few transitions that complement the theme of your images. This is one situation where less is certainly more.

PRINT PACKAGES

Print packages are an extension of the photographic prints you would normally produce to showcase your images. They allow you to print multiple images on a single page in a specific format. The tools in this category offer one of two options. The first type allows you to print an index print or contact sheet that includes thumbnails of a large number of images, possibly spanning several pages. The second type allows you to create a package of prints on a single page. You can specify which image (or images) should be used and how large each should be. The result is similar to the print packages you would purchase at a portrait studio. Besides allowing you to generate packages of prints for your clients, these packages are also a great way to create a print portfolio of your images.

Both of these types of print packages allow you to share your images, but which to choose depends on whom you are sharing your images with and for what purpose. For example, a contact sheet is best for sharing images with a client who needs to decide which image they would like to use for a particular purpose. Picture packages are best for sharing images with family and friends, or as a portfolio to show your work to prospective galleries.

Photoshop Contact Sheet

Photoshop's built-in Contact Sheet II automation tool allows you to quickly generate a document with thumbnails of selected images, which can be saved or printed for sharing (**Figure 13.9**). To use it, select File > Automate > Contact Sheet II.

Figure 13.9 Contact sheets are an excellent way to share a batch of photos, and Photoshop's built-in Contact Sheet tool makes it easy to create these index prints.

The Contact Sheet dialog is divided into sections listing the various options available to you. The Source Images section allows you to select images to be included in the final contact sheet. If you have images open in Photoshop, you can select the Current Open Documents option to put those images into the contact sheet. If you have already selected images in the Photoshop File Browser, the Selected Images from File Browser option will use those for the contact sheet. We normally use the Folder option so that we can create a contact sheet from a full folder of images. The Browse button allows you to select the specific folder; selecting Include All Subfolders includes all images in all folders within the selected folder.

The Document section is where you specify the dimensions of the final document, as well as the color mode (we recommend using RGB). If you don't plan to fine-tune the image placement after creating the contact sheet, then selecting the Flatten All Layers check box will create a smaller file size. Even if you don't plan to save the image, this setting can be helpful for reducing the amount of memory required for the final contact sheet.

In the Thumbnails section you define the actual layout of the thumbnail images on the contact sheet. You can place the images across first or down first, as well as set the space between images automatically.

Setting values for Columns and Rows will define the number of thumbnails on each page. The more you squeeze onto a page, the smaller the thumbnails will be. To provide the largest thumbnails possible within the available space, you select the option to Rotate For Best Fit.

If you select Use Filename As Caption, you'll be able to adjust the font and size to be used for text. You are not able to define your own captions other than the filename.

The right side of the Contact Sheet dialog provides information about the layout. This includes a thumbnail view of what the page layout will look like, as well as an indication of how many pages will be required and how many images will be included. Width and height values are provided so you know how large each image will be.

The Contact Sheet II automation tool in Photoshop provides a quick and easy way to quickly create contact sheets for your images. It offers flexibility in terms of image layout, though it lacks options for creating page titles and customized caption information.

Other Contact Sheet Options

While Photoshop offers a built-in way to create contact sheets, many other tools create them as well. Just about every image browsing software package includes the ability to create thumbnail prints of a selection of images. They also offer varying degrees of customization for the layout of the final print. If you're using software such as ACDSee (Windows and Macintosh, www.acdsystems.com), CompuPic Pro (Windows only, www.photodex.com), and Photo Explorer (Windows only, www.ulead.com) to view your images, you can also print thumbnail contact sheets.

Photoshop Picture Package

When you need to print several images on the same page, whether it's a group of different images or the same image multiple times and possibly at different sizes, the Picture Package tool in Photoshop automates the task (**Figure 13.10**).

Figure 13.10
Photoshop's Picture
Package tool allows
you to create print
packages that can
include different
images in a variety of
sizes, excellent for
showing off your
favorite images.

To get started, select File > Automate > Picture Package from the menu. You'll need to select a source for the images that are to be included in the package. This source can be a single file, a folder of images, the currently active image in Photoshop, or the images you have selected in the File Browser. For the File or Folder options, you can click the Browse button to select the source to be used. When you select Folder as the source, you can also select the Include All Subfolders check box.

The Document section allows you to adjust both the paper size you'll use for the final print, as well as the basic image layout that defines how many images will be included and at what sizes. The Page Size determines the maximum dimensions of the print package. The Layout option allows you to select from a list of default page layouts for the picture package, ranging from options such as two 5-by-7-inch prints to twenty 2-by-2-inch images. You can set the final output resolution, along with the color mode. For printing on an inkjet printer, we recommend setting the Resolution to 300 pixels/inch with the Mode set to RGB Color. Unless you intend to refine the final layout, we recommend selecting the Flatten All Layers check box to minimize the file size and memory usage of the final package.

Once you've defined the basic layout using the options in the Source Images and Document sections, you can adjust the package with the Layout section. While this section may look like a simple preview, if you click on an image you can change the file used as the source for that particular image location. You can also define your own layout options, or revise the existing ones, by clicking the Edit Layout button and adding, deleting, or adjusting the image zones used to define the area to be used for each image.

In the Label section you can also define text labels for the images in the picture package, using the Filename or other options to create captions for the images in the package. You can even select a Copyright option that will place the copyright text in the File Info dialog over the images to mark them as being protected by copyright (see the sidebar "Copyright in Metadata" earlier in this chapter).

Whatever text you choose to include, you can adjust its size, color, and position. If you are using text labels for your images, we recommend that you don't select the Flatten All Layers option, so you'll be able to fine-tune the position of the text to your liking.

With the basic layout defined, you can change the images included within the picture package. When you click on an image in the preview, you can select a different image to be used in that location in the page layout. This helps to cut down on wasted paper and makes it easy to provide the client with a choice of images.

Qimage

A popular option among photographers who want to produce print packages is Qimage from Digital Domain (www.ddisoftware.com). This software automatically creates a print layout to maximize the space available on the printed page (**Figure 13.11**). You simply drag and drop images onto the page, and Qimage automatically rotates the images and sizes them based on the settings you choose. The result is a print of very high quality with minimal waste of paper area. It isn't an ideal solution for producing images to share as a page of images because you can't control the layout too much, but it's an excellent way to economically produce a series of small prints on the minimum amount of paper necessary, so you can share the images with family, friends, and clients.

Figure 13.11 Qimage is a software tool that makes it easy to create print packages that make the most use of the available space on paper for your images.

THE BENEFITS OF SHARING

Once you've created a digital portfolio to show off your images, you may find yourself a bit busier. New clients may want to hire you for your photographic services, advertising agencies may want to use your images, and those who appreciate your photographic images may want prints to hang on the wall. When you start to get those inquiries, you'll want to be sure you can actually find the right image when you need it.

In the next chapter, we'll show you how to organize and back up your images so they'll always be safe and you'll always know exactly where they are.

CHAPTER FOURTEEN
Archive, Catalog, and Backup

Artists—a group that of course includes photographers—and creative people in general have a reputation for not being the most organized creatures in the world. Regardless of whether that reputation is deserved, we photographers have ways to keep our images organized so that we can find an image when a family member, friend, or client wants a copy. Nothing is more frustrating than knowing you have an image that you just can't locate. In fact, before we started organizing our images, we wasted countless hours looking through hard drives, CDs, and contact sheets in an effort to find the exact frame we needed. Digital images require a bit more effort to organize than simply depositing slides in file drawers, but they also offer a big advantage: Once you've done the up-front work, you can cross-reference your images, perform searches, and place them in multiple categories.

In addition to keeping your images organized, you also need to keep them safe to ensure that you'll be able to access them in the future. Whether you store your images on hard drives, CD, DVD, or other media—you'll want to safeguard the media and also create a backup.

As you can imagine, organizing a few snapshots is straightforward—but as you take more and more digital images, all those files can start to get very confusing. In this chapter, we'll take a look at tools and methods of archiving, organizing, and protecting your images—legally through copyright registration and physically by backing up your image files.

These "housekeeping" chores aren't nearly as much fun as taking pictures, optimizing them, and making prints, but they are important tasks that will ensure that your images are available for many to enjoy long into the future.

MASTER IMAGES

You can spend hours and hours finessing, tweaking, perfecting, and slaving over every pixel in a file to create the perfect image. This final image file contains both the original image capture and the interpretive layers dedicated to clean-up, dodging, burning, and creative additions. It's very important that you save this file as a layered file—what we refer to as the *master file*. It's the file you'll return to the next time you decide to make a change, create a print, or send someone a copy (**Figure 14.1**). You should save the master image file in PSD or TIFF format, with all layers, channels, and paths intact. This is the image file that you'll need to archive, catalog, and back up for safekeeping. You can take advantage of special image-management software to perform these tasks for you, which we'll discuss later in the chapter.

Figure 14.1 When you've optimized an image to your satisfaction, it's important to keep the image file organized and backed up so you'll be able to find it and safely retrieve it in the future.

Metadata

It is the rare photographer who can look at any image he or she has ever shot and tell you exactly where it was captured, the camera and lens that was used, and what the aperture and shutter speed were set to. Fortunately, for digital photography we don't have to even try to remember such details because digital cameras store additional information, called *metadata,* with the image file when you take a picture. As we mentioned in Chapter 9, "Download, Edit, and Convert," metadata is information *about* the image that is written into the digital camera file; it includes a wide variety of information, such as time, date, camera and lens used, f-stop, shutter speed, color space, and—if equipped—even GPS (Global Positioning System) information. You can use metadata not only to analyze your images, but also to edit, sort, track, organize, and retrieve them.

For example, if you photographed moving water with various shutter speeds and then reviewed the images to see which achieved the effect you wanted, the metadata could tell you what camera settings you used so that you could reproduce the same effect based on that knowledge rather than having to guess which settings might be best.

You can also use the metadata to look for a particular photo based on capture settings. If your favorite images of the moving water used slow shutter speeds in the range of ¼ to ⅛ second, you could search for all images that were captured at those shutter speeds to find similar photos.

Most image-management or image-viewing software—such as Adobe Photoshop Album—allows you to view metadata but not search based on it. Others, such as Photoshop's File Browser, Extensis Portfolio, and Canto Cumulus, allow you to set up your database of images so that you can search on metadata values. As we review the options available for managing your images, we'll discuss this capability, as well as other factors to help you keep your images organized.

DIGITAL ASSET MANAGEMENT

Digital asset management (DAM) is the name applied to software that allows you to organize digital images, but it's more than just software to use. We prefer to think of digital asset management as a comprehensive image-management system that enables you to name images, back them up, categorize and assign keywords to them, store file attributes and metadata, and most important, do all of these things in a consistent way. Geared toward providing sophisticated organization for the professional photographer with a large library of images, an image management system provides a more robust solution for image management than a simple folder structure as discussed in Chapter 9. Of course, a good

DAM system will let you find the right image when you need it, but it offers a lot more than that, which we will discuss in the following sections. In the long run a little effort on the front end to create a consistent system you can work with will pay you dividends in less time wasted, much less frustration, and fewer gray hairs.

> **TIP:** You may not think you're going to take enough pictures to merit a DAM system. Mark our words: If you avoid organizing your digital camera files, you'll find yourself using the D word with the other connotation pretty regularly as you look for an image you desperately need but just can't find.

Developing a DAM System

Before you start organizing your images with digital asset management software, you need to develop a system that fits your workflow. (You don't have to do this step yourself—the DAM software serves this purpose.) But unless you have all your images files scattered across your system's desktop, you probably already have some rudimentary folder system. We organize our images on the hard drive using the various software tools we already have available, such as the File Browser in Photoshop. We delete outtakes, rotate verticals, rank images, and possibly sort them into folders representing categories. While the master images that you've fully optimized are perhaps the most important ones to organize with DAM software, you should probably also include the other images that you haven't yet optimized. Just because you didn't work on the file now doesn't mean you won't be looking for it later.

If you archive your images to CD or other removable media, it is important to create a naming system that will both help you stay organized and last over time. The volume label you assign when you burn a CD can be used as a reference, and is what your DAM software will use to tell you which CD to insert when you ask for a particular image. For example, Katrin names her digital photography CDs with a prefix of "DC" for digital camera, and then a number. She therefore would have CD names such as DC_001, DC_002, and so on. Just be sure to leave enough digits in your system so that as your library grows you won't run out of available numbers.

DAM Software

A variety of software exists to help you manage your growing library of digital images. When considering software, give careful thought to how you organize your images in your own mind, and what image attributes you use to identify the right image for a particular need. For example, a wedding photographer needs to be able to search by name and date, a product photographer might search by job number, and a nature photographer might search by location or time of year.

Adobe Photoshop Album

Photoshop Album—available only for Windows users—is targeted toward the snapshot photographer who needs to organize images in a manner similar to a series of scrapbook albums. However, its features are actually quite robust and can suffice for more serious photographers who need to organize their images. Album lets you do a plethora of image-management tasks:

- **Browse thumbnails.** Album functions as an image database, storing pointers to your original images in the form of thumbnails. Therefore, you can't browse for images unless you import them into Album. You'll start by importing all of your existing images. We recommend doing this in manageable chunks of no more than about 100 images at a time. Otherwise, the time you spend importing the images and creating thumbnails might be excessive. For example, if you already have your images organized in a folder structure on your hard drive, bring the images into Album one folder at a time to make the task less overwhelming.

- **Use timeline view.** A unique feature offered by Album is the timeline view of your images. This is a scrolling timeline at the top of the Album window that shows a bar chart representing the number of images for particular periods of time on the time-line. This is an excellent feature for photographers who want to organize their family snapshots, but it can also be helpful for photographers who may need to find images by date range, such as wedding photographers or photojournalists (**Figure 14.2**).

Figure 14.2 Adobe Photoshop Album's timeline view gives photographers who can organize their images by date (such as wedding photographers or photojournalists) an excellent way to locate particular images.

- **Tag images.** The other method of organizing your images in Album is through the use of categories, which are referred to as *tags* in Album. These can be created up to three levels deep, which provides reasonably good flexibility. For example, landscape photos can be organized under a main category of Places, with subcategories for State, and with City under the State category. Tagging an image is a simple matter of dragging the category's tag onto the image. You can tag multiple images at the same time by first selecting the images and then dragging the appropriate tag to one of the selected images. The tag will be assigned to all selected images.

Images can have more than one tag assigned to them, letting you cross-reference images easily. For example, if you have photos of fish at the Monterey Bay Aquarium in California, each of those images might be tagged with categories called Fish, Monterey, and California.

- **Catalog and search with tags.** When you launch Album you'll be able to see all images that have been added to the catalog. When you double-click on a category tag, you'll see only the images that are tagged with that category. You can return to a display of all images by clicking the Clear button on the Search Criteria bar displayed above the search results.

 Besides double-clicking on a tag to see images in that category, you can also drag-and-drop tags to the Search Criteria bar to search for images with that tag assigned to them. That may not sound like a benefit, but you can also drag more than one tag to the Search Criteria bar, and the results will display only images contained within multiple categories. You can also drag images to the Search Criteria bar to search for images with similar color. This is a great way to find images with a similar theme or mood, based on the content. It will include images of similar subjects, but also images of completely different subjects but with similar color properties. When you've found the right image, you can open it directly in Photoshop by selecting Edit > Edit with Photoshop.

- **View metadata.** Album lets you view the metadata for your images, but unfortunately it won't let you search based on metadata values.

The one bone we have to pick with Album is its lack of RAW image support. For the casual photographer that Album was intended to help, this isn't a major factor. However, Album can be quite helpful for even the professional photographer, so we would very much like to see support for RAW captures added to a future version.

Overall, Album offers some excellent organizational tools for the photographer who wants to browse images by date and organize using categories. It also allows you to do a variety of other tasks such as email photos, create picture packages, and burn images to CD or DVD.

Canto Cumulus

Canto Cumulus (Windows and Macintosh, www.canto.com) is an image-management solution targeted at professional photographers and others such as museum curators, graphic designers, and publishers who need to manage a large collection of images. Cumulus is offered in both a single-user version that provides all of the image-management features and a workgroup version that allows multiple people on a network to access images.

Cumulus offers a flexible combination of category and keyword organization that lets you do the following image-management tasks:

- **Categorize images.** You add images to the catalog by selecting Catalog > Catalog Assets. This allows you to add either individual files or a complete folder. They will be added to the category you've selected, but you can also create additional categories and add images to multiple categories by dragging them onto the other categories. As with Album, you aren't duplicating the image files themselves, but rather just the pointers to those files. This gives you a lot of flexibility in creating an organizational structure that best meets your needs without having to know where your images are actually stored (**Figure 14.3**).

Figure 14.3 Canto Cumulus lets you organize your images into categories, as well as assign keywords that you can search on using the Notes field.

- **Assign keywords.** Cumulus doesn't provide a feature specifically for assigning keywords to your images, but you can achieve the same thing by adding keywords to the Notes field for each image. You can then search for images based on filename, date, and the contents of Notes or other fields you can modify for each image. The Search

dialog allows you to create highly customized searches, using multiple search terms in any of the available fields. Unfortunately, you can't search for images based on metadata.

- **Locate and open images.** Once you've found the images you want, you can select an image and choose Asset > Show Location to have your operating system display a folder view showing you the location of the selected image. You can then copy, open, or perform any other action on the image. You can also open the image in Photoshop or any other application from within Cumulus by selecting Asset > Open With > Other from the menu and navigating to that application.

Cumulus is not particularly user-friendly—it takes some time to master thoroughly. However, it does offer all the tools necessary for you to organize your images by keyword (using the Notes field) and categories that you can customize. But because it's cumbersome to assign keywords for each image, Cumulus is best suited for photographers who primarily want to organize their images by category. The Workgroup Edition is also a good choice for photographers who need to have images available to all members of their staff at the same time.

Extensis Portfolio

Extensis Portfolio (Windows and Macintosh, www.extensis.com) takes a similar approach to Cumulus's in organizing images using folders, but unlike Cumulus it includes a straightforward method for assigning keywords, as well as features that streamline the task of organizing your images (**Figure 14.4**). It lets you perform the following tasks:

- **Import folders.** You can create a folder structure to organize your images based on categories, but you can also import folders in their entirety, including subfolders. This is helpful if you've already organized your images into folders on your hard drive. The feature will still work for images stored on CD media, but these are generally not sorted into folders so you won't get as much of a benefit. Simply add the main folder to the Portfolio catalog, and all images will be imported with the folder structure maintained.

- **Customize folders.** You can also customize the folder structure in the Portfolio catalog by creating folders the way you want to organize your images, and then adding images to each folder individually. This is a great method for fine-tuning the organization of your images. For example, if you've created a folder structure for your images, you might have them sorted by photo shoot. With Extensis you can import the images from each photo shoot into specific categories based on the content of the images.

Figure 14.4 Extensis Portfolio provides the ability to categorize images into folders, as well as strong keywording capabilities, making it an excellent way to organize your images.

- **Use thumbnails.** The thumbnails here work the same way they do in Album—as pointers to the actual image files (meaning they take up only a fraction of the file size that image files do) that allow you to cross-reference your images across multiple categories.

- **Assign keywords.** One of the features we like most about Portfolio is the ability to assign keywords to a batch of images when they are added to the catalog. Portfolio will actually assign keywords to your images automatically, based on the filename of the image and the name of the folder where the image was stored. If you've already started organizing your images with a folder structure, this can be a huge benefit. However, you can also assign any number of custom keywords to your images when they are imported. You simply enter the keywords at the start of the import process for a group of images. This can be incredibly helpful later when you're trying to find a particular image. For example, if you just spent a couple weeks photographing at Yellowstone National Park in the winter, keywords such as *winter, snow, cold,* and others that describe all of the pictures from the trip will make the process of organizing your images more efficient.

- **Search by metadata values.** Besides searching for images by category or keyword, you can search by metadata values such as aperture and shutter speed. However, Portfolio doesn't create keywords for these values by default. If you want certain metadata values to be automatically assigned as keywords for your images, you must first create custom fields for those values. Then you need to map specific metadata values to those custom fields—and you must do this for every metadata field you want to be able to search on. Once you've established these settings, images imported into the catalog will have keywords assigned automatically based on the metadata values you specified. It is important to configure this option before you import any images into Portfolio so all images in the catalog will have the metadata values assigned as keywords.

- **Search by other field values.** Portfolio includes the ability to search for values in any field, using complex options such as *starts with* and *contains*. You can also build complex searches by including additional parameters to search by, with the option to find images that satisfy some or all of the search parameters you've defined.

- **Open images.** Once you've found the image you're looking for, you can edit it by selecting Item > Original > Edit. The first time you select this option, you'll need to select the program to be used—in other words, choose Adobe Photoshop. After that, Portfolio will remember which program should be used and will launch it automatically when it opens your image.

Because of the automation and flexibility it provides for keywords, Extensis Portfolio is an excellent choice for photographers who want the power of keyword searches without spending unnecessary time assigning those keywords to their images.

ImageStore

TTL Software's ImageStore (Windows only, www.ttlsoftware.com) provides a workflow solution that allows photographers to store and organize images by category, metadata, and keyword. It offers you the option of importing images into the database directly from digital media cards, digital cameras, scanners, and hard-drive storage, and then allows you to organize those images (**Figure 14.5**). Here's a list of the tasks you can perform:

- **Convert file formats.** As a workflow solution, ImageStore supports RAW, TIF, JPEG, and PSD images, and it automatically converts from RAW capture to JPEG and TIF, allowing you to view, adjust, and print the images using a standard file format.

- **Batch-name files.** ImageStore enables batch renaming of images, either on image acquisition or at a later date.

Figure 14.5 ImageStore includes extensive support for organizing your images by category and keyword, but also adds workflow tools to make the task of editing and organizing your images more efficient.

- **Deal with outtakes.** ImageStore combines the analogy of a digital light table with the capability to organize your images by categories. When you import the images from your digital media, they are placed in a temporary category and displayed on a virtual light table. This includes an "outtakes" section so you can quickly and easily remove images you don't want to keep by dragging and dropping the images into the outtakes section. However, the outtakes are not immediately deleted. Instead, they are maintained in the outtakes section of the light table, enabling you to change your mind. When you're sure you no longer want to keep the outtakes, they can all be deleted with the click of a button. At any time during the process, images can be rotated, renumbered, and grouped, enabling like images to be viewed together.

- **View images.** ImageStore provides a slider to adjust the size at which you view the images. The sizes range from thumbnail to half screen, enabling you to compare two images side by side. Double-clicking an image increases it to full screen and provides a detailed view of the metadata information and keywords. From here, buttons are

provided for cropping and to display the image at its true pixel dimensions. These different views enable you to quickly view all images, group them, crop them, compare side by side, and check sharpness at full resolution. In addition, images can be individually or collectively adjusted using white balance and exposure compensation features.

- **Categorize images.** Once you've removed outtakes, the next task is to categorize your images to keep them organized. To add one or more images to a specific category, you select them and then drag them onto the category folder. You have the ability to put each image into multiple categories. ImageStore ships with two categories (an *unclassified* and a *classified* category), allowing you to create as many subcategories as you want within each category, including nesting them within each other, providing the ability to categorize by date, location, subject, color, type, or any other criteria of your choosing. Images are flagged when they have been assigned to at least one category. By clicking the Hide Categorized button, you can clear images that have already been assigned to categories from the temporary import folder. Clicking on a category in the list of categories displayed will show you all of the images contained in that category.

- **Assign keywords.** In addition to organizing your images by category, you can assign keywords to images, providing for more detailed searching. You can select multiple images, and assign the same keywords to all of them at once. You can then search for images based on keywords.

- **Search by metadata values.** Another powerful feature of ImageStore is the ability to search based on metadata values. This makes it easy to find images captured at similar shutter speeds, similar focal lengths, or any other value stored in the image metadata.

- **Export images.** Once images have been stored and categorized, ImageStore can export images to Photoshop for manipulation and then reimport the retouched images back into ImageStore.

- **Display images.** When your images are ready for display, a slide-show mode is provided, and a contact sheet or single image can be printed directly from ImageStore.

- **Back up images.** ImageStore can back up your images and associated information, enabling you to archive any or all images to an external hard drive or CD.

For photographers who primarily want to manage their images with categories, similar to the way slides would be organized in file drawers, with the additional benefit of being able to assign images to multiple categories for cross-referencing, ImageStore provides a complete workflow solution for managing your images, making the process much more efficient.

Developing a Keyword System

Assigning appropriate keywords to your images requires imagination, creativity, discipline, and accuracy. A good keyword system will help you find the exact image you need based on a variety of factors, including subject matter, theme, color, and any other concept you can imagine.

Before you begin preparing a keywording strategy, though, you should consider whether you even want to assign keywords. If you rarely need to find an image by anything other than category or the date it was created, it might not be worth the time to assign keywords to your images. Searching based on keywords can help you find the right image faster, but will the time saved searching be of more value than the time spent assigning keywords in the first place? On the other hand, keep in mind that right now you may be able to browse your few hundred digital camera files pretty easily in the Photoshop File Browser, but what about next year and the year after that, when the few hundred images have grown to a few thousand? Chances are, you'll find that it's well worth investing the time to do it.

The first step in devising a keyword system is to create a strategy for selecting the right keywords for your images. To ensure consistency, you should do this before you actually start assigning keywords to your images. You want to be sure to assign the same words to similar images to describe particular concepts.

When you're planning your keyword system, consider the following issues:

- **Subject matter.** Which words define the subject matter clearly? Do you need to include both common names and scientific names? Will you need to search for both specific and general categories of subject matter, such as the term *beach,* the name of the specific beach or nearby towns, the name of the body of water, or other factors?

- **Concepts and themes.** Will you need to search for images based on the concept they present, or the mood they exhibit? Besides looking for specific subjects, do you need to be able to find images that show particular emotions, moods, or sentiments? A single image can be interpreted in many ways, with concepts that apply to a wide range of attributes. It can be difficult to consider all possible concepts that might apply to a given image, but the most obvious ones will provide a good starting point. For example, if your photos from the beach include shots of a bird flying close to a breaking wave, you might include keywords such as *freedom* or *power*.

- **Dates and events.** What was going on when the picture was taken? Are there important dates or events associated with particular images? While the date may not seem important to you at the time the picture is taken, it may prove to be more significant later, so you may want to plan for this.

- **Color.** In addition to the concepts and themes demonstrated by an image, you may want to consider the overall color of an image. Do you find yourself looking for an image of a landscape, but in particular an orange-colored autumn landscape? If an image contains a strong color element, particularly when a single color dominates the image, it may be helpful to use that color as a keyword.

- **Other categories.** You know your images best, and you know how they may be used. If you operate a stock image service, concepts and color may be more important. If your images get used in magazines and textbooks, the subject matter may be the most important factor. If you are a photojournalist, dates and events will be critical. Beyond these categories, there may be others that apply to your images or the type of usage you anticipate. If they will help you find the right image later, use them as keywords.

When you have considered what categories of keywords will be helpful for your needs, it can also be helpful to create a system for assigning those keywords so that you use the same word to describe the same concept. Some software, such as Extensis Portfolio, allows you to maintain a master keyword list. This can be incredibly helpful because you can then select keywords from a list when applying them to your images, rather than adding them from memory. If such an option isn't available in the software you're using, you might want to maintain a document with the master keyword list. You can then refer to this list when assigning keywords (**Figure 14.6**).

Photo by Jeff Greene / ImageWest.

Figure 14.6 Taking the time to assign appropriate keywords that cover a wide range of possible concepts for your images will help ensure that you can find the image you need at a later date. For example, you might assign keywords such as *freedom* and *Americana* to this image, along with the more obvious keywords that describe the content.

There is no question that developing and implementing a system for assigning keywords to your images can be time-consuming. Using keywords isn't necessarily worth the investment for all photographers, but it can be invaluable for those who need to find just the right image quickly.

PROTECTING YOUR IMAGES

Protecting your images from unauthorized use is an important aspect of reinforcing the value of your images. Scarcity has a major influence on the value of any commodity. While limiting the number of prints for an image doesn't guarantee it's worth anything (it has to be a good image in the first place), controlling how your images get used can help ensure whatever value it has is retained. Furthermore, each time one of your images is used without permission, you lose potential income from that use. This may be in the form of a print hung on the wall, an image used in an advertisement, or unauthorized Web site use (**Figure 14.7**).

Figure 14.7 Licensing images for a particular use is an additional source of potential income for photographers. It's important that you protect your images with copyright registration, and that you make an effort to ensure that any use is properly licensed.

Simply by virtue of the fact that you created your photographic images, you own the rights to those images. For anyone to use your images for any purpose, they must obtain your permission. If an image is used without your permission, you can pursue legal action against the infringer. One of the most important things you can do to increase your chances of successful litigation against someone who uses one of your images without permission is to register your images with the United States Copyright Office.

Copyright

Copyright is a legal form of protection for any original work expressed in a tangible form. This includes works such as books, poetry, paintings, and of course, photography. Owning the copyright means you own the exclusive rights to use your creation. Your work cannot be used by anyone else without your specific permission. Only you the copyright holder have the legal right to copy (in other words, sell and profit from) the image.

Any work—such as a photograph—that is eligible for copyright protection is considered to be protected as soon as it is created. As soon as you take a picture, it's protected by copyright law and belongs to you. You don't have to register your images with the U.S. Copyright Office for them to be protected by copyright law, but in case your images are used without your express permission, image ownership is much easier to establish if the image has been registered.

Copyright Mark

Since you own the copyright for all of your images, it's a good idea to mark them as being protected by copyright whenever the images are shared. In Chapter 13, "The Digital Portfolio," we discussed some of the methods for marking your images as being copyrighted when displayed online. There are other situations where you may want to mark your images as being protected by copyright.

Many photographers either include the copyright symbol on their prints when they sign them or add the symbol along with their name as part of the actual printed image. You can also require that whenever an image is licensed from you that it include an appropriate copyright notice. It's standard that such notice not be included for use of an image in an advertisement, but for any other use of your images we encourage you to require that an appropriate copyright notice be included.

You may need to provide images to others in the form of digital files in situations (such as for advertising usage) where a copyright mark won't be included on or adjacent to the image itself. In those situations, you should still add copyright information in the File Info option in Photoshop, as discussed in Chapter 13.

Copyright Registration

Again, while you're not required to register your photographic images with the U.S. Copyright Office for them to be protected under copyright law, we strongly recommend that you do so as soon as possible after the images are created.

Registering your images provides a number of benefits. It establishes a public record of your claim to copyright for the work. It also satisfies the requirement that your work be copyrighted before you file any infringement suit. In addition, it allows you to pursue statutory damages and attorney's fees if you are successful in pursuing legal action against an infringer. If you haven't registered the images prior to an unauthorized publication, you can still sue (once you've registered the image after the fact), but only actual damages can be awarded.

Fortunately, registering your images with the copyright office is easy. You must submit a copyright application form, a nonrefundable filing fee (currently $30), and a copy of your images. This copy can be in the form of a contact sheet (see Chapter 13 for details on creating a contact sheet) or as digital image files on a CD-ROM. If you are putting the images on CD, they can be relatively small JPEG images, so that you can fit many images onto a single CD (see the sidebar below "Batch Process for Copyright Registration").

Batch Process for Copyright Registration

If you have a large number of images you want to process for copyright registration, it helps to reduce the size of the image files so you can fit more onto a CD to submit with your application. This is a perfect use for an action in Photoshop (see Chapter 11, "Digital Darkroom Expert Techniques," for details on recording actions).

Most likely, when you are submitting a batch of images from a photo shoot they were all captured using the same camera. That means if you size them to the same percentage of their original size rather than sizing them to specific pixel dimensions, the longer of the two sides for every image will become the same size, regardless of whether the image is a horizontal or vertical. To use this method, when recording an action simply change the unit of measure in the Image Size dialog box to "percent" rather than "pixels". If you aren't sure what percentage you want to use, first set the zoom for the image to an appropriate size, and then select Image > Image Size and enter the zoom percentage shown on the title bar for the image as the percentage to resize the image.

If you're working with images from a variety of sources, or that otherwise have varying pixel dimensions, resizing them all by the same percentage value won't achieve the desired result. Instead, you'll need to size the images to specific pixel dimensions. In this situation, we would use the option to fit the images to a specific size. Select File > Automate > Fit Image, and enter the height and width you want to constrain the image to. The image will then be resized so that it fits within the size values you entered.

Once you send a copy of your images, the application form, and the nonrefundable filing fee to the U.S. Copyright Office, the application will be processed and you will receive a certificate confirming the registration of your images. It will likely take six months or more for you to receive this certificate, due to the huge volume of applications processed by the copyright office.

We recommend filing for copyright registration for all new images as soon as you return from a photo trip. If this is not practical, create contact sheets or duplicate copies of your images for copyright registration, and set them aside for future registration. Then submit the images on a regular schedule. If images are published, they should be submitted for registration by the photographer or by any third party to whom the photographer has assigned rights. For example, stock agencies generally handle the registration in the photographer's name.

More details about registering your images with the U.S. Copyright Office, along with other valuable information about copyright protection, are available at the U.S. Copyright Office Web site at www.loc.gov/copyright.

BACKUP

Computers are incredibly reliable, and it's rare that a hard drive fails—but when it does, you'll want to have backed up your images redundantly to ensure that the images are safe. With hard drive capacities constantly increasing and prices constantly decreasing, we tend to replace hard drives (or the computer containing them) long before they get anywhere near the end of their useful life. The fact that our image files continue to accumulate only accelerates the upgrade cycle.

Because of the high reliability of our computers and storage media, it is easy to become complacent and ignore the need to back up. Don't! Backing up is a critical aspect of working with your images in the digital darkroom. Every time you add new images or do significant adjusting of images, you should perform a backup of your important image files. Also, make a plan to back up your data on a regular basis. Some backup software even allows you to schedule automatic backups so that you don't have to remember to initiate them. This is a convenient feature, but if you implement an automatic system be sure to confirm on a regular basis that the backups are being performed successfully as scheduled.

And redundancy is a good strategy: One backup is good, but multiple backups provide additional security. If you're using rewritable media for your backups, don't just use the same media over and over again. For example, if you are using an external hard drive for backing up, get two of them and alternate them between backups. There are a number of methods you can use for backing up your data, and you may want to use more than one method to provide greater redundancy.

Burn to CD or DVD

A drive that can burn to CD or DVD media has become an invaluable tool for the digital photographer. Most new high-end computers include a drive that can burn to CD media, and most are also available with a drive to burn DVD media as well. These drives make it easy to put images on a disc to send to a client, as well as providing an excellent form of archival storage to help prevent your computer's hard drive from filling up.

While both types of media offer similar advantages, DVD offers the clear advantage of capacity. With CD media you can fit 700 MB of image files, which may not be very many images, particularly if you've optimized the images using multiple layers with the techniques described in Chapters 10 and 11. That isn't very many images, especially considering how easy it is to create new images with a digital camera.

DVD offers higher capacity, with current media available in 4.7 GB capacities. Double-sided discs are becoming more common, and they allow you to store 9.4 GB of image files. As we discussed in Chapter 8, "Building a Digital Darkroom," competing DVD standards create compatibility issues. However, for your own backup purposes, a DVD burner is a good solution because you're the only one who needs to be able to read the discs in the event of a data loss. You'll always be able to read DVD discs on the same drive they were burned on.

DVD media is more expensive than CD media, but the cost per megabyte is actually very close. In effect, you're paying more for DVD media because you are getting higher capacity. The brand of either media can determine the longevity of the images on the disc. Some inexpensive discs can't be read reliably after just a few years, even when stored in an environment that doesn't include extremes in temperature, humidity, or light. We recommend brands that have demonstrated excellent longevity, such as Verbatim DataLifePlus CD or DVD media, or Mitsui Gold Standard CDs.

Backing up your images to CD or DVD media is a simple matter of writing the image files onto a backup disc. We recommend that as you work with your latest images, you save them to a specific folder to be backed up from. When this folder reaches the capacity of the CD or DVD you'll be using for backup, immediately copy the images to a disc and remove these duplicate copies from your hard drive.

Burning your images to two discs when using CD or DVD backup provides an inexpensive form of redundancy, and is a habit that we strongly recommend you get into. Keep one copy at the same location as your digital darkroom so you'll have easy access to your images. Keep another copy at a separate physical location such as a bank safe deposit box or a secure office location, so if there's a fire or other catastrophe at one location, you'll still have a safe backup elsewhere.

External Hard Drives

External hard drives provide an excellent way to back up your data or supplement the storage capacity of the hard drive inside your computer. They are convenient to use because once they are connected to your computer through either a USB 2.0 or FireWire connection, they appear as just another hard drive on your computer. They also offer high storage capacity—hundreds of gigabytes—in one package.

There are several ways you can use an external hard drive:

- **Auxiliary storage.** When your internal hard drive fills up, an external hard drive is easy to add to gain additional storage capacity.

- **Backup of internal drives.** Because of their high capacity and convenience, external hard drives are an excellent way to back up your internal hard drives, including your system folder and applications.

- **Redundant storage.** If you're using an external hard drive for auxiliary storage, you'll need to back up that data as well.

When using an external hard drive for backup purposes, you can simply copy files from your internal hard drive to the external drive using the file-management capabilities offered by your operating system. In this case, any time you update your images files on your internal drive, you would want to make a duplicate copy on the external hard drive.

A more convenient solution would be to use software such as Dantz Retrospect (www.dantz.com) to perform a backup to your external drive, which would automatically compress the data. The disadvantage to this approach is that the backup isn't an exact copy of the original files, but rather a backup volume that can only be accessed by using the Restore function in the backup software.

Another excellent option if you're using an external drive for backing up an internal drive, or if you are using it for redundant storage, is to use drive mirroring software that allows you to maintain two identical copies of all data on a hard drive automatically. For example, Techsoft's MirrorFolder (Windows only, www.techsoftpl.com) and SoftRAID (Macintosh only, www.softraid.com) allow you to configure automatic hard drive mirroring, where the contents of one drive are automatically duplicated in real time to a second drive. The only disadvantage to real-time mirroring is that if you are using full-time drive mirroring, you can't really store the backup copy in a different physical location, which is something we strongly recommend. Fortunately, these and other drive mirroring solutions also allow you to synchronize on command, which is effectively the same as performing a backup except that the files are duplicated from one drive to another. This is a perfect solution for most photographers using external hard drives to back up their images.

Tape

Tape drives are not our preferred method of backing up our image files. They don't offer very high capacity except in expensive units, making the other available solutions much more attractive. We also don't like that the files on a tape drive aren't easily accessible. Because the data gets compressed and stored in a single volume file during backup to a tape drive, the image files can't be accessed except through a restore procedure. With other options you are simply copying image files directly to different media, such as a CD, a DVD, or an external hard drive. That means that you can open the images directly by simply accessing the media they are stored on. This is a great convenience to have, especially when you're on deadline and you need quick access to an image that's been lost and must be recovered from a backup copy.

If you already have a tape drive and don't want to change your backup strategy, then by all means continue using your tape drive. We'd prefer that you use a different method, but the important thing is to have a backup of your images, whatever method you use. If you're using a tape drive to back up your files, we recommend that you cycle through tape cartridges rather than using the same one repeatedly. After you have performed a backup to a tape cartridge, store it offsite and use a different cartridge for the next backup. By cycling through two or three sets of tape cartridges, you'll have redundancy built into your backup system. If you experience a catastrophic loss of your computer while the tape is in the drive, you'll still have a slightly older copy stored safely at another location.

Offsite Storage

To ensure the safety of your images, we strongly recommend making multiple copies of your backup, and storing at least one of those copies at a separate physical location. That may mean storing it at a safe deposit box at the local bank, at your home or office, or at a friend's house. If a fire destroys your computer, you don't want the backup to be on the desk above the computer, also consumed by the fire. The more cautious you are about backing up your critical data, the less chance that you'll suffer the permanent loss of important images.

Software

You'll need software to back up your image files and other data efficiently. In many cases the hardware you purchase for backing up your images will include software for performing the backups. For CD and DVD drives, this is simply software such as Roxio's (www.roxio.com) Easy CD Creator (Windows) or Roxio Toast (Macintosh) that allows

you to copy files onto discs (**Figure 14.8**). For tape drives the software is generally more sophisticated, allowing you to select the files to be backed up and to actually schedule automatic backups. External hard drives generally don't come with any backup software, although you can use the file copying options in your operating system for a basic solution.

Figure 14.8 Roxio Easy CD Creator provides a simple method for copying your important images to CD or DVD media.

If the hardware you'll be using for backup doesn't include software, or if you want more control over the backup process, a variety of software tools will do this. Look for software that allows you to specify which files should be backed up and that supports scheduled backups. Some backup software options we recommend include Veritas Backup Exec (www.veritas.com) and Dantz Retrospect (www.dantz.com).

Long-Term Maintenance Issues

Unfortunately, your backup efforts don't end when you implement a system for creating frequent and redundant backups of your data. You also need to consider the long-term maintenance of your backup solution.

As technology develops, it is important that you periodically reevaluate your backup and archival storage methods. The CD is one of the most common storage devices available today, which may lead you to believe that it will be around forever. It most certainly won't. As DVD burners and drives become more common, CDs usefulness will wane. So if you have a library of images stored on CD you'll want to start thinking about moving that data onto a different storage media, such as DVD.

Most external hard drives use USB 2.0 or FireWire connections. These are certainly commonplace on today's computers, but before long new technology will replace existing connections, and you may find that in the future you won't have the port required on your computer to connect today's external hard drives.

Digital photography includes a wide range of advantages, and we absolutely love it. However, we also need to keep in mind that there are issues that come with these advantages. One of them is the need to maintain our digital image file storage over time. If you give some thought to planning an archival storage strategy for your images that includes redundant backup and maintenance over time, you'll ensure that your images will be available for enjoyment by many future generations.

BACK TO PHOTOGRAPHY

Now that you have peace of mind knowing your images are organized and safe, it's time to get out of your digital darkroom, go out there, and take more pictures. Enjoy!

INDEX

3D to 2D translation, 267
8- *vs.* 16-bit images
 capturing, 24
 and number of tonal values, 23
 when to use, 23, 24
16-bit addressing, 222
18 percent gray card, 181–182, 328
64-bit addressing, 222
5000-kilowatt bulbs, 328, 329, 608

A
A to D (A/D) conversion, 53, 58, 65
AC power supply, 119
accessories, 133–195
 aluminum foil, 186
 backdrops, 190–192
 batteries, 135–140
 bubble levels, 185
 camera bags, 133–134
 camera manuals, 135
 chargers, 140
 clamps, 194
 cleaning, 179–181, 183–184
 digital darkroom, 349–351
 exposure tools, 181–183
 filters, 171–179
 flashlights, 184
 gaffer's tape, 194
 hot glue gun, 194
 lenses, 164–171
 lighting/flash, 156–163, 184, 187–188
 notepads, 185
 photo studio, 186–194
 plastic bags, 184
 portable solar panels, 141
 reflectors, 189
 Silly Putty, 194
 storage media, 142–147
 tables/carts, 192–193
 toolkit, 184
 tripods, 147–155
 in typical digital camera package, 119
 Velcro, 185, 194
 voltage adapters, 140
 white cards, 181
 wire, 185, 194
ACD Systems, 376
ACDSee, 376, 638, 650

Adams, Ansel, 255
additive color space, 473
adjustment layers
 dodging and burning with, 530–535
 and global tonal correction, 438–440
 importance of, 438–440
 Photo Filter, 492–493
 and Photoshop versions, 440
 purpose of, 435
 toning with, 563
Adobe
 Camera RAW. *See* Camera RAW
 Color Picker, 403
 Photoshop. *See* Photoshop
 Photoshop Album, 659–661
 Photoshop CS. *See* Photoshop CS
 Photoshop Elements, 353–354, 402, 440
Adobe Gamma, 415, 601
Adobe Photoshop 7.0 for Photographers, 592
Adobe Photoshop CS Studio Techniques, 592
Adobe Photoshop Master Class, 2nd Edition, 592
Adobe RGB, 220, 418–419
AE lock button, 286–287
Alien Skin Software, 357
aluminum foil, 186
Amberg, Jeff, 13
ambient light, 327
Ames, Kevin, 141
analog photography, 12. *See also* film photography
analog to digital conversion, 53, 58, 65
antialiasing filters, 130–131
aperture
 defined, 225
 and depth of field, 225
 illustrations of, 226
 priority, 111, 231
 and shutter speed, 227
 size, 41, 168
Aperture Priority mode, 231
Apple
 Image Capture utility, 368
 iPhoto, 371–372, 376, 638
 Keynote, 646
 QuickTake 100, 4, 70
 Web site, 330
Apple RGB, 420–421
Applied Science Fiction, 584–585
Arca-Swiss tripods, 151, 153, 154

architecture, photographing, 8
archives, 626, 656, 658. *See also* backups
artifacts, color, 67
artwork, photographing, 7–8, 56
aspect ratio, 126–127
Associated Press, 4
asymmetrical balance, 249–250
Atkinson, Bill, 598
Auto Color Options feature (Photoshop), 484–489
Auto FX Software, 359
Auto Renumber option, 222
Auto Reset option, 222
autobracketing, 112–113, 310–312
autofocus zone, 284
automatic white balance feature, 214–215
average seek time, hard drive, 332
AWB feature, 214–215

B
backdrops, 190–192
backlight, and light meters, 288
Backlight mode, 235
Backup Exec, 677
backups, 673–678
 burning to CD/DVD, 674, 676–677, 678
 creating prior to editing, 435
 developing strategy for, 673, 678
 for digital *vs.* film photography, 341
 long-term maintenance issues, 678
 offsite storage of, 676
 software for creating, 676–677
 using hard drive for, 675, 678
 using ImageStore to create, 667
 using tape for, 676
bags, camera, 119, 133–134
balance
 symmetrical *vs.* asymmetrical, 249–250
 white. *See* white balance
ballhead tripods, 150–151
Barco Reference Calibrator, 340
barrel distortion, 44, 45, 125
batch processing
 for copyright registration, 672
 of images, 398
batch-renaming feature
 ImageStore, 665
 Photoshop, 387–388
batteries, 135–141
 charging, 139–140, 141
 disposable, 138–139
 high-capacity, 139
 mixing brands of, 139
 rechargeable, 101, 119, 135–137
 replacing, 139

battery grips, 138
Bayer pattern, 66
beach scenes, 288–289, 577–581
Beach/Snow mode, 235
belts, photographic shooting, 134
benchmark tests, computer, 330
Bicubic interpolation, 403–404
bit depth
 8-bit *vs.* 16-bit, 23–24
 defined, 22, 128–129
 and imaging sensors, 65, 128–129
 and number of tonal values, 22–23
 and professional digital cameras, 129, 130
black, distinguishing shades of, 338
black and white images
 colorizing, 358
 converting to color, 556–562
 and generic printer profiles, 624
 improving print accuracy of, 625
 and inkjet printers, 344, 624
 specialized inks for, 344–345
Black and White mode, 236, 263
black and white photography, 263–265. *See also* black
 and white images
black and white toning, 358
black body radiators, 213
Black Point Compensation option (Photoshop), 622
black points, 18, 456–458
Blatner, David, 356, 591
blending modes, 440
blooming, 57
bloopers, learning from, 269
blower brush, 184
blue screening, 192
Bluetooth, 364
blur filters, 130–131, 520–526
Bogen tripods, 151
boot speed, 102–103
bounce cards, 163
bracketed shots, 113
brackets, flash, 160
Breeze Systems, 371, 379
BreezeBrowser, 371, 379, 391
brick-and-mortar camera stores, 132
brightness, 272, 438. *See also* tonal correction
Brightness/Contrast command (Photoshop), 469–470
brightness control, LCD, 315
Brightness slider, Camera RAW, 395
bubble levels, 185
bulb setting, digital camera, 112
bulbs
 5000-kilowatt, 328, 329, 608
 daylight-balanced, 328
 sources of, 328, 608

Burkholder, Dan, 592
Burn tool (Photoshop), 529–530
burning, 529–538
 in corners of image, 535–536
 defined, 325, 529
 with overlay layer, 536–538
 with PhotoKit, 358
 with Photoshop's Burn tool, 529–530
 with selection-based layer mask, 547–549
burning CDs/DVDs, 674, 676–677
burst rate, 104
bus speed, 331
buying guide, 81–132
 assessing requirements, 94–101
 important camera features, 102–119, 123–131
 roadmap to camera purchases, 93
 types of digital cameras, 81–93
 where to shop, 131–132

C
cache settings (Photoshop), 411–412
Calibrate tab, Camera RAW, 397
calibration, monitor, 340–341, 415, 602
Camedia Master, 370
camera bags, 119, 133–134
Camera Bits, 357
camera dealers, 131–132
camera lenses. *See* lenses
camera manuals, 119, 134, 199
Camera RAW, 393–398
 batch-processing with, 398
 calibrate settings, 397
 converting images with, 397–398
 detail settings, 396
 histogram display, 394
 interpolation options, 616
 lens settings, 398
 navigation controls, 393–394
 output settings, 397–398
 tonal/color adjustments, 395
 white balance slider, 394–395
camera resolution, 16, 19
cameras. *See also* digital cameras
 accessories for. *See* accessories
 buying. *See* buying guide
 discussion groups/forums, 122
 leasing/renting, 131
 stabilizing, 114–115, 147–148. *See also* tripods
 technical reviews of, 122
 test-driving, 122–123
 types of, 81–93. *See also* specific types
Canon
 CRW format, 28
 EF-S lenses, 166, 168

ImageBrowser, 368
PowerShot S50, 37
printers, 342
ZoomBrowser, 368–369
Canto Cumulus, 657, 661–663
Capa, Robert, 246
Caponigro, John Paul, 592
Capture 4 software, 506–507
Capture One DSLR, 392
captures
 and bit depth, 24, 65
 color considerations, 65–67
card readers
 advantages of, 143–144, 349
 advice on choosing, 350
 cost of, 143
 downloading images via, 143, 362, 364–365
 editing images in, 366
Catalog feature
 Canto Cumulus, 662
 Photoshop Album, 661
categorizing images
 with Canto Cumulus, 662
 developing keyword system for, 668–670
 with ImageStore, 667
 with Photoshop Album, 661
CCD sensors, 54, 55
CD burners, portable, 146
CDs, burning images to, 146, 674, 676–677
cell phones, taking pictures with, 92
Center-Weighted metering mode, 276, 278–279, 280
Channel Mixer (Photoshop), 557, 561
characterizing monitors, 600
charged coupled devices, 51, 54
chargers, battery, 139–140, 141
checker patterns, 67
chromatic aberration, 44, 45, 125, 397, 587–588
Chromira printers, 627
CIS, 344
clamps, 194
classes, digital photography, 12
cleaning accessories, 179–181, 183–184
clock speed, 330
Clone Stamp tool (Photoshop), 494–498, 504, 587–588
Close-Up mode, 235–236
close-up photography, 246–249
cloth backdrops, 191
clothing, avoiding bright-colored, 328
CMOS sensors, 54–55
CMYK, 26, 422–423
collages, 569
color
 artifacts, 67

color *(continued)*
 balance, 431
 capturing, 65–67
 converting to black and white, 556–562
 correction. *See* color correction
 desaturating, 556–557
 fringing, 125, 587–588
 how Photoshop handles, 414–416
 importance of, 473
 interpolation, 53, 66
 management. *See* color management
 models, 473
 modes, 25–26
 profiles, 414, 416
 rendition, 130
 temperature, 210–214, 217–218, 312
 theory, 473–474
Color Balance command (Photoshop), 476–477
color-correcting filters, 178
color correction, 473–493
 and adjustment layers, 438–440
 and color theory, 473–474
 in Photoshop
 with Auto features, 484–489
 with Color Balance command, 476–477
 with Curves dialog, 489–492
 with Levels dialog, 478–489
 with Photo Filter adjustment layers, 492–493
 with Variations command, 474–475
 working with individual color channels, 482–483
 recommended book on, 591
Color Efex, 359
color management, 595–610
 and digital camera profiling, 598–600
 importance of, 595–596
 and monitor profiling, 600–605
 and printer profiling, 605–610
Color Management Policies options (Photoshop), 424–428
Color Noise Reduction setting (Camera RAW), 396
Color Picker (Adobe), 403
Color Range command (Photoshop), 541–543, 566–567
color-rendering index, 328
Color Sampler points (Photoshop), 444–446
Color Settings dialog (Photoshop), 416–429
 accessing, 416
 Advanced Mode check box, 428
 Color Management Policies section, 424–428
 and offset printing, 628
 preset configurations for, 417–418
 purpose of, 413
 saving settings for, 428–429

working spaces options, 418–423
color-space settings, digital camera, 219–220
ColorByte Software, 625
ColorChecker (GretagMacbeth), 130, 181–182, 599
colored gels, 163
colored halos, 44
ColorMatch RGB, 419
ColorVision
 DoctorPRO, 607
 PhotoCAL, 341
 PrintFIX, 606–607
 Spyder Colorimeter, 341, 602
combat photography, 246
compact digital cameras, 49
CompactFlash cards, 70, 129, 143
composition, 240–257
 allowing for cropping in, 245–246
 background *vs.* foreground elements in, 250
 for digital *vs.* film photography, 240
 experimenting with different camera angles for, 243–245
 horizontal *vs.* vertical, 241–243
 and point of view, 251
 relationships among images in, 249–257
 role of viewfinder in, 240–241
 using LCD monitor to experiment with, 266
 violating traditional rules of, 256–257
compression
 JPEG, 203–205
 lossless, 27
 lossy, 27, 75, 205
CompuPic Pro, 638, 650
computer, 329–341
 bus speed, 331
 buying/upgrading, 330
 clock speed, 330
 connecting digital camera to, 361–362
 downloading images to, 361–373
 hard drives, 332, 675, 678
 Macintosh. *See* Macintosh
 monitors. *See* monitors
 networks, 333–334
 platform issues, 329
 processor speed, 330–331
 RAM, 331, 411
 Windows. *See* Windows computers
Concord Camera Corporation, 364
Cone Editions, 344, 345
Contact Sheet tool (Photoshop), 649–650
continuous inking system, 344
continuous-numbering feature, 221
continuous shooting, 104
continuous-tone printers, 611, 627
contrast

adding, with S-curve, 464–468
 reducing, with reverse S-curve, 466–468
contrast range, 261
contrast ratio, monitor, 337
Contrast slider (Camera RAW), 395
conversion
 audio-to-digital (A/D), 53, 58, 65
 color to black and white, 556–562
 of RAW files, 391–398
copper wire, 185
copyright, 670–673
 and downloaded images, 640
 filing fee, 672
 purpose of, 671
 registering images for, 638, 670, 671–673
 storing in metadata, 641
 symbol, 671
Crop tool (Photoshop), 508–512, 615
cropping
 of digital *vs.* film photos, 245–246
 and focal-length magnification, 164
 perspective, 510–512
 with Photoshop's Crop tool, 508–512
 resizing images via, 615
 in viewfinder, 508
CRT monitors
 calibrating, 602
 contrasted with LCD, 335–336
 flat-screen *vs.* curved, 336
 specifications for, 336
Crumpler, Wendy, 591
CRW format, 28
Cumulus, 657, 661–663
Cunningham, Imogen, 255
Cursors preferences (Photoshop), 407–408
curves
 moving precisely, 468–470
 placing points on, 461
 shoulder of, 460
 using lockdown, 468–471
Curves dialog (Photoshop), 459–472
 adding/reducing contrast with, 464–468
 color correction with, 489–492
 contrasted with Brightness/Contrast command,
 469–470
 contrasted with Levels dialog, 459
 creating lockdown curve with, 468–470
 modifying mask edge with, 550–551
 placing points on curve with, 461–463
 purpose of, 459
 toning with, 564–565
 value systems used in, 460–461

D
D-Lock, 644
DAM software, 657–670
 developing keyword system for, 668–670
 features
 Adobe Photoshop Album, 659–661
 Canto Cumulus, 661–663
 Extensis Portfolio, 663–665
 ImageStore, 665–667
 meaning of acronym, 657
 purpose of, 657–658
 and workflow/filing system, 658
Dantz Retrospect, 675, 677
dark capture, 60
darkroom. *See also* digital darkroom
 digital *vs.* traditional, 4, 11
 magic/excitement of, 4
 purpose of, 325–326
Davis, Jack, 592
daylight-balanced bulbs, 328
DCS 100, 4, 70
deluxe point-and-shoot cameras, 82, 83–85, 97
depth of field
 and aperture setting, 111, 225
 and background/foreground elements, 250
 combining exposures to extend, 574–575
 defined, 111
 and Group f64, 255
 how sensor size affects, 258–259
 optical *vs.* software enhanced, 259–260
 using shallow, 255, 259–260
Desaturate conversion method, 556–557
desaturating color, 556–557
design, camera, 118–119
details, photographing, 247–249, 251
device profiles, 596–610
 and color management, 596
 downloading, 606
 purchasing, 606
 purpose of, 596
 saving/storing, 597
 sharing, 597–598
 for specific devices
 digital cameras, 598–600
 monitors, 600–605
 printers, 598, 605–610
Dfine, 356–357, 584
Dice America, 147
diffusers, 162
digital asset management software, 359–360, 657. *See
 also* DAM software
digital backs, 82, 89–91
Digital Camera Battery, 139
Digital Camera System 100. *See* DCS 100

digital cameras. *See also* cameras; digital SLR cameras
 accessories for. *See* accessories
 buying. *See* buying guide
 connecting to computer, 361–362
 cost considerations, 13, 120–121
 downloading images from, 361–373
 and dynamic range, 68–69
 editing images in, 317–320
 exposure modes for, 223–236
 file formats for, 27–29, 74–77
 and focal length, 37, 62–63, 257–258
 framing images with, 240–241
 history of, 4–6
 how they work, 33–34
 and image quality, 7–8
 lenses for, 34–45. *See also* lenses
 light meters for, 274–275
 and metadata, 237–239, 388–389
 metering modes for, 276–281
 passage of light through, 34
 profiling, 598–600
 recording video clips with, 77, 91
 resolution considerations, 16–19
 setting up, 199–223
 software for, 130
 storing images from, 69–77
 types of, 81–91
 versatility of, 8
 zooming with, 38–39
digital darkroom, 325–360. *See also* image enhancement
 accessories for, 349–351
 computer considerations, 329–341
 contrasted with "wet" darkroom, 325–327
 expert techniques, 513–591
 blurring, 520–526
 converting color to black and white, 556–562
 dodging and burning, 529–538
 improving image structure, 584–588
 improving the light, 526–556
 merging images, 569–584
 selection-based layer masks, 539–544
 sharpening, 513–520
 toning and tinting, 563–568
 working with high-bit files, 589–591
 and image backups, 341
 lighting for, 327–329
 printer considerations, 342–349
 software for, 352–360
Digital Domain, 652
digital film, 69
Digital Gem, 584
Digital Image Pro, 353
digital images

adjusting brightness levels of, 438. *See also* tonal correction
 attaching keywords to, 389–390, 662, 664, 667, 668–670
 backing up prior to editing, 366, 435
 batch-processing, 398
 batch-renaming, 387–388, 665
 categorizing, 661, 662, 667
 clarity and crispness of, 7–8
 cleaning up, 493–512
 creating slide shows of, 645–648
 deleting, 319
 developing, 325–326. *See also* digital darkroom
 downloading to computer, 361–373
 editing. *See* editing
 flagging/protecting, 318
 merging/blending, 569–584
 naming/renaming, 221, 386–388
 noise in, 59–60, 209, 210, 584–586
 numbering of, 221–222
 optimizing, 399. *See also* image enhancement
 organizing/managing, 359–361, 365–366, 376–379, 385, 657–670
 postprocessing of, 13
 preventing unauthorized use of, 638–644, 670–673
 printing. *See* printing
 ranking, 386
 rotating, 384–385
 safe-handling considerations, 434–436
 saving, 29–30, 435
 scrolling/zooming thumbnails of, 318
 sharing, 629–654
 sharpening. *See* sharpening
 sizing, 613–615, 613–616
 sorting, 385
 storage considerations, 69–77
 viewing EXIF data for, 238–239
digital imaging
 and color management, 595–596
 contrasted with digital photography, 12
 defined, 12
 key concepts regarding, 15–32
 software, 352–360
digital light table, 374–379
digital media, 69–77
 contrasted with film, 69
 evolution of, 70
 file-format considerations, 74–77
 size/speed considerations, 72–74
 types of, 69–72
digital photography. *See also* digital cameras; digital images
 and black-and-white photos, 263–265
 classes on, 12

contrasted with digital imaging, 12
contrasted with film photography, 240, 257–269
defined, 12
and depth of field, 258–262
downsides to, 12–13
efficiency/convenience of, 10
enhancing with LCD monitor, 266–268
flexibility/control afforded by, 10–11
fun of, 4, 12, 14
and image backups, 341, 435
and image quality, 7–9
and ISO settings, 266
learning curve required for, 12–13
learning from mistakes in, 269
and lens focal length, 257–258
and lens quality, 34
and multi-image collages, 569
postprocessing tasks, 13
and resolution, 15
Digital Pro, 377–378
digital single lens reflex cameras. *See* digital SLR cameras
digital slide shows, 645–648
digital SLR cameras
contrasted with deluxe point-and-shoot, 97
and focal length, 63
LCD *vs.* viewfinder on, 58
lenses for, 40–41
"digital *vs.* film" debate, 3, 12
digital wallets, 144–146
digital zoom lenses, 39, 126
Displays and Cursors preferences (Photoshop), 407–408
disposable cameras, 81
distortion, lens, 43–45
DoctorPRO, 607
Dodge tool (Photoshop), 529–530
dodging, 529–538
with adjustment layers, 530–534
defined, 325, 529
with overlay layer, 536–538
with PhotoKit, 358
with Photoshop's Dodge tool, 529–530
dot gain, 423, 617–618
dot pitch, 336
dots per inch, 16, 22
Downloader Pro, 371
downloading images, 361–373
creating folder structure prior to, 365–366
direct from camera, 362–364
to Macintosh, 367–368
software for, 368–373
via card readers, 364–365
to Windows systems, 367, 368–373

dpi, 16, 22
drag shutter technique, 254, 268
drift, monitor, 597
DSLR cameras. *See* digital SLR cameras
Duggan, Seán, 591
dust, 179–181, 506–507
Dust Off Removal feature (Nikon), 506–507
Dust Reference file (Nikon), 506
DVD, burning images to, 674, 676–677
dye-based inks, 343
dye-sub(limation) printers, 345–346, 611
dynamic range
alternate terms for, 261
combining exposures to extend, 569–573
defined, 127–128
and imaging sensors, 68–69

E
Eastman Kodak. *See* Kodak
Easy CD Creator, 676–677
edge effects, 358, 359
Edgerton, Dr. Harold, 249
editing, 373–391. *See also* image enhancement
from camera cards, 366
copying images prior to, 366, 435
defined, 373
in-camera, 317–320
on light table, 374–375
with Photoshop, 379–391, 401–402. *See also* Photoshop
software, 352–359, 401–402
with tablet and stylus, 350–351
workflow, 432
Edmund Industrial Optics, 42
Eismann, Katrin, 591
electronic gain, 60
electronic SLR viewfinder, 108
Elliptical Marquee tool (Photoshop), 539, 547–548
email, sending images via, 31, 632–634
Embedded Profile Mismatch warning (Photoshop), 426
enhancing images. *See* image enhancement
enlargers, 325
entry-level cameras, 82–83
Epson
printers, 342–343, 347, 598
Ultrachrome inks, 343
ergonomics, camera, 118–119
Ethernet, 333–334
Evaluative metering mode, 277
Evening, Martin, 358, 592
Exchangeable Image File format, 237. *See also* EXIF data
EXIF data, 185, 237–239, 406

Export Cache feature (Photoshop), 391
exposure compensation
 and autobracketing, 112–113
 flash, 117
 how and when to use, 291–296
 purpose of, 112, 290
exposure controls
 Camera RAW, 395
 digital camera, 109–115
exposure latitude, 261–262, 294
exposure-lock feature, 286–287
exposure modes, 223–236
 Aperture Priority, 231
 Full Auto, 230
 Manual, 232
 Program, 231
 Scene, 233–236
 Shutter Priority, 231–232
exposure range, 127
exposure(s)
 combining
 to extend depth of field, 574–575
 to extend dynamic range, 569–573
 compensation. *See* exposure compensation
 defined, 223–224
 determining settings for proper, 224
 evaluating
 with histogram, 296–307
 with LCD, 266
 locking, 286–287
 modes. *See* exposure modes
 over- *vs.* under-, 224, 294–296, 431
extended graphics array. *See* XGA
Extensis
 PhotoFrame, 358
 Portfolio, 657, 663–665
 pxlSmartScale, 616
external card readers, 364–365. *See also* card readers
external flash, 117, 157–159
Eye-One Display, 341, 602
Eye-One Photo, 608
Eyedropper tools (Photoshop)
 measuring tones with, 444–446
 neutralizing highlights/shadows with, 478–480
 neutralizing midtones with, 481
 setting white/black points with, 456–458
 setting white/black target colors with, 451–453
EZDigiMagic, 146

F
f-stop, 111, 226
fabric backdrops, 191
fabric reflectors, 189
FAT16/32 systems, 222–223

feathering, 544–547
 by blurring layer mask, 547
 with Gaussian Blur, 544, 545–546
 purpose of, 544
 with Quick Mask mode, 545–547
field of view crop, 164, 165
File Allocation Table, 222
File Browser (Photoshop), 238–239, 379–390, 390, 412–413
file formats, 27–31
 in the camera, 27–29
 for email/Web, 31, 631–632
 for output/printing, 31
 for storing image files, 29–30, 74–77
File Handling preferences (Photoshop), 405–407
file-numbering options, 221–222
File Transfer Protocol, 637
film
 color-balance options for, 213–214
 contrasted with digital media, 69
 cost considerations, 120
 developing, 325–326
 how images are recorded on, 33
 and ISO rating system, 60, 64, 110, 266
 and lens quality, 34
 processing, 13, 401
 shooting, 13
film cameras, shutter on, 51
film effects, 358
film grain, 59, 210
film photography
 and composition, 240
 contrasted with digital photography, 240, 257–269
 and cropping of images, 245–246
 darkroom for, 325–326
 and framing of images, 240
 and image backups, 341
 lenses for, 34
 and light, 33
"film *vs.* digital" debate, 3, 12
filter patterns, 66–67
filters, 171–179
 adapting to different lenses, 178–179
 antialiasing, 130–131
 blur, 130–131, 520–526
 cleaning, 180
 color-correcting, 178
 infrared, 176–177
 neutral density, 174–175
 nik Color Efex, 359
 polarizing, 171–173
 recommended, 171–179
 screw-on, 171
 sharpen, 515–520

skylight, 171
UV, 171
warming, 163
fine art photography, 6
FireWire connections, 350, 363
Fireworks mode, 236
fish-eye lenses, 168–169
fixed lenses, 38
flagging images, 318
flare, lens, 125
flash
 attaching more than one, 79
 brackets, 160
 exposure compensation, 117
 external, 117, 157–159
 limitations of, 156
 off-camera, 78–79, 159
 on-camera, 77–78
 and red-eye reduction, 115–117
 for studio lighting, 187
 ways of using, 78
 wireless control of, 162
flashlights, 184
FlashTrax, 145
flat-screen monitors, 336
fluorescent lighting, 188
foam-core board, 189
focal length, 35–37, 62–63, 257–258
focal-length magnification factor, 164–165
focal-length multiplier, 97–98, 258
focus
 evaluating, 316–317, 431
 sharp *vs.* soft, 255
Food mode, 236
FOV crop, 164, 165
Foveon X3 sensors, 56
frame. *See also* framing
 "breaking," 256
 importance of, 249
frames per second, 104
framing, 240–257
 allowing for cropping when, 245–246
 for digital *vs.* film photography, 240
 experimenting with different camera angles for, 243–245
 getting closer to scene/subject when, 246–249
 horizontal *vs.* vertical, 242–243
 and image relationships, 249–257
 importance of, 249
 using LCD to verify proper, 266
 using viewfinder for, 241–242
Fraser, Bruce, 338, 356, 358, 515, 591
Free Transform command (Photoshop), 404
fringing, color, 125, 587–588

FTP, 637
Fuji
 F700, 7
 Super CCD sensors, 56
Full Auto mode, 230

G
gadgets, 92–93
gaffer's tape, 194
Galen Rowell ND filters, 175
Gamut preferences (Photoshop), 408–409
Gamut Warning option (Photoshop), 409, 620–621
Gaussian Blur filter, 521–522, 544, 545–546
gels, colored, 163
General preferences (Photoshop), 403–405
Genuine Fractals, 615
GIF format, 632, 642
gigabytes (GB), 331
gigahertz (GHz), 330
Global Positioning System, 657
global tinting, 568
glossy papers, 348
GPS information, 657
Gradient Map feature (Photoshop), 561–562, 568
gradient masks, 551–556
Gradient tool (Photoshop), 551–556
graduated ND filters, 174–175
Grain Surgery, 584
Graphics Interchange Format, 632
gray card, 181–182, 328
gray eyedropper, 481
gray-market cameras, 132
gray paint, 328
gray working spaces, 423
grayscale color mode, 25
Grayscale conversion method, 557
green screening, 192
GretagMacbeth
 ColorChecker, 130, 181–182, 599
 Eye-One Display, 341, 602
 Eye-One Photo, 608
 Scale Balance Card, 182–183
GripStrip, 134
Group f64, 255

H
halos, 44, 57
Hamburg, Mark, 407
hard drives, 332, 675, 678
Harrison & Harrison filters, 177
Haynes, Barry, 591
Healing Brush tool (Photoshop), 498–502, 504–505
herringbone patterns, 67
Hewlett-Packard printers, 342

high-bit images, 23, 24, 589–591
high-contrast lighting, 253, 261, 288, 304–305
high-speed photographs, 249
highlights
 adjusting
 with Levels dialog, 447–449
 with Shadow/Highlight dialog, 471–472
 controlling, with exposure settings, 301–303
 neutralizing, 478–480
Histogram palette (Photoshop), 442
histograms
 and Camera RAW interface, 394
 and highlights, 301–303
 image review with, 315
 interpreting, 129, 297, 298–305
 purpose of, 114, 296
 in search of "perfect," 306–307
 and shadow detail, 303–304
 viewing, 114
History feature (Photoshop), 404, 436
history states, 404
Hitachi, 71
HMI lights, 188
horizontal framing, 241–243
hot glue gun, 194
hot-shoe connections, 78–79, 84, 88
Hoya filters, 177
HR sensors, 56
HTML format, 637, 643
hubs, network, 333
Hue/Saturation adjustment layers, 563

I
IBM Microdrive, 71
ICC profiles, 414, 416
ICS, 606
IEEE 1394, 363
Imacon Ixpress 96 Digital Back, 8, 9
image adjustment layers. *See* adjustment layers
Image Cache preferences (Photoshop), 411–412
Image Capture utility (Apple), 368
Image Doctor, 357
image-editing software, 352–359, 401–402
image enhancement, 401–512
 basic image clean-up, 493–512
 cloning, 494–498
 cropping, 508–512
 healing, 498–501
 patching, 502–503
 retouching, 508
 spotting, 504–507
 color correction
 with Auto features, 484–489
 with Color Balance command, 476–477
 with Curves dialog, 489–492
 with Levels dialog, 478–489
 with Photo Filter adjustment layers, 492–493
 with Variations command, 474–475
 working with individual color channels, 482–483
 customizing Photoshop for performing, 402–413
 developing strategy for, 429–437
 evaluating images, 429–432
 interpretive considerations, 433–434
 making editing plan, 432
 safe image-handling, 434–436
 technical considerations, 433
 expert techniques, 513–591
 blurring, 520–526
 converting color to black and white, 556–562
 dodging and burning, 529–538
 improving image structure, 584–588
 improving the light, 526–556
 merging images, 569–584
 selection-based layer masks, 539–544
 sharpening, 513–520
 toning and tinting, 563–568
 working with high-bit files, 589–591
 and Photoshop Color Settings dialog, 413–429
 tonal correction, 438–473
 and adjustment layers, 438–440
 and histogram data, 441–442
 improving contrast with Curves, 459–472
 improving tonal range with Levels, 446–459
 measuring tonal values, 443
 using Eyedropper tools, 444–446
image interpolation, 403–404, 616–618
image-management software, 376–379. *See also* DAM software
image quality
 and camera lenses, 41, 102
 and digital cameras, 7–8
 evaluating, on LCD screen, 314–317
 and imaging sensors, 102
image review feature, LCD, 315
image size
 adjusting
 for online viewing, 630, 639
 with Photoshop, 613–614
 for slide shows, 645
 with third-party tools, 615–616
 camera settings for, 200–202
 importance of, 200
 resolution considerations, 612–613
Image Size dialog (Photoshop), 613–615
ImageBrowser, 368
ImagePrint, 625
ImageReady, 643

images. *See also* digital images; photos
 8-bit *vs.* 16-bit, 23–24
 attaching date/time to, 221
 categorizing, 661, 662, 667
 creating slide shows of, 645–648
 cropping. *See* cropping
 editing. *See* editing
 framing, 240–241
 horizontal *vs.* vertical, 241–243
 merging, 569–584
 movement's effect on, 253–254
 organizing/managing, 359–361, 365–366, 376–379, 385, 657–670
 preventing unauthorized use of, 638–645, 670–673
 printing, 342, 648–653
 proofing prior to printing, 349
 registering for copyright, 638
 sending via email, 31, 631–632
 sharing, 629–654
 sharpening. *See* sharpening
 storing, 69–77
 upsampling, 404
 viewing EXIF data for, 238–239
 watermarking, 639–640, 642
ImageStore, 372–373, 376–377, 665–667
imaging sensors, 53–69
 and bit depth, 65
 cleaning, 179–181, 183–184
 color-blindness of, 65
 and dynamic range, 68–69
 effect of heat on, 60
 and focal length, 62–63
 how they work, 57
 and image quality, 102
 and infrared photos, 176–177
 and ISO rating system, 60–61, 64, 110
 physical size of, 62–64
 purpose of, 53
 types of, 54–56
incident light, 274
infrared filters, 176–177
infrared wireless flash, 162
inkjet printers
 archival issues, 626
 and black and white prints, 624–625
 contrasted with dye-sub, 346
 and dpi, 22
 how they work, 342–343, 611
 inks for, 343
inks, 343–345
 dye-based, 343
 inherent limitations of, 596
 pigment-based, 343
 quadtone, 344
 specialized, 344–345
 third-party, 344
Integrated Color Solutions, 606
Intel Pentium, 330
Intent option (Photoshop), 622
interchangeable lenses, 40–41, 88, 164
International Color Consortium, 414. *See also* ICC profiles
International Standards Organization, 60. *See also* ISO
Internet
 camera retailers, 131–132
 discussion groups/forums, 122
 getting product reviews via, 122
 photo-sharing services, 634–635
 print services, 627
 sharing images via, 634–638
interpolation
 color, 53, 66
 image, 403–404, 616–618
iPhoto, 371–372, 376, 638
IR wireless flash, 162
ISO
 rating system, 60–61, 64, 110, 208
 settings, 208–209, 266
iView, 376, 378–379, 647

J
Japan Electronic Industry Development Association, 237
Jasc Software
 Paint Shop Photo Album, 352
 Paint Shop Pro, 353
JEIDA, 237
JPEG compression, 203–205
JPEG format
 capturing images in, 24, 27, 65, 75
 for online photos, 631–632
 printing, 31
 saving images in, 29
 sending via email, 31
 setting digital camera for, 206
 as working format, 435

K
Kangaru Media X-change, 145
Kelvins, 210, 312
keyboard shortcuts (Photoshop), 436–437
Keynote, 646
keywords
 attaching to images, 389–390, 662, 664, 667
 developing system for, 668–670
Kieran, Michael, 591
Kinetronics, 180, 183
Knoll, John, 298

Knoll, Thomas, 298
Kodak
 DCS 100, 4, 70
 filters, 177
 NC 2000/200E, 4

L
L-plates, tripod, 153–154
Lab color mode, 26
lag time, 52–53, 103
Landscape mode, 234
large-format prints, 90
Lasso selection tool, 539
layer masks
 blurring, 547
 burning with selection-based, 547–549
 modifying edges of, 550–551
 purpose of, 439
 selection-based, 539–544
layers, 435. *See also* adjustment layers
LCD display
 checking focus/sharpness with, 316–317
 contrasted with viewfinder, 48–49, 266–267
 controlling behavior of, 315
 controlling brightness of, 221
 evaluating image quality on, 314–317
 impact on photographic experience, 10, 50
 and in-camera editing, 317–320
 minimizing power consumed by, 47
 pros and cons of, 11, 46–48
 resolution considerations, 20
 shading from bright light, 48
 turning off, 221
 ways of using, 46, 47, 266–268
LCD monitors
 calibrating, 602
 contrasted with CRT monitors, 335–336
 specifications for, 337–339
LCD settings, 315
LCD viewfinders, 106–107
Lee, Shecter, 10
Lens Blur filter, 523–525
lens distortion, 43–45
lens speed, 41
lens test charts, 42
lenses, 34–45, 164–171
 adapting filters for different, 178–179
 and chromatic aberration, 125
 cleaning, 183
 complexity of, 34
 dedicated digital SLR, 166
 for digital *vs.* film photography, 34
 and distortion effects, 125
 evaluating, 42–43, 123–126

 and exposure evenness, 125
 fast *vs.* slow, 41
 fixed, 38
 and focal-length magnification, 97–98, 164–165
 focal length of, 35–37, 62–63, 257–258
 and FOV crop, 164, 165
 and image quality, 41, 102
 interchangeable, 40–41, 88, 164
 macro, 161
 for non-SLR cameras, 168–171
 photography without, 169–171
 prime, 167
 resolving power of, 43
 sharpness of, 123–124
 wide-angle, 165
 zoom, 38–39, 126, 167–168
LensPen miniPro, 183
Lepp, George, 347
Lepp Institute, 12
Levels dialog (Photoshop), 446–458
 accessing, 446
 adjusting midtones with, 449–450
 adjusting shadows/highlights with, 447–449
 color correction with, 478–489
 controlling clipped tones with, 450–451
 finding brightest/darkest points with, 453–456
 and high-bit files, 589
 modifying mask edge with, 550–551
 purpose of, 446–447
 setting white/black points with, 456–458
 setting white/black target colors with, 451–453
 toning with, 564–565
licensing images, 670
light. *See also* lighting
 accessories, 156–163
 ambient, 327
 color temperatures for common sources of, 211
 continuous, 188
 diffusing, 162–163
 and digital photography, 34
 and film photography, 33
 how light meters "see," 272–273
 importance of, 271, 321, 526
 improving, in digital darkroom, 526–556
 incident *vs.* reflected, 274
 measuring, 210, 272–290. *See also* light meters
 ring, 161
 types of, 307
 and white balance setting, 307–313
light meters, 272–290
 and autofocus zone, 284
 deciding what to meter with, 282–285
 and exposure compensation, 292–293
 and exposure-lock feature, 286–287

how they "see" light, 272–273
overriding, 287–290
types of, 274–275
using in-camera, 281–285
light table
purpose of, 374–375
software for simulating, 375–379
lighting. *See also* light
for digital darkroom, 327–329
fluorescent, 188
high-contrast, 253, 261
and wall color, 328
LightJet printers, 627
Lightware, 134
lines, directing viewer's attention with, 252
LizardTech, 615
local tinting, 568
lockdown curves, 468–471
lossless compression, 27
lossy compression, 27, 75, 205
low-light photography, 41, 61, 111
Lumijet, 345
luminance, 272, 396
luminosity, 526–527
Luminous Landscape, 298
Lyson, 344, 345
LZW compression, 30

M
Mac OS X. *See* Macintosh
Macintosh
backup software for, 675, 676–677
downloading images to, 367–368, 368–372
image browsers for, 376
photo-editing software, 353–354
and Photoshop preferences, 402
saving/storing device profiles on, 597
vs. Windows systems, 329, 330
Macro mode, 235–236
macro photography, 161
MacSpeedZone, 330
Magic Wand tool (Photoshop), 541, 555
Magnetic Lasso tool (Photoshop), 540
"MakerNote" EXIF data, 238
Making Digital Negatives for Contact Printing, 2nd Edition, 592
Manual exposure mode, 232
Margulis, Dan, 591
Marquee selection tools (Photoshop), 539
master files, 656
Matrix metering mode, 276–278, 280
Media X-change, 145
megabytes (MB), 331
megahertz (MHz), 330

megapixels
available *vs.* effective, 18
defined, 16, 18
and image output size, 18, 19
marketing hype regarding, 22
memory, virtual, 332, 411
Memory & Image Cache preferences (Photoshop), 411–412
memory cards, 119, 142–143, 222–223
memory colors, 609
Memory Stick cards, 72
menus, camera, 119
metadata. *See also* EXIF data
defined, 237
and Extensis Portfolio, 665
and image-management software, 657
purpose of, 237, 388–389
searching for images based on, 665, 667
storing copyright information in, 641
viewing, in Photoshop Album, 661
metering modes, digital camera, 276–281
Meyer, Pedro, 6
micro reciprocal degree, 312
Microdrive, 69, 71
Microsoft
Picture It! Digital Image Pro, 353
PowerPoint, 647
midtones
adjusting, 449–450
neutralizing, 481
mired value, 312
mirror lockup feature, 155
MirrorFolder, 675
MIS Associates, 345
Missing Profile warnings (Photoshop), 425–428
moiré patterns, 67, 130
MonacoEZcolor, 607
MonacoOptix, 341, 602
monitor calibration utilities, 415, 602
monitor hoods, 327–328
Monitor Off setting, LCD, 315
monitor profiles, 597, 600–605
monitor resolution, 16, 19–20
monitors, 335–341
calibrating, 340–341, 415, 602
characterizing, 600
and digital darkrooms, 335
display size for, 335
inherent limitations of, 596
LCD *vs.* CRT, 335–336
profiling, 600–605
and shades of black, 338
using multiple, 339
monochromatic images, 263. *See also* black and white images

Monochrome mode, 236
monopods, 155
mood, establishing, 527–528
Motion Blur filter, 525
motion effects, 253–254
Mountains of California, The, 271
mouse
 optical *vs.* traditional, 350
 rollover effect, 643
Muir, John, 271
multi-image collages, 569
Multisegment metering mode, 277

N
Natural Green mode, 236
nature photography, 347, 375, 659
NC 2000/200E, 4
ND filters, 174–175
neck straps, 119
NEF format, 28, 30
networks, 333–334, 364
NiCd batteries, 140
Night Landscape mode, 235
Night Portrait mode, 233
night scenes, 289–290. *See also* low-light photography
nik Multimedia
 Color Efex, 359
 Dfine, 356–357, 584
 Sharpener, 357
Nikon
 990 camera, 5
 Capture software, 30, 506–507
 Dust Off Removal feature, 506–507
 Dust Reference file, 506
 DX series lenses, 166
 F3 camera, 4
 NEF format, 28, 30
 View, 369
NiMH batteries, 140
noise, 209, 210, 396, 559–60, 584–586
Nokia Picture Phone, 6
notepads, 185

O
off-camera flash, 78–79, 159
offset printing, 610, 628
Ofoto, 627
Olympus Camedia Master, 370
online resources/services. *See* Internet
optical mouse, 350
optical viewfinders, 107–109
optical zoom lenses, 38
Optipix, 358
OS 9. *See* Macintosh

OS X. *See* Macintosh
Ott-Lite, 328, 329
output file formats, 31
Output Levels sliders (Photoshop), 451
output resolution, 21
outtakes, deleting, 382–383, 666
overexposed images, 294–296. *See also* exposure

P
Paint Shop Photo Album, 352
Paint Shop Pro, 353
"painterly" photography, 255
panoramas
 and aspect ratio, 126
 photographing, 576–577
 printing, 347
 stitching, 575–581
 using tripods for, 115
paper, printer, 348–349
paper profiles, 605
parallax, 107
Partners in Software, 644
Patch tool (Photoshop), 502–503
Pattern metering mode, 277
PC Card adapters, 365
PC Card slot, 365
PC Magazine, 330
PCMCIA, 365
PDAs, 93, 364
Pentium processors, 330, 331
personal digital assistants. *See* PDAs
perspective cropping, 510–512
Pet mode, 236
PhaseOne, 392
photo accessories. *See* accessories
Photo Album, Paint Shop, 352
photo backdrops, 192
photo-direct printers, 612
photo-editing software, 352–359
Photo Explorer, 650
Photo Filter dialog (Photoshop), 492–493
photo floods, 188
Photo/Graphic Edges, 359
photo inkjet printers, 22, 342–345. *See also* inkjet
 printers
photo phones, 92
photo-printing services, 626–628
Photo Pro, 370
photo-sharing services, 634–635
photo studio accessories, 186–194
 backdrops, 190–192
 lighting, 187–188
 reflectors, 189
photo workshops, 12

photo workstation carts, 193
PhotoCAL, 341, 602
Photodex CompuPic Pro, 376
Photodex ProShow Gold, 647–648
PhotoDisc, 609
PhotoFrame, 358
Photographic Solutions, 180–181, 183
photography. *See also* digital photography; film pho-
 tography
 digital *vs.* film, 257–269
 importance of light in, 271, 321
 as personal expression, 3
 "straight" *vs.* "painterly," 255
PhotoImpact, 352–353, 402
PhotoKit, 358, 584
Photomerge feature (Photoshop), 582–584
photos. *See also* images
 cropping. *See* cropping
 deleting, 319
 developing, 325–326. *See also* darkroom
 editing. *See* editing
 framing, 240–243
 horizontal *vs.* vertical, 241–243
 presenting online, 629–645
 preventing unauthorized use of, 638–644, 670–673
 printing. *See* printing
Photoshop. *See also* Photoshop CS
 adjusting image size with, 613–615
 advice for new users of, 402
 attaching keywords to images in, 389–390
 basic image clean-up, 493–512
 cloning, 494–498
 cropping, 508–512
 healing, 498–501
 patching, 502–503
 retouching, 508
 spotting, 504–507
 Batch Rename feature, 387–388
 Camera Raw interface. *See* Camera RAW
 color correction
 with Auto features, 484–489
 with Color Balance command, 476–477
 with Curves dialog, 489–492
 with Levels dialog, 478–489
 with Photo Filter adjustment layers, 492–493
 with Variations command, 474–475
 working with individual color channels,
 482–483
 Contact Sheet dialog, 649–650
 customizing, 402–413
 deleting outtakes in, 382–383
 editing images in, 379–391
 and EXIF data, 238–239, 406
 expert techniques, 513–591

 blurring, 520–526
 converting color to black and white, 556–562
 dodging and burning, 529–538
 improving image structure, 584–588
 improving the light, 526–556
 merging images, 569–584
 selection-based layer masks, 539–544
 sharpening, 513–520
 toning and tinting, 563–568
 working with high-bit files, 589–591
 Export Cache feature, 391
 File Browser feature, 238–239, 379–390
 filters. *See* filters
 Help system, 437
 History feature, 404, 436
 how color is handled by, 414–416
 image-editing strategy, 429–437
 evaluating images, 429–432
 interpretive considerations, 433–434
 making editing plan, 432
 safe image-handling, 434–437
 technical considerations, 433
 "Lite" version, 440. *See also* Photoshop Elements
 and monitor calibration/profiling, 414, 415
 organizing images in, 385
 Picture Package tool, 650–652
 plug-ins, 356–359
 preferences, 402–413
 printing via, 618–626
 and professional photo-editing, 355–356, 401–402
 PSD format, 29–30, 30, 31
 RAM requirements, 411
 ranking images in, 386
 RAW format, 30
 recommended books on, 356, 591–592
 renaming images in, 386–388
 rotating images in, 384–385
 shortcuts, 436–437
 tonal correction, 438–473
 and adjustment layers, 438–440
 and histogram data, 441–442
 improving contrast with Curves, 459–472
 improving tonal range with Levels, 446–459
 measuring tonal values, 443
 using Eyedropper tools, 444–446
 viewing metadata in, 388–389
 Web Photo Gallery, 635–638
 working spaces available in, 416, 418–423
Photoshop 7 WOW Book, The, 592
Photoshop Album, 659–661
Photoshop Color Correction, 591
Photoshop CS. *See also* Photoshop
 Color Settings dialog, 416–429
 accessing, 416

Photoshop CS. *(continued)*
 Advanced Mode check box, 428
 Color Management Policies section, 424–428
 and offset printing, 628
 preset configurations for, 417–418
 purpose of, 413
 saving settings for, 428–429
 working spaces options, 418–423
 History Log feature, 405
 Photomerge feature, 582–584
 preferences panels, 402–413
 Displays and Cursors, 407–408
 File Browser, 412–413
 File Handling, 405–407
 General, 403–405
 Memory & Image Cache, 411–412
 Plug-Ins & Scratch Disks, 410–411
 Transparency & Gamut, 408–409
 Units & Rulers, 409–410
 as professional image-editing tool, 401–402
 recommended books on, 356, 591–592
 saving large files in, 406–407
Photoshop CS Artistry, 591
Photoshop Elements, 353–354, 402, 440
Photoshop Restoration & Retouching, 2nd Edition, 508, 591
pictorialist photography, 255
Picture Package tool (Photoshop), 650–652
picture phones, 6, 82
pigment-based inks, 343
PIMA/ISO Resolution Test Chart, 42
pincushion distortion, 43–44, 45, 125
pinhole photography, 169–171
Pinhole Resource, 170
Pixel Genius, 358, 584
pixels
 physical size of, 64
 total count *vs.* density of, 17
 ways of measuring, 15–16
pixels per inch, 16
Planck, Max, 213
playback options, 119
Plug-Ins & Scratch Disks preferences (Photoshop), 410–411
plug-ins (Photoshop), 356–359
pocket drives, 144–146
point-and-shoot digital cameras, 41, 82, 83–85, 97
point of view, 251
polarizing filters, 171–173
Polaroid cameras, 81
Polygonal Lasso tool (Photoshop), 540
Pool Highlights image, 570–573
portable CD burners, 146
portable solar panels, 141
Portrait mode, 233

portraiture, 8, 10
posterization, 438
power adapters, 140
Power Mac G5 processor, 330
PowerPC, 222
PowerPoint, 647
ppi, 16
prime lenses, 164, 167
print packages, 648–653
print size, 346–347, 612–613
Print Space option (Photoshop), 622
Print with Preview dialog (Photoshop), 621–623
printer profiles, 605–608
 building your own, 606–608
 for Epson printers, 598
 fine-tuning, 609–610
 importance of, 610
 purpose of, 605
 sharing, 597–598
 sources of, 606
Printer Properties dialog (Photoshop), 623–624
printer resolution, 16, 21–22
printers, 342–349
 cost considerations, 348–349
 evaluating prints produced by, 608–610
 inherent limitations of, 596
 inkjet *vs.* dye-sub, 346
 and print longevity, 346
 print media considerations, 348–340
 and print size, 346–347, 612–613
 profiling, 605–610
 resolution considerations, 612–613
 resource for test results on, 346
 sharing, 333
 types of, 342–346, 610–612. *See also* specific types
 wide-format, 347
PrintFIX, 606–607
printing
 black and white, 624–625
 and color management, 595–596
 file-format considerations, 31
 matching monitor image with print, 595–596
 via outside services, 626–628
 via Photoshop, 618–626
printing services, 626–628
prints
 evaluating accuracy of, 608–610
 size/resolution considerations, 612–613
Pro Shooters, 377
processor speeds, computer, 330
professional digital SLR cameras, 82, 88–89. *See also* digital SLR cameras
professional photo-editing software, 355–359, 401–402
Professional Photoshop, 591

Profile Mismatch warnings (Photoshop), 425–428
ProfileCity, 606
profiles
 color, 414, 416
 device, 596–610. *See also* device profiles
profiling services, 606
Program mode, 231
Proof Setup dialog (Photoshop), 618–620
proofing images, 349
ProShow Gold, 647–648
prosumer cameras, 82, 86–87
PSB format, 406
PSD format, 656
 and composite layers, 407
 printing, 31
 saving images in, 30, 435
 using TIFF in place of, 29
pxlSmartScale, 616

Q

Qimage, 652–643
quadtone inks, 344
Quantum Instruments, 139
Quantum Mechanic, 357
Quick Mask mode (Photoshop), 545–547

R

Radial Blur filter, 525
RAM, 331, 411, 412, 590
rangefinders, 107
Rank Files feature (Photoshop), 386
RAW format
 and 16-bit captures, 24
 capturing images in, 28–29, 75
 converting to true image file format, 391–398
 maximizing exposure possibilities with, 307
 pros and cons of, 29, 75–76
 saving images in, 30
 setting digital camera for, 207
 and white balance, 309
Rea, Dave, 147
Real World Adobe Photoshop CS, 356, 591
Real World Color Management, 338
Really Right Stuff, 153, 154, 160
reciprocity, 227–230
 benefits of, 229–230
 defined, 227
 failure, 228
 how it works, 228
Rectangular Marquee tool (Photoshop), 539
red-eye reduction, 115–117
reflected light, 274
reflectors, 186, 189
refresh rate, 336

registration, copyright. *See* copyright
Reichmann, Michael, 298
Reindeer Graphics, 358
remote release, triggering shutter with, 155
rendering intent, 622
Resnick, Seth, 358, 638, 641
resolution, 15–22
 CRT monitor, 336
 determining requirements for, 17–18
 general guidelines for, 95
 and image information, 17
 importance of, 15
 LCD monitor, 337–338
 marketing hype regarding, 22
 and photo-editing process, 18
 and print output size, 612–613
 for slide shows, 645–646
 ways of measuring, 16
resolving power, lens, 43
retouching
 layers, 435
 with Photoshop's Clone Stamp tool, 587–588
 recommended book on, 508
Retro mode, 236
Retrospect, Dantz, 675, 677
RGB color mode, 25–26, 219–220
RGB working spaces, 418–422
right-clicking, disabling, 644
ring lights, 161
ringaround, 474
Rodney, Andrew, 338, 358
rollovers, 643
Roxio backup software, 676–677
Rulers preferences (Photoshop), 409–410

S

S-curve, adding/reducing contrast with, 464–468
safe image-handling, 434–436
Santa Fe Workshops, 12
Saturation slider (Camera RAW), 395
Scale Balance Card (GretagMacbeth), 182–183
scanning, digital *vs.* film, 617
scanning back sensors, 56
scene modes, 109–110, 233–236
Schewe, Jeff, 358
scientific photography, 56
Scratch Disk preferences (Photoshop), 410–411
scroll feature, thumbnail, 318
seek time, hard drive, 332
Selection tools (Photoshop), 539–541
Sensor Cleaning mode, 180
Sensor Swab, 180, 183
sensors. *See* imaging sensors
sepia toning, 359

Shadow/Highlight dialog (Photoshop), 471–472
shadows
 adjusting, with Photoshop's Levels dialog,
 447–449
 and exposure latitude, 261–262
 and LCD monitors, 338
 neutralizing, 478–480
 photographing, 253
 preserving detail in, 303–304
Shadows slider (Camera RAW), 395
Sharpen Edges filter (Photoshop), 520
Sharpen filter (Photoshop), 520
Sharpen More filter (Photoshop), 520
Sharpener plug-in, 357
sharpening, 513–520
 how it works, 514–515
 how much to apply, 517–519
 for online viewing, 631
 purpose of, 513
 with Sharpen Edges filter, 520
 with Sharpen filter, 520
 with Unsharp Mask filter, 515, 516–517
 when to apply, 514, 515
sharpening option, digital camera, 218–219, 513
sharpness
 image, 431–432
 lens, 43, 123–124
Shaw, John, 375
shortcuts (Photoshop), 436–437
shoulder, curve, 460
shutter, 51–53
 on digital *vs.* film camera, 51
 drag, 254, 268
 electronic remote release for, 155
 lag, 51–52, 103
 and mirror lockup feature, 155
 purpose of, 51
 speed, 111–112, 227, 254
shutter-priority mode, 111, 231–232
Shutterfly, 627
Sigma
 Photo Pro, 370, 398
 SD9 camera, 56
Silly Putty, 194
Singh-Ray, 175
single lens reflex cameras, 40. *See also* digital SLR
 cameras
Skurski, Mike, 358
skylight filters, 171
slaves, 162
slide-show software, 646–648
slide shows, 645–648
SLR cameras, 40
SLR viewfinder, 108–109

SmartDisk, 145
SmartMedia cards, 71
SmoothShow, 648
sneakernet, 333
snow scenes, 288–289
soft proofing, 618–620
SoftRAID, 675
software, 352–360
 camera, 130
 for downloading images, 368–373
 image browser, 376
 photo-editing, 352–359
 for sorting/organizing images, 359–360, 376–379,
 659–667
solar panels, portable, 141
solarization, 359
SoLux, 328, 608
Sony
 Artisan monitor, 340, 604
 Mavica Video Still Camera, 4
 Memory Stick format, 72
Source Space option (Photoshop), 622
SpeckGrabber, 180, 183
speed issues, 102–105
split-toning procedure, 565–567
Sports mode, 236
Spot metering mode, 276, 280–281
spot working spaces, 423
spotting images, 504–507
Spyder Colorimeter, 341
sRGB, 219–220, 419–420, 631
stepping rings, 178–179
stitching panoramas, 575–581
storage accessories, 142–147. *See also* digital media;
 memory cards
 camera media, 142–144
 digital wallets, 144–146
 pocket drives, 144–146
 portable CD burners, 146
straps, neck/wrist, 119
studio photography, accessories for, 186–194
stylus, editing images with, 350–351
subtractive color space, 473–474
Super CCD sensors, 56
super extended graphics array, 19
SVGA, 645
swabs, sensor-cleaning, 180–181
sweep tables, 192–193
SWOP2 setting (Photoshop), 628
SXGA, 19
symmetrical balance, 249–250
sync cables, 162

T

tables
hiding online images in, 642–643
light, 374–375
sweep, 192–193
tablets, Wacom, 350–351
tags, image, 660, 661
tape, backing up images to, 676
Tapp, Eddie, 10
Techsoft, 675
Text tool (Photoshop), 433
textured backdrops, 192
thermal printers, 342
through-the-lens viewfinder, 108
throughput rate, hard drive, 332
thumbnails
generating, for contact sheets, 649–650
and in-camera editing, 317–318
using ImageStore to view, 666–667
using Photoshop Album to view, 659
TIFF format
and 8-bit captures, 24
capturing images in, 27–28, 75
and master images, 656
printing, 31
and RAW captures, 28
as replacement for PSD format, 29
saving images in, 29–30, 75, 435
setting digital camera for, 206–207
tinting, 568
Toast, Roxio, 676–677
tonal correction, 438–473
and adjustment layers, 438–440
and histogram data, 441–442
improving contrast with Curves, 459–472
improving tonal range with Levels, 446–459
measuring tonal values, 443
using Eyedropper tools, 444–446
tonal range, 127, 441–442, 446–447
tonal values, 443
toning, 563–568
with Hue/Saturation layer, 563
with Levels and Curves, 564–565
sepia, 359
with split-toning procedure, 565–567
Transparency & Gamut preferences (Photoshop), 408–409
tripods, 147–155
aluminum *vs.* carbon fiber, 148
contrasted with monopods, 155
heads/controls for, 150–151
L-plates for, 153–154
mounts for, 114–115
positioning third leg of, 150
purpose of, 147–148
quick releases for, 152, 153
TTL Software, 372, 376, 665–667
TTL viewfinder, 108
tungsten-halogen lamps, 188

U

Ulead
Photo Explorer, 376, 650
PhotoImpact, 352–353, 402
Ultra ATA/100 interface, 332
UltraChrome inks, 343
umbrellas, reflector, 189
underexposed images, 294–296. *See also* exposure
United States Copyright Office, 673. *See also* copyright
Units & Rulers preferences (Photoshop), 409–410
Universal Serial Bus, 362. *See also* USB connections
Unsharp Mask filter (Photoshop), 515, 516–517
upgrades, camera, 131
upsampling images, 404
U.S. Copyright Office, 673. *See also* copyright
USB connections, 350, 362–363
UV filters, 171

V

Variations command (Photoshop), 474–475
Varis, Lee, 435
Velcro, 185, 194
Veritas Backup Exec, 677
Versace, Vincent, 120
vertical framing, 241–243
video clips, 77, 91
viewfinders
defined, 46
framing images in, 240–245, 249
types of, 106–109
using LCD display as, 46, 47
vs. LCD display, 48–49
viewing angle, monitor, 337
viewing booths, 608
vignetting effect, 179, 397
virtual memory, 332, 411
Visual Infinity, 584
voltage adapters, 140

W

Wacom tablets, 350–351
war photography, 246
warming filters, 163
warranties, camera, 131, 132
watermarks, 639–640, 642
Web gallery software, 635–638
Web Photo Gallery (Photoshop), 635–638

Webcams, 92–93
wedding photography, 659
Weston, Edward, 255
white balance, 210–218, 307–313
 and autobracketing, 310–312
 and Camera RAW interface, 394–395
 and color-correcting filters, 178
 and color temperature, 210–214
 and colored gels, 163
 creating custom, 308–309
 as creative tool, 313
 experimenting with, 307
 presets for, 215
 purpose of, 307
 and RAW format, 309
 science behind, 210–214
 setting, 181, 214–218
 using as filter system, 218
white card, 181
white points, setting, 456–458
Wi-Fi, 334
Wi-Pics, 147
wide-angle lenses, 165
Wilhelm Imaging Research, 343, 346, 626
Willmore, Ben, 592
Windows computers
 backup software for, 675, 676–677
 downloading images to, 367
 image browsers for, 376
 photo-editing software for, 352–354
 and Photoshop preferences, 402
 saving/storing device profiles on, 597
 vs. Macintosh, 329, 330

wire, 185, 194
wireless fidelity, 334
wireless image transfer, 147
wireless networks, 334, 364
workflow, 432, 658
working spaces, 418–423
 CMYK, 422–423
 downloading, 421
 gray, 423
 purpose of, 416
 recommendations regarding, 418, 421
 RGB, 418–422
 spot, 423
workshops, digital photography, 12
workstation carts, photo, 193
Wratten filters, Kodak, 177
wrist straps, 119
write speed, 104

X
X-Rite, 602
xD-Picture cards, 72
XGA, 19, 645

Z
ZIP compression, 30
zoom feature, thumbnail, 318
zoom lenses, 38–39, 167–168
ZoomBrowser, 368–369